Cinema Studies: The Key Concepts

This is the essential guide for anyone interested in film. Now in its second edition, the text has been completely revised and expanded to meet the needs of today's students and film enthusiasts. Some 150 key genres, movements, theories and production terms are explained and analysed with depth and clarity. Entries include:

- auteur theory
- Black Cinema
- British New Wave
- feminist film theory
- intertextuality
- method acting
- pornography
- Third World Cinema
- War films

A bibliography of essential writings in cinema studies completes an authoritative yet accessible guide to what is at once a fascinating area of study and arguably the greatest art form of modern times.

Susan Hayward is Professor of French Studies at the University of Exeter. She is the author of *French National Cinema* (Routledge, 1998) and *Luc Besson* (MUP, 1998).

Also available from Routledge Key Guides

Ancient History: Key Themes and Approaches

Neville Morley

Cinema Studies: The Key Concepts (Second edition)

Susan Hayward

Eastern Philosophy: Key Readings

Oliver Leaman

Fifty Eastern Thinkers

Diané Collinson

Fifty Contemporary Choreographers

Edited by Martha Bremser

Fifty Key Contemporary Thinkers

John Lechte

Fifty Key Jewish Thinkers

Dan Cohn-Sherbok

Fifty Key Thinkers on History

Marnie Hughes-Warrington

Fifty Key Thinkers in International Relations

Martin Griffiths

Fifty Major Philosophers

Diané Collinson

Key Concepts in Cultural Theory

Andrew Edgar and Peter Sedgwick

Key Concepts in Eastern Philosophy

Oliver Leaman

Key Concepts in Language and Linguistics

R. L. Trask

Key Concepts in the Philosophy of Education

John Gingell and Christopher Winch

Key Concepts in Popular Music

Roy Shuker

Key Concepts in Post-Colonial Studies

Bill Ashcroft, Gareth Griffiths and Helen Tiffin

Social and Cultural Anthropology: The Key Concepts

Nigel Rapport and Joanna Overing

Cinema Studies: The Key Concepts

Second edition

Susan Hayward

London and New York

791.4303 HAY

68445

First published 2000 by Routledge 11 New Fetter Lane, London EC4P 4EE

Simultaneously published in the USA and Canada by Routledge 29 West 35th Street, New York, NY 10001

Reprinted 2001

Routledge is an imprint of the Taylor & Francis Group

© 2000 Susan Hayward

Typeset in Bembo by Florence Production Ltd, Stoodleigh, Devon

Printed and bound in Great Britain by St Edmundsbury Press, Bury St Edmunds, Suffolk

All rights reserved. No part of this book may be reprinted or reproduced or utilized in any form or by any electronic, mechanical, or other means, now known or hereafter invented, including photocopying and recording, or in any information storage or retrieval system, without permission in writing from the publishers

British Library Cataloguing in Publication Data A catalogue record for this book is available from the British Library

Library of Congress Cataloging in Publication Data A catalogue record for this book has been requested

ISBN 0-415-22739-9 (hbk) ISBN 0-415-22740-2 (pbk)

For my students.

CONTENTS

Preface to the first edition	1X
Acknowledgements	xi
List of Key Concepts	xii
KEY CONCEPTS	1
Bibliography	476
Index of Films	495
Name Index	505
Subject Index	517

ZIJE TRO

and the same of

N N

Secretary of

in an

y later

PREFACE TO THE FIRST EDITION

Key Concepts in Cinema Studies has been two years in the writing. It is intentionally an in-depth glossary which, it is hoped, will provide students and teachers of film studies and other persons interested in cinema with a useful reference book on key theoretical terms and, where appropriate, the various debates surrounding them. The glossary also gives historical overviews of key genres, film theory and film movements. Naturally, not 'everything' is covered by these entries. In a later edition further entries may be included, and I would welcome suggestions of further entries from readers. The present book is based on my perception of students' needs when embarking on film studies; its intention is also to give teachers synopses for rapid reference purposes. Entries have been written as lucidly and as succinctly as possible, but doubtless there will be some 'dense' areas; again I welcome feedback. My own students have been very helpful in this area.

All cross-references are in bold. Sometimes the actual concept cross-referred may not be the precise form in the entry (for example, **ideological** in bold actually refers to an entry on ideology). Bibliographical citations at the end of certain entries refer to the bibliography at the end of the book. Wherever it is useful to explain the particular relevance or direction of a suggested text, this has been done. Cross-references and bibliographies are given in order of importance wherever this seemed significant, otherwise in alphabetical order.

Finally, instead of a table of contents in traditional style I have supplied a list of all concepts dealt with in this book. Where a concept is part of a larger issue, the entry is a cross-reference to the main entry where it is discussed (thus, 'jouissance' is entered under the 'J' entries but as a cross-reference to 'psychoanalysis'

Preface to the first edition

where it is explained. At the beginning of most entries there is a parenthesis suggesting that you consult other entries – I believe you will find this dipping across useful and that it will help widen the issue at hand.

ACKNOWLEDGEMENTS

My thanks for the Second Edition extend to Jacqueline Maingard for her help on certain entries (specifically Postcolonial Theory, Third Cinema, Third World Cinema); to my mother Kathleen Hayward for her assistance on the Bibliography. All other thanks remain the same. Thus, I would like to thank various people who have helped this project along. First, Rebecca Barden, my editor, whose unfailing enthusiasm for the project has made it such an enjoyable book to write. Second, colleagues, students and Routledge readers who put a lot of effort into giving me feedback on the different entries. Third, I must express my thanks to the British Film Institute for its existence and the extremely helpful librarians who made my task that much easier. My thanks for the First Edition also go to Professor Jennifer Birkett for making time available to complete the project.

ACKNOWLEDGEMENTS

Languard's affective of the company of the company

LIST OF KEY CONCEPTS

A

absence/presence
adaptation
agency
ambiguity
anamorphic lens
animation
apparatus
art cinema
aspect ratio
asynchronization/asynchronous sound
audience
auteur/auteur theory/politique des auteurs/Cahiers
du cinéma
avant-garde

B

backstage musical see musical
Black cinema – UK
Black cinema/Blaxploitation movies – USA
B-movies
body horror films see horror films
British New Wave
buddy films

C

Cahiers du cinéma group see auteur/auteur theory, French New Wave

castration/decapitation see psychoanalysis

censorship

cinema nôvo

cinemascope

√cinéma-vérité

class

classic canons see codes and conventions

classic Hollywood cinema/classic narrative cinema/ classical narrative cinema

codes and conventions/classic canons

colour

comedy

connotation see denotation/connotation content see form/content

continuity editing

costume dramas

counter-cinema/oppositional cinema

crime thriller, criminal films see film noir, gangster/criminal detective thriller, private-eye films, thriller

cross-cutting

cut

D

decapitation see castration/decapitation

deconstruction

deep focus/depth of field

denotation/connotation

depth of field see deep focus

desire see fantasy, flashbacks, narrative, spectator, stars, subjectivity

detective thriller see gangster films

diachronic/synchronic

diegesis/diegetic/non-diegetic/extra- and intra-diegetic

director

director of photography

discourse

disruption/resolution

dissolve/lap-dissolve distanciation documentary dollying shot see tracking shot dominant/mainstream cinema

E

editing/Soviet montage
ellipsis
emblematic shot
enunciation
epics
European cinema
eyeline matching
excess

expressionism see German expressionism

F

fade fantasy/fantasy films female spectator see spectator feminist film theory fetishism see film noir, voyeurism/fetishism film industry see Hollywood, studio system film noir film theory see theory flashback / foregrounding form/content framing Free British Cinema French New Wave/Nouvelle Vague K French poetic realism futurism

G

gangster/criminal/detective thriller/private-eye films gaze/look gender genre/sub-genre
German expressionism
Germany/New German cinema
gesturality
gothic horror see horror

H

Hammer horror see horror

 ✓ Hays code hegemony historical films/reconstructions Hollywood
 ✓ Hollywood blacklist

Hollywood majors see classic Hollywood cinema, studio system horror/gothic horror/Hammer horror/horror thriller/body horror/vampire movies

/ iconography

identification see distanciation, spectator-identification identity see psychoanalysis, spectator-identification, subjectivity idealogy.

ideology image
 image

| Imaginary/Symbolic independent cinema

/ intertextuality
Italian neo-realism

J

jouissance see psychoanalysis jump cut

L

lap dissolve see dissolve

lighting

look see gaze/look, imaginary/symbolic, scopophilia, suture

M

mainstream cinema see dominant/mainstream cinema matchcutting

mediation
melodrama and women's films

metalanguage

metalanguage
metaphor see metonymy/metaphor
method acting
metonymy/metaphor
mise-en-abîme
mise-en-scène

misrecognition see psychoanalysis, suture

modernism
montage see editing, Soviet cinema
motivation
musical
myth

narrative/narration

N

naturalizing
naturalism
neo-realism see Italian neo-realism
New German cinema see Germany/New German cinema
New Wave/Nouvelle Vague see French New Wave

0

Oedipal trajectory
180-degree rule
opposition see narrative, sequencing
oppositional cinema see counter-cinema

P

paradigmatic/syntagmatic see structuralism/post-structuralism parallel reversal parallel sequencing see editing patriarchy see Imaginary/Symbolic, Oedipal trajectory, psychoanalysis performance see gesturality, star system plot/story see classical Hollywood cinema, discourse, narrative point of view/subjectivity see subjective camera, subjectivity politique des auteurs see auteur, French New Wave, mise-en-scène pornography

postcolonial theory postmodernism

post-structuralism see structuralism/post-structuralism

preferred reading

presence see absence/presence private-eye films see gangster films producer

projection see apparatus, psychoanalysis projector see apparatus

psychoanalysis

psychological thriller see thriller

Q

Queer cinema

R

• realism

reconstructions see historical films repetition/variation/opposition see narration, sequencing representation see feminist film theory, gender, sexuality, stereotypes, subjectivity resistances see avant-garde, counter-cinema reverse-angle shot see shot/reverse-angle shot road movie rules and rule-breaking see counter-cinema, jump cut

S

science fiction films scopophilia/scopic drive/visual pleasure seamlessness semiology/semiotics/sign and signification sequencing/sequence setting sexuality

shots
shot/reverse-angle shot
sign/signification see semiology/semiotics

social realism
 sound/soundtrack
 Soviet cinema/school

Soviet montage see editing, Soviet cinema

space and time/spatial and temporal contiguity spectator/spectator-identification/female spectator stars/star system/star as capital value/star as construct/star as deviant/star as cultural value: sign

and fetish/stargazing and performance

stereotype structuralism/post-structuralism studio system subject/object subject/subjectivity subjective camera surrealism

syntagmatic see paradigmatic

T

theory
Third Cinema
Third World Cinemas
30-degree rule
thriller/psychological thriller
time and space see spatial/temporal contiguity
tracking shot/travelling shot/dollying shot
transitions see cut, dissolves, fade, jump cut, unmatched shots,
wipe

transparency/transparence travelling shot see tracking shot

U

underground cinema unmatched shots

V

vampire movies see horror movies variation see repetition
vertical integration
violence see censorship, voyeurism/fetishism
visual pleasure see scopophilia
voyeurism/fetishism

W

war films
Westerns
wipe
women's films see melodrama and women's films

Z

zoom

absence/presence (see also apparatus) A first definition: cinema makes absence presence; what is absent is made present. Thus, cinema is about illusion. It is also about temporal illusion in that the film's narrative unfolds in the present even though the entire filmic text is prefabricated (the past is made present). Cinema constructs a 'reality' out of selected images and sounds.

This notion of absence/presence applies to character and gender representation within the filmic text and confers a reading on the narrative. For example, an ongoing discourse in a film on a central character who is actually off-screen implies either a reification (making her or him into an object) or a heroization of that character. Thus, discourses around absent characters played by the young Marlon Brando, in his 1950s films, position him as object of desire, those around John Wayne as the all-time great American hero. On the question of genderpresence, certain genres appear to be gender-identified. In the western, women are, to all intents and purposes, absent. We 'naturally' accept this narrative convention of an exclusively male point of view. But what happens when a western is centred on a woman, for example Mae West in Klondike Annie (Raoul Walsh, 1936) and Joan Crawford in Johnny Guitar (Nicholas Ray, 1954)? Masquerade, mimicry, cross-dressing and gender-bending maybe, but also a transgressive (because it is a female) point of view - absence made presence.

Absence/presence also feeds into nostalgia for former times. This is most clearly exemplified in the viewing of films where the **stars** are now dead. Obviously, the nostalgia evoked is for different types of 'realities' depending on the star yearned after. For example, Marilyn Monroe and James Dean elicit different

nostalgia responses from those of Cary Grant and Deborah Kerr. A second definition (see also apparatus, Imaginary/Symbolic, psychoanalysis, suture): film theorists (Baudry, Bellour, Metz, Mulvey (all 1975) making psychoanalytic readings of the dynamic between screen and spectator have drawn on Sigmund Freud's discussions of the libido drives and Jacques Lacan's of the mirror stage to explain how film works at the unconscious level. The mirror stage is the moment when the mother holds the child up to the mirror and the child imagines an illusory unity with the mother. This is a first moment of identification. with the mother as object. This moment is short-lived, for the child subsequently perceives either his difference from or her similarity with the mother. At this point the child imagines an illusory identification with the self in the mirror but then senses the loss of the mother. In Lacanian psychoanalytic terms this part of the mirror stage is termed the Imaginary. The next phase of the mirror stage is termed the Symbolic and can be explained as follows. The child, having sensed the loss of the mother, now desires reunification with her. But this desire is sexualized and so the father intervenes. He enters as the third term into the mirror/reflection, forming a triangle of relationships. He prohibits access to the mother by saying 'No'. In this way language functions as the Symbolic order. For the child to become a fully socialized being/subject, she or he must obey the father's 'No': that is, the 'Law of the Father'. In so doing, the child enters the realm of language (enters the Symbolic Order): she or he conforms to the Law of the Father which is based in language (the uttered 'No'). The process of socialization for the male child is complete, supposedly, when he finds eventual fulfilment in a female other; the female child, for her part, turns first to her father as object of desire and later transfers that desire onto a male other. (For further clarification see Imaginary/Symbolic and Oedipal trajectory; and for a full discussion see Lapsley and Westlake, 1988, 80-90.)

By analogy with this psychoanalytic description of the mirror stage, the screen is defined as the site of the Imaginary: making absence presence (bringing into the spectator's field of vision images of people or stars who are not in real life present). The screen also functions to make presence absence: the spectator is absent from the screen upon which she or he gazes. However, the interplay between absence and presence does not end here; if it did it would end in spectator alienation. Although the

spectator is absent from the screen, she or he becomes presence as the hearing, seeing subject: without that presence the film would have no meaning. In this respect the screen is seen as having analogies with the mirror stage. The screen becomes the mirror into which the spectator peers. At first the spectator has a momentary identification with that image and sees herself or himself as a unified being. She or he then perceives her or his difference and becomes aware of the lack, the absence or loss of the mother. Finally, she or he recognizes herself or himself as perceiving subject. According to this line of analysis, at each film viewing there occurs a re-enactment of the unconscious processes involved in the acquisition of sexual difference (the mirror stage), of language (entry of the Symbolic) and of autonomous selfhood or subjectivity (entry into the Symbolic order and rupture with the mother as object of identification). It is through this interplay of absence/presence that cinema constructs the spectator as subject of the look and establishes the desire to look with all that it connotes in terms of visual pleasure for the spectator (see gaze). But this visual pleasure is also associated with its opposite: the shame of looking. Absence/ presence now functions so as to position the spectator as 'she or he who is seeing without being seen'. In this regard, cinema makes possible the re-enactment of the primal scene - that is, according to Freud, the moment in a child's psychological development when it, unseen, watches its mother and father copulating (see scopophilia, voyeurism/fetishism).

A third definition: woman as absence (as object of male desire), man as presence (as perceiving subject). The woman is eternally fixed as feminine, but not as subject of her own desire. She is eternally fixed and, therefore, mute.

For further discussion, see feminist film theory, gaze, scopophilia, spectator-identification.

adaptation Literary adaptation to film is a long established tradition in cinema starting, for example, with early cinema adaptations of the Bible (e.g., the Lumière brothers' thirteenscene production of La Vie et passion de Jésus Christ, 1897, and Alice Guy's La Vie de Christ, 1899). By the 1910s, adaptations of the established literary canon had become a marketing ploy by which producers and exhibitors could legitimize cinemagoing as a venue of 'taste' and thus attract the middle classes to

their theatres. Literary adaptations gave cinema the respectable cachet of entertainment-as-art. In a related way, it is noteworthy that literary adaptations have consistently been seen to have pedagogical value, that is, teaching a nation (through cinema) about its classics, its literary heritage. Note how in the UK the BBC releases a film, made for screen and subsequently television viewing, and then issues a teaching package (video plus a teacher and student textbook). The choice of novels adapted has to some extent, therefore, to be seen in the light of nationalistic 'value'.

A literary adaptation creates a new story, it is not the same as the original, it takes on a new life, as indeed do the characters. Narrative and characters become independent of the original even though both are based – in terms of genesis – on the original. The adaptation can create stars (in the contemporary UK context, Colin Firth, *Pride and Prejudice*, 1995, Ewan McGregor, *Trainspotting*, 1995, Robert Carlyle, *The Full Monty*, 1997), or stars become associated with that 'type' of role (Emma Thompson, Helena Bonham-Carter, Nicole Kidman, Holly Hunter), whereas the novel creates above all characters we remember and associate with a particular type of behaviour (e.g. Mrs Bennett, Darcy in *Pride and Prejudice*). As André Bazin says 1967, 56), film characterization creates a whole new mythology existing outside of the original text.

Essentially there appear to be three types of literary adaptation: first, the more traditionally connoted notion of adaptation, the literary classic; second, adaptations of plays to screen; and, finally, the adaptation of contemporary texts not yet determined as classics and possibly bound to remain within the canon of popular fiction. Of these three, arguably, it is the second that remains most faithful to the original, although contextually it may be updated into contemporary times, as with several Shakespeare adaptations (for example, Baz Lurhmann's Romeo and Juliet, 1996, which is recast into contemporary Los Angeles). The focus of this entry is primarily on the first type of adaptation, although mention will be made of the third type.

Literary adaptations are, within the Western context, perceived as mostly a European product – almost as if Europe has the established literary canon and northern America has not. It should be pointed out, however, that, while this European heritage cinema is the one that predominates and while it represents a deliberate marketing ploy for exports (Europe sells its

culture to the 'rest of the world'), the United States does have its own literary classics that get adapted – the novels and short stories of Henry James and those of Edith Wharton spring to mind (e.g., Portrait of a Lady, Jane Campion, 1996; The Age of Innocence, Martin Scorsese, 1993). Jack Clayton's 1974 version of Scott Fitzgerald's The Great Gatsby is arguably the benchmark movie of lavish literary adaptation Hollywood-style. Modern classics, written by African-American novelists, also rank quite highly (e.g., Alice Walker's The Color Purple, Spielberg, 1985, and Toni Morrison's Beloved, Demme, 1998). Otherwise, Hollywood is more commonly associated with popular fiction adaptations (especially detective fiction).

In relation to other generic types, critical literature on literary adaptations is somewhat thin. There appears to have been a surge of interest during the 1970s (e.g., Bluestone, 1971, Marcus, 1971; Horton and Magretta, 1981; Wagner, 1975) and then again in the mid-1980s through the 1990s (e.g. Morrissette, 1985: Friedman, 1993: Marcus 1993: McFarlane 1996: Griffith, 1997). While literary adaptations have not attracted much analytical attention in the field of film studies per se, one could speculate that the first manifestation of critical writing in the 1970s is linked to the introduction of film courses into Departments of English and Foreign Languages. The fact that the focus of these studies was on questions of fidelity to the original text would tend to support this argument. Furthermore, this interest in literary adaptations could be read as a reaction to the more difficult branch of film theory being practised at that time, namely, structuralism and a bit later post-structuralism. The more recent interest appears to correspond to a time when literary adaptations are at their most popular on screen (particularly in Britain and France).

Fidelity criticism, which makes up a great deal of literary adaptation criticism, focuses on the notion of equivalence. This is a fairly limited approach, however, since it fails to take into account other levels of meaning. More recently (Andrew, 1984; Marcus, 1993) have stressed the importance of examining the 'value' of the alterations from text to text. For example, films are more marked by economic considerations than the novel and this constitutes a major reason why the adaptation is not like the novel. Furthermore, it is clear that the choice of stars will impact on the way the original text is interpreted; adaptations will cut sections of the novel that are deemed un-cinematographic or of no interest to

the viewers. In other words, there is always a motivation behind the choices made. Marcus (ibid.) and Monk (1996, 50-1) have pointed to the need for a third level criticism: that is, to see the adaptation within a historical and semiotic context. Thus, it is not sufficient to show, through fidelity criticism, the difference between the texts, nor does it suffice to do a textual analysis based on a demonstration of how the film renders (or not) the language and style of the original through mise-en-scène, editing techniques, the symbolic use of images and, finally, the sound-track and music. We need to understand the meaning of these differences within a socio-political, economic and historical context. We need to understand the signs of difference. Adaptations are a synergy between the desire for sameness and reproduction on the one hand, and, on the other, the acknowledgement of difference. To a degree they are based on elision and deliberate lack and at the same time in the privileging, even to excess, of certain narrative elements or strategies over others.

Film adaptations are both more and less than the original. More not just because they are in excess of the written word (through having both image and sound). But more also because they are a mise-en-abîme of authorial texts and therefore of productions of meaning. To explain: there is the original text (T^1) , the adapted text (T^2) , the film text (T^3) , the director text(s) (T^{4n}) , the star text(s) (T^{5n}) , the production (con)texts (T^{6n}) , and finally the various texts' own intertexts (T⁷ⁿ). Such a chain of signifiers makes it clear that the notion of authorship becomes very dispersed. Thus, quite evidentially, the film is less because the original author is only one among many (we hear complaints from the audience: 'it's not what the author wrote'). But it is also more because of the density of new texts (and textual meanings, purposes and motivations) clustered around the original (again audiences complain: 'it's not at all like the book'). Imagine, finally within this context, the effects of modernizing a classic literary text.

Audiences might complain. And yet they go in their droves to see the classics on screen. Higson (1993, 120) is right to say that the replaying or downplaying of the original material is at least matched by if not superseded by the 'pleasures of pictorialism'. Our pleasure is deeper than our pained expressions at the end of the film. Strong (1999, 61) usefully invokes the term 'neutering'. Although he uses it in a somewhat more specific context – namely, when the adaptive process alters the original's

rendering of their own time — essentially this effect of neutering and appropriation of a text is a basic practice of adaptation. To a greater or lesser degree, the adaptation neuters the original interest (or a part of the novelist's intention) thereby appropriating it so that it 'makes sense' within the present context (for example, Emma Thompson's script for Ang Lee's Sense and Sensibility, 1995, provides a feminist re-inscription of the original Austen novel).

Classic adaptations are less than transparent. They materialize the novel into something else and the result is a hybrid affair, a mixture of genres. More crucially, a temporal sleight of hand and thus intention occurs. By way of illustration of this point let's take the Austen, Forster and Pagnol novels and their subsequent adaptations. These novels were modern texts of their day and set in their time yet they were deeply nostalgic for a lost time in the past (be it for social, economic values or traditions). A major motivation of the narrative, then, is a nostalgia for what is no more. A sense of lack, of loss is redolent within the novel. Over time, however, these once modern texts become classic texts entering the literary canon. By the time they get to the stage of film adaptation they are no longer of the present time and so become transformed into what we know as costume or heritage films. What was present is now of the past. A further shift occurs, however, in our reception of the film. It is nostalgic pleasure we are after, not understanding. Thus our focus shifts from a desire to know the times the novel is referring to in socio-economic or political terms, to a desire to see the times (in terms of costume and décor). Thus the earlier intention of the narrative - a nostalgia for a past - is neutered. What drives us, the audience, is a nostalgia for the present times of the novel, the lived moment of Austen's heroines, or Pagnol's and Forster's characters - our 'imagined' past, not that of the original text for which that present time represents unwanted change. Both the novel and the film are looking backwards nostalgically, but not at the same past.

Production values tend to match the perceived value of the original text. Thus, literary classics have high production values and the aim is for an authentic re-creation of the past through appropriate **setting**, quality mise-en-scène, minute attention to décor and costume, and for star vehicles to embody the main roles. Audience expectation is such that demand for authenticity and taste is carefully respected. Popular fiction adaptations make

no such demands of taste. Sets can be flimsy, actors unknown, the whole purpose here is for cost-effectiveness. A small budget therefore means low production values. It does not necessarily mean, however, a loss of value. Indeed, many of the 1930s' and 1940s' Hollywood B-movies have gained such value that they have entered the Western cinematic canon. Nor have contemporary literary adaptations, while inexpensively produced, been without impact in the evolution of film history. The British New Wave of the 1960s, for example, relied heavily on contemporary texts for their source of inspiration and produced a grainy socio-realism (closely aligned with kitchen-sink drama) which mainly focused on the socio-economic crises of young workingclass males. The so-called New Scottish cinema also draws on modern literary sources and provides low-budget movies with a raw realism of economic deprivation that mostly, but not exclusively, concerns the young male in crisis and the drug culture of contemporary Glaswegian youth (particularly male youth). The adaptation of Irvine Welsh's novel Trainspotting (Danny Boyle, 1996) is the benchmark movie in this context.

Modern adaptations of contemporary novels have national value to the degree that they tell us something of the current political culture that surrounds us; the adaptation of classics have nationalistic value in that they mirror a desire to be identified with values of tradition, culture and taste to which certain elites. especially political elites, and generations aspire. They only indirectly refer to the current climate in so far as they disguise through the past, a present that is not always without provoking anxiety and fear. But the traces are there. As Strong (1999, 286-91) points out, the gay subtext of Forster's Room with a View (Ivory, 1986) comes seeping through even if it does not threaten or challenge the particularly homophobic political culture and legislation of the Thatcher government in Britain at that time. Strong (1999, 63) makes a particularly interesting point about the distinction between contemporary and classical adaptations - one that comes down to gender. Classic literary adaptations with their almost obsessive focus on detail - an effect of miniaturizing lead to an increased feminization of the original text. If we take this idea further, it is as if the film clothes its male protagonists in such a way as to make them safe, contain them as an ideal male who mirrors in the fanciness and detail of his own costume that of his female counterpart. We may forget the very real power wielded by men as we stand in awe of their prettiness. Viewed

in this light, this feminization comes to represent a containment and displacement of our contemporary myth of sexual equality and even unisexuality. The contemporary adaptations such as those of the British New Wave, argues Strong (ibid. 62) and to which we could add the Scottish New Wave, are ones which masculinize the original text in their over-investment in the individual youthful male protagonist. These films that focus on the male represent him as unruly, potentially threatening, powerful, wild. But given the process of masculinzation inscribed into the filmic text, the vicious twist at the end that he is doomed to fail, die or remain the same should give us pause for thought.

(For further reading consult authors mentioned in the text. See also Cartmell and Whelehan, 1999.)

agency (see also subjectivity) Refers essentially to issues of control and operates both within and outside the film. Within the film, agency is often applied to a character in relation to desire. If that character has agency over desire it means that she or he (though predominantly in classic narrative cinema it is 'he') is able to act upon that desire and fulfil it (a classic example is: boy meets girl, boy wants girl, boy gets girl). Agency also functions at the level of the narrative inside and outside the film. Whose narration is it? A character in the film? A character outside the film? The director's? Hollywood's? And finally, agency also applies to the spectator. In viewing the film, the spectator has agency over the text in that she or he produces a meaning and a reading of the filmic text.

ambiguity (see also film noir and naturalizing) 'Double meaning', a term that has been incorporated into film analysis. Ambiguity can occur at all levels of a film: characterization, narrative, type of shot, space and time. Often the mise-en-scène and lighting function to signal ambiguity. For example, mirrors offering reflections of a character point not just to the myth of Narcissus but also to the idea of duplicity. The use of highlighting through side-lighting of a character's face when all else is in shadow and the use of contrasting light and dark within one shot, are two lighting effects that signal character ambiguity. These particular codes are common to film noir and are employed to point to the moral ambiguity of the central protagonist. But ambiguity is

not exclusive to this genre and can be found in both mainstream and art cinema. In the former case, Clint Eastwood's later westerns are exemplary because he uses character ambiguity to question the genre itself (as in Pale Rider, 1985, and Unforgiven, 1992, both directed by and starring Eastwood). The hero's own self-doubt or questioning leads to the genre itself being ambiguously positioned. The genre itself now questions what its codes and conventions serve to normalize (the opposition of 'good' and 'bad', the 'civilized' White man and the 'natural' Indian, and so on). In art cinema where film-makers are seeking to question film-making practices and the standardization of genres, ambiguity is one of the means used to achieve that effect. For example, lack of diegetic/narrative continuity creates a sense of ambiguity and has a destabilizing effect on both the film itself and the spectator. Codes of time and space are deconstructed through the use of jump cuts and asynchronism between image and sound, causing the spectator to feel disorientated. Often the central characters will appear to reflect a similar disorientation or confusion, revelatory of states of mind that cannot easily be read by the spectator.

Ambiguity, then, can come about as a result of more than one focused reading: that is, there is not a single preferred reading. The above are some examples of how this is achieved, but mention should also be made of the effect of the depth of field shot and multi-track sound. In both cases it is the closeness of these effects to 'reality' that paradoxically signifies their ambiguity. Bazin (1967, 23ff.) qualifies depth of field filming as objective realism. He makes the point that it is an open shot that allows the spectator greater reading potential because its meaning is not as strongly encoded as is the case with montage. Although it constitutes a unity of image in time and space and as such is a realistic structure, none the less because it is open to wider interpretation it does not lose its potential for ambiguity. Similarly, the greater fidelity and range of multi-track sound, if there is no foregrounding of one sound over another, can lead to a greater realism and a less encoded meaning. One sound is not artificially privileged over another; rather, the spectator hears the sounds in their 'true' relation and can evaluate the significance of that relation.

anamorphic lens (see also aspect ratio) A French invention devised by Henri Chrétien for military use during the First

World War, this is a wide-angle lens that permits 180-degree vision (see 180-degree rule). It was not introduced into cinema until 1928 when it was used experimentally by the French filmmaker Claude Autant-Lara. Characteristically, the French film industry did not invest in this new technology which could have done much to aid its ailing fortunes, and it was the United States who bought the rights to the system in 1952. The following year Fox studios was the first to release what was termed a cinemascope film, The Robe (Henry Koster). The wide-screen effect of cinemascope is achieved by a twofold process using the anamorphic lens. First, the lens on the camera squeezes the width of the image down to half its size so that it will fit on to the existing width of the film (traditionally 35 mm). Then the film is projected through a projector supplied with an anamorphic lens which produces the wide-screen effect with an aspect ratio of 2.35:1. Without the anamorphic lens on the projector the image would be virtually square and its contents hugely distorted - horizontally squashed and vertically stretched as if caught in a concave mirror. The wide-angle effect is now more usually accomplished without the anamorphic lens. through the use of the wide-gauge 70 mm film or by printing 35 mm onto 70 mm film for special releases.

animation (also known as cartoons) Traditionally, animation has been achieved by shooting inanimate objects, such as drawings, frame by frame in stop-motion photography. In succeeding frames, the object has very slightly shifted positions so that when the stop-motion photos are run at standard speed (twenty-four frames per second) the object seems to move. John Hart (1999, 3) gives a very useful thumbnail sketch of the essential ingredients needed for animation. In cartoons, he explains, artists must make dynamic use of space, compositional devices and colour. They must also use fore, middle and background effectively. Traditionally, the main narrative action revolves around the principle of conflict which is mirrored by visual conflict on three levels within the image: size (large and small characters), strong verticals against horizontals, and colours (red against green).

Animation dates back to the early days of cinema. It first appeared in the form of a special effects insert into a live-action film with Georges Méliès's animation of the moon – which he achieved through stop-motion and trick photography – in *Voyage*

à la lune (1902). The Frenchman Émile Cohl is credited with having brought the comic strip to film. Unlike printed comic strips, however, he used line drawings creating stick figures among other objects. His first product Fantasmagorie (1908) was a huge success even though it was a spectacle effects film (to use Richard Abel's term, 1994, 286) and not strictly a narrative text. The film was a series of illogical but seamless transformations of the line drawings (an elephant turning into a house, for example). Cohl's line drawing technique was imitated and adapted by the American Winsor McCay who was himself originally a comic strip artist. McCay introduced personality or character animation through his anthropomorphization of animals. Thus, in 1914, he produced the first animated short, Gertie the Dinosaur. In this vein of anthropomorphic stars, Otto Messmer's famous Felix the Cat - first conceived of in 1915 eventually became a series (starting in 1920).

Walt Disney Productions (founded in 1923) continued with this popular tradition of anthropomorphization, providing even greater **realism** to the animated creatures. In 1928, Disney produced the first synch-sound cartoon (*Steamboat Willie*, featuring Mickey Mouse). Disney is also credited with being the first to bring **colour** to **sound** cartoons (by 1932). Full feature-length colour and sound cartoons came into their own with his *Snow White and the Seven Dwarfs* (1937) which won a special Oscar. In terms of animated dolls, arguably the most famous is the gorilla doll who is the eponymous hero of *King Kong* (Ernest B. Schoedask, 1933).

Disney Productions are not necessarily the pioneers of animation. Prior to the establishment of Disney studios, the Fleischer brothers (Dave and Max), in 1920, launched their *Out of the Inkwell* series. The success of their cartoon character, the clown Koko, allowed them to establish their own studio, Red Seal, in 1921. Although their business was to fail, the brothers went with their studio to work at Paramount and created, most famously, the Betty Boop character and Popeye the Sailor series. Apart from the importance of their contribution to cartoon style – direct address to the audience, illogical plot developments (reminiscent of Cohl perhaps) – they were also technological pioneers. Dave Fleischer invented the rotoscope process (*circa* 1920) which, simply explained, is a process whereby individual frames of filmed action of live figures are projected onto the back of a glass then traced and rephotographed. Thus the movements of the animated

figures are based on those of live figures and cartoon characters move much like human beings. The Fleischers also introduced, in 1934, the stereoptical process which gives the illusion of actual depth in the image. Disney Productions would incorporate both these processes into their own cartoon–making practices, either by imitation or by finding a similar process.

The Disney style and look have tended to dominate the Western cartoon tradition. However, the realistic movement for which Disney cartoons are so renowned is not the only trend of animation. The United Productions of America (UPA, established in 1941 as a breakaway group from Disney) is perhaps best remembered for its Mr Magoo series. UPA was to have an important impact on the evolution of cartoon style. It used modern art styling which created, in particular, a counter-realistic effect of jerky movements; it also wrote non-violent scenarios - thus again breaking with tradition. Its impact in the late 1940s and early 1950s was felt both on home territory and abroad. particularly in Eastern Europe. Also in the USA, Tex Avery, worked for Warner Bros' cartoon unit (1936-42) and helped them launch, along with Bob Clampett and Chuck Jones, the cartoon character Bugs Bunny, before going on to work for MGM (1942-55). His fast-paced, often violent, surrealist gagstyle cartoons which were based on the principle of 'surprise the audience' had, and still have, a great influence (both on animation and advertising). During this same period, Warners produced a cartoon series entitled Merrie Melodies which include two animation shorts that warrant a mention given the reputation Warners enjoyed at the time for producing feature films with social content or criticism at their core (see studio entry on Warners). The two cartoons are Clean Pastures (Fritz Freleng, 1937) and Coal Black and De Sebben Dwarves (Bob Clampett, 1942). In the first cartoon, which features an all-black cast, Saint Peter sends his angels down to 'Harlem' to clean up the night-life. The cast is made up of caricatures of, among others, Cab Calloway (whose music figures in many cartoons of this period), Louis Armstrong, Fats Waller, Stepin Fetchit, and Bill 'Bojangles' Robinson. The second is a racist spoof on Disney's Snow White and the Seven Dwarfs which, to Warners' credit, it eventually banned from projection (both these shorts are titles held by the British Film Institute's archival collection).

Elsewhere, apart from the USA, there were famously several Eastern European Schools of Animation which, starting in the

early 1960s, underwent artistic and quantitative growth (Bendazzi, 1994, 333). The Czech School established itself as a major player in the world of animated films. Its world-wide renown begins with its puppet and cartoon animations, many of which cast doubt over reality as a means of subversion. Jiri Trnka's The Hand (Ruka, 1965) and Jana Marglova's Genesis (1966) are exemplary of this allegorical use of animation. Otherwise, the former Republic of Czechoslovakia enjoys a wide reputation as makers of children's puppet fables, and Surrealist mixed-medium animated cartoons (toys, puppets, clay figures, drawings, etc.). Its reputation as a significant school is matched in Eastern Europe primarily by Poland which also has a strong tradition in animation. Walerian Borowczyk and Jan Lenica's use of cut-out graphics (Dom, 1957) and Witold Giersz's painting on glass (Maly Western, 1960) are just two animation styles introduced by this country into the cartoon milieu. While there is stylistic variety, the Polish 'School' has a definite 'look' which Bendazi (1994, 341), in his very comprehensive book on world animation, sums up as follows: 'a preference for dark-toned images . . . and gloomy themes mostly marked by existential questioning . . . and heavy pessimism'. Finally (in the former Yugoslavia), the Zagreb School's legacy stems primarily from a group of Croatian cartoonists, working in the 1950s and 1960s, whose style (inspired by the modern art styling of UPA) represents a reversal of the Disney realistic tradition.

Animation, although dominated by the American market, is a form of film-making that is widely practised in the Western world and the East. Japanese animation is becoming known to us through its presence on television. The industrial expansion of Japanese animation began in 1958 (Bendazzi, 1994, 411). Two major production companies were established around that time: Toei (1958) and Gakken (1959). Gakken, a puppet animation studio, was one of the few companies under the leadership of a woman director, Matsue Jimbo (Bendazzi, 1994, 411). Toei's feature film production tended to focus on two subject areas: legends from the Far East and tales of **science fiction**. These films, as with many others emanating from Japanese studios are fast-action, fast-produced cartoons which are often violent both in terms of their subject matter and fast editing style (ibid.).

Recent technological advances have seen the introduction of computer-aided graphics, producing greater realism in terms of movement. Pixar (John Lasseter's studio in California) is considered a pioneer in the computer-animated format. Lasseter's

studio is closely linked with Disney and he made *Toy Story* (1995) for them, the first wholly computer-generated animated film. This new technology should reduce production costs. One minute of traditional animation requires on average 1500 drawings and the medium is therefore very costly and labour-intensive. However, it is sobering to recall that Steven Spielberg's digitally animated dinosaurs in *Jurassic Park* (1992), made by George Lucas's independent company Industrial Light and Magic (ILM), cost \$25 million alone (representing over a third of the total costs of \$66 million).

There is a massive bibliography on animation, what follows is only a suggested list: Hoffer, 1981; Solomon, 1987; Grant, 1987; Culham, 1988; Lassiter and Davy, 1995; Pillig, 1992; Bendazzi, 1994; Solomon, 1994; Ohanian and Phillips, 1996; Taylor, 1996; Pillig, 1997; Furniss, 1998; Lord and Sibley, 1998.

culhane

apparatus (see also agency, spectator-identification and suture) Baudry (1970) was among the first film theorists to suggest that the cinematic apparatus or technology has an ideological effect upon the spectator. In the simplest instance the cinematic apparatus purports to set before the eye and ear realistic images and sounds. However, the technology disguises how that reality is put together frame by frame. It also provides the illusion of perspectival space. This double illusion conceals the work that goes into the production of meaning and in so doing presents as natural what in fact is an ideological construction, that is, an idealistic reality. In this respect, Baudry argues, the spectator is positioned as an all-knowing subject because he (sic) is allseeing even though he is unaware of the processes whereby he becomes fixed as such. Thus the omniscient spectator-subject is produced by, is the effect of the filmic text. A contiguous, simultaneous ideological effect occurs as a result of the way in which the spectator is positioned within a theatre (in a darkened room, the eyes projecting towards the screen with the projection of the film coming from behind the head). Because of this positioning, an identification occurs with the camera (that which has looked, before the spectator, at what the spectator is now looking at). The spectator is thereby interpellated by the filmic text, that is the film constructs the subject, the subject is an effect of the film text (see ideology). That is, the spectator as subject is constructed by the meanings of the filmic text.

Later, after 1975, discussion of the apparatus moved on from this anti-humanist reading of the spectator as subject-effect, and the presupposition that the spectator is male. Now, the spectator is also seen as an active producer of meaning who is still positioned as subject, but this time as agent of the filmic text. That is, she or he becomes the one viewing, the one deriving pleasure (or fear, which is another form of pleasure) from what she or he is looking at. She or he also interprets and judges the text. On the 'negative' side of this positioning it could be said that, in becoming the camera, the apparatus places the spectator voyeuristically, as a colluder in the circulation of pleasure which is essential to the financial well-being of the film industry (Metz, 1975). The economic viability of the latter depends on the desire of the former to be pleasured. Cinema in this respect becomes an exchange commodity based on pleasure and capital gain pleasure in exchange for money. On the 'positive' side it could be said that as agent the spectator can resist being fixed as voveur, or indeed as effect, and judge the film critically.

For further discussion see Lapsley and Westlake, 1988, 79–86; Mayne, 1993, 13–76; De Lauretis and Heath, 1980.

art cinema (see avant-garde, counter-cinema) This term refers predominantly to a certain type of European cinema that is experimental in technique and narrative. This cinema, which typically produces low- to mid-budget films, attempts to address the aesthetics of cinema and cinematic practices and is primarily, but not exclusively, produced outside dominant cinema systems. For example, the French New Wave and the new German cinema, which come under this label, received substantial financing from the state. Other art cinemas, such as the American underground cinema were funded by the filmmakers themselves. Art cinema is also produced by individuals – often women film-makers – who do not come under any particular movement (for example Agnès Varda, Liliani Cavani, Nelly Kaplan and Chantal Akerman).

Art cinema has been rightly associated with eroticism since the 1920s when sexual desire and nudity were explicitly put up on screen. However, for American audiences during the censorship period under the **Hays code** (1934–68), 'art cinema' came to mean sex films. With an eye to the export market, film producers were quick to exploit art cinema's sexual cachet. Perhaps one of the most famous instances of this is the case of Jean-Luc Godard's *Le Mépris* (1963), starring Brigitte Bardot. Upon its completion, two of its producers (Levine and Ponti) insisted that Godard should insert some nude scenes of Bardot. He did this, but not with the anticipated results – far from titillating or sexual, these scenes are moving, tragic.

The term cinéma d'art, was first coined by the French in 1908 to give cinema - which until then had been a popular medium - a legitimacy that would attract the middle classes to the cinema. This earliest form of art cinema was filmed theatre (mostly actors of the Comédie Française) accompanied by musical scores of renowned composers - making it a quite conservative artefact. During the 1920s, however, owing to the impact of German expressionism and the French avant-garde, art cinema became more closely associated with the avant-garde. From the 1930s onwards, partly owing to the French and Italian realist movements. its connotations widened to include social and psychological realism. And the final legitimation came in the 1950s when the politique des auteurs made the term auteur sacrosanct. This politique or polemic argued that certain film-makers could be identified as auteurs - as generators or creators rather than producers of films. This further widening of its frame of reference has meant that, although art cinema is considered primarily a European cinema, certain Japanese, Indian, Australian, Canadian and Latin-American film-makers are also included in the canon - as well as certain films made by representatives of some minority groups: women, Blacks and self-called queers (see Black cinema, queer cinema; for women's cinema see Kuhn, 1990).

Historically, art cinema was not intentionally devised as a counter-Hollywood cinema, even though its production is clearly not associated with Hollywood. It is interesting to note, however, that the 1920s art cinema was a period of great crossfertilization between Hollywood and European cinema. Generally speaking, in art cinema narrative codes and conventions are disturbed, the narrative line is fragmented so that there is no seamless cause-and-effect storyline. Similarly, characters' behaviour appears contingent, hesitant rather than assured and 'in the know' or motivated towards certain ambitions, desires or goals. Although these films are character- rather than plot-led, there are no heroes – in fact this absence of heroes is an important feature of art cinema. Psychological realism takes the

form of a character's subjective view of events; social realism is represented by the character in relation to those events. The point of view can take the form of an interior monologue, or even several interior monologues (Alain Resnais's and Ingmar Bergman's films are exemplars of this). Subjectivity is often made uncertain (whose 'story' is it?) and so too the safe construction of time and space. This cinema, in its rupture with classic narrative cinema, intentionally distances spectators to create a reflective space for them to assume their own critical space or subjectivity in relation to the screen or film.

aspect ratio This refers to the size of the image on the screen and to the ratio between the width and height. It dates back to the days of silent cinema, when the ratio was fixed at 1.33:1 (width to height) thanks to a standardization of technology brought about by hard-nosed business strategies on the part of the Edison company. Edison contracted its rivals into a cartel which had to use Edison equipment and pay royalties to the company. The cartel dominated the market from 1909 to 1917 when an anti-trust law broke it up. Ironically, this ratio was the one adopted by television for its own screens, even though HDTV uses a ratio of 1.76:1. Edison went out of business. but the aspect ratio for a standard screen remained the norm internationally, until the early 1950s, when the threat posed to film audiences by television obliged the film industry to find visual ways to attract or retain audiences. Although there had been experimentation with other screen sizes, it was not until economic necessity forced the film industry to invest heavily in technology that screens took on different dimensions. The first innovation in size was **cinemascope** with a standard aspect ratio of 2.35:1. Nowadays, films are more commonly projected either from the wide-gauge 70 mm film frame with an aspect ratio of 2.2:1 or from 35 mm film with its top and bottom pre-cropped with an aspect ratio of 1.85:1 in the United States and 1.66:1 in European cinemas.

asynchronization/asynchronous sound (see also sound, seamlessness, space and time) Asynchronization occurs when the sound is either intentionally or unintentionally out of sync with the image. In the latter case this is the result of faulty editing (for example a spoken voice out of sync with the moving lips).

In the former, it has an aesthetic and/or narrative function. First, asynchronization calls attention to itself: thus the spectator is made aware that she or he is watching a film (so the illusion of identification is temporarily removed or deconstructed). Second, it serves to disrupt time and space and thereby narrative continuity, and as such points to the illusion of reality created by classic narrative cinema through its seamless continuity editing. Finally, it can be used for humorous effect, as occasionally in the earliest talkies when the advent of sound was met by film-makers with mixed reactions. There were two camps of thought: those who embraced the new technology and those who feared it would transform cinema into filmed theatre. As an example of this latter camp, the French film-maker René Clair was concerned that sound would limit visual experimentation and remove the poetic dimension inherent in silent film. His early sound films (mostly comic operettas) play with sound. By confounding the actual source of sound (for example, we see a woman singing framed in a window, then there is a cut and we go into her room and we realize that in fact she is miming to a record player), he draws attention to its pretensions at the 'reality effect' (see his A nous la liberté, 1931).

audience (for a fuller discussion see spectator) Always recognized as important by film distributors and exhibitors, the audience has now become an important area of research for film theorists and sociologists (for references see spectatorship). Considerable work has been done on reception theory (how the audience receives and/or is positioned by the film). More recently, the debate has focused on how the spectator both identifies with the film and becomes an active producer of meaning as subject of the film (see agency). The film industry has since its beginnings targeted films to attract large audiences; this has meant that the product is predominantly audience-led. As the audience changes (for example, from working-class men and women before the Second World War to women after the war, to youth from the late 1950s), so too does the type of product.

auteur/auteur theory/politique des auteurs/Cahiers du cinéma Although auteur is a term that dates back to the 1920s in the theoretical writings of French film critics and directors of the silent era, it is worth pointing out that in Germany, as early

as 1913, the term 'author's film' (Autorenfilm) had already been coined. The Autorenfilm emerged partly as a response to the French Film d'Art (art cinema) movement which began in 1908 and which proved extremely popular. Film d'Art was particularly successful in attracting middle-class audiences to the cinema theatres because of its cachet of respectability as art cinema. The German term, Autorenfilm, is, however, also associated with a more polemical issue regarding questions of authorship. In this respect, some writers for the screen started campaigning for their rights to these so-called Autorenfilm. That is, they staked their claim not just to the script but to the film itself. In other words, the film was to be judged as the work of the author rather than the person responsible for directing it (Eisner, 1969, 39). In France the concept of auteur (in the 1920s) comes from the other direction, namely that the film-maker is the auteur - irrrespective of the origin of the script. Often, in fact, the author of the script and film-maker were one and the same (but not always), for example, the film-maker Germaine Dulac worked with the playwright Antonin Artaud to make La Coquille et le clergyman (1927). During the 1920s, the debate in France centred on the auteur versus the scenario-led film (that is, scenarios commissioned by studios and production companies from scriptwriters and subsequently directed by a studio-appointed director). This distinction fed into the high-art/low-art debate already set in motion as early as 1908 in relation to film (the so-called Film d'Art versus popular cinema controversy). Thus, by the 1920s within the domain of film theory, auteur-films had as much value if not more than canonical literary adaptations which in turn had more value than adaptations of popular fiction. After 1950, and in the wake of Alexandre Astruc's seminal essay 'Naissance d'une nouvelle avant-garde: la Caméra-stylo' (L'Ecran français, 1948) this debate was 'picked up' again and popularized - with the eventual effect, as we shall see, of going some way towards dissolving the high-art/low-art issue. The leader in this renewed auteurdebate was the freshly launched film review Cahiers du cinéma (launched in 1951) and the essay most famously identified with this debate is François Truffaut's 1954 essay 'Une certaine tendance du cinéma'. Although it should not be seen as the sole text arguing for auteur cinema, none the less, it is considered the manifesto for the French New Wave.

In the 1950s, the Cahiers du cinéma (still in existence today) was headed by André Bazin, a film critic, and was written by a

regular group of film critics, known as the Cahiers group. This group did not pursue the 1920s theorists' thinking (see avantgarde); in fact, they either ignored or totally dismissed it. This later debate is the one that has been carried forward into film theory. Through the Cahiers discussions on the politique des auteurs (that is, the polemical debate surrounding the concept of auteurism), the group developed the notion of the auteur by binding it closely up with the concept of mise-en-scène. This shift in the meaning of the auteur was largely due to the avid attention the Cahiers group paid to American/Hollywood cinema. During the German occupation of France in the Second World War, American films had been proscribed. Suddenly, after the war, hundreds of such films, heretofore unseen, flooded the French cinema screens. This cinema, directed by the likes of Alfred Hitchcock, Howard Hawkes, John Ford and Samuel Fuller, seemed refreshingly new and led the Cahiers group to a reconsideration of Hollywood's production. They argued that just because American directors had little or no say over any of the production process bar the staging of the shots, this did not mean that they could not attain auteur status. Style, as in mise-en-scène, could also demarcate an auteur. Thanks to the Cahiers group, the term auteur could now refer either to a director's discernible style through mise-en-scène or to film-making practices where the director's signature was as much in evidence on the script/ scenario as it was on the film product itself. Exemplars of auteurism in this second form (total author) are Jean Vigo, Jean Renoir, Jean-Luc Godard, Agnès Varda in France, Rainer Werner Fassbinder, Wim Wenders, Margarethe von Trotta in Germany, Orson Welles and David Lynch in the United States. Certain film-makers (mostly of the mise-en-scène form of auteur) have had this label ascribed to them by the Cahiers group even though their work may pre-date this use of the term (for example Hawkes, Ford, Fuller and Hitchcock on the American scene).

The politique des auteurs was a polemic initiated by the Cahiers group not just to bring favourite American film-makers into the canon but also to attack the French cinema of the time which they considered sclerotic, ossified. Dubbing it le cinéma de papa, they accused it of being script-led, redolent with safe psychology, lacking in social realism and of being produced by the same old scriptwriters and film-makers whose time was up (François Truffaut was by far the most virulent in his attacks). This quasi-Oedipal polemic established the primacy of the

author/auteur and as such proposed a rather romantic and, therefore, conservative aesthetic. And, given the hot political climate in France during the 1950s, it is striking how apolitical and unpoliticized the group's writings were - pointing again to a conservative positioning. A further problem with this polemic is that by privileging the auteur it erases context (that is, history) and therefore side-steps ideology. Equally, because film is being looked at for its formalistic, stylistic and thematic structures, unconscious structure (such as the unspoken dynamics between film-maker and actor, the economic pressures connected with the industry) is precluded. Interestingly, of two of the writers in the Cahiers group who went on to make films, Godard and Truffaut, it is Truffaut's work that is locked in the conservative romantic ideology of the politique des auteurs and Godard's which has constantly questioned auteurism (among other things).

This politique generated a debate that lasted well into the 1980s. and auteur is a term which still prevails today. Given its innate conservatism one might well ask why. The first answer is that it helped to shift the notion of film theory, which until the 1950s had been based primarily in sociological analysis. The second answer is that the debate made clear that attempts to provide a single film theory just would not work and that, in fact, film is about multiple theories.

What follows is a brief outline of the development of auteur theory through three phases (for more detail see Andrew. 1984: Caughie, 1981; Cook, 1985; Lapsley and Westlake, 1988). The figure outlined opposite gives a graphic representation of auteurism.

The term 'auteur theory' came about in the 1960s as a mistranslation by the American film critic Andrew Sarris. What had been a 'mere' polemic now became a full-blown theory. Sarris used auteurism to nationalistic and chauvinistic ends to elevate American/Hollywood cinema to the status of the 'only good cinema', with but one or two European art films worthy of mention. As a result of this misuse of the term, cinema became divided into a canon of the 'good' or 'great' directors and the rest. The initial impact of this on film courses and film studies in general was considerable, the tendency being to study only the good or great canon. Thankfully the impact of cultural studies on film studies in the late 1970s has served to redress this imbalance as well as developments in film theory.

The debate did not end there. It was picked up in the late 1960s in the light of the impact of structuralism. In France, the

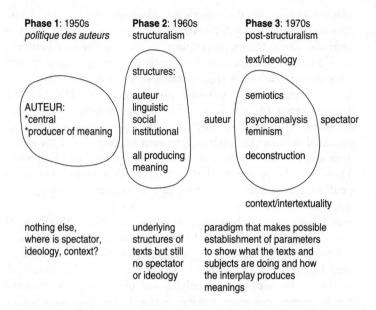

Cahiers du cinéma was obliged to rethink and readjust its thinking around auteurism, and in Britain the film journal Movie significantly developed the debate. As a concept, structuralism dates back to the beginning of the twentieth century primarily in the form of Ferdinand de Saussure's linguistic theories. However, it remained little known until the theories were brought into the limelight by the French philosopher-semiotician Roland Barthes in the 1950s - especially in his popularizing essays Mythologies (1957). Saussure, in his Cours de linguistique générale, sets out the base paradigm by which all language can be ordered and understood. The base paradigm langue/parole was intended as a function that could simultaneously address and speak for the profound universal structures of language or language system (langue) and their manifestations in different cultures (parole). Claude Lévi-Strauss's anthropological structuralism of the 1960s (which looked at American Indian myths) continued in a similar vein, although this time it was applied to narrative structures. Lévi-Strauss's thesis was that since all cultures are the products of the human brain there must be, somewhere, beneath the surface, features that are common to all.

Structuralism was an approach that became extremely popular in France during the 1960s. Following the trend set by Barthes and Lévi-Strauss, the Marxist philosopher Louis Althusser

adapted it into his discussions on ideology and Jacques Lacan into his writings on **psychoanalysis**. The fundamental point to be made about this popularization of structuralism in France is socio-political and refers to structuralism's strategy of total theory. This popularization of structuralism coincided with Charles de Gaulle's return to presidential power in 1958. His calls for national unity (in the face of the Algerian crisis), the era of economic triumphalism and the consequent nationalism that prevailed were in themselves symptomatic of a desire for structures to be mobilized to give France a sense of national identity. Thus, the desire for total structure, as exemplified by structuralism, can be read as an endeavour to counter the real political instability of the 1960s.

It is also worth labouring the point that this 'rethinking' of film theory in the 1960s did not come via film criticism (as it did in the 1950s) but through other disciplines, namely structural linguistics and semiotics. This pattern would repeat itself in the 1970s with psychoanalysis and philosophy pushing the debate along, and then history in the 1980s. The significance of this new trend of essayists and philosophers turning to cinema to apply their theories cannot be underestimated. Not to put too simplistic a reading on their importance, it is unquestionably their work which has legitimated film studies as a discipline and brought cinema firmly into the academic arena.

Structuralism was eagerly seized upon by proponents of auteurism because it was believed that, with its scientific approach, it would facilitate the establishing of an objective basis for the concept and counter the romantic subjectivity of auteur theory. Furthermore, apart from its potential to give a scientific legitimacy to auteurism, the attraction of structuralism for film theory in general lay in the theory's underlying strategy to establish a total structure.

Symptomatic of this desire for order in film theory were Christian Metz's endeavours (in the mid-1960s) to situate cinema within a Saussurian semiology. Metz, a semiotician, was the first to set out, in his Essais sur la signification au cinéma (1971, 1972), a total theory approach in the form of his grande syntagmatique. He believed that cinema possessed a total structure. To adopt Saussurian terms, he perceived cinema as langue and each film as being parole. His endeavour — to uncover the rules that governed film language and to establish a framework for a semiotics of the cinema — pointed to a fundamental limitation with

such an all-embracing, total approach: that of the theory overtaking the text and occluding other aspects of the text. What gets omitted is the notion of pleasure and **audience** reception, and what occurs instead is a crushing of the aesthetic experience through the weight of the theoretical framework.

This is not to say that structuralism did not advance the debate on film theory and auteurism. It did. Auteur-structuralism brought about a major positive change to auteur theory (à la Sarris). The British film journal Movie pointed out the problems of a resolutely romantic aesthetic in relation to cinema, but saw ways to deal with them. By situating the auteur as one structure among others – such as the notion of **genre** and the film industry - producing meaning, the theory would yield to a greater flexibility. Cahiers du cinéma was also critical of the romantic notion of auteurship because the auteur is not a unified and free creative spirit and film as a text is a 'play of tensions, silences and repressions' (Caughie, 1981, 128). Thus the auteur was displaced from the centre of the work and was now one structure among several others making up the film text. This displacement allowed other structures to emerge, namely, the linguistic, social and institutional structures and the auteur's relationship to them. And even though in the late 1960s the tendency was still to perceive the auteur structure as the major one, it was also recognized that the studio and stars - amongst others - were equally important contributors to the production of meaning in film. Still absent from the debate, however, was the spectator - the question of pleasure and ideology.

After 1968 Cahiers made a first attempt to introduce ideology into the debate in its exploration of Hollywood films that either 'resisted' or reflected dominant ideology. (In what is referred to as 'the Young Mr Lincoln debate', the Cahiers group claimed that this film mediated Republican values to counter Roosevelt's Democratic New Deal measures of 1933–41 and to promote a Republican victory in the 1940 Presidential elections.) Althusser's discussions on ideology, particularly his concept of interpellation, made it possible for both Cahiers and the British journal Screen to start to address the screen–spectator relationship. At this juncture, both journals accepted what, with hindsight, turned out to be a profoundly anti-humanist analysis of spectator positioning. According to Althusser, ideological state apparatuses (ISAs) interpellate individuals as subjects: that is, as pre-existing structures, ISAs function to constitute the individual as a subject to the

ideology. ISAs manifest themselves as institutions of the state: the police, government, monarchies are ISAs. Just to illustrate: the British are subjects to the monarchy. The individual is, therefore, an effect of ISAs and not an agent. As subject-effects, individuals give meaning to ideology by colluding with and acting according to it. A mirroring process occurs which provides the subject with a reassuring sense of national identity (of belonging). Applied to film this means that cinema, in terms of meaning production, positions the spectator as a subject-effect who takes as real the images emanating from the screen. Thus, meaning is received, but not constructed, by the subject.

It would take the impact of post-structuralism (see structuralism), psychoanalysis, feminism and deconstruction to make clear finally that a single theory was inadequate and that what was required was a pluralism of theories that cross-fertilized each other. Post-structuralism, which does not find an easy definition, could be said to regroup and, to some extent, cross-fertilize the three other theoretical approaches (psychoanalysis, feminism and deconstruction). As its name implies, it was born out of a profound mistrust for total theory, and started from the position that all texts are a double articulation of discourses and nondiscourses (that is, the said and the non-said, le dit et le non-dit). In terms of auteur theory the effect was multiple: 'the intervention of semiotics and psychoanalysis' 'shattering' once and for all 'the unity of the auteur' (Caughie, 1981, 200). Because poststructuralism looks at all relevant discourses (said or unsaid) revolving around and within the text, many more areas of meaning-production can be identified. Thus, semiotics introduced the theory of the textual subject: that is, subject positions within the textual process, including that of the spectator and the auteur, all producing meanings. Furthermore, semiotics also made clear that the text is a series of signs producing meanings.

Having defined the auteur's place within the textual process, auteur theory could now be placed within a theory of textuality. Since there is no such thing as a 'pure' text, the **intertextuality** (effects of different texts upon another text) of any film text must be a major consideration, including auteurial intertextuality. That is, the auteur is a figure constructed out of her or his film: because of x hallmarks the film is ostensibly a certain film-maker's and also influenced by that of others, etc. Psychoanalysis introduced the theory of the sexual, specular, divided subject (divided by the fact of difference, loss of and separation

from the mother (see psychoanalysis)). Questions of the subject come into play: who is the subject (the text, auteur, spectator)? What are the effects of the enunciating text (i.e. the film as performance) on the spectator and those on the filmic text of the spectator? What are the two-way ideological effects (film on spectator and vice versa) and the pleasures derived by the spectator as she or he moves in and out of the text (see spectator-identification)? To speak of text means too that the context must also come into play in terms of meaning production: modes of production, the social, political and historical context. Finally and simultaneously, one cannot speak of a text as transparent, natural or innocent: therefore it is to be unpicked, deconstructed so that its modes of representation are fully understood.

avant-garde It is perhaps curious that a military term should come to define what is now usually an anti-establishment positioning. The term avant-garde was first used in the modern sense to typify various aesthetic groupings immediately before and after the First World War, from about the dates given: cubism and futurism (both 1909), dadaism (1916), Constructivism (1920) and surrealism (1924). It is also curious to note that, in part, it was in reaction to the horrors of that war that the later avant-garde movements came about. The avant-garde seeks to break with tradition and is intentionally politicized in its attempts to do so. In cinema the avant-garde cachet was first used in the 1920s when a group of French film theorists (most famously Louis Delluc, Germaine Dulac and Jean Epstein) turned their hand to film-making and sought to create a cinema of the avant-garde. The first point to be made about this loosely banded collective is the pluralism of its members' theoretical approaches to cinema, which clearly inflected their film-making practices. Between them, they addressed issues of high and popular art, realist versus naturalist film, the spectator-screen relationship, editing styles (particularly that of the Soviet school and montage), simultaneity, subjectivity, the unconscious, and the psychoanalytical potential of film, auteur cinema, cinema as rhythm and as a sign (see semiology). Once they turned their hands to making film, experimentation was central to their practice. This experimentation functioned on three overlapping levels: reworking genres, exploring the possibilities of film language and redefining the representation of subjectivity. Genres were mixed, intercalated and juxtaposed. Similarly the popular was fused with the experimental (mainstream cinema with counter-cinema), socio-realism with the subjective (documentary with melodrama). Working within these popular genres allowed them to extend, distort, even subvert dominant discourses. In so doing, these avant-garde filmmakers attacked the precept of filmic narrative and spectator omniscience. Their films raised questions about subjectivity and its representation by disrupting diegetic time and space. This was achieved in a number of ways: shifts from diegetic continuity to discontinuity, fast editing, disruption of conventional transitional shots, disorientating shots through unmatched shots or a simultaneous representation of a multiplicity of perspectives. Thus, the fetishizing gaze of the male was also examined, showing an awareness of the underprivileging of female subjectivity. Subjectivity not only became a question of point of view but also included the implicit notion of voyeurism and speculation (of the female other - see gaze) as well as the issue of desire, and the functioning of the conscious and the unconscious mind (see Abel, 1984, 241-95; Flitterman-Lewis, 1990; Hayward, 1993, 76-80 and 106-11).

Soviet cinema and German expressionism with, respectively, their characteristic editing and lighting practices greatly influenced this first avant-garde, as did the surrealist movement and psychoanalysis. This avant-garde went through three different stages: subjective cinema (showing the interior life of a character, as in La Souriante Mme Beudet, Dulac, 1923), pure cinema (film signifying in and of itself through its plasticity and rhythms, as in Entr'acte, René Clair, 1924) and surrealist cinema (a collision of the first two stages with the intention of giving filmic representation to the rationality and irrationality of the unconscious and dream state, as in La Coquille et le clergyman, Dulac, 1927 and Un chien andalou, Luis Buñuel, 1929).

Since that period, other influences have also come into play. And, interestingly, once again there are three dominant types: first, what Wollen (1982, 92) calls the self-reflexive avant-garde (predominantly American), or what Andrew (1984, 124) terms the American romantic; second, the avowedly political avant-garde (Wollen, 1982, 92) or the European structural materialist film (Andrew, 1984, 125); finally, the narrative avant-garde of the cinema of *écriture* (Andrew, 1984, 126).

Where the American type is concerned, the major influences are the works of what are now called modernist painters but which are in fact those of the avant-garde movements of the early part of the twentieth century (see above). These films have an abstract formalism displaying a self-reflexivity that brings them close in their concerns to the pure cinema of the 1920s avantgarde (as in Maya Deren's Meshes of the Afternoon, 1943). As for the second type of avant-garde film, the major influences were Bertolt Brecht and his theory of distanciation and Sergei Eisenstein's montage theory. The film practice invoked here is one whereby the film displays its very structures and materiality - that is, it makes an exhibition of its signifying practices, draws attention to the 'artifice' of cinema. Point of view and narrative structure do not exist so the spectator is under no illusion that what she or he is watching is a two-dimensional projection of the process of film-making. This is what Jean-Luc Godard termed making political films politically. This cinema reflects the revolutionary role of the avant-garde, assailing ideology by revealing the structures that put it up and keep it in place (as in Godard's Weekend, and La Chinoise, both 1967). The third type more readily recalls the first and last stages of the 1920s avant-garde but also has some parentage with materialist film. Here the narrative avant-garde works with or on cinematic codes, bringing the theory of counter-cinema into practice. This cinema denaturalizes cinema to show that dominant cinematic language is not the only cinematic language and that new modes of subjectivity are possible, including that of the spectator as a producer of the text (see agency). Again, this is a predominantly European cinema and, unsurprisingly perhaps, because it addresses issues such as identification, representation, screen-spectator relations and subjectivity as well as production practices (film as work or labour) it is also a cinema associated with feminist film-makers (for example Chantal Akerman, Jeanne Dielman, 23 Quai du Commerce, 1080 Bruxelles, 1975; Marguerite Duras, India Song, 1975; Agnès Varda, Sans toit ni loi, 1985).

For further reading see Andrew, 1984, 119–27; Flitterman-Lewis, 1990; Gidal, 1989; Lapsley and Westlake, 1988, 181–213.

B

backstage musical - see musical

Black cinema - UK (see also Black cinema - USA, postcolonial theory and Third Cinema) Perhaps because British cinema itself does not have a supremely first-world track record in film production, we should not be too surprised to hear that within UK cinema, Black cinema is, in relation to its counterpart in the USA, quite a small affair. It is, however, a significant cinema although its roots go back only as far as the 1950s and 1960s. If we consider that the major waves of immigration to the UK from either the British colonies or former colonies occurred after the Second World War, then it becomes clearer still that, since diasporic communities only came into existence in a real way at that time, then it is hardly surprising that a diasporic cinema should not begin to emerge until that period. What has to surprise, undoubtedly, is that presently British Black cinema, in terms of feature films, has not grown significantly in numbers since that time.

Karen Ross (1996, 53) provides us with some revealing statistics as to the status and availability of Black cinema products. Between 1988 and 1992, the total number of Black films available for hire or archival viewing only grew from 130 to 204 (two-thirds of which are in **documentary** format and therefore are not counted as feature films). Seventy-four films in four years — especially those four years during which Black issues were very much to the fore in British consciousness — is a small output particularly if we consider that only a handful are full feature films. Black cinema certainly became a presence during

the 1980s and was born out of a governmental response to the civil disobedience of the late 1970s and early 1980s. The many so-called riots of the early 1980s led to numerous enquiries, the results of which made it abundantly clear that the Black communities felt seriously disenfranchised and without a voice. Public sector financing at a local and governmental level, including grants from the British Film Institute (BFI), was invested into five workships around the country in major cities where innercity strife had been at its most vocal. At the same time as the public sector was assisting in financing the workshops, the birth of Channel Four in 1982, with its remit to represent the voices of minorities, meant that there were outlets for the workshops in the form of commissioned work for the channel. Today Sankofa and the Black Audio Film Collective remain the best known of these workshops. The workshops were concerned as much with film practice as with debates on representation including historical representation and issues of identity and hybridity. It is perhaps for this reason that much of their production cuts across or is a fusion of documentary and fiction. Given the workshops' ethos, it is not difficult to see how certain film theorists and practitioners have identified this cinematic practice with that of Third Cinema (for a fuller debate see Third Cinema entry).

Before the public sector provision of financing for projects came into being (however modest), the output of British Black cinema was very tiny indeed. Among the few film-makers around, we can list Lloyd Reckord, Horace Ové and Lionel Ngakane (a Black South African in exile who has been claimed by the British as one of their first Black film-makers). These film-makers directed a handful of feature and non-feature films during the period 1960-80 and largely financed their projects themselves. Most of these films are available through the BFI National Film Archive. All, without exception, deal with the question of marginalization and race relations - thereby establishing a tradition that would, to a degree, be perpetuated in the later cinema of the 1980s and 1990s. Reckord's Ten Bob in Winter (1963) tells the story of African-Caribbean immigrants newly arrived in the UK. Ngakane's Jemima and Johnny (1966) is about an inter-racial friendship between a Black girl and a White boy that survives the racist hostility of the street upon which they live by being kept secret in the basement of a ruined house. Ové's documentary, cinéma-vérité style informs his

early shorts *Baldwin's Nigger* (1969) and *Reggae* (1970) as well as his first feature film *Pressure* (1975), which is heralded as the first Black British feature film. This film tells the story of an English-born son of Trinidadian parents. Alienated from his White friends and the White values that surround him, this unemployed youth is drawn into the world of thieving and smoking dope. Like other Black youths in his community he becomes the target of police harassment. As a result of all this cumulative pressure it is not long before he joins his older brother and gets involved with Black Power.

The 1980s-90s and a new era of Black cinema As a BFI production, Menelik Shabazz' Burning an Illusion (1981) was the first feature film to come out of the new climate in British Black film-making. It is therefore a landmark film even though, as we shall see, in some ways it continues the earlier realist tradition that was very much based in the present and not in considerations of history. It is a landmark film in that it sets an agenda - both by what it includes and what it omits - of issues that will concern the politicized Black cinema of the 1980s and 1990s. The film tells the story of a young Black woman, a secretary who, as a result of her Black boyfriend's brutal arrest and subsequent unjust imprisonment, changes from being apolitical into an active participant in Black politics. Her political 'coming out' is both one of style and politics. As a marker of her new political consciousness she rejects her White-based dress codes and straightened hair and adopts an Afrocentric dress and hairstyle. She gives up reading Barbara Cartland and takes on board (at the suggestion of her boyfriend) the writings of Malcolm X. What distinguishes this film from its precedents is the fact that it is a woman-based point of view. What makes it similar is its basis in the contemporary. What makes it ground-breaking is its broader address of race, class and gender and its attempts to show, as Lola Young puts it (1996, 155) 'that relationships are constructed within a racialized social context'. Conflicts of gender are present for a first time in this film even though, as Young (ibid., 159) points out, the centrality of this issue disappears towards the end of the film and is subsumed under the question of racial politics.

The debates on and practices of issues of representation were closely inter-linked and were a founding ethos of the workshop production of the 1980s and 1990s. It could be argued, therefore, that the nature of the film-work that followed *Burning an*

Illusion took up and explored many of the issues raised (either by their presence or absence) in this landmark film. But it also has to be said that, even though outside funding was now available, the amounts were not sufficient to allow for a boom in feature film production and so Black film-makers still found that, if they were to make films, then for the most part these films would have to be shorts, more precisely documentaries. Thus there was not a wide-spread or mass audience knowledge about this new Black cinema (as opposed to what was happening in the United States). John Akomfrah's film career to date best exemplifies this trajectory. His Handsworth Songs (1986) is a 60minute essay on race and disorder in Britain. The film examines the historical, social and political contexts of racial unrest and seeks, through that broad and historicized optic, to explain why the current anger and disillusionment felt within the Black communities are running so high. Akomfrah's Seven Songs for Malcolm X (1993) is a 52-minute documentary on the Black leader who was assassinated in 1965. But to date, Akomfrah has only directed one narrative feature film Speak Like a Child (1998). an intense story about three friends in a children's home in Northumbria.

Isaac Julien, in a different way, has made docu-shorts and features. Perhaps best known for his highly successful Young Soul Rebels (1991), he has also made what might be considered more art-style experimental documentaries on important personas in Black history: Looking for Langston (1988) is a 45-minute essay on the private world of Langston Hughes, a founding member of the Harlem Renaissance and a homosexual who had to hide his sexuality in a climate of disapproval, both within White society and Black - where Black manhood could not be queer. In 1997, Isaac Julien made Frantz Fanon: Black Skin White Mask (sic), a remarkable composite film made up from documentary footage and re-enacted scenes from the life of this major Black intellectual of the 1950s and 1960s. Black women film-makers are also present in equal numbers, although few have broken through to making a full feature film as yet. Maureen Blackwood's The Passion of Remembrance (1986) was made with Isaac Julien and was the first full feature film to come out of a Black workshop, in this instance Sankofa. Elsewhere, Blackwood has mostly made shorts Perfect Image? (1988) and Home Away from Home (1993). Other Black women film-makers to have made shorts include Martine Attile (Dreaming Rivers, 1988), Ngozi Onwurah (*The Body Beautiful*, 1990) and Amanda Holiday (*Miss Queencake*, 1991).

What unites all the productions in this new wave of Black British cinema is a desire to speak not for the diasporas but from within them and to reveal the heterogeneity of Black communities - to undo the myth of sameness and at the same time give images that do not show Blacks as unmitigated and powerless victims of racism but as citizens with all the complexities of life before them including choices of political awareness. The issues involve representation, truth in representation and thus 'the positive' is in the frankness of the representation not in the disguising of bad qualities to enhance only the good. Furthermore, history is often a core element to these Black films. Gurinder Chada's feature film Bhaji on the Beach (1993) is exemplary of this tendency. It tells the story of a small community of Asians living in Birmingham. A day trip is organized to Blackpool by a worker at the Saheli's women's centre. These women of all different generations head off to Blackpool. As the day progresses their various tales unfold. One woman is the victim of a wife-beating husband, another is pregnant by her Black boyfriend who only agrees to share the responsibility for the baby right at the end of the film, older women express their weariness at always 'doing' for their family and dream of more fanciful ways of spending their days. Chadra reveals her men and women characters in all their complexities and multiplicity at the same time as she addresses questions of identity and belonging. This consciousness about diasporas and identities has led some film critics and film-makers (e.g., John Akomfrah) to align this film production with Third Cinema.

For further reading see Attile and Blackwood, 1986; Martin, 1995; Mercer, 1988 and 1990; Ross, 1996; Young, 1996; for list of films see Givanni, 1992, and for availability of films see Alexander, 1998; for useful bibliography see Vieler-Portet, 1991. Journals: Channel Four Black Book, Black Phoenix now called Third Text Incorporating Black Phoenix, Black Film Bulletin, Black Filmmaker.

Black cinema – USA including Blaxploitation movies (see also Black cinema – UK, postcolonial theory, Third Cinema)
A term that presently appears to refer almost exclusively to African-American film production. However, more recently it has come to encompass Black British cinema and, in future

years, it may well extend to include other European disaporic cinema such as French Black or Beur cinemas. Although there is huge debate around the term 'black', for the purposes of this entry the term Black cinema will be primarily used in its more common and 'traditional' conceptualization to refer to a cinema emanating from Black diasporic communities in the USA (there is a separate entry for the UK), to a cinema written from within (but not for as in 'on behalf of') those communities and which is made by individuals who come from those communities. Diaspora refers to a dispersion of people originally belonging to one nation (country) or having a common culture. Black is generally used to refer to people of African or Caribbean descent/ancestry, however, it is a reference that also extends to Asian-Indians. Within the American context we must not forget that other diasporic communities exist: Native Americans (incorrectly referred to as Indians), Chicanos, and Asian-Americans (of Eastern Indian and Asian origin), and that as far as cinematic production is concerned, it is the latter that has been visibly active in film-making (e.g., Wayne Wang and the Indian filmmaker now based in the USA, Mira Nair, whose film Mississippi Marsala, is about Indians settled in the USA, 1991). Other Black cinemas, such as African or Indian cinemas tend to come under the overall umbrella term of Third World Cinema. This problematic term is one conceived to englobe cinemas that are neither of the First World (USA/Hollywood) nor the Second (European cinema) but come from a third space, often a colonized and subsequently post-colonial one. This so-called Third World Cinema refers therefore to indigenous cinemas (primarily those of Latin America, Asia, Africa, and Middle Eastern countries) not to those of the Black diaspora. This is further complicated by the presence of another term in this context, that of Third Cinema which refers to a cinema of resistance emanating from so-called Third World countries. (And see entry on Third Cinema since certain debates have argued for including all diasporic cinemas under the rubric of Third Cinema.)

In discussing Black cinema, one is also talking about race/racism and cinema's own racism. Daniel Bernardi (1996, 7) makes the useful and valid point that 'cinema's invention and early development coincided with the rise in power and prestige of biological determinism' (i.e. belief in the superiority of certain races over others). As Clyde Taylor (1996, 17) explains, it is impossible to talk about Black cinema without referring to racism and to

Hollywood's 'negrophobia' and equally to Film Studies' 'passive racism'. In defence of film studies and thanks to the impact of cultural studies, as Bernardi (1996, 5-6) points out, the 1990s has seen a growth in scholarship in this area of Black cinema, even though there is a lot more to do (see Bernardi's comprehensive list, ibid.). By way of illustrating his remarks about Hollywood's negrophobia, Taylor, using the classic epic film of American film history, Griffith's The Birth of a Nation (1915), demonstrates how this film is an epic of White supremacy whose theme of national unity rests on the basis of White values - in particular the hatred of miscegnation (1996, 19), Ford's western film The Searchers (1956) reminds us, lest we believe the mythology of White nationalism has disappeared, that some fifty years later, very similar fears were being expressed. Containment and displacement are at work in this 1950s' film, just as it was in Griffith's film forty years earlier. While set in the immediate post-Civil War period with its own set of anxieties over the cultural function of race (post-slavery) – which are expressed through fear of the Native-American (Indian) predator on White womanhood - The Searchers also reflects America's contemporary late 1950s' anxieties about the growth of the Civil Rights Movement's campaign activities. Fear of miscegnation and the genetic determination of race is at the heart of Ford's film, just as it is in Griffith's. If, after Griffith's film, mainstream cinema never again portrayed Blacks as a mass menacing White society, then, as Clyde Taylor points out (ibid., 32), this did not prevent western epic after western epic from picturing the mass slaughter of Indians (or indeed Mexican bandidos).

Black cinema early days 1890s–1960s Both Thomas Cripps (1977; 1982) and Ed Guerrero (1993) have documented the Black presence in early American cinema, not just as figurantes or actors, but also as independent producers and directors in their own right. Thus while Edison and others were making their race films using Black artistes (Pickanninies, 1894, Negro Dancers, 1895, Dancing Darkies, 1897, The Dancing Nig, 1907, For Massa's Sake, 1911), African-Americans were not slow to come forward with images to counter these negative stereotypes of Black people. Thus, first Bill Foster and then Emmett J. Scott, George and Noble Johnson, and Oscar Micheaux formed their own independent production companies to produce realistic images of African-American life for Black audiences.

Before saying more about these early pioneers of Black cinema in America, a brief point needs to be made about race films since some ambiguity surrounds the terminology. Race films specifically target Black audiences and are mostly made by White directors. These race films, in the early days of cinema (when short films were part of a mass of other visual attractions at fairs and exhibitions), appealed to White audiences as well. The idea of the Black body as object for the gaze, as exotic other, came into play very early within cinema history, therefore. Over time, however, race films did not necessarily carry these overly negative connotations. During the years of segregated cinema theatres (starting in the 1900s and lasting in some states as late as the 1960s). Black audiences were the recipients of films 'made for them' but which were not necessarily 'about them'. If race films were all-black films, not all of them typecast their actors. In this context, it is worth mentioning the case of Francine Everett, the Black actress, singer and dancer who, during the 1930s and 1940s, starred in a number of low-budget independent films. Although she could have gone to Hollywood (she was offered but turned down a role in the all Black-cast musical The Green Pastures, 1936). Everett refused to accept the stereotyped roles imposed upon Blacks. Instead, she made several short musical films and featurettes, which were extremely popular with Black audiences. She made these so-called race films with both White and Black directors (e.g., Keep Punching, John Clein, 1939; Big Timers, Bud Pollard, 1945 who were White directors, and in 1946. Dirty Gertie from Harlem USA, by Spencer D. Williams, an African-American film-maker).

Returning now to our pioneers: Bill Foster set up his production studios (the Foster Photoplay Company) in Chicago in 1910 and set about producing comedies based on the Hollywood formula but recast in a Black mould. The important point here is that he was the first to turn genre inside out, to reverse it (to practise what some Blacks term 'grinning'). In his films, Blacks are not the unidentified shuffling, obsequious caricature of Black manhood, nor the de-sexed and obedient Black Mama. His films showed a slice of Black community life, including a thriving Black middle class (see *The Railroad Porter*, 1912 and *The Fall Guy*, 1913). Other companies quickly followed: the Lincoln Motion Picture Company (1916, Los Angeles) and Oscar Micheaux' Micheaux Book and Film Company (1918).

Following the outrage felt by Black audiences at the screening of Griffith's *The Birth of a Nation*, Black independent film-makers retorted with a cinema of their own (most symbolically perhaps

with Emmett J. Scott's *Birth of a Race*, 1918). This was not the sole cause for the emergence and quite long duration of a Black independent cinema sector (late 1910s to the 1940s). Other contributory factors were, first, economic and, second, cultural ones). Economic because there was a Black audience out there, in a sense already 'targeted' because of segregation (implicit or actual, depending on the state). Cultural, because the Harlem Renaissance Movement of the 1920s gave a new pride and voice to Blacks and tackled head-on the question of Blackness and issues of racism. As we shall see, this phenomenon of cinema-as-resistance to negative or incorrect imaging of Blacks re-occurs in the early 1970s and again in the mid-1980s and is equally politically, economically and culturally motivated.

Oscar Micheaux' film work in this context is perhaps best known and because his work spanned some thirty years (1918-48), during which he made between twenty-five and thirty feature films, he has left a legacy that acts as an extremely important reference point to historians and makers of Black cinema. Micheaux set up his production company in 1918, the Micheaux Book and Film Company. Half of his output was produced during the first half of his career (1918-29) and most of his films were based on novels written by him. His early films show the complexities of race but there is no easy binary opposition. He did not offer a sanitized, idealized image of Blacks to counter the Hollywood White image. He attempted to show his personal view of the contemporary Black experience. Thus his films deal with such difficult questions as concubinage. rape, miscegenation, lynching, gambling, wife-beating, debt, urban graft and passing. For example, in The Symbol of the Unconquered (1920), Micheaux exposes the problem of betrayal of one's own race (and Black manhood) when a Black man passes as White. The problem is explored further since the Black not only successfully passes but also simultaneously oppresses his own people (the 'passing' villain collaborates with the Ku Klux Klan to drive homesteaders off valuable oil fields). Inter-marriage is an issue that re-occurs in his work and the expressed fear of betraying one's own race if one marries a White woman (The Homesteader, 1920, and The House Behind the Cedars 1925). Finally, The Brute (1920) was a sharply observed film about gambling and wife-beating which did not please many Black audiences. Micheaux' cinema was based on essentially two environments: the urban and the western frontier. The frontier held

hope for Black people (in Micheaux' view). It was there that they could find a better life freer of the racism and violence of the city.

Micheaux' cinema was a political enterprise - to bring an awareness to Black audiences of the real social and moral difficulties they faced as Blacks and also to bring them strong, identifiable images of their own lives. But his representation of Blackness has raised some criticism among more recent historians of Black cinema. As one set of critics puts it, Micheaux' drive for 'racial uplift, which was so important to counter accusations of "inferiority", challenged White definitions of race without changing the terms' (Bowser and Spence, 1996, 67). He did not question those terms and saw himself as 'an empowering interpreter of Black life for the community' (ibid.). This has led to further criticisms that Micheaux reproduced White versions of urban Blacks as lazy, unambitious and as wanting something for nothing (ibid. 72-3). Other critics have remarked how Micheaux' narratives appear to valorize the palerskinned Blacks over very dark-skinned Blacks (Karen Ross, 1996, 60-1, usefully provided a detailed summary of critics holding this position). But bell hooks (1992, 135) argues convincingly that what Micheaux was really doing was 'calling into question the Western metaphysical dualism which associates Whiteness with purity and blackness with taint', hooks goes on to argue that by doing so Micheaux provided a subtext by which he 'interrogates internalized racism and the color caste system'. The fact that the 'baddie' in The Symbol of the Unconquered was a Black 'passing' as a White and was therefore pale-skinned would give credence to this intention. The fact also that passing is an issue in his films from the earliest to the latest (see, for example, Ten Minutes to Live, 1932) should lead us to agree with bell hooks (ibid.) that 'Micheaux' work offers an extended cinematic narrative of black sexual politics', including the exploration of 'black heterosexual pleasure within a rigid color caste system that makes the desired object the body most resembling Whiteness'. Micheaux' interest in the expression of desire between Blacks within the heterosexual context is also extremely modern precisely because he shows the complexities of this desire and, equally significantly, because he makes women in his films the agents of desire as much as the men.

Micheaux' films offer an early form of urban realism; they were some of the earliest Black action genre movies and as such

his work represents an important heritage to present film-makers. However, much of contemporary African-American cinema seems obsessed with the ghetto, male protagonists are driven by a machismo measured by guns and drugs-dealing and hatred of women and they seem determined that there is no way out except through death. All of which seems to strongly counteract the hopes behind Micheaux' work. That direction, however, appears to have been followed by the work of the so-called new Black aesthetic – predominantly the work of film-makers trained at the UCLA film school during the 1970s and early 1980s (see below). Although it should be pointed out that, during the 1960s, there were a few African-American independents making low-budget films that perpetuated the challenge to the stereotyping of Blacks initiated by Micheaux and his contemporaries (e.g., The Cool World, Shirley Clarke, 1963, One Potato, Two Potato, Larry Peerce, 1964, and Still a Brother: Inside the Negro Middle Class, William Greaves and William Branch, 1968). Furthermore, during this same period, Sidney Poitier came to embody the new image of the Black man. A middle-class, highly educated and well-mannered African-American who fought racism by example (and by a few occasional outbursts of welltimed and supremely controlled anger), Poitier's roles were emblematic of the integrationist politics advocated by Martin Luther King and the films he figured in were about social conscience and the fight against racism. An exemplary film of Poitier as this new Black hero is the inter-racial film and murder melodrama In the Heat of the Night (Norman Jewison, 1967) in which he fights Southern bigotry to save the life of a racist White youth from conviction for a murder he did not commit. Despite this positive image, critics have argued that Poitier, as 'the ebony saint', was not afforded in his roles any hint of a sexual life - at least on the surface. Close readings of his performance style would suggest, however, that a strong sense of sexuality is present and indeed a great sensuousness.

Black cinema of the 1970s: the authentic Black experience and Blaxploitation movies By the 1970s the social conscience movies of the 1960s had given way to a new set of images inspired by the new Black militancy and Black pride that emerged as a result of the renewed Civil Rights action of the late 1960s. The Watts riots in Los Angeles in 1965, the assassination of Martin Luther King in 1968, and the galvanizing of the student movement of protest as a result of the killing of four White students

at Kent State University in 1971 all contributed to this resurgence of a new type of Civil Rights activity. The late 1960s early 1970s was the time in America of the Black Power movement: the mid-1970s, of Blacks going to (previously) all-White universities in significant numbers. In Black history, this time was one of politicized opposition to the dominant ideology (not one that sought integration in the way, arguably, Martin Luther King had done and that the 1960s' Civil Rights movement had advocated). Between 1971-2, three films rooted in African-American urban culture all made by Black directors were big hits, particularly with Black audiences (Sweet Sweetback's Baadasssss Song, Melvin Van Peebles, 1971, Shaft, Gordon Parks Snr, 1971, Superfly, Gordon Parks Jnr, 1972). The heroes of these films were rough, tough and, most important of all, were winners. And the films themselves were direct challenges to Hollywood action films and Hollywood's representation of Blacks, Subgenres with a message, therefore.

Although, undoubtedly at the time (1971), Melvin Van Peebles never thought that his independently produced film *Sweet Sweetback's Baadasssss Song (Song)* would be the cornerstone for some 40 Blaxploitation movies, none the less his, and the two other films mentioned, became the founding stones for a series of very profitable ventures for Hollywood. In the early 1970s, Hollywood was suffering financially (see **studio system**) so, during the period 1971–6, with an eye to profit, it capitalized on this initial success and made a plethora of what have become known as Blaxploitation films. These films, starring Black actors – but produced by Whites and mostly directed by Whites – deliberately targeted Black audiences. This heritage moment for Black cinema is not, therefore, without some irony and points to the problem faced by all (so-called) minority groups – the danger of co-optation by the dominant culture.

In all three films, Song, Shaft, Superfly, the heroes/anti-heroes succeed against the (White) system. However, it is Van Peebles' film Song that remains the clearly politically motivated one, hence the irony of this sub-genre's co-optation by Whites. Van Peebles' film reflects the politicization of Black America of the early 1970s. Song is about the Black community, more specifically about the law as an enemy of Black people. The eponymous anti-hero, Sweetback, is a pimp (and a stud) who gets elevated to cult hero when he kills two White policemen who have acted abusively within the Black community. He then escapes

to Mexico. This film, which was independently produced and cost \$500,000 to make, grossed \$20 million in the first few months of its release. Similarly, *Shaft* and *Superfly*, produced by Hollywood (but directed by African-Americans), made tidy profits. These three films represented a positive moment in Black cultural history. Blacks, who hitherto had remained asexualized on the screen now expressed their sexuality. Blacks were given strong heroes who do not get dragged down but who actually escape from the ghetto. Aggressive and rugged individualism was put up on screen and undoubtedly provided Black audiences with images that both articulated their anger and gave it a positive outcome.

For Hollywood the success of Shaft (which won an Oscar for Isaac Hayes' music score) and Superfly meant cheap products bringing in high returns. Now Black actors became the flavour of the month, provided they were not expensive. However, if they were inexpensive (i.e., not Sidney Poitier), generally speaking, they were not known by the public at large. So Hollywood turned to musicians and sportsmen (sic) to find their stars (thereby guaranteeing further White audience interest as well - what is known as 'cross-over' value). White directors and producers pumped out sequels to these original hits - all much of a muchness (pimp or private eye beating the system) and simplistically racist (the White as the fat villain). The success of these mix and match, push-button formulaic films led Hollywood to cast its net a bit wider, generically speaking (e.g., monster movies Blacula, William Crain, 1972, westerns, Boss Nigger, Jack Arnold, 1974, and the series featuring the football star Fred Williamson The Legend of Nigger Charlie, 1972, The Soul of Nigger Charlie, 1973, Black Bounty Killer, 1974) (for a persuasive counter-reading of Blacula, see Leerom Medovoi, 1998).

For all that the Blaxploitation movies were exploitative of Black audiences, it was surely the first time that a Black presence was so widely visible in movie theatres. Blaxploitation movies had a double-edged result, therefore. On the one hand (and this is particularly true of the earlier Blaxploitation movies – and of course the three pre-blax films), these movies gave a representation of Blackness and Black ghetto life not seen since the Micheaux films. They established an African-American identity that was different from the safe-sexed Poitier (or indeed Harry Belafonte). They created new stars, new super-heroes: Jim Brown, Ron O'Neal, Richard Rowntree, Tamara Dobson and

Pam Grier (some of whom disappeared during the 1980s only to reappear in the 1990s as Pam Grier did in Quentin Tarantino's film Jackie Brown, 1998). The men and women heroes of Blaxploitation movies were not White defined. Although the point needs to be made that women heroes in Blaxploitation movies were far from numerous and only two became true stars - Tamara Dobson of Cleopatra Jones fame (Jack Starrett, 1973) and Pam Grier - all these heroes were sexed, armed and potent and fought their own case and cause (e.g., drugs, corrupt White cops). The women-based Blaxploitation movies, while thin on the ground, did none the less, as Leerom Medovoi (1998, 15) points out, 'activate feminine narratives concerning racial loyalties and black pride'. Medovoi notes in particular that Pam Grier's roles in Coffy (Jack Hill, 1973) and Foxy Brown (Jack Hill, 1974) reveal her as facing anxieties actually felt by Black women viewers between their loyalty to the new African-American way (as exemplified by the Black Power Movement and the new heroic images of Black manhood in Blaxploitation movies) and their longing for an Afrocentrism (a passion for a retrieval of African roots). Finally, on the positive side of Blaxploitation movies we must count the dress code, language and music that were so firmly Black-encoded.

On the other hand, the down-side of the Blaxploitation movies, particularly the later ones, was the stress Hollywood placed on sex and violence at the expense of the more complex intertwining of identity factors. If sex and violence were a part of this identity, they certainly were not the whole of it in the first three African-American products that Hollywood sought to reproduce in a formulaic and stereotyped fashion. Many Blaxploitation movies deal with the drug plots against the Black community, but these can now be read as attempts by Hollywood to recuperate any articulation of a politicized message such as Black empowerment. The hero may well be a powerful masculine presence, however, the image of militant Black manhood has gone.

In 1976, the Blaxploitation movie craze crashed. For predominantly two reasons: one economic, the other political. On the economic front, although Blacks were by far the greatest audiences of these movies, they 'only' represented 12 per cent of the population. Demographically speaking, they are not then a large target audience, something that Hollywood requires to make profit. So the 'genre' died out. Cynically, now that, in the late

1980s early 1990s, cable and syndicated television and video sales have upped the demand for all sorts of films and made targeting 'small' audiences a profitable concern, Hollywood is back in there making Black-cast movies. The fading of the Blaxploitation boom was also politically motivated. In the late 1970s, as a result of the politicizing effects of the Black Power Movement – at least as far as the representation of Black men was concerned – images of Blacks as pimps, junkies, dealers, thieves ran counter to the new images Black men had of themselves. If, however, in the Black cinema of the 1980s and 1990s, Black male images have become more diversified, such is not the case for Black women. Images of Black women as 'bitch' or 'ho' (whore) still prevail (see below).

After 1976 - towards a new Black aesthetic and a Black cinema From the late 1970s through the 1980s three discernible styles emerged: the populist tradition which comes down to a revival of the Blaxploitation movie (for example, the Eddie Murphy films of which Vampire in Brooklyn, Wes Craven, 1995, merely continues the Blacula tradition, comedy-style). At its best, this populist style parodies its antecedents. The second discernible style is the urban African-American ghetto street-life hip-hop-rap movie (Spike Lee's films are exemplary of this tradition). And, finally, the third is the socio-realist/ethnographic cinema. This last category is known as the new Black aesthetic, but is one that has only impacted on a part of Black cinema (see Diawara, 1993 for greater detail). In the late 1970s Black students, writers and film-makers got together on American campuses (most famously perhaps the UCLA group) and sought to broaden the frame of reference of Black experiences in America - including that of Black women - and to challenge the stereotypes surrounding their representation. This cinema is one that hits out against stereotypes (including those that Blacks produce of themselves) and does not conform to the image of 'Black hero as oppressed' but offers images of self-determination for both men and women. This cinema looks at traditions of Black cultures. Equally, it also addresses issues of post-White colonialism and neo-colonialism. Of this category, the films of Charles Burnett and Julie Dash are perhaps the best known (e.g., respectively, Killer of Sheep, 1977, and Daughters of the Dust, 1991).

Of the populist/post-Blaxploitation category, Keenan Ivory Wayans' *I'm Gonna Git You Sucka* (1988) was the first and is, arguably, one of the best Blaxploitation parodies. Playfully **intertextual**, it sends up not just the clothes worn during the 1970s

(as 'funny to look at now') but exposes their original parodic/ironic value. That is, the clothes chic of flares, tight polyester shirts, platform shoes, hot pants so preponderant in Whites' dress-code of the 1970s was none other than a restoration into mainstream culture of the dress-code of double-marginals – Black pimps and prostitutes! Wayans also brought back in the **stars** and the music from the earlier films: we all 'remember' the music of *Shaft* – nostalgia for all, including the stars who were willing to come back and make fun of their previous selves.

If Black cinema became a visible phenomenon in the 1980s, it was thanks partly to the success of the star Eddie Murphy an examplar of the populist tradition (and great puller of White audiences). But it was also thanks to the success of early 1980s' hip-hop-rap films. This category of Black cinema, though perhaps not ideological, does represent the revival of a specific cultural nationalism: Black urban street life - mainly as it concerns men. Thus, for feminists, Black feminists, it is not an unproblematized revival, nor is it an unproblematic representation of Black culture (see below). However, these films are compositions that do run counter to classic narrative cinema in their syncopated jazz-like structure their strong reliance on the rhythm of rap music. They are low-budget products all made for under \$10m and grossing up to five times that figure. Lee's She's Gotta Have It. 1986, was made for \$175,000 and grossed \$8.5m; Do the Right Thing, 1989, cost \$6.5m and grossed over \$27.5m. Lee's success has opened the door for others, which is a positive outcome. For example, 1991 saw nineteen Black-cast and Black directed films and since then there has been a boom in African-American cinema products. It is also the case that the 1990s has witnessed a big increase in the number of African-American stars - mostly male stars it is true - and it is difficult not to attribute this greater presence to Hollywood's realisation (thanks to the boom in Black cinema) that Black actors are bankable items and should be more widely used.

However, as Jacquie Jones (1991) says, Hollywood still holds the purse strings – it chooses the Black directors, actors and the storyline. And these films represent a cinema that does not threaten existing conventions. Citing numerous films, but focusing on Mario Van Peebles' New Jack City, 1991, which was independently produced so was perhaps not the best choice to illustrate her otherwise not invalid argument, Jones claims that this cinema proffers a new ghetto aesthetic that magnifies the

grim realities of Black urban life, plays on the 'Black on Black crime' **myth** and, finally, serves to illuminate the image of the Black male for the American audience. At best, then, Blacks become sociologically interesting. Ed Guerrero (1994, 30) argues differently that these 'male-focused, "ghettocentric", action-crime-adventure' movies differ from the standard Hollywood studio action-film product and 'implicitly undermine Hollywood's inherent tendency to repress or coopt resistant or oppositional social perspectives in its films'. Guerrero sees *New Jack City* (among other contemporary ghettocentric films) as 'caught up in the aspirations and communal problems of the social worlds they depict' and as historicizing 'the cultural, political and economic issues of the resistant communities they represent'.

Undoubtedly, Hollywood co-opted this cinema in the same way as it had the early 1970s' Black action cinema. And it did so quite swiftly. These cheapies were good value at a cost of between \$1.5m and \$10m. At that price, returns were guaranteed by Black audiences alone, so any cross-over revenue was pure profit. Once the budget was in the \$30m range, then cross-over became an imperative, however. While this could seem to compromise Black film-makers, most African-American film-makers working within the studio system argue that they are there 'to expand the definitions and possibilities of being black and to subvert the dominant norm by marketing a "black sensibility" to as broad an audience as possible' (Guerrero, 1994, 30), including of course a White audience.

Leaving that polemic aside, what is interesting in the evolution of Black cinema since its beginnings is the way in which this latest boom - unlike the new Black aesthetic - has not drawn on its historical past but is in many ways deeply ahistorical. While the ghettocentric movie draws on the ghetto culture of 1970s-Blaxploitation movies, gangster/gangsta chic has replaced the imagery of Black identity proposed by the earlier movies whose own image is based on the historical and political context of the 1960s' Civil Rights Movement and later the Black Power Movement. Gangsta-chic is based on violence and addiction which, of course, the 1970s failed to remove (despite the evidence to the contrary in the Blaxploitation films). There is no apparent desire to leave the ghetto - or the 'hood - only to die in it. Guerrero (ibid.) makes the point that Blacks today are worse off economically speaking than they were before the 1960s' Civil Rights Movement. The ghetto culture is back but

with a difference. The ghetto culture has spiralled down in one long social continuity of governmental neglect. The music is rap and is based on violence and revenge, as is the narrative. The implicit brotherhood of the Blaxploitation movie has gone and now it is gang warfare. The fight is over drugs and who controls them, not how to get rid of them (this gangster warfare is somewhat reminiscent of the 1930s' gangster movies where the fight between gangs was over alcohol).

The film Menace II Society (Allen and Albert Hughes, 1993) shows this regressive reality of the 'hood film. The film starts with an evocation by the young protagonist of his father's involvement with the Watts Riots, and then interfaces, through his flashbacks, his parents' life in the 1970s (represented very much in the Blaxploitation movie style) with that of his own life now in the 1990s (represented in the form of the now familiar contemporary hip-hop 'hood film). Ultimately, the present is just a worse manifestation of what was before. Leerom Medovoi (1998, 7) sees the problem in such representations as being located in the fact that they are based on a very narrow historical field, one that is not tied to the destructive legacy of the slave trade but only to the immediate past. The broader history behind the current anger, Black rage and destructiveness is what is missing in these films. Such representations are very few and far between, emanating from the independent films of the new Black aesthetic group (e.g., Burnett and Dash) and which looks at the past - the deep past - as well as to the 'new formulations of identity and subjecthood' (Guerrero, 1994, 28).

In these ghettocentric films, the reappropriation of Black women by Black male film-makers has not represented a sign of liberation for women either – a deep disappointment given the positive heritage of their representation in Micheaux' films and some Blaxploitation movies. So far in the majority of these movies women occupy predominantly two positions: 'bitch', the wilful woman ripe for being brought down, or 'ho', the sexually demanding and not easily satisfied woman. There is, occasionally, the presence of the 'good' woman, the 'rescuer' the one who utters (however ineffectually) the words of salvation, the one who perhaps represents the 'missing' parent (e.g., Menace II Society). For the most part, woman is usually defined in relation to the other male characters, she has no narrative of her own. Misogyny also hits out at the mother, who is often seen as ineffectual, and in return patriarchy is valorized. This is particularly

the case in the films of two film-makers, John Singleton (Boyz'n the Hood, 1991) and Matty Rich (Straight Out of Brooklyn, 1991). In mainstream cinema, Leslie Harris' Just Another Girl on the IRT (1993) stands more or less alone as a film that counters this deeply misogynistic view of women in the 'hood.

Who is the speaking subject? These three categories of films (socio-realist/ethnographic, populist/comedy, urban/ghetto) all raise the question of who is the speaking subject? Is it 'just' Black? Is it 'just' male and Black? What, in America, is its originating space (i.e., East or West Coast, North or South)? How is it situated in time and space (i.e., in relation to its history)? Speaking the Black subject raises further questions. To whom are these images destined? What about the risks involved in becoming the voice of the Black cause? That is, of speaking about the Black condition rather than from it? Of setting in place a new set of stereotypes (e.g., 'Black as victim')? What, in the final analysis, is to be the relationship with Hollywood? Can Black cinema co-exist with Hollywood in the same time and space?

Blacks represent 12 per cent of the American population, they presently make up 25 per cent of the cinema-going audience which is primarily a youth audience. Black culture permeates American society, particularly the youth class. This should make Black cinema an attractive proposition for Black investment. As yet, however, this has not transpired. The emergence of Black cinema is not thanks to Black financing but is a result of Hollywood's economic policy which has co-opted Black cinema into its industrial monopoly. There are kicks against this, which may herald change. First, there was Spike Lee's much publicized defiance over the financing of Malcolm X (1992). Warners produced it but would only put up \$28m, Lee needed \$34m. He publicly exposed Warners when he named the Black celebrities who helped make up the \$6m short-fall. Second, Lee and other film-makers have set up an association based in Yew York: the Black Filmmakers Foundation, to counter Hollywood's control and to help finance Black film-makers' work (founding members include Charles Burnett, Iulie Dash, Reginald and Warrington Hudlin, Charles Lane). Third, Black film-makers have refused, through their film practices, to be measured by the two key modalities usually imposed by critics on films coming from the margins: authenticity and realism (Kennedy, 1993). Thus, although critics may decry the failure of films that

refer to rap culture both texturally (through their structures) and intertextually (through the presence of rap artists and their songs within the film) to convey the authenticity of the concerns of rap lyrics, they are missing the point that this cinema is not one that is seeking to marginalize itself as avant-garde but one that is seeking to deconstruct **hegemonic** practices from within (Kennedy, ibid.). Similarly, why must realism mean one thing only - ghetto Black violence - and not middle-class success? Finally, there is another voice from the margins that is at last getting heard - that of the Black female and African-American female film-maker (currently there are twenty African-American female film-makers in America). This is a voice that gives a different image of Black womanhood to that offered by Black male cinema. To the misogynistic and homophobic images of Lee, Singleton and Mario Van Peebles, Kathleen Collins counters with images of middle-class professional womanhood (Losing Ground, 1982), Heather Foxworth with images that expose Black male sexism within the Black community (Trouble I've Seen. 1988). More recently, Mira Nair's Mississippi Marsala (1991) comes at inter-racial desire from a new and different perspective that points to the multicultural reality of the United States. In this film, the two young lovers are an African-American man and an Asian-Indian woman - inter-racial marriage in this context reveals itself as having the immense potential of a rich mixture (a Marsala) of cultural backgrounds.

For further reading see authors quoted in above text and see also: Imruh Bakari, 1993; Bogle, 1988 and 1994; Cripps, 1978 and 1993; Diawara, 1993; Givanni and Reynaud, 1993; Guerrero, 1993; Snead, MacCabe and West, 1994; Martin, 1995; Taylor, 1986; Wilkins, 1989. For a list of films see Givanni, 1992, for a list of women film-makers see Oshana, 1985, and for a list of available films in the UK, see Alexander, 1998. For a bibliography on Black cinema see Vieler-Portet, 1991. Finally for journals see Black Film Review (1986–91) and Black Camera.

B-movies (see also **studio system**) Cheap, quickly made movies first came into prominence in the United States during the depression (early 1930s) when audiences demanded more for their money – a double bill: two films for the price of one. So a B-movie was screened as a second feature alongside a major feature film (called an A-movie). Monogram and Republic made

B-movies only, mostly **thrillers** and **westerns**; the major studios also had to turn some of their studios over to B-movie production and some of their productions met with astonishing success (for example RKO's *Cat People*, Val Lewton, 1942). The Supreme Court decision in 1948 to end the major studios' cartel over distribution and exhibition opened the screens to independently produced films. The impact of this decision on the Hollywood studios was to recreate fierce competition among the majors. As a result the cost of making films in and for Hollywood went sky-high. The effect was to put an end to the production of B-movies and to the double bill.

body horror films - see horror films

British New Wave (see also Free British Cinema) The British New Wave, like its French counterpart, was quite short-lived: 1958–64. As a movement, it coincided with the social and cultural changes occurring in Britain largely as a result of the emergence during the 1950s of a youth class. This was a period marked by radical change in music, fashion and sexual mores – this was the era of the 'swinging sixties'. It was also the era of 'kitchen-sink' drama, of a gritty new realism on stage starting with John Osborne's play Look Back in Anger (1956).

The legacy of the British New Wave is both that particular kitchen-sink theatre of realism and the radicalized documentary tradition of the Free British Cinema. Given that the film-makers who dominated the New Wave - Lindsay Anderson, Karel Reisz and Tony Richardson - were the same as those of the Free British Cinema group, this part of the heritage is hardly surprising. The Free British Cinema group's work had focused on the youth and working classes at work and in leisure; the New Wave was one that focused on contemporary social issues of youth growing up in a culture of increasing mass communication. Prostitution, abortion, homosexuality, alienation caused by mass communication culture, failures in couples' relationships - these were some of the dominant 'social problems' dealt with. The documentary-realist style is everywhere in evidence in this cinema of the New Wave, with the predilection for location shooting, particularly in northern industrial cities, the use of black and white fast stock film (which gave a grainy, newsreel look to the images), and natural lighting. Stars were not used,

although actors who were used, such as Alan Bates, Albert Finney, Richard Burton and Michael Caine, soon found star status thanks to their roles in these films. It is noteworthy that the two women actors most associated with the films of this movement, Rachel Roberts and Rita Tushingham, never gained such status. The majority of the films were based on books or plays written by authors who had first-hand experience of working-class life: Alan Sillitoe, John Braine, David Storey, Shelagh Delaney.

Although some film historians nominate Room at the Top (Jack Clayton, 1959) as the first New Wave film, it would be more accurate to say that that film was a precursor to the movement and that Richardson's adaptation for the screen (1959) of Osborne's Look Back in Anger is in fact the real beginning of this movement. Osborne and Richardson were also flag-bearers in that they were the first to form an independent production company, Woodfall Films, to finance their projects. This was swiftly followed by Joseph Janni's Vic Films, then Bryanston - a subsidiary of British Lion and made up of a consortium of sixteen independent producers - and, finally, Beaver Films, formed by Richard Attenborough and Bryan Forbes. Soon after being established. Woodfall Films sought financial backing from Bryanston to produce Shelagh Delaney's A Taste of Honey (Richardson, 1961). This link-up with the British Lion subsidiary would in part seal the fate of this movement in 1964.

Look Back in Anger with Richard Burton in the protagonist's role as Jimmy Porter was the first of the so-called 'angry young men' films, shortly followed by Albert Finney in Saturday Night and Sunday Morning (Reisz, 1960) and Alan Bates in A Kind of Loving (John Schlesinger, 1962). The real difficulties of single motherhood and the loneliness that social marginalization imposes on homosexuals are central themes to A Taste of Honey. The hypocrisy of authoritarian institutions such as the Borstal comes under fire in The Loneliness of the Long Distance Runner (Richardson, 1962). This Sporting Life (Anderson, 1963) exposes the corruption and commercialism of the Rugby League business and the brutality to which lovers can be pushed by a lack of communication.

By 1963, over a third of film production was New Wave. The movement was riding high and proving that the British film industry could resist **Hollywood** domination. It was, however, this very success, in particular of Woodfall Films which produced

the majority of the New Wave films, that brought about the movement's - and thereby the British film industry's - demise. Richardson wanted to make a film adaptation of the novel Tom Iones. He wanted to shoot it in colour and full costume. This required a considerably larger budget than was typical for a New Wave production. British Lion refused to back the project and so Richardson turned to the American production company United Artists. At this time Hollywood was experiencing severe financial difficulties and was only too pleased to turn its attention to Britain and invest money where overheads and talent were cheap. United Artists' agreement to finance the production of Tom Jones (1963) was the thin edge of the wedge that broke the back of the British independent companies and, ultimately, British Lion. Taken by the British success, the major Hollywood studios invested in British production projects and, by 1966, 75 per cent of British films were American-financed. By 1967 this figure grew to 90 per cent. By the end of the 1960s, when Hollywood began to experience an upswing in its fortunes, the American companies had upped stakes and gone home, leaving the British film industry virtually incapable of financing itself. Add to this the selling-off in 1964 of British Lion, which had released the majority of the New Wave films, and the picture of the industry's demise is complete.

For further reading see Hill, 1986.

buddy films Traditionally buddy films are for the boys. That is, the narrative centres on the friendship between two male protagonists. This genre was very much in vogue in the 1960s and 1970s, perhaps as a response to the dehumanizing effects of the Vietnam War in which the United States became heavily entangled after 1962. Paul Newman and Robert Redford are the icons of this genre, often appearing together (Butch Cassidy and the Sundance Kid, 1969; The Sting, 1973, both George Roy Hill). This friendship is totally heterosexualized, there is no possible misreading since the heroes are always doing actionpacked things together (shooting themselves out of trouble, primarily) - 'boys will be boys' - and a woman will be 'around' even if very marginal to the narrative (she guarantees the heroes' heterosexuality, just in case). The buddy genre has now developed, in the 1980s and 1990s, to include a proto-father-son friendship, again with the icon Newman but accompanied this

time by a younger alter-ego, Tom Cruise (*The Color of Money*, Vincent Lauria, 1986) – signifying a restoration of family values or at least of the value of the father ('every boy needs a man to show him how to be a man'). Though considered a male genre, recently this phallocentrism has been called into question, in some instances to hilarious effect, as in the film *Thelma and Louise* (Ridley Scott, 1991) in which two women buddies hit the road. Another 'inverted' buddy movie is the very camp and funny Australian–British co-production *The Adventures of Priscilla, Queen of the Desert* (Stephan Elliot, 1994). Buddy films have also, in the light of AIDS, stretched in meaning and produced a subgenre that addresses gay male friendship (for example *Longtime Companion*, Norman René, 1990). In this manifestation the buddy film has come to represent what it most eschewed or feared in its earliest manifestations.

Cahiers du cinéma group - see auteur/auteur theory, French New Wave

castration/decapitation - see psychoanalysis

censorship In some countries censorship is quite benign and limited to a rating system to protect minors and to inform audiences of the content of films. Other countries still pursue a very strong line in censorship, banning films in their entirety or insisting on cuts being made. Censorship tends to be imposed in three main areas: sex, violence and politics. The first two have been of primary concern to groups lobbying for the welfare of minors; the third more clearly has been the concern of state institutions and governments. Relaxation of censorship laws is very recent: late 1960s for the United States; mid-1970s for the United Kingdom, France and Spain - and so on. In some countries, the United States and Germany for example, it is constitutionally illegal to censor films, even though censorship may be maintained. Generally a country that is more assured in its political culture and does not feel its hegemony to be under threat is less inclined to draconian censorship. However, the fact that this is not always the case points to the notion that consensuality is not always a given. Incidents in France around Scorsese's film The Last Temptation of Christ (1988) show that the Catholic lobby still has a strong foothold within smaller communities. Although there is supposed to be a separation between church and state in France, the Catholic lobby obliged mayors to cancel screenings. Similarly in this seemingly contradictory vein, repressive regimes have enacted sensible censorship laws. During the Nazi regime and also during the occupation of France, the Germans imposed strict regulations to protect minors, so that certain films were forbidden to those under sixteen.

Because the United States' film industry is dominant, the American Hays Office/Code is the best-known censoring body. Its official title is the Motion Picture Producers and Distributors of America, popularly renamed the Hays Office after its first president, William H. Hays (serving from 1922-45). The Hays Office was established in 1922 in response to public furore over the morality of some of Hollywood's stars. However, the point should be made that this office was established by the film industry itself, which thought it in its own interests to set it up as a way of protecting itself against federal intervention. It is curious that sex scandals off-screen should bring about censorship of narratives on-screen. But that's what happened - and many careers were broken, even if the scandals were not proved or indeed if a star was acquitted in a trial, as was the case, most notoriously, for Fatty Arbuckle. Havs wanted Hollywood to act as self-censors rather than let state or federal censorship intervene. This meant of course that stars were even more in the pocket of the production companies, thereby finding themselves in the paradoxical position of having simultaneously to be larger than life and yet also totally 'normal' and ordinary - a schizoid conflict that killed some of them (for example James Dean, Marilyn Monroe, Judy Garland, River Phoenix).

While the film industry may have been reasonably successful in watching over its stars, it did not fare so well in self-censoring its own product. Movies privileging the underworld and gangsters, for example, were severely condemned by critics. So in 1934 a production code (based on the Ten Commandments) was published to which all companies had to adhere. In 1968 the code was discarded in favour of a ratings system which still prevails. The office is now the MPAA: Motion Picture Association of America.

For further reading see Kuhn, 1988 (cinema of the silent period); Black, 1994 (Hollywood in the 1930s); Matthews, 1994 (censorship in the United Kingdom).

cinema nôvo A cinema that emerged in Brazil in the early 1950s and whose style and critical aesthetic were at first influenced by

the Italian neo-realist movement - not surprising given that several of the directors active in this cinema had studied film in Rome in the early 1950s, the peak period of Italian neo-realism. Films of this first period were primarily documentary in style and portrayed the lives of ordinary people. Later, in the 1960s, this movement became more radicalized and a cinema co-operative was formed that sought to renovate a film aesthetic appropriate to contemporary Brazil where poverty, starvation and violence were the daily diet of most, and concentrated wealth the good fortune of the very few. Film-makers in this co-operative included Glauber Rocha, Nelson Pereira dos Santos and Rui Guerra. This cinema was populist and revolutionary: populist because of its blend of history, myth and popular culture; revolutionary because, if in its populism it could advocate rights for the disenfranchised and landless peasants (for example Rocha's Antonio das Mortes, 1969), none the less, it made clear that such populist advocacy could do nothing against the harsh conditions in which most Brazilians lived and which dos Santos' film, Vidas Secas (Barren Lives, 1963) so admirably captures.

Although cinema nôvo is more readily associated with its 1960s' manifestations, it is important to remember that it pre-dates most of the 'new wave' movements that occurred in Europe. It is also important to recall that it was far more radical in its purpose than any of its European counterparts. It not only attacked mainstream cinema (including Hollywoodized Brazilian cinema), it was also fiercely polemical and based on what Rocha termed an 'aesthetic of hunger' and an 'aesthetics of violence'. Within this context, the films, such as dos Santos' Vidas Secas and Rocha's Terra em Transe (Land in Anguish, 1967) to mention but two, are to be read as 'allegories of underdevelopment' (Stam, in Shohat and Stam, 1994, 256) and also as signifiers of impotence not just in the light of poverty but also in the light of the military coup d'état of 1964. Nor did this cinema stand still. It evolved from this aesthetic of hunger to an 'aesthetic of garbage' (ibid., 310), that is, to a syncretic film style that was known as Tropicalist and which was based on Afro-Brazilian culture and mythology. In film this manifested itself as an 'aggressive collage' (ibid.) of many simulataneous discourses and speeds of narration, much like a palimpsest. As Stam explains in his lucid study of Brazilian cinema (ibid., 310-12), Tropicalism had moved beyond cinema nôvo's 'opposition between "authentic Brazilian cinema" and "Hollywood

alienation" to a juxtaposition of 'the folkloric and the industrial, the native and the foreign'. This garbage style, which also feeds off itself (waste recycling waste) was seen as entirely 'appropriate to a Third World country picking through the leavings of an international system dominated by First world capitalism' (ibid.) (for a magisterial study of this cinema see Stam's Chapters 7 and 8 in ibid. p. 248–337).

By the early 1970s, the cinema nôvo group's activities had been suppressed by the military dictatorship which had come to power in 1964 and whose repressive measures became total by 1968. But this cinema has left an important legacy. It was one of the indigenous film movements in Latin America to bring a cinema called Third World Cinema to world attention. As a protest cinema it was also an important influence in the thinking behind the Third Cinema manifesto published by the Argentinian film-makers and theorists Fernando Solanas and Octavio Getino in 1969. And as Ismail Xavier argues (1997), although cinema nôvo 'disappeared' it re-emerged in Brazil in a different form. No longer able to make a cinema of direct social critique, former cinema nôvo film-makers turned to melodrama and more specifically to family dramas to make their comments obliquely and ironically on Brazil's conservative modernization. This they did with narratives exposing the powerlessness of the patriarch (see Ruy Guerra's Deuses e os Mortos/The Gods and the Dead, 1970).

For further reading see Chanan, 1983; Johnson and Stam, 1995; Pick, 1993; Screen special issue on Third Cinema, 24: 2, 1983.

cinemascope (see also anamorphic lens) Cinemascope and colour were introduced in the early 1950s by the American film industry in an attempt to stem the commercial decline of its cinema due to falling audience numbers. Cinemascope is a wide-screen effect made possible through the use of the anamorphic lens.

In film theory, cinemascope was welcomed by the Cahiers du cinéma group primarily because it extended the possibilities for mise-en-scène. For some critics in this group, it also represented the death of montage. Montage for the Cahiers group, but most especially for Bazin (1967), was an anti-realistic film-making practice that manipulated the audience through its juxtapositioning of shots and the carving-up of reality. Realism

and objectivity could be assured only by the predominance of depth of field/deep focus with its long takes and implicit unimpeded vision. Cinemascope, the Cahiers group argued, would privilege mise-en-scène and extend the merits of depth of field - meaning would be produced through the framing of shots and movement within the shots. Cinemascope implied a number of things for the Cahiers group. First, it gave breadth (that is. space) and thereby created a frieze effect on the screen. In so doing, it recognized the sculptural nature of cinema's narrative (Cahiers du cinéma, no. 25, 1953). Second, cinema should not try to create depth but should suggest depth through breadth. Cinema is about lateral movements and space, and cinemascope allowed for a freer expression of those two concepts (Cahiers, no. 31, 1954). Third, cinemascope implied location shooting and the definitive arrival of colour (Cahiers, no. 31, 1954). Finally, because cinemascope provided the spectator with almost panoramic vision (that is, virtually consonant with the way human vision functions), it was the perfect solution to the arbitrary divide between audience and screen.

Although in the 1950s and 1960s Hollywood perceived cinemascope as appropriate to certain **genres** (such as **westerns** and **epics**), European cinemas – starting with the **French New Wave** – used it to a subversive effect for intimist films about the failure of human relationships (as for example in Jean-Luc Godard's *Le Mépris*, 1963, or *Pierrot le fou*, 1965).

cinéma-vérité Initially the title of a Soviet newsreel – Kino-Pravda ('film-truth') – which was the filmed edition of the Soviet newspaper Pravda, the term was not used to describe a particular documentary style until Dziga Vertov (the documentarist who in the 1920s shot this newsreel/newsreal for the paper) coined it in 1940 in reference to his own work. Vertov characterized this cinema as one where there were no actors, no décors, no script and no acting. The French ethnographic documentarist Jean Rouch followed in this tradition, at first quite stringently. His earlier 1950s documentary work was an 'objective' filming of the activities of indigenous people in Francophone Africa – what was termed cinéma direct. There was no staging, no miseen-scène and no editing – so these documentaries were as close to authentic as they could be. Later, in the 1960s, Rouch moved away from this very purist cinéma direct to a more

sociological investigation where he did intervene in the staging of shots and put his footage through the editing process - what has come to be termed cinéma-vérité. Less objective but no less real, this cinéma-vérité attempted to catch reality on film. Ordinary people testified to their experiences, answered questions put by Rouch or his colleagues. A handful of French or French-based film-makers followed in Rouch's tradition (Joris Ivens, Chris Marker, Mario Ruspoli, François Reichenbach, Jacques Panijel and Jean Eustache). Cinéma-vérité is unstaged, non-dramatized, non-narrative cinema. It puts forward an alternative version to hegemonic and institutionalized history by offering a plurality of histories told by non-elites. As such, it is quite a politicized cinema, although Gidal (1989, 129) challenges this reading and sees cinéma-vérité as espousing a crude ideology. In any event, cinéma-vérité impacted on the radical collectives which formed in the immediate aftermath of May 1968 in France - including Godard and Guérin's Dziga-Vertov group.

class Because film is a system of representation that both produces and reproduces cultural signification, it will ineluctably be tied up with questions of class. Because the film industry is a mode of production in itself, based in capitalism and geared to profit, it is necessarily bound up with considerations of power relations which are also related to issues of class. In both these aspects, clearly, the questions of **gender** and race will also be of significance. Debate around class in film **theory** has been mostly inflected by Karl Marx's definitions of class and by subsequent rethinkings of those definitions first by Antonio Gramsci, Louis Althusser and Herbert Marcuse and then by **post-structuralist** theorists.

The Marxian definition of class and its rethinking According to Marx, class refers to groups of people who have similar relations to the means of production. That is, they get their living in the same way. Thus, the working class works the modes of production (mines, factories, etc.), the capitalist class owns the means of production. In between these two distinct classes are others: the middle and lower middle classes who can be for example small business owners or management or trained professionals. Marx also recognized that there can be fractures within each class (for example between skilled and unskilled workers or between trained professionals (i.e., diploma-holders) and those

who have made it to the same status through work on the ground, and so on). Class is based on objective differences among sets of people and defined, quite negatively, as in opposition to other sets of people: a set of people will forge a class identity to protect its interests against another class. Therefore class is about not just economic relations but also power relations (O'Sullivan *et al.*, 1992, 39–42).

The conflict of ideas is secondary to this first set of conflicts and normally occurs when new material modes of production come into being. However, because new modes of production will cause new ways of thinking about production, the dominant class will endeavour to prevent new thinking by advocating ideas based on the previous order (Burns, 1983). A contiguous way of controlling potential class conflict and maintaining the status quo is through the fracturing of the productive labour force. The worker is alienated from the total means of production in that she or he is only a part of it (on a production line doing assembly work): mass production and technology cause work to be fragmented. The worker is also alienated from the commodity produced which is destined to the market and for profit. Her or his work is built into that profit, she or he pays for it - that is, the exchange value of the commodity is based in part on the repression within the worker's wage of the profit margin (for example, a worker gets paid the real equivalent of four hours although she or he has worked for eight).

Given that class difference is predominantly based in power relations, it follows that different classes are characterized by divergent **ideologies**. This is the most evident site for the making visible of class conflict. Marx, and Gramsci after him, argue how cultural artefacts manifest these differences (think of punk as opposed to *Vogue* dress-codes). They also make the point that culture functions to make sense of those differences (for example, early **melodrama** 'explains' class difference between the bourgeoisie and the proletariat). Thus, in Marxist thinking, cultural aesthetics is very bound up with the concept of class.

Later Marxists, Marcuse and Althusser, thought that by the 1960s it was less a bourgeois/proletariat divide and more an impersonal power that dominated: 'The System' (Marcuse) or 'ideological state apparatuses' (Althusser). This idea, that there was no longer a dominant class, was taken further by French thinkers. On the one hand it was argued that there was in the

post-industrial society, with its new wealth and cheaper products, an emergence of a new middle class and the obliteration of major class differences. Others maintained that class differences had become internalized in new kinds of conflict (for example, around race issues). To Althusser's and Marcuse's anti-humanist position (man (sic) as subject-effect of the system/state), Alain Touraine argued that the old class divide had been replaced by different sets of people: those who are in control of the structures of political and economic decision-making, and, conversely, those who are reduced to the condition of dependent participation (Bottomore, 1984).

Although it was grounded in Saussurean structural linguistics and **semiotics**, the **structuralist** debate of the 1960s also embraced Marxist thinking. Of particular interest and relevance to film studies was Marx's cultural aesthetic, which determined that an art object should not be considered outside or as separate from both its mode and its historical moment of production. Marxist aesthetics necessitates a move away from textual analysis as a be-all and end-all of aesthetic evaluation and demands contextual analysis — an examination of the underlying structures (labour, finance, manufacture, etc.) that went into the making of the aesthetic text.

Relevance to film studies and film theory The Marxist theory of class and cultural aesthetics found its way into film studies and theory in predominantly four ways: analysis of class relations within the text; the historical and cultural contexts of the production; modes and practices of production, and, finally, the ideological effect of the cinematic apparatus upon spectatortext relations (see apparatus, ideology and spectator for discussion of this last point).

On the first point, it is clear that certain **genres** yield more readily to class analysis than others: **comedy**, melodrama and social problem films (that are a sub-genre of **social realism**) are perhaps the most obvious. To illustrate the point let's take melodrama. One of the earliest traditions in this genre was to pitch the bourgeoisie against the proletariat. Most often, that conflict was also gendered. Here are a few sample scenarios: poor young girl or fallen woman (*sic*) at the mercies of rich fat bourgeois male; poor young man (often an artist . . .) at the mercies of some rich, upper-class vamp or female (often she is married, so it is not her money – but never mind since she still represents her husband's wealth); wealthy widow falls for

proletarian hero; professional woman falls for proletarian criminal (and so on). Melodramas of the 1930s and 1940s centred on social mobility (for example the self-sacrificing or scheming mother trying to better her offspring's (usually the daughter's) future).

Given Western governments' policies to get women out of the factories and back into the kitchen, melodramas from 1945 centred more on the family - particularly the middle-class family. This was especially the case in the United States, where there was a concerted mediation of the desirability of a return to the hearth (desirable for economic reasons for the government, but not for the woman). In Marxist terms, whatever the narrative context, clearly the bourgeoisie is the class vested with capital power. In some film narratives capital is corrupt so must be resisted. However, since that representation is often caricatural. capital as a bad thing is not being targeted but rather abuse of capital power, for which an individual will be punished. Capital in and of itself, according to the narrative, still remains intact as a good thing. Film, in this instance, naturalizes capital and power. In the later melodramas the family under capitalism comes to be unquestioningly represented. The father is the head of the household and wage-earner, the wife the agreeing consensual woman who will produce children. In Marxist terms, the bourgeois family is a product and thereby a representer of patriarchy and capitalism and of course a reproduction and reproducer of that system. In these melodramas, although class is there. implicitly, as an issue, class struggle is not. But because these films deal with family structures, issues of dominance have now become gendered (see Cook, 1985, 76ff.).

As this starts to make clear, historical and cultural contexts of the production (the second of our four points) yield readings in relation to capital as well as class and gender. The overdetermination or valorization of the family, that is, over-investment in its importance in 1950s melodramas and, incidentally, comedy – the Doris Day factor: the squeaky-clean girl next door – is a case in point. The modes and practices of production (the third point) also yield readings. For example, the film industry functions in exactly the same way as the class system described above. There is the same dynamic of the owning and producing classes, the same principle of alienation through fragmentation in that each worker does her or his part of the production process. The traces of manufacture (such as make-up) are elided

by the camera-work, the **lighting** and the **editing**. Thus, the mark of the worker is not present in the final commodity which is produced not for her or his pleasure but for profit. The real value, labour, gets lost in the exchange value, the film as a saleable commodity. **Stars** have an exchange value in much the same way as commodities in any marketplace do – they too must make profit: they are the form of value, not value itself. That is, they are not stars as persons but star images as exchange-value or capital exchange (we pay to see them, agree to the price of the ticket).

Class in cinema is iconographically denotated, is signified by certain referents (clothes, language-register, environment, and so on). Film presents itself as real, places before the spectator the illusion of reality (see iconography, spectator and suture). So these icons serve to naturalize class, as does the homogeneity of classical narrative cinema, structured around the orderdisorder-order nexus (similar to the Victorian novel that has a beginning, middle and end, where end means marriage). No matter that there may be new production practices, the film industry will continue to advocate the earlier ideas rather than allow the promotion of new ones. Film-makers attempting innovative ideas quickly find themselves marginalized by the Hollywood studios - as indeed was the case at different times in their careers for Orson Welles, Francis Ford Coppola and Martin Scorsese. In this respect, mainstream cinema represents only the thinkable, that which does not challenge our sense of identity, which, as cinema constantly tells us, however subliminally, is ultimately determined through our gender, and more pervasively our presumed heterosexuality - not through our class or race. In other words, because self-identity or spectator identification is the constant 'reality-effect' of mainstream cinema - we look into the screen-mirror. Our first priority is with whom (not what) we identify. Our first identification is with a person as gender, not a person as class, age or race. In this respect, cinema as a cultural artefact serves hegemonic purposes. The dominant ideology is structured in such a way - at its simplest level because there must be (re)production - that we necessarily think of ourselves as gendered subjects. To think otherwise would be unthinkable (think about the still predominantly negative, even hostile, attitudes to transsexuals, transvestites, same-sex love, etc.). Viewed in this light, representations of class might appear to be a sort of red herring. Far from it.

As part of the representation of 'reality' or dominant ideology, they serve to reinforce the belief that the unthinkable is just that, unthinkable – which is of course what keeps patriarchy, class and hegemonic structures in general in place.

For further reading see Hill, 1986; Stead, 1989.

classic canons - see codes and conventions/classic canons

classic Hollywood cinema/classic narrative cinema/classical narrative cinema (see also narrative) So-called to refer to a cinema tradition that dominated Hollywood production from the 1930s to the 1960s but which also pervaded mainstream western cinema. Its heritage goes back to earlier European and American cinema melodrama and to theatrical melodrama before that. This tradition is still present in mainstream or dominant cinema in some or all of its parts.

Classic narrative cinema is what David Bordwell (in Bordwell, Staiger and Thompson, 1985, 1) calls an 'excessively obvious cinema' in which cinematic style serves to explain, and not obscure, the narrative. This cinema, then, is one that is made up of motivated signs that lead the spectator through the story to its inevitable conclusion. The name of the game is verisimilitude, 'reality'. However, an examination of what gets put up on screen in the name of reality makes clear how contrived and limited it is and yet how ideologically useful that reality none the less remains (see ideology). The narrative of this cinema reposes upon the triad 'order/disorder/order-restored'. The beginning of the film puts in place an event that disrupts an apparently harmonious order (marriage, small town neighbourliness, etc.) which in turn sets in motion a chain of events that are causally linked. Cause and effect serve to move the narrative along. At the end the disorder is resolved and order once again in place.

The plot is character-led, which means that the narrative is psychologically and, therefore, individually motivated (see motivation). Thus, by implication, if the initial event is not individually or psychologically motivated it is more than likely that it will be left without explanation. Bordwell (Bordwell, Staiger and Thompson, 1985, 13) citing Sorlin, makes the point that this is particularly evident when it is an historical event that is

supposed to have initiated the narrative line. The event happens 'just like that'. An exemplary film is Gone With the Wind (Fleming, 1939). Hyped as 'the greatest love story ever told', it gets told against the backdrop of the American civil war which gets represented duopolistically as a clash between the southern states' traditions and the northern states' ideological conviction that slavery must be abolished. In this respect, history becomes ahistorical (events have no past, no explanation, no cause). As such, history is eternally fixed, naturalized (in a not dissimilar way to the way in which woman in this cinema gets naturalized (see counter-cinema)). For example, in a war movie we might see that war is bad, but only because of the effects it has on the characters - we do not learn about the causes of the war, nor do they get examined. Think of the Vietnam War films made by Hollywood - even if the representation of that war is harrowing to watch and war, thereby, is not glamorized (as it was in films about the Second World War), the complex set of historical circumstances whereby the United States got enmeshed in that war is not touched upon - rather it is the psychological effect of the war on GI Joe that we see. If, in a war-context, a cause is given at all then it is in the form of an individual (as with Hitler and the Second World War).

Classic narrative cinema, no matter what genre, must have closure, that is, the narrative must come to a completion (whether a happy ending or not). Any ambiguity within the plot must be resolved. For example, in Psycho (Alfred Hitchcock, 1960), Norman Bates may still remain psychotic, but in terms of the narrative or plot-line he has been caught for his murderous activities, so there is closure. Whatever form the closure takes, almost without exception it will offer or enunciate a message that is central to dominant ideology: the law successfully apprehending criminals, good gunmen of the Wild West routing the baddies, and so on. What is interesting, however, is which ideological message supersedes all others. In his study of classic Hollywood cinema, Bordwell (1985, 16) notes that of the sample of a hundred randomly chosen films he examined, ninety-five involved heterosexual romance in part of the action and eightyfive had romance as central to the action. Closure mostly means marriage (as with Victorian novels, incidentally), with all that that entails: family, reproduction, property. That is, the representation of the successful completion of the Oedipal trajectory is central to the classic narrative cinema. Such a high percentage of romance films points again to the ideological effects of dominant cinema and to its motivated function as myth-maker. However, in its **naturalizing** heterosexual coupledom and family it also makes the point that all else must (potentially) be read as deviancy. To return to the example of Psycho: Marion Crane is murdered by psychotic Bates, but we know from the narrative that she would never have ended up in his motel and therefore been murdered if she had not stolen money from her male boss in order to buy or lure her lover away from his wife (ex-wife, really, but he is paying alimony to her and so cannot afford to 'leave' for Marion). Double-theft. Man as exchange commodity. So Marion is 'punished' for transgressing the patriarchal order: stealing money (from one man) and trying to 'break' up a marriage (by stealing another man and ending his ties with his wife). Why else at the end of the film does her sister do the right thing (and not get killed), do coupledom the right way and get her man (the same one her sister failed to purchase)?

In this cinema, style is subordinate to narrative: **shots**, **lighting**, **colour** must not draw attention to themselves any more than the **editing**, the **mise-en-scène** or **sound**. All must function to manufacture **realism**. **Ambiguity** must be dissolved through the provision of **spatial and temporal contiguity** — the spectator must know where she or he is in time and space and in relation to the logic and chronology of the narrative. Reality is ordered, naturalized: 'life's just like that'. The narrative is goal-orientated and so, naturally, are the characters. This mythico-realistic storyline reflects the other great American myth: that of upward mobility and success. The dream factory makes the American dream come true.

Let's show how this is done. Bordwell (Bordwell, Staiger and Thompson, 1985, 5) makes the point that this classic cinema is normative not formulaic (which implies fixity). This normativity is, presumably, what enables it to be affected by the force of other cinemas and to integrate or co-opt some of their practices, notably those of the **avant-garde** and European **art cinema**. But back to the reality-effect. To achieve the fundamental principle of realism, editing must function to move the narrative on logically and, predominantly but not exclusively, chronologically (even a flashback will, in the main, be narrated chronologically – or the causal chain will be clear). However, editing must not call attention to itself, so continuity is essential. To achieve this, generally speaking, a whole scene is shot in one take – usually

in a long shot — called a master shot or master scene. After this, parts of the same scene will be reshot, this time in close-ups and medium shots. These are then edited into the master scene and redundant parts of the master scene are cut. To ensure continuity, **match cuts** and **eyeline** cuts need to be consistently observed. Match cuts link two shots — one in long the other in medium shot, for example, but related in form, subject or action — creating a **seamless** continuity (we do not 'see' the cut). The eyeline match allows us to see the direction of the character's **gaze**: we move, unobtrusively, from watching the character watching, to watching what she or he is watching (see **continuity editing**).

There are other aspects of editing that might seem not to have reality inherent in them. Cross-cutting is an example of how, despite its lack of realism, the reality-effect works. Cross-cutting allows us to see two separate sets of action in different spaces but juxtaposed in time – normally with a view to creating suspense. However, since we have been stitched into the narrative as omniscient spectator we do not question our ability to be in two places at once, in fact we expect to 'see it all' (see suture). The camera also has a vital role in this reality-effect. The shot/reverse-angle shot used for dialogue establishes a realistic set of exchanging looks - again stitching us into a particular character's point of view. Where necessary, establishing shots are used to orientate the spectator, after which the camera can hone in on the character or part of the setting. Because the plot is character-led there is an excess of close-ups, not just on the face but on other parts of the body, thus fragmenting the body - which would seem to fly in the face of reality. However, because such shots offer us greater access to the body, they function to reinforce the myth of intimacy. We are the subject of the gaze and simultaneously identify with the character in the film looking at those parts of the body. The natural effect produced by three-point lighting (see lighting) furthers the naturalness of this realism. Colour must suit the emotional or psychological mood of the sequence, setting and/or entire film. Music serves only to reinforce meaning (danger, romance, and so on).

These audio-visual cinematic norms are just as ideologically inflected as the classic narrative norms which they serve. Feminists have pointed out how, with its representations of romantic love, the family, and male-female work relations, classic cinema perpetuates and so normalizes patriarchal ideologies

which assume the naturalness of unequal relationships – predominantly those of **class**, race and **gender**. The reality-effect means 'It is just like life, just like that'.

For further reading see Bordwell, Staiger and Thompson, 1985; Cook, 1985.

codes and conventions/classic canons (see also classic Hollywood cinema, and narrative) All genres have their codes and conventions (rules by which the narrative is governed). These are alternatively referred to as classic canons or canonic laws. For example, a road movie implies discovery, obtaining some self-knowledge; conventionally the roadster is male and it is his point of view that we see. The narrative follows an ordered sequence of events which lead inexorably either to a bad end (Easy Rider, Dennis Hopper, 1969) or to a reasonable outcome (Paris Texas, Wim Wenders, 1984). These canonic laws can of course be subverted as they usually are in art cinema or counter-cinema. Codes and conventions should not be viewed just within their textual or generic context but also within their social and historical contexts. Codes and conventions change over time and according to the ideological climate of the time - compare any John Wayne western with Clint Eastwood's characterization of the gunman as a problematic hero or antihero; or again compare science fiction films of the 1950s with those of the 1980s and 1990s. These shifts may not represent real social change (how many men really question their machismo?), but they reflect, however indirectly, changes in social attitudes (for example, the effect of the women's movement has rendered unequal power relations between men and women less desirable than before).

colour The history of colour in cinema is a more chequered one than that of **sound**. It was not until the advent of colour television in the 1960s and 1970s (first in the United States, later in Europe) that it became fully dominant. Until that date its only peak period had been the early 1950s and even then accounted for only 50 per cent of the production (Cook, 1985, 29).

History As an idea, colour had been thought of as early as the first days of cinema. By 1896, the American Edison was employing teams of women to hand-paint images in the whole or part of the frame. In France, Méliès was doing much the same thing – single-handedly. A little later, as films got longer and therefore more expensive to paint, Pathé Frères invested in stencil painting – again carried out by women (who incidentally also did the **editing** for these longer films) – a process which the American industry also adopted. By the 1920s, Hollywood had moved on from stencil coloration and was tinting or toning films that were for major release.

The first experimentation with colour film itself came about in 1912 in the United Kingdom when it was used for **documentaries**. Colour film was produced by an additive process, that is, by filming through colour filters and subsequently projecting through the same colour filters. But this process did not prevail. Instead, modern colour technology was based on the subtractive process (eliminating unwanted colours from the spectrum). This was first done in the 1920s by Technicolor Motion Pictures Corporation (a company set up in 1915).

The principle of technicolour is that of a dve transfer. Technicolor first used two-strip cameras and negatives quite successfully in the 1920s until, in 1932, it perfected three-strip cameras and negatives. After shooting, these negatives were processed through an optical printer on to three separate positives through a filter for one of the primary colours. These positives were then individually imbibed with the appropriate complementary colour (also known as the subtractive colour). Thus the original image when projected would have the appropriate colour gradations. Since this colour system could be achieved only through using three-strip cameras and since they had been patented by Technicolor, the company by 1935 had complete control of its product in relation to Hollywood control that would last almost twenty years. It hired out its cameras and its technicians, and processed and printed the film. Technicolor supplied its own colour consultant, Natalie Kalmus (ex-wife of one of the founders of the company), whose job it was to fit the technology to Hollywood's needs - a factor that would considerably affect the ideology surrounding colour (see below).

In 1947 the US government's anti-trust law started the process of erosion on Technicolor's monopoly of 35 mm colour film. At that time, Eastman-Kodak, in a mutual agreement, was not in competition with Technicolor. It had a cross-licensing agreement with the company to use colour for its smaller gauge,

16 mm, film - and in any event colour film was still not the dominant factor in film production in the 1930s and 1940s. Colour was mostly used for musicals, costume dramas and cartoons - often with great success (A Star Is Born, George Cukor, 1937, Gone With the Wind, Victor Fleming, 1939). Incidentally, Walt Disney, who was the first to use technicolour, was so pleased with his short colour cartoons' success that he acquired exclusive rights for colour cartoons. However, by the early 1950s the two companies had rescinded their agreement since the anti-trust law had charged both companies with monopolistic practices. Eastman-Kodak now went on to develop its own technology and produced an integral tripack colour film (in 1954) that could be used in any camera and was cheaper and easier to use than Technicolor. It was also cheaper to process because it was a single negative. Technicolor's demise in the film industry was further accelerated by the fact that its dye process did not adapt well to cinemascope. Although Technicolor finally resolved those problems, it was not before Eastman had garnered most of the market. The Technicolor company is still involved in feature films but to a small degree and focuses more on research and laboratory processing.

Colour and theory Colour film is an ambiguously positioned concept. On the one hand it can reproduce reality more naturally than black and white film. However, it can also draw attention to itself and, indeed, have symbolic value. Hollywood had a double response to this. At first, in the 1930s and 1940s, it decreed that colour should be reserved for certain genres that in themselves were not particularly realistic – stylized and spectacle genres (musical, **fantasy**, **epics**). Later, in the 1950s, when colour was more widely used, Hollywood concurred with Natalie Kalmus's dictat that all colour films should endeavour to use colour to underscore mood and meaning. To that effect bright and saturated colours were discouraged (Bordwell, in Bordwell, Staiger and Thompson, 1985, 356).

But colour also has value and functions in relation to the **scopophilic drive**. Steve Neale's (1985) analysis of the value of colour in film representation makes three essential points. First, colour has a dialectical (that is, a dual conflictual) function. This came about because colour was initially associated with spectacle and, therefore, was not seen as realist. Subsequently, however, following the advent of colour television – with its documentary and news or current affairs programmes

- colour also obtained the cachet of **realism** (thus, incidentally, going back to one of its original meanings in the earliest experiments). Henceforth, the key terms centring the **discourse** about colour became nature/realism on the one side and, on the other, spectacle/art – two contradictory sets of terms. Simply expressed, if colour is used as spectacle it cannot refer to its realist function, any more than if its aesthetic mode prevails. If the realist mode is invoked, then the film must reflect nature (the colour on screen is the colour 'out there' in the real world) and, thereby, deny its function as spectacle and/or art.

Neale's second point about colour is possibly the most important (certainly for feminist film theory). Referring to the contradiction between the two sets of terms, Neale (1985, 152) says that it is at this point that another element enters into consideration: the female body. Women already occupy, within patriarchal ideology, the 'contradictory spaces both of nature and culture' (that is, nature and artifice) and they are also the 'socially sanctioned objects of erotic looking' (i.e., spectacle). For these reasons, women 'naturally' function as the 'source of the spectacle of colour in practice' (colour within the film will be determined by the female star's colouring, that is, what colour most complements her (but why so much orange for Rita Hayworth and Deborah Kerr, and so much yellow for Doris Day?)). Women also function as 'a reference point for the use and promotion of colour in theory' (the female star is an essential vehicle for colour, she gives pleasure in her look-at-able-ness). Neale concludes, first of all, that 'the female body . . . bridges the ideological gap between nature and cultural artifice', that is, she bridges the gap caused by colour's ambiguity - so she is both real(ism) and spectacle. But the female body simultaneously marks and focuses 'the scopophilic pleasures involved in and engaged by the use of colour in film'. Colour positions her as the site of pleasurable viewing and makes the spectator want to look at her.

What is significant in this reading, at least for feminists, is that, in being the embodiment of the dialectical function of colour, the female figure must implicitly be placed in other sets of dialectical functions. Thus at the same time as the female body bridges the gap between the two sets of terms within the discourse on colour (realism and spectacle), she both *marks* and *contains* 'the erotic component involved in the desire to look at the coloured image' (Neale, 1985, 155). That is, in relation to the erotic, she is simultaneously positioned as **subject** (she contains, she is the

holder of the erotic) and as object (she marks, she is the site of the erotic, the 'to be looked-at-ness'). Even though in main-stream or **dominant cinema** it is doubtful that this double positioning (subject and object) leads the female body, through its visual treatment, to assume **agency** (to become subject), it is clear that in non-mainstream cinema such agencing could occur. In this respect colour could be used **counter-cinematically** to subvert the canonical **codes and conventions**.

Neale's third point develops further this potential for colour to subvert. Referring to Kristeva's writings on colour, Neale (1985, 156) argues that, because colour is so closely associated with the psychic and erotic pulsions, it is capable of escaping, subverting and shattering the symbolic organization (i.e., colour subordinated to the narrative) to which it is subject. According to Kristeva, colour operates on three levels simultaneously: the objective, the subjective and the cultural. Within the domain of visual perception, the objective level refers to an outside whereby an instinctual pressure is articulated in relation to external objects. In the case of cinema this 'outside' would be the images up on screen at which the spectator looks (instinctual pressure). This same pressure motivates the subjective level and causes the eroticization of the body proper ('seeing is responding'). Finally, the cultural level functions to insert this pressure under the impact of censorship as a sign in a system of representation. That is, the cultural operates to contain what happens between the objective and the subjective. It is a form of censorship in that the cultural's intentionality is containment of the subjective and erotic processes ('seeing is responding but watch it does not go too far'). The cultural is not always successful in its purpose of course. Pornographic films are an easy example of this. However, certain scenes in un-X-rated movies can be so erotically charged as to catch the spectator by surprise!

For further reading on colour technology see Bordwell, Staiger and Thompson, 1985; Konigsberg, 1993; on colour and theory see Neale, 1985.

comedy (see also **genre**) In film history comedy is one of the very earliest genres. This is not surprising, given that the first actors to come on to the screen were predominantly comedians from vaudeville and music-hall theatres. Early exhibition practices also explain this phenomenon. The first films were short

one-reelers and were included in a mixed-media show presented by a compère in a vaudeville theatre, a music-hall or a tent at a fair. At that time, then, cinema catered for popular taste and the humour on screen tended to reflect popular comedy – as opposed to comedy of manners or social comedy. The early silent tradition of comedy was gag-based (as indeed was the very first comic film, Louis Lumière's Arroseur arrosé, 1895). This developed into routine comedy (Mack Sennett's Keystone Kops comedy series, of the 1910s, with their inevitable chase sequences) and into the emergence of the comic hero (sic) as. for example, Charlie Chaplin, Buster Keaton and Fatty Arbuckle. This primarily gestural tradition was, in its later manifestations, especially in sound cinema, closely allied to farce. Gestural gags now became verbal gags in comedies by the Marx brothers and W. C. Fields. But, as with the earlier tradition, violence was never far from the surface and this comic tradition is noteworthy for its aggressive humour.

As a genre, comedy deliberately goes against the demands of realism - hardly surprising given film comedy's heritage. Yet it is a genre that is perceived as serving a useful social and psychological function in that it is an arena, or provides an arena, where repressed tensions can be released in a safe manner. Apart from the gag-based comic tradition, the other dominant style of comedy comes from the more 'polished' comic theatre tradition. The plot-line is less anarchic than in the earlier vaudevillesque tradition and therefore less ostensibly aggressive until one examines characterization. Stereotypes are far more foregrounded in this comedy, starting with gender (screwball comedies, as we all know, are about 'the battle of the sexes'), but including race, national prejudice and so on. Some comedy parodies this stereotyping. For example, Marilyn Monroe is much smarter than the dumb blonde she is purported to be in Gentlemen Prefer Blondes (Howard Hawks, 1953), The Seven Year Itch (Billy Wilder, 1955) and Some Like it Hot (Billy Wilder, 1959). Or again, Katherine Hepburn may have to comply with Hollywood's insistence on closure meaning marriage but she'll choose her man, she'll whip him into shape before she's at all prepared to consider him as a suitable partner (Philadelphia Story, George Cukor, 1940; The African Queen, 1951, and the innumerable combinations with Spencer Tracey).

Comedy is still a big tradition in Europe, especially in France where half the film industry's production is comedy. Britain has

a strong tradition with its Ealing Comedies and Carry-On movies. But these are past history (1940–50s and 1958–78 respectively) – as indeed is the British film industry itself. In the United States comedy is no longer the big audience puller it used to be. Production tends to target youth audiences, which means action-packed narratives, not sassy talk. For this reason, the comedy that is produced tends to be more in the farce and gag tradition than the supposedly more sophisticated talk-humour (note the popularity of the *Wayne's World* movies of the 1990s). Certain film-makers, notably women, have taken the genre on board to explore its subversive potential. Susan Seidleman's *Desperately Seeking Susan* (1985) is exemplary in this respect.

For further reading see Brunovska Karnick and Jenkins, 1995.

connotation - see denotation/connotation

content - see form/content

continuity editing (see also seamlessness and spatial and temporal contiguity) This is a strategy in film practice that ensures narrative continuity. The film does not draw attention to the way in which the story gets told. The editing is invisible, and as such offers a seamless, spatially and temporally coherent narrative. Spatial continuity is maintained by strict adherence to the 180-degree rule, temporal continuity by observing the chronology of the narrative. The only disruption of this temporal continuity in mainstream cinema comes in the form of a flashback.

However, theoreticians have made the point that this seamlessness masks the labour that goes into manufacturing the film and as such has an **ideological** effect. This cinema gives the **spectator** the impression of reality, presents as natural what is in fact an idealistic reality (no 'fault-lines' can be perceived). The spectator has a sense of unitary vision ('it's all there, before me') over which she or he believes she or he has supremacy ('it's all there, so I know everything that's going on'). In this respect, the spectator colludes with the idealism of the cinematic reality-effect.

For further discussion see **apparatus** and **spectator**. Bordwell and Thompson (1980) provide a very full and useful introduction to the

concepts and strategies of continuity editing, and also to alternatives. For more detail on the continuity system within classical Hollywood cinema see Bordwell, Staiger and Thompson (1985, chapter 16).

costume dramas (see also adaptations, genre) Not to be confused with historical films or with period films, costume dramas are set in an historical period but do not, like historical films, purport to treat actual events. They refer in general terms to the time in history through the costumes which, by convention, should be in keeping with the time. A period film is a different, looser term in that it can be used to refer to costume dramas and also to more contemporary times but where dress-codes and setting are clearly of another period (for example period films could be set in the 1910s, 1920s or 1930s but a film shot in the 1990s and set in the 1980s is not a period film - the time-lapse is not long enough). Thus, the Merchant-Ivory adaptations of E. M. Forster's novels, because they are set in the 1910s, are more readily period films than costume dramas. However, in that they refer to earlier times, Roman Polanski's adaptation of Hardy's Tess of the D'Urbevilles (Tess, 1979) is a costume drama, as is Martin Scorsese's Age of Innocence (1993), a film based on Edith Wharton's novel of the same name. Many costume dramas are literary adaptations (the French film industry is particularly strong in this tradition). Arguably, the most famous of them all is Victor Fleming's Gone With the Wind (1939).

For further reading see Cook, 1996; Harper, 1994.

counter-cinema/oppositional cinema (see also deconstruction, feminist film theory and naturalizing) This type of cinema can be found in a variety of cinemas: experimental, avant-garde and art cinema. At its simplest it is a cinema that, through its own cinematic practices, questions and subverts existing cinematic codes and conventions. In its aesthetic and often political concerns with the how and the why of film-making, it is a cinema that can be quite formalist and materialist and, therefore, very discontinuous in its look. That is, the structure and texture of film will be visible on screen. For example, spatial and temporal contiguity will be deconstructed, the security of the setting offered by a logical mise-en-scène will be decomposed and all other elements of seamlessness and compositional continuity

will be exposed. This is then a cinema that draws attention to itself, its man/u/facture and the production of meaning. There is no safe **narrative**, no beginning, middle and end, no closure or resolution. Needless to say, spectators are not stitched into countercinematic films but are intentionally distanced by these practices so they 'can see what is really there', and reflect upon it rather than be seduced into a false illusionism.

Although as a practice this questioning and, potentially, selfreflexive cinema goes back to the 1920s, it was in the early 1970s that the term counter-cinema was coined - largely because film theorists and some film-makers (notably Jean-Luc Godard and Agnès Varda in France and the underground film movement in the United States) began to question Hollywood's hegemony and dominant cinema's system of representation. It is in this latter respect that feminist film theorists first took an interest in the possibilities of counter-cinema to do more than just retransmit women's issues by doing it politically - by exposing the way in which dominant cinema has represented as natural woman's position as object and not subject of the gaze, as object and not agent of desire (see agency). Women filmmakers, in subverting cinematic codes, not only denaturalized dominant film **hegemony** in so far as verisimilitude is concerned. Through their films they also made visible the meaning of phallocentric fetishization of women as spectacle and receptacle. By denormalizing dominant practices, they made visible what was made invisible: woman's subjectivity and difference - which fetishism denies (see subjectivity). An example is Sally Potter's Thriller (1979), which rejects the male gaze and seeks to find and assert woman's right to her own subjectivity.

Counter-cinema, then, is oppositional, exposes hegemonic practices, unfixes – renders unstable – **stereotypes**, makes visible what has been normalized or invisibilized.

For further reading see Johnston, 1976; Kaplan, 1983, 142ff.; Gidal, 1989.

crime thriller, criminal films - see film noir, gangster/criminal/detective-thriller/private-eye films, thriller

cross-cutting Literally, cutting between different sets of action that can be occurring simultaneously or at different times, this term is used synonymously but somewhat incorrectly with *parallel*

editing. Cross-cutting is used to build suspense, or to show the relationship between the different sets of action.

For further discussion see cut and editing.

cut (see also sequencing) The splicing of two shots together. This cut is made by the film editor at the editing stage of a film. Between sequences the cut marks a rapid transition between one time and space and another, but depending on the nature of the cut it will have different meanings.

jump cuts, continuity cuts, match cuts and cross-cuts These are the four types of cut typically used for cutting between one sequence or scene and another, although jump cuts and match cuts are also used within a sequence or scene.

Jump cuts Cuts where there is no match between the two spliced shots. Within a sequence, or more particularly a scene, jump cuts give the effect of bad editing, of a camera that, literally, is jumping about without any desire to orientate the spectator, or of jolting the spectator along. Spatially, therefore, the jump cut has a confusing effect. Between sequences the jump cut disorientates not only spatially but also temporally. The most quoted film which exemplifies all of these uses of the jump cut is Jean-Luc Godard's A bout de souffle (1959). The most famous jump cut of all comes between sequences 1 and 2: in a countryside lane the protagonist shoots a motorcycle cop dead, runs across a field - cut - to the protagonist in a Paris telephone booth. Within sequences, jump cuts around enclosed spaces make those spaces unfamiliar. Most unusual of all is the use of jump cuts within dialogue. In the same film the two protagonists (Michel and Patricia) at one point are sitting talking in a car. However, we never fully decipher what they are saying because of the numerous jump cuts inserted into the dialogue. Godard (1982) claimed that he had to insert these jump cuts because he had made his film (his first) far too long, by an hour. He may be pulling our leg. However it does go to show how economies of scale force decisions that eventually become canonized as art (see 30-degree rule).

Continuity cuts These are cuts that take us **seamlessly** and logically from one sequence or scene to another. This is an unobtrusive cut that serves to move the **narrative** along.

Match cuts The exact opposite to jump cuts within a scene. These cuts make sure that there is a spatial—visual logic between the differently positioned shots within a scene. Thus where the camera moves to, and the angle of the camera, make visual sense to the spectator. **Eyeline matching** is part of the same visual logic: the first shot shows a character looking at something offscreen, the second shot shows what is being looked at. Match cuts then are also part of the seamlessness, the reality-effect, so much favoured by **Hollywood**.

Cross cuts These are cuts used to alternate between two sequences or scenes that are occurring in the same time but in different spaces. Generally they are used to create suspense, so they are quite commonly found in westerns, thrillers and gangster movies. These cuts also serve to speed up the narrative.

montage cuts, compilation shots and cutaways These are all used within sequences or scenes, although montage cuts can in fact compose a whole film (see editing).

Montage cuts A rapid succession of cuts splicing different shots together to make a particular meaning or indeed create a feeling (such as vertigo, fear, etc.). First employed by the **Soviet school**, they have become incorporated into **avant-garde** or **art cinema**. They can be used to deconstruct one set of meanings and put in place another (for example the slow pomp of a funeral procession can be deconstructed and reconstructed by a rapid montage of shots into an indictment against the bourgeoisie, as in René Clair's Entr'acte, 1926).

Compilation shots Series of shots spliced together to give a quick impression of a place (shots of Paris, London or New York to establish the city) or a quick explanation of a situation (police arriving at a murder scene: shots of the crowd, journalists, police, detectives, finally the corpse) or a character's impression of an event (watching the highlights of a sporting event, or a performance of some sort).

Cutaways Shots that take the spectator away from the main action or scene. Often used as a transition before cutting into the next sequence or scene. For example: inside a court scene the day's proceedings are coming to an end, cutaway shot to the outside of the courthouse then cut to the next day in the lawyer's or solicitor's office.

Cuts give rhythm to the film, so getting that tempo right is essential. A film, therefore, goes through several cuts before the editor – usually working in tandem with the director – comes up with what is known as the rough cut (within Hollywood this cut is sometimes referred to as the director's cut, but it is not the final cut). Adjustments and changes are then made to produce a fine cut before the final cut is made and the film is ready for the post-synchronized **sound** mix to be transferred on to its optical track.

D

decapitation - see castration/decapitation

deconstruction Although the term originates with the French philosopher Jacques Derrida in the late 1960s and is seen as coterminous with post-structuralism, in terms of film history deconstruction was being practised and deconstructive films were being made as early as the 1920s. Noël Burch (1973) argues that the first deconstructive film was the German expressionist film The Cabinet of Dr Caligari (Robert Wiene, 1919), an interesting claim given that the codes and conventions of dominant cinema, which this film contested, were barely in place. But this claim also suggests that any new cultural discourse, once it assumes a dominant status, will bring in its wake an oppositional cultural discourse. In film theory the term deconstruction is largely perceived as synonymous with counter-cinema. Deconstructive film does what the term implies: it deconstructs and makes visible through that deconstruction the codes and conventions of dominant cinema; it exposes the function of the cinematic apparatus as an instrument of illusionist representation and attacks the ideological values inherent in that representation. It refuses the logic of a homogenous filmic space and narrative closure. Deconstructive films are counter-cinematic in both aesthetic and political terms. However, politics and aesthetics until recently have rarely meant sexual politics. With the exception of Germaine Dulac's and Maya Deren's surrealist films of, respectively, the 1920s and the 1940s, feminine subjectivity had hardly been addressed at all until the impact of the women's movement

of the 1970s brought in its wake **feminist theory** and feminist films.

For further reading see Gidal, 1989; Kuhn, 1982.

deep focus/depth of field (see also editing) These two terms are not interchangeable but they are deeply interconnected because the technique of deep focus is dependent on a wide depth of field. Depth of field is a cinematographic practice whereas deep focus is both a technique and a film style with theoretical and ideological implications. Depth of field refers to the focal length any particular lens can provide. Greater depth of field is achieved by a wideangle lens and it is this type of lens that achieves deep focus. With deep focus, all planes within the lens's focus are in sharp focus thus background and foreground are both in focus. Deep focus then is a technique which uses fast wide-angle lenses and fast film to preserve as much depth of field as possible. Although some critics have credited the film-maker Jean Renoir with first using this type of focus so that he could make long takes and not have to edit to create movement (movement of course occurring within the frame), it is traditionally Orson Welles who is credited as the first to use the effect in Citizen Kane (1941). Because deep focus requires a small aperture, it also requires fast film stock and this was not available until the late 1930s. Renoir created the illusion of deep focus by creating depth of space through staging in depth and adjusting the focus according to what was of main interest. Staging in depth is a perspectival strategy that dates back to the 1910s in cinema history. It is a system whereby the illusion of depth is created by characters moving from the back to the foreground or by the mise-en-scène privileging the background or middleground characters. The background could be brought ('pulled') into sharp focus and the foreground would be slightly out of focus (Salt, 1983, 269). However, as David Bordwell (in Bordwell, Staiger and Thompson, 1985, 344) makes clear, neither Renoir nor Welles was in fact the first to achieve deep focus. Bordwell (Bordwell, Staiger and Thompson, 344-6) lists several examples of its use in 1940s films and points also to the work of the US cinematographer Gregg Toland (who, incidentally, shot Citizen Kane), where it is already in evidence as early as 1937 (Dead End). In fact, Toland had already experimented with deep focus in his silent cinema work, the earliest example of which is Arthur Edeson's The Bat (1926).

The theoretical and ideological debate over the merits of deep focus over montage was first launched, in the 1950s, by André Bazin in his essay 'The Evolution of the Language of cinema' (Bazin, 1967, 23-40). When speaking of montage, Bazin does not mean it entirely in the more limited way in which we now tend to refer to it (as the Soviet cinema style of editing), but to an 'ordering of images in time' (ibid., 24) used by many cinemas in the pre-sound era. Bazin offers a definition of montage as 'the creation of a sense of meaning not proper to the images themselves but derived exclusively from their juxtaposition' (ibid., 25). Pre-war classics of the American screen, Bazin tells us, used montage just as much as any of the more experimental schools (Soviet or German expressionism), it just did so in an invisible way (ibid., 24). He goes on to explain that montage, however used, imposes its interpretation on the spectator and takes away from realism (ibid., 26). To formulate his debate. Bazin distinguishes between two trends in cinema, the one pre-sound that is much invested in the image and which has major recourse to the use of montage; the other, the cinema of the 1940s and which is primarily invested in reality (ibid., 24). His first point is not to dismiss montage as a cinematic style appropriate only to silent cinema, but to state that the spatial unity of a film should dictate the dropping of montage in favour of what he terms 'depth of focus' but which we now refer to as deep focus. For Bazin, deep focus made a greater objective realism possible. Since deep focus, contrary to the fast editing style of montage, usually implies long takes and less editing from shot to shot, this style of shooting is one that draws least attention to itself and, therefore, allows for a more open reading. As Bazin says (ibid., 36) 'depth of focus reintroduced ambiguity into the structure of the image if not of necessity . . . at least as a possibility'. Certain films, according to Bazin (thinking specifically of Citizen Kane), are unthinkable if not shot in depth. Deep focus's great virtue for Bazin was that the spectator was not subjected to the ideological nature of montage which rests as it does on a priori knowledge (i.e., that montage will produce x meaning). Rather, deep focus presents the spectator with a naturalism of the image that refuses all a priori analysis of the world (see ambiguity and ideology). But we would argue that montage and deep-focus editing, while seemingly ideologically opposed, are about two different ways of reading film. In both instances, the spectator is 'responsible'

for creatively reading what he or she sees. Montage creates a third meaning through the collision of two images. A meaning that is produced outside the image in point of fact. The sequence of images in conflict (what Eisenstein termed a montage of attractions) provokes a creative reaction within the spectator who produces for him/herself a third meaning. Whereas deepfocus editing produces meaning within the image, the spectator takes his/her own reading from the image before him/her.

denotation/connotation Two key terms in semiotics. Following on from Ferdinand de Saussure's work on signification (see semiology/semiotics), Roland Barthes coined these two terms to give greater clarity to the way in which signs work in any given culture. They are what Barthes termed the two orders of signification. Thus there is a first order of signification (denotation) and a second order (connotation). These in turn produce a third order: mvth. Denotation means the literal relationship between sign and referent; thus, three denotes the object referred to. In film terms, this first order of meaning would refer to what is on the screen, that is, the mechanical (re)production of an image: for example, three people in a frame (a three-shot), two men and a woman. The second order of meaning, connotation, adds values that are culturally encoded to that first order of meaning. And it is at this second order of signification that we can see how signs operate as myth-makers. That is, they function as crystallizers of abstract concepts or concepts that are difficult to conceptualize - they make sense of the culture (for example, institutional, social) in which individuals or communities find themselves.

Returning, by way of illustration, to this three-shot. At the denotative level, the two men are standing either side of the woman. The main source of **lighting** is coming from the side, casting one of the men into the shadows. The camera is at a slight low angle, thereby slightly distorting the features of the characters. At the connotative level of meaning, the reading produced is as follows: this image is signifying the dangers of a triangular relationship. In **classic narrative cinema** — which reposes on the triad order/disorder/order-restored — convention has it that a triangular relationship must end with the demise of one character (the man in the shadows), so that order can be re-established. Within that cultural convention we can also

see how the third order of signification, myth, gets produced and feeds into **ideology**. The myth that triangular relationships are doomed, and cause disruption to order, implicitly makes clear that heterosexual coupledom is the only ideologically acceptable face of sexuality.

depth of field - see deep focus

desire - see fantasy, flashbacks, narrative, spectator, stars, subjectivity

detective thriller - see gangster films

diachronic/synchronic These terms are taken from linguistics, where they refer to two different approaches to language study. Diachronic linguistics is the study of language over time, its history. Synchronic linguistics studies language in a specific moment in time. The former examines language as an evolving process: the latter as a structured whole whose internal relations must be examined. Applied to film studies, a diachronic approach would examine film as an evolving language and industry, from its beginnings in 1895 to the present day. It would also examine any individual film in terms of its chronological linear narrative movement in time from one point to another (that is, basically, the development of the film's story through the typical narrative triad order/disorder/order-restored). A synchronic approach would examine a particular film in relation to its contemporary cultural context and would also view the film as a structural entity whose internal relations must be analysed (see theory). Film studies now tends to see these two approaches not as mutually exclusive but indeed as well worth combining to give a fuller reading of the film as text and context.

diegesis/diegetic/non-diegetic/extra- and intra-diegetic Diegesis refers to narration, the content of the narrative, the fictional world as described inside the story. In film it refers to all that is really going on on-screen, that is, to fictional reality. Characters' words and gestures, all action as enacted within the screen constitute the diegesis. Hence the term diegetic sound. which is sound that 'naturally' occurs within the screen space (such as an actor speaking, singing or playing an instrument on screen). The term non-diegetic sound refers to sound that clearly is not being produced within the on-screen space (such as voice-over or added music). Of course film is about the illusion of reality into which the spectator gets comfortably stitched (see suture). And to a degree even diegetic sound and space are totally illusory and falsely constructed: the sound because with most films it is post-synchronized; the space because the actual images and shots we see are the result of countless takes - so neither is ultimately 'naturally' there (see naturalizing). Certain film-makers will play on or with this illusory nature of cinema through the use of extra-diegetic sounds. Extra-diegetic sounds or shots apply to sounds or shots that come into screen space but have no logical reason for being there. They are inserted as a form of counter-cinematic practice or deconstruction to draw the spectator's attention to the fact that she or he is watching a film. Jean-Luc Godard is a famed practitioner of this.

The term diegetic also refers to **audiences**, so that there are diegetic audiences: audiences within the film. These are often used to draw attention to the **star** in the film or to act as a backdrop to display the star. These diegetic audiences also serve to draw us, the extra-diegetic audience, into the screen and thereby into the illusion that we too are part of the diegetic audience. **Musicals** very commonly use diegetic audiences, dancing and singing around the main protagonist(s) – usually a couple – just to show off how brilliant they are in performing their song and dance. **Westerns** also use the diegetic audience to show off the bravery of the hero in contrast with their own cowardice (see, for example, Gary Cooper in *High Noon*, Fred Zinnemann, 1952).

Finally, intra-diegetic sound. This refers to sound whose source we do not see but whose presence we 'know' to exist within the story: for example, the voice-over of a narrator whose story we are being told and who is also portrayed in the film, that is, who exists on the same level of reality as the story and characters in the film. Michael Curtiz's *Mildred Pierce* (1945) is a classic in this domain. At times we only hear the heroine's disembodied voice recalling moments of her past in voice-over as we **flashback** to images of her in the frame, but we know the voice belongs

to her and that she is a character in the story. She recalls in voiceover in the first flashback: 'I felt all alone ... lonely' after her husband. Bert, had left her. Another classic example of this use of intra-diegetic sound is Rebecca (Alfred Hitchcock, 1940). At the very beginning we hear the disembodied voice of a woman say: 'Last night I dreamt I went to Manderley'. A little later in the film we realize that that 'I' and the 'I' of the female protagonist are one and the same. At that moment we realize the earlier sound was intra-diegetic – an interesting way of creating suspense. The voice-over of a protagonist who is announcing a flashback in her or his life, then, is intra-diegetic. Most typically the protagonist's face will dissolve into an image of an earlier time as we hear the voice-over say 'and yet it was only yesterday . . .' (as in Le Jour se lève, Marcel Carné, 1939). In fact flashbacks themselves could be seen as intra-diegetic because although they are part of the narrative they none the less interrupt the narrative flow in the present. Interior monologue is also intra-diegetic and is quite distinct from the non-diegetic voice-over of an omniscient narrator who gives information about the story but is not personally part of the story. Intra-diegetic sound, then, at its simplest refers to the inner thoughts or voices of a narrator whose story we are witnessing. It also creates a different order of audience identification. During those intra-diegetic moments the character's subjectivity becomes ours: there is a double privileging - we are positioned not only physically but also psychically as the subject.

director (see also director of photography, producer, studio system, vertical integration) The person responsible for putting a scenario or script onto film. Sometimes, but not always (particularly in Hollywood) the director has complete responsibility for the final version of the film (known as director's cut). In the early days of cinema, the director typically had complete control over the whole product. With the coming of sound, as products became more expensive to make, that control diminished (to varying degrees depending on the film industry) and the director worked in closer collaboration (or disharmony) with the producer and stars. By the 1950s, thanks to the effect of auteur theory, the role of the director was once again elevated to the status of creative artist on the basis that they could be said to have a discernible style. Since the 1970s in the

West, film has become so expensive and the **audience** primarily a youth audience that studios or producers have had to target audience demand. This has meant that, with the exception of a few directors who are well known on the international circuit (e.g., Spielberg, Scorsese, Besson), stars are once again in the ascendancy and films are **genre**-led (mostly action movies, grand spectaculars and romance). The role of the director remains, however, as the one responsible for seeing the film as a whole and seeing it through to completion. In film studies the term more commonly used for director is film-maker since it refers very clearly to their function.

director of photography/cinematographer/cameraman The person responsible for putting the scene on film. This person is responsible for the general composition of the scene (the mise-en-scène, the lighting of the set or location, the colour balance). The director of photography is also responsible for the choice of cameras, lenses, film stock and filters. Camera positions and movements, the integration of special effects are also the director of photography's responsibility as is the overall style from scene to scene (including balance of light and colour). Finally, they are directly concerned in the process of the actual printing of the film.

discourse This term is enjoying great currency, replacing the more imprecise word 'language'. Discourse refers to the way in which texts are **enunciated**. For example, cinematic discourse differs from that of a novel or a play, for it tells the story through **image** and **sound**. Discourse also refers to the social process of making sense of and reproducing reality, and thereby of fixing meanings. Cinematic discourse reproduces 'reality' and tells stories about love and marriage, war and peace, and so on.

In that discourses are simultaneously the product and the constituter of reality (they speak for and speak as the **hegemonic** voice), they both reflect and reinforce **ideology** and in this respect they reflect power relations – that is, there will be dominant and marginal discourses. In cinema, for example, there is mainstream/**dominant cinema** which is the dominant discourse and then the marginal discourses of, say, Black, Third World and women's cinemas (for example, Latino women's cinemas: Black, Asian, White).

Discourses 'differ with the kinds of institutions and social practices in which they take shape, and with the positions of those who speak and those whom they address' (Macdonell, 1986, 1). Thus, there are different types of discourses: institutionalized discourses (law, medicine, science); media discourses (television, newspapers); popular discourses (pop music, rap, comic strips, slang). These discourses, although they fix meaning, do not fix them as eternal. Thus, discourses cannot be separated from history any more than they can be disassociated from ideology since they serve to make sense of the culture in which we live. For example, legal or medicinal discourses fix the way in which the treatment of crimes or illnesses are dealt with at a particular time in history. It is clear that seventeenth- and eighteenthcentury legal and medicinal practices are not the same as today (we do not use the stocks for punishment of petty crime nor leeches for curing ailments).

Discourses, then, are social productions of meaning and as such are wide-ranging: political, institutional, cultural and so on. Although film is predominantly perceived as a cultural discourse, social and political discourses are, of course, equally present. And dominant film discourse both reflects and reinforces dominant ideology (starting with heterosexuality and marriage). Furthermore, as with other discursive texts, there are discourses not just within film but also around it. Discourses around cinema attempt to fix its meaning, and these can range from theoretical discourses on cinema (auteurism, spectator-film relations, sexuality, etc.) to more popular discourses such as film reviews, trade journals and articles in fanzines. Or these discourses can be based in other discourses not necessarily related to cinema (such as psychoanalysis and feminism). Or, finally they can be either critical discourses (for example film reviews, students' essays) or populist ones (as in fanzines, popular press).

To illustrate how film discourses within a film operate in relation to history, ideology and reality construction, see the discussion of the shift in meanings in the entries on **horror** and **science fiction** movies.

disruption/resolution (see also narration) This term refers to the classic formula of film narrative (particularly in cinemas of the Western world, but it is also found in many other national cinemas). In this formulaic narrative system the original order,

with which the film's narrative begins, is disrupted and then, over the course of the film, the crisis gets resolved and order restored.

dissolve/lap-dissolve These terms are used interchangeably to refer to a transition between two sequences or scenes, generally associated with earlier cinema (until the late 1940s) but still used on occasion. In a dissolve a first image gradually dissolves and is replaced by another. This type of transition, which is known also as a soft transition (as opposed to the cut), suggests a longer passage of time than a cut and is often used to signal a forthcoming flashback. If it is not used for a flashback but as a transition between two sequences or scenes then it usually connotes a similarity between the two spaces or events – even though that similarity may not at first be apparent.

distanciation (see also naturalizing, and spectator-identification)

A term first coined in relation to theatre, specifically by Bertolt Brecht in relation to his own theatre production in the 1920s and 1930s, although the principle on which it is based, alienation, comes from the Soviet cinema/school of the 1920s. Brecht's purpose was to distance the audience, through numerous strategies, so that it could adopt a critical stance and perceive how theatre practices and characterization serve to reproduce society as it is ideologically and institutionally constructed (see ideology). By denormalizing theatre, by showing its artifice (staging and acting), he wanted to politicize his audience into thinking that society itself could be denormalized and therefore changed. Distanciation in film is an integral part of avant-garde films and counter-cinema and is achieved in a number of ways. First, on a visual level, fast editing, jump cuts, unmatched shots, characters speaking out of the screen to the audience, unexplained intertitles (written or printed words on a blank screen between shots to explain the action or supply dialogue, common in silent films), non-diegetic inserts - all serve to distance and indeed disorientate the spectator (as in Jean-Luc Godard's films). Second, on the narrative level, distanciation is achieved by either over-filling or under-filling the narrative with meaning (Chantal Akerman's films are exemplary of the latter, Godard's of the former). Finally, characterization: distanciation occurs here through the anonymity of the character.

her or his two-dimensionality and inscrutable physiognomy (Robert Bresson's and Alain Resnais's films are good illustrations of this practice).

documentary The first film-makers to make what were in essence travelogues and called documentaires were the Lumière brothers in the 1890s. Thirty years later the British film-maker and critic John Grierson reappropriated the word to apply to Robert Flaherty's Moana (1926). Grierson was the founder of the 1930s documentary group in Britain and was one of the theorists influential in determining the nature of documentary. According to Grierson, documentary should be an instrument of information, education and propaganda as well as a creative treatment of reality. In the late 1940s, the academicism of Grierson's position was severely criticized by Lindsay Anderson and other founder members of Free British Cinema. According to these critics the use of the documentary as a means of social propaganda took away the aesthetic value of documentary film and, on an ideological level, normalized intellectual condescension and social elitism (see naturalizing and ideology). Although Grierson's position, with hindsight, does appear elitist, if we examine the climate of the times in the late 1920s, the reasons for that position do at least become clear. In the United Kingdom (as in the United States) after 1918 there began a progressive development in popular democracy. By 1928 both men and women in the United Kingdom had equal rights to vote. Grierson, who had worked in the United States during the period 1924-7, was struck by the intellectual concerns about mass democracy - such as lack of education among the electorate, making the ordinary voter uninformed when making choices - and was determined to do something about it. This feeling of the need to educate was held by other members of the British establishment who, like Grierson, saw cinema as an excellent means of education. So he worked between 1930 and 1939, first with the Empire Marketing Board and subsequently with the GPO, as producer of some forty-two documentaries on aspects of British life, institutions, governmental agencies and social problems - all with the intention of involving citizens in their society. Coalface (1935), about the miners and their labour, and Night Mail (1936), about the Post Office workers are exemplary films in this regard.

An alternative voice in documentary work emerged a little later, during the Second World War primarily, in the films of Humphrey Jennings. Jennings was a poet and a painter, interested in surrealism and Marxism, in literature and science. Unlike Grierson's liberal elitism, which focused on the dignity of labour but as divorced from the social context, Jennings's films focused on the everyday life and sounds of ordinary men and women (as in Spare Time, 1939). He was the first documentarist to go outside London into the northern parts of the UK and to make films about industrial workers. A great concern of his was the Industrial Revolution and its effects on Britain and British people. Many of Jennings's films were made, appropriately, for the Mass Observation Unit – a unit set up by left-wing thinkers to observe ordinary people through registering accounts of their lives and feelings. Jennings's intimate observation of the ordinary also had a poetic, surreal quality to it, shown in the way he framed his images of industrial Britain and juxtaposed images of the ordinary with those out of the ordinary.

Although the tradition of recording other cultures dates back to the travelogues made by the Lumière brothers, it is really Robert Flaherty who was the first documentarist in that tradition. The first so-called documentary is his Nanook of the North (1922), about Eskimo life. Flaherty also directed a film for Grierson, Industrial Britain (1931-2) - surprisingly given Flaherty's romantic world-view. In the Soviet Union during the 1920s Dziga Vertov recorded Soviet progress in his documentaries made for Kino-Pravda 'Film-Truth'. Interestingly, in his work we can trace the possible heritage of the two British tendencies mentioned above. Vertov, like Grierson, saw documentary as an educative tool, but his style - an avant-garde formalism, achieved by montage, to the point of deconstruction - showed an aesthetic preoccupation with the image that we find in Jennings's work. During the 1930s the Soviet film-maker Medvedkin took the possibilities of documentary on to a new stage: he shot, developed and projected filmed documentation on the spot to workers as he travelled around the Soviet Union by train - this work became known as ciné-train.

Owing to lack of financial resources following the Second World War, many aspiring film-makers in Europe had to turn to documentary work before they could go on to make feature films (Alain Resnais, Georges Franju and Agnès Varda in France and Ken Russell in the United Kingdom spring to mind).

Although some of these directors, especially those mentioned, made important politicized documentaries they hardly constituted a movement. The next important development to occur was in the 1960s with the rise of the cinéma-vérité group in France and the direct cinema in the United States. Two new technological developments contributed to this documentary style - television and the lightweight camera. Television news had the appearance of live images. The lightweight camera made it possible to be unobtrusive and mobile and to catch reality on film. Certain earlier documentary traditions also inflected their work: ordinary people testified to their experiences whether, for example, it was the everyday experience of Parisians in the summer of 1961 (Jean Rouch and Edgar Morin's Chronique d'un été, 1961), the French people's experience of the German Occupation (Marcel Ophuls, Le Chagrin et la pitié, 1970) or the miners' strike in the United States (Barbara Kopple's Harlan County USA, 1976).

In the liberal climate of the 1970s in western society, many film-making collectives and independent film-makers made documentaries challenging the establishment. Feminist films were much in evidence and were about individual women's lives, motherhood, prostitution. Black women and women of colour also got their first foothold in the film-making process. Lesbian and gay film-makers found a voice through the documentary and dealt with their lifestyles as well as gay politics. During this period some of the major themes tackled were abortion (even in France, where it was then still illegal: see *Histoire d'A*, Charles Belmont and Marielle Issartel, 1973), sexual identity, racism and economic exploitation.

More recently since the 1980s, the advent of video technology has led to the emergence of numerous collectives and workshops in Europe and the United States. It has also led to a further and a still greater democratization of the camera and to more voices from the margins finding a mode of expression. Changes in television broadcasting have also helped to raise the visibility of the documentary. With the advent of cable and satellite television there is a need for more programmes, including ones that target specific audiences.

For further reading see Barsam, 1992, for a general history; Nichols, 1991; Renov, 1993, for theory on the documentary; Lovell and Hillier, 1972 and Winston, 1995, for the British documentary.

dollying shot - see tracking shot

dominant/mainstream cinema Dominant cinema is generally associated with Hollywood, but its characteristics are not restricted to Hollywood. As Annette Kuhn says (1982, 22), it is in the relationship between 'the economic and the ideological [that] dominant cinema takes its concrete form'. Thus all countries with a film industry have their own dominant cinema and this cinema constantly evolves depending on the economic and ideological relations in which it finds itself. Given the economic situation, the film industry of a particular country will favour certain production practices over others. For example, the assembly-line system and vertical integration of Hollywood's studios in the 1930s and 1940s have now given way to a fragmentation of the industry and to the rise of independent film-makers whom Hollywood studio companies now commission to make films. On the ideological front, the dominant filmic text in western society revolves round the standardized plot of order/disorder/order-restored. The action focuses on central characters and so the plot is character-driven. Narrative closure occurs with the completion of the Oedipal trajectory through either marriage or a refusal of coupledom. In any event closure means a resolution of the heterosexual courtship (Kuhn, 1982, 34). This resolution often takes the form of the recuperation of a transgressive female into the (social) order (Kuhn, 1982, 34). Visually, this ideological relation is represented through the 'reality' effect - the illusion of reality. The continuity of the film is seamless, editing does not draw attention to itself. The mise-en-scène, lighting and colour are appropriate to the genre. Shots conform to the codes and conventions dictated by the generic type.

For further reading see Bordwell, Staiger and Thompson, 1985.

editing/Soviet montage (see also sequencing, spatial and temporal contiguity) Editing refers literally to how shots are put together to make up a film. Traditionally a film is made up of sequences or in some cases, as with avant-garde or art cinema, episodes, or, again, of successive shots that are assembled in what is known as collision editing or montage. At its simplest there are four categories of editing: (1) chronological editing (2) cross-cutting or parallel editing (3) deep focus and (4) montage.

A film can be constructed entirely using one category (as for example Sergei Eisenstein's montage films of the 1920s); generally speaking, however, it tends to be made up out of two if not all categories. Each category has different implications in terms of temporal relations. Time can seem long or short. Time can have an interior or an exterior reality. Interior temporality is suggested by the sequence and is fictional. Exterior temporality occurs when there is a direct correspondence between sequence time and time within the **narrative**: reel time equals real time (in its most extreme manifestation see Andy Warhol's 1960s films). Again, generally speaking, a film will use both kinds of temporality.

Chronological editing As the term implies, this type of editing follows the logic of a chronological narrative, and is very close in spirit to **continuity editing**. One event follows 'naturally' on from another. Time and space are therefore logically and unproblematically represented. Beginnings and endings of sequences are clearly demarcated, shots throughout the sequence orientate the spectator in time and space and the end of a sequence safely indicates where and when the narrative will get

picked up in the following sequence. This type of editing is one most readily associated with **classic Hollywood cinema** and is one which produces a very linear text. This linearity or chronological order gets broken only when there is a **flashback** or a cross-cutting to a parallel sequence. In both instances this break with linearity is signalled: a fade or dissolve with a voice-over ('and yet it was only yesterday . . .') for example, to signify that a flashback is coming; a quick series of cuts between two locales at the beginning of a parallel sequence to link them up logically for the spectator. (For detailed discussion, see Bordwell, 1985, 60–9.)

Cross-cutting editing Cross-cutting is limited as a term to the linking-up of two sets of action that are running concurrently and which are interdependent within the narrative. The term parallel editing has been used incorrectly to refer to the same effect, probably because it is a literal way of explaining the effect of cross-cutting: putting in parallel two contiguous events that are occurring at the same time but which are occurring in two different spaces. However, as a term, parallel editing actually refers to the paralleling of two related actions that are occurring at different times (a classic example is Alain Resnais's Hiroshima mon amour, 1959). Both styles of editing are used for reasons of narrative economy (they speed it up) and of course suspense. They also assume that there will be a resolution in one space and time of these two sets of action. Unsurprisingly, Hollywood, with its love of linearity and safe chronology, makes little use of real parallel editing and primarily uses cross-cutting. Commonly cross-cutting is used in westerns (John Wayne or Clint Eastwood on the way to rescue some damsel or town in distress) and gangster or thriller movies (cuts between the goodies and the baddies, victim and killer for example). Jean Cocteau makes imaginative use of parallel editing in his fantasy fairy tale La Belle et la bête (1946) - real and fantasy time and space are in inverted order to each other and yet they run in parallel.

Deep focus editing André Bazin was the first to qualify this style of editing as objective **realism**, although the United States cinematographer Gregg Toland was arguing as early as the mid-1930s for the realism of **deep focus**. Shooting in deep focus means that less cutting within a sequence is necessary so the spectator is less manipulated, less stitched into the narrative and more free to read the set of shots before her or him. Ideologically,

then, as an editing style it can be considered counter-Hollywood, or at least counter to **seamlessness** (see **ideology** and **suture**). Certainly Hollywood, at different times in its history, used deepfocus photography, that is, shots staged in depth; it did not, however, use deep-focus editing – clearly, with its emphasis on stardom, cuts to the close-up are inevitable. (For detailed analysis see Bordwell, in Bordwell, Staiger and Thompson, 1985, 341–52.)

[Soviet] montage (see also Soviet cinema) Montage editing came out of the Soviet experimental cinema of the 1920s and, although it was Lev Kuleshov who first thought of the concept of montage, it is primarily associated with Sergei Eisenstein (director of Strike, Battleship Potemkin, both 1925, and October, 1928). In his films of the 1920s, Eisenstein adapted Kuleshov's fundamental theory that collision or conflict must be inherent to all visual signs (see semiology) in film. Juxtaposing shots makes them collide or conflict and it is from the collision that meaning is produced. A simple illustrative example, provided by Eisenstein himself: the first set of shots depicts a poor woman and her undernourished child seated at a table upon which there is an empty bowl; cut to the second set of shots depicting an overweight man with a golden watch and chain stretched over his fat belly; he is seated at a table groaning with food - the rapid juxtaposition of these two sets of images through fast editing cause a collision that in turn creates a third set of images (construed in the spectator's mind), that of the oppression of the proletariat by the bourgeoisie. A first principle of montage editing, then, is a rapid alternation between sets of shots whose signification occurs at the point of their collision. Fast editing and unusual camera angles serve also to denaturalize classic narrative cinema, and this is a second principle of montage editing. In fact, as far as narration goes, given Einsenstein's revolutionary task (to present the proletarian story), it is unsurprising that his editing style indicated a privileging of the image over narrative and characterization (that is, there is no single hero, only the proletariat as hero). Montage is largely used by art and avant-garde cinemas, but mainstream cinema has also incorporated it to spectacular effect (as in Jaws, Steven Spielberg, 1975). Perhaps the most ironic of all recuperations of montage editing, though, must be the use of these principles in film and television advertisements.

Montage and deep-focus editing are seemingly ideologically opposed. Yet in both instances, the spectator is 'responsible' for

creatively reading what he or she sees. Montage creates a third meaning through the collision of two images. A meaning that is produced outside the image in point of fact. The sequence of images in conflict (what Eisenstein termed a montage of attractions) provokes a creative reaction within the spectator who produces for him/herself a third meaning. Whereas deep-focus editing produces meaning within the image, the spectator takes his/her own reading from the image before him/her. Montage is also a style of editing that works towards deconstruction because it draws attention to itself, and that is certainly a major way in which it has been used by art and avant-garde filmmakers, even though the closed reading effect never in fact disappears. A good illustration is Luis Buñuel's surrealist film Un chien andalou (1929). The montage editing of this film gives an aesthetic plasticity to it, pushing the film form forward. However, the juxtaposition of images clearly produces anti-clericalism and anti-bourgeoisie meanings (as well as profound misogyny).

It is also evident that these two editing styles create opposite rhythms through their visual impact. Montage editing is fast, jerky and abrupt; deep focus quite slow and uniformly even. An alternation of these two styles in a film would create two very distinct times, either juxtaposed or contradictory. In other words, the temporal exteriority (that is, real time) and objectivity of deep-focus editing would juxtapose or indeed be contradicted by the temporal interiority and subjectivity of montage editing. Perhaps one of the most extreme examples of this incorporation of both styles into film is Alain Resnais's L'Année dernière à Marienbad (1961), where time is completely destroyed by the juxtaposition, particularly within sequences, of these two styles.

ellipsis A term that refers to periods of time that have been left out of the narrative. The ellipsis is marked by an editing transition which, while it leaves out a section of the action, none the less signifies that something has been elided. Thus, the fade or dissolve could indicate a passage of time, a wipe, a change of scene and so on. A jump cut transports the spectator from one action and time to another, giving the impression of rapid action or of disorientation if it is not matched (that is, if the spectator does not know where she or he has 'jumped' to). Cross-cutting and parallel editing also imply ellipsis.

emblematic shot A procedure in early cinema, introduced in 1903 by the film-maker Edwin S. Porter in his film The Great Train Robbery (in this case a medium close-up of the mustachioed gang-leader holding a gun and poised to shoot). Porter recognized the need to situate the genre and narrative for the spectator, hence the use of the emblematic shot. The shot, usually placed at the beginning of the film, was to act as a metonymy for the whole film, that is, it would sum up the diegesis of the film. This shot could also be placed at the end of the film to sum up what had been seen. Noël Burch (1990, 193) describes this use of the shot at the beginning as the earliest attempt to establish the narrative - acting, therefore, much as establishing shots in current mainstream or dominant cinema (shots at the beginning of a film or sequence that serve to orientate the spectator in time and space). It also serves to create ocular contact between actor and spectator and so represents an early form of suture. When placed at the end, such emblematic shots constitute the first attempts at narrative closure - that is, the film has a meaningful, constructed and signalled ending - it is no longer a case of the film just having run out, as with the earliest cinema.

enunciation Film theorists have adapted this term into discussions of modes of cinematic address. As a concept it was first developed by the French semiotician Emile Benveniste (1971) in an attempt to study the operation of **discourse** within specific social contexts. It is more specifically the three key terms that come under the general rubric of *énonciation* that are particularly helpful to discussions of modes of cinematic address and **subjectivity**. The key terms are: *énonciation*/enunciation: the time-bound act of making a speech act; *énonciateur*/enunciator: the person responsible for making the speech act; *énoncé*/enounced: the verbal result of that act (that is, what is spoken).

The first important point is the distinction between enunciation and enounced: the enunciation is a time-bound speech act (the speech act as it is happening); the enounced is the result of that act, so it is now out of time, out of the time at which it was uttered. Thus, on a time scale, they are not one and the same. The next point concerns the terms enunciator and enounced. These two terms allowed Benveniste to make a distinction between two types of **subject**: the subject of the enunciation, as opposed to the subject of the enounced. The

subject of the enunciation is the enunciator (the one who utters). But who is the subject of the enounced? Who is represented within that utterance? The enunciator? Are they necessarily one and the same? We may think so but this it not always the case, says Benyeniste. And to illustrate his point he gives the paradox of the 'liar'. If the enunciator says 'I am lying', to which subject is she or he referring? Who is telling the truth? If the subject of the enunciation is telling the truth ('I am lying') then the subject of the enounced is lying. They cannot both be lying because they are not one and the same. The subject of the enunciation (the one who utters) has already moved on. If the subject of the enounced is telling the truth, then the reverse is true and the subject of the enunciation is lying (the one who utters is lying). Therefore to the earlier temporal difference of the two speech acts (enunciation and enounced) is added the idea of subject difference (see Lapsley and Westlake, 1988, 50). The following diagram illustrates this.

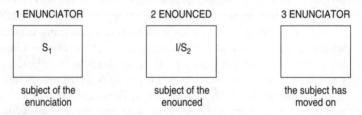

It is not difficult to see how this reasoning fits in with Jacques Lacan's concept of the divided subject and misrecognition (for a fuller discussion, see subjectivity and suture). Lacan (1977) points to the crucial nature of the unconscious in this process of enunciation. The subject of the enunciation is both the conscious and the unconscious subject. Thus, as the conscious subject seeks to represent itself in language, it does so at the expense of coming after the word, by which time the unconscious subject is already not there but becoming something else, a situation Lacan refers to as 'future anterior'. In other words, the conscious subject of the enunciation utters 'I' and in becoming situated as 'I' becomes the subject of the enounced (see above, diagram 2). The spoken subject becomes presence. However, the unconscious subject is already beyond that 'I' and becoming something else. The spoken subject, subject of the enunciation, now becomes absence. To say 'I', therefore, is not to be it, because the subject of the enunciation (who in enunciating is making a time-bound speech act) has already gone past it and is saying and being something else. What is absent for the subject of the enounced, then, is the unconscious – it is outside the unconscious subject and fixed in language. The belief that both subjects are one and the same, whereas they are not, is to misrecognize the self. That is, the mirrored 'I' (this time in language) is not the same as the one standing before the mirror – that one has already gone on (see above, diagrams 2 and 3).

Relevance to film theory/cinematic address In terms of spectator—film relations, the spectator—as—subject is both constituting and constituted through the process of 'reading' the film text. In terms of cinematic address (that is, the interaction or interrelatedness of film as text and the spectator), the spectator is, therefore, both the enunciator (the subject-spectator making sense of the text) and the enunciated (the spectator—subject being situated by the text). The self-reflexivity of art, avant—garde and counter—cinema keeps those two subjects distinct. However, dominant cinema produces films that are seamless and do not draw attention to the apparatus (that is, the way films are made): the story 'naturally' unfolds, the text makes sense of itself so the constituting subject-spectator, because she or he has no role to play, is no different from the constituted spectator—subject. And this leads to the illusion of unity between the two subjects, in other words, to misrecognition.

Although not referring to film per se, Benveniste makes a clear and useful distinction with regard to these two implicit modalities of enunciation. According to Benveniste, enunciation is articulated in one of two registers: histoire (meaning story) and discours (meaning discourse). Story, or better histoire since it connotes both story-telling and history, indicates the enunciation of past events by a dissimulated author (authors in this register do not announce their presence - they are not there). Discours, however, implies that active ongoing social production of meaning and the subject of enunciation in this register is ever present and so too is the receiver (since discourse implies dialogue and therefore an interlocutor). As Kuhn (1982, 49) clearly puts it: 'discours foregrounds subjectivity in its address, while in histoire address is more impersonal'. We can see here the usefulness of these registers in relation to cinematic address. The more impersonal register of histoire means that the actual process of story-telling - the authorial voice or point of view - is absent. All markers of subjectivity are hidden. The story unfolds 'naturally', as 'always there', complete, with no hint as to how it got there.

In mainstream and classic narrative cinema, the narrative itself – through the effects of continuity editing and its ensuing seamless appearance – does precisely the same. As histoire, the narrative represents itself, because complete, as reality. And the spectator, confronted with this completeness, gets positioned as the all-knowing subject. Since sexual identity (read: heterosexuality) is Hollywood's great subject, it is not difficult to see the ideological resonances of this reality-effect.

Of course mainstream cinema is not devoid of discours. Character subjectivity within the diegesis occurs, for example through point-of-view shots, dialogue, flashbacks. But, as Lapsley and Westlake (1988, 51) make clear, such 'explicit instances of enunciation are [still] contained within a supervening narrative that specifies who is speaking and looking'. However, I would tend to nuance this and concur with Kuhn (1982, 53) that histoire 'is a defining feature of dominant cinema' but that is not the end of it. By very dint of the presence of discursive elements it 'might be possible to envisage modes of address which, in mobilising the discursive, constitute viewing subjects rather differently' (Kuhn, 1982, 53). This point relating to positioning is developed in the spectator entry. But Kuhn's other point, that narrative point of view as an element of cinematic address 'is worth examining for what it reveals about the place of women as enunciator' (1982, 52) is one I would now like to examine in relation to the flashback.

In terms of modes of address within film, Benveniste's concept of enunciation does seem particularly useful when discussing flashbacks. It would seem to be able to show what is going on in terms of subjectivity. As Turim (1989) makes clear, there are several types of flashbacks. I only want to deal next with the broad concept of flashback and enunciation and then see how it relates to the female protagonist as enunciator. The first point to make is that the protagonist-as-subject, like the spectator, is a constituting and constituted subject. The subject both performs the text, that is, plays her or his part in the narrative, and is performed by it, is placed in it. The protagonist is, then, simultaneously subject of the enunciation and subject of the enounced. A first 'mirroring' occurs: let us call it A,. A, then goes into flashback mode through a dissolve and possibly a voice-over. The subject of enunciation is now signifying that she or he is becoming the subject of the enounced - a 'past-interior' to rephrase Lacan's term. The subject of the enounced is about to be re-enounced. A second mirroring

occurs: A2. In the flashback proper, the subject of the enounced, A₂ (that which has already been spoken and so is past-anterior) is now masquerading as the subject of the enunciation. Masquerading because there is a reperformance of the past, a making over again, in a time-based speech act, which has already occurred. So there is an apparent subject reversal. But there is also a doublemirroring: first, the subject of the enounced in relation to the subject of enunciation (which the former is pretending to be, hence the 'abnormal' subject reversal) and, second, the subject of the enunciation in its 'normal' relation to the subject of the enounced (but in the past). So now we are confronted with a third and fourth order mirroring: A, (the subject reversal, the masquerading subject) and A₄ (the subject of the enunciation set in the past). It is A3 which points to the most intriguing effect of the flashback. All others of course point to the narcissism inherent in this cinematic trope or figure of speech, but A₃ suggests the distorting effect of the flashback on time and memory (both are back to front). Because there is a double agencing of subjectivity (the subject of the enounced and the subject of the enunciation are both at work here), it also suggests a mise-en-scène of the relationship between the conscious and the unconscious. In this respect, absence (the unconscious) is made presence - almost as if the 'I' of the subject of the enounced is looking back and catching the 'I' of the subject of enunciation.

Given this parametric reading, using variables on a constant, the flashback, then, can be the moment when the psyche has control of its unconscious. So flashbacks for whatever gender should represent an ideal moment of empowerment. But is this the case? Leaving avant-garde and counter-cinema aside, if we look at classical narrative cinema it is with little surprise that we find that male flashbacks dominate, including male flashbacks narrating a woman's story - as is ultimately the case in Mildred Pierce (Michael Curtiz, 1945). In this film, of the three flashbacks it is the last one, the detective's flashback, that in essence rewrites/interprets Mildred's two preceding ones. It is his flashback that resolves the enigma around the murder and Mildred's role in it (Kuhn, 1982, 50-2). Women's flashbacks in the films of the 1940s and 1950s, which are often triggered off by a male 'expert' (doctor, detective), are used to 'explain away' their psych(ot)ic disorders (suicide attempts or just plain insanity). In other words, they tend to be frameworked by the male protagonist, so that it is he who is reaching into the unconscious of the

woman, not the woman herself. In these instances, clearly the female protagonist remains the subject of the enounced – her unconscious is therefore 'beyond' her (read: her comprehension).

Maureen Turim (1989, 117) looks at the issue of women's flashbacks in mainstream and art cinema, and attempts to read against the grain of some of the 1940s and 1950s obvious readings of mainstream films' use of flashbacks.

epics (see also genre) In the beginning there was The Ten Commandments (1923) and Ben Hur (1926), and they were so successful they went forth and multiplied and, born anew in sound, there was The Ten Commandments (1956). Ben Hur (1959), but then there was Cleopatra (1963) and she was so wilful and costly she ruined Hollywood and did the epic in.... So one official version of this genre's rise and fall might have it. And of course, because epics cost so much to make, it is a case of economies of scale. Epics not only cost a monumental amount of money, they require huge sets, casts of thousands and, above all, a monumental hero (sic) played - at least since the advent of sound – by a monumental star. And as for topic, it is usually taken from history: Biblical or 'factual'; certainly most preferably from a distant past so that the ideological message of national greatness would pass unremittingly. Generally speaking, in western society, the nation is the United States because the epic is predominantly an American genre, Hollywood having the resources necessary to produce it.

Arguably D. W. Griffith's Birth of a Nation (1915) was the first great epic and David Lean's Lawrence of Arabia (1962) the last. The heyday of the sound epic was the 1950s, starting with The Robe (Henry Koster) in 1953, the first colour film to be made in cinemascope. The major reason for a resurgence in production of this genre was of course economic. Hollywood's popularity was on the decline. Home leisure, especially television, was keeping audiences away from the movies. To attract them, film studios were having to produce big spectacles that no television set could muster. So colour, 'scope and epics seemed a surefire cocktail to seduce audiences back in. Another factor in their appeal was the grandeur of the themes based in heroic action and moral values which of course fed into the dominant cultural climate of the time: the United States as a superpower, the need to be cleaner than clean in the face of McCarthyism

and the need for clearly defined **gender** roles in the economic restructuring of the nation's post-war job market (that is that women should relinquish jobs they had taken up during the war period and go back into the domestic sphere).

From this, it might seem easy to see why an epic based on Cleopatra might sound the death-knell for the genre. After all, it was about a woman, a leader, a queen (even) who picked and chose her men and spat them out (that is, had them killed) when she had had enough. Strong, self-assertive women were not the norm on screen and the feminist movement had vet to come to the United States. In any case this brand of 'Hollywood feminism' (to use Thomas Elsaesser's term, 1987, 69) was far removed from any feminist ideology. So that was not the reason why this film was the swan-song for Hollywood and its epic tradition. This was the period of John F. Kennedy (the youngest president of the United States), of optimism, change and collectivism. As a topic, Cleopatra was out of date - even though in terms of fashion the creations designed for Elizabeth Taylor's Cleopatra had a profound influence on women's garments, hairstyle and make-up well into the late 1960s. None the less, the cost and the epic grandeur on and off screen, the numerous changes of directors, locations, scripts, Taylor's illness, her affair with Burton, represented a type of excess that was out of touch with the spirit of the age. And so it was that Cleopatra marked the end of Hollywood's movie imperialism, old-style.

European cinema Entries in this book have been made on various individual European cinemas when, at a point in history, they could be said to constitute either a movement or a school (for a list, see the end of this entry). When talking about European cinema it must be borne in mind that political ideologies have meant that Europe has never been a stable unified entity. For example, from the Second World War until very recently (1990) there were two Europes, as is best exemplified by the former division of Germany into two Germanies (East and West). So clearly it is impossible to talk about a European cinema – at least from this side of the Atlantic. Viewed from the United States, more particularly Hollywood, European cinema since 1920 has been construed as a global concept and perceived as meaning two distinct things (at least). First, European cinema is predominantly art cinema and is often more sexually explicit

than the home product (see Hays code). Second, it is the only true rival to Hollywood and must at all costs be infiltrated and dominated. The most recent trade agreements between the United States and Europe are but the latest in a series of attempts of the American film industry to secure favourable deals for the export of its products into Europe - an attempt which France, as the only European country still to possess a viable film industry. has robustly resisted. (The agreements included, at France's insistence, a quota limitation on the number of films to be imported into France annually from the United States. The United States wanted unlimited access to the screens; France kept the quota to around 180-200 films a year.) Although the United States is a very dominant presence in the share of the film market in Europe, if we compare the United Kingdom with France it is clear how much of a resistance France has put up. In 1981 the US share of the film market in the UK was 80 per cent, in France 35 per cent. In 1991 the figures were 80 per cent and 59 per cent. But these figures also show how, over the last decade, protectionism notwithstanding, the United States has eroded that resistance.

Because Hollywood is still so dominant in western culture, it continues to be the point of reference. Thus in western Europe a nation's cinema is defined, in part, in relation to what it is not (that is, 'not-Hollywood'), in relation to an 'other'. This in turn produces two strategies. First, European countries produce films with the intention of intruding into that 'other's' territory. France and the United Kingdom in particular have done this with some degree of success with their heritage films (such as Manon des sources, Claude Berri, 1985; Cyrano de Bergerac, Jean-Paul Rappeneau, 1990; A Room with a View, 1985; Howards End, 1992 both Merchant/Ivory). Second, with a view to protecting its own financial interests, an indigenous industry makes products specifically for the national audience, thereby drawing on its nation's cultural specificities, something which Hollywood of course cannot do. France, Germany and Spain in particular follow this practice.

For an interesting example of an attempt to bring some cohesion to bear when talking about European cinema see Sorlin, 1991. See (listed chronologically) German Expressionism, Soviet cinema, French poetic realism, Italian neo-realism, Free British Cinema, French New Wave, British New Wave, Germany and New German cinema.

eveline matching (see also editing, 180-degree rule) A term used to point to the continuity editing practice ensuring the logic of the look (see gaze). In other words, eveline matching is based on the belief in mainstream cinema that when a character looks into off-screen space the spectator expects to see what she or he is looking at. Thus there will be a cut to show what is being looked at: object, view or another character. Eveline then refers to the trajectory of the looking eye. The eyeline match creates order and meaning in cinematic space. Thus, for example, character A will look off-screen at character B. Cut to character B, who - if she or he is in the same room and engaged in an exchange either of glances or words with character A – will return that look and so 'certify' that character A is indeed in the space from which we first saw her or him look. This 'stabilizing' (Bordwell and Thompson, 1980, 167) is true in the other primary use of the eyeline match which is the shot/reverseangle shot, also known as the reverse angle shot or shot/ countershot, commonly used in close-up dialogue scenes. The camera adopts the eyeline trajectory of the interlocutor looking at the other person as she or he speaks, then switches to the other person's position and does the same.

excess Usually used in terms of performance (see stars) but also for certain genres. In terms of performance, excess points to a highly stylized performance through gesture (as with the mannered style of Bette Davis) or to a contrast in actorly style when the whole performance is minimalist bar a momentary outburst of verbal and gestural excess (Robert De Niro, Jeremy Irons and Meryl Streep are actors in this vein). In the first instance, the star is drawing attention to herself or himself as star - as being more than the part - and as such is pointing to her or his authenticity as star persona (that is, we expect Jack Nicholson to 'act like that'). In the second, the star points to her or his authenticity as actor. And by being both less than the part (minimalist) and more in a moment of excess (such as an outburst of anger) the star proves that she or he can impersonate a role, and yet be more of a star than one who merely personifies a role.

Other aspects of excess can be found in **narrative** and **mise-en-scène**. Classic narrative cinema contains and does not expose its signs of production. However, there are certain genres,

such as the epic, musical, science fiction movies, that are readily associated with excess by Hollywood. With others, the excess is not deliberately on display but may be uncovered through a reading against the grain or close textual analysis. As Kuhn (1982, 35) says, narrative excess can be found in the film **noir** genre of the 1940s. Not only is the detective or private eye investigating a murder or a crime of some order or another, he (sic) is also involved in investigating and scrutinizing the female protagonist. To the solution of the crime is added the 'woman question' - and as such the narrative is in excess. In terms of mise-en-scène and excess, melodrama, with its obsessive attention to décor within the domestic sphere, is a genre that comes to mind. Part of the reason for excessive mise-en-scène has to do with consumerism and targeting the female audience. But a more subversive reading can be made of melodrama's highly stylized look. Elsaesser (1987, 53) points out that this is to do with the effects of censorship and morality codes - very much in effect until the 1960s. In this regard, style becomes used as meaning. In order to convey what cannot be said, primarily on the level of sexual and repressed desire, décor and mise-en-scène had to stand in for meaning (see melodrama).

expressionism - see German expressionism

fade A transition between sequences or scenes generally associated with earlier cinema – up until the late 1940s – but still used on occasion. In this transition an **image** fades out and then another image fades in. In use from 1899, the fade was one of the first forms of transition that could be edited within the camera, so its historical importance resides in the fact that earliest film-makers realized they could now make films that were composed of more than just a single action taken in one take. The **cut** as a transition came a little later, in 1901. The use of the fade suggests a lapse of time and possibly a change of space (for example, if a character gets knocked out she or he may go out with a fade and come back 'some time later' through a fade-in in the same room).

fantasy/fantasy films Generically speaking, fantasy films englobe four basic categories: horror, science fiction, fairy tales and a certain type of adventure movie (journeys to improbable places and meetings with implausible 'creatures', such as *Planet of the Apes*, Franklin Schaffner, 1967). Fantasy films are about areas 'we don't really know about' and, therefore, areas we do not see as real. However, fantasy is the expression of our unconscious, and it is these films in particular that most readily reflect areas we repress or suppress — namely, the realms of our unconscious and the world of our dreams. It is also true that these films, as indeed with other genres, act metonymically as enunciators of dominant ideology and social myths. As we know, mainstream Hollywood cinema's great subject is not sexual identity but heterosexuality and more precisely the family.

When this dream is threatened, the 'threat' must be removed. The doubly deviant woman in Fatal Attraction (Adrian Lyne, 1987) - she is not a mother but a career woman and she is sexually voracious - must be removed so that family life can go on. Norman Bates's victim in Psycho (Alfred Hitchcock, 1960), was a deserving one because she was a double thief: stealing her boss's money and stealing another woman's husband. The fairly recent spate of cyborg movies (the artificial reproduction of humans), as Kaplan (1992, 211) argues, are clearly related to the issue of reproduction rights and who controls them. (It is noteworthy that probably the first cyborg novel was written by a woman. Why did Mary Wollstonecraft Shelley first dream of (1816) and then write (1818) Frankenstein?) It is also noteworthy that the number of these films has increased since the legalization of abortion in many countries in the western world. Men are wanting either to have control over reproduction, as in The Fly (David Cronenberg, 1986) and Alien³ (David Fincher, 1992) or to destroy the reproductive organism, as in Dead Ringers (Cronenberg, 1988).

Fantasy is inextricably linked with desire, which, according to Lacan, is located in the Imaginary (see Imaginary/Symbolic and suture) – that is, the unconscious. Fantasy, then, is the conscious articulation of desire, through either images or stories – it is, then, the mise-en-scène of desire. In this context, film puts desire up on screen. The film industry is the industry of desire, Hollywood is the dream factory. But film is not just film, it is also a nexus of text relations which function as fantasy structures enunciating unconscious desire. Film—text relations can best be described as a series of overlaying triangles of equal importance that are enclosed within the desire/fantasy parameter – as the diagram on p. 110 illustrates.

There is no single set or level of fantasy (just as there is no one desire). In the first instance, each triangle in the diagram generates a set of fantasies that are both interrelated and yet distinct from each other. Just to illustrate: the fantasy created by the film-maker is in relation to but distinct from the fantasy perceived by the **spectator** as constituted subject; and, as constituting subject the spectator creates yet another fantasy; but, given that fantasy structures are multiple, spectator identification is equally multiplicitous. For example (but of course by way of fantasy!), with *Rebel Without a Cause* (1955) the film-maker Nicholas Ray could have fantasized that his film was about

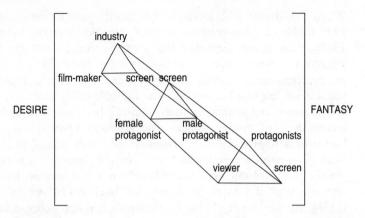

teenage malaise and alienation in 1950s America and that James Dean was an archetypal anti-hero. Given Ray's own background - as a loner, something of a drifter and misfit - he could also have fantasized Dean as his alter ego. A male teenage spectator, seeing the film when it was released, would identify with Dean which, as constituted subject, he is supposed to do, but in this context he would fantasize Dean as his alter ego. As constituting subject, his reading of the film and the character portrayed by Dean could concur with the documentary realism created by Ray, but not necessarily read the film as a 'problem film' per se in which, as Dean exclaims, 'we are all involved'. He could read it instead as a realistic portrayal of youth culture and, too, its embattlement against uncomprehending adults or parents. The film becomes appropriated, encultured - a 'cult film' of the spectator's life (as he fantasizes it). Finally, given the multiplicity of identificatory positions, this spectator can identify with both Sal Mineo and Natalie Wood (Dean's friends) as Dean's diegetically adoring audience - thus satisfying both homoerotic and heteroerotic desire.

The second point to make in relation to these structures of fantasy is that, since fantasy is the mise-en-scène of desire and since desire is located in the unconscious, it follows that cinema, in creating images that we as spectators wish to look at, calls upon the structures of our own unconscious and makes us privy to them. The cinematic **apparatus** functions in this respect to position us as voyeurs to our own fantasies. According to Sigmund Freud, storytelling is a child's way of dealing with its anxiety around sexual differences and dependencies, most particularly on its mother. Storytelling, then, is creating fantasies that

emerge from our unconscious desires and fears. Cinema narratives relay these fantasies before our eyes, the primary ones being as follows: the fear of abandonment by and desire for unity with the mother/([m]other); the fear of castration (Freud) or the fear of being devoured by the mother (Melanie Klein); the bastard and foundling fantasies; the desire for illicit viewing (of parental coitus) – the primal scene.

Let's take Jurassic Park (Steven Spielberg, 1993) to explore this set of fantastic mise-en-scènes. The devouring mother(s) are of course the recreated dinosaurs - all female (at least at birth) and the result of genetic engineering (men tinkering with reproductive rights). These dinosaurs who become sexually ambiguous after birth - they are able to change sex - are also the attacking father and terrifying parents illicitly viewed/fantasized as copulating. The children, Lex and Tim, fear abandonment, and this is fulfilled when they are separated from their 'parents', the two palaeontologists Ellie Sattler and Alan Grant, in whose care they have been placed. Incidentally, it is this same 'father' (Grant) who poses the threat of castration in the opening sequence when he draws the talon of a dinosaur over a young boy's stomach in reply to his persistent questions about dinosaurs - no child-liker he. Father as life-giver and life-destroyer is also exemplified in the role of this reluctant 'father': when Lex and Tim are being attacked in the Land-Rover. Grant eventually has to try to rescue the life-threatened children.

In this film the foundling fantasy, whereby the child can reject the family because the parents are not her or his and are too lowly, is inverted. The foundlings, Lex and Tim, are eventually accepted by Grant when, at the end of the film, he fulfils the Oedipal trajectory by saving his 'family'. He even feels protective to the point that the boy ends up cradled asleep in his arms. The only 'bastards' in this movie are the illegitimate dinosaurs. They are the illegitimate children of the billionaire entrepreneur John Hammond - their 'mother'. Again an inversion, this time sexual. In the bastard fantasy, the mother is perceived by the child as not being possessed by the father - because of her illicit liaisons with other men. She is also perceived as lowly and immoral - a prostitute. This fantasy then breaks up the notion of the family unit: the child sides with the real mother against the father and, moreover, because of her status, the child can even possess her. In the film, as a result of Hammond's illicit reproductive practices, the dinosaurs do break up the 'family' unit; and they unite with

Hammond as mother against the father (all the people they kill are men); they also leave Isla Nublar (!) with Hammond in the form of the blood in the amber on his stick – but now Hammond is a fallen (wo)man, exposed for his immorality, a potential prey to be possessed by his dinosauric children.

For further reading see Donald, 1989.

female spectator - see spectator

feminist film theory (see also theory) Although there were women film-makers back in the 1920s and even earlier (see Hayward, 1992) making statements about the suitability of the camera to a woman's expression of her own subjectivity, feminist film theory did not come about fully until the late 1960s as a result of the second wave of feminism - the first being the Suffragists and Suffragette movement of the early 1900s. This second wave took the world of academia and journalism in the western world and Australia by storm and very quickly began to generate texts related to women's issues and, just as importantly, to disciplines taught within academia - including film studies. Indeed, no discussion of film (or television for that matter) can ignore feminist film theory which, since the early 1970s, has so strongly impacted on film studies starting with the issue of gender representation. Essentially, to date, we can distinguish three periods in the evolution of this theory: the early 1970s; the mid-1970s to the early 1980s; the mid-1980s to the present. The following three sections set out the history and the debates of those periods and look at the impact of each period as well as the problems and outcomes each generated, thus pushing the debate along.

Feminist film theory 1968–74 Although we use the term 'feminist film theory', Annette Kuhn (1982, 72) rightly points out that there does not exist one single theory, rather a series of 'perspectives'. The logic for this can be found in two occurrences directly linked to the second wave of feminism. The first is a contemporary occurrence, an effect of the 1960s. The second is based in a longer look at history. Women (mostly students), radicalized during the 1960s by political debate and so-called sexual liberation, reacted against being placed second after men in the intellectual – and at times violent (as in the United States) – pursuit of political change. The failure of radicalism, which

culminated and then crashed in 1968, to produce any substantive change for women led them to form consciousness-raising groups that effectively galvanized women into forming a women's movement. This rejection of male radicalism in intellectual terms can be interpreted also as a rejection of the pursuit of 'total theory' as exemplified by the totalizing effect of **structuralism** (the debate of the 1960s) – although, as we shall see, feminists did not reject some of the fundamental principles of structuralism. Indeed they were party to moving that debate on to the more pluralistic one of **post-structuralism**.

The second occurrence was in some ways an outcome of the first. Looking at what had happened to them in recent history, women saw the need to look longer and further at woman's history and from a number of perspectives. Annette Kuhn's definition of feminism, in this instance, most aptly sums up how feminism and feminist film theory after it are composed of a number of tendencies, so resisting the fixity of one 'single theory': '[feminism is] a set of political practices founded in analyses of the social/historical position of women as subordinated, oppressed or exploited either within dominant modes of production (such as capitalism) and/or by the social relations of patriarchy or male domination' (1982, 4). By extension, feminist film theory, then, is political. And as early as its first period it set about analysing, from different perspectives, dominant cinema's construction of women. As we shall see, at this juncture, the differences in perspectives were particularly marked between feminists on either side of the Atlantic.

The effect of this first period of feminist film theory was to shift the debate in film theory from class to gender. Feminist film critics examined the question of feminine identity and the representation of women in film images as the site/sight or object of exchange between men. At this point the focus of these analyses was exclusively Hollywood cinema and had the sobering effect of dismissing films, which previously had been elevated to auteur status, for their male-centred point of view and objectification of women. Exemplary of this approach was Molly Haskell's book From Reverence to Rape: The Treatment of Women in the Movies (1974). (It is noteworthy that the person to coin the term auteur theory was Andrew Sarris, Haskell's husband – see Auteur.) In her book Haskell, an American journalist, made two very important points. First, she suggested that film reflects society and vice versa and in so doing reflects the

ideological and social construction of women who are either to be revered (as the Virgin) or reviled (as the whore). Second, in her analyses of the 1930s and 1940s Hollywood cinema she made the important distinction between melodrama and women's films – the latter, as she pointed out, being made specifically to address women. This second point, that of the central role of the female protagonist and female spectator, led to a renewed and different focus on genre and the possible aesthetic and political consequences of gender difference. This very crucial point was one which was developed in the second period of feminist film theory. For the moment, however, let's focus on the first point, since this was the one that revealed differences in perspectives held by feminists on either side of the Atlantic.

In the United States in the early 1970s, Molly Haskell, Marjorie Rosen (1973) and Joan Mellen (1974), were the three leading feminists writing on the representations of women in cinema. The approach they adopted was sociological and empirical – which was consonant with the state of the art in film criticism in the United States at that time. Their critical approach was intended to expose the misrepresentation of women in film, which it did, but in a specific way. Consistently with a sociological-empirical approach, which aims to ascribe – to fix meanings based on fact – they also assumed a presumed feminine essence repressed by patriarchy. That is, their analyses presumed a predetermined sexual identity, difference. In simple terms what was being said was 'the facts show that women get represented in images as Virgin or whore because that's how patriarchal society represents women to itself'.

With hindsight this conclusion now seems quite reductionist. But the fact remains that these findings constituted a first important stage. Meantime in Europe (particularly in the United Kingdom) this essentialist debate represented three major problems for feminist film theorists, who included Claire Johnston, Laura Mulvey, Pam Cook and Annette Kuhn. These feminists were influenced by the more scientific and definitely antiempirical approach offered by **semiotics** and structuralism. They argued that the essentialist debate assumed, first, that all women possessed an innate ability to judge the authenticity of the representation of women in film, and, second, that all women film-makers were feminists. Most critically of all, they pointed out that a belief in a fixed feminine essence meant legitimating patriarchy through the back door. By accepting the fixed essence

of woman as a predetermined, 'given order of things', implicitly what was also being accepted was the 'naturalness' of the patriarchal order (Lapsley and Westlake, 1988, 25). The British feminists, arguing along Althusserian lines, also pointed out that film was as much productive of as it was a product of ideology, and, furthermore, that – in the same way that Althusser theorized that the **subject** was a construct of material structures – so too was the **spectator** a constituted subject when watching the film. The time was ripe for a moving on from a causal and reductionist debate. Historical materialism (an analysis of the material conditions within historical contexts that placed women where they were), semiotics and **psychoanalysis** were the tools invoked to investigate beyond the currently superficial findings and reflectionist statements produced by the American authors.

These criticisms notwithstanding, Haskell's, Mellen's and Rosen's work represented a significant first benchmark that had important outcomes. Their 'saying that it was there' made it clear that the next step was to find out 'how it got there', the better to change 'it'. Their work led to the definition of three basic approaches to achieve this uncovering and subsequent changing of the way women are constructed in film. There was a need for, first, a theoretical analysis of the way in which mainstream cinema constructs women and the place of women; second, a critical analysis of the work of women film-makers; and, third – as a conjuncture of these two points – the establishing and implementation of feminist film practices.

The final point that needs to be made about this period is that women were becoming a presence in all areas of the cinematic institution. The year 1972 witnessed the first feminist film festivals in the United States and the United Kingdom. Women film-makers formed collectives to encourage women into film-making (for example the London Women's Film Group, formed in 1972). Women and Film, the first feminist film journal, was also published in the United States between 1972 and 1975. The next period then had a powerful heritage already as it set to its own trail-blazing practices.

Feminist film theory 1975–83 In 1972 Claire Johnston, Laura Mulvey and Linda Myles organized the Women's Event at the Edinburgh Film Festival. To accompany the Event Johnston edited a pamphlet, Notes on Women's Cinema, published in 1973, which contained her own ground-breaking essay: 'Women's Cinema as Counter-Cinema'. This text was one of the first

to make clear that cinematic textual operations could not be ignored. To change cinema, to make women's cinema, Johnston argued, you had first to understand the ideological operations present in actual mainstream film practices. The task was to determine both the 'how' of female representation and the 'effect' of female positioning in the process of meaning construction. Under the 'how', of first importance was a reading of the iconography of the image. How was the female framed, lit, dressed, and so on? Under the 'effect', of primary significance was the female's positioning within the structure of the narrative. In the first instance what was required was a reading of the image as sign, a need to understand the denotation and connotations of the image. In the second instance the psychology of the narrative had to come under scrutiny: why, repeatedly, do so many narratives in mainstream cinema depict the woman as the object of desire of the male character embarked upon his Oedipal trajectory? Camera-work and lighting make it clear that she is a figure upon whom he can fix his fantasies. These, then, are the textual operations constructing ideology which, argues Johnston, we must come to understand through a deconstruction of the modes of production, which in turn leads to an exposing of the cinematic and narrative codes at work. Only then can an oppositional counter-cinema become a possibility. It is worth quoting from her conclusion to make the point that the cinema she envisaged was not one that relied on self-reflexivity or foregrounding the conditions of film production alone (what she refers to here as political film) but one that would draw on female fantasy and desire:

a strategy should be developed which embraces both the notion of films as a political tool and film as entertainment. For too long these have been regarded as two opposing poles with little common ground. In order to counter our objectification in cinema, our collective fantasies must be released: women's cinema must embody the working through of desire: such an objective demands the use of entertainment film. Ideas derived from the entertainment film, then, should inform the political film, and political ideas should inform the entertainment cinema: a two way process. (Johnston, 1976, 217)

This formidable recipe of foregrounding film practices and female subjectivity would, Johnston believed, effect a break

between ideology and text – a dislocation that would create a space for women's cinema to emerge.

The other ground-breaking essay of this period was Laura Mulvey's 'Visual Pleasure and Narrative Cinema' (1975). Mulvey's focus was less on textual operations within the film and more on the textual relations between screen and spectator. This important text is perceived as the key founding document of psychoanalytic feminist film theory. Since this issue is discussed in much greater detail under spectator, I will confine myself to a brief summary here. In this essay, Mulvey seeks to address the issue of female spectatorship within the cinematic apparatus. She examines the way in which cinema functions, through its codes and conventions, to construct the way in which woman is to be looked at, starting with the male point of view within the film and, subsequently, the spectator who identifies with the male protagonist. She describes this process of viewing as scopophilia - pleasure in viewing. However, she also asks what happens to the female spectator, given that the narrative of classic narrative cinema is predominantly that of the Oedipal trajectory and since that trajectory is tightly bound up with male perceptions and fantasies about women? How does she derive visual pleasure? Mulvey can conclude only that she must either identify with the passive position of the female character on screen, or, if she is to derive pleasure, she must assume a male positioning. This deliberately polemical essay met with strong response by feminist critics. The next section details the development of that debate. For now let's examine the third aspect of theoretical work during this period: textual analysis. But first a brief synopsis of the relevance of psychoanalysis to feminist film theory.

The introduction into feminist film theory of psychoanalysis represented a major departure from the first, sociologically based period. It made it possible to address feminist issues such as identity and memory; it also led to the discussion of femininity and masculinity as socially constructed entities as opposed to the more simplified binary divide along biological lines into female and male. This important distinction meant that it was now possible to analyse sexual difference rather than just assume it as a predetermined reality. If it was socially constructed, then that construct could be deconstructed and changed. Difference could be analysed in terms of language rather than in terms of biologism. Until Jacques Lacan's analysis insisted on the importance of the

Symbolic (that is, language) in the construction of subjectivity, feminine **sexuality** had languished under the Freudian principle of penis envy – that is, of lack. Given that Sigmund Freud privileged the penis, it is hardly surprising that he never managed to theorize the female **Oedipal trajectory** satisfactorily. Why should he, since it would mean a loss of power? According to a Freudian analysis, then, power relations are based in sexual difference. This ignores the social and material conditions that construct human sexuality. This is why the shift from sex to language, which Lacan's approach did much to assist, meant that the ideological operations of language (patriarchal language) could come under scrutiny. By bringing structuralism and psychoanalysis together, feminist film theorists had at their disposition an incisive analytical tool. The text was ready for deconstruction!

In the United States particularly, feminists turned their attention to analyses of the textual operations in film and their role in constructing ideology. Essays in the influential journal Camera Obscura - launched in 1976 by a breakaway group from the earlier Women and Film collective - were instrumental in revealing the ideological operations of patriarchy; and through applications of structural-psychoanalytic theories they demonstrated how narrative codes and conventions sustain patriarchal ideology in its conditioning and control of women. Note that, for the moment, historical materialism has disappeared from the theoretical triumvirate. That was to go on the back-burner until the third period. Currently, textual analysis focused on narrative strategies and, in particular, picked up the question of genre and its role in structuring subjectivity - a point which, as we have seen, Molly Haskell had raised in drawing the distinction between melodrama and women's films.

The intervention of psychoanalysis and feminism now brought melodrama and women's films into the critical limelight, focusing on the **discourses** that construct the symbolic place of 'woman and the maternal'. The **western** too was investigated. The dominance of male-defined problematics within the narrative, the role of women as mere triggers (*sic*) to male action and choice and, finally, the counter-Oedipal trajectory of so many of its heroes – all these narrative strategies are exposed. Why indeed do so many gunmen ride off into the sunset leaving 'the woman' behind? **Film noir** was another genre which under scrutiny could not hide the dominance of a male subjectivity whose **gaze**, motivated by the fear of castration, either fetishizes the 'threatening',

dangerous woman into the phallic and therefore unthreatening other or seeks to control and punish the perceived source of this fear. (See **melodrama**, **western** and **film noir** for a full discussion; and for more detail on these points see **psychoanalysis**.)

Another part of the feminists' strategy in their textual analyses was to read against the grain and, in particular, to foreground sexual difference. Horror and film noir, because of their voyeuristic 'essence', were prime targets of investigation, but so too were melodrama and women's film because of their focus on the family and the so-called 'woman's space'. Thus, for example, in a film noir or horror film a woman's annihilation, which on the surface might appear as a result of her own actions, may in fact be read as the male repressing the feminine side of his self by projecting it on to the woman and then killing her. Alfred Hitchcock's Psycho (1960), for example, plays on this sexual identity in crisis in a number of very complex ways. Norman Bates adopts numerous positions: that of his 'castrating phallic mother' who constantly reminds him that women are filth; so in disguising or dressing himself up as her, he becomes that filth - which, of course he must eradicate; he is also the voveuristic gaze of mainstream cinema looking through numerous holes (peeping Tom) at the woman's body and, finally, the male gaze that must annihilate that which he must not become - woman and filth.

Melodrama is historically perceived as a theatre form that reflects nineteenth-century bourgeois values whereby the family at all costs will prevail, remain united and in order. When the genre was taken up by early cinema this reflection continued. Superficially, by the 1930s and 1940s, melodrama and women's films appeared not to challenge the patriarchal order. However, in their narrative construction these films gave space for a woman's point of view. And it was in this respect that a reading against the grain was possible. Closure for these films meant that order and, if possible, harmony in the family had to be restored. But what caused the initial disorder? Most often conflict between the two sexes. As Laura Mulvey (1977, reprinted 1989, 39) points out, melodrama is the one genre where ideological contradiction is allowed centre screen: 'Ideological contradiction is actually the overt mainspring and specific content of melodrama. . . . No ideology can ever pretend to totality: it searches for safety-valves for its own inconsistencies'. And melodrama is just one of those safety-valves. But what are interesting in this context are the implications of the setting specific to melodrama: the domestic sphere, the woman's space or place and the family. The male character at the centre of the conflict has to resolve it within that sphere. 'If the family is to survive, a compromise has to be reached, sexual difference softened, and the male brought to see the value of domestic life. . . . The phallocentric, misogynist fantasies of patriarchal culture are shown here to be in contradiction with the ideology of the family' (Mulvey, 40). And because it is the female character's subjectivity to which we are privy, it is her emotions with which we first identify. Unlike the western or gangster movie and the dominance of male-defined problematics which only the hero's action can resolve, here we are confronted with 'the way in which sexual difference under patriarchy is fraught, explosive and erupts dramatically into violence within its own private stamping ground, the family' (Mulvey, 39). There is something tantalizing in the implications of this reading against the grain that goes something like this: 'If melodrama and women's films are the only sites where narrative strategies expose the contradictions in patriarchal ideology, and if the domestic sphere is the private stamping-ground of patriarchy, then how much indeed the rest of mainstream cinema must work to assert in public spaces that patriarchal ideology is without contradiction. And how "dangerous" it would be if female subjectivity crept out of the private domestic sphere and exposed those contradictions'. If melodrama did not exist, Hollywood would have had to invent it.

Feminist film theory 1984–90s The revalorizing of certain genres that previously had been dismissed, scorned even, was an important accomplishment, as was the opening up of the debate around female spectatorship. However, by the mid-1980s feminists felt that the focus on the textual operations of films was too narrow and that a film needed to be examined within its various contexts - that is, the historical and social contexts of its production and reception. Clearly this move broadens the debate around spectatorship and reintroduces the question of class, which had been superseded during the last two periods by questions of gender. Since Mulvey's 1975 essay on female spectator positioning as male, the debate had moved on to consider that positioning as masochistic (Silverman, 1981), or as either masochistic or transvestite (Doane, 1984). But the significant breakthrough came in De Lauretis's (1984, 152) rereading of an earlier essay by Modleski (1982) from which she deduced that the female spectator enjoyed a double desiring position. As a result of the mother/daughter relationship, in which the daughter

never fully relinquishes her desire for her mother, the female spectator is positioned bisexually. And it is her constant shifting back and forth between the two positions that creates woman's enigma (Modleski, 1988, 99). This shifting means also that women can never become fully socialized into patriarchy – which in turn causes men to fear women and leads them, on the one hand, to establish very strict boundaries between their own sex and the female sex and, on the other, to the need to 'kill off' the woman, either literally or by subjugation.

Explicit within Modleski and De Lauretis's arguments is that there is a female Oedipal trajectory and that the notion of lack and penis envy is a patriarchal construct designed to preserve the status quo of male dominance and to side-step the issue of sexual difference. Williams (1984, 89), arguing against Stephen Heath's reading (1978) of horror films as a mise-en-scène of sexual difference where the woman represents castration, draws on Susan Lurie's challenge (1980) to Freud's notion of the male child's perception of the mother's body as castrated. Williams (1984) resumes Lurie's argument: 'The notion of the woman as a castrated version of a man is, according to Lurie, a comforting, wishful fantasy intended to combat the child's imagined dread of what his mother's very real power could do to him'. The fact that texts have been constructed around the castration myth does not, argue these feminists, make it any more real but merely points to the lengths to which patriarchal ideology will go out of its fear of the (m)other. Modleski and De Lauretis single out women's films as rare exceptions to this neglect or disavowal of a female Oedipal trajectory in cinema. But this does not necessarily make them a 'good thing'. In this genre, that is deliberately womancentred (the story is apparently told from the woman's point of view) to attract female audiences, the narrative often plays on the 'two positionalities of desire [male and female] that define the female's Oedipal situation.' (De Lauretis, 1984, 153). By the end of the film, however, this shifting back and forth will and must be brought to an end and desire for the female suppressed in favour of desire for the male. Moreover, even when the mother or surrogate mother is represented as quite monstrous, as the phallic mother, the Oedipal trajectory is still there and is completed. Hitchcock's Rebecca (1940) is one such film where the heroine eventually turns away from her evil set of surrogate mothers (especially Mrs Danvers) and enters into maturity (that is, a full relationship with her father-figure husband).

This revelation of a female Oedipal trajectory, according to De Lauretis (1984), is not where feminist film theory must stop. After all 'the cinema works for Oedipus', which means that the heroine's double desiring within the film narrative is eventually resolved along Oedipal lines. She will 'kill off' the mother and marry her father. The ideological operations of patriarchy cannot tolerate women sustaining their double desire. Why else in both Now Voyager (Irving Rapper, 1942) and (although a thriller and not a women's film per se) Marnie (Alfred Hitchcock, 1964) is it a male – more specifically with Now Voyager a psychiatrist – who 'rescues' the heroine from the (phallic) mother? (For discussion of Rebecca see Modleski, 1988; for Now Voyager and Marnie, Kaplan, 1990.)

In this analysis we can see one of the ways in which women's cinema can foreground woman's own construction of meaning: that is, by constructing differently a different social subject, a double-desiring subject whose duplicity need never be resolved. Not a counter-Oedipus, but, as De Lauretis (1985) so felicitously puts it, an 'Oedipus Interruptus'. What is extraordinary (but maybe not) is that women film-makers from cinema's earliest days were constructing differently desiring subjects, as Sandy Flitterman-Lewis's study (1990) so admirably demonstrates.

So far so good. However, feminist thinking by now was also perceiving the limitations of psychoanalysis. Although Lacan's notion of the construction of the subject through language/ discourse opened up the debate on sexual difference, there still remained the problem that femininity was still defined in relation to masculinity - the feminine other to the masculine subject. Power relations were also seen in that light. The limit of this approach was to create an ideology of gender: that is, to construct the concept 'Man'/'Woman' (or if you prefer: patriarchalsubject-man/patriarchal-object-woman), in the end to essentialize Woman, and in the final analysis Man (as the subject of the gaze, power, etc.). It was not so much that the issue of gender had been done to death, but that, in focusing their attention in this way, critics had neglected issues around Woman and women - or that through such an approach women could not be talked about. There was a need to move on from questions of gender and to broaden the debate to include questions of class and power relations between women, of differences among the spectating female subjects, of the film industry as more than just an ideological institution or apparatus of patriarchy that

renders women invisible and constructs Woman – and also to see these questions in relation to history. Only after this broadening of the debate could gender be reintroduced – because, as we shall explain, it had been relocated.

In the United Kingdom, feminists began to incorporate the historical-materialist approach of work done in cultural studies – which examined popular culture within the sphere of class, gender and race and in relation to power and resistances to that power. In the United States, feminists more specifically turned their attention to the French philosopher Michel Foucault and his theory of power as well as his 'notion of the social as a practical field in which technologies and discourses are deployed' (De Lauretis, 1984, 84). By technologies Foucault meant the conjuncture of power (technos) and knowledge (logos). Logos also means discourse. Thus technologies means discourses of power. This last point will be discussed more fully when we examine the effect of another of Foucault's theories, the technology of sex, on feminist theory. But first to power theory.

Since Foucault also had an impact on cultural studies debates, what follows is a brief explanation of how his writings influenced both American feminists and cultural studies and how this influence in turn affected feminist film theory. There are certain problems with adapting Foucauldian theory to film theory (see De Lauretis, 1984, 84-102), but, in the sense that he more or less evacuates gendered subjectivity, it makes it easier to see what else is there. In arguing, in relation to power, that 'discourses produce domains of objects and modes of subjection' (Lapsley and Westlake, 1988, 101), Foucault points to a multiplicity of positionings; some where individuals have power, others where they do not. Foucault's statement (1977, 194) that 'power produces; in fact it produces reality' means that, as a product and producer of power, the individual is both a producer and a product of reality. But it also means that reality is produced from a multiplicity of positions within the power network. It is for this reason that Foucault argues that power comes from below. It is useful, he states, to see power not as hierarchized from the top down but rather as being omnipresent (1978, 93) since all social relations are power relations. Domination evolves from a complex set of power strategies or investments, so it is possible to pinpoint not one source but, rather, several. Foucault also makes the point that, at all stratifications of power, there are resistances to those power relations and that these resistances, far from being in a position of 'exteriority in relation to power', coexist alongside the nexus of power relations (1978, 94–6). Finally, within the context of this synopsis, Foucault insists that power, in and of itself, is neither negative nor positive and that what does matter is how it gets exercised (1977, 194). That is, power in its exercise is a 'silent, secret civil war that re-inscribes conflict in various "social institutions, in economic inequalities, in language, in the bodies themselves of each and everyone of us" (Merquior, 1985, 110–11).

In terms of feminist film theory, there are two main points of application of Foucault's thinking on power. First, the notion of cinema or the film industry (particularly Hollywood) as unique producer of the reality-effect no longer holds. The multiplicity of positions that produce the reality-effect include not just the textual operations of the film products themselves but also the conditions or (im)positions of production and reception. Thus the social relations of power between the different parts of the industry (that is, scriptwriter(s), continuity and location assistants, camera and lighting crew, editor(s), director(s), producer(s), distributor(s), exhibitor(s), and so on) are as much parts of the reality-effect as the spectators. (The use of the plural here draws attention to the fact that several scriptwriters, directors, etc. may be involved in the making of a single film, thus increasing the notion of a plurality of producers of meaning.) How that reality is produced is as much an effect of the power relations and resistances within the industry as it is within the audiences. The spectator can no longer be seen as the single construct of an ideological apparatus. Audiences are multiplicitous. There is not a 'female' or 'male' spectator but different socio-cultural individuals all busy producing reality as the film rolls by. Age, gender, race, class, sexuality affect reception and meaning production. This broadening of the context in which a film is analysed has enabled feminist film theorists to move away from the male-centred effects of psychoanalytic readings, but without necessarily having to throw out psychoanalysis itself, which could be refocused within this context. In other words, femininity no longer needs to be defined in relation to masculinity; nor does it have to be perceived as a single construct, Woman. As Doane (1982, 87) says, femininity can now be seen as a position constructed 'within a network of power relations'. So femininity becomes more than just a male construct. Femininity can be viewed as multiform and pluralistically positioned:

women. By implication femininity can be viewed, as De Lauretis says (1989, 25), from 'elsewhere' – from women's points of view.

This point leads on to the second, which concerns resistances. Resistances, as Foucault says, exist alongside the nexus of power relations. As always present, they filter through social and institutional strata - they leave their traces. This means also that they get caught up at some point within power relations, even though as resistances themselves they have moved on. I am talking here about counter-cinema. Interestingly, Foucault talks about resistances as counter-investments (1978, 97) - that is, counterinvestments are the opposite of what occurs with power, whereby individuals have vested interests in adopting one discursive practice over another. In this light, counter-cinema counters the workings of power relations in mainstream cinema but does not stand as exterior to them. It gives voice to a multiplicity of discourses that are in contradiction or counterpoint, thus simultaneously exposing the complex set of stratifications and power strategies that lead to domination (hegemony) and proposing a making visible of what is so palpably dissimulated by hegemonic investment (that is, the discourses that get dropped). This means that patriarchal hegemony is revealed as no more of a fixed essence or totality than femininity. Rather, what this counter-cinema discloses is that patriarchy has come about as a result of investments in certain discourses over others (including psychoanalysis). By extension these counter-cinematic practices expose the silent civil war mentioned earlier that reinscribes conflict into institutions, language and individuals. In this respect, women's counter-cinema is about discursive disclosure, that is, the expression of other knowledges normally passed over in silence. Moreover, because counter-cinema is not exterior to power relations, those practices of exposure and disclosure get recuperated to some degree into dominant cinema. In the meantime new resistances are in formation. Although recuperation into the mainstream does serve to normalize resistance, recuperation in Foucauldian terms means also to choose to invest in a discourse until now ignored and unpractised. Vested interests change as we know; so too then must the present hegemony, however slowly. As Claire Johnston (1976, 217) said several decades ago: 'we should seek to operate at all levels: within male-dominated cinema and outside of it'. The fact that women currently do this, although the numbers are still quite small, attests to that possibility for change.

If we bear this in mind, it should become clear why gender could be reintroduced into the debate. In his first volume of The History of Sexuality (1978), Foucault talks of the technologies of sex, by which he means the way in which sexuality is constructed by discourses that are in the culture's vested interests. In her brilliant and ground-breaking essay 'Technology of Gender', Teresa De Lauretis (1989, 2) argues that gender is also a product of various social technologies, including cinema. Foucault's discussion of the technology of sex, just like his theory of power, evacuates the idea of gendered subjectivity. But to do this De Lauretis asserts, is to ignore the 'differential solicitation of male and female subjects' and 'the conflicting investments of men and women in the discourses and practices of sexuality' (1989, 3), which is why she insists on a technology of gender. In the first instance, De Lauretis is referring to the ways in which the technologies of gender construct gender in terms of sexual difference – in this respect institutional discourses, which are 'implemented through pedagogy, medicine, demography, and economics' (1989, 12), are the power/knowledge investments producing 'meanings, values, knowledges and practices' as they concern or interpellate or solicit the male and female subject differently (1989, 16). Division of 'labour' (sic) is a prime example: Man as producer, Woman as reproducer. As far as cinema is concerned, we have seen (above) how feminist theory was already focusing on how discourses construct the symbolic place of Woman. So the institutional representation of femininity was, as De Lauretis acknowledges, already under scrutiny. What is different about this way of looking is that male and female subjects are viewed not in relation to masculinity but in relation to different power strategies.

In the second instance, De Lauretis is signalling that men and women do not have the same investments in terms of discourses and practices of sexuality. How could they, given their different histories? Women 'have historically made different investments and thus have taken up different positions in gender and sexual practices and identities' (1989, 16). And it is at this point that De Lauretis starts to 'rough-map' (her term) the possibilities for changes or dislocations in the social – that is, power-relations of gender. She goes on to argue that the 'female-gendered subject [is] one that is at once inside and outside the ideology of gender' (1989, ix). We saw earlier how the ideology of gender fixes Woman (as feminine, maternal or eternal): that is, Woman fixed

on-screen inside the ideology of gender – not woman as a multiplicity of discourses, nor the multiplicity of women. This multiplicitous woman is the female-gendered subject outside the ideology of gender, the one that is not represented, the one that is off-screen and yet by being off-screen, as off-screen space implies, is inferred on-screen (1989, 26).

the movement in and out of gender as ideological representation, which I propose characterises the subject of feminism, is a movement back and forth between the representation of gender (in its male-centred frame of reference) and what that representation leaves out, or, more pointedly, makes unrepresentable. . . . These two kinds of spaces are neither in opposition to one another nor strung along a chain of signification, but they co-exist concurrently and in contradiction (1989, 26).

Even if mainstream cinema through its textual operations and industrial practices tries to conceal the off-screen space, it no longer can, says De Lauretis, because the 'practices of feminism have shown them to be separate and heteronomous [subject to different laws] spaces' (1989, 26).

Feminist film theory over the past two decades has exercised considerable influence over film theory in general. But the debates have to broaden further still. It has not yet, as Black feminists have said, dealt with the social and cultural experiences of all women. And the feminist voices have been predominantly White and middle-class. The effects of cultural studies in the United Kingdom since the early 1980s have caused change in this respect. The study of popular culture has not been a White-only area of investigation. Blacks and Asians are writing about and creating their own experiences. Increasingly Black women are entering into the academy, particularly in the United States. The voices of Latin American women, Asian women and Asiatic women as well as those of Black and White women are being heard and seen on the screen – and in growing numbers. The debates move on, as the reading list makes clear.

For readings on feminist film theory see Kuhn, 1982; Kaplan, 1983 1990 and 1997 De Lauretis, 1984 and 1989; Doane, Mellencamp and Williams (eds), 1984; Penley, 1985 and 1988; Mulvey, 1989; Mellencamp, 1995. For readings against the grain see Kaplan, 1980; Mayne, 1984; Williams, 1984; Kuhn, 1985; Modleski, 1988; Penley, 1989; Doane, 1992; Creed, 1993. For profiles on women film-makers see

Kuhn and Radstone, 1990. On female spectatorship see Pribham (ed.), 1988; Mayne, 1993; Stacey, 1993. On Black feminism see Davis, 1981; hooks, 1981; Moraga and Anzaldúa (eds), 1981; Hull, Scott and Smith (eds), 1982; Attille and Blackwood, 1986; Davies, Dickey and Stratford (eds), 1987.

fetishism - see film noir, voyeurism/fetishism

film industry - see Hollywood, studio system

film noir (see also genre) This is a term coined by French film critics in 1946 to designate a particular type of American thriller film. After the liberation of France in 1944, which saw the lifting of the ban (imposed by the occupying Germans) of the importation of American films, French screens were inundated with Hollywood products, including a new type of thriller. By analogy with the label given by the French to categorize hard-boiled detective novels - roman noir - the term film noir was coined to define this new-looking film. The film noir, predominantly a B movie, is often referred to as a sub-genre of the crime thriller or gangster movie - although as a style it can also be found in other genres (for example, melodrama, western). This is why other critics see film noir as a movement rather than a genre. These critics point to the fact that, like all other film movements, film noir emerged from a period of political instability: 1941-58, the time of the Second World War and the Cold War. In the United States this was a time of repressed insecurity and paranoia: the American dream seemed in tatters and American national identity under severe strain. As a result of the war, women had moved into the workforce and had expanded their horizons beyond the domestic sphere; at the same time men were removed from that sphere - which they had controlled - to go and fight. The men's return to peacetime was a period of maladjustment: what had 'their' women been up to? where was their role at work and in the political culture generally? and what had they fought the war for, only to find the United States involved in a new kind of hostility based in suspicion and paranoia? So the question of national identity was also bound up with the question of masculine identity.

Rather than a genre or movement it might be safer to say that film noir is above all a visual style which came about as a

result of political circumstance and cross-fertilization. Film noir has a style of cinematography that emphasizes the impression of night-time photography with high-contrast lighting, occasional low-key lighting, deep shadows and oblique angles to create a sense of dread and anxiety. The various claims, therefore, to a single heritage are not really in order. The French claimed a first with Marcel Carné's Le Jour se lève (1939) - a very dark film; the Americans believed they had strong claims to the honour with their thriller films of the 1940s (for example, arguably the first one, John Huston's Maltese Falcon, 1941). Certainly the visual codes given to express the deep pessimism of the French poetic realist films of the latter part of the 1930s (exemplified by the work of Carné, Julien Duvivier and Jean Renoir) were in part antecedents to the film noir. But so too was the 1920s German expressionist style in so far as the distorted effects created by lighting, setting and use of shadows reflected inner turmoil and alienation so associated with film noir. However, it would be political events that would complete the cross-fertilization. In the late 1930s and early 1940s, as the threat of war increased and anti-Semitic pogroms continued, a considerable number of European film-makers and technicians fled to America, more particularly Hollywood. The most significant impact was made by the émigré film-makers who had worked in Germany and who were associated in one way or another with German expressionism. Fritz Lang, Josef von Sternberg, Billy Wilder, Richard Siodmark, Otto Preminger, Douglas Sirk, Max Ophuls are but the most famous names.

There are three main characteristics of the film noir which emanate from its primary founding on the principle of contrastive lighting: chiaroscuro (clair-obscur/light-dark) — the highly stylized visual style which is matched by the stylized narrative which is matched in turn by the stylized stereotypes — particularly of women. The essential ingredients of a film noir are its specific location or setting, its high-contrast lighting as well as its low-key lighting, a particular kind of psychology associated with the protagonist, and a sense of social malaise, pessimism, suspicion and gloom (not surprising given the political conjuncture of the time). The setting is city-bound and generally a composite of rain-washed streets and interiors (both dimly lit), tightly framed shots often with extreme camera angles — all reminiscent of German expressionism. The cityscape is fraught with danger and corruption, the shadowy, ill-lit streets

reflecting the blurred moral and intellectual values as well as the difficulty in discerning truth. Characters are similarly unclear, as is evidenced by the way their bodies are lit and framed: half in the shadows, fragmented. The net effect is one of claustrophobia, underscoring the sense of malaise and tension. The protagonist (according to classic canons the 'hero' is a male) is often side-lighted to enhance the profile from one side and leaving the other half of the face in the dark, thus pointing to the moral ambiguity of this main character who is neither a knight in shining armour nor completely bad (interestingly the prototype for this characterization goes back at least as far as Edward G. Robinson's gangster portraval in Little Caesar, Mervyn LeRoy, 1930). He usually mistreats or ignores his 'woman' (either the wife, very much tucked away out of the city, or the moll with the golden heart who invariably sees the 'truth') and gets hooked on a femme fatale who, more often than not according to the preferred reading, is the perpetrator of all his troubles (see Double Indemnity, Billy Wilder, and Murder My Sweet, Edward Dmytryk, both 1944). This 'hero' is often obsessive and neurotic and equally capable of betraval of his femme fatale. The ambiguity of his character is paralleled by the contortions of the plot, whose complexities seem unresolvable, particularly by the hero, who, until the very end, seems confused and unclear about what is happening. In this respect, film noir is about power relations and sexual identity. The power the femme fatale exerts over the hero is his own doing, because he has over-invested in his construction of her sexuality at the expense of his own subjectivity. He has allowed her to be on top because of his own insecurities about who he is. (For a full discussion of this crisis in masculinity see Krutnik, 1991.)

But that's only half the story, because film noir is not so clear-cut in its misogyny. Film noir gives a very central role to the femme fatale and privileges her as active, intelligent, powerful, dominant and in charge of her own sexuality – at least until the end of the film when she pays for it (through death or submission to the patriarchal system). In this respect, she constitutes a break with classic Hollywood cinema's representation of woman (as mother/whore, wife/mistress – passive). These women are interested only in themselves (as the frequent reflections of them in mirrors attest) and in getting enough money, by all means foul, to guarantee their independence. By being in contradiction with the ideological construct of women, such

an image construction makes readings against the grain eminently possible. As Janey Place (1980, 37) says, as far as these women are concerned, 'It is not their inevitable demise we remember but rather their strong, dangerous and above all, exciting sexuality'. These women are symbols of 'unnatural' phallic power: toting guns and cigarette holders like the best of the men – to get what they want. They move about easily in traditionally male spaces, bars, etc. They might even dress like men with their very tailored suits with broad shoulder-pads; or they might slink out of the shadows, thigh-first, dressed in clinging sequinned evening gowns – either way they are mysterious, ambiguous and deadly (guns and looks can kill). In both instances they are empowered by their sexuality. (Examples are Woman in the Window, Fritz Lang, 1944; Gilda, Charles Vidor, 1946; Kiss Me Deadly, Robert Aldrich, 1955.)

Ultimately film noir is not about investigating a murder, although it might at first appear to be. Generally speaking, in the film noir the woman is central to the intrigue and it is therefore she who becomes the object of the male's investigation. But, as you will have guessed, it is less her role in the intrigue that is under investigation, much more her sexuality because it is that which threatens the male quest for resolution. The ideological contradiction she opens up by being a strong, active, sexually expressive female must be closed off, contained. That is the diegetic trajectory and visual strategy of film noir. However, there are obvious difficulties in containing this woman. And this is reflected by the **narrative** strategies inherent in film noir. There is, as Gledhill (1980, 14) points out, a proliferation of points of view. Whose voice do we hear through these multiple discourses each telling a story? Who has the voice of author/ity? The devices used in film noir - voice-over and flashbacks (which primarily privilege the male point of view), diegetic narratives issued by different characters (the woman, the police, the private eye) – are just so many discourses vying for dominance. In the end, film noir is about which voice is going to gain control over the storytelling and - in the end - control over the image of the woman (Gledhill, 1980, 17). This struggle occurs both between men and between the man and the woman, but, more importantly what this struggle foregrounds is the fact that the woman's image is iust that: a male construct - which 'suggests another place behind the image where woman might be' (Gledhill, 1980, 17). Food for feminist thought, but not the director's cut! There has to be

closure – which means implicitly a closing-off of the ideological contradictions that such a suggestion makes plain. And in the end, closure does occur, but at a price. It is the male voice (that of the Symbolic Order, the Law of the Father) that completes the investigation (see **Imaginary/Symbolic**). However, as the multiplicity of points of view that prevailed until the closing moments show, guilt is not easily ascribed to only one person. Because of the lack of clarity it is not quite so easy to 'Put the blame on Mame, boys'. (For an interesting play on female/male subjectivities see *Mildred Pierce*, Michael Curtiz, 1945. Of the three flashbacks, the first two are hers, the last and 'truthful' one is that of the male and representative of the law, the police detective.)

There are contextual reasons for this struggle for dominance. As Janey Place (1980, 36) says, myths do not only mediate dominant ideology, they are also 'responsive to the repressed needs of culture'. Thus, in film noir this construction and subsequent destruction of the sexually assertive woman must be viewed within the economic and political climate of the 1940s and 1950s. I have already mentioned the repressed insecurity and paranoia respective to the political climate of those two decades. On the economic front, thanks to the Second World War, women went into work in the 1940s in huge numbers to help the war effort - and in many cases did so by replacing 'their' men who were at war. By the end of the war, these formerly independent women were being pushed back into the family and the domestic sphere. The film noir challenged the family by its absence and so did the film noir woman who, as sexually independent, contributed to the instability of the world in which the male protagonist found himself. The 1940s film noir was, then, an expression of male concern at women's growing economic and sexual independence and a fear of the men's own place in society once they returned from war. The 1950s film noir functioned to reassert the value of family life not just so that the men could get their jobs back but so that national identity, so much under siege in postwar United States, could be reasserted. We see here how film noir articulated the repressed needs of American culture. Furthermore, the masochistic sexual fantasies implicit in the threat the femme fatale poses for the male protagonist are, in this respect, tied up with questions of (male) identity. But they are 'nothing' really in relation to the sadistic closures designed for the woman: death, being outcast or being reintegrated into the family.

For further reading see Cameron, 1992; Copjec, 1993; Kaplan, 1980; Krutnik, 1991; Modleski, 1988; Stephens, 1995.

film theory - see theory

flashback A narrative device used in film (as in literature) to go back in time to an earlier moment in a character's life and/or history, and to narrate that moment. Flashbacks, then, are most clearly marked as subjective moments within that narrative. Flashbacks are a cinematic representation of memory and of history and, ultimately, of subjective truth. Interestingly, flashbacks date back to the very beginnings of film history - at least as early as 1901 with Ferdinand Zecca's Histoire d'un crime - thus coinciding with the birth and burgeoning of psychoanalysis. In this respect flashbacks are closely aligned therefore with the workings of the psyche and an individual's interpretation of history. Furthermore, because flashbacks almost always serve to resolve an enigma (a murder, a state of mental disorder, etc.) they are by nature investigative or confessional narrative codes, which again brings them close to the process of psychoanalysis. Finally, because they also reconstruct history, flashbacks can serve nationalistic purposes or conversely can be used to question certain social values.

Let's now unpick this. Most of what follows is very largely based on Maureen Turim's excellent and thorough analysis: Flashbacks in Film: Memory and History (1989). First we'll look at the codes of the flashback; second, flashbacks and history; third, flashbacks and the psyche.

Flashback codes In the first instance the spectator is given visual and aural codes to signify the beginning and ending of a flashback. Normally there is a **fade** or **dissolve**, often on the face of the person whose flashback we are about to witness, and generally a voice-over by a narrator (again usually, but not always, the person whose flashback it is). The **image** shifts from the present to the past. However, although there is a shift in temporal and spatial reality, that shift does not undermine the narrative logic. Already then the flashback is exposing itself as a double-edged code. There is an assumption of temporality and order in the flashback but simultaneously – by its very nature – it is patently calling into question our assumptions about chronological time. Time is carved up and layered. It is both the past

and the present, the past made present visibly before our very eyes. We are watching the flashback, so the assumed time is the past. However, we 'understand' cinema in the present (the reel/real is unreeling before our eyes in the always present). The **spectator** is doubly positioned in relation to time. She or he is aware, thanks to the visual and aural codes that mark out the flashback, that she or he is in the past; but also unaware of being in the past because of the 'naturalising processes within the fiction' (Turim, 1989, 17) – naturalized, that is, because the shift in time and space does not disrupt the narrative logic, rather it keeps it safely in place (see **enunciation** and **spatial and temporal contiguity**).

Part of this naturalizing process can be pointed to by the fact that the spectator is rarely in a position, thanks to the **seamless** codes, to question whose **subjectivity** the flashback might represent, whose truth it is and whether or not it is truth (see Kuhn's discussion (1982, 50–3) of *Mildred Pierce*, Michael Curtiz, 1945). If we do believe that flashbacks are more authentic than a chronological tale it is because of their confessional nature and also because they are supposed to be answering an enigma. In both instances there is an implicit truth, even if it is one-sided.

Flashbacks are hermeneutically determined: that is, they will yield a solution to an enigma in the end. So flashbacks come to a 'natural' end when the past has either caught up with the present or has explained the present state of affairs. They can also be seen in this light as a retardation device creating suspense and delaying the answer to the enigma. Alfred Hitchcock's films are notorious for this; he even went so far as to hold the flashback back to keep the enigma alive (as in *Marnie*, 1956, when a last-minute flashback tells us the reasons for Marnie's psychological disorders).

Flashbacks and history Flashbacks are 'naturally' aligned with history since they make the spectator aware of the past. They are both history and story (the French word histoire usefully encapsulates this double nature of the flashback). But they are a particular representation of the past because it is subjectivized through one or several people's memories. History/story becomes personalized and is narrated through the heroics or eyes of the individual. The ideological, and indeed nationalistic, implications of this are clear. By framing history as an individual experience and because a film in flashback is based on the premise that cause and effect are reversed (we know the result

before we know the cause), history can become didactic: a moral lesson is to be learnt – alternatively, as in times of war, it can lead to patriotic identification (Turim, 17). To illustrate these two possible outcomes I quote the disastrous effects of Hollywood and stardom on a woman's psyche as in *Sunset Boulevard* (Billy Wilder, 1950), the inadvisability of a wife and mother having too much socio-economic and class ambition for her family, especially an ungrateful daughter as in *Mildred Pierce*, and, as a classic example of the displacement of the meaning of war on to personal relationships (which makes identification possible), *Casablanca* (Curtiz, 1942) with its call to American patriotism and engagement in the Second World War (see Turim, 1989, 126ff. and 133ff.).

In the framework of history, biographical flashbacks are also redolent with ideological connotations. Because they represent an evaluation of a life, but through a subjective framing of history, they tend to mythologize the 'great man' (sic): as, for example, in Abel Gance's Napoléon vu par Abel Gance (1927). In this film there are various levels of ideological and nationalistic readings to be made. First, of course, is the might and intellect of Napoleon - the brilliant battle strategist since early boyhood when he had to prove against bullying schoolboys that, although from Corsica, he was just as good if not a better Frenchman than they. There is also the man of destiny and vision: l'homme providentiel who can help France to find national coherence and assert its greatness in the world. His success in war and his emblematic eagle reflect the glory and the stability of France's First Empire under his emperorship as opposed to the factionalism and instability of France's republican periods (a clear pointing to Gance's own political dissatisfaction with the then Third Republic).

Only occasionally do biographical flashbacks put in question a nation's power structures and its belief in the legitimacy of capitalism. *Citizen Kane* (Orson Welles, 1941) is a classic in this respect in its demythologizing the American way of life and the **myth** of capitalism that allows men to become tycoons. This is a film that deconstructs larger-than-life ideological statements on class and power in American society (see **deconstruction** and **ideology**). This deconstruction is achieved by the fact that the flashbacks are not those of the dead Kane. They are a third-person compendium-narrative, put together by a journalist, of other people's subjective readings of him (see Turim, 1989, 112–17).

The trial testimonies that make up the flashbacks in this film do more than expose Kane and American societal values, they also put journalism on trial (to make the Kane story sellable, truth must be compromised). Last but not least, *Citizen Kane* exposes Hollywood's cinematic practices of seamlessness that produce the reality effect (that is, film's ability to dissimulate that it is only a representation of reality up on screen, not reality itself).

Flashbacks and the psyche The flashback is a mimetic representation of thought processes looking to the past, whether they be dreams, confessions or memories. They are then subjective truths, an explanation of the present through the past. Flashbacks show how memories are stored and repressed. They also function on an associative level with memory (the protagonist might see something that reminds her or him of a similar sight in the past that has deep resonances for her or him). Because we are positioned as witnesses to these divulgences of the past we become the proto-analyst, and the protagonist our analysand. Often this spectator positioning is strengthened by the presence of an actual psychiatrist or confessor within the film. Flashbacks that deal with psychological motivation were particularly popular in American cinema during the 1940s and 1950s when popularizing Sigmund Freud was very much the order of the day. This popularization must be seen in the context of the very deep malaise felt during the 1940s at the relinquishing of isolationism and entering the Second World War and then, in the 1950s, the aura of suspicion generated by the Cold War and the deep cynicism of the younger generation in relation to their elders' values and beliefs. Freud did not necessarily offer easy solutions, but at least popular Freudianism resolved enigmas or provided simple explanations as to why a character was as she or he was.

What is interesting first of all about flashbacks in this context is that they tend to predominate in two **genres** – **film noir** and psychological **melodrama** – and that they tend to be gendered (see **gender**). But before explaining this statement it should first be said that both genres start from a similar positioning in relation to the representation of the past. The past is seen as an object of nostalgia, therefore of desire or as an object of despair. In both cases this object of fascination is also frightening and dangerous because of the nostalgic desire to repeat (Turim, 1989, 12). This desire to repeat is of course deeply atavistic and masochistic, but it is also bound up with the notion

of fate – this notion of fatalism is particularly evident in the film noir genre. Patterns of repetition generated by flashbacks point to psychotic fears that are acted out in the present. Such patterns as the abandoned child syndrome, the rejected child, the controlled/(s)mothered child, the abused child are just some of the psychoses that motivate the flashbacks particularly in the psychological melodrama. However, they are also present in film noir, especially (but by no means exclusively) if the victim of the psychosis is a woman.

This brings us to the issue of the gendered nature of these flashbacks. Predominantly, in these films of the 1940s and 1950s the film noir focuses on the male protagonist, the psychological melodrama on the female. What is surprising is that the flashbacks do not break down into such neat genderized categories. In the psychological melodramas, which often represent the woman as dysfunctional, over-ambitious, mad or making repeated suicide attempts, the flashback functions as an exploration of the woman's psyche, not necessarily by the woman herself, but rather by her analyst, doctor, enquiring detective, and so on. Furthermore, when necessary, women are given truth serums and electric shock treatment in order to 'get at the truth'. So the flashback is not their subjectivity but others' subjective view of them - a return to the past provoked by a probing or electrifying of the female psyche. Implicitly the ideological purpose being served here is the message that women do not control their unconscious. but men do (control the women's and of course their own). Women are stripped of their own narration and, therefore, subjectivity (Turim, 1989, 160). Given that during the war women had been able to enter the workforce and 'do men's jobs' and that they were separated from their men who were at war and very far away, the independence they had gained would 'naturally' unsettle the returning servicemen. Viewed in this context such films as Mildred Pierce, The Locket (John Brahms, 1946) and Possessed (Curtis Bernhardt, 1946) say more about masculinity in crisis than they do about the female psyche particularly when one considers that in all three of these films it is the investigator (doctor or detective) who resolves the enigma to the woman's disturbed psyche, not the woman herself. (For further reading on these films see Cook, 1980; Turim, 1989, 157-64.)

What of the male protagonist in the film noir? The flash-backs are clearly inscribed as his and are most generally marked by his voice-over. They are either investigative or confessional

and unlike the flashbacks in psychological melodrama, with their redemptive quality, they are strongly inscribed with fatalism. They are also more retrospective than introspective: a summing up or evaluative judgment of the past events (Turim, 1989, 172). The flashbacks serve to underscore the profound ambiguity of the male protagonist. As Turim says (171), the voice-over bridges the gap between the past and the present, the present is speaking about the past and as such the voice-over represents a subjectivity that is a controlling of the past 'exhibiting a self-reliant masculinity'. The protagonist is also streetwise. However, he is driven by a fatal neurosis, a fatal compulsion that is triggered off by an 'evil' woman to whom he is fatally attracted, but who is forbidden to him (because either she or he is married). The fact that he is attracted to the 'evil' woman and will transgress to 'get her' reveals his desire to play the death scenario. The fact that he repeats the scenario through his confessional or investigative flashbacks shows also how compelling the masochistic scenario is - the past as object of desire.

Turim (1989, 175) describes the film noir as 'a romance of the death drive', but such a romance cannot be accomplished without the inscription of the evil female protagonist. In other words, the male protagonist cannot fulfil his masochistic fantasy without the woman. The woman stands as a projection of the protagonist's psyche, and as such she is the agent of evil, forcing him into a cycle of repetition that can be stopped only with death (his or hers). This projection, however, does make clear just how alluring the wish to transgress is to the protagonist. The forbidden woman in this respect becomes that which is forbidden to him by patriarchal law: namely, the mother. So now the masochism inherent in the fatal compulsion of repetition and death also points to a refusal to complete the Oedipal trajectory. Rather than enter into the Law of the Father, the male protagonist chooses to transgress it (see Imaginary/ Symbolic).

A brief analysis of *Double Indemnity* (Billy Wilder, 1944) will serve to make these points clear. In this film the protagonist, Walter Neff, is an insurance broker. He is the site of exchange between client and his company and is directly answerable to the claims-investigator Barton Keyes. In this respect he is doubly inscribed into the Law of the Father: the company and more specifically his boss – who 'locks' him into it, even (through his name, Keyes). He is also quite 'feminized': as site of exchange

for money which he never gets to handle. The film opens with Neff (a weak name suggesting naff, inept) stumbling into his office, fatally wounded. What has happened? Through his confessional flashback, which he records for Keyes to hear – presumably after he dies – we learn that, in an attempt to get his hands on insurance money fraudulently, by killing off a client to whom he had sold a double indemnity package, he has ended up getting himself shot by the client's wife to whom he had become fatally attracted and with whom he had dreamt up the fraudulent scheme. During his whole confession, Keyes is standing listening, unnoticed, by Neff's office doorway.

The confessional flashback is doubly confessional: the tape and the listening Keyes. The nature of the confession shows how desperately Neff wanted to procure the money, that is to pull off the fraud successfully. In other words, in his transgression, Neff was willing himself to defy Keyes (the claims-investigator/ defrauder). In so doing, he was defying the Law of the Father as represented by Keyes - testing his masculinity against Keyes's. The transgression marks, then, a desire to assert his masculinity over his 'feminized' position - which of course in and through his confession he makes clear he failed to do. During this confession his 'father' is listening; the father listening to the 'feminized' son who cannot assert his masculinity over his father. Furthermore, we discover during the confession that his fatal wounding is at the hands of his desired forbidden woman/other/mother. Phyllis Dietrichson. Although he kills her before he returns to his office (site of the patriarchal law, the company) to make his confession, she – as fetishized woman, therefore phallic mother - is the one to shoot first.

Let's tie this all up. The double confession points to an atavism around his 'feminized' self and to a masochistic desire to repeat the failure either to usurp the father or to fulfil successfully the Oedipal trajectory. Although Neff does not know Keyes is listening, he intends him to listen eventually. So he clearly wishes to display his 'feminized' self to Keyes as well as his failure to assert his masculinity. Counterpointed to this homoerotic display of Neff's desire for the father is the father witnessing, unseen: a reversal of the primal scene with the father watching the son desiring. Absent from this scene is the mother: she has already been killed by the son but not before she let loose the fatal (castrating) shot. Because she is forbidden, she represents fascination and danger, the very qualities that make her desirable. In this

respect she functions on two levels. First, she embodies the very nature of the flashback in relation to the past as object of desire but also frightening and dangerous. The nostalgic desire to repeat, which is an inherent code of the flashback and which we know is redolent with masochism, is exemplified by her dual gendering as fetishized object of desire and as phallic mother who actually carries a gun. Since he cannot assert his masculinity over the father, his masochistic scenario must lead him to death. The 'feminized' son is shot by the 'phallicized' mother – death at the hands of the father. Second, by shooting the son, she forces him to return to the father and to expiate his transgression, first through confession and then through death. True to the Oedipus myth, Neff confesses and then dies, thereby reasserting the primacy of patriarchal law as ultimately unviolable.

foregrounding Bringing to the fore or front, in this instance, the front of the screen. Formal elements of a film may function to show that it is a particular character's story that is being foregrounded: subjective camera **shots**, medium close-ups of the character in the foreground, voice-over. By extension, but also by analogy with linguistics, foregrounding means drawing the **spectator**'s attention to a particular element in a film through the use of an unusual filmic device. Because foregrounding can be used to draw attention to the practices of film-making itself, clearly it is much in evidence in **counter-cinema**. But mainstream cinema makes use of it as well. For example, Alfred Hitchcock foregrounded his 'self-as-auteur' by making a brief appearance in most of his films.

Michael Powell's *Peeping Tom* (1960) is arguably the best example of foregrounding. Starting with foregrounding film-making itself, this film is a film about movies *and* about the spectators who watch them and their (in this case morbid) urge to gaze (that is, **scopophilia**). It foregrounds the three looks that characterize the cinema: the look of the camera; that of the character; that of the spectator. It foregrounds the power of the film-maker: Mark Lewis, the protagonist. He is a compulsive film-maker who, by the time the film picks up with him, has taken to murdering the women he is filming by pointing a spiked leg of his camera tripod at their throats and stabbing them to death. The spectator is positioned behind the camera (foregrounding her or him as director or murderer or voyeur).

But she or he also, in a complex set of shots towards the end of the film, gets doubly positioned behind and in front of the camera (foregrounding her/him as voveur and victim). This latter instance deserves some further elaboration because of the density of the mise-en-abîme of foregrounding. This series of shots occurs towards the end of the film when Mark, returning home, finds his lodger sitting in the dark watching one of his 'murder' films. He confesses his crimes and then sets the scene to show her 'fear itself' (let us not forget that in horror and thriller films abject fear is gendered feminine). He approaches her with his camera, spiked leg pointed at her throat and with a mirror fixed to the camera so that she can see her face reflected in it. The spectator sees the shots from behind the camera and, in a reverse-angle shot, those of the face reflected in the mirror. The first set of shots foregrounds the role of the director/ spectator/voveur: the second set foregrounds the victim, not as victim but as voyeur of her victimness. The chilling effect for the spectator, first of all, is the double foregrounding both of woman-as-victim and of fear (the spectator becomes the womanas-victim in fear watching her own fear). The second effect is equally unnerving. As the mirrored image looks out to the spectator she or he is caught in the co-conspiratorial role as accomplice to the director/murderer. In other words, the film is watching the spectator watching the film.

form/content In film studies form and content are seen as inextricably linked. The form of a film emerges out of the content and the content is created by the formal elements of the film. Thus the contents of a character's memories are given form through the use of a series of flashbacks which, in turn, are formally signalled by a dissolve or a fade (the spectator would not expect to sit through an hour and a half of watching the character, seated in a chair, recalling her or his memories). Film form guides the spectator's expectations. Thus if the content is about a triangular love relationship, the film form will follow the classic narrative plot structure of 'order/disorder/order-restored', shots will frame the threesome in different readable ways to show who in the end 'will have to go'.

framing (see also mise-en-scène, shots) The way in which subjects and objects are framed within a shot produces specific readings.

Size and volume within the frame speak as much as dialogue. So too do camera angles. Thus, for example, a high-angle extreme long shot of two men walking away in the distance (as at the end of Jean Renoir's *La Grande illusion*, 1937) points to their vulnerability – they are about to disappear, possibly die. Low-angle shots in medium close-up on a person can point to their power, but it can also point to ridicule because of the distortion factor.

For a more detailed discussion see Bordwell and Thompson, 1980, 104–36.

Free British Cinema According to Lindsay Anderson, one of the founders of Free Cinema, this movement coincided with the explosion on to the theatre boards of John Osborne's Look Back in Anger (1956). Free Cinema was a term Anderson coined in 1956 to designate a series of documentaries and shorts he was putting together for screenings at the National Film Theatre. There were six programmes (from 1956 to 1959) and the basic ethos linking the films, which included the work of French and Polish film-makers, was that the films were free because they were made outside the framework of the film industry and because their statements, which were commentaries on contemporary society, were entirely personal. Although these films were personal statements, none the less there was a strong emphasis on the relationship between art and society and an insistence that the film-makers were committed to the values expressed in their work.

Rather than a movement, however, we should speak of a tendency in cinema. First, because the Free Cinema programme itself was international and made up of an eclectic grouping of films made by young contemporary film-makers – and as such represented the deep-felt need for new voices to be heard: this constitutes an appeal not a movement. Second, because, on a national scale, Free Cinema films were produced by only a handful of film-makers, and while they may have shared common ideals, they had no style in common with the exception of the work of the three film-makers who founded this so-called movement: Lindsay Anderson, Karel Reisz and Tony Richardson. As Richardson himself stated, in an interview in *The Listener* (2 May 1968), Free Cinema was a label invented to designate a number of **documentary** films made by the three film-makers during the 1950s; it was not a case of a movement but a sharing

of common ideals where cinema was concerned. In any event, the legacy of Free Cinema is closely related to the work of these three film-makers and it is on this that the rest of this entry will focus. (For a wider debate see Lovell and Hillier, 1972.)

Among the common ideals held by these film-makers, two stand out as most significant: first, documentary films should be made free from all commercial pressures and, second, they need to be inflected with a more humanist and poetic approach. In this respect, Free Cinema was born out of the 1930s documentary tradition of Humphrey Jennings rather than John Grierson (whom this group of film-makers criticized). A third important point in relation to the emergence of this cinema is that both Anderson and Reisz were critics for the film review Sequence, which was launched by Anderson in 1946, and that it is out of writings for this review that the ethos of Free Cinema was born. This review criticized the British documentary for its conformity and apathy and feature film for its conventionality and lack of aesthetic experimentation. Sequence was a new departure in film criticism. In their articles Anderson and Reisz examined the style rather than the content of a film and deplored British cinema's adherence to classic narrative cinema. They denounced the bourgeois, suburban tradition inherent in this cinema and accused it, through its lack of transparence on the working class, of avoiding reality.

These three Free Cinema film-makers were unanimous in their condemnation of the monopolizing practices of the British film industry. In the 1950s full feature films were produced by only two companies: Rank Organisation and ABC (a branch of Warner Brothers). And the films that predominated were, according to Anderson et al., insipid comedies or war films that glorified the British fighters, trivialized the horrors of war and, last but not least, perpetuated the tradition of the class system (The Dam Busters, Michael Anderson, 1955, being exemplary of this second type of film). Needless to say financing for their own film projects was not forthcoming from those two giants. On the whole they had to self-finance, which is why their first films were shorts or documentaries. They did, however, manage to obtain some resourcing from the British Film Institute's Experimental Film Fund and the giant industrial company Ford of Dagenham. In the event, Ford was a 'greater' patron of Free Cinema than the British Film Institute, which helped to finance only one film: Momma Don't Allow (Richardson and Reisz,

1956). Ford commissioned a series of documentaries – entitled Look at Britain – of which Free Cinema were responsible for two: Anderson's Every Day Except Christmas, 1957, and Reisz's We are the Lambeth Boys, 1959.

The primary characteristic of these film-makers' documentaries and shorts was their belief in the importance of everyday life and people. They were committed to representing workingclass life as it was lived, not as it was imagined. In their images nothing is forced, giving an authenticity that makes their films close in spirit to the humanism of Jennings's documentaries (what Anderson (1954) terms 'public poetry'). What links the three film-makers is the fact that their work focuses on the individual and the collective: that, in terms of editing, they use juxtaposing rhythms (slow or fast). Indeed, their rhythmic editing had strong connotations with jazz - deliberately, since jazz was part of the working-class subculture (Momma Don't Allow deals explicitly with jazz and dancing as a social and sexual liberation for the working-class youth). The other important link between the three is the continuity in the style of their films, undoubtedly due to the presence on four out of their six Free Cinema films of the cameraman Walter Lassally. Finally, a contributing factor to the continuity in their style was the homage their films paid to those film-makers they considered constituted their own heritage: John Ford, Marcel Carné, Jean Cocteau, Robert Flaherty, Jean Grémillon, Humphrey Jennings, Jean Renoir, Vittorio de Sica, Arne Sucksdorff and Vigo.

What of the legacy of the Free Cinema? Certain critics claim that it left very little trace at all, and that the British New Wave Cinema of the late 1950s (of which Look Back in Anger, Richardson, 1959, was the first film) was not, as other critics claimed, a direct outcome of Free Cinema but of the literature and theatre of the time. The 'truth' of course lies somewhere in between: the New Wave movement came out of the conjuncture of literary trends and the Free Cinema documentary tendency. This argument is sustained by the fact that the names of these three film-makers reappear as directors of these New Wave films. In 1959 Tony Richardson founded a production company with John Osborne, Woodfall Films (with financial support from Bryanston Films, a subsidiary of British Lion!). This company produced most of the New Wave films. Richardson, who had earlier directed the stage performance of Look Back in Anger, now made it into a film. Reisz made Saturday

Night and Sunday Morning (1960) and Anderson This Sporting Life (1963) – two key films for British cinema.

For more details of this legacy see British New Wave cinema.

French New Wave/Nouvelle Vague (see also auteur/auteur theory)

Not really a movement, but certainly an important moment in film history. The French New Wave came about in the late 1950s, although, as we shall see, it did have precursors. The term refers to films made, on the whole, by a new generation of French film-makers which were low-budget and, most importantly, went against the prevailing trends in 1950s cinema of literary adaptations, costume dramas and massive co-productions – a cinema which had been labelled by the *Cahiers du cinéma group* as the 'cinéma de papa' (old fogeys' cinema; see **auteur**).

The term Nouvelle vague was not in the first instance associated with these film-makers. Indeed it was originally coined in the late 1950s by Françoise Giroud, editor of the then centre-left weekly L'Express, to refer to the new socially active youth class. However, the term very quickly became associated with current trends in cinema because of the appeal of the youthful actor Gérard Philipe and, more especially, the tremendous success of twenty-eight-year old Roger Vadim's Et Dieu créa la femme (1956) and the mythologizing effect it had on Brigitte Bardot. This meant that producers in the late 1950s wanted work made by 'young ones' - both on screen and behind the camera. This demand helped to propel a new wave of film-makers on to the screen. This was not the exclusive reason, however, for this 'new' cinema. In demographic terms the older guard of film-makers, who had held the reins from the 1930s through to the 1950s, were ageing fast or dying off. This created a gap for a new wave of film-makers (some 170 in the period 1959-63) who in turn became associated in people's minds with the Nouvelle Vague. In the collective memory, all that remains of La Nouvelle Vaque today is this group of film-makers - not the new youth class. A misnomer made myth.

Misnomer or not, an important effect of this demand for a *jeune cinéma* was that it created the myth that those making it were all young. There was also a commonly held belief that, because some of the more notorious first films of the New Wave to hit the screens were made by critics from the influential *Cahiers du cinéma* group (Claude Chabrol, Jean-Luc Godard, Jacques Rivette, Eric

Rohmer, François Truffaut), all of this cinema came from film-makers who had not been through the normal circuit of assistant-ship to established directors. The facts attest differently. The film-makers loosely grouped into this so-called 'jeune cinéma' were in their early thirties. During the period 1959–60, of the sixty-seven film-makers making their first feature film, only 55 per cent came from backgrounds not directly attached to film-making, and the remaining 45 per cent was made up of short-film directors (like Alain Resnais or Agnès Varda) and film assistants.

Another myth perpetuated was that this cinema coincided with the birth, in 1958, of the Fifth Republic, Two films, Le Beau Serge (Chabrol, 1958) and Les 400 Coups (Truffaut, 1959), were seen as the trail-blazers of this New Wave, shortly followed by Godard's A bout de souffle (1959) and Resnais's Hiroshima mon amour (1959). History is not so convenient. There were of course precursors. On the one hand, there was the influence on filmmaking practices of the theoretical writing, primarily emanating from the Cahiers du cinéma journals of the 1950s, which advocated the primacy of the auteur and mise-en-scène. And, on the other, there were film-makers who were already making films that went counter to dominant cinematic practices of the 1950s. They were just not associated with any group. Low-budget, non-studio films were being made. In fact Agnès Varda's 1954 film La Pointe courte is often cited as the herald of this movement. The modes of production and the counter-cinema practices she put in place became commonplace by the late 1950s. Location shooting, use of non-professional actors (or unknown ones from the theatre, such as the young Philippe Noiret in Varda's film), a deliberate distanciation so that spectator identification cannot occur, no necessary sense of chronology or classic narrative are a first set of hallmarks of Varda's style that are recognizable in the New Wave films. Her subversion of genres, her use of counterpoint, of juxtaposing two stories - one based in the personal, the other in the social – and her deliberately disorienting editing style are other important features of her cinematic style which Resnais for one has acknowledged as influencing his own film-making practices.

Another last myth that needs examining is the belief that because this cinema was controversial or different in style it was also a radical and political cinema. This is predominantly not true: the New Wave film-makers were largely non-politicized. If their films had any political aura it came down to the fact

that some film-makers carried on the 1930s tradition of criticizing the bourgeoisie, but now placed their narratives in contemporary **discourses** – that is, viewing the bourgeoisie from the youth point of view. The other reason why the New Wave might have been perceived as political, or a reason *post facto*, is that there were in fact two New Waves. The first occurred in the period 1958–62, the other during 1966–68. The first New Wave was anarchic, but only in relation to what preceded it: the *cinéma de papa*. As we shall see, the second New Wave was more clearly a politicized cinema. Hindsight may have conflated the two moments into one and perceived it as political. Politicized or not, both were to inform and have an impact on future cinemas.

1958-62 As we already know, the New Wave film-makers rejected the cinema of the 1950s and focused their attention on the auteur and mise-en-scène. The individual film-maker and his (sic) signature was all. Paradoxically, given their so-called modernity and innovativeness, this was rather a romantic ideal and conservative aesthetic. But it must be reiterated that they were not a politicized group. Their cinema marked a complete rupture with the 1950s cinematic codes and conventions on both the narrative and the visual level. In terms of narrative. there was often no récit, no completed or necessarily realistic story as such; there was no beginning, middle and end - more often it was a slice of life; gone were the literary adaptations of the 1950s, no 'high art' literature but rather pulp or popular fiction if adaptations were being made (with a particular liking for American detective pulp fiction). There were no stars. The time was the 'now-ever-present' of the 1960s. Discourses were contemporary and about young people. Taboos around sexuality were 'destroyed' (partly the effects of the so-called 'free-love' phenomenon) and the couple was represented as a complex entity with issues centring on power relations, lack of communication and questions of identity. The representation of women was more positive, women became more central to the narrative. and more agencing of their desire.

On the visual side, the institutional **iconography** was **deconstructed**. The establishing **shots**, which safely orientate the spectator in terms of **space and time**, were excised. A fast **editing** style, achieved by **jump cuts** and **unmatched** shots, replaced the **seamless** editing style that had prevailed before. The newly adopted lightweight camera, more commonly used

for television, abandoned the **studios** and went out into the streets and suburbs of Paris (Paris was the one icon that did not disappear). Film stock was fast and cheap. These two latter aspects of technology gave this cinema a sense of spontaneity and **cinéma-vérité** more readily associated at the time with television production, which was mostly live at that time.

1966-68 By the time of this second New Wave, the contemporary discourses of the earlier New Wave had generally become more politicized and there was no positive reflection of the dominant ideology. Godard's films are particularly exemplary in this context (Deux ou trois choses que je sais d'elle, 1966; La Chinoise and Weekend, both 1967). Bourgeois myths (especially those surrounding marriage, family and consumption practices) were taken to bits and denormalized. The consumer boom, nuclear war, Vietnam, student politics, adolescence - all were subjects for treatment. By now the consumer boom (already criticized in the first New Wave) was not about comfort and a better way of life but about prostituting the self in order to be better able to consume. The most important consumer durable of that time, the car, was exposed as the machine of violence and death into which our covetousness had transformed it - a minotaur of our age (la déesse), the consumer durable that consumes us.

This cinema then was as much about the process of filmmaking as it was about denormalizing the sacred cows of the bourgeoisie. Film-making practice, the technology of the media, exposed social practice, consumption. It was also a counter-Hollywood cinema that did not seek to emulate the American giant, as the 1950s products had done, but addressed first the personal and later the political tensions that the younger generations were experiencing during the 1960s. Both New Waves put in place a counter-cinema to the standardization effects of American technology (hand-held camera, no studio, editing practices that drew attention to themselves, no star-system). It did not de-Parisianize itself, but it did secure a social sphere for the youth class, for both men and women. The first New Wave was not politically engaged but it was anti-bourgeois in sentiment (especially Chabrol's films). And it was motivated by a desire to present the point of view of the individual in society. Moreover, the themes it treated filtered into mainstream cinema as early as the mid-1960s. In the late 1960s, by the time of the second New Wave, this cinema had become politicized,

questioning institutions and their power effects over individuals – questions which filtered into the more evidently political cinema of the 1970s (the exemplary director being Constantin Costa-Gavras, but also Louis Malle).

It is worth noting that the brief popularity of both New Waves coincided with the political culture in which they found themselves and with the most politically tense moments in France's history of that period. The first period of popularity. 1958-62, coincided with the radical effect on institutions of the advent of the Fifth Republic and its new constitution which invested the presidency with executive powers - giving the president virtually supreme power over the parliament. This period also marked the bloody decolonization of Algeria. In this light it is easy to see why the disruptive anarchy of the first New Wave was seen as political. The second period of popularity, 1966-8, coincided with the progressive disenchantment with de Gaulle's authoritarian presidential style, unrest on social and educational levels owing to lack of resources to accommodate the expanding urban society and student university numbers. workers' concern at their conditions, and concern with unemployment - all of which culminated in the events of May 1968.

Although this cinema was criticized for its focus on the individual – its emphasis on auteur and the confessional style of the films – it left one very important legacy. Thanks to the huge influx of film-makers into the industry (around 170), production practices had to be reconsidered. For money to be spread around, films had to be low-budget. Given the number of film-makers, the cheaper, lightweight camera came into its own. As a result there was a democratization of the camera. This pioneering effect was to make the camera more accessible to voices formerly marginalized and by the 1970s and 1980s women, Blacks and Beurs (the Arab community in France) were entering into film-making.

French poetic realism In the mid-1930s the liquidation of the two major film trusts in France, Pathé and Gaumont, meant that the small independent producer could take up pole position. Whereas before 1935, the two majors had dominated production, after 1935 and until 1939 on average 90 per cent of the French films produced were by small independent film companies. This had a fortunate effect on the French film industry. The collapse of the major commercial studios facilitated France's

art cinema. Independent producer-directors were, for a while, free to make their films, and moreover could access the majors' studios and technical services, as well as their cinema circuits. A small faction of these independents, most famously Yves Allégret, Marcel Carné, Julien Duvivier, Jean Grémillon and Jean Renoir, became loosely banded under the label of the Poetic Realist school. But, despite their small number, they none the less re-established France's ailing international cinematic reputation which had been on the decline ever since the First World War, by which time the Hollywood majors had completely cornered the international market.

→ Poetic realism has been seen in relation to its historical context as shadowing the rise and fall of the Popular Front - a consolidated party of the left which eventually came to power in 1936. The party was voted in on a wave of optimism for its platform of social reforms. However, because of the economic climate and the threat of war these were never fully implemented. The party was in power for a thousand days, but after only six months in office it was obvious that little or no change was going to be possible given the political and economic climate. To the optimism of its advance come the filmic echoes of workingclass solidarity as exemplified in Renoir's Le Crime de M. Lange (1935) and the optimistic title of his La Vie est à nous (1936). As markers of the decline of the Popular Front and of the desperation felt at the ineluctability of war come deeply pessimistic films like Marcel Carné's Quai des brumes (1938), Le Jour se lève (1939) and Renoir's La Règle du jeu (1939).

This simplistic reflection needs nuancing however, since not all the films in this grouping necessarily gave this straightforward early-optimism, later-pessimism message. Furthermore, not all the film-makers in this school were sympathetic to the left. At least two 1936 films are undyingly pessimistic in their message. These are Julien Duvivier's Pépé le Moko and La Belle équipe (both starring the poetic realist fetish star, Jean Gabin). In the first, Pépé dies at his own hands. Wanted by the police, he holes up in the Casbah in Algiers where he is surrounded by an adoring gang and mistress; but all he can dream of is returning to Paris – the price for fulfilling that desire is death. In La Belle équipe male working-class solidarity is exposed for its weakness as it swiftly becomes eroded by the alluring presence of a woman. Duvivier was certainly not a man of the left, which might explain his dark films in this euphoric period of the early Popular

Front. However, another film-maker, Jean Grémillon, this time of the left, was making similarly bleak films around the same time. His *Gueule d'amour* (1937) portrays the destruction of a man who foregoes his duties (as a soldier) for his passion for a 'heartless' woman (whom he eventually murders).

In poetic realist films there is a strong emphasis on mise-enscène: décor, setting and lighting receive minute attention and owe not a little to the influence of German expressionism. Poetic realism is a recreated realism, not the socio-realism of the documentary. In this respect the realism is very studiobound and stylized. For example, parts of Paris are studiously reproduced in the studio - an almost inauthentic realism. This stylized realism of the mise-en-scène is matched by the poetic symbolism within the narrative. The narrative is heavily imbued with the notion of fatalism. The male protagonist is generally doomed and the film's diegesis is so constructed as to put the degeneration in his mood on display. This is the mise-en-scène of male suffering par excellence. Setting, gestures, movement (or lack of it), verbal and non-verbal communication are all markers for this degeneration and so too are the lighting effects. To this effect side-lighting, for example, is used on the protagonist's face, or part lighting of the space in which he finds himself, or highlighting objects that are of symbolic value to him. Indeed objects are endowed with symbolism to quite a degree of abstraction and resonate throughout the film, measuring the state of degeneration as the protagonist responds to their recurrence in the film.

A major reason why all aspects of the film process function so intensely to create this aura of poetic realism is that these films are, in the final analysis, the result of team work. There is the director, but there are also – of major importance – the scriptwriter, the designer for the sets, the lighting expert and the composer of the music soundtrack. Carné for example worked with the poet Jacques Prévert who scripted several of his films, he had Alexander Trauner as his set designer and Joseph Kosma was a frequent composer to his films.

For further reading see Andrew, 1995.

futurism (see also **Soviet Cinema**) A revolutionary modernist movement, founded in Italy at the beginning of the twentieth century when in 1909 the poet Filippo Tommasso Marinetti

published a literary manifesto calling for the obliteration of past Italian culture and the creation of a new society, literature and art extolling the virtues of modern mechanization. Although short-lived in Italy, this movement had considerable impact on several aesthetic movements: the vorticists in the United Kingdom (inaugurated 1913) and the Russian futurists (1912). The Russian futurists adopted an experimental and innovatory approach to language that was to filter through into the post-Revolutionary movement of constructivism. The pre-Revolutionary movement, influenced as it was by the abstract forms of European modernist art, primarily exemplified by cubism and futurism, believed in technique and the evacuation of fixed meanings. After the Revolution, the constructivists, seeing in technology the huge potential for social change, advocated a new order in which workers, artists and intellectuals would work together to produce a new vision of society - art and labour were seen as one. This notion of art as production was eagerly embraced by the newly emergent Soviet Cinema of the 1920s - and also admirably suited the political exigencies of post-Revolutionary Russia of the 1920s who needed the propagandizing effect of cinema to spread the message that all workers were pulling together to secure the national identity of the new Soviet republics.

G

gangster/criminal/detective thriller/private-eye films (see film noir and the separate entry for thriller; see also psychoanalysis)

These different titles point to the difficulty of allocating a single generic name to a set of types of film – a difficulty due primarily, as we shall see, to the shifting contexts in which a particular genre finds itself and which dictate that it must change its system of signification.

The gangster film is the one most readily identified as an American genre even though the French film-maker Louis Feuillade's Fantômas (1913–14) is one of the earliest prototypes. It is in the contemporaneity of its **discourses** that the gangster film has been so widely perceived as an American genre. This genre, which dates from the late 1920s, came into its own with the introduction of **sound** and fully blossomed with three classics in the early 1930s: Little Caesar (Melvyn LeRoy, 1930), The Public Enemy (William A. Wellman, 1931) and Scarface (Howard Hawks, 1932). In the United States this was the period of Prohibition (1919–33), during which the manufacture, sale and transportation of alcoholic drinks was forbidden, and the Depression (1929–34), when worldwide economic collapse precipitated commercial failure and mass unemployment.

These two major events in the United States's socio-economic history helped to frame the mythical value of the gangster in movies. Prohibition proved impossible to enforce because gangsters far outnumbered the law enforcers. Prohibition, however, brought gangsters and their lifestyle into the limelight as never before. Gang warfare and criminal acts became part of the popular press's daily diet and soon became transferred on to film. In fact, many of the gangster films of that period were based on real

life. Gangsterism viewed from this standpoint was about greed and brutal acts of violence – in summary about aggression in urban society. But the gangster movies were not as straightforwardly black and white as that. The male protagonist embodied numerous contradictions that made **spectator identification** possible. If we look to the second socio-economic factor mentioned above, we can find a possible reason for the complex and nuanced characterization of the gangster-hero.

The Depression exposed the American dream - which said that success, in the democratic and classless society guaranteed by the American Constitution, was within the reach of everyone - as a myth. How could this be so when the society was so evidently hierarchized into the haves and have-nots - as the effects of the Depression made so blatantly clear? According to the American Dream, success meant material wealth and, implicit within that, the assertion of the individual. The gangster was associated with the proletarian class, not the rich and moneyed classes of the United States. Therefore the only way he (sic) could access wealth and thereby self-assertion - that is success, the American Dream - was by stealing it. Accruing capital meant accruing power over others. In this respect, the gangster embodies the contradictions inherent in the American Dream: success comes, but only at the expense of others. And because the gangster points up these contradictions, his death at the end of the film is an ideological necessity. He must ultimately fail because the American Dream cannot be fulfilled in this cynical way; and he must also fail because he cannot be allowed to show up the Dream's contradictions.

The classic gangster film came into its own with the advent of sound, which reinforced the realism of this genre. Warner Brothers (see **studio system**) was the first studio to launch this genre in a big way with *Little Caesar* and *The Public Enemy*, and their films are seen as the precursors to the film noir. By 1928 this production company had finally become vertically integrated and entered into full competition with the other majors. It was the first company to introduce sound (1927, *The Jazz Singer*, Alan Crosland) and was now poised, as a major in its own right, to outstrip the other four. Warner Bros became associated with the genre because its production practices had set a certain house style of low-budget movies and short shooting schedules. Cheapto-make films influenced the product, and so **backstage musicals** and gangster films were the genres to prevail. Warners were

also very much associated with social content films, and indeed after the launch of Roosevelt's New Deal (1933–4) became identified with the new president's politics of social and economic reform. **Social realism** and political relevance combined with a downbeat image endowed Warners' films with a populism that made their products particularly attractive to working-class audiences, a major source of revenue for film companies.

The gangster movie, in its naked exposure of male heroics, has been likened to an urban **western**. But unlike the western, where rules are observed, the gangster movie knows no rules, other than death. Central to the gangster film is the antagonism between the desire for success and social constraint. The gangster will choose to live a shorter life rather than submit to constraints. Hence the aura of fatalism that runs through the film. But, as far as the spectator is concerned, for the duration of the film, where violence is countered with violence, where there are no rules, she or he is witnessing an urban nightmare as the **narrative** brings the plot to the brink of a social breakdown.

The gangster film is highly stylized with its recurrent iconography of urban settings, clothes, cars, gun technology and violence. (In recent history, the film that most fulsomely parodies and yet pays homage to this genre and its iconicity is Quentin Tarantino's Reservoir Dogs, 1992.) The narrative follows the rise and fall of a gangster; a learning curve that of course has ideological resonances for the spectator - but not before there has been a first pleasure in identifying with the lawlessness of the 'hero'. During his (fated) trajectory towards death, the protagonist's coming to self-awareness - rather than self-assertion, which is what he initially sought through success - functions cathartically for the spectator: we 'learn' from his mistakes. Furthermore, the use of the woman who is romantically involved with the protagonist and in whose arms he (often) dies - as the law enforcers stand menacingly around the prostrate couple, armed to the teeth - positions the spectator like her and therefore as sympathetic, understanding even, to the gangster. And thus, although the 'message' of the film - 'the gangster must die for his violent endangering of American society' - intends to provide the spectator with a sense of moral justification, there is none the less an inherent criticism of American society which says that ultimately the 'little guy' must fail.

The classic age of the gangster movie (1930-4) was brought to a swift halt in an ambience of moral panic. Pressure was put

on the Hays office to do more than ask the film industry to apply self-censorship. In 1934 the Production Code (see Havs code), which condemned among other things films glorifying gangsters, became mandatory. Given the popularity of the genre. film companies were not going to give up such a lucrative scenario. Forced to water down the violence, they produced a set of sub-genres: private-eve films and detective thrillers. That is, without dropping much of the violence, they now foregrounded the side of law and order resolving disorder. Told to put a stop to the heroization of gangsters and violence, they simply shifted the role of hero from gangster to cop or private eve. Thanks to the Hays code intervention, the seeds for the film noir were sown. The sadism of the gangster became transformed into the guilt and angst of masculinity in crisis of the film noir protagonist. Against the ambiguous urban landscape of some modern American city, the hard-boiled detective seeks justice. The ambiguity of the city reflects the ambiguity and complexity of a society where corruption reigns and law cannot easily bring the guilty to justice. Thus the detective is often a private eye, outside 'official' law, a law unto himself. As a marginal, by being outside he can solve the crime and bring the perpetrators to justice (Cawelti, 1992). Traditionally the detective is male; however, recent hard-boiled detective novels written by women (such as Sara Paretsky) have introduced the phenomenon of the woman private-eve detective, who has subsequently found her place on the screen - they are 'just as tough' and as equally poor as their male counterparts. Being poor is part of the construct of the private-eye, pointing to the fact that, even though their methods may be outside the law, none the less they are not in the job for the money. Women in the detective thriller, on the whole, have a more central role than in the earlier gangster movies. They are beautiful and dangerous, often the murderess and therefore subjected to investigation by the detective.

For more on this sub-genre, see film noir.

gaze/look (see also apparatus, psychoanalysis, scopophilia, spectator) This term refers to the exchange of looks that takes place in cinema. But it was not until the 1970s that it was written about and theorized. In the early 1970s, first French and then British and American film theorists began applying psychoanalysis to film in an attempt to discuss the spectator—screen relationship

as well as the textual relationships within the film. Drawing in particular on Freud's theory of libido drives and Lacan's theory of the mirror stage, they sought to explain how cinema works at the level of the unconscious. Indeed they maintained that the processes of the cinema mimic the workings of the unconscious. The spectator sits in a darkened room, desiring to look at the screen and deriving visual pleasure from what she or he sees. Part of that pleasure is also derived from the narcissistic identification she or he feels with the person on screen. But there is more; the spectator also has the illusion of controlling that image. First, because the Renaissance perspective which the cinematic image provides ensures that the spectator is subject of the gaze. And, second, given that the projector is positioned behind the spectator's head, this means that it is as if those images are the spectator's own imaginings on screen. Let's see what the theorists have to say about all of this.

Christian Metz (1975) draws on the analogy of the screen with the mirror as a way of talking about spectator positioning and the voyeuristic aspect of film viewing whereby the spectator is identified with the gaze (since the gaze cannot be returned, the spectator is voyeuristically positioned). However, Metz argues, because he (sic) is identified with the gaze, this also means that he is looking at the mirror. In other words, through the look, the spectator is re-enacting the mirror stage. In this respect, this identification is a regression to childhood. Raymond Bellour (1975), for his part, talks about the cinema as functioning simultaneously for the Imaginary (that is, as the reflection, the mirror) and as the Symbolic (that is, as language through its film discourses). In both instances, these two theorists assert, the spectator is at the mirror stage and about to acquire sexual difference (in looking into the mirror the boy child sees his sexual difference from his mother). You will note that the female spectator got left out of this debate. It would take the work of the British feminists Laura Mulvey (1975) and Claire Johnston (1976) to take this debate further, closely followed by American feminists. But by the early 1970s the debate around the gaze had got as far as saying that at every film viewing there occurs a re-enactment of the boy-child's unconscious processes involved in the acquisition of sexual difference (mirror stage), of language (entry of the Symbolic) and of autonomous selfhood or subjectivity (entry into the Symbolic order and, thereby, the Law of the Father, and, consequently,

rupture with the mother as object of identification). Thus the spectator is constructed as subject, derives visual pleasure from seeing his self as having an identity separate from his mother, and – aligned with his father whose patriarchal law he has entered – he can now derive sexual pleasure in looking at the (m)other; that is, woman – the female (m)other. (For greater detail see **Imaginary/Symbolic** entry.)

It is not difficult to see that Oedipal desire is indeed a male reality (as opposed to fantasy). In fact, Bellour (1975) particularly draws attention to the notion of male representation or characterization in cinema as a reiteration of the Oedipus story (see Oedipal trajectory). Cinema actively encourages Oedipal desire. Hollywood's great subject is heterosexuality, the plot resolution 'requires' the heterosexual couple formation. Cinematic practices, then, are a perfect simile for Oedipal desire in that their looking-relations structure woman as object and man as subject of desire. In so far as the exchange of looks is concerned, in dominant cinema, it comes from three directions - all of which are 'naturally' assumed as male. First, there is the pro-filmic event - the look of the camera, with behind it the cameraman (sic). Then there is the diegetic gaze: the man gazing at the woman, a gaze she may return but is not able to act upon (see agency). Finally there is the spectator's gaze which imitates the other two looks. The spectator is positioned as the camera's eye and also, because as spectator he (sic) is subject of the gaze, as the eye of the beholding male on screen. A nice naturalizing of Oedipal desire if ever there was one!

Small wonder feminists took up this concept of the gaze and submitted it to some more rigour. As E. Ann Kaplan (1983, 30) says: 'Dominant Hollywood cinema . . . is constructed according to the unconscious of patriarchy; film **narratives** are organized by means of a male-based language and discourse which parallels the language of the unconscious'. And it is for this reason that she makes such a strong plea for feminists not to reject psychoanalysis as a male construct, which it is, but to examine it and by exploring it learn how to counter its effects. The first step was to expose the naturalization of the triple position of the look. Laura Mulvey's vital and deliberately polemical article 'Visual Pleasure and Narrative Cinema' (1975) started the debate by demonstrating the domination of the male gaze, within and without the screen, at the expense of the woman's; so much so that the female spectator had little to gaze upon or identify

with (for greater detail, see **scopophilia** and **spectatorship**). The exchange or relay of looks (as it is also known) within film reproduces the **voyeuristic** pleasure of the cinematic apparatus, with all that that connotes of the male child viewing, unseen, his parents copulating (what in psychoanalytic terms is called the primal scene). Visual pleasure equals sexual pleasure, yes, but for the male.

Kaplan (1983) asks 'Is the gaze male?' She comes up with an answer that opens a door for readings against the grain, for readings that do not necessarily show the woman as object of the gaze. While conceding that in mainstream Hollywood cinema it is men on the whole who can act on the desiring gaze, she none the less makes the point that to own and activate the gaze is to be in the 'masculine' position, that is to be dominant. She then goes on to argue that both men and women can adopt dominant or submissive roles. But of course this does not mean any real change, the same binary opposition (masculine/feminine) is still in place. And as Linda Williams (1984) cautions 'When the Woman Looks' (that is, becomes 'dominant') she usually pays for it, often with her life. 'The woman's gaze is punished . . . by narrative processes that transform curiosity and desire into masochistic fantasy' (1984, 85). So this ability to switch roles is not necessarily fortunate - it is even potentially

Having recognized the existence of the dominance/submission structure, the next stage, Kaplan (1983) argues, is to question why it is there. What need, whose need does it fulfil? If cinema does mimic the unconscious, then it must reflect what is repressed – latent fears around sexuality and sexual difference. It is for this reason that she advocates investigating film through psychoanalytic methodology as a first step towards 'understanding our socialization in patriarchy' (1984, 34). It is here that the readings against the grain become possible. By exposing how woman is constructed cinematically, this reading refuses to accept the normalizing or naturalizing process of patriarchal socialization.

For further detail see feminist film theory, see also Kaplan, 1997.

gender (see also feminist film theory, Oedipal trajectory, sexuality, stereotypes, subject/subjectivity) Gender has a socio-cultural origin that is ideological in purpose and must be seen as quite distinct from the notions of biological sex and sexuality. Part of

the ideological function of gender has been to dissimulate this difference and to see sex and gender as the same. This in turn, as we shall see, makes possible numerous slippages, including the notion of a fixed sexuality. The ideological function of gender 'has been to set up a heterogeneous and determinate set of biological, physical, social, psychological and psychic constructs as a unitary, fixed and unproblematic attribute of human subjectivity' (Kuhn, 1985, 52, my emphasis). The ideological function of gender is to fix us as either male or female and is the first in a series of binary oppositions that serve to construct us as male or female. As Kuhn points out, these binary oppositions are socially, psychologically, physically and biologically grounded. Thus the female is economically inferior to the male, is associated more with the domestic than the public sphere, is more emotional, less strong than the male. She is the site of reproduction and not production which is the male domain, and so on. It is clear how this essentialist approach (woman is this/man is that) fixes gender and leads to a naturalizing of gender difference (we accept it as 'natural').

During the 1980s, feminist critics marshalled gender relations into the centre of the debate around sexuality. In so doing they sought to problematize gender relations which up until then had not been considered as problematic. In western culture, masculinity had not been seen by men as determined by gender relations. It was free from such considerations, natural and therefore unproblematic. In language, the masculine is the linguistic norm and the female is defined in relation to it (for example, actor/actress). During the 1970s the focus of feminist thinking had been on issues of femininity. But it became clear that, in order to challenge any essentialist reading of the female, gender relations would have to come under scrutiny. Femininity could not be seen in isolation but as part of other categories of difference starting with the vexed issue of gender difference. This, in turn, would finally place scrutiny of masculinity on the agenda.

There are, arguably, two dominant debates surrounding gender relations, both of which found a voice first within feminist theory, and subsequently within cultural studies, gay studies, literary and film theory. These debates are rooted in **psychoanalysis** and Marxist materialism. Both debates have contributed significantly in moving the whole question of gender relations into wider arenas and in so doing have helped, rather than hindered, an understanding of how gender is not a simple case

of sexual difference as ideology would have us believe, but a series of hierarchical power relations cleverly disguised so as to hide the way in which gender is imposed by force. Furthermore, these debates have shown the importance of historical and social processes with regard to gender relations and have stressed the way in which they can occlude other forms of social determination such as race, **class** and sexuality. These debates have examined how cultural practices reproduce gender ideology and have demonstrated the importance of understanding how the inscription of gender and renditions of sexual difference operate in dominant culture. To understand the construction of gender and how gender ideology functions are vital first steps to countering them, to the uncovering of alternative readings (see **ideology**).

The psychoanalytic debate draws largely on Jacques Lacan's rooting of subjectivity in language (see Imaginary/Symbolic). The child, in order to complete its socio-sexual trajectory, must move from the Imaginary illusion of unity with the self and desire of the mother into the Symbolic Order. This order is the patriarchal order and represents social stability, and is governed by the Law of the Father. The father prohibits his son from incest with the mother and the male child obeys for fear of castration by the father. This order, then, is also determined as phallic since sexual difference is marked by the possession or lack of a penis. This approach shows how patriarchal language serves to perpetuate gendered subjectivity and how it is hierarchically deterministic. The male is fixed in language as 'he', but he is also subject of that language since, in entering the Symbolic Order, he joins ranks with his father to perpetuate the Law of the Father. Conversely, the female in entering the Symbolic Order is fixed by language as 'she'. But because she is not of the patriarchal language she is not subject but object. This approach, then, makes it possible to see how sexual relations are rooted in power relations that are linguistically based and as such does expose the ideological functions of gender relations. It does not go far enough, however, for two reasons. First, it smacks of a self-fulfilling essentialism: 'it will always be like this'. Thus psychoanalysis explains subject construction and so to a degree sanctions it. Second, if it does show a way to challenge gender ideology it assumes that it will take place at the level of language. But this is to ignore the other forms of social determination such as history, class and race.

This was the objection of the Marxist materialists. And it is their debate that has served both to balance the psychoanalytical approach and to broaden further the frame of investigation. They see gender ideology as a social and cultural construction that attempts to construct gender upon purely binary lines. The notion of a fixed and gendered subjectivity becomes impossible as a concept, they argue, since it assumes that only one category of difference exists: masculinity and femininity. The impossibility of such an ideological stance becomes clear if one considers that power relations also affect gender relations. Because masculine is the linguistic norm, a first hierarchy imposes itself. In the western world we live not only in a patriarchal world but also a homosocial world. Power is invested in the masculine and, in order for it to stay there, men bond (the political and economic establishment, military forces, just to mention two obvious instances). Why is there such a prevalence of homophobia in society if it does not be peak this desire to conceal that we live in a homosocial environment? And how far removed is the homosocial relation from the homoerotic one? Racial and class difference are other categories that gender ideology seeks to dissimulate. Why otherwise the prurience with the potency of the Black male or the working-class hero? They are perceived first as their sex and sexuality.

This fixing of a gendered subjectivity attempts to disguise the fact that gender is not as stable as ideology would have it. And it is here that we understand why gender ideology seems so necessary to the safe functioning of a patriarchal world. Gender is constructed not just through language but through social ascriptions and cultural practice. Thus, gender ideology is represented in a variety of cultural practices: literature, mass media, cinema and so on. However, it is the examination of the inscriptions of gender into cultural practices that allows not only for a deconstruction of gender ideology to take place but also for other differences to emerge. Where to situate cross-dressing, transsexualism and transvestism if gender is so fixed? What to do with lesbians and gay men? What about masquerade and metaphorical transvestism? The sexual subject or subjectivity here is 'defined' in terms of either otherness (transvestism, etc.) or sameness (homosexuality, etc.) but not difference. Clearly, the binary oppositions start to collapse under such questions.

A film which poses these questions and remarkably exposes the problems inherent in gender ideology is Neil Jordan's *The*

Crying Game (1992). Here no sexual identity is fixed. A Black soldier, Jody, posted in Northern Ireland, falls into an IRA trap by letting a woman seduce him. Taken captive, he shows a photograph of his lover, Dil, to his captor, Fergus, with whom he has established a rapport. His lover, also Black, lives in London and works as a hairdresser. After Jody dies, Fergus, who is on the run from his IRA masters, goes to London and seeks her out. He goes to the salon where she works and has her cut his hair. He has already changed his name to Jimmy so the haircut completes the disguise. He is immediately attracted to Dil. However, Dil is a transvestite. But her/his cross-dressing is so successful that she/he dupes all, including Fergus/Jimmy. Only when their relationship gets to the point of making love does Jimmy 'discover the truth'. At first he is horrified and runs away. But Dil seeks him out and their relationship resumes. The IRA masters are closing in on Jimmy, but they also 'know' about his relationship with Dil so her life is in danger. In order to save her, Jimmy disguises Dil into a slimmer version of her/his dead lover Jody by cutting her hair and making her dress in Jody's cricket whites (!).

The point here is that no sexuality, no gender identity is fixed. Jody, it now transpires, was bisexual – the name Jody itself is sexually unidentifiable. Dil (an equally ungendered name) can assume any gender and so is completely unfixable. All is in a fair state of flux. Indeed, the mirroring of the double disguise of Fergus/Jimmy and Dil/Jody makes this point clear. Fergus, until meeting Dil, thought of himself as heterosexual. His attraction to Dil changes his perceptions of his identity. When he transforms Dil into Jody he assumes Dil's earlier role when she completed his disguise as Jimmy. All sorts of levels of play around Fergus/Jimmy's sexuality are encoded into this: metaphorical transvestism (becoming 'Dil'), homoeroticism (fabricating 'Jody'), homosexuality (loving Dil).

Mainstream cinema does not function, however, to undermine dominant ideology. Quite the reverse. But this does not mean that its own functioning as an ideological apparatus cannot be unpicked nor that alternative readings to the preferred reading cannot be given. Conventional signs of gender fixity can come under scrutiny. Lighting and colour are but two primary and evident areas for this scrutiny. Lighting, particularly with black and white films, was used differently for male and female stars to point to their gender difference and to a set

of binary oppositions. The use of back-lighting to give the heroine a halo effect and front-lighting to bring out the whiteness of her skin was intended to point to the virginal and pure nature of American womanhood. It was used also to point to her fragility when contrasted with the deliberately contrastive lighting used for the hero. This lighting brought out his handsome dark looks, pointing to his strength and manliness. Colour is also used to point to gender difference. Indeed, since the introduction of colour it is noteworthy how the female and male protagonists are shot differently. As Neale (1985, 152) makes clear, colour is used to signify woman's look-at-able-ness, woman as the 'source of the spectacle of colour'. And since the advent of colour there has been an even greater emphasis on the fragmentation of the female body (Turner, 1988, 81). Other conventions play into this strategy of gender differentiation. Thus mise-en-scène, the iconography of the image, gesturality in performance styles, the function of the gaze, just as much as lighting and colour, are also conventions at the service of gender ideology that can be questioned. Clearly, if these can be questioned then so too can the idea of a fixed gendered spectator (see spectator).

By way of illustrating this notion of questioning, let us take a fairly extreme example, that of cross-dressing. As we shall see, the function of cross-dressing in mainstream cinema can be critically examined in the light of the debates around gender. For a start, why is it that we must not be allowed to be completely duped by cross-dressing? Why in the film Tootsie (Sydney Pollack, 1982) must we always be aware of the phallus under Tootsie's dress? How come neither Jack Lemmon nor Tony Curtis is allowed to convince fully as a woman in Some Like it Hot (Billy Wilder, 1959)? In other words, why is it that male sexuality must not be completely repressed? What occurs to women who cross-dress? Annette Kuhn's brilliant essay on cross-dressing (1985, 48-73) addresses these questions and provides some illuminating answers. Cross-dressing, she argues, foregrounds the performance aspect of dress and problematizes gender identity and sexual difference (1985, 49). Clothing as performance threatens to undermine the ideological fixity of the human subject: change your clothes and you change your sex (1985, 53). Cross-dressing plays with the distance between the outer-clothed self (gendered clothing) and the self underneath (the gendered body). Thus sexual disguise plays on gender fixity, makes it possible to think about it as fluid (1985, 56). With its potential to denaturalize sexual difference (1985, 55), it is small wonder that cross-dressing is so contained in mainstream cinema. Thus we are always in the know. We derive pleasure from knowing/not-knowing: we know it is a masquerade but we do not know if or how it will be found out (see naturalizing).

It is probably because of its potential to threaten ideological fixity that for the most part cross-dressing occurs only in comedies or musicals (genres that operate in fairly asexual and unrealistic spaces). Given that Hollywood is obsessed with selling gender difference and particularly heterosexuality, it is naturally wary of destabilizing cultural stability. Not surprisingly, then, cross-dressed women for the most part have to suppress desire, or suspend it until their 'true identity' comes out. Not so the male cross-dresser. He can make clear his desire for the woman - indeed it is an essential ingredient to the comedy. What this tells us is that 'lesbianism', as evinced by a male crossdresser attracted to a woman, is safe. The joke is at the lesbian's expense - because the cross-dresser is so evidently straight. If, however, he is not straight, he threatens the status quo - and for this reason is unlikely to be seen in mainstream cinema (compare for example Tootsie with The Kiss of the Spiderwoman, Hector Babenco, 1985). A female cross-dresser must suppress her sexuality if she wants to occupy a central position. No other comportment can be countenanced, otherwise she implicitly masquerades as homosexual - which as we have already discussed is one of the greatest taboos of all, and is no position for a woman to play with. To make this cross-dressing completely safe, even though she is cross-dressed, the male protagonist continues to probe and seek to assure himself of her sex. Unlike the male cross-dresser whose disguise within the diegesis is taken as a given, the female cross-dresser's disguise then is not. In either case, male or female cross-dresser, it is not genderbending but gender-pastiche that is on offer.

For further reading, see De Lauretis, 1989; Showalter, 1989; Butler, 1990; Tasker, 1993; Dines & Hurnez, 1995; Kirkham & Thumin, 1995.

genre/sub-genre (see also **specific genres**) As a term genre goes back to earliest cinema and was seen as a way of organizing films according to type. But it was not until the late 1960s that genre was introduced as a key concept into Anglo-Saxon film

theory, even though the French critic André Bazin was already talking of it in the 1950s with reference to the **western**. The debate around genre at that time served to displace the earlier debate around **auteur theory** – even though, in more recent times, genre and auteur theory have become reconciled.

Genre is more than mere generic cataloguing. As Neale (1990, 46 and 48) points out, genre does not refer just to film type but to spectator expectation and hypothesis (speculation as to how the film will end). It also refers to the role of specific institutional discourses that feed into and form generic structures. In other words, genre must be seen also as part of a tripartite process of production, marketing (including distribution and exhibition) and consumption. Generic marketing includes posters, souvenirs, film press releases, hyperbolic statements: 'the greatest war movie ever!' - all the different discourses of 'hype' that surround the launching of a film product on to the market (think of the tremendous marketing strategy surrounding Jurassic Park, Steven Spielberg, 1993). Consumption refers not only to audience practices but also to practices of critics and reviewers. Clearly, genres are not static, they evolve with the times, even disappear. Generic conventions as much as genres themselves 'evolve', become transformed for economic, technological and consumption reasons. Thus, genres are paradoxically placed as simultaneously conservative and innovative in so far as they respond to expectations that are industry- and audience-based. In terms of the industry, they repeat generic formulas that 'work' and yet introduce new technologies that shift and modernize generic conventions. This same paradox holds true for audiences with their expectations of familiarity as well as change and innovation.

Some general principles Neale (1990, 63) remarks that the term genre is a fairly recent one at least in its reference to popular mass entertainment. Prior to the nineteenth century it was literature or high art that was generic. But with the impact in the late 1800s of new technologies which made popular entertainment more accessible, the position has reversed. The need to commodify mass culture and target different sectors of the public has meant that it is now popular culture that is generic.

Genre is seemingly an unproblematic concept, but this is not the case. And this is particularly evident with film. First, because generally speaking a film is rarely generically pure. This is not surprising if we consider film's heritage which is derivative of other forms of entertainment (vaudeville, music-hall, theatre, photography, the novel and so on). As Neale says (1990, 62) film constantly refers to itself as a cross-media generic formation. Thus, a clear generic definition cannot immediately be imposed on a film even if a genre can be defined by a set of codes and conventions (as in, say, our expectations of a road movie or a musical). But, because genres themselves are not static and because, as we have just mentioned, they are composed of several intertexts, they are, of course, mutable (see intertexts). They rework, extend and transform the norms that codify them (Neale, 1990, 58). As we shall see, attempts at straitjacketing a genre are virtually impossible. Neale (1990, 58) offers a term that helps to clarify this problem when he refers to 'genre texts' which could be seen as distinct from genre itself. Genre would stand for the generic norms and genre texts for the actual film products. In a similar drive for clarity Alan Williams (quoted in Neale, 1990, 62) speaks of 'principal genres' to refer to what he sees as the three main categories of film: narrative film. avant-garde film and documentary. He reserves the term 'sub-genres' to refer to what we term film genres.

A second problematizing factor is that genres also produce sub-genres, so again clarity is proscribed. For example, subgenres of the war movie are Resistance films, certain colonial films, prisoner of war films, spy films (most of which cross boundaries with the thriller film genre) and so on. A third factor is that a genre cannot be seen as discrete and ideologically pure (see ideology). As Robin Wood (1992, 478) makes clear, genres are not 'safe' but are ideologically inflected. Ideological inflections within film genre find representation through a series of binary oppositions which, among other hegemonic 'realities', reinforce gender distinctions. For example, constructs of sexuality are based around images of the active male versus the passive female, independence versus entrapment (that is, marriage and family). Sexuality is constructed also as good/bad, pure/perverse. Furthermore, these are attributes which are most commonly attached to women - thus reinforcing the virgin/whore myth of woman. Constructs of society, beyond heterosexuality and the 'desirability' of marriage and reproduction, posit the evils of city versus rural or small town life, the work ethic and capitalism versus fraudulent attempts to get rich quick (that is, good capitalism versus bad capitalism).

Although it is important to be aware of the ideological function of a genre, it is equally important to be aware of the dangers

of reductionism inherent in an ideological approach to genre. As we shall make clear in the next section, genres are inflected as much by the capitalist imperatives of the film industry as they are by audience preference and the socio-historical realities of any given period. And, as we have already mentioned, genres evolve and change over the years, some even disappear. This would indicate, as Leo Baudry (1992, 431) believes, that genre serves as a barometer of the social and cultural concerns of cinema-going audiences. Genres have codes and conventions with which the audience is as familiar as the director (if not more so). Therefore, some genre films 'fail' because the audience feels that they have not adhered to their generic conventions sufficiently or because they are out of touch with contemporary times - see what has happened to the epic. Alternatively, the nonconformity of a film to its generic conventions can lead an audience to make it into a cult film. Film genre, therefore, is not as conservative a concept as might at first appear: it can switch, change, be imbricated (an overlapping of genres), subverted. Indeed, in terms of product, genre films do get parodied (Mel Brooks's Blazing Saddles, 1974, for example). And also, films are read against the grain by spectators.

Some approaches: structuralism, economies of desire and history Mention was made at the beginning of this entry of the genre debate displacing the **auteur** debate. You will note from the auteur entry, however, that the auteur debate did not disappear. Indeed, it went through several phases, much like the genre debate itself. Gledhill (in Cook, 1985, 58–68) gives a superb synopsis of the debates so I will make only brief mention of the impact of the structuralist debate on genre theory (see **structuralism**). This debate made two things possible. First, it relocated genre in a much wider set of structures (after it had been through the 'total structure' rites of passage in the 1970s). Second, it reconciled the auteur/genre debates and dissipated the misconception that the two concepts are mutually exclusive.

Until the late 1960s genre had been considered only in terms of codes and conventions and as a system for codifying films. However, it is easy to perceive why such a reading of genre made it a prime site for **structuralist** practice. Metz (1975) argued that genres go through a cycle of changes: 'a classic stage, to a self-parody of the classics, to a period where films contest the proposition that they are part of a genre, and finally to a critique of the genre itself' (Turner, 1988, 86). Although not all genres

necessarily follow this dynamic, some do seem to (for example, the western). Most helpful in examining the dynamic nature of genre, however, was the application to genre of Vladimir Propp's description of the narrative as a set of oppositions. An analysis, over a period of time, of the structure of a genre through a set of oppositions made it possible to see where change had taken place - even to the point of being able to discern where inversion occurred. The classic example of this Proppian approach is Wright's (1975) investigation of the western. Wright demonstrates how a first set of oppositions established in the classic western evolves over time so that in more recent westerns there is a completely inverted set of oppositions. For example, what was valued in the earlier western was civilization and strong socialization. It was the hero's function to ensure that those outside society, the bad, weak-willed villains, remained out in the wilderness. Having saved a situation, the hero might well move on, but society and order had been made secure and were seen to be good - so the hero has upheld the values of civil society. In later westerns, the hero is no longer inside society as an upholder of civilization. Rather, civilization is now seen as corrupt and weak. And it is the villains who now live inside society, the hero outside, in the wilderness.

Wright makes the point also that these changes reflect social change and audience expectations. Thus, for example, Butch Cassidy and the Sundance Kid (George Roy Hill, 1969) says much about the young generation of that time and their desire to be free and on the road. Wright's analysis serves, usefully, to make the point that genres are less about ritual than we might at first believe. As Neale (1990, 58) puts it, conventions of a genre 'are always in play rather than being, simply, re-played'. Moreover, since genres are about spectator-text relations as well as sociohistoric relations, it becomes evident that genre must be discussed in relation to the numerous structures that serve not to fix it but to sustain it. The value of structuralism in relation to genre history is, then, that it broke the hold auteurism had on critical thinking about film and showed how structures other than that of the auteur had to be taken into consideration in so far as the production of meaning was concerned.

In an earlier informative essay on genre, Neale (1980, 19) argues that genres are a fundamental part of cinema's machinery. The cinema machinery or **apparatus** regulates the different orders of **subjectivity** including that of the spectator (1980,

19). This means that a genre, just like the apparatus of which it is a part, becomes part of a system that regulates desire, memory and expectation (1980, 55). Neale draws a useful conclusion on the strategies that genres fulfil in relation to the economies of desire (1980, 55). First, genres operate over a series of textual typologies (that is, **war movies**, **westerns**, etc.), what Neale calls 'instances', and so offer the possibility of regulating desire over a determined number of genre texts (that is, there are only so many textual instances possible). In this way they help the industry to control demand and, therefore, production. Second, genres contain the possibilities of reading. That is, generic codes and conventions give a **preferred reading**, thus regulating memory and expectation. This provides the industry with the wherewithal to control 'the effects that its products produce' (1980, 55).

The idea of generic limitation is clear enough: we can actually see how that worked during the heyday of the studio system when studios specialized in the production of certain genres and not others - in other words, economies of scale dictated that their production machine was geared to specific output. The second point needs further clarification and can best be explained in relation to four essential component parts of genre: technology, narrative, iconography and stars. Genres exhibit the technology of cinema. Depending on the genre, different aspects of cinema's technology are put on display. For example, colour and cinemascope or wide screen are important technological devices for the western; science fiction requires special effects. Not to use them could be to frustrate spectator expectations and therefore not to regulate desire. Indeed the voyeuristic and fetishistic (see voyeurism/fetishism) nature of film technology the camera as probe and as container of the image - makes possible the fusion of desire and technology into an eroticization of technology (for example, Stanley Kubrick's 2001: A Space Odyssey, 1968; David Cronenberg's Dead Ringers, 1988). Genres also act as vehicles for stars. But stars, too, act as vehicles for genres. As we know, narrative structures and iconography are two functions whereby the audience recognizes the genre. Thus, the star becomes the site of generic enunciation - that is, the star now becomes a vehicle for the genre. In this light, genres are the discursive or narrative site in which the star can exhibit her/his potential to fulfil the demands, codes and conventions of a particular genre and perhaps even surpass them (take any Robert De Niro film as an example). Genres are also the iconographic site in which the star can display the body, or have it displayed. On these two counts (narrative and iconography), memory, expectation and desire are all activated within the spectator and regulated by the strategies of performance: we recall the genre and the star and we expect certain things of them and are gratified.

Genres refer to others of their own type and so are both inter-referential and intertextual. This means also that they are inscribed in history. The latest western refers back generically to the other westerns made since the very first one. But there are also social motivations behind the making of a genre: why do westerns or gangster movies exist? what needs do they fulfil? So genres are therefore motivated by history and society even though they are not simple reflectors of society (Neale, 1980, 16). For example the Cold War films of the 1950s made on both sides of the 'Iron Curtain' were an attempt to allay fears of insecurity in the face of technological advancement (atomic bombs, space exploration), and to vindicate the merits of either western or eastern block ideologies (capitalism and communism). Film noir, as a sub-genre of the thriller, had its heyday in the 1940s, a time when the United States was at war and immediately afterwards. During that time, the role of women had fundamentally changed. They were now at work, part of the social and public sphere. But what of 'their men' over 'there' fighting? What could they expect to find once they got 'home'? Home, the United States, was no longer the safe patriarchal regime they had left behind them. Nor did peace hold much promise given the apparent threat of communism. Film noir, viewed in this light, has been seen as an expression of male insecurity in the face of social change and a growing disillusionment with the lasting efficacy of peace. Genre can be identified by the iconography and conventions operating within it. But genre is also a shifting and slippery term so it is never fixed and, as we have seen, what makes genre have meaning is constantly changing.

For further reading see Altman, 1999; Grant, 1986 and 1995; Grodal, 1997; Schatz, 1981.

German expressionism (see also modernism and horror) A term used to refer within cinema studies to a particular filmic style

which emerged in Germany during the years 1919-24 and which is associated with a period in world cinema history - that of Weimar Germany's cinema of the 1920s. German expressionism has been applied to cinema by analogy with the preoccupations of the expressionist movement in modern art of the early part of the twentieth century whose aim was to convey the force of human emotion and sexuality. The word expressionism means 'squeezing out', thus making the true essence of things and people emerge into a visible form. Its themes are revolt, selfanalysis, madness, and primitive, sexual savagery (Courthion, 1968, 7-9). A deliberately anti-bourgeois aesthetic movement, its precursors number, among others, Edward Munch (The Scream being arguably the emblematic painting of expressionism) and Vincent Van Gogh. The expressionist movement was famous for its crudely painted forms and vibrant colours (landscapes, figures and still lives). Expressionism (whose history loosely spans some thirty years, 1900-30) was primarily the work of artists from northern and central Europe (Austria, Germany, Scandinavia and Switzerland) and its exponents came primarily from two main groups of artists: the Blaue Reiter (based in Munich) and the Brücke group (based in Dresden) which was founded in 1905 and disbanded in 1913. Many, indeed some of the greatest, exponents of expressionism were not part of these groups but solitary painters. Artists of that movement who are most renowned today include Wassilv Kandinsky, Gustav Klimt, Egon Schiele and Chaim Soutine.

In its reaction to bourgeois aesthetics, through its rejection of realist modes of representation, expressionism can be qualified as a modernist movement. In its preoccupation with sexuality and emotional uncertainty it stands as a movement that does not necessarily embrace the optimism of modernism, but looks rather at the psychological effects of this new age of technology on the invidivual. The impact of Freud and psychoanalysis particularly his work on hysteria - must not be ignored in this discussion of expressionism. Expressionism, in its attempts to display a metaphysics of the soul, mirrors to a degree the efforts in psychoanalysis to bring the workings of the unconscious to the fore, to the level of consciousness where the malaise or hysteria can be expressed. Expressionism was not limited to painting but was manifest in the literature, theatre and architecture (again primarily) of Scandinavian and German-speaking countries and spread from these domains into cinema in terms

of narrative, set, and mise-en-scène. Indeed, expressionistic architecture with its strange and distorted structures found its major outlet in theatre and film sets - the economics of the time were not in a position to permit experimentation on real buildings (Silberman, 1996, 307). The impact on cinema of the famed Max Reinhardt theatre in Berlin - especially Reinhardt's theatre work of the period 1907-19 - can be read as emblematic of this cross-fertilization process between different cultural arenas. Several of the main film actors associated with German expressionistic film came from his troupe (Conrad Veidt, Werner Krauss and Emil Jannings, to name the most remembered today). Furthermore, Reinhardt's use of expressionist sets and highcontrast chiaroscuro lighting were later to become two of the major mise-en-scène strategies of German expressionist film. It should be added, of course, that German expressionism's famed predilection for chiaroscuro (the use of highly contrastive lighting, literally light and dark) which is already in evidence in German films of the 1910s, was undoubtedly due in part to the influence of Danish cinema lighting practices of that time.

The German expressionist film movement emerged for several conjunctural reasons. Critics of different generations have read different things into this movement. Some have seen it as reflecting a German mentality on the brink of madness, obsessed with death and fatality and ready to encompass fascism (Kracauer, 1992, and to some extent Eisner, 1969). Others have seen these films as an attempt to escape, even into horror, from the dreadful effects of the economic crisis and inflation (Manvell and Fraenkel, 1971). More recently, this movement has been relativized within a broader context of German film production and seen as more of a continuation of pre-war film traditions than a new departure (Elsaesser, 1996, 143; although Eisner also hints at this, 1969, 17).

In terms of context, post-World War One Germany was facing a period of terrible poverty and constant insecurity. The reprisals taken on the vanquished Germany by the implementation of the Versailles Treaty, in the form of heavy reparation payments, were such that the period 1918–24 was one of civil strife and staggering inflation. Thus, this nation, which had (like its enemies) suffered terrible losses on the battlefields, lost its empire (its colonies became mandates of the League of Nations) and, in the early post-war year of 1919 faced civilian deaths of three quarters of a million from malnutrition. Insecurity took the form

of political instability as well as fears on the part of the Weimar Republic and its ruling government (1919–33) of what was perceived as the communist threat. Nor was Weimar Germany itself exempt from accusations of corruption and decadence, despite the fact that the 1920s was a period associated with 'Expressionism, Weimar culture and a time when Berlin was the cultural centre of Europe' (Elsaesser, 1996, 136).

Berlin might well have become the cultural capital of Europe in the 1920s, but it was also perceived as the capital of decadence primarily because the pre-war 'strictures in morality and social convention were thrown aside by the young' (Manvell and Fraenkel, 1971, 13), censorship was abolished (albeit briefly: 1918–20), politically there were pockets of communist activity and, finally, sexualities of all types had emerged onto the civic scene. Berlin was red and it was hot. But economically speaking it was a city of crashed markets and rampant poverty. It was, then, a city of huge contrasts and paradoxes. To this effect, German expressionist film could be said to reflect the mood of the times.

The thematic preoccupations of pre-war cinema – which had shown such a fascination with the trappings of modernity through its representation of the modern city and its technologies, mostly associated with speed and the motor car, trains and telephones (particularly in crime and detective films) – were not replaced by post-war cinema as such, but were given a darker treatment in films associated with German expressionism. Fascination with modernity was replaced with a representation of its dehumanizing effects (e.g., Lang's *Metropolis*, 1926). And the effects of the economic conditions on the metropolitan realities of Berlin are reflected in Lang's *Dr Mabuse*, the Gambler (1922), a sinister tale in which Mabuse acts as a cypher for the corruption and social chaos so much in evidence not just in Berlin but more generally, according to Lang, in Weimar Germany.

There is considerable debate as to whether German expressionism was in fact a film movement. For example, Thomas Elsaesser argues (1996, 141) that thematically and stylistically there were precedents in pre-war German cinema, particularly in the form of the fantastic films which exploited, among other literary trends, German Gothic-Romantic legend and fairy tales. The fantastic film was an important tradition in pre-war cinema associated primarily with the film-maker Paul Wegener (ibid.).

It was a tradition which married conservative content with experimental style. For Elsaesser, therefore, the German expressionist film movement was not a new departure but a tail end of the fantastic film tradition (ibid.). Manvell and Fraenkel (1971, 33) make the point that legendary costume films and costume dramas were far more prolific at the time than German expressionist films. What is clear is that German expressionism cannot be seen as standing for all of the so-called Golden Age of German cinema (1920–29) although its impact on the evolution or development of film style was quite significant. In real terms, German expressionist films were very much in the minority of film production during the 1920s (only ten or so have survived into the canon) and their existence has perhaps more to do with film industry practices than with necessarily a conscious aesthetic or film movement *per se*.

In the post-war years the move was to consolidate the German film industry and to rationalize it much along the lines of the Hollywood vertically integrated studio system. A major merger operation took place in 1917 combining larger production firms with smaller ones. This merger brought about the foundation of UFA (the Universum-Film Aktiengesellschaft). The German film industry became largely identified with UFA although some production companies managed to remain – albeit only for a short while - independent from UFA. One such company was Decla, headed by Erich Pommer. And, in a sense, it is thanks to him and his willingness to take a risk on something new that the 'first' so-called expressionist film, The Cabinet of Dr Caligari (1919) saw the light of day (although its Berlin première, according to Silberman (1996, 307), was 26 February 1920). It appeared to herald a new cinema. However, this film was part of a broader strategy put in place by Pommer at Decla. Namely, a production programme that was aimed more particularly at producing a cinema that was based, as Thomas Elsaesser (1996, 143) puts it, on 'a concept of product differentiation'. In any event this new cinema was one which was to last in reality for a short five-year period (1919-24). Thus, the expressionist film was one film style amongst others. For its part, in this age of consolidation, Decla merged with Bioskop in 1920 (becoming Decla-Bioskop) and subsequently with UFA in 1921 (although some film historians quote 1920) - Decla-Bioskop remained under the tutelage of Pommer who continued to produce expressionist films.

The German expressionist film is a highly stylized type of film. Hallmarks of this style are oblique camera angles, distorted bodies and shapes, bizarre and incongruous settings that are almost gothic in their look and framing. Lighting is similarly highly stylized in its use of heavy contrast between light and dark (known as chiaroscuro or high-contrast lighting) creating dramatic shadows. The subject matter is equally surreal and gothic and about unnatural acts or realities - a projection on screen of a character's subjective and often mad world. Marc Silberman (1996, 308-10) makes some interesting points in relation to the dynamic tension between setting and actorly style. The expressionist film focused on the formal issues of the image. mise-en-scène was abstract and primarily two dimensional. The lack of depth of the image contrasted with the 'obsessive interiority' of the acting - at least the acting of the central male protagonists. The actor's body, Silberman explains (ibid., 309), was a 'formal element within the mise-en-scène that could be coupled with or set off against other elements like set design'. At times, then, the body 'conforms to architectural lines' (ibid.) - as in the case of Cesare, the somnabulist in The Cabinet of Dr Caligari, and his movement along the walls, or Nosferatu's shadow ascending the stairs in Murnau's 1921 film of the same name. As such, set design, lighting and the body are all interrelated squeezings-out of a psychology. At other times, the actor's gestures can be mechanical and abrupt, 'creating a mechanical, artificial rhythm' (ibid.) - the evil Mephistopheles (played by Emil Jannings) of Murnau's Faust (1926) is the embodiment of this type of deliberately contrastive dramatic and explosive acting.

In German expressionist films, then, the actor's body is as much a producer of meaning as the mise-en-scène. But, as Silberman argues (ibid., 310), the centrality of the body as 'the focus for the metaphysics of the image' was not a new tendency but one which owed its heritage to the *Autorenfilm* (the art film) of the early 1910s. What is also striking in these expressionist films is the contrast between the intensity and interiority of the angle and the limited camera action and sparse editing style. The camera is quite static, and editing is quite standard and basic. Silberman is right to make the point (ibid.) that as far as the concept of the modernity of the cinematic **apparatus** is concerned, expressionism effectively denied, or missed the opportunity of experimentation with the technology of the apparatus – at least until the process of editing known as **montage** (see entry on **editing**)

impacted on German cinema (by the mid-1920s). The later expressionist films (e.g., Murnau's *The Last Laugh*, 1924, and Lang's *Metropolis*, 1926) show a new approach to camera and editing practices. The camera is 'unchained' and has 'replaced the actor as producer of meaning' (ibid., 312) and fast, at times montage-style of editing reflects the modernity of the apparatus as a twentieth-century technological instrument of speed (ibid.).

The emblematic film of this movement was the film that 'launched' it, the Austrian Robert Wiene's The Cabinet of Dr Caligari. This horror film tells the story of the delusions of a young lunatic, Francis, whose perception of reality we are treated to until the very final twist at the end of the film when we discover that he is the madman not Dr Caligari. According to Francis's version of reality, Dr Caligari is a mad and sinister doctor who wants to display his somnambulist Cesare (played by Conrad Veidt, the fetish star of this movement) at the local fair. Display, however, is not his real motive, or so Francis would have us believe. The doctor's secret, hidden motive is to exploit the sleepwalking Cesare to carry out the murders of people who thwart his, the doctor's, desires. The film ends with us discovering that Francis is the true lunatic and that what we have just witnessed is no more than his delusions for which he is now receiving treatment from the doctor he believed to be Doctor Caligari.

Although the look of the film is definitely expressionistic (the sets were painted and designed by the expressionist artists Hermann Warm, Walter Reiman and Walter Röhrig), in terms of the narrative, with its themes of death, tyranny, fate and disorder, this film continues the long line of German romanticism (as exemplified by the Brothers Grimm and Friedrich Schiller) and can also be seen as a film following in the fantastic tradition established by Paul Wegener before the 1914-18 war (Elsaesser, 1996, 141). As we recall, the expressionist movement itself was deliberately anti-romantic and anti-naturalist in its focus. So it could be argued that while the film is stylistically expressionistic it is not so thematically. The final outcome of the film is fairly estranged from the expressionist ideal as well. The submission by the youth (the son) to the all-knowing paternalistic doctor suggests a quite conservative reading, one which advocates obedience to a strong authoritarian figure (Murray, 1990, 26-7). However, in that the film appears to be a psychological outpouring of Francis' sexual repressions (through his expression of an imagined and distorted world view), it is close to the expressionistic practice of squeezing out the inner self. (It is worth reading Kracauer's (1992, 21–33) account of the making of this film and that of Manvell and Fraenkel (1971, 17–18) since the original script, by Carl Mayer and Hans Janowitz, was far more radical and politicized.)

Whatever our reading of it now, at the time of its release, The Cabinet of Dr Caligari met with huge international success particularly in France and the USA. The German film industry imagined that it could impose itself on the international scene by capitalizing on this success. Decla-Bioskop was absorbed into UFA by 1920-1 and this major conglomerate, with the help of Erich Pommer as Head of Production, set about producing expressionist films that would export well. Fritz Lang's Destiny (1921) and Dr Mabuse, the Gambler as well as Friedrich Murnau's Nosferatu (1921) were hugely successful and allowed Germany to enter foreign markets in a way unknown before (the sale of just one of these films to one foreign country would finance the production of a new film). Added to this financial success story was the cultural respect these films obtained for a country that had lost a world war and with it a considerable international prestige. In this regard it is not possible to dissociate the German expressionist film from nationalistic values. So, once again, this movement strikes us as more conservative than perhaps its avantgarde experimental style would lead us to believe.

For a number of different reasons the fortunes of this movement soon waned and by 1924 it more or less came to an end although the style lived on for a while in a handful of films: Lang's *Metropolis* (1926) — which was a box-office failure — *M* (Lang, 1931) and Georg Pabst's *Kameradschaft* (1931). There were two major reasons for this movement's decline. The first was economic. The Mark had regained strength by 1923 and its stabilization meant that the former export trading advantage disappeared (Elsaesser, 1996, 144). The second had to do with the emigration of personnel, primarily to the United States who — either for political or professional reasons — went to Hollywood to work. Thus, Leni, Lubitsch, Murnau and Lang — to name but the most renowned — left Germany and took with them their own film-making practices which had considerable influence on Hollywood production styles particularly in relation to the horror film and **film noir**.

For further reading other than authors mentioned in the text see also Coates, 1991.

Germany/New German cinema A movement that came into forceful being by the early 1970s although its roots go back to the early 1960s when, inspired by the French New Wave and the Free British Cinema, twenty-six young film-makers and film critics signed the Oberhausen Manifesto in 1962. The manifesto declared its intention to create the new German feature film. It swore a death to the established film industry (*Papas Kino*, daddy's cinema) and promised the birth of a new cinema that would be international.

However, this new wave cinema was quite distinctly marked from its two sources of inspiration in that it was directly politically motivated as a movement. Indeed this film movement needs to be understood within its historical, political, economic and geographical moment. Officially, the movement spans twenty years 1962-82. Its 'death' being marked by the suicide of one of its major proponents, the film-maker Rainer Werner Fassbinder. However, such a date would exclude many films made during the 1980s that are clearly part of the New German Cinema ethos. Thus it might be better to say that by the mid-1980s three conjunctural moments did, in some respects, serve a semi death knell to this cinema. These were: the effect of television and, equally importantly, the conservative Kohl government which withdrew much of its financial support from this radical cinema, plus the departure of a number of the original and more renowned film-makers to work on the international production scene.

If we regard the movement as beginning in 1962, then in political terms, we must recall that in 1961 the Berlin Wall was erected, thus effectively signifying the already very real division of Germany into two parts. This New German cinema emanated from West Germany and, unlike films produced by the industry in East Germany, it was a cinema which attempted to come to terms with its nation's recent past, namely, the Nazi era. The cinema it was rejecting was that of the National Socialist film industry of the 1930s and 1940s, a cinema which still prevailed in the 1950s in the mainstream production with its highly popular provincial films (the so-called Heimat films - a genre which Edgar Reitz, in his 16-hour TV series Heimat, 1984, would subvert and reinscribe into a completely new meaning: a German political history told through the chronicle of provincial family life from the end of the First World War to 1982). The motivation of the New German cinema was to give a renewed credibility to

the cinematic **apparatus** and industry after the abuse it had received under Nazi rule (as a propaganda tool).

In economic terms, this new and resisting cinema emerged at the very moment when the industry was itself in decline due to a major drop in audience numbers thanks to the increased consumption of television sets. With the industry under threat it was easier for spaces to open up for a new type of cinema. This same phenomenon occurred in Britain and France with their new waves, although it was a much slower process. Moreover, with West Germany the reception of this new wave German cinema was by no means as enthusiastic as the initial reception of the French and British new waves in the two other countries. Indeed, German audiences showed very little interest in this new indigenous product. It was left to the French and American audiences to appreciate this new and strongly politicized cinema.

The names most famously associated with this movement, or perhaps it would be more appropriate to call it a collective of young, independent film-makers much in the auteur tradition, are those of Rainer Werner Fassbinder, Wim Wenders, Werner Herzog, Volker Schlöndorff, Hans Jürgen Syberberg, Alexander Kluge, and Jean-Marie Straub (a Frenchman living in Munich and who worked in close collaboration with Danièle Huillet, also French). And the fetish stars most commonly linked with these film-makers are Hanna Schygulla and Klaus Kinski. Kaes (1996, 616) distinguishes two phases in this cinema: the Young German Cinema of the 1960s and the New German Cinema of the 1970s. During the first phase, Alexander Kluge, a legalist by profession, was an effectual negotiator with the German government and successfully brought about the establishing of a film school at Ulm and an official fund (of 5 million marks) for the young German film-makers (the Kuratorium Junger Deutscher Film). The government appeared eager to fund a national cultural product and the collective only too ready to accept state subsidies. The established film industry, however, took a different view and lobbied the government to pass a Film Subsidy Law whereby films borrowing from the government would have to commit themselves to a return of at least halfa-million marks, effectively closing the door on this new movement's access to that form of state funding. Other forms of funding, at a federal level, came into play. So too did grants, prizes and awards which went part of the way to helping this

new cinema. By 1971, after several years of making short films and a few feature films under considerable hardship, some of the film-makers decided to take on board the distribution and international sales of their films. They formed the Authors' Film Publishers and were particularly successful in selling films outside West Germany (as it then was) but less so within the country.

Perhaps it was the subject matter of their films that deterred home audiences, because as Kaes (1996, 617) points out, the Young German Film 'was a cinema of resistance - against the mass-produced entertainment industry of the Nazi period and the 1950s, against the visual pleasure of lavish productions, and against the ideology of the economic miracle'. This new cinema strove for authentic documentary and its style was one of grainy realism. The films of the first phase, in the main, explored the fraught relationship of Germany to its past (Straub and Huillet's Machorka-Muff, 1962; Kluge's Yesterday Girl, 1966; Schlöndorff's Young Törless, 1966). Respectively, the themes dealt with in these films range from the continuing power wielded by the German military during the 1950s, the inescapability of one's past, and the conformity of intellectuals during the Nazi era (for further details see Kaes, 1996, 616-7). Films of the second phase continued to be socially and politically motivated and examined not just the German-speaking countries' recent past but also the contemporary scene. Fassbinder's Fear Eats the Soul (1974), Kluge's Strongman Ferdinand (1976) and the collectively directed Germany in Autumn (1978) take a hard look at contemporary Germany from the point of view, respectively, of racism, fascism and the state of the nation in general including political censorship. Herzog's films stand out as different within this movement in that they tend to be in the romantic tradition and historical in their settings (as with Aguirre, Wrath of God, 1972). In most of his films, Herzog blends documentary, ethnographic authenticity with a surrealistic vision to narrate the story of an individual who is either driven mad by his own aspirations to fulfil an impossible ambition or alienated by the society in which he finds himself. His films, often based on the real lives of historical personages, treat the extremes of colonialism - that is, racism and total disregard for otherness.

But that is not the whole story of this cinema. Also part of the New German cinema was an important group of women film-makers, mostly overlooked by histories of cinema – the exceptions being Thomas Elsaessser's book (1989), a special *Jump*

Cut issue (no. 2, 1982), and more recently Julia Knight's book (1992) and, finally, the two-volume edited Gender and German Cinema (Frieden et al., 1993). Some fifty-six women directors have contributed films (shorts, experimental video or feature length) to this movement. They, like their male counterparts, were mostly born after the Second World War and were in the 1960s part of the new generation of film-makers. If the male film-makers encountered difficulties with the establishment, at least not so many doors were closed to them as to the women. In the 1960s it was difficult for women to get into film schools and mostly, if they did get in, they received very little by way of technical training. Unlike their male counterparts, they did not 'burst onto the scene' in the 1960s. Perhaps it is their late start that has made them less 'noticeable' to film historians.

Primarily their output started in the 1970s - a significant date since their emergence coincided with the feminist movement in Germany (as elsewhere in the Western world) - a movement to which many were firmly committed. Exemplary of this commitment was the founding in 1974 by Helke Sander of the first and only European feminist film journal Frauen und Film (Women and Film). The journal's major objectives were to analyse the workings of patriarchal culture in cinema and to develop a woman's cinema and a feminist aesthetics. Among the women film-makers whom we can count as better known abroad we should include Jutta Bruckner, Margarethe von Trotta, Doris Dörrie, Helke Sander and Helma Sanders-Brahms, although obviously there are many others. The 1970s' films tended to focus on real-life issues such as abortion (illegal in West Germany), domestic violence, the myth of the economic miracle of the Adenauer era of the 1950s, working conditions and the possibilities of social change. Sabine Eckhard's Paragraph 218 and What We Have Against It (1976–7), Cristina Perincioli's The Power of Men is the Patience of Women (1978), Jutta Bruckner's Years of Hunger (1980) and Barbara Kasper's Equal Wages for Men and Women (1971) are, respectively, examples of these tendencies in the women's cinema in the 1970s. Later, in the 1980s, the tendency was to explore the issue of whether there is a feminine aesthetic and a different even disruptive, way of viewing the world (as in Ulrike Ottinger's The Mirror Image of Dorian Gray in the Yellow Press, 1984, or Helke Sander's The Trouble with Love, 1984). In any event, by the 1980s, West Germany, as Knight (1992, 13) points out, 'boasted a highly acclaimed women's

cinema and a vibrant feminist film culture as part of its new cinema', a point that negates the assumption made by film historians that the New German cinema died in 1982.

Women film-makers associated with New German cinema continue to practise their art within Germany. Many of their male counterparts have, however, left and relocated in the USA (either in Hollywood or New York). This contestatory cinema of resistance has not therefore died as such but has become very much a minority production within an already minority national cinema. Dorris Dörrie's *Happy Birthday Türke!* (1991) serves to remind us that there are still issues on the political agenda – such as the question of difference – that need voicing and constant vigilance. Thus the legacy of New German cinema lives on.

For further reading see Corrigan, 1983, Elsaesser, 1989; Kaes, 1996; Knight, 1992; Rentschler, 1988.

gesturality (see also stars) Stars are signs of indigenous cultural codes. Gestures, words, intonations, attitudes, postures - all of these separate one nation's stars from another's, thus affirming the plurality of the cultures. Indeed, it could be argued that the gestural codes, even more so than the narrative codes, are deeply rooted in a nation's culture - which is why some stars do not export well. Traditions of performance, then, have national as well as individual resonances and need to be borne in mind when analysing a star's performative style. Gesturality is also tied up with the question of authenticity. We expect certain rituals of performance from our stars, indeed the camera colludes with this process of recognition by giving us close-ups of the particular gesture that authenticates the star in question (the Garbo smile, the Bette Davis wringing of hands, the Clint Eastwood side-mouth delivery of the few lines he ever utters, and so on).

gothic horror - see horror

Hammer horror - see horror

Hays code (see also censorship) In 1922, the Motion Picture Producers and Distributors of America (MPPDA) was established. It quickly became more popularly known as the Hays Office - after the MPPDA's first president, Will H. Hays (1922-45). The MPPDA (later to become the Motion Picture Association of America) was established in response to public outrage at the sex scandals in Hollywood and the sexual contents of films. The MPPDA was a bulwark between state and federal governments on the one hand and the film industry on the other. Hays was politically powerful and had a strong moral reputation and his job was to prevent intervention and censorship being governmentally imposed. The MPPDA applied pressure on the film companies to control their stars and the content of their films - a form of self-censorship which more or less worked until 1930. In 1934, under renewed pressure from the general public (and the moral brigades), the MPPDA produced the Motion Picture Production Code which was to act as a guideline for the industry on taste and decency. However, by 1934 public reaction to the industry's products again became vociferous, particularly at the violence portrayed in gangster films, and so the production code became mandatory.

Hegemony (see also **ideology**) A concept devised by the Italian political thinker Antonio Gramsci to describe the winning of consent to unequal class relations. It is a more succinct term for the expression often used in its place: dominant ideology, which

within the western world, is taken to be a white, middle-class, male construct. That particular socio-economic group exercises leadership in such a way that the subordinate groups see that it is in the general interest to collude with that construct. The dominant groups (elites) make sense of the institutions through which they govern those not in power by showing that they (as elites) are but representatives of those institutions that govern us all. Thus they use consensual terms such as 'our government, our economy, our educational system'. Those who are subordinate to it, then, are not 'coerced' but their consent and collusion in being so dominated emanates from a desire to belong to a social-political-cultural system, to a nation - to have a sense of nationhood. Mainstream or dominant cinema functions consensually in its mediation of hegemonic values (the family, social mobility, etc.) and as such is inscribed within that hegemony. In its transparency on the class interests of the dominant group, cinema reveals them as 'natural', therefore unquestionable and desirable.

historical films/reconstructions (see also epics, genre, costume drama) Authenticity is the key term where historical films are concerned, at least in terms of the production practices. From setting, costumes, objects to use of colour (once it was finally introduced in 1952), every detail must appear authentic. Hence the very high costs of producing such films. The narrative focuses on a real event in the past, or the life of a real person. Often highly fictionalized, the historical film invests the moment or person with 'greatness'. 'Authenticity' serves a different purpose in this context. In this respect, historical films have an ideological function: they are serving up the country's national history before the eyes of the indigenous people, teaching us our history according to the 'great moments' and 'great men or women' in our collective past — our heritage on screen.

Hollywood (see also classic Hollywood cinema, studio system, stars) Known as the 'dream factory', Hollywood was originally an escape route from the controlling powers over film companies of the Eastern Trust (1909). The climate, the mountains and plains and low land prices of California made Hollywood an ideal and profitable place to set up film studios. Huge studios were built in the Hollywood neighbourhood as well as extravagant

mansions for the stars in nearby Beverly Hills. Production techniques were unique. By the 1920s Hollywood was producing 90 per cent of the American film product, and exporting massively abroad so that it was the most important film industry worldwide. By the 1930s the Hollywood studios were totally vertically integrated (controlling production, distribution and exhibition). In the same period, Hollywood was making around six hundred films a year (six times the number of most western nations at that time) and exercised a major influence over American **audiences**. All changed in 1948 when a Supreme Court decision put an end to the vertical integration of the Hollywood studios. Then came television, destined to be Hollywood's major rival. Thought of as an intrinsically American phenomenon, Hollywood is presently losing its all-American status and being bought up by multinational, primarily Japanese, companies.

For details on all these issues see **studio system**. For further reading see Bordwell, Staiger and Thompson, 1985; Higson and Maltby, 1999; Neale and Smith, 1998; Vasey, 1997.

Hollywood blacklist As a reaction to the Cold War, the United States was extremely preoccupied with the Red Scare ('Reds under the beds'), and the fear that its institutions were in grave danger of infiltration from communists or subversives. To track down subversives the House of Un-American Activities Committee (HUAC) was established in 1947 and, under the leadership of Senator McCarthy, a witch-hunt was led to unearth people who had associations in any way with communism or subversive activities. People denounced people, people tried to protect people. And Hollywood was no different. It too came under HUAC's scrutiny and Hollywood, to protect itself against government intervention, blacklisted numerous people in the industry who had been accused or denounced as communists or subversives. Hollywood wanted to show that it was patriotic, but many careers were destroyed. Only ten members of the industry (known as the Hollywood Ten) refused to testify before HUAC and were sent to prison for their courage.

Hollywood majors – see classic Hollywood cinema, studio system

horror/gothic horror/Hammer horror/horror thriller/body horror/vampire movies (see also genre, science fiction films) This genre has its origins in the late nineteenth-century Victorian gothic novel although it does have earlier antecedents, most famously Mary Shelley's Frankenstein (1818), and Dr Polidori's lesser-known The Vampyre (1819). It is for reasons of its English and European heritage that this genre is not considered a particularly Hollywoodian one (unlike the westerns which are based on and in US history). Even so, Hollywood has a long track record with this genre dating back to 1931, in terms of sound movies, like Dracula (Tod Browning, 1931) and Frankenstein (James Whale, 1931). The earliest prototype is Feuillade's Les Vampires series (1915-16), starring the music-hall actress Musidora as the notorious Irma Vep (anagram of Vampire). Feuillade's series picked up on the earliest tradition of vampire stories which had women as the predatory beasts. Lesbian desire is foregrounded in this series (women/virgins swoon under Vep's advances before succumbing to her) rather than the more stereotypical representation of woman as vamp, the bloodsucking killer of men. This is not, however, the dominant tendency of the vampire film, which tends to centre on the male. There are literary reasons for this male predominance since the earlier vampire stories themselves underwent a regendering. The vampire was last 'seen' as a woman in Sheridan Le Fanu's novel Carmilla (1871) and was superseded some twenty years later by Bram Stoker's Dracula (1897). The rest is history. With one or two rare exceptions, the agent of vampirism is male (see Kuhn and Radstone, 1990, 243).

The vampire film had its heyday in Hollywood during the 1930s. The mise-en-scène at that time was influenced by German expressionism – more particularly by the lighting and sets of two German silent horror movies, Robert Wiene's The Cabinet of Dr Caligari (1919) and Friedrich Murnau's Nosferatu: A Symphony of Terror (1922). After the Second World War the vampire film tended to disappear – being replaced by other sorts of alien 'unnaturalness'. However, it made a brilliant and vigorous comeback in the United Kingdom under the name of Hammer Horror films (produced by Hammer Production Limited). These were made from the late 1950s to the late 1960s and starred Christopher Lee and Peter Cushing (for Hammer's policy and strategy see Cook, 1985, 44–7). During the 1970s, the acid-cold dinner-suited vampire hitherto so much in evidence

gave way to the acceptable face of vampirism: the vampire became more romantic to the point of deserving love (flower-vampire) and the female vampire made a brief reappearance (as in Vampire Lovers, Roy Ward Baker, 1970, Le Rouge aux lèvres, 1970, Vampyres, 1974, and as late as Tony Scott's The Hunger, 1983). By the early 1980s vampire films all but disappeared doubtless due to their unsuitability in the face of AIDS. But Francis Ford Coppola has come back with a Dracula (1992) supposedly faithfully based on Bram Stoker's original. And in 1994 Neil Jordan's Interview with the Vampire transformed vampirism into a sexual aesthetic not without homosocial/sexual overtones.

Vampire films, however, are not the whole or even the main canon of horror movies. Essentially horror is composed of three major categories: the 'unnatural' (which includes vampires, ghosts, demonology, witchcraft, body horror); psychological horror (for example Peeping Tom, Michael Powell, 1959; Psycho, Alfred Hitchcock, 1960); and massacre movies (for example The Texas Chainsaw Massacre, Tobe Hooper, 1974). These last two categories (which are also loosely labelled horror-thrillers) are a distinctly post-Second-World-War phenomenon. As for the first category, it is pre-eminently the body-horror movie that is associated with post-1950s, post-nuclear mentalities. Bodily mutation from man (sic) to beast and back again had a forerunner in the 1920 film Dr Jekyll and Mr Hyde (John Robertson). But, by the 1950s, mutilation, destruction or disintegration of the body was at the core of horror films conscious of the effects on the human body of real science (the dropping of the atom bomb on Hiroshima and Nagasaki). The Japanese produced holocaust films of these effects (for example Godzilla, Inoshiro Honda, 1955), and the Americans did not neglect them either (as with Them, Gordon Douglas, 1954). After this incursion into horror-realism this mutation/mutilation re-entered the realms of fiction, though not necessarily losing its political edge, particularly during the 1970s, starting with The Night of the Living Dead (George Romero, 1969) and culminating in David Cronenberg's 'body-as-host-to-mutants' films of the late 1970s (Shivers, 1976; Rabid, 1977; The Brood, 1979). During the 1980s and 1990s this type of film has continued to express anxiety of the body (often, but not always male) as a diseased space (The Thing, John Carpenter, 1981; Alien3, Ridley Scott, 1992). And it is not difficult to read into these films of the last three decades a

preoccupation with the politics of health, a fear of invasion of un(fore)seeable substances (cancer, AIDS). This represents quite a shift from the earlier 'unnatural' category of films – especially the vampire films that were so clearly about sexuality and bourgeois conformity.

The psychological horror film and the massacre movies (also known as slasher movies) reveal, albeit in very different ways, a particularly vicious normalizing of misogyny (see naturalizing and psychoanalysis). Very few fall short of being 'hate-womenmovies'. By way of understanding this quite dominant trend in this cinema it is useful to look at what Richard Dyer has to say, in an article on Coppola's Dracula (Sight and Sound, January 1993, vol. 3, 1), about vampirism. He makes the point that nineteenth-century vampirism originates in a bourgeois society that had become aware that its concealed dependency on the working class (which came about as a result of the industrial capitalist democracy) is now being uncovered. In other words dependence of the stronger on the weaker as it is about to be exposed breeds an almost irrational fear which is registered through the body. The vampire assails bourgeois morality by seducing its virgins and drinking their life blood (what chance the bourgeoise surviving the attacks of the mob?). Class issues are sexualized: the brute force of the working class (bestiality) will undo (deflower or destroy) the future of middle-class capitalism. Similarly, in the psychological horror films and massacre movies, male dependence on the female for his subjectivity (sense of identity derived from his difference from the female) again becomes registered through the body. Female presence exposes the dependency. Thus penile instruments (phallus replacements or substitutes) such as knives or chainsaws are used to recastrate the phallic woman. Although the woman is hierarchically positioned as weaker, as is the working class, none the less she is finally stronger since she holds the key to male identity through her difference. The killing therefore is an irrational response to the fear of exposure. He must kill her before the dependency is exposed.

Cook (1985, 99) explains that, despite its popularity as a genre, the horror film did not achieve respectability in critics' circles until the 1970s. She attributes this change to the impact of **psychoanalysis** on film **theory**. To have taken the genre seriously prior to this time would have meant dealing with the suppression of the id, a repression of certain unspeakable desires

(sexual and psychological). It is instructive that until the psychological thriller of the 1960s, which suggested that the monster is repressed in us and not external to us (although Cocteau's La Belle et la bête, 1946, certainly makes this point), our id, our own Other, took the form of an alien or monster outside of us — as if the genre itself could not face up to the suppression of the id either. This would suggest that the **spectator**, beyond the thrill of being frightened by the terror and violence made visible before her or him, is also attracted by the implicit ambivalence inherent in the genre as to where it should locate sexual and psychological 'abnormalities'. In this context what do we make of *The Silence of the Lambs* (Demme, 1990) in which we almost come to like the charismatic Hannibal Lecter, the cannibalistic and cultured serial killer?

For further reading see Creed, 1993; Milne and Willemen 1986; Jancovich, 1992; Kuhn, 1990; Paul, 1994; Tudor, 1989.

iconography A means whereby visual motifs and style in films can be categorized and analysed. Iconography can study the smallest unit of meaning of a film, the image, as well as the largest: the generic qualities of the whole film. Iconography then stresses both mise-en-scène and genre. Iconography also refers to the dress-codes of characters in the film. Iconography is then historically marked – the icons of one period will not be icons for another – and so it points to the shift over time of the look of a particular genre. It also points to social and sexual changes. If there appears to be no change, that too merits investigation.

For illustrative purposes let's take the iconography of the western and the gangster film. Both genres have their dresscodes and their 'tools of the trade' (Cook, 1985, 60). The horse, the six-shooter, the spurs, boots, waistcoat, neckerchief (etc.) for the western; fast cars, automatic rifles, flashy suits for the gangster film. The western's hero smokes a cheroot, the gangster a cigar. The gangster lives in urban spaces, mostly in dark enclosed environments - at least in the gangster movies of the 1930s and 1940s. Action takes place at night. In more contemporary gangster films action takes place day or night. In the western the hero is mostly moving across vast plains or desert land, arriving in small towns, tying his horse up to the inevitable cross-bar in front of the saloon (or wherever else he is headed). What differentiates these genres primarily is that the western almost 'never changes' - the iconography remains almost the same, even in Clint Eastwood's late films, despite their challenge to the ideological message of westerns (as in Pale Rider, 1985; Unforgiven, 1992 - both directed by and starring Eastwood). Gangster movies' iconography does shift with the times. The special

lighting effects of the 1930s and then 1940s films noir are no longer present in gangster films. Even the iconography of violence has 'evolved' - nothing is spared in its mise-en-scène. Part of the reason for this absence of change for westerns has to do with audience expectation. The western refers to a time gone by, but it is still part of the United States' cultural history and, as part of the currency for the society for which it works, it must perpetuate the existing iconography. If it does not, it disturbs. Such is not the case for the gangster film. Audience expectation is quite the opposite. Urban violence is very much an everyday preoccupation in the United States, as is gang warfare. This might explain why a new form of the gangster genre, Black gangster films, is currently so popular - speaking, as it does, to both the reality and the myth of Black urban violence (for example New Jack City, Mario Van Peebles; Boyz 'n the Hood, John Singleton, both 1991).

Iconography has connotative powers beyond the visual imagery. For example, dress-codes reflect more than just the historical period. Gangsters in 1930s films wear very flashy suits as opposed to the detective in his sober suit, connoting **excess** versus order. Women, in particular, 'say' a lot through their clothes: the power-dressing woman, almost masculinized in her shoulder-padded tailored suit (as in 1940 movies); the untrust-worthy *femme fatale* in a long slinky gown – preferably with a slit thigh-high – and so on.

identification see distanciation, spectator-identification

identity see psychoanalysis, spectator-identification, subjectivity

ideology (see also hegemony and class) Ideology as a theoretical term comes from Marxism. Ideology is the discourse that invests a nation or society with meaning. And, since it reflects the way in which a nation is signified, it is closely aligned to myth. Ideology, then, is at the interface of language and political organization (the discourse, logos, of or on ideas). It is a system of ideas that explains, makes sense of, society. But the 'making sense', as Karl Marx points out, is predominantly the domain of the ruling classes, who assume their right to rule as natural.

Thus, according to Marx, ideology is the practice of reproducing social relations of inequality. The ruling classes not only rule, they rule as thinkers and producers of ideas and so control the way the nation perceives itself and, just as importantly, they regulate the way other classes are perceived or represented. From this 'misrepresentation' (that is, the ruling classes' assumption of their natural right to govern and to determine the status of other classes) comes Marx's idea of ideology as false consciousness. But the subordinate classes also act with false consciousness, says Marx, if they accept that their position is natural, that is, if they accept the prevailing ideology as it makes sense of their subordination (see naturalizing).

Louis Althusser (1984, 37) takes issue with Marx's notion of false consciousness and makes the point that ideology is not just a case of a controlling few imposing an interpretation of the nation upon the subjects of the state. He suggests that, in ideology, the subjects also represent to themselves 'their relation to those conditions of existence which is represented to them there' (1984, 37). In other words, they make ideology have meaning by colluding with and acting according to it. Why this consensuality? Because of the reassuring nature of national identity. The nation state gives people a sense of identity, status and pride. The state is their state, the governing body is their indigenous governing body, not some foreign ruler's, and so on. Ideology, then, is a necessity and it is produced 'by the subject for the subjects' (1984, 44). Thus society renders ideology material (gives it a reality) and so too do the subjects. Individuals recognize and identify themselves as subjects of ideology. Althusser's central thesis that 'ideology interpellates individuals as subjects' (1984, 44) - that is that ideology constructs the subject, that the subject is an effect of ideology - has had profound implications for the theorizing of spectator-text relations. As we shall see, this recognition and identification process by which ideology functions is one that film readily re-enacts.

Ideology infiltrates everyday life and serves the ruling classes, collusion notwithstanding. The rulers are after all those who have produced and control the institutions in which we as subjects function and by which we understand our society. School, the family, the media, are obvious institutions that are permeated by ideology. However, even though dominant ideology serves the ruling classes (who put it there in the first place), ideology is not a static thing nor is it immutable. Within

dominant ideology, because it is composed of so many diverse institutions and institutional practices, there are bound to be contradictions. So while ideology is dominant (and despite its 'naturalness') it is also contradictory, therefore fragmented, inconsistent and incoherent. Moreover it is constantly being challenged by resistances from those it purports to govern: groups such as the Black Power movement in the United States, the feminist movement in the western world and some parts of the eastern world, subculture groups like the punk movement – these are just some of the most obvious examples.

Where does ideology fit into a discussion of cinema? Cinema is an ideological apparatus by nature of its very seamlessness. We do not see how it produces meaning - it renders it invisible, naturalizes it. Mainstream or dominant cinema, in Hollywood and elsewhere, puts ideology up on screen. Hollywood's great subject, heterosexuality, is inscribed into almost every genre. So genre is a first place to examine the workings of ideology. The other area is, of course, that of representation (class, race, gender, age and so on). Genres function ideologically to reproduce the capitalist system. They are hermeneutically determined, that is, there will always be closure, a resolution at the end. In this respect they provide simple common-sense answers to very complex issues, the difficulties of which get repressed. Already, however, we can see how generic convention is opening itself up as ideologically contradictory. Even though it is seemingly producing meanings that support the status quo, none the less, generic convention is quite distinct from the social reality which it purports to reflect. Social reality does not present easy solutions, life is not 'order/disorder/order restored' as the classic narrative would have us believe. But because of the reality-effect which seamlessness produces, the spectator is easily stitched into the narrative (see suture), the process of recognition and identification is under way and so too the ideological function of film - which is why generic repetition works so well and we go back again and again to the movies.

Because ideology is contradictory, some films unintentionally show 'disjunctures in their relation to ideology' (Kuhn, 1982, 86), what Kuhn calls structuring absences (1982, 87). In other words, what gets repressed, left out, draws attention to itself by its absence. The much-quoted example is the **historical** biopic film *Young Mr Lincoln* (John Ford, 1939) which the *Cahiers du*

cinéma group subjected to a detailed textual analysis (Screen, Vol. 15, No. 3, 1972). Although supposedly a historical film about a man of enormous political importance, it is precisely history and politics that are the structuring absences of that film. The question then becomes why? To 'imbue the figure of Lincoln with qualities of universalism - precisely to represent the man as outside history, and thus to elevate him to the ahistorical status of myth' (Kuhn, 1982, 87). Another reason could be the historical context. At the time of its release (1939), the United States was maintaining an isolationist policy as Germany began its war on Europe. It was choosing to stand out of history. So this was not the time for political history lessons, nor for statements (good or bad) about the nation state. As ahistorically positioned, the United States could not 'show' history, the 'reality' of Lincoln's time. Thus, it could not proselytize about the abolition of slavery or show the nation as politically divided (the Civil War). The need for a man (sic) of mythic status also points to a nation facing a contradiction or dilemma which it seeks to resolve through the very creation of that myth. Universalism implies being above all conflict. Finally, still within the historical context, the Cahiers group's reading examined the film within its domestic political sphere and claimed that it mediated Republican values to counter Roosevelt's Democratic New Deal measures (1933-41) and to promote a Republican victory in the presidential election of 1940 (see auteur; and Cook. 1985, 189).

There are, then, films which show the contradictions inherent in ideology. Two of the earliest advocates of applying symptomatic readings to expose the ideological operations in film, Comolli and Narboni, put it succinctly when they say that such films contain an 'internal criticism ... which cracks the film apart at the seams. If one reads the film obliquely, looking for symptoms, if one looks beyond its apparent formal coherence, one can see that it is riddled with cracks: it is splitting under an internal tension which is simply not there in ideologically innocuous film' (1969/1977, 7). Melodrama and women's films would seem to be just such innocuous films with their ideologies of romantic love, the family and maternity. But feminist readings against the grain have rendered visible the patriarchal ideology upon which these films feed and exposed the ideological contradictions inherent in that ideology (see feminist film theory).

image (see also shots, denotation/connotation, iconography) As a basic definition, the image is the smallest unit of meaning in a filmic text in the sense that it is composed of a single shot. The image lends itself to a series of readings depending on the type of shot. Volume and size of objects within the shot give a first denotative reading; the angle of the camera further informs the meaning or preferred reading at a denotative level. When one is considering the image, considerable importance must be given to what is called the iconography of the image, for this will yield a second-order or connotative reading.

Imaginary/Symbolic (see also psychoanalysis, Oedipal trajectory, suture, apparatus, sexuality, spectator, subject/subjectivity) These two key psychoanalytical concepts were first devised by Jacques Lacan to refine Sigmund Freud's theory on the child's unconscious and conscious drives in the development of its subjectivity (sense of identity). Freud described these drives in sexual terms, referring to them as the mirror phase followed by the Oedipal phase. The merit of Lacan's theory was to place the discussion of this development more evidently in a linguistic rather than a purely sexual domain. And, although he focused primarily on the male and paid less attention to the female child, none the less, by frameworking subjectivity within language his theory greatly facilitated feminist theory in general and feminist film theorists in particular when discussing sexual difference and subjectivity (see feminist film theory). What follows is a brief outline of the earlier Freudian theory and the nuances brought to it by Lacan - after which its relevance to film theory will be explained.

According to Freud, there is a stage at which the child goes through the mirror phase. The mirror phase is, of course, an abstract concept and it is used to describe a first part of the process of achieving sexual and (for Lacan) social identity. The mirror phase normally occurs when the child is weaned from the mother (so the age of the child varies). Until that moment the child has had an illusory notion of unity with the mother – it feels as one with the mother. In Lacan's terminology this identification with the mother is the first stage of the Imaginary. Subsequently, the mother holds the child up to the mirror. The child now has an illusory sense of identification and unity with that image of her or his self in the mirror. This is the second

stage of Lacan's Imaginary and what Freud referred to as the narcissistic moment in the child's development towards a subjectivity (sense of identity). It is at this juncture that the male child perceives his sexual difference from his mother, or the girl child her sameness with the mother. The child becomes aware of the illusory nature of his or her sense of unity with the reflected image in the mirror – it is not one and the same. Simultaneously, it senses the loss/absence of the mother (the loss of the breast, and the ensuing loss of a sense of unity with her).

The male child perceives that he is sexually different from his mother: that he has a penis and she does not (remember she is in the mirror too, holding him up to look at his reflection). According to Freud, the male child perceives the mother as lacking a penis and, as Freud explains, it is that lack that fills the male child with the fear of castration. The mother represents what he could lose. So she is potentially, in Freudian terms, a castrating mother. The female child meanwhile, says Freud, perceiving her sameness with her mother, wishes she had a penis - the notorious penis-envy myth. Lacanian psychoanalysis does not challenge the idea of the castrating mother but does make the point that the child's subjectivity is dependent on the presence of the mother, the female other. Lacan is, of course, referring to the male child; he is less clear where the female child is concerned. Thus, male subjectivity is dependent on the (m)other. Without her, the sense of self as subject is not secure.

At this stage, the mirror phase, or the Imaginary, draws to a close. The male child now moves on to the next stage in his development: the Oedipal phase. Sensing his difference from his mother, but still desiring unity with her to assert his identity (that is, his difference, his subjectivity), the male child now wishes to bond sexually with his mother. According to Freud, the father must impose the sexual taboo – forbidding intercourse with the mother. The male child must seek to bond with a female who is not his mother. If he disobeys, the punishment he risks is castration, this time by the father. That is, he could realize his worst fear and become like his mother – what then of his identity?

Lacan gives a different emphasis to this stage, which he refers to as the Symbolic, by situating it in language. At the moment that the male child recognizes his desire for his mother, the father intercedes and imposes the patriarchal law. The father is the third member to enter the reflecting mirror. It is he who

represents to the child the authoritative figure in the family. So the child imagines what the authoritative figurehead would say - the father is, therefore, a symbolic father. The father proscribes incest. This taboo is imposed linguistically through the 'No' that is defined by Lacan as the Law of the Father. Because it is based in language, patriarchal law is a Symbolic Order. The male child must then decide whether to obey. To obey means to repress desire. This repression founds the unconscious. However, in exchange for this repression, the male child enters into the Symbolic Order, becomes part of the patriarchal law, joins forces with the father and so perpetuates the Law of the Father (for more detail see psychoanalysis). By entering into the Symbolic Order the male child enters into language and becomes subject to it. Where he was prelinguistic in the Imaginary he is now subject of language - patriarchal language. By entering into the Symbolic Order the male child conforms to the Law of the Father, acknowledges his misrecognition of the object of his desire, the mother, and seeks now to fulfil his Oedipal trajectory not through his mother but through a female other. His sexual security depends on it as does his subjectivity (remember that Freud and Lacan concur that the male child's sexual identity is reliant on his sense of difference from his mother, the female

The whole notion of identity for the male child is then bound up with the question of sexual difference and language. What of the female child? First, she will never fully relinquish her desire for her mother because there is no recognition of it within the Law of the Father. Second, she will never fully enter into the Symbolic Order because the Law of the Father does not apply to her. She is then doubly poised both sexually and in relation to language. With regard to the first point, we recall that her subjectivity is determined by her sameness with her mother. She is then doubly desiring, first, of her own sex (the mother) and also the male sex (her natural trajectory is to desire the father, and, forbidden that desire by the father, she will then seek to fulfil it by finding a male other). In terms of language, again she is doubly positioned. On the one hand, she is prelinguistic: because she can never be subject of patriarchal language she is always outside it. On the other hand, however, she is also in the Symbolic Order. Even though she is not subject of language (unlike the male child) but object of the Symbolic Order, she must be there in the patriarchal constructs of sexual

identity: her reflection as (m)other must be in the mirror for the male to recognize his difference.

Relevance to film theory These concepts can serve to illuminate, first the **ideological** operations at work within the film **diegesis** and, second, those taking place at the level of the spectator—text relationship. I will deal only with the first point here since the second is amply discussed in the entries on **spectator** positioning and **suture**.

Cinema has been widely acknowledged as revelatory of psychological states and mental experiences since before 1914 by film-makers and some critics. However, prior to the impact on film theory of Lacan's re-thinking of Freud, prevailing readings of films tended to be based not so much in psychoanalysis as in sociological and aesthetic interpretations. If psychoanalysis did motivate reading and theorizing on film - as it did in the 1920s and again in the 1940s and 1950s - then the focus, in the earlier period, was on film's ability to translate the workings of the unconscious on to the screen and, in the later period, on the mise-en-scène of a populist interpretation of Freud. The 1920s films of the avant-garde certainly addressed questions of subjectivity and male dependence on woman to provide that sense of sexual identity, and in that respect predate Lacan. Conversely, the 1940s and 1950s films - many coming from Hollywood in the light of the popularization of Freud produced narratives of mother/daughter relationships which portrayed the mother as either self-sacrificing or as controlling and repressive (see Kaplan, 1992, for detailed analyses of mother/ daughter relationships). Otherwise film narratives gave potted versions of (usually male) youth's dysfunctionality in the contemporary United States. In this instance it is the neglect of the father or the overpowering nature of the mother which brings about their offspring's tormented state.

However, it is in the new readings of film through Lacan and post-Lacanians (including Lacanian feminists) that we can begin to measure the helpfulness of these key concepts of the Imaginary and the Symbolic. This is particularly the case with recent readings of film noir and women's films (see melodrama and women's films). These readings have been able to demonstrate that the ideological operations at work, for example in the film noir, seek to disguise the fact that the *femme fatale* or 'woman who knows too much' must be punished because she is 'bad'. These new readings suggest also that she ends up victim, not

only because she is 'bad' but because the male protagonist has been unable to assert his difference in relation to the female other and has failed therefore to complete his Oedipal trajectory satisfactorily. Woman threatens the male's sense of subjectivity because the assertion of his difference depends on the presence of the woman, of the (m)other reflected in the mirror. Indeed, she may refuse to be in the mirror. In this case the male protagonist often feels obliged to spy on her and follow her in a desperate attempt to make her comply with her assigned role in patriarchy. But that is not the only way in which woman threatens. She also threatens because she is the 'mother'. And the male knows he must move on to the Symbolic Order or face castration, because he may not make his mother the object of his desire. Because that threat points to the instability of his dependence on the 'other', and brings in its wake the apparently concomitant threat of castration, the male adopts two strategies: voyeurism and fetishism. Voyeurism places the woman under constant surveillance and is a way of controlling her (to the point of sadistic murder, as in Psycho, Alfred Hitchcock, 1960). Fetishism commodifies the woman's body by over-investing parts of the body with meaning (breasts, legs, torso in slinky dresses) and thereby denies its difference: the male produces a masculinized female image that is phallic and therefore reassuring. In both instances, he neutralizes the threat. In both, however, we are in the presence of masculinity in crisis and the projection of the male's fears on to women - a mise-en-scène of a profoundly ambivalent attitude towards femininity. And it is in this respect that the perceived misogyny of film-makers (most notoriously Hitchcock but there are plenty of others) can be seen in a far more complex and indeed more interesting light.

For further reading on Lacan see Benvenuto and Kennedy, 1986; Grosz, 1990. For psychoanalysis and film see Kaplan, 1990; Penley, 1988 and 1989. For film readings see Fischer, 1989; Kaplan, 1980 and 1992; Kuhn, 1985; Modleski, 1988; Mulvey, 1989.

independent cinema (see also avant-garde, counter-cinema, underground film) This term refers to films made by film-makers independently of the dominant, established film industry. Because they are made outside mainstream cinema practices they tend to be avant-garde and counter-cinematic, and, even if not experimental, they all tend to give an alternative voice to

dominant **ideology**. They are mostly low-budget films either privately financed or subsidized by government.

intertextuality Literally this expression means texts referring to texts, or texts citing past texts. Intertextuality is a relation between two or more texts which influences the reading of the intertext. This latter term refers to the present existing text which, in some part, is made up by reference to other texts. Most films are intertextual to some degree - a text referring to other texts, an intertext in whose presence other texts reside. For example, a film may be based on an original text, a novel or play. The shooting style of the film may be painterly, suggesting painted texts to which it might be referring. Shots or combinations of shots might refer back to earlier films (by way of a homage to earlier directors). Songs within a film are an intertext. Thus, if the star playing the central protagonist is also a well-known singer the audience will expect a song. That performance refers to another part of the star persona that has been developed outside of film-making and so refers to another text: the star as singer.

Italian neo-realism A film movement that lasted from 1942 to 1952. Even though critics credit Roberto Rossellini's 1945 Roma città aperta (Rome Open City) as being the first truly neo-realist film, Luchino Visconti's Ossessione (1942, Obsession) was really the herald of this movement. And in fact the scriptwriter of Visconti's film, Antonio Pietrangeli, coined the term neo-realism in 1943 when talking about Ossessione. The main exponents of this movement are Visconti, Rossellini and Vittorio De Sica.

Rossellini called neo-realism both a moral and an aesthetic cinema, and in order to understand what he meant we need to look at the historical context in which that cinema emerged. During the period of fascist rule under Mussolini the type of cinema that was being produced was divorced from reality and concerned only with promoting a good image of Italy. The government had decreed that crime and immorality should not be put on screen. The films primarily produced were slick middle-class **melodramas**, disparagingly called (after fascism) 'white telephone movies'. During the fascist government's control of the film industry, some 'good' did come about: the famous Cinecittà studios (Italy's answer to **Hollywood**) were

built and the Italian Film School was established. And, perhaps more significantly, some film-makers took a moral and aesthetic stance against fascism.

Neo-realism, then, owes its existence in part to these filmmakers' displeasure at the restrictions placed on their freedom of expression. And it is in this light that Visconti's 1942 film can be seen as the harbinger of neo-realism. But he too had precedents to his own film style. During the 1930s Visconti worked as an assistant with the French film-maker Jean Renoir: a significant apprenticeship, first, because of Renoir's association with the French poetic realist movement and, second, because he worked with Renoir on a film that historians perceive as the precursor to the Italian neo-realist movement, Toni (1934). Undoubtedly the social and pessimistic realism of poetic realism did cross-fertilize into neo-realism, but the point to make about Toni is that it was a film based on a true story of an Italian immigrant worker in France whose passion for a woman led him to murder. Renoir used non-professional actors, shot the film on location and kept to the original soundtrack. The film has a grainy, realistic look which the crackling sound-track reinforces in its documentary verisimilitude. Visconti's Ossessione, while not a true story, was loosely based on an American pulp fiction novel, James M. Cain's The Postman Always Rings Twice. The film was shot on location in northern Italy and tells the story of a labourer who becomes obsessed by a woman and agrees to her plan to murder her husband. Having accomplished the deed, she gets killed in a car crash ('naturally'!). With this tale of sordid obsessions and shots redolent with lust and sensuality, Visconti was deliberately defying governmental decrees of cleanliness and propriety on screen. The film was released, but in a heavily censored cut and Visconti did not make another film until 1948, La terra trema (The Earth Trembles). However, the seeds for neo-realism were sown.

By 1943 fascist rule in Italy was coming to an end and in 1944 Italy was occupied by the Allies. The fall of fascism allowed for the truth to be told about the impoverished conditions of the working **classes** and of urban life. And this is precisely what a small group of film-makers did. They rejected the old cinema and its codes and conventions and went for the gritty reality. The basic tenets of this movement were that cinema should focus on its own nature and its role in society and that it should confront audiences with their own reality. These principles had

implications for the style and content of this cinema. First, it should project a slice of life, it should appear to enter and then leave everyday life. As 'reality' it should not use literary adaptations but go for the real. Second, it should focus on social reality: on the poverty and unemployment so rampant in postwar Italy. Third, in order to guarantee this realism, dialogue and language should be natural - even to the point of keeping to the regional dialects. To this effect also, preferably nonprofessional actors should be used. Fourth, location shooting rather than studio should prevail. And, finally, the shooting should be documentary in style, shot in natural light, with a hand-held camera and using observation and analysis. These are very exacting demands, and in fact only one film meets with all these tenets: De Sica's Ladri di bicicletti (1948, Bicycle Thieves), although Visconti's Terra trema comes very close (it falls short because it is a literary adaptation) as does Roma città aperta (which used a mixture of professional and non-professional actors. including the fetish star Anna Magnani, and used three small studio sets).

Roma città aperta was based on real events that Romans lived through during the period 1943–4. This was before the Allied forces had arrived in the city and the Germans were still in control. The **narrative** is focused on the goings-on of the Italian Resistance during a three-day period. However, it is the difficulties of the production that give this film its authenticity. Rossellini had to use newsreel stock, which gave the images their grainy realistic look. Money and film stock were extremely difficult to come by. Virtually the whole film was shot in Rome. Resistance fighters die during this three-day period, but the impression given is that we have picked up on their story and that of others in the film and that these people's lives go on once the film has ended.

As film movements go, neo-realism was not particularly short-lived. It lasted ten years, even fourteen if we take into consideration that the last neo-realist film was De Sica's *Il tetto* (1956, *The Roof*). In a sense, neo-realism was officially 'demised' in the early 1950s by the government when it appointed Giulio Andreotti as Director of Performing Arts and gave him extensive powers. Any films giving a bad image of Italy were denied screening rights in Italy and, because he controlled bank loans, Andreotti could go so far as to withhold money from films he considered too neo-realist in **motivation**. The Cold War mood

of the early 1950s also contributed to governmental dislike of the **social realism** inherent in these films, which they perceived as politicized and of the left – even though of the film-makers concerned only Visconti was avowedly a Marxist.

Despite its demise, neo-realism had a huge impact on future film-making practices in Europe, the United States and India. The French New Wave widely acknowledged its debt to this movement, and resonances of its style are clearly in evidence in the British New Wave. A younger generation of Italian film-makers was also much influenced by the neo-realists' work, in particular Emmanuel Olmi, Michelangelo Antonioni and Federico Fellini. And in India Satyajit Ray's films of the late 1950s are strongly marked with the tenets of neo-realism.

J

jouissance - see psychoanalysis

jump cut (see also cut, match cutting, spatial and temporal contiguity) The opposite of a match cut, the jump cut is an abrupt cut between two shots that calls attention to itself because it does not match the shots seamlessly. It marks a transition in time and space but is called a jump cut because it jars the sensibilities; it makes the spectator jump and wonder where the narrative has got to. Between sequences, the jump cut has quite the reverse effect of the standard cut. The narrative is transposed from one time and space to another without any explanation such as a shot or voice-over. This fragmentation of time and space can either produce a disorientation effect (within the diegesis and for the spectator) or put in question the idea that all lived experience can be explained by the comforting cause-effect theory. Those two effects can coexist. Jean-Luc Godard is undoubtedly one of the best exponents of this use of the jump cut (especially in his 1960s films). His characters appear disoriented in a world where reason seems incapable of imposing a logical order on events. Equally, the spectator is disoriented and troubled by the non-causality of the images and the narrative.

Within a sequence, the jump cut cuts two shots of the same person together, but neither the **30-degree rule** nor the **reverse angle shot** is observed. Thus, the impression of fragmentation is even more strongly felt, to the point where the brutality of this transition can suggest madness or, at the least, a state of extreme instability (as in Alain Resnais's films – for example

Hiroshima mon amour, 1959; L'Année dernière à Marienbad, 1961). Certain sequences in Godard's A bout de souffle (1959) are quoted as illustrations of this disorientation effect. However, Godard (1980, 34) himself puts a question mark on the aesthetic intentionality of his use of the jump cut when he states (but is he pulling our leg?) that his film was an hour too long (as are all first films he adds) and he had to cut. The cuts included a lengthy dialogue scene between the two main characters, Patricia and Michel, as they drive through Paris. The dialogue scene was cut in such a way that one of the interlocutors was cut out and only one remained. The decision whom to cut was taken by tossing a coin (in the end it was Michel, played by Jean-Paul Belmondo, who was cut). Thus, we see and hear only Patricia (played by Jean Seberg) at four different junctures in time and space as this scene unfolds. We first see and hear her and the backdrop is one part of Paris. Then there is a cut, we see and hear her speak again but what she says bears little or no relation to what she said before. Similarly, the backdrop of Paris has changed, showing some other part of the city. We are aware that time and space have moved on and that we have made a jump in time and space. However, nothing in the diegesis serves to explain how we have got there. The shots are edited together without a change in the camera position (the camera is in the back of the car focused on Patricia). Thus, each time we 'come back' to Patricia via the cut, we experience it as a jerky movement - as if the camera has jumped.

kauta Mala

lap dissolve - see dissolve

lighting This entry is in three parts: technology, practice, ideology.

Technology In the earliest cinema only natural lighting was used, most of the shooting was done in exteriors or in studios that had glass roofs or roofs that could open to the sunlight. As narratives became more complex (early 1900s) and as increased demand for products meant working to tight shooting schedules, clearly using ordinary sunlight was not satisfactory enough since it was not easily controllable. Thus, artificial lighting was introduced to supplement existing light. The first type of lighting was the mercury-vapour lamp (invented in 1901 by Peter Cooper-Hewitt). These lights (known as Cooper-Hewitts) look much like neon strip-lights - they were packed into units of nine strip-lights. These units were then fixed in pairs one on top of the other onto wheeled, goose-necked units (so as to create wall and overhead lighting) and placed along the three walls of the studio (some twelve units in all). This lighting was based on blue and green wavelengths which suited the then orthochromatic film stock. Orthochromatic stock was sensitive to the blue and green end of the spectrum, but not to vellow and red. Used in studios, this lighting gave a gentle and soft effect to the image which then had to be matched, for consistency's sake, by any 'outside' or real sunlight shooting through the use of light diffusers. While enormously efficient, the mercury-vapour lighting system had one main drawback. It could not provide directional light and therefore could not achieve

contrast or highlighting effects. Thus, while maintaining the diffused lighting effect provided by vapour lamps, other systems of lighting had to be developed for effects lighting and to give a greater **realism** to the filmed image. To achieve contrast and a greater naturalism, non-incandescent arc spot-lights (which gave a blueish light) – known as Klieg lights (named after the Kliegl brothers who designed them) – were introduced (perhaps as early as 1905, but certainly by the early 1910s). It was at this point that **Hollywood** developed its three-point lighting system (key, fill and back-lighting).

After the First World War, another type of arc-light was introduced into the panoply of lighting devices: the sun-arc. Originally, the sun-arc had been a high-powered arc-searchlight used during the war to spot (among other things) enemy aircraft. This powerful carbon-arc lighting was as bright as sunlight – the range of these floodlights varied from 650 to 10,000 watts. It gave much more flexibility to shooting schedules, shooting at night became possible for example. While most of these carbonarc lights have been replaced over time first by tungsten-filment lighting and later by tungsten-halogen lamps, the so-called Brute, a 225-amp carbon-arc spotlight is still used today for colour films and especially for creating sunlight. Carbon-arc lighting disappeared slowly, beginning in the late 1920s. Carbon-arc lighting was expensive to run both in terms of electricity costs and maintenance. When sound was introduced and with it panchromatic film, incandescent lighting had to become the chief source of lighting - carbon-arc lamps on their own produced too much blue light and were very noisy. Panchromatic film was a black and white film sensitive to all colours of the spectrum and so could provide more subtle shades of 'colour' in gradations of greys unlike the orthochromatic film which was sensitive only to blue and green and so produced, in the main, highly contrasted black and white images. (For more details on this period see Bordwell, Staiger and Thompson, 1985, 270-5, 294-7; Dyer, 1997, 84-96.)

Colour film has worked with an association of tungsten and carbon-arc lighting. Whether black and white or colour, there are two basic systems for lighting: floodlight and spotlight. Floodlight gives diffuse illumination, while spotlight, as the name implies, focuses on a specific area or subject. As colour stock and lighting systems improve so a more natural image can be obtained for those film-makers whose drive is for realism. The latest development in lighting technology is the HMI lamp.

Originally introduced by Osram of Germany in the 1970s, this is a metal hydrargium medium arc-length iodide lamp. These lamps, though expensive and heavy to transport, yield three to four times more light than that produced by incandescent lights. HMIs were originally used for exterior key and filler lighting but are now being used for studio work. (For a useful reference book on lighting terminology and use see Richard Ferncase, 1995.)

Practice As far as Hollywood was concerned (and still is in the main), lighting should not draw attention to itself although it should be used for dramatic and realistic effect. In other countries' cinemas, however, lighting was used to aesthetic effect quite early in cinema history. For example, the low-angle and low-key lighting effects so closely identified with **German expressionist** cinema of the 1920s and the high-contrast lighting (called chiaroscuro) for signalling the mood and workings of the unconscious had already been used for emotional effect in Danish films as early as 1910.

These exceptions aside, lighting for dramatic effect became quite standardized by 1915 for probably two reasons: the predominance of studio shooting and the advent of the star system (both in Europe and the USA). As mentioned above, lighting became a three-point affair. It is one that is still in practice today albeit with the variations one would expect with technological progress. There are three primary positions for lighting: key lighting (hard lighting focused on a particular subject), fill lighting (extra light(s) to illuminate the overall framed space fully), and back-lighting (normally used to distinguish the figure in the foreground from the background, and so known also as a separation light). This is the basic system of lighting and one of its first effects is to eliminate or greatly reduce shadows. The key light is placed to the front and side of the subject who is looking between the key light and the camera; the fill light is a soft light normally placed near the camera on the opposite side of the key, it is a soft light that fills in areas of shadow cast by the key light and thus decreases the image-contrast. The fill light can also be placed on top of the camera - this is known as an Obie, so-named after Merle Oberon for whom the light was designed to give maximum effect to her face in close-up (curiously this light fitting is also known as a basher!). The rover fill is - as the name suggests a fill light mounted onto a dolly so that it can follow the subject. The back-light highlights the edges of the subject, it is aimed

towards the camera from above and behind the subject; when in this position this form of lighting is known also as a hair light because it creates a halo effect on the head. Hair lighting was very much a feature of **classic Hollywood cinema** (1930s–1960s), but it was already in use as early as the 1910s. Back-lighting that comes from behind but to the side of the subject is known as a kicker or kick-light.

There are two types of lighting for a scene: high-key and low-key. High-key lighting refers to a brightly lit scene with very few (if any) shadows - and is often used in musicals and comedies. Low-key lighting refers to a scene where the lighting is predominantly dark and shadowy, the key light does not dominate. Low-key lighting is not the same as but often includes the concept of high-contrast lighting effects (also known as chiaroscuro) – a use of contrasting tones of highlight and shadow which is predominantly associated with film noir, horror. psychodramas and thrillers. Some film analysts are adamant that low-key lighting and high-contrast lighting must not be confused (Konigsberg, 1993, 191), precisely because they are not the same. High-contrast lighting means what it says - there is a strong contrast between light and shadow. Thus a film noir may have moments when the shooting is done with low-key lighting and at others with high-contrast - and it is perhaps worth keeping the distinction clear.

Day-for-night and night-for-night shooting are the last two elements of lighting practice that need mentioning (there are of course many more variations and fine details to lighting and Ferncase's book on lighting, mentioned above, is an invaluable reference tool). Day-for-night shooting is when night-time is simulated while shooting exterior scenes during the day. François Truffaut famously made a film entitled *Day For Night* (1973) which shows you exactly how this conceit is achieved. Essentially the day-for-night effect is achieved by shooting late in the afternoon, and most importantly through the use of underexposure (small lense aperture) and filters. Night-for-night means shooting exterior night scenes at night – often using very fast film stock.

With all this detail on lighting to bear in mind it is quite helpful to embrace Bordwell and Thompson's (1980, 82–4) useful identification of the three major features of lighting: quality, direction and source – since this little triumvirate neatly encompasses film lighting practice. Thus the quality of light can be hard or soft, the direction can be front, side, back, and occa-

sionally under (the light comes from below the subject), the source will be key and/or fill.

Ideology As we have seen, classic Hollywood cinema frowns upon lighting that is not subordinate to the demands of the narrative, and adheres therefore to quite strict rules of dramatic lighting: the lighting should fit the situation but never supersede it to the point of artificiality or extreme abstraction which, it was believed, would create unease in the audience. The idea that cinema-going and watching must be safe, unchallenging and non-disruptive is a key ideological aspect of what we call the seamlessness of Hollywood and mainstream cinema. Lighting, in this context, colludes with an editing style that does not call attention to itself. The desired effect, realism, is of course totally artificial given that the cinematic apparatus is not presenting real-life to us - either through its images or its narrative. Use of lighting that does draw attention to itself is in some way challenging to this effect of realism and is, therefore, crucial in considerations of mise-en-scène precisely because it disrupts and distorts the reality effect. Thus, for example, frontal lighting on its own flattens the image and removes the illusion of threedimensionality; it draws to our attention the fact that film is in fact two-dimensional and that perspectival space is an illusion (indeed, to some avant-garde film-makers, perspective is a bourgeois aesthetic that comes to film from painting). Side-lighting on its own highlights objects or people in a distorting and denaturalising way catching only one side of their volume. Similarly, back-lighting on its own disorients and distorts, bringing out menacing silhouettes for example. In each and every case we are made aware that lighting is at work.

Richard Dyer in his book White (1997, 82–142) makes some extremely valuable points about the ideological effects of lighting as it is practised in the Western world. Dyer points out how from very early cinema, lighting along with film stock and make-up has always assumed the construction of whiteness as its touchstone (ibid., 90–1). He speaks of the white-centricity of the aesthetics of lighting that still prevails today (ibid., 97). And he goes on to discuss what this implies in the filming of blackness and black faces. The history of light technology is one that has always privileged the white face. It has also been a device for highlighting gender differentiation. For the woman, light reveals her glowing whiteness and blondness (in all her purity). Differently marked by light, the dark-haired, dark-suited

white male finds his face illuminated by a source of light (sidelight for example) that exposes his intelligence, virility or whatever - or indeed at times his own white face will be illuminated in a reflective way by the woman whose face is the 'source of all light'. Back-lighting, while it is used to suggest depth to the different planes in the image, has ideological effects when it is used as a hair light which was very much the case of classic Hollywood cinema. It brings out the blondness of the white woman's hair signalling her great virtue. Dyer (ibid., 91–2) explains how in early cinema when orthochromatic film stock was used, fair hair became black or looked dark unless special lighting in the form of back-lighting was used. Similarly, female stars had to wear extremely heavy white make-up so that their skin would show as white (almost pasty white to our contemporary eyes) on the screen. These white faces had to be arc-lit because tungsten lighting (with its red and vellow wavelengths) would have brought out those same colours in white faces thus making them look dark or black on the film stock. Under these fierce lights not only did make-up frequently melt and run, but the eyes suffered terribly from burning under the Klieg lights (the so-called 'Klieg eyes').

Neither film stock nor lighting has been significantly altered or evolved to take on board the representation of blackness on screen. Even when film directors speak of their attempts to shoot correctly black actors the process is represented as a problem (as Mike Figgis did in speaking about shooting *One Night Stand*, 1997). The assumption is hardly ever made that the technology might be the problem.

Dyer (1997, 102) argues carefully to show how 'movie lighting discriminates on the basis of race' and confines the black person to the shadows. Moreover, because movie lighting practice 'focuses on the individual' and 'hierarchises' (it signals who or what is important and who or what is not), it is clear that in its inability to show blackness and therefore the black person as important and as an individual it 'expresses a view of humanity pioneered by white culture' (ibid., 103).

look - see gaze/look, imaginary/symbolic, scopophilia, suture

mainstream cinema -see dominant/mainstream cinema

matchcutting (see also cut, editing and eyeline match) A cut from one shot to another where the two shots are matched by the action or subject and subject matter. For example, in a duel a shot can go from a long shot on both contestants via a cut to a medium close-up shot of one of the duellists. The cut matches the two shots, is consistent with the logic of the action. This is a standard practice in Hollywood film-making, to produce a seamless reality-effect.

mediation Literally, acting as an agent for conveying information or meaning. Thus a film mediates, but so too do the characters mediate meaning. It is not, of course, a direct transferral of meaning. Meaning is encoded to give a preferred reading. Thus films have an ideological function in their act of mediation, as do the characters (as an extreme case, think of John Wayne, the western and what those two media together mediate about America).

melodrama and women's films (see also genre) (Major references for this entry include Elsaesser, Mulvey, Nowell-Smith, Harper and Gledhill, all in: Gledhill (ed.) 1987; Feuer, 1982; Kaplan, 1983 and 1992; Cook, 1985; Doane 1982, 1984 and 1987; Modleski, 1988 and 1992) Melodrama's earliest roots are in medieval morality plays and the oral tradition. Subsequently the tradition found renewed favour in the French romantic drama of the eighteenth and nineteenth centuries and the English and French sentimental

novel of the same period. These dramas and novels based in codes of morality and good conscience were about familial relations, thwarted love and forced marriages (Elsaesser, 1987, 45). The melodrama coincides, then, with the rise of modernism and can be seen as a response to the French Revolution, the Industrial Revolution and modernization. In the early 1800s the post-Revolutionary bourgeoisie sought to defend its newly acquired rights against the autocratic aristocracy – including the droits de seigneur. According to Peter Brooks (quoted in Kaplan, 1992, 60), with the emergence of the bourgeoisie as a propertied class 'the ethical imperative replaces the tragic vision'. The melodrama focus is essentially on the family and moral values and not the dynastic and mythic deities (as it was in Greek tragedy). Thus, the melodrama - at least in these earliest stages - pitted bourgeoisie against feudalism. Many a tale related the ravishment of the middle-class maiden by the villainous rich aristocrat. In this respect, class conflict was repressed sexually and manifested itself via sexual exploitation or rape.

It is important to remember that, as a genre, melodrama also developed alongside nineteenth-century capitalism - and that capitalism gave rise to the need of the family to protect, through the inheritance system, the bourgeoisie's newly acquired possessions (including property). The family becomes the site of patriarchy and capitalism - and, therefore, reproduces it. The Industrial Revolution, for its part, placed the family under new and different kinds of pressures. It brought about the separation of the work from the home environment. Middle-class women withdrew from the labour market and working-class women and children entered the factories - leading to an increased urbanization of the proletariat (Gledhill, 1987, 20-1). This in turn led to the fear of the mob. The middle class felt assailed on both sides, by the aristocracy and the working class. In Europe. in particular, classes became increasingly polarized as opposed to hierarchized as they had formerly been. Since the United States denies, constitutionally, that it has a class structure, it would be fairer to say that its citizens were socio-economically constituted into different groupings. The early melodrama reflects these preoccupations. However, it is noteworthy that the cinematic melodrama, until the Second World War and in some isolated cases until the 1950s, also reflected class concerns.

The end of the nineteenth century marked the birth of the consumer culture. It should be recalled that, prior to the exis-

tence of cinema theatres (the first appearing in 1906), one of the venues for cinema was the department store (both in Europe and the United States). The idea was that the film screenings would attract not just audiences but also customers. Film, then, was very early identified with consumerism. Because it was seen as an integral part of selling consumer culture, it quickly became evident that it was necessary to address a female audience as much as a male one since the woman is supposedly the arbiter of taste in the home — as opposed to the male who is the arbiter of justice outside the home (as in Westerns for example). A legacy of this targeting women through the melodrama is the high investment, if not over-investment, in mise-en-scène — a surplus of objects and interior décor. But this is not the only reason for excessive mise-en-scène (see below).

It is in its relationship to social change and upheaval that melodrama is such an interesting genre to investigate, particularly since it does not marginalize the woman (as do so many other genres). Having been derided for years, in the early 1970s melodrama finally became recognized, in terms of cultural history alone, as an important generic type to examine. Peter Brooks and Thomas Elsaesser, closely followed by Geoffrey Nowell-Smith, were pioneers, examining the genre from both a Marxist and a psychoanalytic point of view. By the late 1970s, given that it primarily foregrounded the female character, it was also taken on as a genre for investigation by feminist film critics (see feminist film theory). Laura Mulvey and Mary Ann Doane led the way, shortly followed by a host of feminist theorists (Kaplan, Mellencamp, Williams, Cook, Gledhill, LeSage, Kuhn, Brunsdon to name just a few).

Melodrama does two things in relation to the social changes and advent of modernization. It attempts to make sense of modernism, and of the family. To take the first point, modernism exposed the reality of the decentred **subject** caused by alienation under capitalism and technological depersonalization (see **modernism**). Melodrama becomes an attempt to counter anxieties produced by this decentring and the massive scale of urban change – hence the 'moral polarisation and dramatic reversals' that structure this genre (Gledhill, 1987, 30). Bourgeois values are felt to be under threat – perhaps because they never had time to become fully established (unlike feudalism) – and, viewed in this light, the melodrama is quite paranoid. Thus, for the bourgeoisie the social, which to them means firstly Victorian

morality and what assails it, must be expressed through the personal (Elsaesser, 1987, 29). The everyday life of the individual must be invested with significance and justification (1987, 29). The melodrama as a popular cultural form takes this notion of social crisis and mediates it within a private context, the home (1987, 47). Melodrama, then, reflects the bourgeois desire for social order to be expressed through the personal. In this respect, we can also see how there is an over-investment in the family, how its starting point is in excess (Gledhill, 1987, 38). Because the social is internalized, there follows an externalization of the psychic states (Gledhill, 1991, 210). In the process of internalizing the former, the latter are pushed out into the open. And because the melodrama is focused on the family, its conflicts and related issues of duty and love, characters adopt primary psychic roles. They are more ciphers than developed personalities, they lack depth. As Gledhill (quoting Brooks) puts it, 'melodrama of psychology' is what you get (1987, 210). Dramatic action takes place between and not within the characters (210).

Melodrama serves to make sense of the family and in so doing perpetuates it, including the continuation of the subordination of the woman. However, there is a twist. In the melodrama, the male finds himself in the domestic sphere (home). So he is in the site no longer of production but of reproduction. The home represents metonymically the site for the ideological confrontation between production and reproduction. The alienation of the labour process becomes displaced (the man brings the experience of alienation home with him) and the family especially the woman and children - is supposed to fulfil what capitalist relations of production cannot (Cook, 1985, 77). The cost of this displacement is repression (sexual) and woman's self-sacrifice. If, for the bourgeoisie of the nineteenth century, melodrama's ideological function was to disguise the socioeconomic contradictions of capitalism, then in the final analysis it failed. Because it reproduces the family and within it the displaced sense of alienation, the melodrama makes visible, in the form of familial tensions, the exploitation and oppression differingly experienced by members of the family. Laura Mulvey (1987, 75) argues that 'ideological contradiction is the overt mainspring and specific content of melodrama . . . its excitement comes from conflict not between enemies, but between people tied by blood or love'. Mulvey goes on to say 'there is a dizzy satisfaction in witnessing the way that sexual difference under patriarchy is fraught, explosive and erupts dramatically into violence within its own private stomping ground, the family'. Finally on this point Mulvey (1987, 76) states that for 'family life to survive, a compromise has to be reached, sexual difference softened, and the male brought to see the value of domestic life'. The male is not in his typically ascribed space, in the work sphere, the sphere of action. He is in the domestic, female sphere which is the non-active, even passive sphere. In order to achieve a successful resolution to the conflict the male has to function on terms that are appropriate to the domestic sphere. In this way he becomes less male and in the process more feminized. And this is undoubtedly one of the reasons why the melodrama appeals to the female spectator. The female spectator also derives pleasure from seeing the ideological contradictions exposed on screen - they provide her with a mise-en-scène of her own experience. As for the male spectator, pleasure is derived from seeing the contradictions 'resolved'.

In this same essay, Mulvey develops these points by relocating melodrama in relation to sexual difference. She distinguishes between the masculine melodrama and its function of reconciliation and the female melodrama and its function of excess and unresolved contradictions. Because patriarchal culture, in its over-evaluation of virility, is in contradiction with the ideology of the family, the male in the masculine melodrama has to achieve a compromise between the male and female sphere. In female melodramas there is not necessarily a resolution or reconciliation. Indeed it is 'as though the fact of having a female point of view dominating the narrative produces an excess that precludes satisfaction' (1987). What Mulvey is arguing is that the female point of view often projects a fantasy that is, in patriarchal terms, transgressive - and so cannot be fulfilled. Despite the fact that in the end the female protagonist loses out, the female spectator identifies with and gains pleasure from her behaviour during the unfolding of the narrative. The example Mulvey quotes is All that Heaven Allows (Douglas Sirk, 1955). A middle-class widowed mother ('past' the age of child-bearing, we are informed) falls in love with her younger male employee, a gardener. But she is only allowed to 'unite' with him once he has been rendered impotent (and bedridden!) by a car accident. For fantasizing too far, she gets only half her man.

Codes, conventions and structures A first point is that whilst there are arguably two dominant categories of melodrama,

(masculine and feminine), none the less as a genre it remains remarkably unfixed in that traces of its generic make-up can be found in many other genres or sub-genres (such as the **musical**, the **thriller** – especially the **film noir** when the hero is pushed to wish his own death – and the gothic thriller of which Hitchcock's work is exemplary). This section makes some general points about melodrama; the next deals specifically with the woman's film and female melodrama.

The melodrama focuses on the victim. The earliest scenarios staged persecuted innocence and the drive to identify the good and the evil. Alternatively, the melodrama offers a triangular setup, with the male tempted away from his family and all that is 'good' (and usually rural) by an 'evil' temptress or vamp living in a sumptuous city apartment. Variations include the 'fallen' woman, the single or abandoned mother, the innocent orphan, the male head of household as ineluctable victim of modernization. The two main driving forces behind the genre are Victorian morality and modern psychology (Gledhill, 1987, 33). For the most part, melodrama is nostalgic: it looks back at what is dreamt of as an ideal time of respectability and no anti-social behaviour. It dreams of the unobtainable - emotions, including hope, rise only to be dashed, and for this reason the melodrama is ultimately masochistic. Melodrama plays out forbidden longings, symptomatic illness and renunciation (Imitation of Life, John Stahl, 1934 has all of these). Before the advent of Freud in a popularized form to the cinematic melodrama in the late 1940s, masochism was displayed in the form of inner violence, the selfsacrificing mother or wife (Stella Dallas, King Vidor, 1937; Mildred Pierce, Michael Curtiz, 1945). In male melodramas the focus was less on masochism - unless the film was in the gangster and subsequently film noir tradition. In the 1930s they focused on the protagonist's unwillingness or inability to fulfil the Oedipal trajectory. French male melodramas of that period, in particular, exemplify this, especially the films starring Jean Gabin. The characters played by James Dean in his films of the 1950s certainly reflect an unwillingness to fulfil society's expectations of male adulthood.

The heyday of the melodrama as far as **sound** cinema and **Hollywood** are concerned is from 1930 to 1960. In the period after the Second World War, the genre became revitalized, thanks to the introduction of a popularized reading of Sigmund Freud. Interestingly, by the early 1950s the male weepie really came

into its own and the focus now became either the father-son relationship as conflict, or the middle-class husband or lover or father who has succumbed to social pressures. Nicholas Ray's Rebel Without a Cause (1955), and Bigger than Life (1956), respectively illustrate these representations. In male weepies, through a portrayal of masculinity in crisis, melodrama exposes masculinity's contradictions. The male either suffers from the inadequacies of his father (Rebel Without a Cause), or is in danger of extinction from his murderous or castrating father (as in Home from the Hill, Vincente Minnelli, 1959), or, finally, he fails in his duty to reproduce (the family), or simply fails his family (Bigger than Life; The Cobweb, Minnelli, 1955). (For more detail on male weepies see Grant, 1986; Schatz, 1981.) Numerous readings can be offered for this development. First, the change in women's lives that resulted from their entry into the workforce during the war gave them an unprecedented economic independence and created great unease for the returning menfolk after the war. Second, the feeling of paranoia generated by the Cold War. and the failure of post-war American ideology to deliver promises, left veterans wondering why they had fought the war after all. And, finally, the fairly dominant presence in the production of this genre of European immigrant film-makers (Sirk, Max Ophuls, George Cukor, Minnelli) and those outside the Hollywood system (Ray) meant that the contemporary United States, and American masculinity in crisis, could be viewed from a distance.

Ideas about psychoanalysis were introduced into film melodrama, where they made women 'safe': women's behaviour was easily explained away through psychology so their psychosis was not a threat. They explained the newly emerging youth culture and revealed the male as victim, trapped in late capitalism. It did not vastly alter the narratives of this genre (so earlier prototypes can always be found), it simply provided open psychological interpretations and discourses to explain why clashes, conflicts and ruptures occur in the family. Thus, the father-figure is marked as more dysfunctional than in the earlier melodrama, he becomes transgressive as in madness (Home from the Hill) or completely ineffectual and unable to uphold authority (Rebel without a Cause). The female is also represented as transgressive, but mostly quite differently from her male counterpart. She puts on display the conflicts at the heart of feminine identity between female desire and socially sanctioned femininity (Kuhn, 1990, 426). Socially

sanctioned femininity – that is, motherhood, and integration into the family – means that she has in the end to resume that position or disappear (All that Heaven Allows; Imitation of Life, Sirk's 1959 remake of Stahl's 1934 film; and, as an earlier example of the disappearing woman, Christopher Strong, Dorothy Arzner, 1932). The female rejoins her male counterpart in the melodramas that position her as suffering from some psychotic malaise: the major difference being that only a doctor – or at least a man – can help her resolve it (as in Marnie, Alfred Hitchcock, 1956 – with an earlier prototype, Now Voyager, Irving Rapper, 1942). However, for an interesting reversal of this plot line (e.g. woman doctor treats male neurotic) see Hitchcock's Spellbound (1945).

The melodrama is an oxymoronic product in that it has to produce dramatic action whilst staying firmly in place; this gives it an inherently circular thematic structure, hence often the recourse to flashbacks (Cook, 1985, 80). This circularity also signals claustrophobia. The melodrama is played out in the home or in small-town environments. Time is made to stand still, suffocating the child, teenager, young adult - especially women. Windows and objects function similarly to suffocate, entrap and oppress. The décor or mise-en-scène become an outer symbolization of inner emotions, fragility or torment (Elsaesser, 1987, 59). And the desire for the unobtainable object or other is just one final nail in the coffin of this claustrophobic atmosphere. The melodrama as a genre turns inwards for drama. So too do the characters, in the form of inner violence which can take the form of substitute acts (Elsaesser, 1987, 56). Aggressiveness by proxy or behaving in a way that is completely at odds with what is desired are forms of displacement-by-substitution (1987, 56). Elsaesser demonstrates how this principle of substitute-acts is Hollywood's way of portraying the dynamics of alienation. And he cites (1987, 64) the pattern of Written on the Wind (Sirk, 1956) as exemplary: 'Dorothy Malone wants Rock Hudson who wants Lauren Bacall who wants Robert Stack who just wants to die'.

Melodramas are often highly stylized. Elsaesser (1987, 53) points out that this is to do with the effects of **censorship** and morality codes – very much in effect until the 1960s. In this regard, style becomes used as meaning. In order to convey what could not be said (primarily on the level of sex and repressed desire), décor and mise-en-scène had to stand in for meaning. Curiously here, as Elsaesser (1987, 54) makes clear, the popular cultural form of melodrama has a modernist function. Given

that the melodrama seeks to be grounded in realism and modernism does not, but wishes to signify through process and form and not content, melodrama, by signifying meaning (repressed desire) through style or form, finds itself making sense of modernism in a most unexpected way (see entry on modernism). On this issue of realism and stylization, Nowell-Smith (1987, 73-4) talks about the syphoning off of unrepresentable material into excessive mise-en-scène and refers to it via Freud's concept of conversion hysteria - the return of the repressed ('if I can't have a phallus, I'll have a doric column'). According to Nowell-Smith, the repressed for the woman may well be female desire, but for the male it is the fear of castration. Acceptance of that fear or possibility is repressed in melodrama at the level of the story but reappears, returns through music or mise-en-scène (Nowell-Smith, 73-4). Gledhill (1987, 9) summarizes Nowell-Smith in the following succinct terms: 'if the family melodrama's speciality is generational and gender conflict, verisimilitude demands that the central issues of sexual difference and identity be 'realistically' presented. But these are precisely the issues realism is designed to repress'.

The female melodrama and the woman's film These two obviously overlapping categories of film have been subdivided by various feminists into different types. Doane (1987) defines four: the female patient, the maternal, the impossible love, and the paranoid melodrama. Kaplan (1992), focusing primarily on the mother melodrama, has three typologies: the sacrifice paradigm, the phallic mother paradigm, and the resisting paradigm. Modleski (1992) speaks of hysteria, desire and muteness as behavioural comportments of women in melodrama. Masochism is everywhere, except in the resisting paradigm – and even there it comes close.

Before going into further detail on these matters, it is useful first of all to consider that most of these melodramas were adaptations of female fiction – particularly those films produced during the 1930s and 1940s. This fiction embraces stories in women's weeklies, women's romance novels and women's historical romances. Second, apart from Dorothy Arzner in the United States, most film-makers making these films were men. Given that the novels at least were often very long, scriptwriters and film-makers went for stage adaptations of the fiction if they existed, or reduced the text to a narrative that held together and lasted around ninety minutes. The point here is that this

leads to a density of **motivation** which in turns feeds into this notion of melodrama and excess (Elsaesser, 1987, 52). The gender shift from female author to male film-maker or **auteur** also poses some interesting questions. Traditionally, the male is used to working in the non-domestic sphere. Here, however, the film-maker finds himself in the very sphere in which he is expected to reach compromise. Thus, not only is he reproducing the site of reproduction by the very act of filming, he is also functioning on terms that are appropriate to the domestic sphere. This potential feminization of the film-maker makes possible an unintentional opening up of gaps for moments of subversion within the filmic text and subversiveness in terms of spectator pleasure – including, of course, readings against the grain (see Modleski, 1988, and her readings of Hitchcock).

In the female melodramas, also known as weepies or tearjerkers, the central character is female and what is privileged is a female perspective. We are in the world of emotions not action. The appeal of the woman's film for the spectator (primarily female, but also male) is the mise-en-scène of female desire. It thematizes female desire, it produces, therefore, female subjectivity. It puts woman's jouissance (unspeakable pleasure) up on screen. Of course, the genre also destroys her for this, in the end. One way or another she is reinscribed into her 'Lawful' place as (m)other (see psychoanalysis). In this respect, it comes as no surprise that women's films function ideologically as repression of female desire and reassertion of the woman's role as reproducer and nurturer. Or, if she is incapable of resuming or assuming that role, then she must stand aside, disappear, not be. The tears come because of the ultimate unfulfillability of desire - the spectator sees only the dream. The dream-fantasy stands for the real (Fischer, 1989, 101).

Women's films then reproduce the scenarios of female masochism (Doane, 1984, 80). As Doane explains, female masochistic fantasies are de-eroticized. This is particularly evident in the impossible love melodrama. Lucy Fischer (1989, 101) examines Max Ophuls's Letter from an Unknown Woman (1948) as an example of masochistic fantasy functioning not as a vehicle 'for sexuality but instead of it'. The woman in the film, Lisa, is seduced as a young woman by a 'brilliant' pianist. He abandons her, she bears his child. Even though she never meets him again, at least not until it is too late, she devotes her life to him. She lives her life through her fanciful desire for him. An entire life

for one night. She survives on imaginary **images** of her lover, thereby substituting fantasy for eroticism (1989, 101). Melodrama reproduces here, unquestioningly, the assumption that a woman's main concern in life is love. The woman in love is the one who waits and as she waits she fantasizes *he* who is absent (1989, 95). Desertion of the man is a frequent trope in this type of melodrama and until recently this meant being left with nothing, including financial support. However, these latter considerations seem never to enter Lisa's fanciful world.

A similar de-eroticization takes place within the paranoid woman's film, often also referred to as the gothic woman's film. This latter typology includes some Alfred Hitchcock vehicles: Rebecca (1940); Gaslight (1944). In both films the woman is entrapped in the house. Doane (1984) talks of these films as 'horror-in-the-home' melodramas where marriage and murder are brought together in the female protagonist's mind. After an often hasty marriage (why, one wonders?) the wife fears that her husband has murderous intentions - she even hallucinates them. However, because the actual narrative assumes that this fear is based in female frigidity, fear of sex or even rape, it is evidently a male fantasy that is up on screen. As Doane says (1984, 79) this has consequences for the gaze and subject positioning. She argues that a despecularization and hence deeroticization takes place because it is supposedly the woman's point of view but it is a male fantasy. This two-way 'gazing' cancels out real agency and similarly empties the gaze of knowledge. A first point, then, is that what gets taken away is female desire. But the question arises: does not the female spectator identify with the female protagonist and get commodified up on screen? Thus we too get positioned masochistically. Further, the 'investigating' gaze may well be female but since we too are positioned in it there occurs a doubling of the fear factor (good suspense tactics if you are Hitchcock, though it says much about his own pathologies!). The twist of course, as we have just noted, is that even though she appears to agence the gaze, she does not really understand what she sees. She misreads the information, often because part of the picture is proscribed her. In these films the home becomes the body (Doane, 1984, 72-3) which the female investigates (remember that in film noir it is usually the male who gets to investigate the female body). This is far too dangerous for patriarchy to countenance. Thus, the male contains a secret space of his own, a final space the woman is

not allowed to see (1984, 80). This space is either within the house (usually a room in the attic) or mentioned by name (so contained within patriarchal law) – as by De Winter in *Rebecca* when he talks of the boathouse. In the end, although she sees, the woman understands nothing. What she sees will only have meaning once the male respecularizes it for her – as De Winter does at the end of the film.

Women's films point to Hollywood's capacity to produce a female subjectivity and then destroy it. This occurs even more strikingly in patient melodramas. Here, female subjectivity, female desire, is rearticulated on to the body as a site of symptoms and illness. Conversion hysteria functions to transfer desire not on to objects or mise-en-scène but on to the body itself. Women suffer from some sort of psychosis. This is induced either by their own sense of guilt, unfulfilled love or transgressive behaviour or by the effects on the psyche of a dominating, aggressive 'phallic' mother. In the first instance, this illness is a 'punishment'. In the second, the illness so cripples the daughter that she cannot entertain 'normal' relations with men. In these films the gaze shifts away from the woman and becomes relocated in the eyes of the male, usually a medical expert who investigates the problem and, naturally, resolves it. Hysteria can cause muteness as in Joan Crawford's case in Possessed (Bernhardt Curtis, 1947) and she can be brought to speak only by the administration of a special drug injected (!) into her body by the doctor. We come to understand what traumatized her through the flashbacks which only the all-knowing doctor can induce. Language then is the 'gift' of the father - he is the Symbolic Order into which she may step at his say-so (see Imaginary/Symbolic). (See Doane's excellent analysis of muteness, 1984, 76-7 and Modleski, 1992, 536-48.)

In phallic mother scenarios, as for example in *Now Voyager*, again it is the male, a psychiatrist this time, who releases the victimized daughter and 'castigates' the bad, possessive mother for oppressing her daughter. Even untrained psychiatrists can dabble in the art, as does the rich business-man Sean Connery in *Marnie*, or the detective in *Mildred Pierce*. The point is that they represent the all-seeing, all-knowing male. The point is also that, under the medical or pseudo-medical gaze, the female body is de-eroticized. But, as Doane says (1984, 80), in patriarchal society 'to desexualise the female body is ultimately to deny its very existence'. It is of course also to deny the woman

the 'epistemological gaze'; effectively 'a body-less woman cannot see' (1984, 80). The point is, finally, that in this way any threat to male dominance is safely contained.

Quantitatively speaking, the melodrama since the advent of sound cinema is not as prolific a genre as other more identifiably male genres. As we have seen, it has produced a great volume of research into its typologies and to its systems of repression. This entry ends on a brief consideration of two types of resisting paradigms to this predominantly repressive genre (primarily of women's desire, but also on occasion of male sexuality). The first type, convincingly argued and analysed in detail by Kaplan (1992, 149–79), is that of the 'modern' or 'liberated' woman. I will focus on just one of Kaplan's examples: Katherine Hepburn in *Christopher Strong* (1932). The second is that of the Gainsborough costume melodramas of the 1940s, analysed in an exemplary fashion by Harper (1987, 167–96).

The Hepburn vehicle is an Arzner film. But, as Kaplan states. Arzner should not be taken for a feminist. She was, it transpires, 'sympathetic' with her hero (rather bizarrely since he is far from 'strong' and quite a cad really). Kaplan argues that the 'film contains an ironic subversion of its surface meanings' (1992, 150). The story concerns Cynthia (Hepburn), an independent woman aviatrix who falls in love with Strong, a married man. He urges her to give up flying. She succumbs to this request; but she also becomes pregnant by him. She decides in the end not to tell him. She bases this decision mostly on his spineless behaviour towards her after their sexual encounter - basically. he gets cold feet and clings to his wife. Crucially, when she asks him 'what would you do if I were pregnant?', he answers 'it'd be my duty to marry you and take care of you first'. Duty is not the word she wants to hear. She takes the fateful decision to attempt an altitude record, thereby ensuring her death - but not without the possibility of Strong discovering the reason. She writes him a note: 'I am breaking my promise to take no more risks; you will know why when I don't come back. Courage conquers everything, even love'. Having given up her desire for self-fulfilment in the public sphere, she now resumes it and the ultimate recognition of her bravery will be the monument erected in her honour.

Cynthia never perceived love and work as a conflict, but patriarchy does. 'Patriarchy can barely permit the coexistence of female erotic desire and female achievements in the public sphere

... but even less can it tolerate *motherhood* outside of marriage' (Kaplan, 1992, 156). Significantly, once her affair is consummated she gives up flying. But what is also significant is that both the affair and her pregnancy reduce her power. She becomes progressively silenced, a passive object to Strong's subject. Her only way to reassert her power is to refuse those positionings (so typical of patriarchy). In returning to flying she reasserts her self against the 'prevailing maternal discourse that threatens to confine and reduce her' (157). We would also add that she rejects the patriarchal discourse as well – even if to do so means death at her own hands but on her own terms.

As far as the Gainsborough costume melodramas (made in Britain in 1944-6 in the Gainsborough Studios) are concerned, the standard definitions of melodrama do not operate. There is no family melodrama - only sexual melodrama. These melodramas were based on novels originally written for the middleclass female reader. However, the films were targeted towards a working-class female audience. The timing of these dramas, during the Second World War, was also fairly crucial to their unexpected success. Beyond the attraction of the female and male stars, the costumes themselves were equally a very important factor for audience pleasure. Clothes couponing was introduced in the United Kingdom during the war (primarily to oblige the labour force to move into munitions); thus pleasure was derived from looking at the stylized, sometimes flamboyant, clothing on screen. These dramas also responded to popular taste in another way, given their historical context. They helped women to be patient about the war, gave them a form of escapism from the real conditions of that time of extreme uncertainty (Harper, 1987, 171). These films were about surplus, excess. There was excess in costume, sexual behaviour and class power, including aristocratic surplus (1987, 172). Aristocracy, gypsies, aggressive women alike all 'exhibit exotic energy' which the audience is invited to take pleasure in (1987, 172). Indeed it is primarily women who are the site for this sexual excess and, of course get punished for it in the end. But only after the audience has seen a movie full of female excess. Pleasure in identification indeed! Retribution for excess can wait until the last frames.

For further reading see Bratton, Cook and Gledhill (eds), 1994; Brooks, 1976; Harper, 1994; Kuhn, 1982; Mayne, 1984; Rosen, 1973.

metalanguage Meta is Greek for 'with' or 'after', thus metalanguage means literally a language with or after a language, a language that refers after another language – that is, a language about a((n)other) language. Metalanguage is an articulated discourse on other discourses, that is, a speech act or text about other speech acts and texts. In this respect, film theory is a metalanguage: it is a language about film texts or discourses.

However, metalanguage does not refer just to languages that are outside but about another language. Texts and speech acts can produce their own metalanguage from within. An example is a narrative that refers to its own narrative procedures: in its self-referentiality it is producing a metalanguage. Film texts when self-referential (pointing, say, to how they are made) serve as their own metalanguage. Embedded narratives - narratives about other narratives in the text - are metalanguages, more commonly termed metanarratives. The effect is often to problematize the **spectator**'s reading of a film. The interrelatedness of the different levels of narration at work in the text function to reposition the spectator - it is not intended for there to be a 'safe' or single reading. Alain Resnais's films are remarkable exemplars of this sustaining of multiple metanarratives, but mainstream cinema of course uses these practices just as widely. The film starring Clint Eastwood, In the Line of Fire (1993) is an excellent example of embedded narratives. In the film Eastwood is responsible for the security of a presidential visit. However, Eastwood's deadly enemy, played by John Malkovich, reminds him over the telephone how some thirty years earlier he failed to protect John Kennedy from being assassinated. We even see Eastwood embedded in the real footage of the Kennedy assassination (thanks to virtual technology). His enemy threatens to reproduce the same failure, and thereupon hangs the plot. The earlier narrative informs and comments upon the present one: will Eastwood catch his man this time and save the president?

metaphor - see metonymy/metaphor

method acting (see also motivation) A style of acting that was adopted by the Actors Studio, founded in 1947 in the United States and which was derived from the Soviet actor and director Konstantin Stanislavsky. The method was to act completely naturally, to so infuse one's own self with the thoughts, emotions

and personality of the character that one became that character. Simultaneously the actor must draw on her or his own experiences to understand what motivates the character she or he is to play. Often the performance is understated — certainly never in excess. The method is seen as totally realistic and is best exemplified by the actors Marlon Brando, Montgomery Clift, James Dean, Rod Steiger and Julie Harris (see, for example, A Streetcar Named Desire, Elia Kazan, 1951; From Here to Eternity, Fred Zinnermann, 1953; On the Waterfront, Kazan, 1954).

metonymy/metaphor According to to the linguist Roman Jakobson, metonymy and metaphor are the two fundamental modes of communicating meaning. Although they are separate in function, they are examined together here as two sides of a coin.

Metonymy From the Greek meta, 'change' and onuma, 'name'. So a first meaning is that metonymy is a substitution of the name of an attribute for that of the thing meant (for example, 'crown' for 'queen'). In speech and writing it means the application of a word or phrase that belongs to one object or subject on to another with which it is normally related (for example, the cleaning person is referred to as the 'daily'). Jakobson also includes under the heading of metonymy the term synecdoche that is, the use of a part standing for the whole (for example, the 'sail' for the sailing ship). In this way, metonymy has come to mean, first, a word representing another word (that is absent but implied) and, second, a term that, although only a part of the term to which it refers, stands as meaning the whole of that term. Thus in film, metonymy can be applied to an object that is visibly present but which represents another object or subject to which it is related but which is absent. Thus, in Orson Welles's Citizen Kane (1941) the toboggan named Rosebud functions metonymically for the mystery that surrounds Kane - an enigma which the journalist tries desperately to unravel. Or the series of objects accumulated on François's mantelpiece, in Le Iour se lève (Marcel Carné, 1939) act as metonyms for his past life to which they refer. They stand as substitutes for the events that have pushed him to kill a man (Valentin). The photograph of a cyclist points to the dream he will never fulfil of going with his beloved Françoise to the sea to collect lilac and mimosas. The teddy bear, which was Françoise's but which he took home with him after being rebuffed for his sexual advances, stands for

him (Françoise remarks on how the two resemble each other, with one sad eye and one happy). It also refers to the potential happiness (the happy eye) he could have had with Françoise had not fate or his own melancholic defeatism (the sad eye) pushed him to destroy that happiness. Finally, the brooch, which is the token of exchange between his rival (Valentin) and the women he has seduced (among them, Françoise), refers to the reason why he killed Valentin.

An opening or credit sequence can function metonymically for the whole of a film (the shots refer to the unravelling narrative to come) - for example, the credits and opening sequence of Alfred Hitchcock's Vertigo (1958). The credits come up over an extreme close-up of a woman's face. In fact the credits are formed out of spirals that emanate from her eyes! In the opening sequence there is a chase over some rooftops. Two policemen, one uniformed, the other (we assume) a plain-clothes detective, are in pursuit of a third man. The detective loses his footing and holds on for grim life as the policeman returns to help him. In his attempt, the policeman falls to his death. The title of the film refers to this incident, which incapacitates the detective from properly investigating a case involving a woman who hallucinates (remember the spirals) and makes suicide attempts by running to the top of towers intent on throwing herself off. The detective's vertigo prevents him from following her.

Metaphor Literally, the transference or application of a name or descriptive term to an object to which it is not in real fact applicable (for example, to go or be green with envy). Similes are types of metaphors (for example, to run like a rabbit). The metaphor then substitutes the known for the unknown, or rather it communicates the unknown by transferring it into terms of the known. In film, metaphor applies when there are two consecutive shots and the second one functions in a comparative way with the first. Take, for example, a lovers' embrace that is followed by a shot of a train running wildly through a tunnel! The second shot communicates the meaning of the embrace — which is unknown, because unseen, at least to the **spectator** — and transfers it into known terms: speed of the train equals rush of emotion, tunnel equals excitement of penetration, and so on.

With metaphors, we come to understand the unknown through reference to the known, through associative relations. In this respect, metaphors function paradigmatically. That is, the unknown gets explained by being inserted into a paradigm – a

framework or pattern, or, in the case of cinema, an image – that is new to it, but known to us. In cinema, an image when used metaphorically functions as a substitute for the real meaning.

Metaphors, then are very visible. They draw attention to themselves. Metonyms are not. And this is why the two terms can be seen as two sides of a same coin. Metaphors render the unknown visible, make the unknown have presence. Metonyms represent what is absent, stand as part of the whole story to which they refer, which is why they work invisibly. In these examples, you can see how metonyms are understood to be such only when the story to which they refer has been told. Until then they seem natural, unnoticeable (see naturalizing). However, they are only one part of a whole, and what if another part of the whole were given? Would the meaning of the story to which it refers change? Metonyms, then, are encoded, they organize meaning in a precise way. Metaphors have to be decoded. The juxtaposition of shots has to be read, understood by the spectator.

A useful way of distinguishing metonyms from metaphors is to understand that metonyms work syntagmatically and metaphors paradigmatically. By paradigmatically what is meant is a system of substitution: an image will act as a substitute for the real meaning and convey that meaning clearly even though it is a substitute (see above on metaphor). By syntagmatically what is meant is that a story is constructed from the part that is given. For example, the fact that we all experience finishing someone else's half-completed sentence; or, in Hitchcock's Strangers on a Train (1951) we know that the broken spectacles belong to the woman who has been murdered: we saw her wearing them earlier, they now refer to her dead body but it is we who supply that part of the story. Metonyms have syntagmatic value: there is a story to which they refer. In film, which works in ways similar to our psyche, metonyms often get the combination of meanings to which they refer played out. Thus, in the example of Le Jour se lève, each object gets explained, has a story woven around it through a series of flashbacks which the protagonist has as he looks at them, picks them up in turn.

mise-en-abîme This occurs within a text when there is a reduplication of images or concepts referring to the textual whole. Chinese boxes or Russian dolls are concrete examples of miseen-abîme – the outer shell being *the* full-size *real* thing, those within a constant referral to the original. Mise-en-abîme is a play of signifiers within a text, of sub-texts mirroring each other. This mirroring can get to the point where meaning can be rendered unstable and in this respect can be seen as part of the process of **deconstruction**. Some examples taken from films will make these points clear.

The film within a film is a first example of mise-en-abîme. The film being made within the film refers through its miseen-scène to the 'real' film being made. The spectator sees film equipment, stars getting ready for the take, crew sorting out the various directorial needs, etc. (as in François Truffaut's La Nuit américaine, 1973). The narrative of the film within the film may directly reflect the one in the 'real' film (as in Karel Reisz's The French Lieutenant's Woman, 1981). Voyeurism gets ruthlessly mise-en-abîme in Michael Powell's Peeping Tom, 1960 - at the same time as it is a mise-en-abîme of cinema itself (for clarification of this point with regard to this film see foregrounding). Mise-en-abîme can also function at the level of characterization: objects serve to reflect the basic nature of a protagonist - for example, games or toys collected by and played with by an adult (male) protagonist point to an inherent childishness, to an unwillingness to complete the Oedipal trajectory.

mise-en-scène Originally a theatre term meaning 'staging', it crossed over to signify the film production practices involved in the framing of shots. Thus, first it connotes setting, costume and lighting, second, movement within the frame. It became endowed with a more specific meaning by the Cahiers du cinéma group (established in 1951) who used it to justify their appellation of certain American film-makers as auteurs (for further clarification see auteur). Given that these directors were working under the aegis of Hollywood they had no control over the script but they could stage their shots and so be deemed to have a discernible style. Mise-en-scène is the expressive tool at the film-maker's disposal which a critic can read to determine the specificity of the cinematographic work. That is, the critic can identify the particular style of a specific film-maker and thereby point to it as an authorial sign.

misrecognition - see psychoanalysis, suture

modernism (see also postmodernism) Modernism is most easily understood as an art movement, although it does have sociopolitical resonances as explained below. You will note from the entry on postmodernism that it is difficult to pinpoint where modernism ends and postmodernism begins. It is better to think in terms of an overlap between the two – an overlap that occurs, first, because not all aspects of art became postmodern simultaneously and, second, because there is not often full agreement, among critics and theorists, on the categorizing of a particular cultural artefact. Thus a novel, say, might find itself being termed a modernist text by one critic but a postmodern text by another. This happens with the novels of Samuel Beckett. This inability to insert a dividing line points to the fact that, to a certain if not considerable - extent, postmodernism reacts less against the conventions of modernism than we might believe, even though we are aware that it must in some way be different, because it comes after (post)modernism. A useful analogy might be drawn with industry. We are acutely aware that we could not now be a post-industrial society if we had not originally possessed an industrial one. Vestiges of our industrialization remain, but they no longer carry the same meaning they once did. Take, for example, the railway systems of the United Kingdom and the United States. These were once heralded as heroic and pioneering in their engineering exploits. Now, in the interest of capital, they have been reduced to a shadow of their former self and face what appears to be permanent decline.

Modernism finds its roots in the Enlightenment period of the eighteenth century and man's (sic) belief in the supremacy of human reason over all other considerations. It was a period that marked the end, or rather decline, in western society of a theocratic (God-centred) interpretation of the world. As evidence of this belief in the power of human reasoning to understand the world, this age was also termed the Age of Reason. This belief in human reason meant that man (sic) could achieve clarity or enlightenment in scientific thought and natural philosophy (that is, natural science - maths, astronomy and physics); he would come to understand the way things really are in the universe and thereby be able to have control over nature and make the world a better place. Jeremy Bentham's enlightened prison reforms came from this spirit - including his concept of the panopticon as an alternative to cell emprisonment and the cruelty of prison treatment. The panopticon was an imagined building

wherein everyone could observe everyone else -a using of the **gaze** as a system of total surveillance. But, as we shall see, the outcome of total surveillance is far from benign.

As such, then, the Enlightenment represented an optimistic belief in progress. Science and technology were man's tools whereby he could implement change. Science, or scientific thought, was the only valid thought, and facts the only possible objects of knowledge. In philosophy the task was to discover the general principles common to all the sciences and to use these principles as guides to human conduct and as the basis of social organization. Man controlled nature and all procedures of investigation had to be reducible to scientific method.

Not all was optimism, however. Even during that period some philosophers expressed disquiet at the totalizing effect of this positivist philosophy of science. Thus a strain of pessimism exists alongside the waves of optimism, a pessimism with which we have to concur if we look at the end of the eighteenth century in France and its bloody Revolution, particularly during the Reign of Terror. Writers of that time pointed to the ends to which man could go. The Marquis de Sade's writings are but one extreme. But consider also the 'humane' invention devised to kill off all those who fell victim to the Revolution: the guillotine. Designed by Dr Guillotine to make death more swift and efficacious and therefore more humane, in the end it allowed for the acceleration of executions because it was so swift. In other words, it became an instrument for mass-execution.

The industrial age of the nineteenth century was a logical continuance of the Enlightenment's belief in science and technology, and represents the optimistic strain of belief in progress. Art, however, echoed the other, pessimistic, strain of the Age of Reason and signified as a counter-culture to scientific thought, producing, first, romanticism (a nostalgia for what was lost) and, second, **realism** (a desire to show the mostly negative effects of technological progress). The Enlightenment then produced two strains, and modernism, as its natural heir, continued in the same vein. Modernism perpetuates the belief in scientific research and the pursuit of knowledge. It believes in the positing of universal truths such as progress of which science and technology were its major proponents. However, it also expresses profound disquiet at those beliefs which it perpetuates.

As a movement we could loosely say that modernism begins at the end of the nineteenth century and 'ends' at the end of

the 1960s, when **post-structuralism** heralded the arrival, if not the existence already, of postmodernism. Modernism was born as a reaction against realism and the tradition of romanticism. As a movement it is often also termed the **avant-garde**. However, it is truer to say that the avant-garde is part of the modernist aesthetic — not all modernist art is avant-garde, but avant-garde art is modernist. In its vanguardism and perception of itself as an adversary culture, modernism is 'relentless in its hostility to mass culture' (Huyssen, 1986, 241). It believes that only high art can sustain the role of social and aesthetic criticism. In this context, modernism's belief in progress means also a belief in modernization — including belief in the 'perpetual modernization of art' (1986, 238) — a constant renewal of that role of art as critique, therefore.

Modernism eschewed the seamless verisimilitude of realism and sought to reveal the process of meaning-construction in art. Formal concerns were, therefore, paramount. To give a couple of examples: with the realist novel, plot and character construction lead us through a narrative where the process of narration does not directly draw attention to itself - we are stitched into the narrative (see suture); a modernist novel, however, deliberately draws attention to its process of meaning-construction from the very first reading - compare a Jane Austen novel with one by Virginia Woolf for example. In painting, the realist aesthetic seeks to create the illusion of 'truth' before your eyes, as in a Constable painting, say. This illusion starts with the principle of perspective which gives a sense of three-dimensionality. A modernist cubist painting removes perspectival space and transposes the three-dimensions 'truthfully' on to a flat twodimensional surface. So, in a Picasso portrait, the eves are flattened out on to the canvas and the nose is placed to the side of the face and not between the eyes. Similarly, just as the novelist draws attention to her or his own mode of meaningproduction, modernist painters draw attention to the materials they use (for example Georges Braque, Jackson Pollock). In that respect, modernism is highly self-reflexive (art referring to itself).

As we know, the modernist movement and the avant-garde are closely associated with modernization and as such espoused a belief in its tools and an investment in self-reflexivity that was deliberately counter-illusionist. None the less, not all its proponents were of the optimistic vein. Indeed, many expressed a mistrust of science and technology – even though, as we have

already noted, they were inextricably part of it. This mistrust was characterized by a deep pessimism about the modern world and came about as a result of the brutal effects of science and technology on human life in the First and Second World Wars. The wanton destruction of human lives through chemical warfare, bombs of mass extinction, the using of technology and architecture to create a final solution - as in the case of the Holocaust – all these were products of man's reason. It may not be possible to see fascism purely as a formidable crisis of modernist culture (Huyssen, 1986, 268). However, it is not impossible to see it as a logical end to the principles of modernism taken to their extremes of anti-humanism. In this respect, then, modernism embraces the two strains evoked in the case of the Enlightenment. The tragedy, and thereby the paradox, for the modernist artist is being part of the culture and age that she or he in some regards despises: 'I am part of this age of self-reflexive formalism that can also build the technology for mass destruction'

It is here that we can see a first set of paradoxes inherent in this movement (as we would in any movement of course). The paradox is this: in its self-reflexivity and focus on the individual, modernism seems quite anti-humanist. Yet, in its mistrust of science and technology, it has all the appearances of a relative humanism. This is further compounded when we consider that the modernist age evolved alongside, and in certain domains was part of, modern industrial technology. If we consider architecture we can make this point succinctly. Modernist architecture believed in drawing on all materials possible - especially modern materials, such as reinforced concrete - to construct buildings heretofore unimaginable. And vet – and here is the anti-humanist aspect of this movement - in its belief in the functionality of cheaply produced materials and their being put to use in the building of community spaces in a rationalized and standardized fashion (as with Le Corbusier's ideal concrete village) it has left many countries with a legacy of concrete jungles and towers which, though inhabited, are essentially uninhabitable. Belief in the unending potential of its materials led modernist architecture to profoundly anti-humanist practices.

Another, related and important, aspect of modernism that needs explaining is the mood of alienation and existential angst that pervades this movement and which comes about as a result of the climate of pessimism generated by the two World Wars.

This mood of alienation emanates from a sense of fragmentation of the self in the social sphere and a concomitant inability to communicate effectively with others. This fragmentation of the self, in turn, raises the question of identity: 'who am I in all of this?' In terms of its manifestation in modernist art, this tendency can best be illustrated by the novel. In the modernist novel, there is no traditional narrative of beginning, middle or end, nor is there an omniscient protagonist. Character definition is mostly, if not totally, absent. In its place, an interior monologue or stream of consciousness explores the subjective experience of an individual. The coincidence of the beginning of this movement with the emerging importance of psychoanalysis especially in the work of Freud - cannot be sufficiently stressed. It is clear that it had a significant impact on modernism and made possible the exploration of the inner self as a way of, if not responding to, then at least describing the effects of alienation on human individuality. In this regard, then, modernism is again very self-reflexive.

Lastly, in its belief in a unified underlying reality modernism once more shows its debt to the Enlightenment. However, as we have already made clear, this leads to conceptual strategies that end up having ideological implications in that modernism can help to legitimate structures of domination and oppression - as in the use of technology in war time mentioned above. In this regard, we can perceive other structures that it has served to legitimate - structures of class, binary structures around sex and race, and so on. Modernism's belief in a rationalistic interpretation of the world found its acme in the 1950s within critical theory and philosophy. The whole concept of structuralism can be seen as an attempt to provide a reassuring set of underlying structures that are common to all: be it in the domain of the human brain, language, cultural artefacts, social organization and so on. Structuralism was to have an important impact on film theory and, albeit to a much lesser degree, on film itself. (For further details on this last point see Gidal, 1989.)

If we now consider cinema's place in the modernist period we come up against a first apparent contradiction. Technologically speaking, the camera, although a modernist artefact, is seen as an instrument for reproducing reality and, as such, it is more readily associated with realism than modernism. The entire cinematic **apparatus** is geared towards creating the illusion of reality

A STATE OF THE PARTY OF THE PAR

and it achieves this primarily through the very seamlessness of its production practices. Second, as John Orr (1993, 60) points out, the camera as a technological instrument has grown up as part of the culture of surveillance. It is also part of war technology - for example the wide-angle lens, which made cinemascope possible, is a product of First World War technology, produced as it was for tanks' periscopes to give a 180-degree view. War technology turns the weapon, the camera. into a gaze. 'Knowledge of the image becomes a form of potential capture of the symbolic, seizure of the image, and as we know the human gaze is part of this quest for knowledge, including self knowledge, a form of mirroring' (Orr, 60). The camera is also extremely self-conscious, not just because it reflects itself but also because someone (film-maker, spectator) has to watch what the camera is watching for it to have any 'meaning'. In its self-reflexivity the camera has built into it the very essence of modernism which it could exercise provided production practices do not render its operations invisible. But, of course, this is precisely what mainstream narrative cinema does.

However, as with all other art forms, cinema also has its avantgarde - although, unlike other modernist art forms, it is not explicitly hostile to mass or popular culture. In fact, many avantgarde film-makers wanted their work to reach mass audiences. Modernist cinema should be seen, therefore, as a global term that includes the work of film-makers of the avant-garde - which, depending on the period in history, can mean surrealist cinema, counter-cinema and underground cinema (to name but the most obvious). The work of these film-makers explores and exposes the formal qualities of film. Modernist cinema, in privileging formal concerns, is one that makes visible and questions its meaning-production practices. In this regard, modernist cinema questions the technology it uses, questions its power of the gaze, questions its power to represent (among other things reality, sexuality, and, just occasionally, the female body). It questions how it represents and what it represents. Modernist cinema turns the gaze into a critical weapon, turns the camera as an instrument of surveillance upon itself, starting with the fragmentation, destruction or deconstruction even of classic narrative structures.

Modernism focuses on questions of aesthetics and artistic construction. And much of modernist cinema follows that trend. Formal concerns are **foregrounded** over content. Certainly, the **Soviet cinema** of the mid- to late 1920s espoused the modernist

principles of meaning being produced from style - principally from editing styles. And the montage effects, produced by fast editing, of Sergei Eisenstein's films (such as Strike and Battleship Potemkin, both 1925) influenced other European cinemas of the avant-garde. The avant-garde and surrealist cinema in France of the 1920s is another early manifestation of this modernist trend. Film-makers of this generation in the early 1920s, were interested in the visual representation of the interior life of a character. that is, a formal rather than narrativized projection on to screen of the character's subjective imaginings and fantasies - dreams even (as in Fièvre, Louis Delluc, 1921, about female subjectivity, hallucination and desire). This subjective cinema gave way by the mid-1920s to a concern with the plasticity of the medium and its temporal and spatial qualities. The intention was to create a pure cinema where film signified in and of itself through its rhythms and plasticity (for example Jean Epstein's Photogénies, 1924; René Clair's Entr'acte, 1924). Later in the 1920s a third avant-garde was conceived out of the earlier two modes. Under the influence of surrealism, this avant-garde cinema became interested in how the temporal and spatial properties of film as well as its plasticity could be employed to reflect the workings of the unconscious – especially its suppression of sexual obsessions or desires. Germaine Dulac was. arguably, the first to combine surrealist and avant-garde preoccupations in her film La Coquille et le clergyman (1927).

The various American avant-garde movements of the 1930s and 1940s pursued the French avant-garde tradition, particularly in its latest manifestation. Maya Deren's haunting *Meshes of the Afternoon* (1943), is an exemplary film in this respect. Deren stars in this film of paranoid dream fantasies. Her experimental play with time and space is just one way by which she achieves this sense of paranoia. By using a loop system (a single piece of film that is continuously repeated) with a sequence of a young woman fearfully coming down an anonymous street, traditional notions of time and space are eroded – instead we feel the urgency and inescapability of the woman's fear as well as the timelessness in which it is felt.

The American avant-garde of the 1960s to the mid-1970s, when it more or less died out (see also **underground cinema**), tends to echo the middle period of the French avant-garde with its notion of pure cinema. It produced, among other cinemas, a minimalist cinema – where the pro-filmic event (that which

the camera is aimed at) is reproduced on screen and becomes, simultaneously, the filmic event (Gidal, 1989, 16). These films were either performed events involving the film-maker or a static camera standing outside a building for hours on end. In each case, time itself is being filmed. Andy Warhol's film *Empire* (1965) is an extreme case. He left his camera running for eight hours outside the Empire State building. Generally speaking, Warhol was more contained, shooting in single takes of thirty minutes (for example *Kitchen*, 1965). The plasticity of the film was also explored by either painting on to it or scratching it and by the use of tight compositional editing (as in Carolee Schneeman's *Fuses*, 1964, which uses all three modalities to provide an intimate portrait of a couple's sexual relationship).

As we indicated above, some modernist cinema, within its formal probings and experimentation, also addressed questions of subjectivity and sexuality. However, it is not a cinema that is readily associated with politics per se. That being said, at certain points in history, aesthetics and politics do combine to produce a political cinema, particularly in Europe. Jean-Luc Godard, in the mid- to late 1960s talked about making a political cinema politically. By that he meant making political films through a political aesthetics of film. As with the other, primarily aesthetic modernist cinema, the process of meaning-production is exposed. The difference here lies with the non-subjective intentionality of this political cinema and the greater degree of fragmentation of meaning-production. In the first instance we are privy no longer to the inner workings of the mind but, rather, as to how ideology constructs us. In the second instance, fragmentation, the gaps between signifier (the meanings produced) and the signified (the modes and means of production) are opened up and the relationship between the two is exposed. The illusion of realism and its ideological resonances are made transparent. The film as sign and as myth is deconstructed before our eyes. Godard, Agnès Varda and Margarethe von Trotta are exemplary film-makers of this second tendency of modernist cinema - a political aesthetic cinema, what is also known as counter-cinema.

A summary of episodes in Godard's film *Pierrot le fou* (1965) can serve as an illustration. Near the beginning of the film Ferdinand (alias Pierrot), who is in the advertising business, is obliged by his Italian wife to attend a cocktail party. He turns up with her, an unwilling guest. This seemingly 'innocent'

beginning is in fact a reference to the state of the French film industry which, in order to compete against Hollywood products, had found itself since the mid-1950s obliged to make co-productions with Italy. At the party, the entire shooting of which is through a pink filter, women and men talk to each other in advertising-speak - but this advertising-speak is also gendered: women, therefore, talk in advertising-speak about bras and hair products, men about cars and the like. At one point Ferdinand asks an American film-maker, Sam Fuller, 'what is cinema?' To which he gets the answer: 'film is like a battleground: love, hate, action, violence, death, in a word, emotions'. At the end of this sequence, Ferdinand picks up a huge piece of angel cake and throws it at a woman's face. He then runs out of the party and dashes home only to elope with his former lover of five years past, Marianne, who just 'happened' to be the babysitter for the evening.

Sam Fuller, then, speaks in the same clichés as the rest of the guests. Hollywood is as empty and full of air as the advertisingspeak and the angel cake (a cake that is particularly American). Marianne, the symbolic name of France, might just rescue Ferdinand/Pierrot from the 'hell' in which he finds himself. In other words, the French film industry might just be able to avoid going under as an indigenous industry in its own right not only by foregoing co-productions with Italy but also by refusing to follow the candy-floss practices of Hollywood (hence the pink filter) and refusing to opt for the safe classic Hollywood narrative (as exemplified by Fuller's clichés) but choosing to run with its own talent (the eloping with Marianne). Of course the ending of the film, where both protagonists die, makes it clear that this is ultimately a utopian scenario. And, as recent figures show, Hollywood is in an even more dominant position in France than it was at the time of the making of this film (in a tenyear period, 1981–91 the American share of the market in France has grown from 35 to 59 per cent).

But Godard does not confine his political statements to the celluloid war. Pierrot le fou is his first ostensibly political film and several international crises get similar parodic treatment, namely, the Algerian crisis and the Vietnam War. Let's take a look at the latter. Much later in the film, Ferdinand and Marianne – who have escaped Paris to some idyllic island in the sun – find themselves strapped for cash. They take a boat over to the mainland where they know they will encounter some American tourists

and be able to fleece them thanks to their brilliant storytelling skills (incidentally, we have already seen that Ferdinand, at least, is not particularly successful at this). Marianne 'disguises' herself as a Vietnamese woman (she actually looks more like a geisha girl) and Ferdinand dons an American sailor's cap and blazer. Their audience is composed of two or three American sailors. Ferdinand and Marianne then act out a sketch, in a Punch and Iudy style, that purports to reflect the United States/Vietnamese conflict. The actual filming of the sketch is very flat, giving the screen a comic-strip appearance and the colour is extremely hard (during his 1960s period Godard almost invariably used Eastman Kodak colour, which allows, in its processing, for the primary colours to be singled out, thus giving a harshness and violence to the image). The sketch shows Ferdinand/'Uncle Sam' dominating Marianne/'Uncle Ho' through brutal if senseless words: 'Hollywood, YAH! New York, YAH!' he yells as he swigs at a bottle of American whiskey - Marianne/'Uncle Ho' meantime crouches, cowed, mumbling in pseudo-Vietnamese. Ferdinand/ 'Uncle Sam' also holds a 'pretend' pistol which he continuously aims at Marianne's/'Uncle Ho's' head.

Godard's prescience is extraordinary here. It is noteworthy that in the mid-1960s, American opinion was very much behind the sending of its troops to Vietnam. By the late 1960s and early 1970s, however, opinion was wavering and was in the end radically changed thanks in part to television coverage. The then president, Richard Nixon, believed that television coverage might galvanize waning support for the war effort. It did precisely the opposite. One image in particular - the holding of a gun to a Vietnamese civilian's head and blowing his brains out - was crucial in turning public opinion against American intervention in Vietnam. The sketch in Godard's film ends with a matchbook made into an aircraft which is on fire and about to crash. Ferdinand holds the matchbook in his hand so that it also looks as if his hand is on fire - a clear allusion to the use of napalm in the war (recalling another image of a little Vietnamese girl running down a road with her back on fire). The Americans, throughout the sketch, respond with stupid, vapid comments: 'Hey, I like that!', 'It's really good' - when the sketch is patently not good but embarrassingly crude.

By placing such an internationally crucial issue within the context of evidently inappropriate cultural texts, the comic strip and Punch-and-Judy vaudeville, and filming it in elemental and

violent colour while simultaneously flattening the image, Godard achieves, through visual parody and irony, a far more virulent satire than he would have done through a straightforward polemic. Nor should it be forgotten that the presence of Sam Fuller at the beginning of the film now has a further resonance: Fuller is *the* American film-maker most associated with the spate of Cold War movies made during the 1950s and his films, set in Korea, were notorious for their extreme violence (see war films). Viewed in this light, Fuller's words uttered at the beginning of the film now take on different dimensions.

montage - see editing, Soviet cinema

motivation Motivation functions on a number of levels within a film to give the diegesis verisimilitude; it is a cinematic convention designed to create naturalism. David Bordwell (in Bordwell, Staiger and Thompson, 1985, 19) defines four types of motivation which serve to give a film unity and make the film's causality seem natural (see naturalizing): compositional, realistic, intertextual or generic, and artistic. Compositional motivation means the arrangements of props and specific use of lighting if necessary as well as the establishing of a cause for impending actions so that the story can proceed. For example, a dimly lit room in which only one object, the telephone, is highlighted suggests that the phone will ring and the protagonist will answer it and take action as a result. Realistic motivation concerns setting. The decor must be motivated realistically. So, in an historical reconstruction attention goes into every detail (costumes, sets, objects, etc.) to ensure that verisimilitude prevails. Realistic motivation also includes narrative plausibility. Motivation for actions must appear realistic. Generic motivation means that all genres have codes and conventions which they follow. Thus, although a musical is intrinsically not compositionally or realistically motivated, within its own specificity the singing and dancing are entirely justified. Intertextual motivation, the complement to generic motivation, refers to the justification of the story as it relates to the conventions of other similar texts. Bordwell (1985, 19) quotes the Hollywood film narrative: 'we often assume that a Hollywood film will end happily simply because it is a Hollywood film'. Or the star can be the source of intertextual motivation: if she or he is a singer as well, the audience will expect a song. If she or he leads in real life the life she or he is portraying on screen, that again is a form of intertextual motivation (guaranteeing authenticity as well as **realism**). Finally artistic motivation appears when the film calls attention to its own aesthetics. With Hollywood this happens particularly when the technical virtuosity of filmmaking practices is highlighted, as in the studio spectacular.

For more detail see Bordwell in Bordwell, Thompson and Staiger 1985, 12–23 and 70–84.

musical (see also **genre**, **studio system**) This entry is in two parts: a schematic history of the genre and an overview of its structures and strategies.

History The musical is seen as a quintessentially American or Hollywood genre, in much the same way as the western. Unlike the western, however, it is a hybrid genre given its descent from the European operetta (particularly Austrian) and American vaudeville and the music-hall. Although Alan Crosland's The Jazz Singer (1927) is generally accepted as the first sound film, the first all-talking, all-singing, all-dancing musical was the The Broadway Melody (1929, directed by Harry Beaumont). It is a noteworthy musical for a number of reasons, not least its title, which generated three further Broadway Melodies in the 1930s alone. Noteworthy too because its title refers topographically to a major source of Hollywood musicals. New York's Broadway. Furthermore, it established the tradition of the backstage story as an integral part of the musical. This tradition developed also into the sub-genre of the backstage musical - of which Singin' in the Rain (Stanley Donen, 1952) is arguably the best exemplar. The Broadway Melody also brought the lyricist Arthur Freed to the attention of the MGM mogul Louis B. Mayer who by the mid-1930s had finally agreed to give him a relatively free rein as producer. Freed was responsible for a major shift in the conventions of the musical, which during the late 1920s and early 1930s had been fairly conservative. He was also responsible for convincing MGM of the need for a stable of musical stars.

MGM is the studio most readily associated with this genre. However, one of the first all-time great musical pairings – Fred Astaire and Ginger Rogers – was with RKO. In 1933 Astaire and Rogers were paired up as a supporting team to the main

story in Flying Down to Rio (1933). Audience response was such that they became an overnight success, and during the 1930s they were regularly RKO's best box-office hit and the ideal romance couple (at least on screen). Traditionally they played the roles of the man-about-town sophisticate and the girl next door and their story was set in contemporary times. The other famous romance pair of that period, Jeannette MacDonald and Nelson Eddy, figured for the first time together in 1935 in an MGM production, Naughty Marietta (directed by Woody Van Dyke). This romantic couple appeared mostly in costume operettas and often the roles were reversed, MacDonald being the woman with class and Eddy the penniless prisoner (as in their first film) or in the role of some kind of out-of-society type (as in New Moon, 1940).

Musicals at this time had a fairly naive plot and were primarily perceived as vehicles for song and dance. However, it is worth considering just what this means. First of all, the narrative did incline towards simplicity - and was based on the Cinderella/ Prince Charming myth. Often it was a case of 'boy meets girl, boy hates girl/girl hates boy', but because there was such an undoubted attraction they come together in the end: 'boy gets girl'. It is in this respect that, as Richard Dyer (The Movie 75, 1981, 1484) says, the musical points to its generic and ideological function as a 'gospel of happiness'. But, as far as the singing and dancing were concerned, routines and performance were a far more complex affair. Some of the greatest names from Broadway - lyricists and composers - were brought in by Hollywood: Cole Porter, Irving Berlin, Ira and George Gershwin, Jerome Kern, Rodgers and Hart, a bit later Oscar Hammerstein. The reason for bringing such talent in was twofold. In the early 1930s the musical genre was experiencing a slump, much like the rest of Hollywood, because of the Depression. To bring some excitement and panache into the musical and thereby attract audiences, Hollywood decided to buy in Broadway hits. In referring to Broadway, Hollywood also sought to bring artistic clout to its own productions.

These great names of American popular music did much in the 1930s to shape the look of the musical. At first, because they were commissioned to package songs for the films, the song and dance routines were worked through more like items in a review show. The songs paid little attention to plot and characterization. Indeed, characters seemed to burst into song and dance in an artificial and arbitrary way. Alternatively, the breaking into song and dance was given a rational explanation - for example, tapping a rhythm or something tapping a rhythm. or using a specific word or expression that necessarily introduces a song. However, once Fred Astaire had broken into the big time this changed and, because of his meticulous planning of his dance routines, composers were brought into closer alliance with the actual production practices. For example, Astaire's work in collaboration with Irving Berlin and Jerome Kern certainly produced some of the best musicals of the late 1930s. Astaire insisted on full shot photography with no cutting away for his dance routines, whether solo or with Ginger Rogers (with whom he made nine films during the period 1933-9). This meant that music and choreography had to be worked out in the minutest detail. Music and dance informed each other (as for example in Top Hat, 1935; Follow the Fleet, 1936; Carefree, 1938).

The other move in the 1930s to counter the slump brought on by the Depression came with the highly stylized films of Busby Berkeley – the master of drill precision with his fanciful and abstract approach to dance routines using hundreds of chorus 'girls' to create geometrical patterns through their movements under the eye of the camera. His 1930s films (made for Warner Brothers) were almost pure spectacle with little attention to narrative but full focus on the capacity of the human form to exude an erotic sensuality. To this effect he used a single camera that roved over the human formations through either tracking or crane shots. Berkeley was the first to put female nudity into the musical (Roman Scandals, 1933); he is equally famous for his 'crotch shots' (Gold Diggers of 1933). As Altman (1989, 257) puts it, Berkeley offered sex through the gaze with the camera acting as the eve - in his spectacles 'the show's power (was mainly) identified with the woman's lure'.

By the end of the 1930s the musical was on the wane again. Ginger Rogers had split from Fred; MacDonald and Eddy were very faded stars indeed. Several strategies were adopted. At MGM, thanks to Freed's insistence that talent should be nurtured amongst the contract actors and thanks too to his success in producing *The Wizard of Oz* (Victor Fleming, 1939), a new musical formula was introduced. This combined youth and music in the form of the 'kids putting on a show' musical. The star vehicles were Judy Garland (launched by *The Wizard of Oz*) and Mickey Rooney (already a star for his Andy Hardy series).

Together they made four musicals in this vein (Babes in Arms, 1939; Strike up the Band, 1940; Babes on Broadway, 1941; Girl Crazy, 1943). At Universal, child actors were used as well, but this time as a vehicle for bringing popular classics into the musical arena. Thus Deanna Durbin sang her way through One Hundred Men and a Girl (1937) and managed to persuade the great conductor Stokowski to conduct an out-of-work orchestra. By the 1940s other, new formulas were introduced. To the classic musicals and putting-on-a-show musicals were added composer biographies (Yankee Doodle Dandy, 1942; Rhapsody in Blue, 1945; Till the Clouds Roll By, 1946; Night and Day, 1946; Words and Music, 1948) and biographical musicals of 'stars' with a show-biz background (Lillian Russell, 1940; Incendiary Blonde, The Dolly Sisters, both 1945).

Of these three traditions it is the last, the 'life-stories' of performers, that fared best in terms of continuation. They went on well into the 1950s and indeed into the 1970s as with A Star is Born (1954); I'll Cry Tomorrow (1955); Lady Sings the Blues (1972); The Rose (1979). What is interesting is that it is mostly the biography of female performers that 'fascinates'. Generally speaking their story is one of an unprecedented rise to success followed by a slow decline through drugs, alcohol and selfneglect - even though they carry on singing. Implicitly fame is too hard or hot for them to handle. Ironically (since it was the opposite of the real-life situation), of the four films quoted above only A Star is Born is an exception - with the husband (played by James Mason) of the emerging star (played by Judy Garland) being the one to fall into alcoholic decline. It is worth matching this prurient concern with falling or failing female performers with the counter-practice of a literal White-washing of a male composer's biography: Cole Porter's in Night and Day. Porter, a homosexual, is portrayed in the film as a straight male (played by Cary Grant). But then little in the other composer biographies was true either!

It was, however, Freed's conception of the musical that was greatly responsible for revitalizing the genre and marking it out as an MGM product, particularly during the 1940s and 1950s. His idea was that song and dance should move the narrative on, that there should be nothing arbitrary about the introduction of song and dance – indeed that the progression from speech to song to dance should be a natural one (see **naturalizing**). Apart from Judy Garland, Gene Kelly (who had been signed up

from Broadway in 1940) was another star vehicle of this period to carry out Freed's conception of a greater **naturalism**. To this effect, Kelly was instrumental in introducing the contemporary urban musical such as *On the Town* (1949), which closely integrated song, dance and story and which was partly shot on location. Similarly, *An American in Paris* (made in 1951, but for which the music had been written in 1937 by George Gershwin shortly before his untimely death) portrayed the vitality of the musical scene in Paris in the late 1930s with the heavy influence of jazz and contemporary music. By the mid- to late 1940s contemporary music in musicals, under the influence of Glenn Miller and Duke Ellington (to name but two), also included Big Band Swing (see *The Glenn Miller Story*, 1953).

Freed's other smart move was to bring the Broadway director Vincente Minnelli to MGM. With a reputation for lavish and stylish musicals on stage, Minnelli was none the less also a firm believer in the integrated type of musical Freed advocated. His first film musical was with an all-Black cast, *Cabin in the Sky* (1943). He then went on to work with Judy Garland and together they produced some of their best work: *Meet Me in St Louis* (1944), *Till Clouds Roll By* (1946) and *The Pirate* (1948).

By the late 1940s, Astaire was persuaded out of early retirement by MGM and enjoyed felicitous dance pairings with Judy Garland and Cvd Charisse. He also joined the studio that housed his only 'real' rival, Gene Kelly. Their styles are so different, however, that rather than considering them as rivals - at least with hindsight - we might better see them as exemplary of the two dominant tendencies of the musical as it relates to the American cultural system: that is, to selling marriage (Altman, 1989, 27). On the one hand, there is the stylized inventive elegance of Fred Astaire; on the other, the brash energetic experimentation of Gene Kelly. Astaire is the witty, cool man about town who gets his woman. Kelly, with his edgy over-insistence on his virility, remains a man-child who is not too convinced about marriage. In terms of a legacy it is fair to say that between them and with Garland and Charisse they helped to revitalize the musical and became part of the heyday of the 1950s colour musical that also included other great musical stars such as Frank Sinatra and Bing Crosby.

The period 1930–60, despite some severe dips, marked the great era of the Hollywood musical. By the 1950s, the studio system was on the decline and there was an increasing need to

target audiences more systematically. Popular Broadway hits still made it on to the screen (for example Oklahoma, 1955; The King and I, 1956; South Pacific, 1958, and - imported from Britain - My Fair Lady, 1964). But dwindling audiences meant that new strategies had to be developed. Thus, Hollywood linked up with the record industry as a means of targeting a new audience: the youth class. So a spate of teenager musicals was produced, mostly starring Elvis Presley - who if he could not act could certainly sing and dance. Presley, literally, sold sex through his song and dance routines (arguably his most famous rock musical is Jail House Rock, 1957). Britain briefly imitated this trend, primarily in the Cliff Richard series of musicals (such as Expresso Bongo, 1959; Summer Holiday, 1963). However, these solo star performances - at least in the United Kingdom - were soon superseded by pop group musicals in the form of the Beatles (A Hard Day's Night, 1964; Help!, 1965).

The trend in the so-called 'hip sixties' was also for a greater **realism** in the musical and non-musical stars. West Side Story (1961) is exemplary in this respect. Set in Manhattan, it tells the story of rival gangs (Whites versus Puerto Ricans). A modern Romeo and Juliet narrative, the film treats racism, juvenile delinquency and young love in a serious fashion. It is also one of the first musicals to create a more believable world and to end in tragedy. This greater realism in the musical gets carried into the 1970s with the disco-dance musicals of Saturday Night Fever (1977) and Grease (1978), both with John Travolta (the former film made him into a star – for a while).

The 1970s saw a profusion of rock musicals that ranged from documentary types (Woodstock, 1970) to realism (the Jamaican film The Harder They Come, 1972) to fantasy-cum-flower-power (Godspell, 1973; Jesus Christ Superstar, 1973; Hair, 1979). But the early tradition of the 1930s did not disappear – the exemplary star vehicle for the traditional musical was Barbra Streisand. Just a few of her films serve to show not just how prolific she was (and still is), but how her range goes from comedy to tragedy to performer biography and so incorporates the heritage of the traditional musical from 1930 to 1960: Funny Girl (1968); Hello Dolly! (1969) (performer biographies); On a Clear Day You Can See Forever (1970) (comedy); The Way We Were (1974) (tragedy); Funny Lady (1975), and so on. Indeed, even after its heyday, the musical – albeit on the decline – never fully abandoned its traditional values. For example, Robert Wise, who directed West

Side Story, went on to direct The Sound of Music (1965) – a sweetly sugary musical that in the final analysis sells marriage. And in France, Jacques Demy had a brief stab at the genre, combining realism with sweet sugariness, with Les Parapluies de Cherbourg (1964) and Les Demoiselles de Rochefort (1967).

As a genre, the musical is now very much on the wane and just occasionally reappears in fairly unextravagant forms such as the backstage musical, for example Fame (1980). Dancing or road movie musicals that use contemporary songs for their musical soundtrack represent another inexpensively produced form of musical. John Travolta resurfaces in Staying Alive (1983) to dazzle us with his disco-dancing technique. The Australian-produced Strictly Ballroom (1992) sets a teenage love story within a ballroom dancing contest. Finally, camp comes to the musical in explicit style with the very gay and very funny Adventures of Priscilla, Queen of the Desert (1994).

Structures and strategies (In this section I refer to several useful and important studies on the genre: Dyer, 1977 and 1986; Feuer, 1982; Altman, 1989.) The musical is extremely self-referential; it spends most of its time justifying its existence – as, for example, with the putting-on-a-show musical (one of the most common generic types) – 'the show must go on!' In this type of musical there is a double referentiality pointing to the narcissistic and exhibitionist nature of the genre. Apart from the sombre-ending musicals, the general strategy of the genre is to provide the **spectator** with a utopia through the form of entertainment. The entertainment is the utopia. So again self-referentiality is at work.

According to Dyer (1977a, 3) there are five categories functioning within this utopian sensibility: abundance, energy, intensity, transparency and community. All are related to the ideological strategies of the genre: selling marriage, **gender** fixity, communal stability and the merits of capitalism. Abundance starts with the décor and the costumes – it insists on the United States' wealth and well-being. Energy is the dance and song routine, but also the camera-work – it is also the hallmark of (White) America's pioneering spirit. Intensity derives from the sense of intimacy that the spectator takes pleasure in when watching the body perform – literally, the body 'putting-itself-on-show'. Transparency refers to the reflection the musical purports to give on the American way of life of which the folk community is an essential ingredient. Altman (1989, 25), for his

part, talks of the musical as an 'ode to marriage' and the marrying of riches (as exemplified by the male) to beauty (in the form of the female). The musical must also be seen in the light of its contextual relationship with social moments (such as the Depression) and structures of pleasure – especially since it is not always the female form that we enjoy watching dance. For example, Gene Kelly and John Travolta provide, albeit in somewhat different ways, visual pleasures that have more in common with each other – starting with the insistence on virile sexuality – than the visual pleasure offered by Astaire.

Altman (1989, 27) makes the point that cause and effect are fairly tenuous in the musical and that it is less a case of chronology or psychological motivation than one of paralleling stories in a comparative mode. He is of course referring to the classic period of the American musical (1930-60) - although his reading still holds true for the reprise classic musical (the happy love musical) that persists after 1960. In that it reconciles terms that seem irreconcilable (starting with sexual difference), the musical 'fashions a myth out of the American courtship ritual' (1989, 27). The musical then is based on the principle of duality or pairings, of male/female oppositions, which it ultimately resolves. Thus the paralleling serves to set up a series of binary oppositions, starting with the one based in gender. Each of the two characters embodies the opposite of the other and it is those oppositions that must be resolved for marriage to occur (1989, 24). These oppositions are what Altman calls dualfocus structures (1989, 19). They generate a chain of oppositions: sexual, background, national origin, temperament, age, colour of hair. Thus, for example, in Gigi (Vincente Minnelli, 1958) characters are paired: Gigi with Gaston, and Gigi's grandmother with Gaston's uncle. Settings, locations, trips and songs are paired. Roles and activities are paired: Gigi is the girl-child about to emerge into womanhood; Gaston is an established businessman, she is frivolous, he serious. However, as their story develops he takes to fun and she to being more serious. Their marriage then becomes a merging of adult and child qualities as well as a containment of the generational problematic and its potential incestual value. Gaston is after all a generation older than Gigi – a gap mirrored, in reverse, in the uncle/grandmother love affair (see Altman, 1989, 22-7).

Opposites eventually attract and can be melded. Even Gene Kelly, who is an interesting exception to the dual-sexuality focus,

is eventually brought into the community: which means marriage, children and so on. We mostly remember Kelly dancing alone, the child-like clown and self-centred show-off who in the end has to grow up. In this way, says Altman (1989, 57), Kelly embodies an American dream - he keeps the 'good' of his childlikeness and also matures. In this respect only, he is also in the vein of the female child role rather than the serious mature male role. Opposites are, then, finally reconcilable, and this applies to all the binary oppositions that the musical generates. This includes the work/entertainment opposition which is often a strategy of the backstage musical. This type of musical opposes the 'real' with 'art'. The real world of work is drab and ordinary; that of the stage is ideal and one of beauty. In Silk Stockings (Rouben Mamoulian, 1957) - a remake of Ninotchka - Cyd Charisse is the serious (that is, dull) businesslike Soviet representative and Astaire the happy-go-lucky (that is, funloving) Hollywood director. Charisse comes to learn that entertainment is in fact good business. This type of opposition can generate a slightly different one if both characters represent different types of 'art'. Thus, in a musical one character can be a musician or ballet dancer, the other a music-hall entertainer or tap-dancer. The former sees her or his 'art' as high art and therefore serious work and, conversely sees the other's work as entertainment, not serious - therefore hardly work at all, and certainly low art. In reverse the entertainer sees the other as a snob who has not lived. By the end of the musical both come to see the merit of the other's work (see An American in Paris. or, on a slightly different tangent of opposing theatre worlds, The Barkleys of Broadway, 1949).

The musical therefore functions ideologically to resolve the fear of difference. In this way, it functions as a text which disguises one of society's paradoxes. By extension, of course, this means that it makes invisible the other sets of paradoxes that are inherent in society, thereby ensuring society's stability. Thus the musical also makes safe the notion of the community as the place to be. Musicals that fall into this category are typically called 'folk musicals', and implicitly deal with the American folk. Small town or agricultural communities are common in this type of musical (as in Oklahoma or Seven Brides for Seven Brothers, 1954). Central to these musicals are home and the family. Family groupings, the extended family – all work towards the well-being of the community. To this effect, this 'joyous' folk musical nearly

always gets threatened by a baddie or gang warfare – the 'other' outside who threatens the stability of the community. Although they are less present, even large cities are represented as a coherent community. For example, St Louis in *Meet Me in St Louis* is humanized to the level of a small-town community (Altman, 1989, 275).

This same levelling also occurred for all-Black-cast musicals (directed and composed by Whites) - of which in the heyday of the musical genre there were only a few. Apart from the first all-Black-cast musical, Hallelujah (Vidor/Berlin, 1929), Cabin in the Sky (Minnelli/Duke) and Porgy and Bess (Preminger/ Gershwin, 1959) are the two most often quoted. These latter two films contain the Black characters within a safely boundaried community (Catfish Row and Kittiwah Island for Porgy and Bess) and give a White-eyed version of the Black folklore. Similarly, Hallelujah contains the Black characters within the family household consisting of shanty houses and the cotton fields. This film, however, is based not on the traditional oppositions evoked above for all-White musicals but on the opposition chain of religion/sexuality, virtue/sin (!). In terms of Black folklore, it includes a further opposition, this time in relation to 'Black' music - or rather the White's perception of it: church music and jazz, where the former is associated with 'virtue and goodness', the latter with sin and woman-temptress. Other than these full-blown White-eyed visions of Blackness (to which we can add the minstrelsy plantation musical The Green Pastures, William Keighley and Marc Connelly, 1936), there is the isolated presence of Paul Robeson playing a slave on a cotton farm in Show Boat (Whale/Kern, 1936), in which he sings Old (sic) Man River), or an ennobled African helping the White man (Sanders of the River, Alexander Korda, 1935; King Solomon's Mines, Stevenson, 1937, in both of which he sings African songs). In all cases he is contained within a White colonialist environment. As a last measure of this levelling and normalizing, tap-dancing which is a Black tradition, is totally recuperated into White musicals with no acknowledgement of its Black origins until the 1970s when tribute is finally paid to that heritage in Black Joy (1977) and Thank God it's Friday (1978).

Altman (1989, 32ff.) isolates four key functions of the cinematic **apparatus** in the musical construction: **settings**, **iconography**, music, dance. A key technique for settings was to use repetition for comparative purposes, to underscore the

duality of the sexual oppositions. Therefore, work and home spaces have similar settings or décor; or the two spaces in which the protagonists move (and dance) - be they work or home mirror each other. Similarly, the proliferation of other couples serves as mirrors to the main couple or pair. In terms of iconography, what dominates is the duet and the solo shot. But even in the presence of the solo shot the spectator fills it in because she or he knows that the coupling is preordained (1989, 39). Similarly with the music. The duet is there for the maximum tension and climax of the parrative. However, the solo carries most of the musical and, as with the solo shot, the spectator fills it in with the missing other (1989, 40). Finally, dance: the camera dances with the characters. It either adopts the position of a watching audience and is, therefore, static and panning left to right; or it is fluid using tracking or crane shots (as we saw with Busby Berkeley). As with the other key functions, the camera catches solo, duet or group dancing. In order to invest these shots with energy - particularly when the camera is static - the tendency is to cut up the shooting with close-ups on feet. hands and faces. The exception to this rule is, as we have seen, Astaire, who insisted on full shots for his routines - whether solo, duet or ensemble.

Dver (The Movie 75, 1981, 1484) speaks of a standard model for a genre as having three periods: primitive, mature, decadent. We have seen how the musical has had a chequered career, reflecting partly audience taste, partly finance (the musical is a very expensive genre to produce), partly due to social conditions (emergence of a youth class, greater choice of leisure pursuits, periods of economic recession). This entry has mostly talked about the first two periods, so a brief word is necessary on the last. By the decadent phase Dyer means that the time in the genre's development has come when its codes and conventions can be questioned. Until the 1960s and 1970s the musical did not question itself - as we have seen it indulged in narcissistic auto-satisfaction. Arguably, the rock musical of the 1960s started the questioning of the codes and conventions of the genre. It is interesting to note that some critics qualify Easy Rider (Dennis Hopper, 1969) as a rock musical - even though there is no on-screen singing and dancing, just a soundtrack of rock music - whereas most see it as a road movie. The point in this debate is not really what genre it is but rather that it typified, for some, a definite change in the orientation of the

musical because the message of the film was politicized in its counter-cultural aspirations and because the use of contemporary songs on the soundtrack was a break with copyright law. Similarly, Blacks started putting their own culture and music up on screen in films like *Shaft* (1971) and *Superfly* (1972) – which in some ways backfired because Hollywood co-opted their work in a series of blaxploitation movies (see **Black cinema**).

A film-maker often quoted in the context of the decadent period of the musical is Bob Fosse, Sweet Charity (1969) and Cabaret (1972) are exemplary of his challenge to Hollywood. He mixes elements of art cinema with movie entertainment the influences of Federico Fellini and Bertolt Brecht respectively are felt in these films. High and low art are therefore reconciled from the beginning. Dance style goes from the fluid to the ugly and brash. The camera-work similarly goes from the fluid to the vertiginous. And there is 'no such thing as happiness'. Nor, incidentally, is there any such thing as the good all-American folk community, or the merits of capitalism. All is either a bit seedy, decadent or just plain vulgar. No 'Nice, nice Miss American Pie' here. But perhaps the musical to end all musicals is Robert Altman's Nashville (1975). Nashville, the socalled heart of country and western music and all-American folk, literally disintegrates before the spectator's eyes. Altman's musical goes nowhere, comes from nowhere, it tells you nothing, it is not about country and western music, no one mirrors anyone, and, finally, what pairing there is is dysfunctional from beginning to end. Nothing is reconciled and the film ends in a solo performance.

myth (for more detailed discussion see denotation/connotation, semiology/semiotics) Myth has become a key concept in semiotics to refer to the way in which reality is represented. Roland Barthes is the main philosopher associated with this concept, the principles of which he set out in his book Mythologies (1957). Having shown how myth operates to produce meaning (see denotation/connotation), he proceeds to analyse certain aspects of popular culture and explain how these cultural artefacts produce meaning. Cultural artefacts have a mythic function, they are just so many ways by which we understand the culture in which we find ourselves. Myth mediates reality. Myth is a concept that primarily refers to a process of signification by

which any given society 'explains' its history and culture. Myths are part of everyday life and change across time. History and culture inform myth but, equally, myth serves as a way by which history and culture are 'explained' as a natural process. Myth, then, is part of the ideological process of naturalization. The structuralist and anthropologist, Claude Lévi-Strauss argued that 'a dilemma or contradiction stands at the heart of every living myth. The impulse to construct the myth arises from the desire to resolve the dilemma' (quoted in Cook, 1985, 90). We can see how this concept of myth is at the heart of classic narrative cinema's discursive strategy of order/disorder/orderrenewed. **Dominant cinema** seeks always to resolve a dilemma. In terms of film as a cultural artefact, Barthes's assertion that film is a sign system that functions mainly on the level of myth which then loses all tangible reference to the real world equally refers to mainstream cinema and its desire for the 'reality-effect'. Mainstream cinema spends a lot of effort disguising the fact that what it is showing is pure illusionism.

narrative/narration (see also classic narrative cinema, diegesis, dominant cinema, Oedipal trajectory) Narrative involves the recounting of real or fictitious events. Narrative cinema's function is storytelling not description, which is, supposedly, a part function of the documentary. Narrative refers to the strategies, codes and conventions (including mise-en-scène and lighting) employed to organize a story. Primarily, narrative cinema is one that uses these strategies as a means of reproducing the 'real' world, one which the spectator can either identify with or consider to be within the realms of possibility. Even science fiction films have a narrative with which the spectator can identify (for example forces of good fighting it out with those of evil). The motivation of the characters moves the story along to make a 'realist' narrative. In mainstream cinema it is traditionally the male who is the prime motivator of the narrative - that is, it is his actions that set the narrative in motion. However, female characters can also act as prime motivators of the narrative even though they mostly remain as object. For example when the woman is at the centre of the enigma around which the film revolves, as is often the case in film noir, she is still, usually, object not subject of the narrative. She is the object of investigation, since it is her 'enigma' or story that must be probed, investigated and finally resolved by the male protagonist (for a classic in this mode, see Laura, Otto Preminger, 1944).

Because narrative exists in so many cultural forms (novel, film, theatre, mythology, painting, etc.) it appears 'as natural as life itself' (Lapsley and Westlake, 1988, 129). And it is this naturalness, or **naturalizing** process that film theorists have sought to

contest, at least since structuralism. Narrative structures and narrative analysis of film first became an area of theoretical investigation as part of the structuralist debates on cinema. The study of the spheres of action and narrative functions in fairy tales by Vladimir Propp (1920s) and the structure of folk narratives by Claude Lévi-Strauss (1950s) were systems applied by film theorists to film narrative (see Metz, 1972 and Heath, 1981). Structuralist narratology looked for common structures underlying the diversity of narratives - as if seeking a grammar of narrative. Theorists currently interested in this approach are now turning to the work of Gérard Genette (1980) because he makes clear and useful distinctions between three types of narration, allowing one to speak of film as a narrative function, the narration going on within the film and the narrating of the film itself. Thus, he distinguishes between narrative, diegesis and narrating. He uses narrative to refer to the undertaking to tell an event. Where film is concerned narrative would refer then to film as a narrative statement, to its function as a narrative text. His second term, diegesis, refers to the succession of events and their varied relations that make up the particular story. Thus, with film, diegesis refers to the story we see projected up on screen and refers, therefore, to both the storyline and the visual mise-en-scène. His third term, narrating, refers to the act of enunciation. In film this third term refers, first, to the acts of utterance within the film, the 'act of producing a form of words which involves a human subject' (Hawthorn, 1992, 57). It refers, therefore, to the characters whose utterances motivate the narrative. In the second instance, enunciation refers to the **spectator**—text relations. In other words, the narrative is being narrated to us. We are witnessing the act of narrating.

A primary focus on narrative by Anglo-Saxon film theorists, however, has been on classic narrative cinema as exemplified by **Hollywood**, especially the cinema of the 1930s to the 1950s. The classic narrative, for the most part, negates the female point of view and is predominantly based on male **sexuality**; thus films tend to be Oedipally over-determined (that is, there is a dominance of Oedipal narratives). Narrative in cinema tends to follow a fairly standard set of patterns which can be defined by the triads order/disorder/order and order/enigma/resolution – often referred to as **disruption/resolution**. These triads often, but not exclusively, trace the successful or unsuccessful completion by the male protagonist of the **Oedipal trajectory** – that

is, simply put, to enter successfully into the social conventions of patriarchy, find a wife and settle down. In this way the narrative achieves closure. In order for these triads to have a cohesive structure, the film narrative is structured on the principle of another strategic triad: repetition/variation/opposition. To keep the film diegesis tight, visual or discursive elements get picked up again during the unravelling of the narrative (repetition) and/or altered somewhat (variation) and/or, finally, shown in a completely contradistinctual way (opposition). A good example of this strategy, which all films use to varying degrees, can be found in the various car sequences that punctuate Thelma and Louise (Ridley Scott, 1991). Compare the first car sequence, where the characters escape from the drudgery of their humdrum existence (one form of a life sentence), with the final one, which represents an exhilarating assertion of their right to an alternative resolution to their predicament than that of a life sentence in prison.

For further reading see Bordwell, Staiger and Thompson, 1985; Bordwell, 1986; Branigan, 1992; McMahon and Quin, 1986.

naturalizing (see also ideology) A process whereby social, cultural and historical constructions are shown to be evidently natural. As such, naturalizing has an ideological function. Thus, the world is 'naturally' shown in film (and in television in much the same way) as White, bourgeois, patriarchal and heterosexual. These images of western society are accepted as natural. Naturalizing, then, functions to reinforce dominant ideology. Naturalizing discourses operate in such a way that class, race and gender inequalities are represented as normal. Images construct woman as inferior and object of the male gaze. Black sexuality is represented as potent and, therefore, dangerous and to be contained. The working class gets fixed as naturally subordinate (intellectually and economically) to the middle classes. And so on. Very slowly resistances to this naturalizing process are emerging through the work of a handful of film-makers. An exemplary film which takes on board the naturalizing of inequalities and exposes the ideological function of such a process is Mike Leigh's Ladybird, Ladybird! (1994).

For further reading see Lapsley and Westlake, 1988, chapter 5; Bordwell, Staiger and Thompson, 1985; Neupert, 1995.

naturalism (see also realism) A term closely associated with realism. Naturalism first came about in the theatre of the late nineteenth century with the work of, among other dramatists and theatre directors, the Frenchman André Antoine, Antoine's theory was to get the actors to move away from the theatrical gesturality so prevalent at the time. To do this he created the principle of the fourth wall, which meant that the actors would not address or acknowledge the audience. They acted as if the audience was not there. In this regard, the proscenium arch of theatre is effectively abolished and the audience feels as if it is witnessing a slice-of-life realism; it as if viewers are literally dropping in, unseen (a fly on the fourth wall!), on the goings-on of the people on stage. To sustain this effect the décor is realistic, the subject matter contemporary and dialogue delivered naturally - 'they speak just like us'. Actors enter the personae of their characters rather than represent them. They impersonate their characters and reveal their complexity from within. This form of naturalistic acting would later become labelled method acting (interestingly, the French talk of actors as 'encamping' their roles).

Antoine went on to direct films and took this principle of naturalism with him, adapting it to the cinema. He insisted on location shooting, the use of a multi-camera point of view (which he believed would parallel the effect of the fourth wall) and an **editing** style that would involve the **spectator** in the narrative (through identification with the mediating camera). He was, incidentally, the first to show female nudity in **narrative** cinema (*L'Arlésienne*, 1922).

Naturalism as an effect, then, places the spectator voyeuristically. We take up the position of the mediating camera. The characters seem so natural, their dialogue or verbal interchanges so real, the **setting** and **mise-en-scène** so totally realistic that an easy identification takes place. We are there alongside the characters. Take, for example, *On the Waterfront* (Elia Kazan, 1954) and the use of the **diegetic** audience to place us as one of the protagonist's entourage (Marlon Brando as Terry Malloy). The reality of what we see before us, with which we identify, stitches us into the illusory nature of the representation so that it appears innocent, natural. In this way, naturalism has an ideological effect much like **naturalizing**. It purports to show reality but in fact has little to do with the representation of the contradictions which underlie social structures and political processes. It gives, therefore, a surface **image** of reality.

neo-realism - see Italian neo-realism

New German cinema - see Germany/New German cinema

New Wave/Nouvelle Vague see French New Wave

Oedipal trajectory (see also classic Hollywood cinema, Imaginary/ Symbolic, psychoanalysis, suture) The term Oedipal trajectory is a concept used in film psychoanalytic theory to refer to a convention of classic Hollywood cinema whereby the male protagonist either successfully or unsuccessfully fulfils the trajectory through the resolution of a crisis and a movement towards social stability. In other words, after much difficulty (depending on the film genre), he finds a woman and 'settles down'. In psychoanalytic terms, the cinematic concept of the Oedipal trajectory is based in Sigmund Freud's conception of the Oedipal complex or crisis and Jacques Lacan's account of the mirror stage. In referring to the Oedipal myth, Freud seeks a means whereby he can explain a child's acquisition of 'normal' adult sexuality. Freud was primarily concerned with the male child's Oedipal phase. The Oedipal phase is also, in Lacanian terms, the latter stage of the mirror phase. The male child who at first is bonded to his mother (through the breast) imagines that he is a united whole with her. However, once he is held up to the mirror by his mother, he perceives his difference from her. He becomes aware of the illusory nature of his unity with his mother and yet still desires unification. The desire for the mother is now sexualized. He is, however, aware of the father whom he currently hates because he has 'lawful' access to the mother, and he, the child, does not. The male child now reads his difference from his mother as one of castration. That is, to his (un)informed eye the mother is castrated. She is not like him, she does not have a penis. To identify or to seek unity with the mother would mean that, in both instances, he would be without penis: in identifying with her he becomes like her, in uniting with her he runs the risk of punishment from the castrating father since

he assumes that the father has the power to castrate. How else would the woman/mother lack a penis? So he now moves to identify with the father and sets about to complete his socio-sexual trajectory successfully by finding a female (m)other – that is, someone who is just like his mother (i.e. a female other). The Oedipal trajectory thus involves identification with the father and objectification of the mother. The male child can now move towards social stability by becoming like his father.

In terms of cinema **narrative** the male protagonist moves, through the resolution of a crisis, towards social stability. In mainstream cinema, the female is a stationary site (that is, passive object) to which the male hero travels and upon which he acts (that is, he is the active **subject**). If he fails to achieve this trajectory, as is often the case in **film noir**, then it is possible to talk about masculinity in crisis. He fails to find social stability by failing to marry the female other (in a film noir, for example, either he or she dies). It is interesting to note that the other genre in which the male hero does not 'settle down' is the **Western**. But in this instance the failure to complete the trajectory is often read positively. Implicit in the western, with its assertion of the **myth** of the west (frontiersmanship, etc.), lies the notion that the cowboy or gunslinger or western hero cannot *yet* settle down: the west is still to be won.

From a psychoanalytical perspective, cinematic narratives that embrace the Oedipal trajectory articulate how the threat of castration (as represented by the woman who lacks) is dispelled and the masculine role of the patriarch is assumed. Two strategies are employed to contain the threat: voyeurism and fetishism. These strategies form part of the narrative. Thus, with the first strategy, the woman is objectified through the gaze, is voyeuristically placed as object of surveillance and therefore containable, safe. The male gaze probes and investigates her. She cannot return the gaze because she is not subject. She is the object (the mother) in the mirror that reinforces or confirms the male's subjectivity. And the male, in recognizing his difference (his subjectivity), asserts his superiority over the female (m)other. The alternative strategy is to fetishize the female, to construct her as a fetishized object, to deny her sexual difference. By a fragmentation of her body and an over-investment in parts of the body (breasts, legs, etc.), the woman becomes commodified as a whole and unified body. The body is fetishized and denied its difference. The body is rendered phallic, a masculinized female

image (tight slinky black dresses, high heels and painted fingernails are good examples of this). Both strategies reinforce the notion of a naturally stable male subjectivity and reaffirm the naturalness of the patriarchal order to which the female must comply through her passivity and, of course, to which the male complies through his activity (see **naturalizing**).

The female Oedipal trajectory is only just coming into focus as an issue in film theory. And it is particularly in relation to women's films and melodrama that it is being investigated in terms, partly, of mother/daughter relations but also, subliminally, lesbian relations. Clearly the female child is never completely free from desiring her mother. Because of their sameness, there is unity in identification. As with the male child, the mother is her first love-object. But there is no perceived difference, so there is no fear of castration. What then will motivate her to turn away from her mother and desire the father? Freudians argue that she turns away through penis envy. The mother cannot provide her with a penis so she will turn to the father for him to provide her with it in the form of a child. Lacanians, at least feminist Lacanians, argue that since she must enter into the social order of things - that is, patriarchy - she will be obliged to turn from the mother even though she will never fully relinquish her desire of the mother. To fulfil her Oedipal trajectory and enter into the social order of things, the female child must function to confirm male subjectivity. To withhold such confirmation means punishment - either through marginalization or death. In classic narrative cinema, independent women eventually 'come to their senses' and marry the guy (if it's comedy), or are 'brought to their senses' (if it's a film noir or thriller).

For further reading see Kaplan, 1992; Krutnik, 1991; Modleski, 1988, 42–55; Penley, 1989.

180-degree	rule	(see als	0 30	-degre	e rul	e) Also	known	as tl	he
imaginary	line,	this i	s a	'rule'	that	ensures	consiste	ncy	of
the spect	ator's	perspec	tive	. Essen	tially,	when sh	nooting a	scen	ıe,
				- 180° -					
C ₁								C ₂	

 C_3

cameras should stay on one side of this imaginary line, otherwise the spectator would get disorientated as the diagram illustrates. The three cameras are on one side of the line pointed at the object on the line. As the film unravels on screen, the spectator takes up any of those three camera positions depending on which **shot**-position has been chosen at any given time and edited into the final cut (camera 1, 2 or 3). There is perfect logic in this perspectival **gaze** for the spectator. But what if a camera went the other side of the line? The spectator's perspective would be reversed: she or he would be seeing things back to front. If the object was two characters in a conversation (a two-shot), their positions would be reversed. Character A would be in character B's position.

opposition - see narrative, sequencing

oppositional cinema - see counter-cinema

P

paradigmatic/syntagmatic - see structuralism/poststructuralism

parallel reversal A useful term used by Modleski (1988, 19) in her discussion of the narrative structure of Alfred Hitchcock's Blackmail (1929). She uses it to describe how the closing sequence parallels or repeats an earlier one, near the beginning of the film, but with the positions reversed. In the early sequence of this film, the female protagonist, Alice White, is visibly annoyed at having to wait for her boyfriend, a detective, Frank Webber. She is waiting for him in his place of work, Scotland Yard. He comes to greet her, at which point she ostensibly flirts with another detective. He whispers something in her ear, she laughs and then exits with Frank but without telling him the joke. At the end of the film, Alice is similarly placed between two men, one of whom is Frank – and again at Scotland Yard – but this time it is she who is the butt of the joke between the two men and thus she who is excluded.

parallel sequencing - see editing

patriarchy - see Imaginary/Symbolic, Oedipal trajectory/ psychoanalysis

performance - see gesturality, star system

plot/story - see classic Hollywood cinema, discourse, narrative

point of view/subjectivity - see subjective camera, subjectivity

politique des auteurs - see auteur, French New Wave, miseen-scène

Pornography Pornography is a topic that has created a great deal of controversy both in terms of its definition and its supposed effects. There is general agreement on the view that pornography in film (or any other text) can be described as any set of images that exist solely for the purpose of sexual arousal and features nudity and explicit sexual acts. Beyond that, opinion diverges into two radically opposed critical camps. A first, perhaps liberal view, holds that pornography gives greater visibility to more and varied sexualities and helps towards a greater tolerance and understanding. As Brian McNair says (1996, 49). it permits 'the affirmation or strengthening of minority or subordinated sexual identities'. Conversely, a conservative view and indeed one held by many feminists (albeit for different reasons) asserts that pornography is a 'fundamentally amoral/immoral category of representation, deeply implicated in negative social phenomena' (ibid.).

Whereas the 'anti-pornography' camp dismisses all pornography as 'bad', the 'pro-pornography' camp takes care to establish differences between various forms of pornography (primarily: hard, soft, child) and, in that distinction, to make clear that while some versions are unacceptable (particularly child pornography), other forms can be liberating. Pornography aimed at women, lesbians and homosexuals can serve to assert their respective sexualities as meaningful, as subjectivized not objectified. Female or marginalized sexualities can also appropriate the dominant form of heterosexual pornography and adapt it to their own readings (that is, read it against the grain). As McNair says (ibid., 129), 'in the private worlds of fantasy and sexual relationships . . . women have increasingly used pornography – subversively decoding male-orientated material on the one hand, consuming material produced by women for women on the other'.

The 'anti-pornography' camp falls into two categories in the main. First, certain feminist groups who see pornography as degrading to the female and as reinforcing patriarchal ideology (for detailed discussion see Dworkin, 1991; Griffin, 1988; Itzin, 1992). Pornographic films, the claim goes, lead to violence against women. The second category, the conservative (moral majority view), condemns pornography for entirely different reasons. Not as a protest against the degradation of women, but as a protest against what this group perceives as an attack on family values and marital sex (McNair, 1996: 49).

For further reading see authors cited in the text and see also: Baird and Rosenbaum, 1991; Dines, Jensen and Russo 1998; Easton, 1994; Rodgerson and Wilson, 1991; Segal and McIntosh, 1992.

postcolonial theory (see also Black cinema - USA, Black cinema - UK, cinema nôvo, Third Cinema, Third World Cinema) The following outline sets out the basic concepts of postcolonial theory. References for further reading are supplied at the end of this entry but a useful starter reader is Padmini Mongia's Contemporary Postcolonial Theory: A Reader (1996) and Ashcroft et al. The Post-Colonial Studies Reader (1995) and Key Concepts in Post-Colonial Studies (1998). There are two ways of spelling 'post-colonial', one with the hyphen one without, and considerable debate surrounds how it should be spelt. One way of distinguishing the usage is to say that the spelling post-colonial refers to the historical concept of the post-colonial state (it refers then to the period after official decolonization). The spelling postcolonial refers to varying practices that is some way are influenced by or relate to the post-colonial moment. Thus postcolonial refers to theory, literature, cultural practices in general, to ways of reading these different cultural practices. It refers too to the postcolonial subject. But clearly one type of post-coloniality does not exist without the other, thus some authors/critics use both spellings simultaneously. Bearing this in mind, the spelling postcolonial is opted for here except where it is clear that the reference is to the historical moment of postcolonialism. Where both concepts are implicitly co-present, both terms will be used.

Edward Saïd's book *Orientalism* (1978) is one of the key texts in postcolonial theory. In fact, it launched many of the debates in the West that have subsequently come to dominate postcolonial

theory. The postcolonial debate is not limited to the West, however. Indigenous African and Asian intellectuals have been part of this (after all) global debate. And it is important to remember that the first major writer on the question of colonialism and post-colonialism was Frantz Fanon whose texts of the 1950s and early 1960s form the foundation of this theory. Fanon was a psychiatrist working in Algeria during the years of the struggle for independence (1950s). His writings on colonialism and racism, Black Skin. White Masks (1967) and The Wretched of the Earth (1968), studied the effects of colonialism on the psyche of the colonized people. In Black Skin, White Masks, Fanon argues (through his famous neo-Freudian question 'What does the Black man want?") that the colonized seeks only to occupy the place of the colonizer. Thus, once the country has obtained independence, the colonized elite class (the intellectual class) will only mimic what the White colonizer has already done. Later, in The Wretched of the Earth, he explores more fully what this means and what the real function of the colonized elites must be once independence is achieved. He goes into great detail about the role of the native poet (the educated intellectual) who must give over his (sic) being to both reviving the past - the bleached out history of the colonized, the memories of traditions whose importance and signification colonialism has attempted to belittle, demean and wipe out - and to helping his people towards a national consciousness. In this process of freeing the wretched of the earth the native poet helps them build the nation anew. In other words, the poet must draw from the past (pre-colonial times) to help make the future, a new national culture. He must help in the forging of a third way that is neither stuck in old traditions that cannot now be reinstituted, nor in the colonialist/post-colonialist moment since that would merely represent a new form of oppression and enslavement.

Fanon's writing held enormous sway in the USA during the forming of its own Black consciousness (1960s and 1970s). And by the 1980s issues of race, identity, colonialism and nationhood and the problem of representation had been brought very much to the foreground of theoretical thinking in the West thanks to the works of Saïd, Stuart Hall, Gayatri Spivak, and Homi Bhabha. During the 1980s the question of post-colonialism/postcolonialism was also being debated in Africa – particularly in the works of Kwame Appiah and V. Y. Mudimbe. Debates here

focus on the transition of African societies through colonialism. Ouestions of the following order arise. Where is the space of post-coloniality - the 'imagined' cleared after-space that 'post' implies – in African nations and cultures to be found? What does postcoloniality/post-coloniality mean to the nations the West so easily describes as post-colonial? Who are the practitioners of this postcoloniality/post-coloniality (politicans? ordinary Africans?) and what does it mean to be a postcolonial/post-colonial subject? In fact what is being raised here is the whole problematic of the term postcolonial/post-colonial and the concept of postcolonial theory. Whose term is it? As Mongia asserts (1996, 6) 'postcolonial theory's provenance is greatest ... in First World academies'. Who voices it? Not just 'authentic' voices from the Third World now working in Western academic institutions, although they are, arguably, the major agencies of this discourse. Finally, what are the dangers inherent in the use of this word and the application of this theory? A new kind of totalizing theory that places all 'post-colonial' nations and their cultures on a par? Clearly there is no stable fixed definition even if the West were to try to establish one – and certainly not from within the nations themselves. The identities of the nations (and thus the postcolonial subject) are diverse and not to be seen as a homogeneous

Saïd's analysis in *Orientalism* begins to raise some of the above questions. He shows how the Orient was and still is simultaneously a construction (as an imaginary exotic other) of the West and constructed (discursively fixed as a homogeneous real geographical space) by the West. In both instances the West is able to exert power over the Orient. Orientalism is a Eurocentric/Occidental view that dominates the Orient through its exercise of knowledge over and about the Orient. It interprets the Orient through its Western applied sciences of anthropology and philology/linguistics and in so doing it achieves 'knowledge' of the other which endows it with authority over the other. That knowledge is the source of the West's power over the Orient. And of course it is this relationship of power that has been evidenced, in the past, by Occidental imperialism/colonialism.

Although colonialism of a geographical kind may be over for the West, none the less, this relationship of power is still one that is practised in cultural terms. Saïd makes the point that the study of the Orient (through anthropology, linguistics etc.) permits a fixing – in homogenizing 'scientist' discourses – of the already constructed other. This erasure of identity (through homogenization) again makes the practice of imperialism a very 'untroubled' one for the West. This practice of orientalism is not limited to the 'Orient' but occurs in all territories colonized by the West (Africa, New Zealand, Australia). And this practice still prevails today in Western studies of the former colonies. It is in this context of 'knowledge of the other imposed from outside' that we can measure the enormous significance of the theory of negritude put forward, in the 1930s and 1950s, by the native poets Léopold Sédar Senghor (from Senegal) and Aimé Césaire (from the former French West Indies) in which they argued for an African subjecthood and aesthetic in their own right. This was the first important movement along with that of the Harlem Renaissance - the African-American diasporic movement (of the 1920s in the USA) - to assert African claims to cultural distinctiveness. Later in the 1950s. Latin America, particularly in its literature of magic realism (which later became transposed into its cinema), would lay equal claim to its right to be understood from within.

Postcolonial theory seeks, in a dialogic process (coming from many points of view), to expose this 'natural' linking of Western knowledge with oppression (i.e., imperialism/colonialism) and to re-think the very way in which knowledge has been constructed. Western modernist thinking, emanating from the Enlightenment of the eighteenth century, has created closely aligned terms which are perceived as interrelated on a one-toone basis. These terms are democracy, nationalism, citizensubject. However, this perception of the relationship between the citizen-subject and the nation-state is far too narrow and it suggests a homogeneity that certainly does not prevail today. There is not a unified (single) citizen-subject any more than there is a unified (single) nation-state and there is not a oneto-one relationship between the two concepts. For a start such a conceptualization of the relation excludes issues of race. ethnicity, gender and sexuality - in other words it excludes all 'othernesses' or multicultures. Postcolonial theory seeks. then, to question and critique the historicism of the West which has posited Europe as its theoretical subject. This European historicism is what is known as Eurocentrism (see Shohat and Stam, 1994). It is a position that 'naturally' assumes that 'history is the West' and that all the rest is 'subaltern' (Spivak, 1985). Subaltern is a term which Gramsci coined to mean the silenced history of those subjected to the ruling classes. It was adopted by South Asian Studies to refer to the 'lost' history of the subaltern cultures of the Asian peoples. In other words, colonial study and indeed some forms of post-colonial study, in their focusing only on the elite cultures of the colonized, have neglected – or reduced to silence – other subaltern voices (peasants, workers, women, and so on).

Postcolonial theory is not a single theory any more than the colonization before it was one homogeneous event with single characteristics. Colonialism is not one and the same and does not produce equal effects. And that is part of what postcolonial theory tries to unravel. It does not seek to impose a grand narrative (obviously that would be to fall into the same trap, or snake-pit, as the historicized, Eurocentric approach before it). Thus care must be taken not to impose the Eurocentric concept of 'history-as-chronological "progress" onto the three key concepts that postcolonial theory investigates: pre-colonialism, colonialism and post-colonialism. These are syncretic terms. They always already co-exist. When we speak of the subaltern's history we cannot speak of a history that is linear.

The most difficult area to date (in terms of agreement between theoreticians) is how to locate the postcolonial subject. One of the main proposals forthcoming is that the postcolonial subject is hybrid, that he or she occupies a space between - or in-between - two cultures. This term avoids being limited to the use of binary terms of opposition self/other or centre/marginal and allows for a subject position that is not defined in relation to a hierarchical notion of subjectivity (such as the speaking subject and the silent/silenced native). This in-between space is one of contradictions and ambivalences, in the first instance because the two cultures do not match, they are distinct. This is turn makes clear that there is no unified culture per se. And that the location occupied by the postcolonial subject is also by its very nature hybrid. This in-between space is, then, a third space (it is neither the first nor the second of the two interdependent cultures whose hybridization makes up the postcolonial subject). Thus the postcolonial subject occupies a third space from which his/her identity is enunciated (see entry on enunciation). However, and this is the crucial point, by occupying this third space, the postcolonial subject is occupying a place of potential resistance. And this is why. By the very nature of his or her location the postcolonial subject embodies the contradictions and ambivalences of the two cultures: thus, he or she makes possible the exposure of those very same contradictions and ambivalences inherent in and between each culture. By so doing the postcolonial subject 'invalidates' the rhetoric of imperialism and colonialism. Namely, at the same time as he or she shows how Western historicism and discursive fixity function, the postcolonial subject exposes the fact that there is no discursive fixity, that Western knowledge cannot fix the 'other' and thereby exercise power and authority over it.

The hybrid nature of postcolonial culture is then the conceptual tool that can prise open rational modernist discourses that make secure an a priori knowledge of the world of the 'other'. Hybrid identity is not fixed but is 'an unstable constellation of discourses' (Shohat and Stam, 1994, 42). Thus syncretism and transculturalism are manifestations of hybrid culture. Syncretism refers to the bringing together of many diverse cultural traditions into one performative text (film, theatre, whatever) (see Third World Cinema entry where this concept is explained in more detail). Transculturalism or transculturation refers to a cross-fertilization effect between two cultures whereby cultural traditions 'migrate' from one culture into another culture. The contact between the two cultures is mediated by the hybrid culture and refashioned to produce a third text (an easy illustration of this process is the re-appropriation of oil drums to make steel-band drums. the band in turn produces a performance - the music of that performance in its turn will most likely be syncretic, drawing on many muscial traditions).

The notion of hybridity is not without its own set of problems. And it has been criticized for emanating from post-structuralist discourses of fragmented subjectivities. The problem becomes that the hybrid subject (as described by Bhabha and others) is such a scattered and fragmented entity that it runs the risk of lacking specificity, of being unrooted in history or space (what is the imagined third space after all?). Furthermore, critics have argued that the cultural hybridity occupied by this subject is specific to the migrant intellectual living in the West from where he (sic) 'comes to signify a universal condition of hybridity' that is superior in understanding to both cultures 'he' represents (Ahmad, 1996, 286). The major criticism levelled at such migrant intellectuals is that they become 'Truth-Subjects' (ibid.). Furthermore, or perhaps worse still, in that this play with identities de-centres the subject (through its aspecificity and ahistory) it also detaches it from any attachment to nation, class or gender

(ibid., 287). This does not mean, however, that we should lose sight of the term hybridity, for reasons explained above it has great subversive value. What this criticism makes clear, though, is that as a concept it is not 'enough'. It too excludes and therein also lies its usefulness. Through its very exclusion it makes visible what also needs to be addressed. Such is the case for the position of women in these debates as well as questions of class and caste. Feminism has made clear that there is not a single category of colonized (see Spivak, 1985 and Suleri, 1992). Indeed, women are subjected to a double colonization or oppression, nor does that oppression evaporate post-colonially (as indeed some Third World women and men film-makers have made evident – see, for example, the Palestinian Michel Kleifi's Marriage in Galilee, 1987 and the Tunisian Moufida Tlatli's Silences of the Palaces, 1994).

Presently, the issue of the speaking subject and his/her location remains unresolved in critical postcolonial theory. However, a part answer to the question of agency - of who is the speaking postcolonial subject - has been to invoke Gramsci's notion of the subaltern (see above). Again it is not an unproblematic term, it runs the risk of essentialism and of creating a binary between elite/subaltern within the concept of the other (that is, the 'other' is made up of 'elite/subaltern' subjects). This in turn risks continuing the modernist train of binarism around subjectivity (self/other). Subaltern is a useful term though. It can and does refer to the voices - especially oral voices and cultural traditions - of those who are seemingly even more disempowered than the elite postcolonial subjects (Guha, 1982). It reminds us that there are other multiple voices to be thought about, listened to. It also reminds us that their discourses of representation are not necessarily grounded in colonial or post-colonial discourses - even though, if they are to be heard as resistant voices, the subalterns' speaking position can only be defined by its difference from the elite.

Postcolonial theory when applied to cinema studies helps us to read (through a non-Eurocentric eye, hopefully) films emanating from postcolonial/post-colonial countries as well as films from the diaspora. These films which explore questions of representation, identity and location politics (i.e., who is the speaking subject and where is he or she speaking from?) question the centre/margin binaries imposed by Western thought. Models of colonialist discourse are exposed, as are the practices

of dependency theory (the way in which global capitalism functions to maintain the impoverishment of the economically colonized Third World). The legacy of the exploitation of the colonized body is explained through a demonstration of how the diasporic movements, generated by slavery, are later matched by the ecological imperialism of the formerly colonizing nations. That is, for example, how Europe's need for immigrant labour replaced the earlier 'transportation' of slave labour to various colonies (see Gilroy, 1993). The colonized raced body was a commodity through which colonialism operated its power, and yet without that body colonialism could not have remained propped up - therein lies the paradox of colonialism (its major contradiction). But this is not the only cinema that postcolonial theory examines. It is used also to analyse products made by the West - both during the colonialist era and in the post-colonial moment - which either directly or indirectly display their Eurocentrism.

For further reading see texts referred to in entry and see also: Ahmad, 1996; Appiah, 1992; Bernstein and Studlar, 1997; Bhabha 1994; Childs and Williams, 1997; Fanon, 1967 and 1968; Gilroy, 1993; Guha, 1982; Low, 1996; McClintock, 1995; Malik, 1996; Mudimbe, 1988, 1992, 1994; Naficy and Gabriel, 1993; Saïd, 1978; Shohat and Stam, 1994; Spivak, 1985, 1987.

postmodernism (see also modernism, structuralism/post-This term entered into critical structuralism, theory) discourse in the late 1960s. As a concept it was seen as exemplifying a counter-position to modernism, especially modernism in its latest manifestation as total theory: structuralism. And for this reason it is a term often associated with post-structuralism, to which it is, arguably, connected. Although the two concepts do indeed co-exist, some critics feel that postmodernism - also known as the postmodern - refers more to an age, particularly the 1980s and 1990s, than to a theoretical movement to which, of course, post-structuralism belongs. There appears to be no easy definition of postmodernism. Indeed there are many different ways in which it is perceived. These are never totally contradictory readings but, depending on the positioning of a particular thinker, writer or theorist, it can be given a different interpretation. This of course points to its pluralism as a concept and is something to be welcomed after the strictures of

modernism and structuralism. It is also a reason why postmodernism gets aligned with post-structuralism, which is similarly pluralistic in its approach. Post-structuralism is more readily concerned with opening up the problematics in modernism and as such constitutes a critical theory of modernism. Postmodernism is perceived more as an historical condition within which are contained social, political and cultural agendas and resonances. These are interpreted, depending on the positioning of the writer or theorist, either as reflective of a mentality of 'anything goes', therefore nothing works, or of a questioning of the modernist ideals of progress, reason and science. In the first instance, theorists claim that the postmodern condition signals the death of ideology. In the second, it heralds a new scepticism about the modernist belief in the supremacy of the western world, the legitimacy of science to legislate the construction and function of gender, and the advocacy of high art over popular culture.

Ultimately, then, postmodernism is a vague term. However, in its eclecticism lies its power to be non- or anti-essentialist, it neither has nor provides a fixed meaning; in its pluralism lies its ability to be read either positively or negatively.

A first set of readings - mainstream postmodern culture and oppositional postmodern culture Some critics see the postmodern as an effect that is a reaction against the established forms and canons of modernism. In this regard it takes issue with modernism's positive belief in progress and a unified underlying reality. Postmodernism reacts against modernism's optimistic belief in the benefits of science and technology to human kind. But, as the entry on modernism makes clear, this optimism is only part of the picture: certain modernists did not share this optimism but mistrusted science and technology. Viewed in this light, then, postmodernism continues the pessimistic vein that already prevailed in modernism. According to Fredric Jameson (1983), postmodernism, as an effect, also represents the erosion of the distinction between high art and popular culture. The postmodern does not really refer to style but to a periodizing concept 'whose function is to correlate the emergence of new formal features in culture with the emergence of a new type of social life and a new economic order' (Jameson, 1983, 113). In other words, it is a conjunctural term at the interface between artefact and the new moment of capitalism. This new moment of capitalism is varyingly called post-industrial or

post-colonial society, modernization, consumer society, media society. The artefact is what is produced by and within that moment in capitalism. What is significant is that the term *post-modern* is consistent with the way in which western contemporary society defines itself – that is, in relation to the past (postcolonial), but also in relation to social practice (modernization, consumer) and technology (media). In its consistency with western definitions, the postmodern looks back, is retrospective, is not defined as other, but as *post*modern, as coming after. In its lack of history (defined only in relation to the past), it rejects history, and because it has none of its own – only that of others – the postmodern stands eternally fixed in a series of presents. This reading places postmodernist culture as ahistorical.

According to this view, the postmodern era has little of the optimism of post-structuralism. It is more akin to a cult than to a movement. Although Anglo-Saxon theorists refer to this concept as postmodernism or postmodernity, it is instructive to note that the country whence the term emanated, France, deliberately omits the 'ism': le postmoderne. This very omission warns us that this is a non-collective phenomenon and that, by implication, it focuses on the cult of the individual (a position not all critics agree with; see below). Curiously, this contemporary hedonism recalls the aesthetic culture of the symbolists at the end of the nineteenth century - particularly in France. The fin de siècle mood of that time - a direct reaction to the political, intellectual and moral crises taking place - manifested itself in a neo-romantic nihilism wherein the individual artist became a cult figure. The death of ideology at that time left the artist in the presence of a spiritual void. How to fill the abyss of nothingness? The response was aestheticism, art for art's sake, as an end in and of itself which led to a self-sufficient formalism. In other words, only form, not content, could fill the void.

It is this pessimistic vein which finds its heritage first in the tragic modernist and later in the ahistorical postmodernist cultures. Both are traumatized by a technology that has created ideological structures of suppression and domination never seen before. Modern technology allowed **images** of this technology at work to be recorded (by the camera) and be brought to our attention. If there was not much footage of the First World War shown publicly, archival film shows enough of the horrors of trench warfare. More recently, images of the apocalyptic events

of the Holocaust and the dropping of the atomic bomb have left modernist and postmodernist alike with seemingly unanswerable questions. How to invent, comes the cry, when invention can lead to such wholesale destruction of humanity? In answer to this daunting set of questions, modernism in its pessimistic mode presents a world as fragmented and decayed and one in which communication is a virtual impossibility. In its response to these same questions, according to theorists providing the ahistoric reading of postmodernity, postmodern culture, which can see itself only in relation to the past, bifurcates. The majority tendency is unoppositional, a unidirectional reflection towards the past, providing a conservative cultural production – that is, mainstream culture. The minority is avant-garde and oppositional.

In relation to the contemporary cultural aesthetic, then, the postmodern adopts two modes. In its mainstream mode, it manifests itself through mannerism and stylization, through pastiche - imitation of what is past. In its oppositional mode - that is, in its despair at the nothingness of the abyss - it turns to parody, an ironization of style, form and content (as in Samuel Beckett's plays and novels). Whether mainstream or oppositional, the postmodern aesthetic relies on four tightly interrelated sets of concepts: simulation, which is either parody or pastiche; prefabrication; intertextuality and bricolage. What separates the two tendencies is that the oppositional postmodern aesthetic experiments with these concepts and innovates through subverting their codes, whereas the mainstream postmodern aesthetic merely replicates them. Hence the need for two distinguishing terms for the first concept, simulation: 'parody' and 'pastiche'. Parody is the domain of oppositional art. Pastiche pertains to the symptomatic in that it imitates previous genres and styles, but, unlike parody, its imitation is not ironic and is therefore not subversive. In its uninventiveness, pastiche is but a shadow of its former thing (parody). Postmodern art culls from already existing images and objects and either repeats or reinvents them as the same. To make the distinction clear, we could turn to the world of fashion and say that punk is parody, chic-punk is pastiche.

The three remaining concepts, then, are either played out in a parodic or pastiche modality. As you will see, there is considerable overlap between the concepts. In postmodern cinema, images or parts of sequences which were fabricated in earlier films are reselected. In much the same way that prefabricated houses are made up of complete units of pre-existing meaning, so the visual arts see the past as a supermarket source that the artist raids for whatever she or he wants. A film could be completely constructed out of prefabricated images (and even sounds). This is particularly true for mainstream postmodern cinema. For example, a film-maker wanting to insert a song and dance routine could select Gene Kelly's dance routine of the title song in *Singin' in the Rain* (1952), for a **flashback** she or he could clip in the beginning of *Sunset Boulevard* (Billy Wilder, 1950), and so on. Robert Altman's *The Player* (1992) makes reference to this pastiche culture of prefabrication (two studio scriptwriters discuss a possible script which they describe as *Out of Africa* meets *Pretty Woman*).

In this context of prefabrication, note how clever Quentin Tarantino's films are. While they appear to be a mise-en-abîme of filmic quotes, the orchestration of the quotes is so brilliantly achieved that what appears pastiche is in fact parody. He selects the quotes and then brutally overturns them. Take, for example, Reservoir Dogs (1991). The ten-minute torture scene in the empty warehouse, which is horrendous in its horror, is also excessively comic because the torturer, the psychopathic Mr Blonde, dances to a 1970s song, Stuck in the Middle with You - a song that relates to a paranoid if not drugged perception of 'reality'. Meantime as he slices up his victim he asks, in tune with the song, 'was that as good for you as it was for me?' According to Tarantino, the filmic quotes are Abbott and Costello monster movies which combine the comic with the horror (Sight and Sound, Vol. 2. No. 8, 1992). They also, in their seemingly gratuitous violence, recall many a Scorsese scene of violence (for example Taxi Driver. 1976). This scene, as with other quotes in the film, also pulls from the B-movies. Again they are pushed to their limits. This particular torture scene derides the false bravura of cops and gangsters who 'shoot it out' - here ears are cut off, faces are slashed (before even a gun is shot!), and people torched - all to the sound of music and dancing. Not even The Saint Valentine's Day Massacre (1967) or The Godfather (Francis Ford Coppola, 1972) could match these extremes of violence-in-excess. It is precisely in scenes like this one that the film achieves the parodic. Through this use of violence, Tarantino exposes the spectator-film relationship as one of sadomasochism. We might bleed with Mr Orange as he lies in the warehouse dying, but we also find ourselves dancing with Mr Blonde. Compounding the parodic is Tarantino's expressed intention of making us brutally aware of the manipulative hand of the director – 'he can shoot scenes like this' – and our collusion with him 'we choose to watch'. In this respect, Tarantino's work must be seen as oppositional. This makes the point that oppositional culture, postmodern or otherwise, can reach mass audiences. Tarantino is one of today's successful postmodern film-makers who can dissolve the divide between high art and low art without reducing his film to pulp, that is, to a

mere series of good images.

Intertextuality, which in many respects can be seen as closely aligned with mise-en-abîme and as overlapping with prefabrication, is a term which refers to the relation between two or more texts. All texts are necessarily intertextual, that is, they refer to other texts. This relation has an effect on the way in which the present constructed text is read. All films are, to some degree, always already intertextual. Within mainstream pastiche cinema, the most obvious intertextual film is the remake. Within the parodic mode and of the more contemporary and popular film-makers, Tarantino's films are exemplary in the way that they refer to other texts. Pulp Fiction (1994), for example, refers in many of its décors to the paintings of Edward Hopper - so in part the intertext is composed of painterly texts. Tarantino readily acknowledges his references to the film texts of Jean-Luc Godard. And certainly Bande à part (1964) with its own references to the American musical - which Godard reinscribes in a parodic mode - is a text to which Pulp Fiction refers. Tarantino talks about his film being based on three storylines that are the oldest chestnuts in the world, filmic narratives based on pulp fiction: a member of the gang taking out the mobster's wife whom he must not touch; the boxer who is supposed to throw the fight; gangsters on a 'mission' to kill (Sight and Sound, Vol. 4, No. 5, 1994, 10). Characters within film can also be intertextual of course. Again to cite Tarantino's film: Butch, the boxer, is an intertext of the character of Mike Hammer in Kiss Me Deadly (Robert Aldrich, 1955) and the look of the actor Aldo Ray in Nightfall (Jacques Tourneur, 1956).

Finally among these concepts comes bricolage. This is an assembling of different styles, textures, genres or discourses. In oppositional postmodern art this takes the form of replicating within one discourse the innovations of another. For example, the deconstruction of time and space that occurs in the *nouveau*

roman is replicated in the films of Marguerite Duras, Alain Resnais and Alain Robbe-Grillet through a use of **montage** that disorientates. The most common replication in cinema of other textural mediums is the plasticity of video and painting which can be found in many of the 1980s film-makers' work – both mainstream and oppositional.

In mainstream postmodern cinema genres are mimicked and not renewed. In terms of subjects, themes and style, the spectator of today is reviewing either images of modernist cinema or mediatic images of its own age. With a few exceptions there are no social or political films (Stephen Frears, Neil Jordan and Dennis Potter are a few who come to mind in the British and Irish environment). Some of the major issues of the 1980s and 1990s go unheard. This dearth of subjects coincides with a cinematographic mannerism which manifests itself in at least three ways. First, by a prurient (necrophiliac?) fixation with genres and images of a bygone cinema - nostalgia at its worst. Second, by a servile simulation of television visual discourses. And, finally, by manipulating and elevating virtual reality and computer graphics to the status of real. It is in this sense that mainstream postmodern filmmakers of today display a disdain for culture with a capital C. All culture, 'high' and 'low', is assimilable or quotable within their texts so that the binary divide is erased. The dissolution of the divide would be a good thing, but the result still has to have meaning. Instead, in their formalism and mannerism they aim purely and simply for the well-made image - 120 minutes of good publicity clips. They invent nothing. John Orr (1993, 12) points out that this cinema of pastiche lends itself to a double reading or, rather, contradictory readings. This cinema will appeal to right and left, Black and White. Forrest Gump (1994) is an excellent example, since both the left and the right have found it consonant with their own ideologies. As Orr says (1993, 12), this cinema, while so patently empty, is also potentially dangerous - schizoid, as Orr puts it.

A second set of readings – negative versus positive readings of the post-modern (Here I am drawing on the useful and illuminating analyses to be found in Huyssen, 1990; Nicholson, 1990; Bruno, 1987; Hawthorn, 1992; Kuhn, 1990.) In terms of current writing about post-modernism, there are at least as many positions as there are areas of concern. What follows is a summary of those positions as they affect readings of postmodern cinema. There is of course some overlapping or cross-fertilization but it is worth spelling them out

if only to reiterate the pluralism of postmodernism. Postmodern discourses have been elaborated with reference to architecture, human sciences and literature, the visual arts, technology, cultural theory, social, economic and political practices, feminism and gender. As has already been mentioned, these discourses generate either positive or negative readings of the postmodern.

Negative readings tend to focus on what is perceived to be the essential schizophrenia of postmodernism: a schizophrenia which can, for example, be detected in contemporary architecture's random historical citations which have been pasted or pastiched on to so many postmodern facades (Huyssen, 1990, 237). Roman colonnades are mixed with Georgian windows, and so on. Jameson believes that this schizophrenia comes about as a result of a refusal to think historically (Kuhn, 1990, 321). Baudrillard sees this post-industrial society as the society of spectacle that lives in the ecstasy of communication (Bruno, 1987, 67). This society, he believes, is dominated by electronic mass media and is characterized by simulation (Kuhn, 1990, 321). Baudrillard explains that this post-industrial society is one of reproduction and recycling, so rather than producing the real it reproduces the hyper-real (Bruno, 1987, 67). By this he means the real is not the real, is not what can be reproduced but, rather, that which is always already reproduced which is essentially a simulation (1987, 67). The hyper-real, then, is a simulacrum of the real. Perfect simulation is the goal of postmodernism; thereby no original is invoked as a point of comparison and no distinction between the real and the copy remains (1987, 68). In this implicit loss of distinction between representation and the real, Baudrillard perceives the death of the individual (note how this is the 'direct' opposite of other postmodern critics' readings of the individual as central, see above).

In order to make this point clearer it is useful to compare the effects of the industrial machine on the individual (the **subject**) versus those of the post-industrial one. Whereas the industrial machine was one of production, the post-industrial one is one of reproduction (1987, 69). In the former case, the industrial machine leads to the alienation of the subject – the subject no longer commands the modes of production. In the latter, the post-industrial machine leads to the fragmentation of the subject, to its dispersal in representation (1987, 69). It has no history, is stuck in the ever-present. It is in effect without memory. According to Jacques Lacan, the experience

of temporality and its representation are an effect of language (1987, 70). If, therefore, the subject has no experience of temporality, has no link with the past or the future, then it is without language - that is, it lacks the means of representing the 'I'. This creates a schizophrenic condition in which the subject fails to assert its subjectivity and fails also to enter the Symbolic Order. Therefore it is stuck in the Imaginary, perhaps even in the pre-Imaginary (see Imaginary/Symbolic). The question becomes 'who am I?' - even 'who made me?' It is remarkable that the past decade or so has witnessed a spate of monster films on screen and that the question of reproduction has been central to the narrative (for example *Jurassic Park*, Steven Spielberg, 1993; Mary Shelley's Frankenstein, Kenneth Branagh, 1994) and identity (Interview with the Vampire, Neil Jordan, 1994). An analysis of these films would doubtless produce the missing link between past, present and future - that is, the figure of the mother who is so pre-eminently absent from these films as site of reproduction, the reproduction machine of post-industrialization (male technology) having reproduced her (genetic engineering).

Postmodernism, as we know, refers to a general human condition in the late capitalist (post-1950s) world that impacts on society at large, including ideology, as much as it does on art and culture. Certain theorists, amongst them so-called neoconservatives (Huyssen, 1990, 255), see postmodernism as a dangerous thing both aesthetically and politically. In terms of aesthetics, the danger resides in the popularization of the modernist aesthetic which, through the dissolution of the divide between high art and low art, promotes hedonism and anarchy. It promotes anarchy because it removes the function of modernist art as critique - 'anything goes' - and hedonism in that it takes the subjective idealism of modernism to the point of solipsism (Hawthorn, 1992, 110). That is, the individual subject becomes the only knowable thing. Politically speaking, because it reacts against modernism's belief in knowledge and progress, postmodernism rejects meaning in the sense of believing that the world exists as something to be understood and that there is some unified underlying reality. Ideology becomes distinctly unstable in this environment.

Postmodernism is not necessarily perceived negatively, particularly by those living in it – primarily the youth generation, but also other groupings (as I will explain). Postmodernism in its positive mode celebrates the present and is far more accepting

of late capitalism and technology. It also celebrates the fact that mass communication and electronics have revolutionized the world (Hawthorn, 1992, 111). Postmodernism delights in and is fascinated by technology. The Internet represents the height of communication in the present through mass technology. Virtual reality can 'let me be there' without moving. Late capitalism means a dispersal of the productive base: commodities are produced where it is most advantageous, the labour market has become internationalized and fragmented. But it has also produced multinational corporations, which means that capital itself is concentrated in the hands of the few. For example, the world is so small that Reebok or Nike can have their central office in New Jersey or Eugene, Oregon but not have a factory outlet anywhere in the United States. The factories are placed in parts of the world where labour is cheapest.

To the criticism that postmodernism has lost the edge of art as critique and that, in its art-for-art's-sake positioning, it resembles the fin de siècle mood of the nineteenth century, postmodern art appears - within its celebratory and playfully transgressive (of modernism) mode - to reject this function of art or proposes that popular culture is just as capable of offering a critique as high art. In this latter respect, the populist trend of postmodernism (as exemplified by pop art and its reference to comic-strip culture, and by pop music: rock, punk, acid) - in its deliberate counter-culture positioning - challenges modernism's hostility towards mass culture (Huyssen, 1990, 241). It also rejects modernist belief in the 'perpetual modernisation of art' (1990, 238) and questions the exploitation of modernism for capital greed and political need. To explain: during the 1940s and the Cold War of the 1950s, modernism, in the form of abstract expressionism (as seen in the paintings of Willem de Kooning), was a school virtually 'invented' and subsequently institutionalized as canonical high art by the United States (read: the CIA and art critics). This was done for propagandistic and political ends. The intent, successfully carried out, was to move the centre of the art world out of Europe (and the threat or taint of communism) and to make New York the world capital (in both senses of that word) of art.

Postmodernism's effect of dissolving the binary divide between high and low art has, domino-style, generated others. The positive side of 'anything goes' is that dichotomies no longer function tyrannically as exclusionary. Modernism had represented a masculinization of culture, due in part to a bohemian lifestyle that excluded most women at least at first (Hawthorn, 1992, 109), but due also to the primary areas of modernism: architecture, painting, film, theatre (the modernist novel coming, arguably, later in the 1930s). Thanks to its creative relationship between high and low art, postmodernism has made space for minority cultures, has brought about a fragmentation of culture that is positive. Thus, where gender and race are concerned, this dissolution of binary divides and deprivileging of a meritocracy within dichotomies have led, first, to a pluralism within the question of subjectivity and, second, to a questioning of defining one group in relation to the concept of 'otherness'. In its rejection of universal norms, postmodernism refutes generalizations that exclude, and advocates a plurality of individualized agency (Nicholson, 1990, 13). In this respect, therefore, gender and race are no longer dichotomized. Postmodernism represents, then, a cultural liberation.

Small surprise that for some groupings – particularly those who had previously been excluded by the high principles of modernism – postmodernism is seen as liberating and celebratory. Voices from the margins, minority cultures, are finding spaces within contemporary culture. In the western world this has meant hearing, among others and in differing degrees of volume, the voices of Blacks, women, women of colour, gays, lesbians, ecologists, animal rights supporters, disabled people and so on. Some of these voices are finding their way on to film. Since the 1980s, for example, there has been an emergence of Black men and women film-makers and Black **stars**, gay and lesbian film-makers are coming on mainstream – marking the beginnings of a pluralism therefore in this highly competitive arena.

This pluralism has extended into film theory perhaps with greater speed than into the film-making practices themselves. And this is due in part to postmodernism's impact upon or coincidence with developments in cultural studies towards a mapping of our cultures – seeing culture as pluralistic (starting in the 1960s with Raymond Williams et al.). It is also due to its conjuncture with feminism. Feminist criticism exposed the masculine determinations of modernist art and culture and as such, albeit through a differing optic, echoed the postmodern position. In its critique of the normalizing function of patriarchy, feminism joins up with postmodernism's critique of the modernist belief in knowledge and its use of 'master narratives'

to legitimate scientific research and the pursuit of knowledge (Kuhn, 1990, 321). In the name of knowledge, modernism has presented a very dislocated and partisan view of the world – one that excludes more than it includes, one that belongs to a particular gender, class, race and culture (Nicholson, 1990, 5). Feminism rejects modernism's belief in reason and objectivity and its concomitant belief in total theory. Feminism opposes, therefore, all generalizations because they exclude.

Because feminism raises the questions of identity, identification and, ultimately, history (or lack of it where woman's place is concerned), postmodernism seems, then, a natural ally to feminism (although not all feminists agree; see Nicholson, 1990). Counter to modernism's construction of the individual as a single subjectivity in relation to the 'other', postmodernism and feminism make possible the notion of a 'plurality of individual agents' (Nicholson, 1990, 13). For example, there is no longer a single standard norm wherein gender, identity and sexual orientation are fixed as heterosexual (1990, 15). Furthermore, it becomes possible to talk in terms of gender- and race-based subjectivities (Huyssen, 1990, 250). (For further detail see feminist film theory.)

The importance of this concept of pluralism for film theory is clear. The construction of subjectivity through the cinematic apparatus can be examined. This in turn generates questions around the gaze and leads to its investigation: who owns it, is it exclusively male? The whole debate around sexuality on screen gets opened up. The issue of spectator—text relations now becomes yet another way by which the filmic text can be understood as an ideological operation. Thus gender issues are no longer reduced to an 'either/or', but discussed within frameworks of gender fluidity, resistance to gender fixing, whether on screen or in connection with the spectator and the text.

post-structuralism - see structuralism/post-structuralism

preferred reading (see also classic narrative cinema, dominant cinema, ideology) In mainstream cinema, images and films as a whole are encoded in such a way as they are given a preferred reading. They are meant to mean what they say. The narrative triad ('order/disorder/order'), the filmic codes and conventions germane to a particular genre (for example the lighting and décor in film noir), characterization (for example

heroic active male, scheming female, passive female victim), the **iconography** of the image – all these become just so many ideological operations of the cinematic **apparatus**, the internal workings of the film text which create a closed text, one where the meaning is encoded from the outset. Of course the **spectator** may not necessarily accept that preferred reading. Indeed, feminist critics have been busy in the last ten to fifteen years making readings against the grain (or oppositional readings) – particularly of the film noir and the **melodrama** (see **feminist film theory**).

presence - see absence/presence

private-eye films - see gangster films

producer (see also director, studio system, vertical integration) The individual responsible for the financial and administrative aspects of a film production (through all the stages from production through to distribution, including advertising). In the studio days of Hollywood and film industries in the West (up until the late 1950s and early 1960s), the producer was, generally speaking, attached to a studio. Since that time producers have mostly functioned as independents and so are responsible for attracting money to a film project. Typically, the producer will be presented with an idea for a film project and will then set about trying to find finance for it (by submitting it to a studio or going to various groups and individuals to obtain financing). The producer manages the entire production and works in close collaboration with the director/film-maker. The producer sorts out locations, studios, schedule of production, controls the management of budgets, the hiring of stars, director of photography, screenwriter, and special effects studios.

projection - see apparatus, psychoanalysis

projector - see apparatus

psychoanalysis What follows is a mapping of the major debates in psychoanalysis as they have been introduced into and developed

in film **theory**. For the sake of clarity and easy reference, major concepts in psychoanalysis and film are given their own full development under separate entries, which are cross-referenced in this synopsis. However, it seems useful to list immediately these major key concepts: absence/presence; apparatus; enunciation; fantasy; feminist film theory; gaze; Imaginary/Symbolic; Oedipal trajectory; scopophilia; shot/reverse shot; spectator; subjectivity; suture; voyeurism/fetishism.

Although psychoanalysis is not such a new phenomenon in literary theory, it is relatively new to film theory. Literary theory took up psychoanalysis in the 1930s and 1940s, but it did not fully enter into film theory until as late as the early 1970s. This might surprise, given that cinema is a contemporary of Freudian psychoanalysis (both emerging at the end of the nineteenth century). And in fact in the early, experimental avant-garde theorizing and film-making of the 1920s (in France) there was considerable debate around the notion of the subjective camera, and film-makers strove to give visual expression to the representation of the unconscious. The delay might also surprise since cinema is so readily associated with fantasy and dreams. Again, although film theory has been in existence since around 1910, on the whole formal, authorial and sociological considerations tended to dominate (see auteur). It would take the coincidence in the late 1960s of two occurrences in theoretical thinking to bring about the entry of psychoanalysis. On the one hand, the late 1960s witnessed a reaction against the effects of structuralism and its 'total theory' strategy. This reaction was exemplified by post-structuralism. On the other hand, this period saw a widening of the debates in Freudian psychoanalysis thanks to the writings of Jacques Lacan. These were subsequently taken up in critical theory in general and film theory in particular.

There are predominantly two strands of psychoanalysis, particularly on the question of subjectivity, that have found their way into film theory: Freudian and Lacanian. And they have so far been applied in three main areas of investigation: the film texts themselves; the **apparatus–spectator** relation which later evolved into text–spectator relations; and **fantasy**. Of course these applications have been refined and reviewed, refuted even, by theorists working in this area of film criticism. This means that psychoanalytic theory has developed significantly in film theory since its earliest applications. Despite the conviction with which some theorists have taken up psychoanalysis, particularly

feminists (for reasons that will become clear), it is noteworthy that not all film theorists are confirmed adherents to the merits of psychoanalysis – so the debate remains an active, not to say controversial, one.

Freud's theory of the subject Sigmund Freud's psychoanalytic approach was to investigate, to probe the psychological functioning of our human psyche and the relations we form with the outside world. Freud believed that we strive to fulfil our needs and desires (including, especially, sexual ones) and suffer pain if we are unable to do so. We also feel guilt for our desires, particularly if they cannot be fulfilled, and become self-critical, even self-hating. Freud maintained that, generally speaking, we repress these feelings of frustration and self-disgust into the unconscious. The unconscious does not remain perpetually buried, and can resurface in dreams or through projection. In the former case, dreams represent a return of the repressed so they are the vehicle for that which re-emerges from the unconscious. In the latter case, we impose, project our frustrations on something or someone external to us (for example, driving a car too fast or picking an argument for no ostensible reason with a loved one).

Freud determined three parts to our psyche: the id, ego and super-ego. The id is the uncontrolled, repressed part of the psyche which the ego, as the consciousness, attempts to control. The super-ego, as the term suggests, attempts to act as a higher-order authority over the id and the ego by trying to gain a greater critical conscience in relation to the workings of the psyche and to understand them. The super-ego is also identified with the 'parental' voice within the psyche. Where the boychild is concerned, the super-ego represents an internalizing of patriarchal authority – that is, he accepts the suppression of desire (of the mother) in order to gain access to the same rights as his father. Thus patriarchy regenerates itself.

Freud distinguished between two ego-types, the realist and the narcissistic. The regulating ego mentioned above is the realist type. It mediates between the pleasure-seeking id and reality. That is, it satisfies some of the id's desires while conforming to social expectation. The narcissistic ego is far less heard of in relation to Freud – unsurprisingly, considering that it is the direct antithesis to the realist ego which presumes improvement, even the perfectability of the ego (Grosz, 1990, 31). It is, however, this ego that Lacan developed in his own analysis, so

it is relevant to explain Freud's concept. The realist ego type was, Freud conceded, too simplistic in its definition. If it was the mediator between the id and reality, this meant, essentially, that it took care of its ego instincts (satisfying some of the id's desires but conforming to social norms) but apparently ignored its own sexual instincts. The question becomes, if it is moderating between the id and its needs and reality how can the realist ego type take part in its own sexual instincts, be part of its subjectivity? How can it be a unified subject if it is the rational moderator standing outside, aloof, from the notion of desire?

In his account of the narcissistic ego, Freud attempts to answer these questions. This ego is linked to early infant narcissism, which means that the ego takes itself as the object of its own libidinal drives. So the ego is both the subject and the object: the subject desiring the mirrored or narcissistic object or other. In this respect, then, the ego is not the unified subject (as it appears to be in the form of the realist ego) but is divided. This concept of the divided self is one that Lacan developed in his own investigation of subjectivity.

The second important point Freud makes, and which Lacan later developed, concerns Freud's description of this narcissistic ego in terms of a libidinal reservoir. According to Freud the narcissistic ego is the boundary around the libidinal reservoir (Grosz, 1990, 30). And it is for this reason that it can invest in itself as one of its libidinal objects (1990, 30). It does of course invest in external objects other than itself. This ego changes shape depending on how much it has invested outside into the external objects (object-libido), including its own body, and how much it has retained within itself (ego-libido). Grosz (1990, 29) refers to this mutation as hydraulic or amoeba-like. But, and here is the crucial point, because the ego's primary relationships are libidinal, they are based in pleasure not in reality (1990, 29). Furthermore, the ego has an object relation with its self, in that it can invest in its body as one of its libidinal objects (1990, 30). So from what source does the self assert its subjectivity, its identity? Whereas the realist ego was a self-contained entity that acted (and, therefore, had agency) as a rational mediator between the id and reality, it is evident that the narcissistic ego - in that it has no direct relation to reality - is not an entity, has no agency, but is 'constituted by its relationships with others. Indeed, its self-identity is . . . always mediated by others' (1990, 29).

These two central points, in so far as they concern first Lacan and then film theory, will be picked up when we come to discuss Lacan. In terms of film theory, however, Freud's account of subjectivity was important in at least one further, significant way. This part of the account concerns his notion of the Oedipal complex. The dyadic mother/child relationship, although a precursor to entry into the social, is none the less narcissistic in its mutual identification and desiring. For growth to take place into a plurality of relations and into the order of civilization and culture the child must be removed or severed from its imaginary unity with the mother. This dyadic structure must give way to a third term. This moment is what Freud terms the Oedipal complex or crisis. The father intervenes, forming a triangular structure, forbidding the child sexual access to the mother. The male child renounces his desire for his mother for fear of castration. He notes that his father has the phallus and his mother does not. He assumes that his mother is castrated and that, therefore, his father - he who possesses the phallus - has the power to castrate him. Both mother and father carry the threat of castration for the male child: he could become 'she who is without' if he disobeys either parent's prohibition (in this respect Alfred Hitchcock's Psycho, 1960, at first sight appears to offer a classic scenario of the castrating mother). The male child obeys the father, enters into a pact with him in that he renounces his mother momentarily until it is time for him to find his own female and accede in his turn to 'paternal' status which is the reward for renouncing the mother. The question of the female child gets less attention in Freud (and for that matter Lacan). That issue will be dealt with below.

The Oedipal crisis for the male child, then, manifests itself by this renouncement of the mother, what Freud terms primal repression. This moment of primal repression marks the founding moment of the unconscious. In other words, those unspoken sexual drives and desire for narcissistic union with the mother are repressed. The male child must repudiate his mother and become like his father in terms of masculinity, but not like his father in terms of his love object – it cannot be the mother (although, as Freud points out, it ultimately always is the mother). And it is here that we have the basis for the so-called Oedipal trajectory that has been associated with classic narrative cinema. The protagonist must successfully complete his trajectory through first resolving a crisis, usually of a triangular nature

(rivalry for a woman, for example), and then attaining social stability. By way of illustration, in the **comedy** genre the protagonist is often seen resolving a misunderstanding he has had with the woman he is attracted to and eventually settling down and marrying her.

Lacan's theory of the subject – including his concept of 'jouissance' Since the entries on **Imaginary/Symbolic** and on **subjectivity** go into Lacan's theories of the subject in considerable detail, what follows is a brief synopsis of the key issues and a quick indication of their impact on film theory. (For more detailed explanation see also **apparatus**, **feminist film theory** and **suture**.)

What of Lacan and his development and rethinking of Freud's theory of the subject? First, he shifted the frame of reference away from Freud's preoccupations with the sexual drives and looked to language as the site for the construction of the subject. of subjectivity. This shift is justifiable in a number of ways, starting with the fact that Freud himself posits the Oedipal complex at an age when the child can talk. In other words, the speaking subject comes into being at the moment of the primal repression (of the desire for the mother). At the same time as the male child enters into the Oedipal complex, Freud notes that he turns his attention to objects other than his mother in order to compensate for the fear of her loss. Freud talks about the child's fort da game. The child throws a reel of cotton away and, in retrieving it, emits the sound 'da'. The cotton reel, according to Freud's reading, is a substitute for the mother, the game a way of coming to terms with the loss of the mother (that is, of being separate from her, abandoned by her). The game and the word become a way of mastering her absence. That absence and control of absence is marked in language: 'da'. For Lacan, the game represents the child's entry into language and the reel functions as a symbol standing in for what is missing. It signifies lack. According to Lacan, the child is born into the experience of lack and spends the rest of his/(her) life trying to recapture an imagined entity which is the moment he associates with pre-lack - the imagined unity with the mother.

A second reason for Lacan turning to a linguistic model follows closely on from the above and concerns the child's shift, thanks to the mirror stage, from the Imaginary into the Symbolic. The mirror stage is a kind of 'half-way house' between the Imaginary and the Symbolic. It belongs to the Imaginary domain, but moves the child from the dyad with the mother

into an identification with its own specular image. Prior to the mirror stage, the child has no sense of separateness from the mother and, therefore, imagines itself as one. It is only after the mirror phase that it knows its difference and/or separateness from the mother. By this time, however, it has entered the Symbolic Order which is based in language – that is the 'Law' of the Father. Until this mirror phase, the child is pre-lack and pre-linguistic. Entry into the Symbolic is entry into language. It is also entry into lack. Language, therefore, becomes indissolubly based in and bound up with the concept of lack. Born into the experience of lack, the child as speaking subject is lack. What does this mean?

Primal repression for Freud is, as we have seen, the founding moment of the unconscious. Lacan, referring to this repression as primary, perceives this moment as an opening up of the unconscious, by which he means that the unconscious emerges as a result of the repression of desire. Lacan explains this occurrence in the following manner: the speaking subject comes into existence only because of the repression of the desire for the mother who is now lost. The child has relinquished its illusory/ Imaginary identity with the mother and entered the Symbolic. Thus every time the child enunciates 'I am' she or he also enunciates 'I am lack'. As Toril Moi (1985, 99-100) felicitously explains this difficult idea:

The speaking subject that says 'I am' is in fact saying 'I am he (she) who has lost something' — and the loss suffered is the loss of the imaginary identity with the mother and the world. The sentence 'I am' could therefore best be translated as 'I am that which I am not' according to Lacan. . . . To speak as subject is therefore the same as to represent the existence of repressed desire: the speaking subject is lack, and this is how Lacan can say that the subject is that which it is not.

Entry into language signifies both the birth of desire (the child recognizes it) and the repression of desire. Entry into language means entry into the social order, but it also means experiencing lack even further because desire can never be fully satisfied. Thus starts the unfulfillable search for the eternally lost object, what Lacan calls *l'objet petit-a* ('little "a"', autre meaning 'little "o"' other, the mother).

A final reason for Lacan's choosing the linguistic model lies in the similarity between the signifying system of language and that of the subject. Words do not have predetermined intrinsic meanings, nor does the subject. Sign and referent are not and do not mean one and the same thing. For example, the word 'tree' refers to tree but it does not *mean* tree. Similarly, when the child looks into the mirror, unity with the mirror image is illusory. Furthermore, words can only be defined in relation to one another. The unified self (as Freud has shown, and Lacan makes clearer still) does not exist and subjectivity cannot be defined in a vacuum but only in relation to others.

According to Lacan there are three determining moments concerning the child's development as it moves from the Imaginary to the Symbolic - which is the necessary progression for development into the social order. The three moments are the mirror phase, accession to language and the Oedipus complex. I have already talked to some extent about the latter two moments in the discussion of the fort da game and submission to the Law of the Father, so I will be brief on those two points. But first let's examine the mirror stage which the child goes through around the age of six to eighteen months. When the mother holds the child up to the mirror it assumes that the reflection it sees in the mirror is itself. In this respect, it begins to develop a sense of identity separate from the mother. This is the moment in which the child sees itself as a unified being at the centre of the world. It experiences a moment of pure jouissance (jubilation) in this narcissistic identification. The body is taken for the love-object. The child sees itself as whole, whereas in actual terms until now it has sensed itself as fragmented and uncoordinated. It sees in the mirror image the ideal image, the unified/whole. This narcissistic moment of self-idealization produces misrecognition in identification. It also produces alienation. This imaginary mastery over the body anticipates what is not yet there, actual mastery of the body. This ideal image is also the one the (m)other is holding up to be seen - she holds up the ideal image. So the child also identifies with what it assumes is the mother's perception of it. The child moves from the utterance of misrecognition, 'that's me', to that of alienation, 'I am another'. That alienation has a double edge. That is, the child senses it is not that unified co-ordinated image in the mirror ('I am another') and because the perception with which the child identifies in the mirror is that of the mother's (she holds up the ideal image), the image is conditioned by the mother's look ('I am who my mother desires me to be').

Alienation occurs, then, because the image can signify as real only because of the presence of the (m)other – what Lacan, as we have seen, terms *l'objet petit-a* – and identification is possible only in relation to another. This exposes the gap between the idealized image and the subject. This means there can never be a unified self, only a divided subject. The child is a divided self between, on the one hand, the ideal image (the ego-ideal) and the false sense of unity with the self and, on the other, the need for its subjectivity to be confirmed by another.

We can see here how Lacan has reworked two key ideas in Freud's concept of the narcissistic ego: the divided self and the mediation of self-identity by others. Lacan's account of the next moment, accession to language, is also based in Freud: the fort da game. According to Lacan, this game represents the child's entry into language. However, Lacan also makes the point that because the other (the mother) is already present in the mirror stage so too is the notion of the Symbolic Order - that is, language. To explain: the self only signifies because of the signifying presence of the other (in this instance the mother); the other is constituted by and in the Symbolic Order, that is to say, in language. Therefore, the Symbolic is already always present in the Imaginary Order because of the presence of the (m)other. When the child enters into the Symbolic, it enters language but it also succumbs to the Law of the Father, laws of society, laws that are determined by the Other (with a capital O). The Other is a term which is coterminous with the Symbolic Order, language and the Law of the Father. Lacan's use of the term Other allows him to formulate clearly the distinction between the Imaginary and the Symbolic orders. Thus in shorthand form he can refer to the capital O as distinct from the little o which refers to the imaginary relations with the other that take place within the Imaginary (the mirror-image, the mother). The capital O represents, then, the Law of the Father and the danger of castration - in these terms decapitation (being de-capitalized from O to o).

In order to obtain a social identity, the child has to suppress its desire of the mother. Again, Lacan's version of the child's Oedipal phase has much in common with Freud's; but the difference is the use of a linguistic model rather than a purely bio-sexual one. This is what Lacan defines as the Symbolic Order. At the moment that the male child recognizes his desire for his mother, the father intercedes and imposes the patriarchal

law. The father is the third member to enter the reflecting mirror. It is he who represents to the child the authoritative figure in the family. So the child imagines what the authoritative figurehead would say – the father is, therefore, a symbolic father. The father proscribes incest. This taboo is imposed linguistically and is defined by Lacan as the Law of the Father. Because it is based in language, patriarchal law is a Symbolic Order. In the Oedipal phase, then, the male child imagines himself to be what the mother lacks and therefore desires - that is, the phallus. However, this is proscribed by the Law of the Father, the patriarchal 'No'. Prohibition of fulfilling the incestual drive is marked in language. And the child will comply for fear of castration by the father. The male child enters into the Symbolic and adopts a speaking position that marks him as independent from the mother. Poor mother! In the pre-Oedipal phase she it is who has the power (to feed, to nurture) and, because she has the power, she is the 'phallic' mother. The post-Oedipal mother is powerless.

The male child conforms to the patriarchal law, upholds it and thus perpetuates it for generations to come - he follows in the 'name-of-the-father' so that when he says 'I' it comes from the same authorized speaking position as the language of the father, the Other. He becomes the subject of the Symbolic. However, as we know, his desire for the mother does not disappear, it gets repressed and enters into the unconscious. This means that his identification with the mother's object of desire, the phallus, does not disappear either, not altogether. For example. Lacan notes how the fetishist articulates this relation to desire around fetishistic objects such as women's shoes and bits of clothing. These are symbols of the mother's/woman's phallus in so far as it is absent and with which the fetishist identifies. We are reminded that in film noir the femme fatale is commodified in a fetishistic way (slinky black dress, high-heeled shoes, painted fingernails), but we could also consider François Truffaut's films with their constant figuration of women's legs. The transvestite similarly articulates this desire for the phallus in that he identifies with the phallus-as-hidden under the mother's dress. In other words, he identifies with a woman who has a hidden phallus. Fetishism, as we also know, is a strategy of disavowal faced by the fear of castration: the fetishist 'completes' the female body and in so doing denies difference, denies the lack. A reading of Psycho in this light shows not only to what

degree Norman Bates had fetishized his mother for fear of castration but also how unable (unwilling) he was to forego his desire to become or identify with his mother's object of desire, the phallus. He plays both fetishist and transvestite.

The subject represents itself in the field of the Other (language), that is, it represents itself through that which is outside of the self. A sense of fragmentation occurs which gets compounded by the fact that the subject can never fully be represented in speech since speech cannot reflect the unconscious. The subject, in representing the self, can only do so, then, at the cost of division (conscious/unconscious; self/Other). As the (conscious) subject seeks to represent the self in the field of the Other, it does so at the expense of coming after the fact or word, by which time the (unconscious) subject is already not there but becoming something else. The conscious subject utters 'I' and becomes situated as 'I': the spoken subject becomes presence. However, the unconscious subject is already beyond that 'I' and becoming something else: the spoken subject now becomes absence. As the spoken subject fades, becomes lack, so the subject will attempt to recapture itself as a unified being. the idealized image (ego-ideal) of the Imaginary. But, as we recall, this image is an external one, the subject as seen from outside, the subject as it imagines others (starting with the mother) see it. Lacan reasons that this is where the subject confronts the divided notion of the self: the image of the self is accurate but delusory. It is the same and other. The subject (mis) recognizes itself both as itself and as other. The subject is decentred, lacking and fading (for further detail see enunciation).

The two orders, the Imaginary and the Symbolic, are, as we have seen, always co-present (sutured as Lacan puts it). The Imaginary is the field of fantasies and images associated with the mirror phase and it never disappears because it involves the **mediation** of self-identification through another. It is, therefore, always already present in adult relationships. The Symbolic is the field of social and cultural symbolism. It is through this Order, which is based in language, that the subject can be represented or constituted. It is through this Order that the subject can articulate its desires and feelings. There is, however, a third Order of subjectivity, what Lacan calls the Real. The Real Order refers to what is outside the subject, what is 'out there', what the subject bumps up against but does not make sense of immediately – because it cannot or it will not. The Real Order is what subsists

outside symbolization, what has been expelled or foreclosed by the subject. If something gets excluded from the Symbolic it appears in the Real. It is what the subject is unable to speak, so it is like a hole in the Symbolic Order. Only through reconstruction can the Real be understood. The Real Order is not repression but foreclosure – it is the disaffirmation (rejection) that something exists for the subject. The Real is often experienced as an hallucination and, unsurprisingly, is linked with death and sexuality – what is 'the beyond of desire'. Thus, for example, the trauma of weaning is not understood then as such by the child but is signified in an hallucinatory form by the child making sucking noises. Fear of castration cannot be symbolized by the child, so it gets expelled into the Real Order, hallucinated say as a cut finger. The primal scene is hallucinated as the father brutalizing, perhaps even killing, the mother. The Real then is that which is prohibited the speaking subject (the subject inscribed into the Other, the Symbolic Order). Language in its first manifestation to the child is marked by the phallic signifier - the patriarchal 'No'. To break that prohibition means castration, death, lack. To enter into it means to adopt the same speaking position, that is, to be subject of that language that prohibits. This means that death and jouissance - because they are 'the beyond of desire', because they violate what the Law of the Father prohibits - must remain unspoken.

The key concepts we need to bear in mind when considering the impact of psychoanalysis on film theory, then, are: the construction of subjectivity and most particularly the notion of the divided self; the three orders of subjectivity, the Imaginary, the Symbolic and the Real; and, finally, the unconscious and the repression of desire. These terms of reference will be briefly elaborated upon below, but first a word about female subjectivity. (For more detail see Benvenuto and Kennedy, 1986; Grosz, 1990; Lapsley and Weslake, 1988.)

Psychoanalysis and the female subject. So far in this entry, little or nothing has been said about the female subject. Freud devotes two essays to the matter but Lacan does not examine it in much detail. Indeed, for Lacan the woman does not exist as subject, she is 'not being', 'not all', she is the other of the phallic function ('l'objet petit-a'). Lacanian feminists and feminist theorists do, however, investigate female subjectivity and argue that there is such a thing as a female Oedipal trajectory (see feminist film theory and Oedipal trajectory).

As far as Freud is concerned, the female child enjoys a pre-Oedipal relationship with the mother that is similar to the male child. Freud sees the Oedipal complex for the girl as dynamically different from the boy (see Freud's essay: 'Female Sexuality', Freud, 1931). According to Freud, the girl sees herself as born in lack so she rejects the mother and turns to the father to get herself a penis (in the form of a baby). That desire for the father gets transferred on to a male other (who ultimately *is* the father). Successful completion for the female is, then, motherhood (getting a penis in the substitute form of a baby). However, Freud argues that because there is no castration fear, the female child never fully gives up the Oedipal complex and that she is thus always bisexually poised.

Freud and Lacan concur (in different terms) that the libido is masculine. For Lacan this is because sexual difference is inscribed in language only in relation to the phallus. Freud talks of the riddle of femininity, asks the question 'what does woman want', speaks of her as the 'dark continent'. Lacan perhaps tells us something of what is going on in this phallocratic discourse when he says that women do not have the fear of castration, that they enjoy something that men cannot, in that they can have the phallus in intercourse - which a man never can (not even a homosexual). Lacan states that male desire is linked to eniovment of the phallus but at the expense of sexual enjoyment. The phallus is the signifier of the Symbolic, but it is also the reminder that one is not a unified self. Phallic enjoyment is achieved in language, that is in mastery: control, not abandonment. Lacan speculates that women derive jouissance (jubilation) from sex, an unspeakable enjoyment (Benvenuto and Kennedy, 1986, 185-93). This sounds very much like an assertion of the unfathomability of female sexuality. Whatever the case, if it is unspeakable then it is something that cannot be symbolized. If this is so, then female sexuality, to some degree or another, has been expelled to the Real Order. We know that sexuality and death are in the realm of the Real: in the realm of the inexpressible. Jouissance is also in the realm of the Real, it is what is forbidden the speaking subject, because it too is 'the beyond of desire' (1986, 180). Thus female sexuality becomes perceivable as hallucinatory because unspeakable, as close to death because of her surplus of enjoyment (jouissance). This will prove interesting when we come to consider film theory.

But for now what of the female subject and what of her Oedipal complex? Lacan is much less, if at all, clear about the girl child than Freud. When she perceives her sameness with her mother, she experiences her lack as being non-phallic. She discovers that she, like her mother, is castrated – is already what the male child most fears. Her sexual drives impel her towards the truly phallic, the father. The father must once again impose the Law of the Father and forbid her sexual access. When the girl child says 'I' the question becomes, whose 'I' is it? She cannot be subject of the Symbolic in the same way as the male child can because the authorized speaking position is that of the father, and language is marked by the phallus. If she cannot be subject then she must be object of the Symbolic (that is, language); and if she is object of the Symbolic then she must also be the object rather than the subject of desire (she is fixed by language since it is not hers).

The whole notion of identity for the male child is bound up with the question of sexual difference and language. As for the female child, first, she will never fully relinquish her desire for her mother because there is no recognition of it within the Law of the Father. Second, she will never fully enter into the Symbolic Order because the Law of the Father does not, in the final analysis, apply to her. And it is here that the questions surrounding female subjectivity become of real interest for feminists, because, as such, the female child is then doubly poised both sexually and in relation to language. With regard to the first point, we recall that her subjectivity is determined by her sameness with her mother. She is then doubly desiring, first, of her own sex (the mother) and also of the male sex (her 'natural' trajectory is to desire the father and, forbidden that desire by the father, she will then seek to fulfil it by finding a male other). In terms of language she is doubly positioned. She is pre-linguistic. Because she can never be subject of patriarchal language she is always outside it. She is not subject of language (unlike the male child) but object of the Symbolic Order. However, and here is the paradox, she is also in the Symbolic Order. As we have seen, she must be there in the patriarchal constructs of sexual identity because her reflection as (m)other has to be in the mirror for the male to recognize his difference.

It is clear that the male child has a vested interest in obeying the father and entering the Symbolic. However, it is equally clear that the female child does not have that same interest. She is never completely free from desiring her mother. Furthermore, because of their sameness, there is unity in identification. As with the male child, the mother is her first love-object. But because there is no perceived difference, there is no fear of castration. What, then, will motivate her to turn away from her mother and desire the father? Freudians argue that she turns away through penis envy. The mother cannot provide her with a penis so she will turn to the father for him to provide her with it in the form of a child. Lacanians, at least feminist Lacanians, argue that since she must enter into the social order of things - that is, the Symbolic - she will be obliged to turn from the mother even though she will never fully relinquish her desire of the mother. However this also means that in order to fulfil her Oedipal trajectory and enter into the social order of things, the female child must function as the other that confirms male subjectivity. To withhold such confirmation means punishment through one form or another of marginalization from the social order. To provide it is not without its problems either. Whose perception of the subject is she confirming? We must not forget that the image in the mirror is also conditioned by the mother's look. The male child identifies not just with his own image but with what he assumes is the mother's perception of him. His subjectivity is, to his mind, conditioned by the (desire of the) (m)other's.

Psychoanalysis and film theory In the 1970s film theorists (primarily French: Metz, Bellour, Baudry, all 1975), recognizing the limitations of a 'total theory' structuralist approach, turned to psychoanalysis as a way of broadening the theoretical framework. Drawing on Freud's account of the libido drives and Lacan's of the mirror stage, they sought to explain how film works at the unconscious level. By establishing an analogy of the screen with the mirror, they discovered a way of talking about spectator-screen relations. They argued that at each viewing there is an enactment for the spectator of the move from the Imaginary to the Symbolic Order, that is, an enactment of the unconscious processes involved in the acquisition of sexual difference, language and subjectivity. In other words, each viewing represents a repetition of the mirror and the Oedipal stages. Bellour makes the point that cinema functions simultaneously for the Imaginary (as mirror) and as the Symbolic (through the film discourses). And the spectator is in a constant state of flux between the two. We have already noted how, in terms of subjectivity, the two Orders are always co-present (to clarify this point further see suture).

According to these early theorists, in that cinema functions simultaneously for the Imaginary and the Symbolic, it follows that the cinema constructs the spectator as subject. In so far as the spectator is positioned voveuristically by the filmic apparatus. the spectator is also identified with the look, with all that that connotes in terms of visual pleasure. The projector functions as the eye, and that eye is all-seeing. Thus visual pleasure is also bound up with the principle of lawless seeing (unwatched by those on screen, the viewer watches). Going to the cinema implies the desire to repeat pleasure in viewing. But, because viewing also involves a re-enactment of the Imaginary narcissistic identification with the image and lawless seeing, it implies that there is a desire to repeat the experience of jouissance (which we know is 'the beyond of desire'). Given this identificatory process, it is not difficult to see why Metz would speak of cinemagoing and viewing as a regression to childhood.

Metz argues that it is not just the process of voyeurism that is involved in film-viewing, but also that of fetishism. Fetishism and voveurism are the two strategies adopted to disavow difference. To contain and make safe the (m)other's lack (absence of a phallus) and to allay thereby the fear of castration, the woman is made object of the gaze (voyeurism), or has a part of her body over-invested in so that what is present (for example, legs or breasts) stands in for what is absent (fetishism). Fetishism occurs on screen within the image, as in the case of the fetishizing of the body of the femme fatale in film noir. But, says Metz, fetishism operates also at a far more basic level. The image as image and the cinematic apparatus as apparatus are both fetish, because they stand in for, make present, what is absent. As such, they disavow what is lacking, they disavow difference. Similarly the spectator, in watching cinema, is disavowing lack, difference. The spectator knows that presence is absence, that what is there is not there, that what is being seen is lack (absence). Yet the spectator, says Metz, disayows it and the apparatus in its seamlessness disguises this absence, it sutures the spectator into that disayowal (see suture).

It is in these investigations into cinema's relation to voyeurism and fetishism and its relation to the Imaginary and Symbolic Orders that these early years of psychoanalytic film theory made their greatest inroads into the advancing of film theory. Cinema was seen to embody psychic desire. The screen became the site for the projection of our fantasies and desires, that is, for our

unconscious. In this way, it was presumed that the cinema positioned the spectator as desiring subject, therefore, as subject of the apparatus – starting with the camera, with which the spectator identifies. These first theorizings were not entirely unproblematic, however. Indeed, they presented at least three problems, not least of which was the exclusively phallocratic reading of cinematic practices. These issues were picked up by feminist film theorists – starting with Laura Mulvey (1975). The identified problems were, first, that in this reading it is assumed that the spectator–screen relation is only one-way; second, that the subject is male in its positioning; and third, that film texts are organized in such a way as to give a **preferred reading**.

Feminist film theorists, while acknowledging that psychoanalysis as a discourse oppresses women, none the less insisted that it was for that very reason that it was important to investigate it seriously, not simply to understand it but to be able to expose the phallocentric construction of subjectivity - starting with Freud's notion of penis envy and Lacan's assertion that our subjectivity is determined in relation to language and its signifier, the phallus. To understand how women have become positioned as they have, the argument goes, is to make possible a deconstruction of that construction. In terms of film theory, the film text in this context stands as a dream, a fantasy or the analysand, and the critic or theorist takes on the role of the analyst. Thus for instance feminist critics have managed to look at 'themes (such as mother/daughter bonding or Oedipal triangles) in order to understand how patriarchal signifying systems have represented such systems' (Kaplan, 1990, 15, her stress). Furthermore through this deconstructionist approach they have been able to give readings against the grain, that is, readings that are not the encoded, preferred reading.

During the 1980s and 1990s, therefore, problems brought about by a phallic-centred reading of cinema have been largely debated and that reading has been contested. As a result, psychoanalytic film theory has developed considerably in the areas of spectator viewing and textual analysis. Spectator positioning is now seen as more heterogeneous or pluralistic (across **gender**, **class**, race, age, sexuality, nationality and creed). The spectator-subject is as much constituting of as constituted by the filmic text (see **ideology**). So the spectator-screen relation is at least two-way. Finally, the Oedipal trajectory of the classic narrative is no longer perceived as exclusively male – particularly within

film genres that are not evidently all-male, such as **melodrama** and **film noir**. The female Oedipal trajectory is now being investigated in terms, first, of mother/daughter relations and, second, of lesbian relations (even if subliminal).

I want to conclude this entry on another related issue with regard to the female Oedipal trajectory, this time in its relation to desire. Whilst from the very beginning of the introduction of psychoanalysis into film theory considerable attention had been paid to the male Oedipal trajectory and desire, it was not until recently that this question, as it concerned the female, came into focus. Barthes, in his book Le Plaisir du texte (1973), makes the distinction between pleasure and jouissance. He is talking primarily about literary texts, but the distinction holds good for other texts, including the bodily text. Pleasure is what the reader derives from the closure offered by realist texts. Conversely, jouissance is derived from modes of narration that do not provide closure. Barthes speaks of jouissance occurring in reading a text when his body follows its own ideas. Jouissance is experienced corporeally not linguistically. He encounters his enjoying body: corps de jouissance is his term. In this way he experiences an erotic investment in the textual object. Barthes seems to be echoing Freud's notion of the narcissistic ego here. Both pleasure and jouissance, says Barthes, can be experienced within the same text. We can now see that pleasure is experienced in the Symbolic Order (social order, control, closure) and can be enunciated in language. Conversely, jouissance is experienced within the Imaginary (since the term refers to when it was first experienced as that moment of imaginary unity with the self as reflected in the mirror). As such it remains unspoken. Since pleasure and jouissance can both be experienced within a same text it follows that both the Imaginary and the Symbolic can be experienced within a single text as well. The Imaginary and the Symbolic, in reading as elsewhere, are always co-present.

But let's pick up this question of *jouissance* and female desire. We recall that *jouissance* is, of course, extra-discursive. *Jouissance* is, first, that imaginary moment in the mirror phase when the image and the self are united in fusional bliss. *Jouissance* is before language, what remains unspoken. Henceforth, upon entry into the Symbolic – now that the child can speak – *jouissance* joins the realm of the Real Order of subjectivity and becomes associated with that which cannot be spoken: death and desire. We noted above that, according to Lacan, woman is both 'not all/not

being' and the site of *jouissance*. We have also noted that she is sexually and linguistically doubly positioned. On the one hand, she is desiring of the Other or father and as such is *in* but not of the Symbolic Order. On the other, she is both pre-Oedipal and pre-linguistic. She can, therefore, experience *jouissance* far more readily than the male for whom such unspeakable enjoyment is prohibited by the Law of the Father. Viewed from this phallocentric point of view, *jouissance* is represented as woman's 'natural' realm. This is her 'deep and dark mystery'.

But, and here is a first complication, jouissance stands for the fusional pleasure of the Imaginary: the moment of narcissistic identification with the ego ideal. It stands also for what the subject always already desires: the desired fusion with the lost object - 'objet petit-a' - the (m)other. This would suggest that the female subject can experience what the male subject cannot: unification with the self and with the mother. She has something that male subject does not. Significantly, beyond the already existing lesbian overtones in this unification, when the woman experiences childbirth for herself she identifies with, becomes her mother as well as being mother herself. She is reunited with her mother's body at the same time as she is giving birth to her self. Lesbianism, reproduction and narcissism unite in unspeakable enjoyment: jouissance. Equally important, since the female subject, according to this phallocentric view, can experience jouissance, she is 'naturally' represented in the Real Order. This means that, in terms of her sexuality, she has been expelled or disaffirmed by the male subject - he who is constituted by language which is marked by the phallic signifier. She is outside symbolization. Her sexuality remains unspoken - in phallic terms it remains a hole in the Symbolic Order, the male subject rejects that it exists. We recall that the Real is often experienced as an hallucination and is, of course, closely aligned with sexuality and death. So the male subject, in foreclosing the female subject's sexuality into the Real Order as jouissance, is in fact experiencing it as an hallucination, as 'the beyond of desire', as death.

It is not difficult to see that a phallocentric world will construct the female subject in such a way that she will not derive power from this. And it is noteworthy that her experience of desire, as in *jouissance*, is mute and biologically, not linguistically, based. Significantly, 'bad' motherhood gets considerable exposure in films as much as in other media. Take for example the wicked mother of Joan Crawford in *Mommie Dearest* (Frank Perry, 1981), the over-zealous mother as the eponymous *Mildred Pierce* (Michael Curtiz, 1945) who is 'punished' by one of her daughters for her over-maternalizing behaviour, or the self-sacrificing but ambitious mother in *Stella Dallas* (King Vidor, 1937) who will relinquish her bond for the sake of her daughter's upward mobility. Cyborg-reproduction movies like *Alien*³ (Fincher, 1992), *The Fly* (David Cronenberg, 1986) and *Coma* (Michael Crichton, 1977) attempt either to punish the woman for having sole rights to reproduction organs or to show that they are not necessary after all. And films that have men as reproducers, as in the recent Schwarzenegger movie *Junior* (Ivan Reitman, 1994), although silly, none the less say much about male fantasies.

Women in film noir are frequently punished for their refusal to conform to patriarchal signifying systems. Rather, they are first constructed as being in control of their own sexuality and then punished for it. In other words, the film noir as a genre puts on screen the 'unspeakable', feminine jouissance. It represents the unrepresentable, the Real Order. It is interesting to note that the male protagonist is usually unclear and confused about what is happening in the narrative - as if he is partly blinded, or as if he is hallucinating (as in Double Indemnity, Billy Wilder, or Murder My Sweet, Edward Dmytryk, both 1944). Arguably the film that best illustrates the male subject's hallucination of female subjectivity is Otto Preminger's Laura (1944). The male protagonist, the detective Marc McPherson, is obsessed by a portrait of a woman he believes is dead, Laura. He is obsessed to the point that he literally hallucinates her. He also pursues women whom he momentarily misrecognizes as her only, finally, to come face to face with her, alive,

As far as film noir is concerned, we can also see that this **mise-en-scène** of the Real Order, at least where female subjectivity is concerned, makes possible a playing out of the fear of castration. Here the strong 'phallic' woman is represented as sexually armed and dangerous. The fact that she is fetishized through her dress-code should not, however, escape our attention. It tells us that she is after all contained by the male and that, although she may behave transgressively throughout the film, she none the less will be put in her place by the end (for example *The Woman in the Window*, 1944; *Gilda*, 1946; *Kiss Me Deadly*, 1955).

For a sample reading of applications of psychoanalysis to film see Doane, Mellencamp and Williams (eds), 1984; Doane, 1992; Kaplan, 1980, 1983, 1990 and 1992; Krutnick, 1991; Kuhn 1982 and 1985; Lebeau, 1994; Lurie, 1980; Modleski, 1982 and 1988; Mulvey, 1989; Rose, 1986; Zizek, 1999.

psychological thriller - see thriller

Queer cinema Queer cinema has been in existence for decades although it lacked a label. Films of Jean Cocteau and Jean Genet in France in the 1930s and 1950s (such as Le Sang d'un poète, Cocteau, 1934, and Le Chant d'amour, Genet, 1950) are cited as the forefathers (sic). It is a cinema that is identified with avantgarde or underground movements (for example Anger and Warhol 1960s films in the USA). In the avant-garde world of cinema, lesbian film-makers' presence is quite strong too (for example Ulrike Ottinger, Chantal Akerman, Pratibha Parmar). Queer cinema itself was introduced as a concept, in 1991 at the Toronto Festival of Festivals, to refer to a spate of films (beginning in the late 1980s) that re-examined and reviewed histories of the image of gays. These films proposed renegotiated subjectivities, men looking at men, gazes exchanged, and so on. They also took over genres previously considered mainstream, subverting them by bringing the question of pleasure onto screen and the celebration of excess. In certain cases, these films reinscribed the homosexual text where previously it had been elided. See, for example, Derek Jarman's historical film Edward II (1991), or Tom Kalin's murder/crime thriller Swoon (1992). The latter is a 'remake/retake', setting the record straight (!) of two earlier versions of the true story of a murder committed by two young men of a 14-year-old boy in Chicago in 1924. The first version was the Hitchcock film, Rope (1948), and the second a Richard Fleischer film, Compulsion (1959). Both films completely elide the homosexual dimension of the two killers' relationship.

Always a cinema of the margins, only in the 1990s, in the light of the tragedy of AIDS, has Queer cinema become a more visible cinema. Indeed, the New Queer Cinema, as this cinema

is also labelled, has presently become a marketable commodity if not an identifiable movement. One of the leaders of the American Queer cinema is Gus Van Sant (My Own Private Idaho. 1991, Even Cowgirls Get the Blues, 1993). New Queer Cinema was a term coined in a 1992 Village Voice article by B. Ruby Rich to describe the renaissance in gay and lesbian film-making represented by the Americans Todd Haynes, Jennie Livingstone, Gus Van Sant, Gregg Araki, Laurie Lvnd, Tom Kalin and the British film-makers Derek Jarman and Isaac Julien. Oueer cinema is not a single aesthetic but a collection of different aesthetics - what Rich delightfully refers to as 'Homo-Pomo'. It is a cinema that takes pride in difference. Queer cinema is above all a male homosexual cinema and focuses on the construction of male desire. Some lesbian film-makers have made films that come under this label and it is instructive that they have made films that address not just their sexuality (as in Go Fish!, Rose Troche, 1994) but that of their male counterparts (Paris is Burning, Jennie Livingstone, 1991).

Queer as a politics has not resolved lesbian invisibility. There exists still (as within the heterosexual world of the film industry) an inequality of funding for lesbian film-makers as opposed to gay film-makers. Gay is perhaps more cool than lesbian at present, and one does wonder - cynically perhaps - if Philadelphia (Demme, 1993) would ever have been financed by Hollywood if the New Oueer Cinema had not come along at the beginning of the 1990s and enjoyed the success it did with mainstream as well as gay audiences. Having said that, there are some lesbian feature films, although for the most part, they pre-date New Queer Cinema – an exception being Patricia Rozema's beguiling When Night is Falling (1995). Of the 1980s' films we can count Born in Flames Lizzie Borden, 1983, Desert Hearts, Donna Deitch, 1985, I've Heard the Mermaids Singing, Patricia Rozema, 1987. Due to lack of financing, most lesbian film-makers have opted for video to develop their counter-cinema in an unfettered way much as other marginal cinemas before them have done such as women's cinema, and cinema nôvo as it developed into garbage cinema (see Sadie Benning, Jollies, 1990, Pratibha Parmar, Khush, 1991, Shu Lea Cheang, Fresh Kill, 1994).

It is quite probable that Queer cinema as a term came about by identification with trends in critical theory begun in the mid-1980s, namely, Queer theory. Queer theory can be seen as a desire to challenge and push further debates on gender and sexuality put in place by feminist theory (amongst others) and also as a critical response to the numerous discourses surrounding AIDS and homosexuality. Queer theory is, arguably one of the first truly postmodern theories to be born in the age of postmodernism. In its practice it is extremely broad. It is a concept that embraces all 'non-straight' approaches to living practice - including, within our context, film and popular culture. As a politics, it seeks to confuse binary essentialisms around gender and sexual identity, expose their limitations and suggest that things are far more blurred (for example, think of the spectator pleasure derived from watching Robbie Williams wearing a dress and singing one of his many hit songs - as he did in one of his video promos). It is more than a subversion of straightness, it is also more than an exposing of the fact of hegemonic homosociality and the hypocrisy of denial. It is in fact far more celebrative than that. In a sense it challenges everyone's assumptions about gender and sexuality. It shows how you can queer-read ('queried') virtually everything as just one other, equal not subordinate, way of reading the texts. Queer readings go 'against the groin' (Verhoeven, 1997, 25). Queer theory examines queer at work, that is, the making or writing about gayness by authors and film-makers. Doing queer work can be done by all sexualities. Thus, straights, bisexuals, transexuals, gays and lesbians who are writing or making texts about gayness are performing, enacting Queer[ly]. Queer theory can open up texts and lead us to read texts that seem straight differently - or view them from a new and different angle. Thus a queer reading can reveal that you are watching (reading) something far more complex than you originally thought you were (think of buddy films for example). The actor or film-maker does not have to be queer, but the text or performance may offer itself up for a queer reading (Joan Crawford as the cross-dressing gun-toting but butchly feminine Vienna in Johnny Guitar, Nicholas Ray, 1954).

New Queer Cinema is unconcerned with positive images of queerness, gayness or lesbianism, but is very clearly assertive about its politics – starting with the expression of sexuality as multiplicity and not as fixed or essentialized. Thus stereotypes of queerness get reappropriated and played with. True camp (not the appropriated camp of straight cinema) privileges form over content but with a purpose. Queer camp is about trashing stereotypes with flash and flounce and dress in excess. It is about ridiculing consumer passivity through deliberate vulgarity. It is about (as in

the original French sense of the word camper: to play one's role) assuming fully and properly one's performative role. In terms of stereotypes, camp itself and narcissism get some royal send-ups in The Adventures of Priscilla, Queen of the Desert, Stephan Elliot (1994) and in Go Fish! Queer cinema challenges the view that homosexuality and lesbianism must have value ascribed to it (as good or bad) - it just is. There are political implications about homosexuality and lesbianism, but so too are there about race - as indeed black gay and lesbian film-makers make clear (Looking for Langston, Isaac Julien, 1988). In Queer cinema and theory, the gaze as well as questions of visual pleasure come under scrutiny. Since the relays of looking are different within the screen, so too must they be outside the screen and in the spectator's eyes. More pleasures can be experienced by the spectator as he or she adopts different positionalities within the narrative. In some ways this is not so new if we think of pornography and the pleasure in viewing for the spectator (male or female) of the typical triad set-up which includes a lesbian scene or two to get things warmed/hotted up. But it may be that Queer theory makes us feel more comfortable speaking about it. Interestingly pornography as a critical debate within film studies has only truly emerged in the 1990s – perhaps coming on the heels of the effects of Queer theory.

New Queer Cinema advocates multiplicity: of voices and of sexualities. Multiplicity in a generic sense also: vampire films and comedy, thrillers and musicals. Unstick the queer from the moribund representation to which much of mainstream cinema has confined 'it'. Queers are neither the depressed anomics nor the serial killers some film-makers would have us believe (see Winterbottom's offensive Butterfly Kiss, 1994). To rewrite Foucault: 'Queer is everywhere'. The signs of queer globalization are there to see. Asian queer is on the scene (Chen Kaige's Farewell My Concubine, 1993, Zhang Yuan's East Palace/West Palace, 1996, Wong Kar-Wai's Happy Together, 1997). It is no longer a case of having to find it, but 'to connect'.

For further reading see Dyer, 1977b, 1990; Russo, 1981, 1987; Weiss, 1990; Bad Object-Choices, 1991; Fuss, 1992; Gever, Parmar and Greyson, 1993; Mell-Metereau, 1993; Burston and Richardson, 1995; Creekmur and Doty, 1995; Dorenkamp and Henke, 1995; Gill, 1995; Whisman, 1995; Horne and Lewis, 1996; Bristow, 1997; Jackson and Tapp, 1997. For a documentary film of queer, see *The Celluloid Closet*, Rob Epstein and Jeffrey Friedman, 1995.

R

realism (see also documentary, naturalism, seamlessness, sociorealism, suture) The term realism comes from a literary and art movement of the nineteenth century which went against the grand tradition of classical idealism and sought to portray 'life as it really was'. The focus was on ordinary life - indeed the lives of the socially deprived and the conditions they had to bear. As far as the film camera is concerned, it is not difficult to see why it is perceived as a 'natural' tool for realism, since it reproduces 'what is there' (that is, the physical environment). Film as cinema makes absence presence, it puts reality up on to the screen. It purports to give a direct and 'truthful' view of the 'real world' through the presentation it provides of the characters and their environment. Realism functions in film on both the narrative level and the figurative (that is, pictorial/ photographic). In this regard, physical realism marries into psychological realism via the narrative structures. Generally speaking, realist films address social issues. However, because the narrative closure of these films tends to provide easy solutions, this form of realism on the whole serves only to naturalize social problems and divisions and not provide any deep insight into causes.

There are, arguably, two types of realism with regard to film. First, seamless realism, whose **ideological** function is to disguise the illusion of realism. Second, aesthetically motivated realism, which attempts to use the camera in a non-manipulative fashion and considers the purpose of realism in its ability to convey a reading of reality, or several readings even. As far as the seamless type of realism is concerned, film technique – supported by narrative structures – erases the idea of illusion, creates the

'reality effect'. It hides its mythical and **naturalizing** function and does not question itself – obviously, because to do so would be to destroy the authenticity of its realism (see **myth**). Nothing in the camera-work, the use of **lighting**, **colour**, **sound** or **editing** draws attention to the illusionist nature of the reality effect. The whole purpose is to stitch the spectator into the illusion – keeping reality safe.

Conversely the realist aesthetic, first strongly advocated by French film-makers in the 1930s and subsequently by André Bazin in the 1950s, is one that recognizes from the start that realist discourses not only suppress certain truths, they also produce others. In other words, realism produces realisms. And, although due caution must be exercised when making a realist film, this multiplicity of realisms means that a film cannot be fixed to mean what it shows - as occurs in seamless realism. The realist aesthetic recognizes the reality-effect produced by cinematic mediation and strives, therefore, to use film technique in such a way that, although it does not draw attention to itself, it none the less provides the spectator with space to read the text for herself or himself. In other words, technique functions in this instance so as not to provide an encoded preferred reading. Rather, it seeks to offer as objectively as possible a form of realism. So this type of realism uses location shooting and natural lighting. Most of its cast is composed of non-professional actors. It employs long shots using deep-focus cinematography (to counter manipulation of the reading of the image), long takes (to prevent the controlling effects of editing practices) and the 90-degree angled shot that, because it is at eye level, stands as an objective shot.

After the Second World War, the American public wanted a more realist view of the country, which it found in the spate of **films noir**. In Italy economic necessity as much as a desire for a non-manipulative realism produced **Italian neo-realism**, which picked up on realist traditions already in place in French and Italian cinema of the 1930s. Indeed, Jean Renoir — one of the major advocates of a politically motivated socio-realist cinema — is credited with making the first film of this kind, *Toni* (1934). In the 1960s France, for its part, pursued its interest in politically motivated realist films, albeit on a small scale, with the **cinéma-vérité** and documentary works of such film-makers as Jean Rouch. Finally, from the late 1950s into the 1960s, new wave cinemas emerged from Britain, France and Germany and

provided the slice-of-life realist cinema (see British New Wave, French New Wave, New German Cinema).

For a full discussion of the debates around realism see Lapsley and Westlake, 1988, 157–80; Williams, 1980.

reconstructions - see historical films

repetition/variation/opposition- see narration, sequencing

representation – see feminist film theory, gender, sexuality, stereotypes, subjectivity

resistances - see avant-garde, counter-cinema

reverse-angle shot - see shot/reverse-angle shot

road movie (see also genre) Road movies, as the term makes clear, are movies in which protagonists are on the move. Generally speaking, such a movie is iconographically marked through such things as a car, the tracking shot, wide and wild open spaces. In this respect, as a genre it has some similarities with the Western. The road movie is about a frontiersmanship of sorts given that one of its codes is discovery - usually selfdiscovery. The codes and conventions of a road movie have meant that until fairly recently this genre has predominantly been a gendered one. Generically speaking, the road movie goes from A to B in a finite and chronological time. Normally the narration of a road movie follows an ordered sequence of events which lead inexorably to a good or bad end (compare the bad ending for the travellers in Easy Rider, Dennis Hopper, 1969, with the reasonable solution for the protagonist in Paris Texas, Wim Wenders, 1984). Genderically speaking, the traveller(s) is male and the purpose of the trajectory is to obtain self-knowledge. Recently, however, women have been portrayed as the travellers (as in Thelma and Louise, Ridley Scott, 1991) and in this we can perceive a readiness to subvert or parody the genre. The Adventures of Priscilla, Queen of the Desert (Stephen

Eliot, 1994) ironizes the macho-masculinity of the genre in a different way – this time a dancing troupe of drag-queens sets off across the Australian desert and all find fulfilment in one way or another.

rules and rule-breaking - see counter-cinema, jump cut

S

science fiction films (see also genre) These are considered by some critics to be a sub-genre of the horror movie (see Cook, 1985, 99); by others as a genre distinct from horror films (see Kuhn and Radstone, 1990, 355); by others yet again as a sub-genre (along with horror movies) of fantasy films (Konigsberg, 1993, 303). These varied critical positions point to the difficulties in demarcating and categorizing genres in general and this one in particular. Interestingly, the French use all three categories fantastique, horreur and science fiction to distinguish between films which other countries might be satisfied to lump under one label, namely horror.

Science fiction as a literary genre came about in the mid- to late nineteenth century in response to advances in science and technology. Two exemplary authors of the genre, Jules Verne and H. G. Wells, from opposing positions, described science's prowess in making possible what up until the turn of the century had seemed impossible (for example submarines and space craft). Film, in so far as it can make visible what is invisible, seems a natural medium for this kind of narrative. However, science fiction films have been more erratic in their appearances on screen than most other genres. For example there were only a few produced during the silent era and it could be said that as a genre it came into its own only after 1950 (for reasons that become clear below).

The earliest examples of science fiction movies date back to Georges Méliès with his *films fantastiques* that portrayed voyages to the moon and to the centre of the earth (1902). These, however, were benign comic narratives of humans encountering a series of adventures with strange phenomena which none the

less ended 'happily' – marked by a return to safety (that is, the earth's surface). Apart from Méliès's work, which was very loosely based on Verne's writing, films in this genre have tended to be grounded more in the Wellsian fear of science outstripping our understanding and taking us over. Science fiction films produce a futuristic vision where we are no longer in control of what we have created (this curiously assumes that we currently do control science). This genre relies on the **audience**'s willingness to suspend disbelief and does so by playing on our fears of science. The few science fiction films made before 1950 tended to focus on technology as the science-demon that would destroy humanity.

After 1950 the trend was for humanity to be at risk from alien intruders that either invaded the earth or caught up with humans in outer space in a space-craft or on an alien planet (upon which the humans unquestioningly had the greater right to be, it would appear). It was not until this period that this genre or sub-genre became identified as a Hollywood genre. Apart from the Flash Gordon serials (1936-40), what little science fiction had been produced in western culture was of European origin - the most remarkable example being Fritz Lang's Metropolis (1926) with its futuristic city, and William Menzies's space fantasy The Shape of Things to Come (1936). However, the 1950s was the period of the Cold War at its highest. 'Reds under the bed', McCarthyism and the House Un-American Activities Committee's witch-hunt of supposed communists, the threat of the nuclear deterrent (albeit only ever used by the Americans against an enemy), the threat or fear of totalitarian regimes - all of these elements fed into the American political culture of the 1950s and found a steady reflection in contemporary film production. Aliens came in their droves from outer space on to the American screen (Invaders from Mars, War of the Worlds, It Came from Outer Space, all 1953 films, and It Conquered the World, 1956, etc., etc.).

After 1968 – the next watershed year, with Stanley Kubrick's 2001: A Space Odyssey – the genre reintroduced technology as man's (sic) potential enemy but in a far more ambiguous way. In this film, man's responsibility as the maker of the technology is highlighted as Hal, the computer aboard the 2001 spaceship reminds us. Although Hal is destroyed because of his severe lifethreatening malfunctioning, it is never resolved whether he is friend or foe. Later, this ambiguity surrounding Hal is mirrored

in the representation of the alien, once science fiction returns in the 1970s and early 1980s (The Man who Fell to Earth, Nicholas Roeg, 1976; Steven Spielberg's Close Encounters of the Third Kind, 1977 and E.T., 1982). This type of alien is generally unthreatening (once you get to know 'him') and often offers us a lesson in humility before departing (presumably back whence it came). It should be remembered that the 1970s was the Age of Aquarius. peace and flower power, sentiments that could extend to an enlightened openness at least towards individual aliens. There were rumblings of nastiness about, however, as in Ridley Scott's Alien, made in 1979. Technology and aliens were now to be feared equally - nay, might even be present in one and the same thing as this film and its two Alien sequels (to date) make clear, although in a very specific way. This Alien trilogy addresses the effects of feminism on patriarchy and male sexuality. Thus, rather than a political culture feeling under threat (as in the 1950s), it is now (White) male sexual culture that feels threatened. In Alien, men give birth to alien babies; by Alien3, the only remaining woman is implanted (artificially inseminated) with an alien egg. Reproductive technology is here, man has made it and as such threatens women's reproductive rights. Although this is not the first series of science fiction films to attract feminist critics to the genre, it sums up why this genre is of interest to them; because it shows the danger of science and technology, explores the underlying social anxieties regarding especially experiments in reproduction technology, and constructs of female sexuality as monstrous (Kuhn and Radstone. 1990, 356).

The science fiction film, then, is politically motivated – mostly, but not entirely, negatively. Technology should be questioned and attitudes to outsiders should come under scrutiny, but this is rare, as a quick gloss over the three main categories of films discussed above will show. The three types within this genre are: space-flight, alien invaders, futuristic societies. Lang's Metropolis is the prototype of this last category. But it also set the agenda for a critique of futuristic urban spaces by challenging the 1920s modernist belief in technological progress as a source of social change – a challenge still apparent today in Ridley Scott's Blade Runner (1982) and Luc Besson's The Fifth Element (1997). Space-flight films, on the other hand, have traditionally devoted more energy to exposing the virtuosities of film technology and as such have functioned as a vehicle for prowess (in real terms for

the film industry, **metaphorically** for the space industry) until the arrival of Kubrick's 1968 film 2001, which placed grave question marks on man's faith in and assumed superiority over technology. Finally, alien invader films, because they are probably the most prolific of the three categories and, arguably, the most conservative – in that they point at otherness as threatening to life and/or social mores – represent the most 'worrying' category of all with their innate potential for misogyny, racism and nationalistic chauvinism.

For further reading see Brosman, 1991.

scopophilia/scopic drive/visual pleasure (see also gaze) Literally, the desire to see. Sigmund Freud used the term scopic drive to refer to the infant's libidinal drive to pleasurable viewing. As such, it is closely attached to the mirror phase and the primal scene. In Lacanian psychoanalysis the mirror phase refers to the moment of recognition by the male child of his difference from his mother. And the primal scene, first identified by Freud. refers to the moment when the male child, unseen by his parents, views them copulating. In psychoanalytic film theory (in the 1970s) scopophilia was adapted to elucidate the unconscious processes at work when the spectator views the screen. This spectator-screen analysis revealed that a double phenomenon occurs: first, cinema constructs the spectator as subject (the beholder of the gaze - that is, at the moment of the mirror phase); second, it establishes the desire to look (the drive to pleasurable viewing – that is, at the moment of the primal scene). Thus, as Metz (1975) stated, at each film viewing there occurs a re-enactment of the unconscious processes involved in the acquisition of sexual difference and, simultaneously, a voyeuristic positioning of the spectator (the viewer watches unseen in a darkened room or theatre).

At this juncture (early 1970s), the meaning of the mirror stage (fear of castration at the sight of sexual difference with the mother) and the implications of scopophilia for masculine erotic desire and the male **fetishizing** gaze were never brought into question. This would not occur until the mid-1970s, when the issue of **gendered** spectatorship finally got addressed, first by Laura Mulvey (1975), then by other feminist critics. They developed a theory to describe the pleasure derived from the gaze (usually male) of the character whose point of view it is within

the film and, also, the pleasure derived by the spectator gazing upon the female body (whether nude or not). This gaze fixes the woman and in so doing fetishizes her, makes her the object not subject of desire. It fixes her, attributes meanings to her that are derived from another (male) perception or reading of the female bodily text. To this effect the woman has no **agency**.

Cinema functions through its codes to construct the way in which woman is to be looked at, starting with the normally male point of view within the film. The source of pleasure offered by that point of view to the male spectator (through identification) is clear. What, however, of the female spectator? Mulvey argues that for her to derive pleasure she must adopt the masculine point of view. Later feminist critics (Doane, 1982) nuance this masculinization of the female spectator, arguing that there are two viewing places: that of the female masochist identifying with the passive female character and that of the transvestite identifying with the active male protagonist or hero. Later still, Bergstrom (1985), Studlar (1985) and Modleski (1988) propose positioning the female spectator bisexually. In this position she can identify with the female character's predicament caught within socio-economic and sexual structures that make her 'victim'. But this identification can then lead to a regendered position that allows for a critique of such structures to take place.

For further discussion see feminist film theory, spectatorship and suture.

seamlessness (see also continuity editing, editing, spatial and temporal contiguity, suture) Used to refer to the Hollywood film style where — in the name of realism — the editing does not draw attention to itself. The spectator is presented with a narrative that is edited in such a way that it appears to have no breaks, no disconcerting unexplained transitions in time and space. Hence its seamlessness (with which lighting, sound and colour collude). Editing style that draws attention to itself (for example, through jump cuts and unmatched shots) is mostly found in oppositional, non-mainstream, counter-cinema.

semiology/semiotics/sign and signification (see also structuralism) Semiology was a term coined by the Swiss

linguistician Ferdinand de Saussure, in his lecture series on structural linguistics (1907–11), to refer to the study of signs within society, which he believed should be possible thanks to the application of structural linguistics to any sign system. Semiotics, coined a little earlier by the American philospher C. S. Peirce, is the term that has most currency in English speaking countries and also refers to the study of signs. However, in general, the term semiotics refers more to Saussure's theories than to Peirce's. And since Saussure's theories have had the greater impact to date in film theory we will limit this discussion to his (those interested in the adoption of Peirce's theories should see Wollen, 1972).

Saussure's structural linguistic theories, which were to remain 'unknown' until Roland Barthes brought them into the limelight in the late 1950s (in his book Mythologies, 1957), gave birth to a new theoretical system known as structuralism. In his Cours de linguistique générale (published posthumously in 1915) Saussure set out the base paradigm by which all language could be ordered and understood. The base paradigm, langue/parole, was intended as a function that could simultaneously address the profound universal structures of language (langue) and its manifestation in different cultures (parole). Saussure made the vital point that the governing conventions in relation to this sign system are very arbitrary and that there is no necessary correlation between the word (the signifier) and the object or idea being designated (the signified). This arbitrariness is manifest in the differences between languages. It is also this arbitrary relationship between signifier and signified which makes it possible for this linguistic system to function as a general science of signs - meaning that it can address other sign systems, can examine other sign systems as operating like a language. Just to clarify the meaning here: semiotics, in that it studies the social production of meaning through linguistic sign systems, stresses that language as a cultural production is societally, not individually, bound. Given that there are social or cultural productions other than language which produce meanings (for example sport, games), that is there are other sign systems, semiotics became a useful tool with which to analyse the process of meaning production in such sign systems as literature, cinema, television and advertising and, ultimately, other forms of popular culture (pop songs, dress-codes and so on). Barthes (1957), for example, used semiotics to examine popular cultural artefacts of the 1950s and the language of mass culture.

Saussure broke new territory in the study of language which, until his new approach, had been limited to philology, that is, to how language has evolved rather than to how language works, produces meaning, which is what interested Saussure. Meaning, he argued, could not exist independently from a system which, in the case of language, meant langue (that which can be uttered) and parole (that which is uttered). Language functions as a system of signs but not in a simplistic one-to-one relation (that is, language does not acquire meaning by referring to things). According to Saussure the linguistic sign was not a name that could be attached to an object but a composite of signifier and signified (word and concept). Because it is not a case of a one-to-one correspondence, language does not therefore reflect reality. Rather, language becomes a signifying system that sets 'reality' before the ears. It constitutes, mediates reality and an as such has an ideological function. It is not transparence 2 cgn/v that it signifies, but myth. And it is this latter point (actually refined by Lacan) along with one other crucial one that made semiotics - especially in its structuralist formation - a fertile theoretical field to be worked by film theorists. The other crucial point is that semiotics received the debate around cinema as language (a debate initiated in the 1920s but closed or shut out by the Cahiers du cinéma group's polemical writings privileging the auteur as producer of meaning). Although cinema could not, in the final analysis, be seen as analogous to the base langue/parole paradigm, it was none the less a sign system that produced meaning, and in that respect could, like all other social or cultural productions, be seen as a language (see discusssion of Metz's work in this context under structuralism).

Semiotics analyses the structural relations, within a system, that function to produce meaning. Signs can be understood only in relation to other signs within the system, and this occurs, in the first instance, in two ways. A sign derives meaning simultaneously by what it is not and by what it is in combination with. Saussure referred to paradigmatic and syntagmatic axes to explain this concept. The paradigmatic axis is vertically connected to the horizontal, syntagmatic axis. The former refers to the choices available, to the possible substitutes (thereby pointing to what the sign is not - man not woman, boy, girl; cat not hat, mat). The latter refers to the combination of elements actually present and how that combination functions as a signifying chain to produce meaning (the cat sat on the mat, the

boy sat on the mat). In this respect meaning is produced out of differences (by what is present in relation to what is absent).

A second way by which signs produce meaning is in relation to their referential reality. The term Saussure used for this concept was signification. Although Saussure had identified the concept, it was Barthes (1957) who developed it more fully in his analysis of the way signs work in culture. Within what he terms the semiological system, Barthes identifies two orders of signification, denotation and connotation, which in turn produce a third - ideology (actually, although Barthes identifies this last order, it is Hartley (1982, 217) who suggests calling it the third). At the first level is denotation: a simple first order of meaning, the surface literal meaning. At the second level, signs operate in two ways: as connotative agents and as mythmakers. This second order of signification occurs when the first order meets the values and discourses of the culture (1982, 215). Connotation, as the word implies, means all the associative and evaluative meanings attributed to the sign by the culture or the person involved in using it - and as such is always sensitive to context. Myth is the way in which we are enabled to understand the culture in which we find ourselves. At this level of signification, signs activate myths, provide cultural meaning.

By way of illustration let us take a photograph of Marilyn Monroe. At the denotative level this is a photograph of the movie star Marilyn Monroe. At a connotative level we associate this photograph with Marilyn Monroe's star qualities of glamour, **sexuality**, beauty – if this is an early photograph – but also with her depression, drug-taking and untimely death if it is one of her last photographs. At a mythic level we understand this sign as activating the myth of **Hollywood**: the dream factory that produces glamour in the form of the **stars** it constructs, but also the dream machine that can crush them – all with a view to profit and expediency.

This second order of signification reflects subjective responses but ones which can only be motivated by the fact that they are shared by the community of a particular culture, a sharing that Fiske and Hartley (1978, 46) refer to as intersubjectivity. This intersubjectivity works in two ways and it is in this respect that we can see the third order of signification coming into operation: ideology, 'This intersubjectivity is culturally determined' (1978, 46). Thus on the one hand our individual response is affected or influenced by the culture in which we find ourselves and, on the other, that response signifies our appertaining to that

culture. This dynamic is a prime way in which ideology functions. Ideology inserts itself at the interface between language and political organization and as such is the discourse that invests a culture (nation) with meaning. Louis Althusser (1984, 37) echoing Gramsci (Althusser is quoted rather than Gramsci because of his influence on film theory during the 1960s and 1970s) - makes the point that ideology is not just a case of a controlling few imposing an interpretation of the nation upon the subjects of the state, but that in ideology the subjects also represent to themselves 'their relation to those conditions of existence which is represented to them there'. In other words, they make ideology have meaning by colluding with it and by acting according to it because of the reassuring nature of national identity or cultural membership. To return to our earlier example, the photograph of Marilyn Monroe and its ideological function, the reading we now get is as follows: the film industry as exemplified by Hollywood is a powerful, rich, organized industry, in which one can succeed only by conforming to the preordained role assigned to one. Deviancy (booze, drugs or sexuality) will not be tolerated. In other words, Hollywood is about reproducing the institution, culture or ideology of the White middle-class United States to which all should aspire, or, if they do not, they will perish. Almost a Taylorization of national identity (a compartmentalized assembly-line approach)!

Semiotics in film theory, then, by opening up filmic texts in the way illustrated above, showing how they produce meaning, has served among other things to uncover, make explicit the **naturalization** process of realist, mainstream cinema. Latterly as it has become inflected with other theories (**psychoanalysis**, Marxism, feminism) it has broadened its frame of reference not just to address the filmic text as producer of meaning but to examine **spectator**-positioning and the spectator's role in meaning-production. By unravelling how meaning is produced, other questions can be raised such as the way in which the inscription of sexual difference in the images is 'taken for granted'.

For fuller analyses and greater examination of the evolution of the semiotic debate see Lapsley and Westlake, 1988; Andrew, 1984; Stam, Burgoyne and Flitterman-Lewis, 1992; Stam, 2000. In terms of applying the theory see Fiske and Hartley, 1978 (although it addresses television and not film it is a very clear text for initiates to semiotics); for analyses of representation and sexuality see De Lauretis, 1984; Kuhn, 1985.

sequencing/sequence (see also editing/montage) A sequence is normally composed of scenes, all relating to the same logical unit of meaning. For this reason, the length of a sequence is equivalent to the visual and/or narrative continuity of an episode within a film (sequences can be likened to chapters within a novel). It is useful when studying film to be able to segment out a film into sequences since this gives the student or spectator a sense of the formal structure of the film as well as the relations between the sequences. Since film is (notionally) constructed around the formula of repetition/opposition/ variation, to be able to perceive this structurally gives a first reading to the filmic text. On average a film has twenty-three or twenty-four sequences if it is a mainstream or Hollywood film: European cinema tends towards a lower number (eleven to eighteen). Traditionally the opening sequence of a film is composed of establishing shots to orientate the spectator safely, and in this respect the beginning of each sequence functions to reorientate the spectator (alternatively, the closing shot or comment in the previous sequence sets up what is to follow). The closing of a sequence is marked by some form of transition: a fade, wipe, iris or a cut. (In an 'iris' the image is phased in or out in imitation of the opening and shutting of the camera lens.) These transitions serve to make the film easy to read. Conversely, jump cuts or unmatched shots are two procedures used to counter the safe orientation provided by traditional transition markers. These transitions are like punctuation marks, so they will also be found within sequences. The fade and iris are soft transitions. Wipes and cuts are hard. The former are more readily associated with earlier cinema, although contemporary films do make use of them (sometimes as a homage to the cinema heritage). These soft transition markers can serve to denote a lapse in time, states of mind and the subconscious, so they are less likely to be found within a sequence but rather between sequences. Of the hard transitions, the wipe is hardly ever seen nowadays. A cut between sequences can imply a direct link between the two, in either narrative or chronology. Cuts within a sequence serve to give a rhythm (fast or slow, depending on how frequently they are used) and also allow relations of space to become clear to the spectator (so long as the various degree rules are 'obeyed': see 30-degree rule and 180-degree rule). If cuts are not used conventionally within a sequence they point to the idea of fragmentation or separation.

For more detail on how sequencing functions throughout a film, see editing.

setting Part of the total concept of mise-en-scène. The setting is literally the location where the action takes place, and it can be artificially constructed (as in studio sets) or natural (what is also termed location shooting). Certain film movements are readily associated with a type of setting: the distorted settings of German expressionist films, the dimly lit rainwashed streets and empty cold interiors in films noir, the natural settings of Italy's cities and countryside in Italian neo-realism films.

sexuality (see also stereotype) Cinema is one structure among others that constructs sexuality. Until the impact of feminist theory (1970s) this was 'normally' taken to mean White male sexuality – as opposed, in the first instance, to White female passivity – that is, women perceived or constructed as sex symbols, sex goddesses (objects to be desired, rather than desiring subjects). Equally, sexuality was 'normally' taken to refer to heterosexuality. Finally, sexuality (and gender) are coded by film genre – for example, the sexuality of characters in a musical differs from that of characters in a Western.

Debate around sexuality in film studies came about largely as a result of feminist theorizing on structures in general which position or construct woman as other in patriarchal society (see scopophilia). Claire Johnston (1976, 209) makes the point that while the earliest stereotyping of woman in the cinema (as vamp or virgin) has changed very little, the image of man has been privileged with greater differentiation. Early cinema required fixed iconography for audiences to follow the narrative, so characters were stereotyped (villain, hero, etc. for men; fallen woman, victim, etc. for women). But once cinema codes became familiar it was felt that this stereotyping of the male contravened 'the notion of character' (1976, 209). In this respect, Johnston argues, Hollywood's conventions around sexuality reflect dominant (by which she means patriarchal) ideology that stereotypes men as active and therefore part of history and women as passive and therefore 'ahistoric and eternal' (1976, 209). Thus, within mainstream cinema especially, but not exclusively, stereotyping is not questioned. Masculinity and femininity as constructs were 'taken for granted' and their representation was not questioned - that is until the 1970s.

Annette Kuhn (1985, 5) acknowledges pre-feminist thinking on representation in Althusser's (1984) work on ideology and in Barthes's (1957) semiotic and structuralist readings of specific images. However, she also points to their 'genderblindness', to which we should add colour-blindness. The feminist and Black movement and cultural studies debates of the 1970s and 1980s, as well as the incorporation of psychoanalysis into theory in general and film studies in particular, have meant that the issue of sexuality has broadened from its somewhat narrow (White) male/female binary opposition. Discussions around spectatorship, which is not a single entity but composed of so many different 'types' (male, female, Black, Asian, White. lesbian, gay and so on), have elucidated the limitations of this binary construct because pleasure in viewing can be derived without reference to this binary paradigm's implicit White heterosexuality. This means that representation is not limited to a reproduction of the patriarchal order - it does that but it does more. It reproduces the dominant ideology but it also reflects those who are inside and those outside the culture or hegemony and also the shifting relationships depending on how close to the centre of the culture they are (for example, in mainstream Hollywood and western cinema, the White female has more power than the Black female; she also has more power than the Black male in terms of the gaze). Thus, the debate on sexuality in the 1990s has evolved and come to be closely identified with gender (including cross-genderization and/or sexual disguise), the representation of sex and desire including its referent (male, female, class, race, age, heterosexuality, male homosexuality, lesbianism, cross-dressing), the historical and social contexts, and the relationship of the spectator to that representation.

The following comments should serve by way of illustration of this shift away from the binary opposition paradigm in relation to sexuality. In **classic narrative cinema** the central positioning of the White male as the site of truth and/or the natural assumption or acceptance of the predominance of the male point of view means that any other **subjectivity** is occluded. Therefore, White masculinity can be defined as more than just 'his sex'; femininity much less so – and if it is (that is, more than just her sex), it is usually transgressive or excessive (see **excess**). Woman becomes other or object to the male's subject – she is defined in relation to his centrality, his point of

view. As such she is fixed as an object of his desire, but an object whose sexuality is also perceived by him as dangerous and therefore to be punished or contained (through death (or its equivalent) or marriage, respectively). This notion of fixity also applies to others whose subjectivity is denied by the centring of the White male. For example, racial difference, especially in the person of the Black male, is linked with heightened sexuality and thereby connected to sexual danger, not just for the White female but also for the White male. He is perceived as other, as an object of fascination (with colour or potency) but also of danger. Oddly, however, he is positioned much like the White woman and as such must be contained or punished. The origins of this fetishization of the Black male are not, however, the same as those surrounding the White female. They are fixed, first, in colonizing history and then slave history - what Jane Gaines (1988) refers to as 'racial patriarchy' - a different order of otherness. And it is in relation to those histories that the Black male is punished or contained. Thus, to conclude on this example of difference, mainstream cinema constructs Black male sexuality against a different set of histories from that of the White male. But these histories are those emanating from White hegemony – the White version of colonial and slave histories - an ideological construct exemplified in this instance by the film industry which, in its mise-en-scène of male blackness, pulls on those histories to construct him. D. W. Griffith's Birth of a Nation (1915) is the very first film to do this, but Steven Spielberg's The Color Purple (1986) also plays on the myth of the bestiality of the lustful Black man. Equally, Sidney Poitier's films of the 1950s and 1960s, which might seem to address blackness in an 'enlightened' manner, are just as problematic. Poitier's image of urbane civility does less to counter images of Black male sexual potency and more to point to the civilizing process of American education (read: 'he (Black Sidney Poitier) can be "just like us""). Nor has that myth disappeared. The depiction of Blacks playing by White rules and losing still persists (for example the Eddie Murphy films; A Soldier's Story, Norman Jewison, 1984). However, this mythification and reification of blackness is being contested in the newly emergent Black cinema.

For further reading see Dyer, 1986; Grosz and Probyn, 1995; Kuhn, 1985; Screen, 1988 and 1992.

shots (see also image, match cut, jump cuts, shot/reverse-angle shot, unmatched shots) In terms of camera distance with respect to the object within the shot there are basically seven types of shots: extreme close-up, close-up, medium close-up, medium shot, medium long shot, long shot, extreme long shot or distance shot. In addition the terms one-, two- and three-shots are used to describe shots framing one, two or three people – usually in medium close-ups or medium shots.

Close-up/extreme close-up (CU/ECU) The subject framed by the camera fills the screen. Connotation can be of intimacy, of having access to the mind or thought processes (including the subconscious) of the character. These shots can be used to stress the importance of a particular character at a particular moment in a film or place her or him as central to the narrative by singling out the character in CU at the beginning of the film. It can signify the star exclusively (as in many Hollywood productions of the 1930s and 1940s). CUs often have a symbolic value. For example a character looking at her or his reflection in a mirror or in the water can have connotations of duplicity (what we see is not true) or death (as in the dream or myth of Narcissus). CUs can be used on objects and on parts of the body other than the face. In this instance they can designate imminent action (a hand picking up a knife, for example) and thereby create suspense. Or they can signify that an object will have an important role to play in the development of the narrative. Often these shots have a symbolic value, usually due to their recurrence during the film. How and where they recur is revealing not only of their importance but also of the direction or meaning of the narrative.

Medium close-up (MCU) Close-up of one or two (sometimes three) characters, generally framing the shoulders or chest and the head. The term can also be used when the camera frames the character(s) from the waist up (or down), provided the character is right to the forefront and fills the frame (otherwise this type of shot is a medium shot). An MCU of two or three characters can indicate a coming together, an intimacy, a certain solidarity. Conversely, if there is a series of two and one shots, these MCUs would suggest a complicity between two people against a third who is visually separate in another shot.

Medium shot (MS) Generally speaking, this shot frames a character from the waist, hips or knees up (or down). The camera is sufficiently distanced from the body for the character

to be seen in relation to her or his surroundings (in an apartment for example). Typically characters will occupy half to two-thirds of the frame. This shot is very commonly used in indoor sequences allowing for a visual signification of relationships between characters. Compare a two-shot MS and a series of separate one shots in MS of two people. The former suggests intimacy, the latter distance. The former shot could change in meaning to one of distance, however, if the two characters were separated by an object (a pillar, a table, even a telephone for example).

Visually this shot is more complex, more open in terms of its readability than the preceding ones. The character(s) can be observed in relation to different planes, background, middle ground and foreground, and it is the interrelatedness of these planes which also serves to produce a meaning.

Medium long shot (MLS) Halfway between a long and a medium shot. If this shot frames a character then the whole body will be in view towards the middle ground of the shot. A quite open shot in terms of readability, showing considerably more of the surroundings in relation to the character(s).

Long shot (LS) Subject or characters are at some distance from the camera; they are seen in full in their surrounding environment.

Extreme long shot (ELS) The subject or characters are very much to the background of the shot. Surroundings now have as much if not more importance, especially if the shot is in high-angle.

A first way to consider these shots is to say that a shot lends itself to a greater or lesser readability dependent on its type or length. As the camera moves further away from the main subject (whether person or object) the visual field lends itself to an increasingly more complex reading – in terms of the relationship between the main subject and the décor there is more for the **spectator**'s eye to read or decode. This means that the closer up the shot the more the spectator's eye is directed by the camera to a specified reading. André Bazin (1967, 23ff.), in his discussion of depth of field, greatly favoured what he termed the objective **realism** of the **deep focus** shot – generally found in a MLS or LS. Shots, therefore, in and of themselves have a subjective or objective value: the closer the shot, the more subjective its value, the more the meaning is inscribed from within the shot; conversely, the longer the distance of the shot

the more objective its value, the greater the participation of the spectator or reader in the inscription of meaning. To avoid confusion with terms such as *subjective camera* it is better to think and speak of shots as being more or less open (MS to ELS) or closed (MCU to ECU) to a reading.

Other factors influence the readability of a shot - primarily the angle of a shot. A high or low camera angle can denaturalize a shot or reinforce its symbolic value. Take, for example, an ELS that is shot at a high angle. This automatically suggests the presence of someone looking, thus the shot is implicitly a point of view shot. In this way some of the objective value or openness of that shot (which it would retain if angled horizontally at 90 degrees) is taken away, the shot is no longer 'naturally' objective. The shot is still open to a greater reading than a CU, however; although the angle imposes a preferred reading (someone is looking down from on high). In terms of illustrating what is meant by reinforcing symbolic value, the contrastive examples of a low- and high-angle CU can serve here. The former type of shot will distort the object within the frame, rendering it uglier, more menacing, more derisory; conversely, when a high-angle CU is used, the object can appear more vulnerable, desirable.

These are of course preferred readings or readings that adhere to the **codes and conventions** of traditional cinema. Filmmakers do not necessarily abide by these rules, however. And it is in their 'breaking', bending or subverting of cinematic rules regarding film-making in general (shots, editing, **soundtrack**, etc.) that their films can be said to have their individual hallmarks.

shot/reverse-angle shot (see also 180-degree rule, suture) Also known as shot/counter-shot, this is most commonly used for dialogue. Two alternating shots, generally in medium close up, frame in turn the two speakers. Normally these shots are taken from the point of view of the person listening – as the following diagam should make clear. In the clearest instances the shoulder and profile of the listener are just distinguishable in the foreground of the frame and the camera is focused on the face of

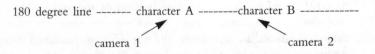

the speaker. But the spectator can assume the presence of both interlocutors even if the listener is not foregrounded because of the series of reverse angles. This type of shot follows visual logic (character A is framed as she or he speaks - cut to character B framed as she or he speaks). Alternatively, but less usually, the camera can frame the listener (particularly if she or he is under threat). In these two types of reverse-angle shots the position of the spectator shifts. In the first type the spectator becomes the privileged viewer of the image in so far as the shot permits identification with the position of the listener (the spectator assumes the position of the one being talked to). In the second, the spectator can be far more ambiguously positioned since he or she assumes the position of the speaker and, in this respect, has more power than is possible (after all, the spectator cannot actually speak into the film). The result can be to make the spectator aware of the collusionary role he or she plays as voyeur of the image. This creates a distancing effect (see scopophilia).

sign, signification - see semiology/semiotics

social realism Although it is argued that the advent of sound, in 1927, brought about a greater realism in film, the realist tradition was in evidence in cinema's earliest productions, as for example in France whose cinematic practices were very much inflected by literary adaptations, especially those of the sociorealist novelist Emile Zola. Social realism in film refers, as it does in literature, to a depiction of social and economic circumstances within which particular echelons of society (usually the working and middle classes) find themselves. The earliest examples of this tradition in sound cinema, however, date back to the 1930s and it is John Grierson and his work in documentary that is generally credited with the introduction of the social-realist aesthetic into narrative cinema. Grierson, who was primarily a producer and theorist, held that documentary should be in the service of education and propaganda for the greater social good - with an insistence on quality and good taste. Grierson surrounded himself with a group of like-minded filmmakers and organized a loosely formed documentary movement that was to impact on several film movements after the Second World War. There were three basic principles to which the group adhered. First, cinema should be taking slice-of-life-reality

rather than artificially constructing it. Second, everyday ordinary people should act themselves in real settings. Finally, cinema should strive to catch the spontaneous or authentic gesture and uncontrived or natural speech (see Armes, 1974).

Although there are examples during the 1930s of individual films that exemplify these principles (such as Jean Renoir's *Toni*, 1934; Carol Reed's *The Stars Look Down*, 1939), it was after the war that actual socio-realist film movements could be discerned. There are three movements in cinema's history that in some way are indebted to this social realist aesthetic – all of which produced what have been termed social-problem films. First, the **Italian neo-realism** movement of the late 1940s. Then the **Free British cinema** and the **British New Wave** of the late 1950s; and, finally, the loosely formed **cinéma-vérité** group in France during the 1960s.

sound/soundtrack Before the soundtrack was introduced to cinema audiences in 1927, film was accompanied by a musical score played by an orchestra or an organist or pianist (depending on the luxury and means of the cinema theatre). Although sound on film dates from 1927, the technology for putting it in place predates the 1920s by at least a decade if not more (depending on which film historian you read). At that time there was no sense of urgency to go to the costly lengths of implementing a sound system, since cinema was proving sufficiently profitable in its silent mode, France, Germany and the United States had been competing almost since the beginnings of the film industry to synchronize sound and image. The first breakthrough occurred in 1911 when the Frenchman Eugène Lauste, working for the American Edison, demonstrated the first sound-on-film movie. This particular system was greatly improved in 1918 by German technicians. Systems of sound on disc synchronized to film, Phonofilm and Vitaphone, were but the latest perfections in the mid-1920s of work started in 1900. Gaumont had been working on a series of processes of synchronized sound since 1902, only to perfect it by 1928. And so on. In the end it would be the American Western Electric and the German Tobis-Klangfilm which, between them, carved up the sound market.

The moment in sound is Alan Crosland's The Jazz Singer (starring Al Johnson) produced by Warner Brothers in 1927. Competition and economic exigencies represent a first reason

for the launch of sound at this time. Warner Brothers was desperately seeking a way to enter into stronger competition with the then four majors (see studio system). The launching of this film shot Warner into the status of a major. In terms of economy of scale, US audiences were dropping - because of the impact of the radio and access to other leisure activities - at the very moment that the film industry had invested massively in luxury grand film theatres. Sound was intended to attract the spectator back. Sound also made possible a bringing together into one unit elements of vaudeville with filmed images which previously had been two disparate entertainment forms in silent cinema spectacles. In the case of Hollywood this produced a new genre - the musical. However, it also put an end to other generic types, such as the gestural, slapstick comedy associated with Chaplin and Keaton. Conversely, it created a new type of comedy: the fast repartee comedy with snappy dialogue (as with the Marx brothers and W. C. Fields) and screwball comedy usually based on the 'battle between the sexes' with stars like Clark Gable and Cary Grant pitted against the likes of Claudette Colbert, Katherine Hepburn and Rosalind Russell (as in It Happened one Night, Frank Capra, 1934; Bringing up Baby, His Girl Friday, both by Howard Hawks, 1938 and 1939).

The consequences of sound for cinema were not just generic. It affected the careers of actors. It also impacted on the narrative. When the spoken element came in, some actors did not survive and went out because their voice did not match up to their image (this was particularly the case for Hollywood actors); other actors with theatre experience left the boards and ascended on to the silver screen. As for narrative, prior to the soundtrack, sound had not been perceived as necessary nor as a crucial element to the registering of authentic reality. Now sound cinema was touted as being closer to reality. Since there could be dialogue, it was argued, there was greater space for social and psychological reality within the narrative. In the event, all critics (whether for or against sound) had to admit that once sound was improved (which it was by the early 1930s) it did permit narrative or diegetic economies - for example, dialogue could move the film's narrative along more speedily than intertitles. In its earliest days, however, sound was more of a regressive step for cinema because it severely limited camera movement. The new cameras fitted with sound recording systems were heavy bulky affairs and could not be moved around. Similarly, at first, a single microphone was the only means of recording sound, so actors could not move around (for an amusing sendup of the beginnings of sound see *Singin' in the Rain*, Stanley Donen, 1952). In both instances visual **realism** was lost. If this problem was quickly resolved, thanks to technical improvements, sound, as a result of these same improvements, reduced options. Renewed camera mobility and the use of the boom microphone or indeed post-synchronization of the soundtrack gave visual and aural depth to film, but improvized shooting and experimentation decreased. The consequences of sound for the film industry were that it became more labour-intensive (requiring dialoguists and sound engineers): a costly affair that was carefully regimented. The standardization of equipment – due to the cartel on the technology (predominantly Western and Tobis) – meant a standardization in production practices.

From the 1930s until the early 1950s sound was single-track and was recorded optically. Optical sound is a system whereby light, modulated by sound waves, is recorded on to film. In the 1950s magnetic tape was used to record sound which was then transferred on to the optical track of the film, and, as with the earlier system, sound was generated by the film passing through a light sensor as it was being projected (a process still used today). This evolution was a natural response to the needs of wide-screen cinema: with such a large screen, stereophonic sound was clearly essential.

In the 1970s Dolby sound, a four-track stereo system that also reduces background noise, replaced the earlier stereophonic system. Nowadays, this four-track stereo system is made up of more than fifteen separate tracks that are used to record dialogue, sound effects and music. These tracks are then transferred on to the optical track of the film (the magnetic track could be placed on to film but the cost of re-equipping film theatres would be too high). Dolby-surround, as its name implies, is a system whereby sound can be separated out and reproduced through speakers from different parts of the theatre. Currently, in the pursuit of ever greater fidelity and purity, digital sound is being exploited in post-production. This is a system whereby sound is stored in a computer (through numbers so the sound stays clean!) and can be recreated in any combination of those numbers.

Until these two most recent developments, sound was very closely related to the image. Films today that are not equipped

with Dolby or Digital sound still create the same illusion. And the *audience* remains in collusion with this relationship. We pretend, accept that it comes straight from the screen; if it is not in synch we notice it and do not particularly like this instance of sound drawing attention to itself and pointing to the fact that what we are seeing up on screen is an illusion. Now, however, that Dolby sound is used in much of mainstream cinema, we do not object to sound drawing attention to itself (especially the wrap–around version). Its realism is not even questioned, so the collusion continues – almost in reverse. That is, we collude with its artificiality and purity.

There is a scarcity of theoretical writings around the **ideological** effects of sound, almost as if the naturalizing effect has passed unheard (but see Altman, 1992; Chion, 1982, 1985; and *Screen*, 1984). However, over the span of sound cinema a few radical film-makers have addressed the issue. Among radical film-makers who have attempted to show the importance of the soundtrack in relation to the image, we can cite Jean-Luc Godard's work during the 1960s (for example *Le Mépris*, 1963; *Pierrot le fou*, 1965). In his **deconstruction** of the two elements into two separate entities he showed the ideological problems inherent in this invisibilization process whereby image and sound are seen as one and as representing reality.

For a very full but succinct review of the development of sound technology and film see Konigsberg, 1993, 331ff.; see also Bordwell, Staiger and Thompson, 1985, 298ff; Chion, 1985; Altman, 1992.

Soviet cinema/school This term refers to a loosely knit group of film-makers who, after the Bolshevik Revolution of October 1917, experimented with film style and technique. As a result of their work they had brought the cinema of the Soviet Union to worldwide attention by the mid-1920s. This experimentation did not occur in isolation. The effect of the Revolution was to bring in its wake experimental foment in all branches of the arts. The beginnings of this experimentation date back to the Russian futurists (1912) who adopted an experimental and innovatory approach to language. This was to filter through into the post-Revolutionary movement of constructivism. The pre-Revolutionary futurist movement, influenced as it was by the abstract forms of European modernist art, believed in technique and the evacuation of fixed meanings. After the

Revolution, the constructivists, seeing in technology the huge potential for change, advocated a new order in which art, science and technology in tandem with workers, artists and intellectuals would combine and work together to produce a new vision of society. Art and labour were seen as one. This notion of art as production was eagerly embraced by the newly emergent Soviet cinema of the 1920s and admirably suited the political exigencies of post–Revolutionary Russia, which needed the propagandizing effect of cinema to spread the message that all workers were pulling together to secure the national identity of the new Soviet Republics.

Lenin and Stalin were well aware of cinema's propagandistic and educative value. This was particularly the case with silent film, which was the ideal visual medium to educate the masses. a great proportion of whom were illiterate and spoke in different dialects. The earliest example of this propagandistic move was during the 1918-21 civil war, when film-shows were delivered all around the country on what were called 'agit-trains'. Incidentally, it was in this area of production practices that many of the famous Soviet film-makers (such as Lev Kuleshov and Dziga Vertov) started their careers. The purpose of the filmshows was to consolidate communist power over the Soviet Republics by telling of the heroic proletarian struggle that made hardship worthwhile and the civil war worth winning for the Revolutionary cause. Trains went out into the country bringing with them documentary footage of the goings-on in the major cities, including the activities of the Bolshevik leader Lenin. Film-makers out in the country on location with these trains took footage of the peasants at work and the rural life in these times of great physical hardship. They then immediately developed this footage and screened it to the assembled audience of workers whom they had just filmed.

A second move to secure cinema in its **ideological** function was the nationalizing of the industry in 1919 and the establishment in that year of a State Film School. At first the effects of nationalizing the industry were disastrous. Many of the previously independent producers left the country and took their equipment with them. In fact the industry did not gain any stability until 1922 when a central co-ordinating company was established: Goskino, renamed Sovkino in 1925. By 1929 the industry had become such a tightly centralized structure that it was able to dictate the future trends of Soviet cinema. Indeed,

in 1928 an All-Union Party Congress on Film Questions decreed that films must eschew pure formalism and focus on content and on socialist realism. The experimental wave that had brought Soviet cinema to the aesthetic forefront of world cinema gave way to the edicts of socialist realism: that is, to a representation of life as it *will* be.

But to return to the heydays of the Soviet cinema of the silent period (1924–29). Until 1924, apart from the agitki (the films shown on the agit-trains), documentary films and newsreel series (called kino-pravda – film-truth – beginning in 1922), production was at a very low level indeed, primarily because new film stock was virtually unobtainable (due to an export embargo imposed by the West but also to the hoarding of raw film stock by private production companies operating in Moscow and Petrograd who resisted nationalization). The kino-pravda series was made possible by the effect of Lenin's New Economic Policy (1921) which permitted private companies to operate once more. Production companies released their stock and equipment and a few conventional feature films were also made as well as the state-endorsed newsreels.

By 1924, the state-controlled Sovkino and its regional outlets in the various Soviet States had full monopoly over all aspects of the film industry. During this early period of a nationalized Soviet cinema, new film-makers emerged eager to participate in and propagate the new revolutionary culture advocated by Lenin and Stalin. They were determined to produce an ideological cinema for the proletarian classes - one which deindividualized the actor (the proletarian classes would be the hero) and which relied upon collective authorship (see auteur entry). In 1924, Sergei Eisenstein and Lev Kuleshov established the Association of Revolutionary Cinematography (ARC) which included amongst others Dziga Vertov and (the woman filmmaker) Esfir Shub. Over the years, however, different tendencies and indeed disagreements on what constituted a revolutionary cinema brought about a divergence of groups and practices. The most radical split came with Vertov who was a major campaigner against the new Soviet cinema fiction film (as produced by Kuleshov and Eisenstein). He left the ARC and established his own Kinoki group (the cine-eye group). His films are strongly in the constructivist vein, they are documentaries celebrating industrialization and the worker (see his radical documentary Man with a Movie Camera, 1929, which best exemplifies this

ethos). Despite divergences, however, what all film-makers shared in common was a concept of a particular revolutionary film style. A style that is known as Soviet montage. How it came about makes for interesting reading.

The effects of the early hardship in the aftermath of the Revolution brought about this cinematic style that has henceforth been indelibly associated with Soviet cinema: montage cinema. Because film stock was in such short supply, the only way forward was to re-edit old films. Thus, in 1918, the Moscow Film Committee established a special Re-Editing Department. Although Lev Kuleshov is credited as being the 'inventor' of Soviet montage, it was in fact Vladimir Gardin who (in 1919) - basing his ideas on this economic necessity of re-editing advocated montage as a fundamental practice of a new film aesthetics. The use of montage was seen as being in touch with the ideology of the Revolution (rapid and energetic change) and the aesthetics of Constructivism (technology and labour as the producer of art). Kuleshov's experiments led the way in this socalled new revolutionary cinema, closely followed by Sergei Eisenstein. Kuleshov's principle started from the idea that each shot is like a building block (a brick) and that each shot derives its meaning from its context (i.e., the shots placed around it). Thus if the context of a shot is changed, by placing it in a different sequence, then the whole meaning of the shot and the sequence changes. From this principle, Kuleshov developed the idea that juxtaposition must be inherent in all film signs. That is, a film shot acquires its meaning in relation to the shots that come before and after it. Shots, like building blocks, acquire meaning when juxtaposed. The famous example taken from Kuleshov's experiments is where he juxtaposes several shots taken from different pieces of film which he then edited into a sequence. These shots comprised a close-up still shot of the actor Ivan Mozzhukhin (Mosjoukine) with three others (a plate of soup, a dead woman in her coffin and a child playing). The effect of the juxtaposition for the spectator is that the actor's face changes expression (which in essence it cannot since it is a still shot). In other experiments Kuleshov created what he terms 'creative geography' by splicing together bits of action taken from other films and re-editing them as one piece of uninterrupted action. In 1920, he assembled five separate bits of action and created an experiment he called The Created Surface of the Earth in which a man meets a woman (in Moscow), he points, they look off - we see a shot of the White

House (in Washington), and then the last shot shows them ascending the steps. This creative geography through montage is one that will later influence Vertov's imagined city-scape of *Man with a Movie Camera*.

Eisenstein's view of montage was more radical than Kuleshov's. A committed Marxist, he came into film-making from engineering (which, it could be argued, makes him a natural ally with the principles of Constructivism). For him, montage is based on the principle of collision and conflict – not just juxtaposition. Conflict occurs within the shot as much as between shots. Shots must collide creating a shock for the spectator (a montage of attractions was Eisenstein's term for this interaction between screen and spectator). To this effect, Eisenstein's shots were staged for maximum conflict (visually, emotionally and intellectually). Eisenstein was an advocate of intellectual montage. He saw the shot as the raw material which film-makers and the spectator use to construct meaning. For him, montage is a political aesthetics, a visual form of Marx's dialectical materialism. That is, he sees montage as possessing a dynamic of conflict that creates a third meaning whose relevance bears directly on the revolutionary history of Soviet Russia. This third image is the one that is synthesized by the spectator thus making him or her as much a producer of meaning as the film-maker.

Kuleshov's principle of montage had an enormous influence on contemporary film-makers, the most famous of whom are Sergei Eisenstein, Vsevolod Pudovkin and Alexander Dovzhenko. Some, those who formed the FEK group (the Factory of the Eccentric Actor), went on to develop, from Kuleshov's system of montage, the principle of alienation (more readily associated with Bertolt Brecht). By placing objects or people in unfamiliar contexts, they sought to alienate the **spectator** and oblige her or him to reflect on the meaning of the **image** (see **distanciation**).

Kuleshov's other significant contribution to the new Soviet cinema was in the realm of acting. He introduced a new style. One that was distinct from theatre acting. Indeed, he discouraged the hiring of theatre-trained actors, preferring to develop a style of acting suitable to the screen. His new model was one that eschewed psychology in favour of a performance based on reflexes and the mechanics of acting. He advocated selecting actors for their type – whose look and performance style would match the role required. He established an acting laboratory to train his actors into the appropriate style. Kuleshov believed in social forces

activating performance, not psychology. After all, securing the New Revolutionary Soviet Union was about dealing with social forces not psychological ones. Thus, in his view, the surface (the exterior, not the interior) of the actor's body was the site of performance, and gesture and movement were primary. The body, then, becomes the site where social forces impacted on the revolutionary hero and it was the reflexes to those forces that constituted the acting. Again this model was followed by many film-makers. Eisenstein went for a more radical concept still of the protagonist and performance. He would use, in massive numbers, non-actors to create a collective proletarian hero, playing down individualism (see Battleship Potemkin, 1925). Again, this was followed by many film-makers, but not, significantly, by Eisenstein. Pudovkin followed Kuleshov's principles of naturalistic characterization and montage, and produced popular narrative films (such as Mother, 1926). Pudovkin's character's are individuals with feelings and separate identities. The plot line is, in many ways, indistinct from Hollywood's own 'good' versus 'bad', although this time it is based in Russia's own Revolutionary history. Indeed, it should be recalled that Soviet audiences very much enjoyed Hollywood film products and its stars (Mary Pickford, Douglas Fairbanks and Charlie Chaplin were great favourites). Dovzhenko, for his part, also continued in the Kuleshov vein and in particular focused on rural Russia by showing individual idealism and effort overcoming the landed peasantry's resistance to Stalin's collectivizing programme for farms (see The Earth, 1930).

Kuleshov's impact was less strong in the Soviet cinema's construction of new genres although he did introduce a different kind of detective-action-comedy (a hybrid of Chaplinesque humour with Soviet ideology, see The Extraordinary Adventures of Mr West in the Land of the Bolsheviks, 1924). By the mid-1920s, stage-screen hybrids (popular during pre-Revolutionary days) had been to a great extent transcended by the completely new genre, the historical revolutionary epic whose greatest exponents were Eisenstein, Dovzhenko and Pudovkin. Within the context of fiction film and epic revolutionary cinema, two basic trends evolved. The first, exemplified by Eisenstein advocated an intellectual montage cinema - one that was closely aligned with Marx's dialectical materialism (see below); the other, exemplified by Dovzhenko and Pudovkin, the so-called emotional or lyrical-symbolic montage cinema (a cinema that was heavily based on image-symbols). Otherwise another trend - more in the documentary vein - was that exemplified by Vertov and, in a slightly different way, Esfir Shub. Vertov was strongly opposed to fiction film (including stage-screen hybrids, the epic and literary adaptations), believing the only true revolutionary cinema was one that subscribed to a cinema of facts. His films aimed at catching life as it was, in a style that can best be described as a cross-fertilization of **cinéma vérité** and montage. Shub's documentary work was based on compilations of earlier footage. In some ways her work represented the earliest form of new Soviet cinema of making a new film through reediting footage from old ones. In this way she compiled three feature length films on contemporary Russian history (1912–28).

Eisenstein is the film-maker most readily associated with this period in Soviet cinema, at least within the Western world, possibly because he obtained international recognition at the time. Although as the above makes clear, he was far from unique (there were many other film-makers around). Nor was he always the pioneer he was made out to be by history – even though. as we saw, he pushed the meaning and function of montage into a new political aesthetics. His film Strike (1925) was awarded a prize at the Paris Exhibition that year. In fact he was much admired and more successful outside the Soviet Union than in it. He lectured all over the Western world: France, Germany and the United States (he also went to Mexico where he made ¿Oué viva México!, 1932). Doubtless the other contributing factor, over time, is the huge legacy of theoretical writings he left and which were translated into English and other languages. Eisenstein advocated a materialist theory of cinema. He saw cinema as the modality for expressing and representing revolutionary struggle. He believed that a revolutionary country should be given a revolutionary culture (cinema in his case) in order for the masses to obtain a revolutionary consciousness (small wonder Grierson admired Eisenstein's ideological educative fervour). For him, montage meant intellectual montage to make the spectator think. In this light he is close to Kuleshov's thinking. He believed in the symbolic counterpointing of human beings with objects or other animate forms to create meaning. Thus in Strike the slaughter of a bull is counterpointed symbolically with that of the strikers. Eisenstein eschewed characterization and went for symbolic ciphers, what he called 'typage'. The actor was but one element in a film. Thus, the proletariat was the hero of the film, not a particular individual.

Eisenstein's most famous film, Battleship Potemkin (1925), was commissioned by the Central Committee. It is exemplary of his radical view of film as an assault on audiences to shock them into political awareness. The film was commissioned to commemorate the unsuccessful Russian Revolution of 1905. Eisenstein focused on one incident, the mutiny on the battleship Potemkin and the subsequent slaughter, on the Odessa steps by the Tsarist militia, of the masses cheering and trying to bring food to the mutineers. In 1927 Eisenstein was again commissioned to make a film, this time in commemoration of the successful 1917 Revolution. His project, entitled October, was to prove the beginning of his falling foul of critics and the state. The film was due to come out in 1927 with other commissioned projects for the Revolution's Jubilee (which included Pudovkin's populist-montage film, Mother). However, Eisenstein's film had to be massively recut because of the expulsion of Trotsky from the party (mainly manoeuvred by Stalin). When the film was finally screened, in 1928, it was criticized for its formalism (although it contained superb ironizing of Kerensky, the provisional head of the Revolutionary government of 1917). In fact, because it had to be so drastically recut, the film made little sense to audiences either as an intellectual montage film or as a commemoration of the 1917 Revolution. In any event, by 1928 the state had decreed that the time for montage cinema was over. The need was for morale-lifting and positive post-Revolutionary discourses of socialist realism. Eisenstein made only two more intellectual montage and formalistically experimental films in the Soviet Union (The Old and the New/The General Line, 1928; Bezhin Meadow, 1937), after which he was subjected to public humiliation for his use of formalism over content and was obliged (or felt obliged) to denounce his former practices. In 1938 he was commissioned to make the patriotic film, Alexander Nevsky, which, while it was undoubtedly an attempt to bolster Soviet national identity against the imminent threat of fascism, lacked the earlier brilliance of his film techniques even though it was the first of his films to have popular appeal with the Soviet audiences.

For further reading see Taylor and Spring, 1993; Taylor and Christie, 1994a and 1994b.

Soviet montage - see editing, Soviet cinema

space and time/spatial and temporal contiguity Within classic narrative cinema space and time are coherently represented in order to achieve the reality effect. Shots reveal spatial relationships between characters and objects and as such implicate the viewer as spectating subject. That is, shots are organized in a specific way so that the spectator can make sense of what she or he sees. The way in which space is carved up within a shot (size and volume of objects or characters) also provides meaning. Equally, given that mainstream classic cinema assumes an unfolding of the traditional narrative of 'order/disorder/ order-restored' (or enigma and resolution), time is implicitly chronological and so must be seen to run contiguously with space. Art cinema has disrupted this notion of temporal and spatial continuity through, for example, jump cuts, unmatched shots, flashforwards, looping images and so on. Interestingly, dominant cinema has adopted many of these techniques, even though they do not serve the same disruptive function but seem to function more like cinematic jokes which the spectator can enjoy (see, for example, Robert Altman's The Player, 1992).

spectator/spectator-identification/female spectator (see also apparatus, gaze, ideology, Imaginary/Symbolic, scopophilia, suture, voyeurism/fetishism) The issue of spectatorship was first addressed 'theoretically' in the early to mid-1970s as a result of the impact of semiotics and psychoanalysis on film theory. The relationship between cinema and the unconscious is not a new concept however. Cinema as the mediator for unconscious desire, the suitability of the screen as the projection-site for the inner workings of the psyche, had been discussed by earlier theorists in the 1920s and 1930s – as had the similitude between the mechanisms of dreams and the unconscious to those of film. But it was not until the 1970s that full consideration was given to the effect of the cinematic experience upon the spectator.

Spectatorship theory has gone through three stages. In stage one, 1970s film theory, Baudry, Bellour and Metz wrote about cinema as an **apparatus** and an imaginary signifier to explain what happened to the spectator as he (*sic*) sat in the darkened theatre gazing on to the screen. In stage two, post-1975 feminist film theory, the 'natural' assumption, implicit in those first writings, that the masculine was the place from which the spectator looks and the 'natural' acceptance that each viewing was an

unproblematic re-enactment of the **Oedipal trajectory** were strongly contested (in the first instance) by the critic and film-maker Laura Mulvey. In stage three, 1980s (mostly feminist) film theory, Mulvey's writings provoked further investigations by theorists who sought to widen the debate by bringing in theoretical approaches other than psychoanalysis. What follows is a brief synopsis of those three stages and the debates surrounding them.

Stage one Baudry, Bellour and Metz drew on Freud's analyses of the child's libido drives and Lacan's mirror stage to explain how film works at the unconscious level. Drawing on the analogy of the screen with the mirror as a way of talking about the spectator—screen relation, these authors state that at each film viewing there is an enactment of the unconscious processes involved in the acquistion of sexual difference, language and autonomous self-hood or **subjectivity**. In other words, each viewing represents a repetition of the Oedipal trajectory. This in turn implies that the **subject** of classic narrative cinema is male (Mayne, 1993, 23). Let's unpick this.

According to Baudry (1970), the cinematic apparatus produces an ideological position through its system and mechanics of representation (camera, editing, projecting, spectator before the screen). The position is ideological because dominant narrative cinema practices hide the labour that goes into the manufacturing of the film and the spectator is given the impression of reality. This seamlessness gives the spectator a sense of a unitary vision over which he (sic) believes he has supremacy. The spectator believes he is the author of the meanings of the filmic text and in this respect colludes with the idealism of the cinematic 'reality-effect' - all of which gives evidence to what Baudry calls the 'spectator as the transcendental subject' (as having supremacy). In reality, argues Baudry, the opposite is true: the spectator is constructed by the meanings of the text. As such, therefore, the cinematic apparatus interpellates the subject as effect of the text. Later, Baudry (1975) moved away from this anti-humanist interpretation of the cinematic apparatus and its ideological connotations and, adopting a more Freudian approach, focused on cinema's ability to embody psychic desire. He also recognized the implicit regressiveness (back to the child) in that particular positioning of the spectator as desiring subject - a point Metz would develop more fully.

Bellour (1975) talked about cinema as functioning simultaneously for the Imaginary (that is, as the reflection, the mirror)

and the Symbolic (that is, through its film discourses as language). As the spectator enters into the filmic experience he (sic) first identifies with the cinematic apparatus: the projector functions as the eye. Second, he has a narcissistic identification with the image and then, as he moves from the Imaginary to the Symbolic, he desires the **image**. Implicit in Bellour's definition of the spectator—screen relation, which is one-way, is the notion of voyeurism and lawless seeing.

Metz (1975), echoing Bellour, talked about spectator positioning and the voyeuristic aspect of film viewing whereby the viewer is identified with the look (see gaze). Drawing on the analogy of the screen with the mirror, Metz perceived spectator positioning as pre-Oedipal, that is, at the moment of imaginary unity with the self. However, through his discussion of cinema practices as the imaginary signifier, he introduced the complication of the absence/presence paradigm. Cinema makes present (signifies) what is absent (the Imaginary) - that is, it shows a recording of what is absent. This play on absence/ presence means that we are confronted with the imaginary completeness of the absent image of the child in the mirror (Lapsley and Westlake, 1988, 82). The spectator is made aware of the illusionism of the imaginary unity with the self and as such is confronted with the sense of lack. This process, Metz argued, has similar properties with that undergone by the child at the mirror stage. The male child looks into the mirror, sees his image, has a momentary identification with the self (narcissism) then perceives his difference from his mother as 'she who lacks a penis'. He then responds in two ways. First, he desires reunification with the mother and his desire is sexually motivated. Second, he denies difference and through that disavowal of difference - because of his own fear of castration - seeks to find the penis in woman (fetishization). In cinema, this Oedipal trajectory is re-enacted within both the narrative and the spectator-text relation (again it was taken for granted by Metz that the subject of the gaze is male).

Stage two Numerous problems arise out of this first stage of theorizing the spectating subject, starting with the assumption that speculation is only a one-way system (spectator to screen), that it is exclusively male in its positioning and that film texts are organized in such a way as to give a **preferred reading**. These issues did not become clear until after the impact of Laura Mulvey's ground-breaking essay ('Visual Pleasure and Narrative

Cinema', 1975) which sought to address the issue of female spectatorship within the cinematic apparatus and psychoanalytic framework established by the authors discussed above. Mulvey's essay represented a turning point in film theory in that it was the first to introduce emphatically the question of sexual difference as a necessary area for investigation. Indeed, she intended it to act as a catalyst - she readily admits that the essay was intentionally polemical (1989). In her essay she examined the way in which cinema functions through its codes and conventions to construct the way in which woman is to be looked at, starting with the male point of view within the film and, subsequently, the spectator who identifies with the male character or protagonist. She describes this process of viewing as scopophilia - pleasure in viewing.

In her analysis Mulvey made clear the implications of the dual response, as described by Metz, of the male unconscious (desiring and fetishizing) for both narrative cinema and the spectator-text relation. For this sexualization and objectification of the female form that the male gaze confers upon it is not just one of desire but also one of fear or dread of castration. She demonstrated how, as a first unconscious response to this fear, the camera (and the spectator after it) fetishizes the female form by drawing attention to its beauty, its completeness and perfection. But, in making the female body a fetish object, the camera disavows the possibility of castration and renders it phallus-like (since it no longer represents lack) and therefore reassuring. Mulvey demarcated the voyeuristic gaze as the other male unconscious response to this fear. This gaze represents a desire to control, to punish the (perceived) source of the castration anxiety, even to annihilate woman. (Mulvey mentioned film noir in this context, but for an extreme example see Peeping Tom, Michael Powell, 1960.)

Mulvey then went on to ask, given that the narrative of classic narrative cinema is preponderantly that of the Oedipal trajectory and since that trajectory is tightly bound up with male perceptions or fantasies about women (difference, lack, fear of castration and so on), what happens to the female spectator? How does she derive visual pleasure? Mulvey could only conclude that she must either identify with the passive, fetishized position of the female character on screen (a position of unpleasure, her lack of a penis signifying the threat of castration) or, if she is to derive pleasure, must assume a male positioning (a masculine third person).

Stage three Mulvey's polemic met with strong response by feminist critics (as she intended) and the ensuing decades have seen extensive work on revising, reworking and extending Mulvey's propositions. In an attempt to refute the phallocentrism of Mulvey's argument, Silverman (1981) and Studlar (1985) described the cinema as an essentially masochistic structure in which the viewer derives pleasure through submission or passivity. Doane (1984), following on from these writings, argued that the female spectator's positioning was twofold. She adopted either a masochistic positioning (identifying with the female passive role) or that of a transvestite (identifying with the male active hero). Mulvey (1989) in her afterthoughts on her earlier essav warned against this kind of binary thinking. And, indeed, already feminists were considering the possibility that the spectator was not so rigidly positioned in relation to sexual identity but that it was possible to postulate the bisexuality of the spectator's positioning whereby she or he would alternate between the two - suggesting a fluidity and heterogeneity of positioning rather than an 'either/or'. Modleski (1988, 98) made the point most succinctly in relation to the bisexuality of the female spectator. The female spectator is doubly desiring because when going through the mirror phase the girl child's first love object is the mother, but, in order to achieve 'normal femininity' she must turn away and go towards her father as object of desire. However the first desire frequently does not go away. So, the female spectator's bisexual positioning is central to the mother/ daughter nexus. The male spectator, much as the male character up on screen, for the most part suppresses his femininity (often projecting it on to the female and punishing her for it). However, as Modleski (1988, 99) argued, he can find himself bisexually positioned if the male character fluctuates between passive and active modes.

The contiguous question of spectator-as-subject in relation to meaning-production has equally been broadened. The spectator is not a passive interpellated subject of the screen. She or he holds a position of power and makes sense of the images and sounds (in fact the effect of **sound** renders the screen/mirror analogy somewhat incomplete or unsound). Even though it is a construct of cinema to endow the spectator predominantly with more knowledge than the characters (at least with mainstream narrative cinema), it does not follow that the spectator occupies only one position in relation to those characters (as

the apparatus reading would have it). Cowie's (1984) discussion of film as fantasy made this clear. In her re-thinking or revamping of Laplanche's and Pontalis's three characteristics of fantasy (the primal scene, the seduction fantasy and the fantasies of castration), all of which are a mise-en-scène of desire, she made the point that the spectator, as subject for and of the scenario, can occupy all those positions. As such, she or he is not monolithically placed but can in fact occupy contradictory positions. As an example take Fatal Attraction (Adrian Lyne, 1987) - a film in which it is possible to occupy at different times within the narrative the positions of the mistress, the husband and the wife. It should not be forgotten that Glenn Close (who plays the mistress) expressed deep shock and disappointment at the audience cheering the end of the film when she is shot to death by the wife. She had assumed (naively) that sympathy or identification with her character would occur.

Essentially these three stages of the debate around spectatorpositioning and identification show how there has been a shift away from the early monolithic view of the spectator (as subject of the apparatus), to a more heterogeneous one. This is doubly the case since spectator analysis has not confined itself in recent years to 'spectator as psychic phenomenon'. The debate has become enlarged (thanks in the main to cultural studies) and the spectator-as-viewer is now equally deemed to be an important area of investigation. Thus historical and empirical models of spectator or viewer analysis have been established. In this respect spectatorship has been perceived as a matter of historically shifting groups. The popularity of cinema has shifted over time and has had different effects and been differently affected depending on the make-up of those groups. Spectatorship has also been analysed in relation to intertextuality: an examination of all the texts surrounding the actual film text and their impact upon the viewer as reader and receiver. Exhibition - where films are screened and the effect felt by the viewer - is another important consideration, as is audience pleasure in identification. Finally, studies of viewer-reception, initiated in television studies, have pointed to the ecclecticism of viewers and acknowledged the difference in readings of the film depending on class, age, race, creed, sexuality, gender and nationality.

For an extremely thorough, comprehensive and well-written book on spectatorship read Mayne, 1993. On spectator-identification see

Ellis, 1982. For specific textual analyses see Modleski, 1988. On female spectatorship see Pribham, 1988 and Kaplan, 1983. On reception, Mayne, 1993, supplies an excellent bibliography to which I would add a recent analysis, Stacey, 1993.

stars/star system/star as capital value/star as construct/star as deviant/star as cultural value: sign and fetish/stargazing and performance (see also gesturality, studio system) A first definition: star as capital value The star system is generally associated with Hollywood, although the French film industry was the first to see its usefulness in promoting its products (especially its comedy series and film d'art productions, starting in 1908). In earliest cinema, films were anonymous productions bearing only the name of the studio. It rapidly became evident that certain performers were greater attractions than others. Henceforth, performers were perceived as having capital value. And by 1919 the star system was established. Although Florence Lawrence, 'the Biograph girl' was the first named star in the United States (1910), the first 'real' star was Mary Pickford (known as 'little Mary' in her films of that period). She was shortly followed by Charlie Chaplin. But this capital value of stars was by no means a one-way exchange. Stars made fortunes - that is, as long as they made the studios' fortunes.

Before **sound** both male and female stars were quite archetypal, so their **iconography** was easily readable. After sound, there was a shift in **stereotypes**, and roles differentiated. But, as Claire Johnston (1976) has noted, this was predominantly the case for male stars only. Female stars remained, much as before, vamps or virgins *or* full-scale sex-goddesses whose main purpose was to give the **audience** (and presumably the male star) a 'human sense of beauty and eroticism' (Konigsberg, 1993, 348). Meanwhile male stars became more complex. No longer just heroes, they could be anti-heroes, rebels-as-heroes, socially aware heroes, and so on.

Hollywood's dominance of the western film industry since the First World War has meant not only that the studios have massively exported their star commodities on celulloid throughout the European continent and the United Kingdom, but also that they have been in a position to offer lucrative enticements to import stars: most famously, arguably, in the silent era, Greta Garbo. For some film stars 'going to Hollywood' could make them into megastars, for others it could consign them to oblivion, or – ultimately – do both (for example Vivien Leigh and Richard Burton).

Officially the star system was 'over' by the 1950s owing to the Hollywood studio system collapse, but rivalry remained strong in the 1950s between Europe and Hollywood. For example, just on the sex-goddess front, Diana Dors and Shirley Ann Field in the United Kingdom, Brigitte Bardot in France, Gina Lollobrigida and Sophia Loren in Italy were star images served up to counter the US sex-symbols Marilyn Monroe, Ava Gardner and Jayne Mansfield. Rather than 'over' it would be fairer to say that the star system went into decline after the 1950s collapse and that it became a case of stars still being manufactured but of being fewer in number. Also with the increase in the youth audience from the 1960s to its present dominant position, stars are of a different order – for example, they are 'even more like us' or hulking heroes, or, again a reverse-type: nasty, malevolent villains – but still stars.

Stars sell films, but their capital exchange value goes further than that of course. Producers will put up money for films that include the latest top star. Stars can attract financial backing for a film that otherwise might not get off the ground. Film scripts are written with specific stars in mind (see Robert Altman's The Player, 1992, for a satire on Hollywood practices in this respect). And while films are indeed vehicles for stars, allowing them to show a wide range of skills over different genres, stars are equally vehicles for film genres (for example Fred Astaire and Ginger Rogers, and Gene Kelly are icons of the musical, Lauren Bacall, Humphrey Bogart and Edward G. Robinson are closely identified with film noir and gangster films). Indeed, a need to re-establish a star's commercial viability could be the impetus to disassociate her or him from one type of genre. (This was attempted with Anthony Perkins but was never successfully pulled off: he will always remain Norman Bates of Psycho, Alfred Hitchcock, 1960.)

A second definition: star as construct (What follows in this section is largely based on Dyer, 1986, and Gledhill, 1991 – two extremely lucid and useful texts on this subject.) Stars are constructed by the film industry, but stars (although not all) also have a role in their own construction, participate in their own myth-making. Similarly, star status is authenticated by the media (press, fanzines, television and radio and so on). But stars also possess markers

of their own authenticity and as such are involved in their own mythification. Think, for example of Doris Day, the representative of nice middle-America womanhood; the sexually charged and ambiguous **sexuality** of Marlene Dietrich; the swashbuckling Errol Flynn; the ice-cold maiden Catherine Deneuve with flawless feminine beauty; the socio-psychologically inept Woody Allen.

Stars are somehow baroque in their image-construction since it is so predominantly about illusionism, about 'putting there' what in fact isn't there. They are appearance in the very diversified meaning of that word: they appear on screen, but they are not 'really' there – their image on screen stands in for them so they are apparence, a semblance (see absence/presence). The look that has been constructed of them that is up there for all to perceive is also an appearance, a carefully manufactured appearance (of flawless beauty, of rugged handsomeness, for example). The rest, as Dyer (1986, 2) puts it, is supposedly 'concealed'. Yet we as **spectator**s accept this construct as real.

As a way of measuring this sense of reality let us pick up on Gledhill's comment that stars reach their audience primarily through their bodies (1991, 210). That is, they reach us through their appearance. But, depending on whether it is a male or a female star, this 'reaching-us-with-their-bodies' changes as they age. Not for nothing do so many female stars decry the lack of roles for older, mature, even old women. For male stars, ageing is not (or is less of) an issue where their appearance is concerned. Thus it is acceptable for a male star to age so long as he is 'healthy', his appearance remains one of good, or reasonable health - read: virile health (for example Paul Newman, Clint Eastwood). Even if he grows old unhealthily, through body abuse, some types of 'unhealthiness' still do not bring about a rejection of the star-body that is reaching us. In this respect, it would be purposeful to compare the responses to Burton and his facial deterioration through alcohol (described as 'cragged'. 'tragic') with the prurient reactions to Rock Hudson, the first star to be openly known to have died of AIDS (even though it was denied for a long time). Certain types of deterioration, such as physical decline from excess in alcohol consumption, are less negatively judged than others, it would appear.

To return to the female star and ageing: the female star has 'trouble' ageing not just for herself (loss of looks equals loss of premier roles) but also in relation to her audience. On the whole,

her fans do not like her to age. Curiously, the process of ageing matters when it is a woman star - it recalls our own, ageing is too real - not the 'real' we want to see. Just to take a few random examples of stars and ageing, Simone Signoret, whose premature ageing was always said to be a result of heavy drinking and smoking, was severely criticized for losing her looks. She, it would appear, should have exercised the control that no one expected Burton to exercise. Cancer, from which she died at the age of sixty-four, could equally have been the cause for her premature ageing as her much quoted excesses. Rita Hayworth was dismissed at forty as a drunk, yet she died of Alzheimer's disease. Ageing here is seen as deviancy. Joan Crawford complained of how hard she had to work to look, and stay looking good (Dyer, 1986, 1). Marlene Dietrich spent a fortune on face-lifts. The price of being not bodily deviant is high. Brigitte Bardot and Greta Garbo left the screen before age set in – taking the appearance away, the other price to pay to 'keep up appearances'.

The star as a construct has three component parts (Gledhill, 1991, 214): first, the real person; second, the 'reel' person/the character she or he plays; third, the star's persona, which exists independently of, but is a combination of the other two. The film industry makes the multi-faceted star-image, so does the star, and the audience selects; in this regard, the star-image has four component parts (Dyer, 1986, 3–4): first, what the industry puts out; second, what the media (critics and others) say; third, what the star says and does; fourth, what we say, what we can select, even to the point of imitating the star (for example James Dean look-alikes) – and each audience will select a different meaning (for example Bette Davis means different things to Black men and women than she does to White heterosexuals, or to lesbian, gay audiences).

Star-images, then, are more than just the image. As Dyer (1986, 3–4) makes clear, they are extensive (can extend in meaning, and over the public and private spheres); they are multimedia (photography, film, press, television, and so on); they are **intertextual** (the star's image gets picked up and used by others – a sulking Dean look-alike in a jeans advert); finally, they have histories that can and do outlive their lives (especially if they die in tragic circumstances). A star, then, is a cluster of meanings and parts. It is not difficult, therefore, to see that the star phenomenon is profoundly unstable (Dyer, 1986, 6) and extremely paradoxical by nature – as the next three sections will go on to show.

A third definition: star as deviant A star's life is controlled by the studio, which means there is very little room for resistance. A few stars have been able to take charge of their meaning construction (for example Mary Pickford, Bette Davis, Barbra Streisand, Meryl Streep, Robert De Niro); and this resistance becomes part of their star-image. However, in general, the starcolludes in the fabrication of her or his self as star, participates in the manufacturing of her or his self as representative of 'normality'. Why for example are there still 'lavender' marriages in Hollywood - marriages of convenience to cover up the fact that one or both partners is gay? Why has fear set into Hollywood as a result of a recent outing campaign led by militant homosexuals? Gay stars are the most vulnerable in relation to the instability of the star-image because they must conceal even more than the straight star. They must convince through their performance that their appearance is 'really real'; their performance is a double masquerade.

It is not difficult to perceive that this collusion in manufacturing a star-image confronts the star with a loss of identity or. at the very least, a fragmented rather than a divided self (see psychoanalysis and suture). In terms of identity loss, the star is positioned paradoxically: she or he is pre-Oedipal playing at being post-Oedipal (being without identity, the star is like the child prior to the mirror phase and 'unaware' of his difference or her/his separateness from the mother). As a fragmented self, the star has more than one image and thus too many mirrors reflecting back the multiple self - which one is the real image or reflection? At its most extreme manifestation, this loss of identity can propel the star to seek out reunification with the lost (m)other (note the important role Liz Taylor has had in relation to a number of male stars: Montgomery Clift, James Dean, Michael Jackson). And it can propel them to a reunification with the absent father. The father is either absent because he has not yet had to be present, that is, the mirror phase has not been gone through (if the star is in the pre-Oedipal phase). Or, he is not yet present because the mirror phase has been so overdetermined with reflections that he has been unable to assert himself as the representative of the Law of the Father. The star as the fragmented self has recognized nothing in these multiple reflections, including his difference or her/his separation from the mother.

Bearing this in mind, let us return to the concept of deviancy. The construction of a star is about excess, excess of meaning ascribed to her or him. This excess is mirrored in the star's lifestyle. If it were not excessive (mansions, swimming pools, parties and so on) would we believe in their star status? Occasionally we accept unexcessed star-images, but they are the exception and that exceptionality is part of the star image. Excess then has positive value for studio, star and spectator. But it soon becomes translated into deviancy once it has negative value primarily for the studio. Sexuality and consumption practices are, unsurprisingly, the areas in which stars 'transgress'. Since their sexuality is set up on screen for us to consume, it is perversely through those very sets of comportment that the star will seek to deny (through excess in sexual practice and consumption abuse) and then (inadvertently?) expose the masquerade of stardom – through disfigurement or death.

A fourth definition: star as cultural value: sign and fetish As a sign (see semiology) of the indigenous cultural codes, institutional metonymy and site of the class war in its national specificity, the signification of the star 'naturally' changes according to the social, economic and political environment. Stars are shifting signifiers, they function as reflectors of the time and as signs to be reflected into society. During the 1950s, when youth emerged as an important class economically and culturally, teenage boys in the United States donned T-shirts, jeans and leather jackets with either Dean or Brando as their icon; in France, teenage girls mimicked the Bardot look - as well as the walk, and so on. Stars have emblematic as well as cultural value in that they 'signify as condensers of moral, social and ideological values' (Gledhill, 1991, 215). Gledhill makes the point that they can also be emblematic of those values being in question (for example Garland in A Star is Born, George Cukor, 1954; Dean in Rebel Without a Cause, Nicholas Ray, 1955).

The star as sign also functions as mediator between the real and the imaginary and, as such, has spectator expectations transferred on to it. The shifts in the representation of female sexuality, just to take one example, over the past sixty years of cinema show how this process of transference and mutation occurs. In Hollywood, for example, during the 1930s and 1940s two types of feminine eroticism prevailed: the 'independent just as good as the boys' (Claudette Colbert, Bette Davis, Rosalind Russell, Katherine Hepburn) or the weak, vulnerable type (Vivien Leigh). In the 1950s the femino-masculine independent type was replaced by the dutiful wife at home supporting her husband

(by staying out of the job market), or the self-parodying brunette who eventually 'settles down' (roles played respectively by Doris Day and Jane Russell). The weak type is replaced by the dumb blonde (guess who?). By the late 1960s a new type has emerged, a 'radical-liberal feminist eroticism' which attributes to women the right to decide what they do with their sexuality (Jane Fonda). This woman-in-her-own-right sexuality has persisted into contemporary cinema, but it has not always sat easily – as if by way of a backlash against feminism. As two contrastive modes of representation, see Glenn Close in Fatal Attraction (Adrian Lyne, 1987) and Jodi Foster in The Accused (Jonathan Kaplan, 1988). These shifts in representation, over time, correspond, first, to different stages in the dominant perception of the American woman's sexuality and, second, to the social, political and economic conditions that prevailed in each of those epochs.

This is also an example of the way in which stars are endowed with national iconicity and as such have cultural value. Clearly a star's meaning can shift in the move from the national to the international level. This is particularly true of the United States' perception of European stars - especially French stars. But stars also signify on a personal level. They articulate the idea of personhood which is a fiction for the reproduction of the kind of society we live in (Dyer, 1986, 8). As (national) icon and (individuated) person the star functions as both extraordinary and ordinary. In the first instance, as extraordinary, she or he is an object of our speculation and impossible object of our desire. In the latter, as ordinary, she or he is 'just like us' - we can identify the stars with us - and so the star is a possible object of our desire. This binary effect functions to fetishize the star - in neither instance is the star subject, always object (see voyeurism/fetishism). Ellis (1982, 91-108) points to the similarity between this binary effect and the absence/presence paradigm. The star on screen is absence made presence and the spectator is the hearing, seeing subject. In this respect the screen is analogous to the mirror into which the spectator peers and has a momentary identification with that image (the star-justlike-us). The spectator then perceives her or his difference and becomes aware of the lack (absence, separation from, loss of the [m]other - the star as absence, as not-like-us). Finally, the spectator recognizes herself or himself as the perceiving subject, a position which in turn creates desire. As holder of the gaze the spectator is positioned voyeuristically, desiring to look, with

all that that connotes in terms of fetishism. But the absence/presence paradigm also points to the simultaneously impossible and possible nature of that desire, which is also a feature of fetishism (desiring that which cannot be had — what is absent, adulating a fixed object — the star or icon present up on screen).

The fetish value of a star is strongly underscored by her or his mise-en-scène, starting with the moment of entrance on screen – awaited with impatience – a use of suspense to give added value to the star. Morphological markers, 'that seem natural or naturally the star's' (such as a certain smile, biting a lip, side-lighting eyes), but which privilege us into their emotions, play into the fiction that the spectator or the camera or the eye has caught them unawares (Ellis, 1982, 106). Voyeuristically we look on: unseen-'presence' watches what was once seen-presence but which is now absence – an image standing for star. Even a film itself can obtain fetish status when, for example, a star has died young and/or in tragic circumstances. The film is all that is left of her or him as movement (a recent example being River Phoenix and My Own Private Idaho, Gus Van Sant, 1991).

A fifth definition: star-gazing: strategies of performance Two questions will frame this last definition of stardom: who is looking at the star? and what are we looking at? The answer to the first will make clear why strategies of performance inform the answer to the second question. Essentially there are two audiences looking at the star: the diegetic and the extra-diegetic ones (see diegesis). That is, those on the inside looking on, and those on the outside looking in – but in both instances also looking at the star, if with different effect. With different effect because the spectator's look is mediated by the diegetic audience. This does not exclude the fact that the spectator's gaze is also mediated by the point of view within the film, which is usually that of the star, but we are here discussing who is looking at the star. (The entry on spectatorship addresses spectator-positioning more fully.)

The effect of diegetic star-gazing on the female star is one of a fairly straightforward fetishization. However, the effect on the male star is twofold. First, if those star-gazers are male, the effect is one of homoeroticism and of a feminizing of the male body (the male body is as much fetishized by the male gaze in this instance as is the female body). This puts an interesting reading on predominantly all-male genres (**Westerns** and **crime-thriller** movies). Second, if the star-gazers are female, even though the

gaze is now heterosexually charged, the feminizing of the male body still takes place. Women's agencing their gaze on to the male body means they are taking up the privileged male position as holder of the gaze (see agency). An analysis of Clint Eastwood's positioning in relation to diegetic audiences in his two films *Unforgiven* (Clint Eastwood, 1992) and *In the Line of Fire* (Wolfgang Petersen, 1993) would illustrate this double effect.

The extra-diegetic audience likes to come and see its stars. This implies that the audience has certain expectations of the star. The star is the point of synthesis between representation and identification. She or he represents or re-presents the 'host culture' of which she or he is a part and with which the spectator identifies (King, 1985, 37). She or he also stands for roles she or he has played before. The extra-diegetic star-gazer, then, has come to see what the star is capable of and, depending on the star, expects either a degree of sameness (acting to type or personification) or unsameness (always changing or impersonation). And to this effect strategies of performance are mobilized by both the industry and the star to satisfy this need on the part of the audience. Irrespective of which mode of acting is in play (personification or impersonation), these strategies function as markers of authenticity. Thus a star who plays roles that are consonant with her or his personality (no matter how constructed that is) will be far more typecast and produce ritualistic performances far in excess of a star who impersonates.

Hollywood tends to prefer the personifying star in the belief that audiences choose films in relation to stars and a knowledge, more or less, of what to expect (for example Eastwood, the non-verbal gunman; Jack Nicholson and the leering grin combined with a macho bravura; the Bette Davis flouncing bitchiness; the soulful Barbra Streisand and her songs; the all-American winner and tough guy, John Wayne; Tom Cruise, less of a tough guy, but still an all-American winner; and so on). Stars who impersonate (that is, who can be true to any conceivable character) are fewer in number and their popularity or success depends to a great degree on how far they go in suppressing the authenticating markers of their real personality or star-image. While the construction of difference (from the star-image or personality) must be convincing, if the suppression is so total the audience is likely to reject that performance. In other words, if the impersonation gets to the point where the disguise prevents the signs of the star from being read, so

that the star to all intents and purposes 'dis-appears', the audience feels 'cheated' of the process of spectator recognition, an essential component of the star-image. The audience can no longer select those bits of the star (authenticating markers) which it recognizes or with which it identifies. In this respect, the star Meryl Streep is the one actress who comes to mind because she sails so close to this 'dis-appearance act'. This could explain why she receives such a mixed reaction to her performances, which are far from universally liked or admired.

stereotype Originally, stereotype was a printing term used to refer to a printing plate taken from movable type, to increase the number of copies that could be printed. Applied figuratively. this expression has come to mean, at its simplest, a fixed and repeated characterization (the drunken doctor in Westerns, the moll with a golden heart in gangster movies). Initially, stereotypes came about in cinema to help the audience understand the narrative. However, it would also be true to say that they are a carry-over from traditions of performance in stage melodrama and vaudeville - the two theatre genres that were most readily adopted by early cinema. They also serve an economic function in relation to the narrative. We 'know' what they stand for so there is no need to elaborate their characterization. This means that stereotypes are little, if at all, nuanced. But this does not mean that stereotyping just operates at the level of secondary characters. Main roles, stars, can equally be reduced to stereotype (the dumb blonde or sex goddess; the hulk with no brain; the all-good middle-American - respectively: Marilyn Monroe, Sylvester Stallone, James Stewart).

Stereotypes come and go; they also change in the light of the shifting political cultural context. Take for example the representation of communists and communism in Hollywood cinema from the 1950s to the 1990s (from threat, alien force that is to be defeated, to an inept, corrupt system that is doomed to failure). Already it can be seen that stereotypes are not simple signifiers, even though they appear to represent types, norms. Because they are social—cultural productions passing as normative, they need to be examined in relation to race, **gender**, **sexuality**, age, **class** and genre as well as history.

Let's take these last two pointers (genre and history) as a way of explaining why stereotypes must be widely examined. Some genres rely more heavily on stereotypes than others. Why? The traditional Western for example abounds with stereotypes – all the better to serve as a backcloth to the main protagonist: the hero-who-puts-things-right against all odds; the hero as positive value versus the stereotypes as negative value. Take the disaster movie – a particular favourite genre of the 1970s and early 1980s (for example, the Airport series and the Towering Inferno types of films). The narrative this time functions a bit in reverse to the Western. That is, the hero is not identified from the beginning but has to identify himself (sic) gradually against the stereotypes present in the disaster arena (neurotic ageing female film star; bigoted priest; drunken doctor (again); dving nun; nymphomaniac; twin orphans). What purpose, then, do stereotypes serve? They clip into codes and conventions associated with belonging and exclusion. We, the spectators, may not be like the hero but we are certainly 'not like the others'. Stereotypes represent a release of our prejudices at the same time as they play on them. They allow us to belong to a social grouping of which they (the stereotypes) are not part.

In terms of history, certain socio-cultural groupings (just as an example) find a stereotypical characterization or representation that is, in the main, unfavourable, at best reductive – even though this representation may shift over time. Certain racial groupings, and gay and lesbian groupings, are prime examples. An examination of the evolution of the representation of Jews in different Western cinemas over the past sixty years of cinema would be highly instructive of how stereotypes have shifted if not necessarily improved. And a question worth asking is, in what way, if at all, do more recent images function less stereotypically than earlier ones? Do they represent more clearly issues surrounding Jewishness or do they still slot into the problematic area of stereotypes? Or are they guilty of historicism? Compare, for example, Woody Allen's films where his Jewishness is at the centre of the narrative, with Alan Pakula's Sophie's Choice (1982) where Jew as victim-survivor of the Holocaust is the driving force behind one individual's suffering.

structuralism/post-structuralism (see also apparatus, auteur theory, feminist film theory, suture, theory) The foundingstone of structuralism was structural linguistics (later to become semiotics) which dates back to the beginning of the twentieth century, primarily in the form of Ferdinand de Saussure's linguistic theories. However, they remained little known until the theories were brought into the limelight, in France, by the philosopher-semiotician Roland Barthes in the 1950s - especially in his popularizing essays Mythologies (1957). Saussure, in his Cours de linguistique générale, set out a base paradigm by which all language could be ordered and understood. He distinguished between language as a system (langue): an underlying set of rules that is universal as a concept; and language as utterance (parole): the speech that can be generated by those rules. The impact of linguistic structuralism in the late 1950s and through the 1960s on other disciplines was quite widespread, affecting anthropology, philosophy and psychoanalysis to mention but three that are of immediate importance in the context of film theory. Exemplary of this impact was Claude Lévi-Strauss's anthropological structuralism of the 1960s, which looked at Indian myths. Although his thesis was to have a widespread influence, because he was examining narrative structures, it was of particular significance in the context of film theory. Lévi-Strauss's thesis was that since all cultures are the products of the human brain there must be, somewhere, beneath the surface, features common to all. This was an approach that became extremely popular during the 1960s and was adapted not just by film theoreticians such as Christian Metz but also by the Marxist philosopher Louis Althusser into his discussions of ideology and by Jacques Lacan into psychoanalysis.

The first point to be made about this popularization of structuralism, in France, is a socio-political one and relates to structuralism's strategy of 'total theory'. This popularization coincided with de Gaulle's return to presidential power in France. His calls for national unity in the face of the Algerian crisis, the era of economic triumphalism which he instituted and the consequent nationalism that prevailed were in themselves symptomatic of a desire for structures to be mobilized to give France a sense of national identity in the face of decolonization and radical constitutional change. Thus, the desire for total structure, as exemplified by structuralism, can be read as an endeavour to counter the real political instability of the 1960s.

The second point to be made about structuralism as it affects film theory is that it represents a rethinking of film theory through academically recognized disciplines, those of structural linguistics and semiotics, hence also its appeal to US and British theorists, among others. This pattern would repeat itself in the 1970s with psychoanalysis, philosophy and feminism, and, again in the 1980s, with history. The significance of this new trend of essayists and philosophers turning to cinema to apply their theories cannot be underestimated. It is doubtless this work which has legitimated film studies as a discipline and brought cinema firmly into the academic arena.

Initially the introduction of structuralism into film theory was perceived as a bold move to deromanticize the film-maker as auteur by introducing a more scientifically based approach that could objectively uncover the underlying structures of film. However, it ended up in rigid formalism which removed any discussion of pleasure in the viewing. Symptomatic of this desire for total order in film theory were Christian Metz's endeavours in the mid-1960s to situate cinema within a Saussurian semiology. Metz, a semiotician, was the first to set out, in his Essais sur la signification au cinéma (1971 and 1972), a total-theory approach in the form of his grande syntagmatique - a linguistic structure that could account for all elements of a film's composition. Thus cinema is a set of syntagmatic relations - that is, of universal rules (much like Saussure's langue), a set of relations that could be described as a grammar of film. Syntagmatic relations then relate to the possibility of combination. Each film will be constructed out of a combination of syntagms, but within these a specific selection of shots will be used (much like Saussure's parole). Let us take, for example, a parallel syntagm two events running in parallel. The universal rules that govern this type of syntagm mean that cross-cutting between the two events must occur. However, no two parallel syntagms are the same (or rarely), because each film-maker, bearing in mind the narrative and genre, selects the shots that make up the syntagm. Thus a film based on a fairy story that opposes two worlds (the real and the fantasy worlds) vastly differentiates itself from a Western or a thriller even though they are similarly composed of parallel syntagms.

It is not difficult to see in Metz's endeavour the problems inherent in such a total approach. First, although structuralist theory purported to reveal the hidden structures behind film-making, it simultaneously ignored modes of production, the impact of **stars** on choices and the socio-historical context of production. Post-structuralism would make this widening possible. Thus structuralism, while it might have deromanticized

the auteur, none the less continued to focus on the film-maker and on her or his product. Analysing film this way meant that a critic could scientifically and objectively evaluate a film, determine the style of a particular auteur/film-maker and indeed determine also if a particular film was consistent with that film-maker's style – hence the term *auteur-structuralism*. The focus, therefore, was on the hidden structures and codes in the text and, in this respect, answers the question of how the text comes to be – but not how it comes to mean. The problem becomes one of the theory overtaking the text and, thus, of being very limiting. What is omitted is the notion of pleasure and **audience** reception. What occurs instead is a crushing of the aesthetic experience through the weight of the theoretical framework.

Post-structuralism It took the impact of post-structuralism, psychoanalysis, feminism and deconstruction to make clear finally that a single theory was inadequate and that what was required was a pluralism of theories that cross-fertilized each other. Poststructuralism, which does not find an easy definition, could be said to regroup and cross-fertilize - to some extent - the three other theoretical approaches mentioned. As its name implies, post-structuralism was born out of a profound mistrust for total theory, and started from the position that all texts are a double articulation of discourses and non-discourses (that is, the said and the non-said, le dit et le non-dit). Because post-structuralism looks at all relevant discourses (said or unsaid) revolving around and within the text, many more areas of meaning-production can be identified. Thus, semiotics introduced the theory of the textual subject - that is, subject positions within the textual process, including that of the spectator and the auteur - and the text as a series of signs producing meanings.

In terms of auteur theory the effect of post-structuralism was multiple: 'the intervention of semiotics and psychoanalysis' 'shattering' once and for all 'the unity of the auteur' (Caughie, 1981, 200). Having defined the auteur's place within the textual process, auteur theory could now be placed within a theory of textuality. Since there is no such thing as a 'pure' text, the intertextuality (effects of different texts upon another) of any film text must be a major consideration, including auteurial **intertextuality**. Thus, the auteur is a figure constructed out of her or his film; for although there exist authorial signs within a film that make it ostensibly that of a certain film-maker, none the less that authorial text is also influenced by those of others.

Psychoanalysis and feminist film theory introduced the theory of the sexual, specular, divided subject (divided by the fact of difference, loss of and separation from the mother (see **suture**)). Questions of the subject come into play: who is the subject (the text, the star, the auteur, the **spectator**)? These newly introduced theories also examined the effects of the **enunciating** text (that is, the text brought about by the spectator) — this included analysing the two-way ideological effect and the pleasure derived by the spectator as she or he moves in and out of the text (see **spectator identification**). To speak of text means too that the context must also come into play in terms of meaning production: modes of production, the social, political and historical context. Finally and simultaneously, one cannot speak of a text as transparent, natural or innocent, therefore it is to be unpicked, deconstructed so that its modes of representation are fully understood.

studio system (see also Hollywood) Normally identified with Hollywood, even though the first country to boast a vertically integrated studio system was France, which in 1910, had three production companies: the two majors, Gaumont and Pathé, and, on a smaller scale, Éclair. Vertical integration means that a studio controls the modes of production, distribution and exhibition. The 'official' date for the birth of the studio system is circa 1920. However, its earliest prototype in the United States can be found in the pioneering work of Thomas H. Ince. who in 1912 built Inceville in Hollywood, where he both directed and produced films much on the lines adopted by the Hollywood studio system from the 1920s to the early 1950s. Ince set himself up as director, producer and manager, and as such supervised all the films being made simultaneously in different studios; it was he who had the final say on everything from the script to the editing. From this production practice it was not long before the full-blown Hollywood studio management style emerged. This style was designed along the following lines: a production head to supervise the whole project, a division of labour and the mass production of films (mostly formula films for sure-fire success), which meant among other things shooting films out of sequence to save on costs, and the last word on the final cut resting with the director-manager-owner.

Vertical integration was initiated in the United States in 1917 when Adolph Zukor acquired Paramount Film Corporation

- then a distribution company (established in 1914) - and aligned it with his own production company, the Famous Players-Lasky Corporation. This brought him control of both production and distribution. This move had important consequences both for financing films and for exhibition practices. Distribution was the way to finance films, and now that Zukor owned production and distribution he could more or less force cinema theatres to accept block-bookings - to rent and screen films as decreed by exhibitors. There was an attempt to counter this potentially monopolistic putsch. In 1917 an exhibitors' company, First National (originally called the First National Exhibitors' Circuit), was established to fight the block-booking system. It lasted some twelve years and in its heyday - 1921 - owned around 3,500 theatres. By 1922 it had entered into production. Zukor responded by buying up theatres himself, and by 1926 owned more than a thousand. During this first cycle in the studiosystem's history (1913-29), four other major production companies consolidated their positions as rivals to Paramount, and full vertical integration for the five majors occurred between 1924 and 1926, the others being Fox Film Corporation (first established in 1913 and fully integrated by 1925); Metro-Goldwyn-Mayer (1924); Warner Brothers (established 1923 and integrated by 1926); RKO (1928). Alongside these five majors there coexisted the 'little three' majors - Universal Pictures (formed 1912), United Artists (1919) and Columbia (1920). They were called 'little' because they were not vertically integrated but had access to the majors' first-run theatres. (For a brief history of these companies see below.)

During the 1920s these major companies had a virtual monopoly over the film industry. Profits were enormous, but so too were costs. To counter these increasing costs – due, first, to the effect of vertical integration (an expensive system to finance) and, second, to the advent of **sound** (1927) – studios increasingly came under the control of bankers and businessmen with the effect that not only economic considerations but also artistic ones became more and more a matter for management-style decisions (see Bordwell, Staiger and Thompson, 1985, 320–9). Only Warner Brothers, Columbia and Universal escaped direct interference from Wall Street, because of their prudent production practices. The director was but one of many specialists hired by the studio companies who were now organized into different departments. Hollywood meant business, as can be determined

by the fact that from 1930 to 1948 the eight majors between them controlled 95 per cent of all films exhibited in the United States and formed a seemingly impenetrable oligopoly (Cook, 1985, 10).

The eighteen-year period of Hollywood's unrivalled studio system (1930-48) can best be summed up as follows. Each studio had a general overseer (usually the vice-president of the company), and its own 'stable' of stars, scriptwriters, directors and designers (which led to a 'house look'). Hollywood produced some six hundred films a year on an assembly-line process (which led to a standardization of the product but also, more positively, to a greater sophistication of genres). Although each company followed similar production practices, they none the less tended to specialize in certain types of films and cultivate a distinctive look (see below). Economic exigency meant that films had to follow certain criteria to guarantee box-office success. During the Depression, in order to give value for money, double features became the rule. This meant that the majors and the minor majors, alongside smaller production companies that specialized in low-budget movies (particularly Monogram and Republic), had now to turn their hand to making B-movies to supplement the programme. With the exception of Warners, Columbia and United Artists, all majors went bankrupt at some point during the Depression and became subject to direct interference from Wall Street (Bordwell, Staiger and Thompson, 1985, 400).

In 1948 the majors suffered a reversal in fortune with the Supreme Court-Paramount decision. Litigation had been begun against the studios in 1938, but the Second World War put a halt to it until 1948. Exhibitors brought an anti-trust action to put an end to the film industry's monopoly over exhibition. On the grounds of unfair practices, the Supreme Court issued decrees that effectively divested the majors of their power as vertically integrated systems. The big five would have to relinquish their theatres, which represented about two-thirds of their capital investment (Cook, 1985, 10), and the little three would, with the big five, have to stop restrictive practices and coercion (blockbooking) in the exhibition of their films. This decision opened the doors to independent film and, to a lesser degree, to foreign imports. In 1951, several appeals later, the majors had no choice but to comply with the law and enter into fair competition with minor production companies. This was but a first step in the demise of the studio system. Rising costs meant that the double bill and the B-movie with it disappeared. The lower costs of location shooting abroad also impacted upon studio use. Outside the system other factors contributed to this decline: first, the rise in the popularity of television and, second, the effect of the House of Un-American Activities Committee on Hollywood both in terms of blacklisting certain actors, directors and scriptwriters and in terms of an unspoken or implicit censorship whereby certain types of films just would not get made (see Hollywood blacklist). Attempts to regain lost audiences through new departures in technology – 3-D, technicolour, cinemascope – had only a slight impact.

To stem losses, studios rented out space to television companies and even turned their own hands to making television programmes (in 1957 RKO was bought by Desilu – Lucille Ball's and Desi Arnaz's television production company – solely for making television programmes). Departments closed, land and real estate were sold off. The studio system became a ghost of its former self. More recently, studios have been bought up by large conglomerates for whom film production is just one of their practices. The current method of producing films is usually for an independent producer to put a package together and sell it to one or other of the studios (Konigsberg, 1993, 358-9).

There follows a brief history of the major and minor Hollywood studios, listed in chronological order in each category.

The Five Majors (Fox, Paramount, Warners, MGM, RKO) The five major studios at that time were Fox, Paramount, Warners, MGM and RKO.

Fox Film Corporation/20th Century Fox Fox Film was established in 1913 by William Fox. Originally an exhibition company (in New York), it quickly became a production company (1915) with studios in Hollywood. Fox's ambition was to be the biggest major; that ambition was to cost his company so dear that he was forced out of it in 1931. In 1935, a small production company, 20th Century, headed by Joseph M. Schenk and Darryl F. Zanuck (formerly production head at Warner Brothers), merged with Fox and the company was renamed 20th Century Fox. Zanuck, as vice-president (a post he held for over twenty years), quickly turned the ailing fortunes of the former company around, and brought it into third position to MGM. This he achieved – at least during the late 1930s, more by the type of films he produced – popular **musicals** – than by his stable

of stars, which he built up only slowly. To the two he inherited from Fox – Shirley Temple and Will Rodgers – he added Tyrone Power, Sonja Henie, Alice Fay, Carmen Miranda and Betty Grable, and eventually, in the 1940s and 1950s, Henry Fonda, Marlon Brando, Marilyn Monroe, Jane Russell and Gregory Peck. In his stable of directors he could count Elia Kazan, John Ford and Joseph Mankiewicz. After 1948, Fox turned to location shooting and extended its repertoire of films to include 'realistic' crime films, **Westerns**, musicals and spectaculars. To attract audiences back into the theatres, Fox led the way in new technology – producing, for example, *The Robe* (1953), the first feature-length film to be shot in Cinemascope. Fox is now owned by Rupert Murdoch.

Paramount Pictures Corporation Originally a distribution company established in 1914 by W. W. Hodkinson. As indicated above, when Zukor became president of the company in 1916, he set about vertically integrating this major, which lay second only to MGM during the studio system's heyday. During the silent era it boasted such famous names as Mary Pickford, Douglas Fairbanks, Gloria Swanson, William S. Hart and Fatty Arbuckle among its stars and Cecil B. de Mille, Erich Von Stroheim, Mack Sennett and D. W. Griffith amongst its top directors. Griffith, Fairbanks and Pickford soon left to set up with Charlie Chaplin their own independent company, United Artists, in 1919. Nor was Paramount short of stars during the sound era, when it produced mainly comedy and light entertainment - with occasional epics (such as The Ten Commandments, de Mille, 1952). Mae West, Marlene Dietrich, Paulette Goddard, Hedy Lamar, Dorothy Lamour, Barbara Stanwyck, the Marx brothers, Bing Crosby and Bob Hope are some of the stars that made up the Paramount stable. During its Hollywood heyday, Paramount - because it owned so many theatres - produced forty to fifty films a year, more than any other studio. Dorothy Arzner was given her first directorial role by Paramount in 1927 - and was one of the very few women to accede to directorial status during Hollywood's years of ascendancy (1930-48).

After 1948, while continuing to make films, Paramount gradually ventured into television production, becoming heavily involved in the 1960s. In 1958 the company sold off all its rights to its 1929–49 feature films to Music Corporation America. In 1962 MCA had also acquired Universal. In 1966 Paramount

was acquired by Gulf and Western. Until recently it was owned by the entertainment group Paramount Communications. But in 1994 it became the centre of a protracted buy-out battle between two rival American cable companies, Viacom and QVC Network, which Viacom finally won.

Warner Brothers A production company established in 1923 by the four Warner brothers. Warner Brothers was the studio that introduced integral sound into films in 1927 with The Jazz Singer (Alan Crosland). This bold move was undertaken to improve the studio's status amongst the majors. Prior to this Warners had been the poor relation to the other studios because it was not yet vertically integrated. The introduction of sound revolutionized production practices, and catapulted Warners into major status. In 1928, it consolidated this status by purchasing its own theatres, first by buying out the Stanley Company (three hundred theatres), then a part share in First National, which it completely bought out in 1930. Warners was now truly integrated. Of all the companies, Warners is the one that rode out the Depression best. This was as a result of careful economic planning and strategies. The company (initially under the aegis of Darryl F. Zanuck, Warners' production head) rationalized its production into assembly-line production methods, low-budget movies and strict adherence to shooting schedules. This had two consequences. First, it meant that the company could produce fast and in significant numbers (around sixty films a year during the Depression period and thereafter through the 1930s). Second, the economic constraints influenced the product itself. Therefore gangster films and backstage musicals were the genres to prevail, because they were cheap to produce. Social realism and political relevance combined with a downbeat image endowed Warners' films with a populism that made their products particularly attractive to working-class audiences (Cook, 1985, 11-12). Little Caesar (1930), The Public Enemy (1931), I Am a Fugitive from a Chain Gang (1933), The Roaring Twenties (1939), They Drive by Night (1940) are but a sample list of 1930s films with social content or criticism at their core. During the war this liberalism gave way to more patriotic statements that were anti-isolationist, anti-pacifist and anti-Nazi. Less known in this category is Sergeant York (1941), but one film which has become legend - more, it has to be said, as a love story than a film about patriotism - is Casablanca (1942). Warners did not have 'stables' as such, but used contract directors, actors and crews. Raoul Walsh was a long-serving contract director (1939–51), Howard Hawks made Sergeant York and To Have and Have Not (1944); actors include Paul Muni, Humphrey Bogart, James Cagney, Edward G. Robinson, Errol Flynn, James Dean, Bette Davis, Ingrid Bergman, Joan Crawford, Barbara Stanwyck, Lauren Bacall.

After 1948, Warner Brothers lost its theatres (as did the other majors because of the Supreme Court–Paramount decision), but it went on to produce numerous successful films (A Star is Born, 1954; Rebel Without a Cause, 1955; My Fair Lady, 1964). The company also went into television production in a big way. In 1967 Warners was sold to Seven Arts (a distributor and dealer in old films). Warner–Seven Arts distributed Bonnie and Clyde (Arthur Penn, 1967). In 1969 Warner–Seven Arts became Warner Communications. Warner Brothers is currently (since 1988) merged with Time Incorporated, and is now known as Time–Warner. Since joining Time Inc., the company was in continuous debt until 1992 when it made its first profit. Time–Warner is currently the largest American entertainment group.

Metro-Goldwyn-Mayer Created by a merger (completed by 1924) of three smaller studios (Metro, Goldwyn and Mayer), MGM was the leader among the majors during Hollywood's heyday. This was the studio of stars, spectacle and glamour that produced such glossy and glittering films as The Wizard of Oz and Gone with the Wind (both 1939 and directed by Victor Fleming). No set was too lavish, no special effects too expensive - for example the earthquake in San Francisco (W. S. Van Dyke, 1936). MGM's house style was influenced by two factors: first, high investment in pre-production and, second, the extremely tight rein on production held by Irving Thalberg, who saw a product through from start to finish. Investment in preproduction meant that films had multiple scriptwriters, and it was not uncommon during production for numerous editors to work on a particular film, or for a director to be replaced by another after previewing. This also meant that directors for this studio during the 1930s were less visible than in others. The same could not be said of its stars. Unlike Fox, which because of its small stable of talent had to make its films its stars, MGM had a veritable galaxy of stars - and was particularly renowned for its grooming of women into stars: Joan Crawford, Greta Garbo, Judy Garland, Greer Garson, Jean Harlow, Norma Shearer

are some of its greatest female stars. Mickey Rooney and Spencer Tracey were two of the great names among the male attractions. But, undoubtedly *the* male star in this stable was Clark Gable – the labourer turned crowned king of Hollywood (1937).

After 1948, MGM's fortunes declined as with the other studios. In 1969 it was bought up by a Las Vegas businessman, Kirk Kerkorian, who sold off much of its real estate and other assets. In 1981, he purchased United Artists. MGM became MGM–UA. The company was then sold to the Turner Broadcasting System, which was subsequently sold back to Kerkorian, but not before Turner had kept the MGM film library for his own purposes (that is, for his film television channel, HBO), causing a serious cash-flow problem to MGM. The company was then taken over by Giancarlo Paretti, who had to relinquish control when the French bank Crédit Lyonnais foreclosed on loans made to him. Since 1992 MGM has been operated by the Crédit Lyonnais, but is losing \$1m a day and has very few assets left (the UA film library is all that remains).

RKO Radio Pictures Incorporated As its name suggests this studio came into existence around the time of the launching of sound (1928). The Radio Corporation of America wanted to get into film production so that it could promote its own sound system, Photophone, against the Movietone system which the other majors had invested in. RCA joined forces with a distribution company which owned the Keith and Orpheum theatres - hence RKO. It became a ready-made vertically integrated company 'overnight'. In its heyday it produced nine Fred Astaire and Ginger Rogers films (most famously Top Hat, 1935). It also produced big hits such as King Kong (Ernest B. Schoedask, 1933), Bringing up Baby (Howard Hawks, 1938), Citizen Kane (Orson Welles, 1941) and Notorious (Alfred Hitchcock, 1946). RKO's production system was introduced early (1931) into the company's existence by David O. Selznick. Termed unit production, it was strikingly different from the other majors' systems in its unrestrictive practices of contracting an independent director to make a certain number of films free of studio supervision or interference. RKO is not associated (as are the other majors) with a specific genre, although alongside its prestige movies it did produce B-movies, particularly the film noir and horror genres. The output of B-movies greatly increased after 1940 to counter the severe losses caused by the studio's prestige-film policy. And by 1942 production of these lowbudget films had become the new adopted policy.

After 1948, this company also went into decline, though more severely than its rival majors – since it would eventually disappear. It was bought up in 1948 by Howard Hughes and was subsequently sold, in 1955, to General Tyre and Rubber Company who then, in 1957, sold the studios to the television programme producing company Desilu.

The Three Minors (Universal, United Artists, Columbia) The first of the three minors, Universal, formed in 1912 by Carl Laemmle, did not build its studios in Hollywood but in the San Fernando Valley (Universal City, 1915). The firm-handed Irving Thalberg was one of its first chiefs of production (later he went to MGM). Its most famed silent stars were Rudolph Valentino and Lon Chaney. During the 1930s Universal specialized in horror movies (Frankenstein and Dracula, both 1931) primarily because at this early stage in sound cinema they were relatively inexpensive to make, depending as they did on sets and lighting rather than a mobile camera (Cook, 1985, 24). The success of Frankenstein, directed by James Whale, sealed Universal's reputation as the 'home of horror'. In fact, the genre became virtually identified with Whale and Universal. Whale went on to make The Invisible Man (1933) and The Bride of Frankenstein (1935). arguably his masterpiece. Considering Universal's low budget policy, the special effects of these three films are all the more remarkable. In the light of the Depression it is interesting to note the popularity of the horror genre. But then again audiences' escapism into horror fantasy was matched by their keen consumption of social realist films made during the same period by Warners. This studio was the first to make a sound movie about the First World War, All Ouiet on the Western Front (1930). which was astonishing not just for its sound effects at such an early stage in sound technology but also for its pacifist message and lack of heroization. This film, directed by Lewis Milestone, became the prototype for many European war movies made during the 1930s. Universal went into receivership in 1933 for two years and Laemmle was obliged to sell off his holdings in 1936. The studio was relaunched and, though far from free of economic worries, its decline was stemmed until the mid-1940s by the popularity of its top stars Deanna Durbin, Abbott and Costello and W. C. Fields. From 1946, to help its ailing fortunes, Universal adopted a new strategy which prevailed until the late 1950s: in order to attract big names that would 'sell' its products, it offered stars a percentage of the profits made on films in

which they starred. This brought them James Stewart, Charlton Heston, Orson Welles, Marlene Dietrich and Janet Leigh amongst others. Also in 1946 it acquired International Pictures, an independent production company: this helped to improve the company's distribution activities.

After 1948, to counter the effects of the anti-trust decision ending the industry's monopoly over exhibition, Universal reestablished a studio identity by specializing in three main genres: thrillers, melodramas and Westerns (Cook, 1985, 24). In 1952 the studio was taken over by Decca Records. Later, in 1962, these two companies became part of Music Corporation of America, a talent agency highly invested in television production. Under MCA management, Universal went on to be successful in both domains by producing small-budget movies (ultimately destined for the television screen) and big-budget blockbuster movies (such as *Iaws*, 1975 and *E.T.*, 1982, both directed by Steven Spielberg). MCA was bought up in 1990 by the Japanese electronic company Matsushita for a staggering \$6.6 billion (compare with the major Paramount valued at \$10 billion) - an investment repaid perhaps by Universal's big Spielberg hit, Jurassic Park (1993).

United Artists Corporation Established in 1919 by Charlie Chaplin, Douglas Fairbanks, D. W. Griffith and Mary Pickford as a protest against the oligarchy of the majors, the corporation was a distribution company for their own films made by them as independents (most famously The Gold Rush, 1925). By 1925 the paucity of films they had produced themselves obliged the corporation to distribute films made by other production companies. During the 1930s its most important releases were City Lights (Charlie Chaplin, 1931), The Private Life of Henry VIII (Alexander Korda, 1933) and Modern Times (Charlie Chaplin, 1936). But the major stumbling-block to its success, the lack (because of the majors' monopoly) of sufficient theatres in which to exhibit, was not fully removed until the anti-trust decree of 1948. After 1948, thanks to the anti-trust decision, United Artists was elevated to the status of a major. Unencumbered by huge overheads of studio ownership, the company flourished (High Noon, 1952; Marty, Delbert Mann, 1955; the James Bond series, Fred Zinnermann, during the 1960s). This state of affairs prevailed, by and large, until the late 1970s when, buoyed by three Oscars in a row, 1975-7 (One Flew over the Cuckoo's Nest, Milos Forman, Rocky, John Alvisdon, and Woody Allen's Annie Hall), the company over-extended itself. Then part of the conglomerate Transamerica (since 1967), United Artists was sold to MGM in 1981. Currently, MGM–UA produces and distributes a small number of films each year.

Columbia Originally CBC Sales Corporation, a distribution company founded by Harry and Jack Cohn and Joseph Brandt in 1920, in 1924 it entered into production and changed its name to Columbia. During the 1930s it produced predominantly B-movies which it sold to the 'big five'. In 1932 Brandt was bought out; Harry Cohn became president and head of production as well as principal shareholder and, much like Warners, imposed a tight rein of careful pre-production planning and short production schedules. Columbia rethought its production strategy when in 1934 its investment in a more upmarket movie, It Happened One Night (Frank Capra), brought great returns. Henceforth it would invest in both A- and Bmovies. Although Columbia is not known for a stable of directors or stars (somewhat like Fox), none the less its 1930s output has been identified with one auteur, Frank Capra, and its 1940s films with one star, Rita Hayworth. The truth is that Columbia could ill afford to have directors and stars of its own and so it tended to buy them in (hired from other studios). As for actors, the company's practice was to have contract players and character actors, only occasionally setting out deliberately to groom an unknown into a star as it did successfully with Rita Hayworth. who became a true star with Gilda (Charles Vidor, 1946).

After 1948, the deregulationary effects of the anti-trust law benefited Columbia, and it began to develop a small stable of stars (Judy Holliday, Broderick Crawford and William Holden). It could afford to follow a production strategy of expensive adaptations of Broadway hits and best-selling novels. This was a successful strategy against television's increasing popularity, but sensibly Columbia also saw the benefit of making products for television and as such was the first studio to recognize the potential of this new medium to effect its own economic growth. In 1950 it created a television subsidiary, Screen Gems; the other studios did not start to follow this trend until 1955. The most renowned of Columbia's earliest television products was the cop series Dragnet (1953). Another key to Columbia's success during the 1950s was its readiness to back not just independents but also foreign productions (for example Elia Kazan's On the Waterfront, 1954, and David Lean's Lawrence of Arabia, 1962). In

the face of dipping fortunes it sold its studios in 1972 and rented space in Warner Brothers Burbank Studios (Konigsberg, 1993, 58). In 1982 the company was bought up by Coca-Cola – an irony given its Poverty Row origins, its populist nature and pro-New-Deal positioning in the 1930s (see Cook, 1985, 14–15). (Poverty Row is an area of Hollywood around Sunset Boulevard and Gower Street where Columbia and other small studios had their base, subsequently an expression used to refer to a low-budget type of production from small companies.) Columbia is now part of the Japanese Sony Group, which bought it in 1989 for \$3.4 billion.

Three smaller Hollywood studios are Essanay, Monogram and Republic.

Essanay Organized in 1907 and of short duration, effectively 'dying out' in 1917 when it was bought out by Vitagraph (a New York-based studio with studios in California, in turn bought out by Warners in 1925). Essanay built its early reputation on its Westerns (360 Bronco Billy films). It was also successful with its comedies and was clever enough to attract Charlie Chaplin away from Keystone. During his two-year stay with the company (1915–17) he made fourteen films – most noteworthy of which is *The Tramp* (1915) (Konisberg, 1993, 105).

Monogram Picture Corporation/Allied Artists Picture Corporation Monogram was established in 1930 and produced very cheap products, the most noteworthy being the Charlie Chan series. It formed a subsidiary, Allied Artists Productions, in 1946 to produce better-quality films. In 1953 the two merged and became Allied Artists Picture Corporation. Its best-known films are Friendly Persuasion (William Wyler, 1956) and The Man who would be King (John Huston, 1975). Later it produced mainly for television, eventually (in 1980) filing for bankruptcy.

Republic Pictures Established in 1935 and particularly reputed for its fast production practices. Specializing in B-movies, it was best known for its Westerns and could boast among its actors John Wayne, Gene Autry and Roy Rogers. The decline of the studio system and particularly the B-movie in the 1950s signalled the end to the company's fortunes but not before it had produced the Oscar-winning The Quiet Man (John Ford, 1952) and the gender-bending Johnny Guitar (Nicholas Ray, 1954, starring Joan Crawford). The company folded in 1958.

See Bordwell, Staiger and Thompson, 1985; Konigsberg, 1993, for more detail on these companies. For an analysis of their history and their 'political' positioning see Cook, 1985.

subject/object In standard classic narrative cinema, which is fixed in phallocentric language, men are the subject, women the object. The narrative discourses deny woman her subjectivity and as such set up the binary gender divide whereby male is active, holder of the gaze, and female is passive and the object of male desire. (See feminist film theory which challenges this view.)

subject/subjectivity (see also apparatus, diegesis, enunciation, ideology, psychoanalysis, spectator, suture, theory) This concept needs to be viewed within three different, if contiguous, contexts: within the film text itself, as part of the structuralist/post-structuralist debate on the subject and, finally, within psychoanalytic theory.

Within the film There are subjective points of view, **shots** as well as narrative techniques, that make it clear that one particular character's point of view is being privileged within the filmic text. For example, the uses of **flashback** and intra-diegetic narrative voice-over (so privileged in **film noir** adaptations of Raymond Chandler's novels) serve as markers to the authenticity of the protagonist's subjectivity. Similarly, point-of-view shots affect the **spectator**-text relation whereby the spectator feels positioned alongside that character's subjectivity and so identifies with that character. **Shot/reverse-angle shots** represent another series of shots that stitch us into the narrative and also into character identification (see **suture**).

As part of the structuralist/post-structuralist debate The structuralist theory of the subject was based primarily in Marxian—Althusserian thinking which perceived the subject as a construct of material structures. Thus we are the subjects of such structures as language, cultural **codes and conventions**, institutions—what Althusser called ideological state apparatuses (ISAs). We are, he argued, interpellated as subject (see **ideology**) by ISAs such as the church, education, police, family and the media. The effect of this totalizing and anti-humanist theory (the subject as effect or construct of institutions) on spectator theory was similarly monolithic. Film, as a pre-existing structure, is like all other ISAs in its ideological functioning, and as such interpellates

the spectator, thereby constituting her or him as subject. Post-structuralists (Michel Foucault, Jacques Derrida, Jean-François Lyotard) argued against this totalizing theory and proposed a different vision of the subject as simultaneously constituted and constituting — as both effect and agent of the text (for further discussion see entry on **spectator**).

Within psychoanalysis (see also psychoanalysis) According to Iacques Lacan, human subjectivity, the unconscious and language are all interrelated. The unconscious is structured like a language and so is produced in much the same way as the subject, through language. When the child goes through the mirror phase it first perceives itself as a unified being (the ego-ideal), although in identifying with the reflection it is in fact identifying with the other (what is there in the mirror) and in so doing misrecognizes itself. Second, because the child is held up to the mirror by the mother, it then perceives its similitude with or difference from the mother, senses absence, loss, separation from the mother and desires reunification with her. The mother becomes the first love-object of the child. However, the child also perceives the mother as lack: lacking the penis. This lack becomes a source of castration anxiety for the boy child as he enters into the Symbolic Order, into language (see Imaginary/Symbolic). The issues around the girl child's entry into the Symbolic are more complex because she simultaneously perceives her mother as her first desired object and sees herself as the same (this point is more fully developed in feminist film theory).

The child's entry into the Symbolic amounts to its entry into and acquisition of language. So the subject is the speaking subject. However, in order to be part of language and human society, the child must conform to the Law of the Father (the site of language) and reproduce it. To do so, the subject has to appear to be a unified being. Thus, libidinal drives for the mother have to be repressed because according to the Law of the Father they are taboo; he forbids access through the utterance of the patriarchal 'No'. These drives also have to be repressed because to be conscious of them is to be aware that one is not a unified being, for the following reasons. These libidinal drives represent a desire to find again the imagined unity with the mother 'pre-lack' (before the knowledge of lack). However, the child, after entry into the Symbolic, does not leave the Imaginary behind even though it must suppress these particular drives. Part of the child's trajectory is forever trying

to return to the Imaginary, but since it may not desire the mother, these particular drives will be repressed into the unconscious (that which is not spoken but which is inscribed in language as taboo or the patriarchal 'No'). The child will seek an alternative moment of imagined unity to compensate for the lack represented by the mother and will imagine an idealized image of itself as complete. In other words it will seek to return to that first stage of the mirror phase when it felt a unified being – the ego-ideal.

Thus the subject is always divided (self/other; unified/not unified). What gets repressed into the unconscious is that which recalls the subject's lack of unity. The unconscious, in this respect, threatens our sense of unity.

It is not difficult to see how this theory of the subject is relevant to film studies. We saw above, considering the structuralist/ post-structuralist debate, that the spectating subject is, in a sense, a divided subject (dialectically positioned as constituted or constituting) in relation to the filmic text. Because film projects before us ideal images in the form of stars and a seamless reality that disguises its illusory unity (see apparatus and suture), film functions metonymically for this imagined unity of the ego-ideal and as such allows us to identify with that ego-ideal (see spectator). But film also does something else. It projects our desires on to the screen, it functions as a release for our repressed unconscious state and our fantasies. Why do so many of us like thrillers, horror movies, melodramas and so forth? So film is, simultaneously, the place where the spectator can find imaginary unity and the site where the unspoken can be spoken - that is, a 'safe' place from which to observe our lack of unity. Pornographic and bondage films would be the most extreme in terms of visioning the unconscious, but many a film noir replicates our most deep-rooted fantasies and repressed 'hatreds or phobias'.

For more depth on this issue see Lapsley and Westlake, 1988; Kuhn, 1982; Kaplan, 1983.

subjective camera The camera is used in such a way as to suggest the point of view of a particular character. High- or low-angle shots indicate where she or he is looking from; a panoramic or panning shot suggests she or he is surveying the scene; a tracking shot or a hand-held camera shot signifies

the character in motion. Subjective shots like these also implicate the **spectator** into the **narrative** in that she or he identifies with the point of view.

surrealism (see also avant-garde, underground cinema) A movement that dates back to the 1920s and which impacted on films of that time but which still has a small influence today – particularly in horror films. This movement, much influenced by Freud, strove to embody in art and poetry the irrational forces of dreams and the unconscious. Surrealist films are concerned with depicting the workings of the unconscious (perceived as irrational, excessive, grotesque, libidinal) and with the liberating force of unconscious desires and fantasy that are normally repressed.

suture (see also audience, enunciation, Imaginary/Symbolic, Oedipal trajectory, psychoanalysis, shot/reverse-angle shot, spectator, subject/subjectivity) This term means, literally, to stitch up (from the medical term for stitching up a cut or wound). In film theory the system of suture has come to mean, in its simplest sense, to stitch the spectator into the filmic text. As a critical concept it was introduced into film studies by theorists, starting with Jean-Pierre Oudart (1977), and was based on studies in child psychoanalysis conducted by Jacques Lacan in the 1960s. It is important to note that Lacan primarily addressed the psychology of the male child and that it is feminist Lacanians - Hélène Cixous, Luce Irigaray and Julia Kristeva who brought the female child's psychosexual development into a central space for consideration. In a similar way, until recently, in terms of its application to film studies, film theorists have blissfully ignored the case for female spectatorship. However, feminist film theory has significantly redressed this imbalance (for details see also spectator).

Lacan used the term *suture* to signify the relationship between the conscious and the unconscious which, in turn, he perceived as an uneasy conjunction between what he terms the Imaginary and the Symbolic orders – two orders which, after infancy, are always co-present. In its initial manifestation, the Imaginary stands for the period in infancy of a child's life when it first glances at its reflection in the mirror and sees itself as a unified being. This period, which Lacan terms the mirror phase, marks

the first stage of the child's acquiring an identity separate from the mother and marks the child's first understanding of space, distance and position. This moment is pre-Oedipal. It is a moment of pure *jouissance* or jubilation (see **psychoanalysis**) and narcissism in which the child, held up to the mirror by the mother, sees or senses itself as a unified being at the centre of the world. This moment cannot last, however, and there occurs a second moment, also during this mirror phase (which lasts overall from the age of six to eighteen months), when the child recognizes its difference from or sameness with the mother and senses the absence and loss of the mother – since it identifies itself as separate from her.

At this juncture, according to Lacan, the Oedipus complex plays its part in dissolving the mirror phase and pushing the child into the Symbolic. In other words, it is by means of the Oedipal phase that the child of either sex is separated from its first loveobject, the mother - she who has become (m)other. The child desires unification, anew, with the mother but this time, because there is separation, absence or lack, the desire to unite is now sexually driven. In the case of the male child this desire is potentially incestuous and it is at this juncture that the Law of the Father, the Symbolic Order is imposed. The child is forbidden access to the mother by the father and the child will comply for fear of castration by the father. He represses his desire, a repression which forms the unconscious. It is the verbal prohibition imposed by the father that constitutes the threat of castration. The Symbolic Order or Law of the Father is therefore, according to Lacan, based in language, and desire is repressed as that which cannot be spoken. In obeying this Law, the male child enters into the Symbolic and adopts a speaking position that marks him as independent from the mother. He conforms to the patriarchal law, upholds it and seeks to fulfil his Oedipal trajectory by finding a female other (other than his mother). He thus perpetuates patriarchal law for generations to come - he follows in the name of the father, so that when he says 'I' it comes from the same authorized speaking position as the language of the father. He becomes subject of the Symbolic (that is, he can speak as subject of the patriarchal language).

Lacan is much less, if at all, clear about the girl child, but, feminist Lacanians have developed his thinking. According to Lacan, when the female child perceives her sameness with her mother, she experiences her lack as being non-phallic. She discovers that, she like her mother, is castrated – is already what the male child most fears. Like the male child, she at first perceives her mother as her love-object. But since she is like the mother and there is no threat of castration, what, ask feminist Lacanians, will motivate her to relinquish her desire for her mother? They argue that, since she must enter into the social order of things (patriarchal law decrees she must) and leave the Imaginary, she will turn away from the mother and enter the Symbolic Order. However, she will never fully relinquish her desire of the mother and so will always remain doubly desiring. The female child's entry into the Symbolic is again, as for the male child, an entry into the Law of the Father. Her sexual drives impel her towards the truly phallic, the father. The father must once again impose the Law of the Father and forbid her sexual access. She must repress her desire for the father and embark on her own Oedipal trajectory and find a male other (than her father). However, the question becomes, when the girl child says 'I' whose 'I' is it? She cannot be subject of the Symbolic in the same way as the male child can because the authorized speaking position is that of the father. If she cannot be subject then she must be object of the Symbolic (that is, of language); and if she is object of the Symbolic then, at least within heterosexual relationships, she must also be the object rather than the subject of desire (she is fixed by language since it is not hers).

Upon entry into the Symbolic both male and female child will feel not whole but divided - as we recall they both felt this for the first time when they entered into the mirror phase. when the mother becomes other (which Lacan signifies with a small 'o'). This time both sexes attempt to signify themselves through language, that which is outside from their selves (the language/Law of the Father). The Symbolic now becomes the Other (which Lacan signifies with a capital 'O'). The subject represents itself in the field of the Other (language) - capital 'O' because the Law of the Father. To this first sense of fragmentation comes another, felt by the fact that the subject can never fully be represented in speech since speech cannot reflect the unconscious (the repressed, unspeakable desire for the mother or the father). The subject, in representing itself, can only do so at the cost of division (conscious/unconscious; self/Other). The difference for the two sexes is of course the degree of division or fragmentation. This is in direct correlation to the mastery as subject in and of that language. The male child can be part of it/in the field of the Other since he follows in the name of the father, even though he is always in danger of being castrated by the big 'O' – hence the *cap*-ital letter (as in capital punishment). The already always castrated girl is excluded by it; however, in exchange she remains always doubly desiring (for more detail on the female child see **psychoanalysis** and **spectator**).

To return to the general question of division, as the (conscious) subject seeks to represent itself in the field of the Other, it does so at the expense of coming after the fact or word by which time the (unconscious) subject is already not there but becoming something else, a situation Lacan (1977, 304) refers to as 'future anterior' (see enunciation and absence/presence). In other words, the conscious subject utters or enunciates 'I' and becomes situated as 'I' (the spoken subject becomes presence). However, the unconscious subject is already beyond that 'I' and becoming something else (the spoken subject now becomes absence). As the spoken subject fades, becomes loss or lack, so the subject will attempt to recapture itself as a unified being, the idealized image of the Imaginary. However, that idealized image is a recall of that first mirror reflection and the child's identification with its own specular image. In other words, that image is an external one, the subject as seen from outside (not from within) - therefore also the subject as it imagines others see it. Lacan reasons that this is where the subject confronts the divided notion of self: the image of the self is accurate but also delusory. It is the same and other. The subject (mis)recognizes itself both as itself and as other. Thus the attempt to produce or reproduce that image is to produce a misrecognition of the self - the self as it cannot be. And it is at this juncture that the conjunction which Lacan terms suture - occurs between the Imaginary and the Symbolic to close the gap opened up by this breach in the subject's identity (between recognition and misrecognition, and between the conscious and unconscious).

In summary The Symbolic does not 'dislodge' the Imaginary but functions to regulate it, which is why the two orders are described as always being co-present. This co-presence can best be summed up in the following way. The early jouissance or jubilation felt at the mirror stage is soon threatened by the child's realization that she or he is not a unified being at the centre of the world but part of a larger social and Symbolic order within and against which the individual is constantly trying to define her or his identity – including reasserting herself or himself as

a unified being. It follows, therefore, that the psyche is also not a simplified entity as it fluctuates between the desire for the ideal of the unified being of the Imaginary and the knowledge imposed by the Symbolic that it is composed of many conflicting forces. In psychoanalytic terms, then, suture is perceived as the striving of the ego to stitch these two orders together, to fill the gaps in the rupture implicitly caused by these two orders, to unify them rather than let them split asunder and thus (one must presume) split the psyche in two. (For further reading on Lacan see Grosz, 1990.)

To return to film theory During the 1970s and early 1980s the debate around suture and its applicability to film was a contested one but one that was introduced because of a perceived need to account fully for the viewing experience of a film during its projection and to describe the relationship between film narrative and spectator. What follows is a synopsis of the arguments. In its first, simplified form, suture was perceived to be the effect of certain filmic codes that stitched the spectator into the film text. For Oudart (1977) the system of shot/reverse-angle shot is the primary suturing device in classic narrative film. In this series of shots, which establishes the point of view of two characters in (say) a conversation, the spectator adopts first one, then the other position and becomes both subject and object of the look. The first shot, through an eveline match, positions the spectator as the one looking, character A. The spectator adopts A's position and looks at character B. The next shot, reverse shot, positions the spectator as character B. But character B, as we know, was the object of character A's look. So the spectator adopts the position of the object that A looked at. However, character B now looks at character A. The off-screen space (where A had been in the first shot) now comes into view. Thus, according to Oudart, the spectator makes sense of off-screen space and becomes stitched into the film.

In general terms, the process of suturing goes as follows. The spectator upon first encountering a cinematic **image** feels much the same jubilation or *jouissance* as does the child in the mirror phase. This image appears to be complete or unified in the same way that the child's specular image appears to it. At first, then, the spectator feels secure in an imaginary relationship with the image. But this image is an idealized image, so in fact the spectator is caught up in a fascination with a delusion, with the unreal. Yet, as we know, the Imaginary and the Symbolic are

always co-present. Thus this secure imaginary relationship with the image is soon under threat as the spectator becomes aware of the image frame (imag(in)e(d) frame) and therefore of offscreen space, of absence, of the absent space off-screen. This gap, this absence or lack of point of view felt by the spectator. is similar to the breach, noted by Lacan, in the subject's identity as same and other, as absence/presence. In this instance the spectator starts wondering whose point of view it is and who is framing the image. The image starts to show itself for what it is, an artefact, an illusion and in so doing threatens to reveal film as a system of signs and codes. What relieves this exposure of film's signifying practices and sutures the spectator back into the illusion, back into her or his earlier imaginary unity with the image, is the reverse-angle shot (the second point-of-view shot). The spectator now sees that the first shot was the point of view of the character currently in the shot. Off-screen space becomes on-screen space. Absence has become presence. The artifice of film can continue. The narrative is safe and the spectator comfortably reinscribed into the filmic discourse.

Daniel Dayan (1974) takes this idea of deception (what Oudart also termed the tragedy inherent in cinematic **discourse**) further and examines it within the context of **ideology**. If, he argues, the system of suture renders the film's signifying practices invisible, then the spectator's ability to read or decode the film remains limited. In this way, this system allows the ideological effect of the film to slip by unnoticed and to become absorbed by the spectator. Film becomes **hegemonic** rather than a reflection of reality. And it is not difficult to point to **Hollywood**, as Kaplan (1983, 132) does, and its dream factory as exemplifying these cinematic strategies of smoothing over any notion of conflict and contradiction and presenting the spectator with an unquestioning or unruptured idea of idealness of the American way of life (see **seamlessness**).

Other theorists saw this interpretation of the system of suture as too limiting both in terms of its enunciation (how it negotiates the spectator's access to film) and in its relation to ideology. With regard to the former point, Salt (1977), Rothman (1976), Heath (1981) and Silverman (1983) all argue that to limit suture to the shot/reverse-angle shot is to lose sight of the fact that, as a shot, it is not a dominant one in cinema – even Hollywood cinema – and that this shot should be seen as just one example of suture alongside other devices consistent with **continuity**

editing. Nor, they argue, should suture be limited to pure cinematic devices. Silverman, especially, demonstrates how suture is synonymous with the operations of classic narrative (that is, film discourse in its widest sense of editing and lighting, as well as compositional and formal narrative elements). According to her analysis, narrative is indispensable to the system in providing the spectator with a subject position.

In terms of ideology both Heath and Rothman (albeit in different ways) turn Dayan's argument around. Rothman argues against the system of suture by saving that the dominant pointof-view sequence is in fact a three- (and not a two-) shot sequence (viewer/view/viewer). He goes on to say that the point-of-view sequence appropriates the viewer's gaze in the second shot to show the spectator what the viewer sees. It is not an authorized shot - that is, the viewer does not authorize it, the point-of-view sequence merely takes over her or his gaze and then cuts back in shot three to the viewer. The question of whose point of view it is, Rothman asserts, simply does not pose itself. The spectator knows it is a point-of-view shot and so is aware of that cinematic code (as much as any others). It is not then a question of deception, nor is it an attempt to render film's signifying practices invisible, and as such its function is not an ideological one. It follows, then, that classic narrative is not necessarily hegemonic and that if there is a question of ideology to be addressed in relation to cinema then it cannot be thought of (as by Dayan) in terms of some abstract ahistorical absolute but rather in terms of history. If cinema is an ideological system, Rothman's argument goes, then it is so only in so far as throughout history it has served a variety of bourgeois ideologies.

Heath does not reject suture, although he does agree with Salt and Rothman that the system cannot be reduced to the function of the single cinematic code of the reverse-angle shot. As with Silverman, he believes that suture – because it is the conjunction between the Imaginary and the Symbolic – is necessarily present at all levels of filmic enunciation and that therefore all texts suture. This is not a sweeping generalization. For Heath the concept of suture is an invaluable one because it draws attention to the fact that the image is not the unified idealized image of the Imaginary it purports to be but, rather, an incomplete one – one therefore that requires the speaking subject (uttering or enunciating from the Symbolic Order) to complete. But, as

has already been pointed out in the Lacan section, the speaking subject fades as soon as it has spoken. Any notion that the image is complete is illusory and it is in this respect that the ideological representations that images construct can be taken to task. Interpreted this way then, suture, contrary to Dayan's contention, leads the way into an understanding of ideological representation.

Arguably the most lasting outcome of the debate around suture concerns the relationship of the spectator to the screen and the pleasure experienced in cinema's reconstruction within the spectator of an illusory sense of the early-in-life imagined unity. Attendant within this identification process is the separation from the mother and the implicit sexual drives that separation brings with it. Cinema in this respect becomes a mise-en-scène of desire: first, it constructs the spectator as subject and, second, it establishes the desire to look with all that that connotes in terms of visual pleasure for the spectator. In its early days, this debate on visual pleasure, which ran concurrently with that on suture, was completely unproblematized in terms of sexuality and scopophilia. Since then, however, feminist film theory has entered into the debate and widened it to include analyses of masculine erotic desire and the male fetishizing gaze as well as female representation and spectatorship (see also feminist film theory and voveurism/fetishism).

For further reading see Kuhn, 1982; Lapsley and Westlake, 1988; Mast, Cohen and Baudry, 1992.

syntagmatic - see paradigmatic

theory This entry limits itself to a reasonably brief history of the development of theory since the beginning of the century. Specific details of major developments are given in other entries.

Although there is no attempt to be deterministic here, there does appear to be a quite convenient way of carving up film theory into epochs of theory-pluralism and theory-monism. Indeed we can determine three epochs: 1910–30s, a period of pluralism; 1940s–60s, a period of serially monistic theories; 1970s–90s, pluralism once more.

1910-30s Cinema was very quickly perceived to be an art form. Arguably, the genesis of film theory was in France. The earliest reference to film as art occurred with the start in 1908 of Film d'Art's productions (the first of which was L'Assassinat du duc de Guise, set to the music of Saint-Saens). However, one of the earliest attempts to align cinema with other arts can be found in the film-maker Louis Feuillade's advance publicity sheet for his series Le Film esthétique (1910). In his manifesto he begged the question: since film appeals to our sight and, therefore, has as its natural origins painting and the theatre, surely cinema can provide those same aesthetic sensations? He also perceived cinema as a popular art and as an economic art (a synergy between technology and the aesthetic) and as an artistic economy (art closely allied with capital). A year later Ricciotto Canudo published in France his manifesto 'The Birth of a Sixth Art', in which he established the two main lines of debate that would preoccupy theorists well into the 1920s and in some respects into the 1930s: the debate around cinema's realism, on the one hand and, on the other, around a pure non-representational cinema based on form and rhythm.

A few years later a German psychologist, Hugo Münsterberg, introduced the idea that cinema was not filmed reality but a psychological and aesthetic process that revealed our mental experiences. After the First World War, the debate widened further, mainly among French critics and film-makers, and addressed issues of high and popular art, realist versus naturalist film, the spectator-screen relationship, editing styles (a debate much influenced by the Soviet cinema of the 1920s), simultaneity, subjectivity, the unconscious and the psychoanalytical potential of film, auteur cinema versus script-led cinema, cinema as rhythm and as sign. In the 1930s, following the advent of sound, the ground shifted and the debate centred on the very polemical issue of whether sound was a good or bad thing for the aesthetics of cinema. Certain critics claimed that it was the death-knell for experimental cinema, others thought that it brought with it the chance of a new radicalization of cinema. In this latter case, film was linked with social praxis (that is, it acted as a transparence on society and its interactions with individuals) but was also revelatory of mental states.

1940s-60s This was predominantly the period where the search was on, particularly after 1946, for a total theory. Speculatively, we could say that this desire for total theory is easily understandable in the light of the Jewish and atomic holocausts - to such irrational acts only a single unified vision can provide security and stability. The two main theories to mention here are, first, the so-called auteur theory (1950s) and, second, structuralism (1960s), although we should also point out that these two were preceded by Alexandre Astruc's (1948) concept of cinema as language (caméra-stylo as he defined it). Seeing film as a matter of authorial signs (whether stylistic or thematic) was too limiting, denying the other structures and production practices that go into making a film (see auteur theory). It was also a conservative romantic aesthetic in so far as the film-maker was isolated as the aesthetic genius. Finally, it was fraught because it introduced the idea of 'great' directors.

Similarly, structuralism and auteur-structuralism, which 'replaced' auteur theory in the 1960s, ran into difficulties, this time of total theory crushing the aesthetic. Structuralism was a theory which, it was believed, could be applied to all aspects of society and culture. However, it ended up in rigid formalism which removed any discussion of pleasure in the viewing. Although this theory purported to reveal all hidden structures

behind film-making (modes of production, impact of stars on choices, socio-historical context of production and so on), in fact it continued to focus on the film-maker and her or his product - hence the term auteur-structuralism. The most central theorist in this debate as it concerned cinema was the semiotician Christian Metz (1971 and 1972), who devised a linguistic paradigm that could account for all elements of a film's composition - almost a grammar of film (see semiotics). Analysing film this way meant that a critic could scientifically and objectively evaluate a film and at the same time determine the style of a particular auteur or film-maker and indeed determine also if a particular film was consistent with that film-maker's style. The focus, therefore, was on the hidden structures and codes in the text and in this respect it answered the question of how the text comes to be - not how it comes to mean. Thus, ultimately, the limitation of this total theory was its formalism (for fuller discussion see structuralism).

1970s-90s Total theory made it evident that a single theory would never be sufficient to explain and analyse film. Where in this total theory, for example, could one talk about the spectator-text relationship? However, there was no need to throw the baby out with the bath-water, hence the term poststructuralism. Psychoanalysis and semiotics in their structuralist phase had started to shatter the concept of the unity of the auteur. The effects of deconstruction theory, introduced by Jacques Derrida around 1967, would help to do the rest. Deconstruction helped to recentre the theory debate in a pluralistic context. In essence, deconstruction stipulates that a text is not transparent, natural or innocent and therefore must be unpicked, deconstructed. The non-transparency must be investigated to show just how many texts there are - all producing meaning. There is no longer any single reading of a text, nor indeed is there any final reading.

Post-structuralism, then, did several things. It defined the auteur's place within the textual process – the auteur was now a figure constructed out of her or his films (a far less authoritative position). It established the importance of **intertextuality** – the effects of different texts upon one another. There is no such thing as a 'pure' text, all texts have intertextual relations with others. As far as film is concerned, this means relations with other films and of course with the 'invisible' texts such as the modes of production, the dynamics between actors, crew

and film-maker (and so on). Post-structuralism also established the fact that film has **ideological** effects, therefore the question of the **subject** comes into play (who is the subject: the text, the auteur, the spectator?). What also comes into play is the question of the effects of the **enunciating** text (the film as performance) upon the spectator. In the final analysis post-structuralism opened up textual analysis to a pluralism of approaches which did not reduce the text to the status of object of investigation but as much subject as those reading, writing or producing it.

In Anglo-Saxon countries the other significant area of film theory, feminist film theory, helped to develop the debate along several new lines of investigation. The whole question of gendered subjectivity and agency, not addressed since the 1920s, was re-opened. Who held the gaze, within and without the screen, was a fundamental issue raised in this area. Genre and gender also generated questions: if certain films were gender specific (for example Westerns for men, melodrama for women), what were the ideological operations at work and what were the spectator—text relationships depending on what sort of genre was being viewed? Further, given the ostensible gendered subjectivity of the viewer, what could be said about pleasure in viewing?

Third Cinema (see also Black cinema - USA, Black cinema -UK, cinema nôvo, postcolonial theory, Third World Cinema) Third Cinema was a term coined in 1969 by the Argentinian film theorists and film-makers Fernando Solanas and Octavio Getino in their manifesto Towards a Third Cinema (reprinted in 1983) in which they call for a 'decolonisation of culture' through a counter-cinema. The concept Third Cinema was used to distinguish it from First cinema (Hollywood) and Second (European art cinema, and the cinema of auteurs). It was also called Third Cinema because it was comprised of countries outside the two dominant spheres of power: the Eastern and Western super-power blocks (which now of course no longer exist since the demise of the Soviet Union). The naming of this Third Cinema was intentionally playful – a riposte to economists and to dominant Western cinemas. Third Cinema refers to films (but not, as we shall explain, to all films) made by countries of the so-called Third World - countries, that is, which do not

belong to the developed industrial countries. It is important, therefore, not to confuse the two terms Third Cinema and Third World Cinema. This is because Third Cinema is ostensibly political in its conceptualization since it seeks to promote the cause of socialism and to counter what Solanas and Getino perceive as the ideologically unsound film-making practices of the two other cinemas, especially Hollywood (see cinema nôvo entry). Clearly, not all Third World Cinema does this. To take the example of popular Indian cinema (Hindi popular films) it is evident that while its own film-making practices might have little to do with Hollywood production styles, none the less, it is a cinema of entertainment geared to promoting popular song, its stars and to the representation of an imagined mythical India (as, for example, in epic melodramas of self-sacrificing mothers and swashbuckling heroes). It is not about resistance to a First or Second world cinema - and in fact in its major studio-city, Bombay, production practices were originally based on an 'imitation' of Hollywood (Bollywood). However, India has and still does produce another cinema that resists. One such cinema is the so-called New Indian Cinema whose beginnings, in 1969, coincide with the publication of the Third Cinema Manifesto (although it is only coincidence, since the funding scheme had been put in place several years before by the state (see below)).

Generally speaking, these Third World countries do not have a fully developed film industry (at least in the sense of Hollywood and some European cinemas like France). The major exceptions are Brazil, Argentina, India, Pakistan (to a degree), China and Egypt. Some of the films produced by these Third World countries, primarily in Latin America, Africa, Asia and the Middle East, or at least the ones that get distributed outside these countries often have political resonances. And these are the films that are counted as Third Cinema. These films are political in terms of making political statements either directly or through allegory in relation to, or about their own country. They are also political stylistically (as a counter-cinema) and again target their own nation's mainstream cinema (see below). Finally, they are politicized in their statements (style and content) against dominant film practices outside their country. This politicization of Third Cinema has occurred and dates back at least to the 1960s when liberation struggles and revolutions in these countries became world-wide news and film-makers made films either advocating or challenging these changes. Since that period

also, the cinema of these countries has been fairly consistent in its opposition to the colonial film practices of the Western world, particularly as exemplified by Hollywood. With the exception of India, which has a huge film industry (producing some 800 to 900 films per year) and has successfully exported to other continents (especially Africa), American and European products have swamped the screens of these Third World countries with their pro-capitalist messages. The need was felt, in the 1960s as now, to project images of the indigenous realities and this was done in a variety of ways depending on the particular country's political culture and the individual film-makers' vision and working conditions.

Despite major differences between the cinemas of the countries constituting Third Cinema, they do have in common a desire to address the effects of colonialism (as in Africa and India) or neocolonialism (as in Latin America, some African countries and Asia, including the Indian continent), exclusion and oppression (all of these countries or continents). This Third Cinema sets out deliberately to politicize cinema and to create new cinematic codes and conventions. Gabriel (1982, 16ff.) discusses the major themes of this Third (politicized) cinema. This cinema addresses issues of class, race, culture, religion, sex, and national integrity. Class struggle between the poor and the rich is at the core of this cinema. But in these films the issue of race is seen within the context of class antagonism (ibid., 16). The preservation of popular indigenous cultures and the representation of them in opposition to the dominant colonial and imperialist values espoused by the ruling classes, constitute an 'aesthetics of liberation' (ibid.) in Third Cinema. Contradictions inherent in political struggle within the context of deeply rooted structures of religion are foregrounded as is, very occasionally the struggle for the emancipation of women.

In terms of Third Cinema practice, several nations have had the term ascribed to their work post facto. While this is not necessarily a problem, insofar as these cinemas correspond to the ethos of Third Cinema, we do come up against the fact that several of these cinemas owe their existence to either state funding (as is the case for Cuba and to some degree India) or to assistance (in the form of training or finance) from previously colonizing countries (as is the case for some African countries). Thus, in terms of state funding, in 1959, right on the heels of the Cuban Revolution, Fidel Castro set up the Cuban Institute

of Cinematographic Art and Industry and **documentaries** and feature films were soon being produced. Cuba very quickly established itself on the international scene. In the second instance, help from former colonizers, some African countries such as Senegal and the North African countries (Tunisia, Algeria and Morocco) have been assisted in their film-making practices, mostly in the form of training (in these cases by France). Similarly, in Ghana the infrastructure of colonial film-making (left behind by the British) was used to build the on-going film industry (see **Third World cinema** entry for more detail on these countries film industries; see also Diawara's useful essay, 1986, 61–5; and for an in-depth study of African cinema see Ukadike, 1994).

What is interesting, however, is how so many of these socalled Third World countries came to a similar position in the late 1960s around the need for a third type of cinema even though they may not have evoked the term 'Third Cinema' itself. Thus, in the late 1960s, film-makers in Africa established independent groups within their own countries and came together to form a PanAfrican organizational means for developing cinema as a revolutionary tool. The manifestos written at that time are very similar to those written in Latin America and the intentions were the same (see above). And in 1969, the Fédération Panafricaine des Cinéastes (FEPACI) was established in Algiers 'to use film as a tool for the liberation of the colonised countries and as a step towards the total unity of Africa' (Diawara, 1986, 69). Furthermore, the bi-annual Film Festival at Ouagadougou in Burkina Faso was also established in 1969 - the Festival Panafricaine du cinéma de Ouagadougou (FEPASCO).

Film-makers from Africa, whose work is clearly politicized and therefore considered as Third Cinema, are not well known in the West, although Ousmane Sembene, Djibril Diop Mabéty and Idrissa Ouedraogo of Senegal, Med Hondo from Mauritania, and Souleymane Cissé from Mali have made the cross-over into Western cinema theatres. Conversely, to take only one example, the Ghanaian independents, active since the late 1970s, are hardly known to us at all. In this context, the Ghanaian independents Kwaw Painstil Ansah and King Ampaw make an interesting comparative study in relation to Third Cinema practice and the need to safeguard creative autonomy. Both claim to have done this, but they have done so at very different prices. For his part, Ansah refused foreign money or partnerships for his films and

thus managed with great difficulty to pull off his productions, making two films in seventeen years (Love Brewed in an African Pot, 1981 which took him ten years to complete, and Heritage . . . Africa, 1988). This story is familiar to other African film-makers, for example, Mambéty who has struggled to finance his few films. The other Ghanaian film-maker, Ampaw, co-produced his films with foreign companies and foreign funds which allowed him to make two feature films in two years (Kukurantumi, 1984 and Juju, 1988) (for more detail see Ukadike, 1994, 131–65).

Continuing our survey, Indian cinema has a strong tradition in Third Cinema practice, beginning as explained in 1969 when state financing made it possible for a new generation of filmmakers to emerge on the scene. Mrinal Sen and Mani Kaul are seen as the originators of this New Indian Cinema. However, the heritage of this contestatory and politicized cinema goes back, first, to the work of the influential communist-backed theatre and film movement, the Indian People's Theatre Association (IPTA) which launched its first film production in 1946 (Dharti Ke Lal/Children of the Earth, K. A. Abbas) and, second, to the art cinema made by Satyajit Ray during the 1950s. Mani Kaul's cinema is more evidentially countercinematic given its formalist concerns and the debates it raises on cinematic practice (e.g. Usi Roti/Our Daily Bread, 1969). But again, Ritwik Ghatak's work of the 1950s and early 1960s predates these concerns, albeit in a slightly different way. Ghatak mixes documentary realism with myth, tribal and folk traditions - truly blurring the boundaries between fact and fiction. See, for example, Nagarik/The Citizen, 1952, Ajantrik/The Unmechanical, 1957. See also his deeply political trilogy about refugee poverty and conditions in Calcutta which is based on his own experience of watching refugees fleeing to Calcutta during the famine of 1943 and the partition of India in 1947 (Meghe Dhaka Tara/The Cloud-Capped Star, 1960, Komal Gandhar, 1961, Subarnareka, 1962). Recently, a new cinema of resistance that appears to follow in Ghatak's tradition - which is not feature film but independent documentary film production - has emerged (see Patwardham's We Make History, 1993, Father Son and Holy War, 1993).

Finally, in this brief overview, we must make mention of Latin American cinema especially since the term Third Cinema emerged from these countries (see Burton 1986 and 1990; Chanan, 1983; King, 1990; King et al., 1993 for more detail). Armed struggle

is a theme particularly identified with this Third Cinema. Indeed, indirect and direct social and political criticism of existing regimes are more commonly associated with Latin American Third Cinema films of the 1960s than with any other. This is particularly the case for Brazil and Argentina. In Brazil this cinema often took the form of an aesthetics of hunger or violence (see cinema nôvo entry) - as, for example in Glauber Rocha's Terra em Transe (Land in Anguish, 1967). In Argentina revolutionary cinema took the form of 'avant-garde militant documentary' (Shohat and Stam, 1994, 260) - somewhat in the same light as Pontecorvo's La Bataille d'Alger/Battle of Algiers (1965). Exemplary of this style are Octavio Getino and Fernando Solanas' La Hora de los Hornos (The Hour of the Furnaces, 1968) and Leopoldo Torre Nilsson's Piel de verano (Summer Skin, 1961). During this same period, Cuba produced a political cinema that was, it has to be said, closely identified with the socialist progamme of the state and to that effect made films that charted the difficulties of implementing the Revolution - as exemplified by Tomás Guttiérez Alea's Memorias del subdesarrollo (Memories of Underdevelopment, 1968) and Humberto Solás' Lucia, 1968 (see Chanan, 1985 for more details on Cuban cinema).

Third Cinema continues to be an active cinema both within its practice and debates. This entry concludes with a brief overview of these shifting debates (and I am indebted here in what follows to Jacqueline Maingard's lucid synopsis of these debates, 1998, 60-93). In 1982, the concept Third Cinema was elaborated by Teshome Gabriel in his book Third Cinema in the Third World: The Aesthetics of Liberation. The crucial issue raised by Gabriel's book is the relation between the term Third World and the concept of Third Cinema as both a concept and a practice. Gabriel's study seems to imply that the two terms Third Cinema and Third World are easily conflatable. As we have explained above, this conflation is not really sustainable. For example, what do we make of China's cinema? In the 1950s at the Bandung Conference, China opted for Third World status, so strictly speaking it falls under the banner of Third World Cinema, but it is not necessarily practising Third Cinema (given the very heavy censorship and state control of the film industry it would be difficult to argue the case). Gabriel's book had the effect, however, of opening the doors where Third Cinema was concerned. It became a referrable concept to other cinemas not coming from the Third World, but made by film-makers living in diasporic communities. Thus, a few years later, in 1986, the concept was further elaborated to embrace the cinema of margin-alized groups in other parts of the world. In the late 1980s in Britain, where Black cinema had begun to emerge, two conferences were held (one in Edinburgh, 1986, the other in Birmingham, 1988) which in a sense 'officialized' this broader meaning of the term. The debates centred, on a far broader scale than that first considered by Solanas and Getino, on cinematic practices that were developing at that time and their relevance to Third Cinema as a political concept.

Pines and Willemen's book Questions of Third Cinema (1989) brought together the Edinburgh conference debates (a special issue of Framework, 1989, published those of the Birmingham conference, of which more later). First to be addressed were the developments in cinema practices in Britain and the United States that were taking place outside the White-Euro-American sphere - that is being made by Blacks (see Black cinema - UK and Black cinema - USA). While not rejecting Gabriel's earlier implicit argument that Third Cinema could refer to non-Third World practitioners, Willemen (1989, 15-17) makes the point that Gabriel's homogenizing Third Cinema (as Third World Cinema) on an internationalist basis disguises the fact that this cinema is profoundly national and regional and must therefore be seen as one of the cinemas making up a nation's cinema. In other words, Third Cinema is a national cinema alongside the mainstream and the auteur-based national cinemas of a nation. It is in this way, in fact, that we can argue for a Black cinema outside the Third World as having the cachet of Third Cinema. Indeed, Gabriel (1989), in his paper, included in Pines and Willemen's book, notes that there can be different types of Third Cinema, depending on the prevailing social conditions in specific places. What is crucial is the relationship between personal memory, identity, history and cinema. Providing the representations are not of official history but of personal memory, then the term Third Cinema may be used as a means of identifying, naming and claiming a consciously transformative space for cinemas in parts of the world that, at least geographically, would not be considered as being in the Third World. This challenge to history would, according to Gabriel (1989, 57-9), take a counter-cinematic form: open-ended narrative, multiple points of view, style that grows out of the material of the film, and so on. On these two counts, therefore, it would appear that

Third Cinema could be used to define British Black cinema. Willemen (1989, 29) did express the fear – and he was not alone – that Third Cinema might be kidnapped and appropriated into the First world (and indeed even Second world). But he also makes the point that British Black film-makers are in a position of being both 'other' and 'in and of' the culture they inhabit. They occupy what he calls an 'in-between' position (what Homi Bhabha terms a third space (see **postcolonial** entry)). Thus, it can be argued that the work of Black film-makers in Britain has both incorporated what can be learned from Third Cinema about 'otherness' and, at the same time, extended and developed already conceived and already received notions of the Third Cinema ethos.

By 1988, the debates had moved on and broadened to embrace more issues still. John Akomfrah made the point that, while Third Cinema had been useful to help place British Black cinema, what was currently needed was 'a re-examination of location and subjectivity' (Akomfrah, 1989, 6). Third Cinema, as a cinema of resistance coming from a third space, raises the two fundamental issues of politics of location and identity politics: where are 'you' shooting from, and what and who are 'you' shooting from? For example, Coco Fusco made the point that the early Latin American Third Cinema films (see above) were made by men from middle-class and upper-class elites and almost always forgot about gender (1989, 9). hooks (1989, 18) argued that this cinema, wherever it emanates from, must be about 'the struggle of memory against forgetting' – a politics/politicization of memory therefore.

The Third Cinema debate remains an open one particularly in relation to what counts as 'in'. In general terms, it encompasses politicized and historicized cinemas of the Third World and the Black diasporas. In more purist terms, it can refer to the countercinemas of Third World countries. For the most part, it is the former reading that dominates, and this should be welcomed on the whole since it will allow for other diasporic cinemas – such as that of the Native American, the Asian-American, the Turkish-German, the Arab-French, and so on – to be imagined and viewed in a different way than they presently are. That is, not as ghetto cinemas, but as national cinemas in their own right.

For further reading consult texts cited in this entry. See also Martin's (1995) edited book which contains most of the manifestos of Third

Cinemas; Vieler-Portet's (1991) Third Cinema Bibliography; Oshana's (1985) Third World women's filmography; and Bobo's history of Black women's film and video work (1998). See also *Screen* special issue on Third Cinema, 24: 2, 1983.

Third World Cinemas (see also Black cinema - USA, Black cinema - UK, cinema nôvo, postcolonial theory, Third Cinema) As the entry on Third Cinema made clear, the 'Third' of that cinema was established to dinstinguish it from two other cinemas which, as their numbering makes evident, are hierarchically placed. Thus, First cinema refers to the USA (and more precisely Hollywood), Second cinema to Europe and auteur cinema. These terms do not refer to the First or Second World economies - although the terms were coined as an intentional ironic parody of the Western world's designation of dominant economic powers. Rather, these terms refer to dominant cinema practices: Hollywood-style cinema and auteur-style cinema (both of which, of course, any country can practise). These First and Second cinemas are not cinemas of political protest or reform. Auteur cinema may challenge mainstream film practice but it is not necessarily committed to or capable of bringing about any profound political change. Third Cinema, however, is a cinema committed to a direct confrontation of the political and cinematic systems. It operates, then, from a third space that is distinct from First and Second cinema positions (for more detail see entry on Third Cinema).

Third World Cinema is not to be confused with Third Cinema. As a term it emanates in the first instance by association with world order spheres of influence (East, West, and the rest of the world). Only later did the terms First, Second and Third World determine specific countries and continents in relation to their global economic spheres of influence. The term Third World was coined in 1952, at the height of the Cold War, to refer to countries that were not aligned with either of the two super-powers (the USA and the former Soviet Union). At that time, the term First World designated the dominant economies of the West, and Second World those of the Soviet Union and its satellites. Presently, First and Second World economies are terms that are rather loosely applied to the economies of North America, Northern Europe, some countries in the Middle East, Australia, New Zealand, Southern and Eastern Europe. Third

World applies as an economic term to all other continents and countries - excluding those countries that became known after the Second World War as the western Pacific rim (a global economic term used to refer to Japan, South Korea, Taiwan, Singapore, Thailand and Malaysia), that is, countries until recently considered as constituting an important economy in their own right (the so-called Tiger economies - a term no longer invoked since their demise in the late 1990s). Some would say the Pacific rim was an artificial economic sphere established by the Americans to ensure a Western, Eurocentric, economic ethos to counter the perceived communist threat (of China and the former Soviet Union). By analogy with the term Third World. Third World cinema refers to the cinemas of the African continent, the Middle Eastern territories, the Indian continent, China and Asian territories, and Latin America. As we can see, the term is again used rather loosely since not all the cinemas included under this broad umbrella are necessarily Third World economies. For example, not all countries of the Middle East are poor, but what they singularly are not is Eurocentric. And just as the term Third World Cinema is loosely applied and is therefore problematic, so too is the use of the term Third World itself. Homi Bhabha (1989, 112-13) makes the point that, although the term is one we are obliged to use, it remains hugely problematic because of its pejorative connotations and its assumptions about a geopolitical world view.

The first paradox to emerge in relation to Third World Cinema is that if we were to take all these cinemas as a whole (as we do with Europe in our definition of it as Second cinema), then it is this cinema that makes up most of cinema (in terms of output and audiences). Yet, this cinema is treated as if it were the subaltern, the shadow cinema of the 'real' cinema of North America and Europe. Furthermore, the Western world has a very poor idea of what this Third World Cinema is and seems far from curious to import it and find out. Even the act of talking of this cinema as one entity (a unified whole) is part of the problem. So a first need is to use the term in the plural: Third World Cinemas. Clearly Third World Cinemas constitute a very diverse set of cinemas – far more so than those emanating from the USA and even Europe. As the Western nations continue to become more multicultural, as studies in postcolonial theory and practice become more widespread, then it is evident that these Third World Cinemas will become increasingly better known (for an explanation of the unhyphenated spelling see the first paragraph of the **postcolonial** entry). And as the technology for the culture of consumption for 'more' develops (through access to movies on the Internet), so more and more images must be made available to the globalized consumers. Here too we must expect and hope that these 'unexplored' cinemas (I use the term in a non-colonialist sense) will become steadfastly more available.

Ella Shohat and Robert Stam's book Unthinking Eurocentrism: Multiculturalism and the Media (1994) is a key text for helping those of us in the Western world avoid falling into what Appiah (1992) calls the pseudo-universalism of Eurocentric theories and their applications onto all cinemas. In other words, we must not imagine the Third World Cinemas through (our) Western, Eurocentric eyes, mentalities and theoretical frameworks. To take an evident example, it is clear that constructions of gender will differ according to the placing of femininity and masculinity within a nation's cultural traditions. Nor must we imagine that Third World Cinemas are without their own traditions and theories. Nor must we imagine that these cinemas 'occurred' only recently in the post-colonial moment or in some cases the post-revolutionary, or coup d'état and post-coup d'état moments. Indeed not. Third World Cinemas in many cases are cinemas that were in place as early as, or shortly after the emergence of cinemas in Europe and North America. For example, the Lumière brothers travelled the world with their cinématographe, thereby encouraging imperialist nations to take their own images of their colonies. By the early 1900s, many colonizing nations had established their Colonial Film Units and, in some cases, were actively encouraging indigenous film-makers to create their own films to entertain local audiences. In other countries, where colonialism was not about cultural assimilation, as in the case of India, indigenous traders financed film-making companies as early as the 1900s. In fact, to cite India again, it is as early as 1896 that we can speak of it as having its 'own' cinema. India's tremendous theatre tradition (the Parsee theatre is perhaps the tradition best known to Westerners) meant that there were 'ready-made' venues for the screening of these early short films as attractions at the end of performances.

A further thought we need to bear in mind is that Third World Cinemas have established their own theorectical **discourses** around film. Again, to take the example of India, we can point to an emergence of film theory as early as 1948 (at least) with the writings of Satyajit Ray and Chidananda Das Gupta on the importance of a post-independence cinema that would function culturally as a national integrating force. Their writings and those, a bit later, of Ritwik Ghatak and Kobita Sarkar (in the 1960s and 1970s) have provided a central core of theoretical debates on realism versus modernism, modernism versus avant-garde, nationalist cinema versus regional cinema, and so on.

Nor must 'our' (i.e. the Western film critics') 'newly found' awareness of Third World Cinemas blind us to the fact that there are also what Shohat and Stam (1994, 32) call the Fourth World cinemas. As Shohat and Stam explain, when we speak of Fourth World we are referring to peoples who are 'the stillresiding descendants of the original inhabitants of territories taken over or circumscribed by alien conquest or settlement' (ibid.), for example, Native Americans in the USA. Native Indians in Latin American countries, Maoris in New Zealand, Aborigines in Australia – all of whom have produced cinemas of their own. I believe this distinction between Third and Fourth Worlds and therefore cinemas is an extremely helpful one when talking about non-Eurocentric cinemas. It prevents a homogenization, by us in the West, of cinemas that we barely know, let alone understand. It also makes it clear that when we think about cinemas and their cultural traditions - wherever they are located - we should be mindful of the fact that belief in Western domination (whether in terms of domination of a market or cultural hegemony) is often a little closer to fiction than fact.

What follows in this entry is an overview of Third World Cinema. It is modest and inevitably schematic, but its intention is to 'point the way'. So what is proposed is a brief description of each continental or territorialized Third World Cinema, highlighting some of the major issues and providing useful bibliographical references for readers who wish to investigate further.

The cinemas of the African continent Unlike China and India, African cinemas are quite new and for the most part post-colonial. Although some African countries, as for example South Africa, have a long tradition of 'a' cinema – that is, a White, colonialist-settler cinema. Nor is it straightforward to talk about African cinema as a concept. Not only are there broad distinctions such as that which can be drawn between Northern African cinemas and Sub-Saharan ones, but there are also other distinc-

tions that can be drawn intra-nationally – what Ukadike (1991, 12) terms the co-existence of ethnic subcultures. For example, the Ife and Nok cultures in Nigeria are quite distinct as are the local languages of that nation. In terms of film production and Nigeria, much of its cinema is based on literary adaptations and is heavily influenced by the Yoruba travelling theatre tradition. Thus, while most of the films may be based on the Yoruba language, other films which are based on different indigenous cultures are shot in the relevant language (for example, Igbo in *Amadi*, Ola Balogan, 1974; Hausa in *Kanta of Kebbi*, Adamu Halilu 1984).

Production practices are, equally, very complex, not just at the level of financing indigenous products, but also at the level of what constitutes an African film. In recent history, several films have been labelled as African but in fact they are not indigenously made, nor indeed financed even though they may well have been shot in African countries and have African actors. A recent example is the 'South African' *Jump the Gun*, 1997, directed by the British film-maker, Les Blair, co-produced by Britain and South Africa. This should not necessarily be read negatively, however, since co-productions are often the only way in which films can be made in countries which do not have a film industry infrastructure.

To facilitate clarity, this entry comes in two parts: Sub-Saharan African cinema and North African cinemas.

Sub-Saharan cinemas: In the colonial period, Sub-Saharan Africa was divided up between Britain, Belgium, Portugal and the Netherlands. This has produced three main linguistic spheres of reference when talking about the cinemas that make up this part of Africa's continent: Francophone, Anglophone and Lusophone (the latter refers to former Portuguese colonies). In the Netherlands' case there has been no such distinct linguistic or cinematic 'legacy'. For although there is an Afrikaner cinema that emanates from South Africa, it has nothing to do with the former Dutch colonialists. Afrikaners were Dutch settlers who. early in Dutch colonialism (some 250 years ago), separated themselves from the Dutch and established their own language and culture. Afrikaans is a dialect of Dutch that exists in its own right. One does not, therefore, speak of a Netherlandophone cinema. Presently, much of Sub-Saharan Africa is at a neocolonialist stage by which I mean that most countries have not yet reached full democratic status primarily because of the indirect domination by Europe or the United States (in the form of military oligarchies or dictatorships) and/or by the economic hi-jacking of these countries to whom huge loans have been made by the World Bank and the International Monetary Fund but which no country is in a state to repay (most African nations' GNP goes towards paying off the interest only).

Cultural colonialism is another great problem encountered by African cinemas. Hollywood monopolizes the cinema theatres of most Sub-Saharan African countries. But there is also a strong presence of Indian musicals and Hong Kong Kung Fu films. African audiences either do not get much occasion to view their cinema, or the attractions of the 'other' cinemas is so great that they neglect their indigenous product. Another form of cultural colonialism is of course the presence (albeit still not huge) of television. South Africa has the largest presence in terms of TV consumption, but most of what it shows is not indigenously produced and since MNET satellite and cable have taken hold, there is a proliferation of foreign products and in particular foreign (mostly American) films. The television in other African nations is state-controlled in most instances and is a tool of control and propaganda.

Cinema arrived in Africa at different periods in its colonial history. As a source of entertainment for indigenous peoples we can locate its presence as early as 1896 in South Africa and the early 1900s in Senegal. Elsewhere, missionary zeal may have led to its use but not much more before the early 1920s. Where cinema did have a more marked presence, however, was in its own colonial practice as an investigative tool of the indigenous people. Under the guise of ethnographic filming, or filming solely for the purposes of entertainment, the black African body and culture were exoticized for consumption by intrigued audiences 'back home' in the West. This cinema soon began to influence and cross over into narrative cinema produced for the most part back in the studios in Europe and the USA. Blacks were represented either as submissive workers for the colonialist master (and mistress) or as savage or cannibalistic. Films made by Westerners exploited the exotic otherness of Africans basically to show their undeniable inferiority to the Whites. A few titles will suffice to make the point: The Wooing and Wedding of a Coon (1905), Kings of the Cannibal Islands (1909), Voodoo Vengeance (1913). Nor did this fascination dissipate. In the 1930s, both documentary and feature films, claiming to offer true images of Darkest Africa, showed us the Black as barbaric and untamed (e.g., in the anthropological-based *Congorilla*, 1932) or as the noble savage (e.g., in the feature film *King Solomon's Mines*, 1937).

Sub-Saharan cinema as an African cinema has its beginnings in the mid-1950s. It first emerged in the form of short films. The very first film is credited to Paulin Soumano Vievra and his Afrique sur Seine (1955), followed not very shortly by Ousmane Sembene's Borom Sarret in 1963. Both film-makers are Senegalese and both are seen as important trail-blazers in the field of film-making and film history. Vieyra is perhaps best known for his didactic documentaries (e.g., Mol, 1957, En résidence surveillée/Under House Arrest, 1981). He is also the author of two important books on African cinema (Vieyra 1975; 1983) which have pioneered 'a' writing of Africa's film history from within. In African film contexts, Sembene is considered the most significant pioneer of African Francophone cinema. Senegal has maintained a leading role in Sub-Saharan African cinema. The first black African feature film is Sembene's La Noire de ... (1966, poorly translated as Black Girl, since it means The Black Woman from . . .). And Senegal also produced the first black African woman's film Kaddu Beykatt (Letter from My Village, 1975, Safi Faye). Senegal's leadership has inspired the development of cinemas in other Francophone countries: Burkina Faso, Niger, Cameroon, Mali and Mauritania. And, although we are only talking in terms of small numbers of films, Francophone cinema is, compared to Anglophone and Lusophone cinemas, an extremely vibrant one producing as it does 80 per cent of the Sub-Saharan cinema.

The crucial problem for all Sub-Saharan cinemas is the lack of a strong infrastructure that could provide training for film-makers, to say nothing of funding and help at the distribution level. Sub-Saharan cinemas emerged after independence and, apart from the Ghanaian Film School in Accra and a few university-based film departments where film-making is taught (or more usually video-making), African film-makers are dependent on film-training abroad. Since becoming a democracy, South Africa has put money into film-training, but mostly television acts as the venue for gaining experience. And that about sums up what is available, which is very little indeed. The fact of having to go abroad is not in itself the problem, what matters is the lack of independence of these cinemas to fully underwrite their products.

Traditionally, African Francophone cinemas have received more support than Anglophone or Lusophone cinemas. All cinemas receive some form of state support, but a more significant contributor to the establishing of African Francophone cinemas on the international front has, undoubtedly, been the support they have received both directly and indirectly from their previous colonizers, particularly the French. French governments through their successive Ministries of Culture (which date from the 1960s) have provided financial support for African Francophone cinemas. They have also helped in terms of distribution outside of Africa, most especially in France and other Francophone countries but also in countries where they have an active cultural attaché and Institute (e.g., South Africa, the UK and Canada). Many film-makers have had the opportunity to study in French film schools: Balogun, Cissé, Faye, Hondo, Mambéty, Sembene. But that was not their only experience. Some also went to Moscow to study the Soviet school of cinema (Cissé and Sembene). Yet others went to Rome to train.

As for Anglophone African cinemas, the paradox is that, although in some instances (particularly Ghana and Nigeria), they were better equipped than the Francophone countries, none the less, they failed to capitalize fully on the legacy left them by the colonizing nations. Broadly speaking, the legacy was twofold. First the Bantu Film Projects (mostly educational and health films), that were founded in 1935 by Major L. A. Notcutt and sponsored by the Colonial Office of the British Film Institute, Second, the Colonial Film Unit (CFU) which was set up by the British in 1939. During this period, Africans were trained to do much of the routine work, but the products made were almost entirely for the purposes of propagating the superiority of British ways and, a bit later, to persuade Africans to fight the Second World War. Further to this, in 1949, the CFU established a film school in Accra, the capital city of Ghana. The effect of the legacy meant that, after independence, Ghana and Nigeria were left with sophisticated film studios. But they were also left with colonialist practices where the structures of film production were concerned. Thus, although President Nkrumah of Ghana greatly developed the film industry's infrastructure, the people who took over the infrastructure itself were not always progressive in their ideologies and continued practices established by their former colonizers. If we take the example of Ghana and Nigeria, those indigenous film-makers who were

fully trained remained neo-colonialist and the types of films they produced reflected colonialist 'aesthetics' (slow-paced films with elementary narratives) (for more detail, see Diawara, 1986). A further complication for Anglophone cinemas since the early independence years is that the nations' economies have suffered terribly under the militaristic rule to which they have been subjected. Thus it is hardly surprising that, in the context of its cinemas, poor planning strategies and lack of finance have meant that Anglophone African nations such as Ghana or Nigeria are far from strong in terms of the number of products they are able to make (for example, Ghana made six full feature films during the 1980s).

To this rather bleak picture of Sub-Saharan cinemas there is, of course, a counter-image. In the manifestos emanating from Black African film-makers (see Third Cinema entry) there is a clearly stated ethos that African cinemas must unite in their opposition to escapist Western cinemas and remain committed to the undoing or counterposing - through full representation of African identities - of the image given to the black African by White Western film-makers. It is an extraordinary feat that, despite the absence of material resources, there has been any cinema produced at all. Extraordinary too that what that lack of resources has meant to film-makers is that it takes many years to complete a project, not that it will not get done. They are prepared to wait lengths of time that might shock and deter film-makers in the West from pursuing the project. It is not uncommon for a project (even as a co-production) to take anything from seven to ten years. Mambéty of Senegal, Hondo of Mauritania, Ansah of Ghana, Ogundipe of Nigeria and Ecaré of the Ivory Coast have all known exceedingly long waits. Ecaré's controversial film Visage de femmes (Faces of Women, 1985) with its explicit eroticism (a taboo in African cinema) took twelve years to make. In recent film history, it is possible to point to only one 'success' story in terms of volume of production. Ola Balogun, a Nigerian film-maker trained in France, set up his own production company in 1973 (Afrocult Foundation Limited) and proceeded to make on average one film per year - some in the Igbo language and others (most predominantly) in Yoruba. The secret to his success was his collaboration with theatre practitioners with whom he fully exploited the rich vein of the Yoruba travelling theatre tradition. Each of his Yoruba-based productions has met with huge audience response which then allows him to recoup expenses and go on to produce the next film. Only when he has stepped out of this format and attempted a more politically motivated cinema has he been unsuccessful (as was the case for his film on the Mau Mau struggle, *Cry Freedom*, 1981).

Much of the cinema that is made is a cinema of national consciousness, one that denounces the effects of colonialism, and one that questions tradition versus modernity. That is, a cinema that looks to tradition and modernity which it then questions or valorizes; a cinema that may seek to entrench certain traditions and scrutinize others, just as it reveals the pluses and minuses of modernity (for an illustration of this, see below a discussion of Mambéty's film work). It is a revolutionary and resisting cinema therefore and one which is identified with Third Cinema (see Third Cinema entry for further details). Initially, in the late 1960s and during the 1970s, much of the thinking that went into its practice was inspired by the writings of Frantz Fanon (see entry on postcolonial theory) and to some extent by Marxist writers (particularly Louis Althusser and his thinking on ideology). In this regard, the presence of numerous black African film-makers in Paris during that period meant that when they returned to their African nations they could bring with them their knowledge of these radical writings. But the other key factor that must be mentioned before discussing further the nature of this cinema is the crucial formation, in 1969, of the Fédération Panafricaine des cinéastes (FEPACI) and the equally crucial launching, in that same year, of the Festival Panafricaine du cinéma de Ouagadougou (FESPACO) a biannual festival of African cinema (in Burkina Faso) - in fact, the biggest film festival in the world. The other important film festival held on alternate years from FESPACO is the Journées cinématographiques de Carthage (JCC). All three (FEPACI, FESPACO, JCC) have been central to the process of identifying what is the Africanness of the continent's cinemas. What is the pan-African cinema? And what must its function be?

There are three main answers. First, this cinema must narrate the nations' histories and cultures. Second, it must focus on the socio-political contradictions apparent in contemporary Africa. And third it must produce a film aesthetics of decolonization. In terms of what actually gets produced, obviously the intention is that all three of these practices overlap. So let us develop them a bit further. The African tradition of history is mostly

an oral tradition and as such it is well suited to cinema. This process of history telling is part of the raising of a national consciousness which Frantz Fanon speaks of when he talks of the poet's duty in pioneering the raising of a national consciousness (see Black Skin, White Masks and Wretched of the Earth). Thus cinema must denounce colonization, but it must not do it in a simplistic (binary) way. It must revivify the lost heritage and identity of its African nation and in so doing lead the nation to a revolutionary consciousness that will build the future. The poet film-maker must not speak for his or her nation, but through film give him or herself over to the process of national consciousness - that is speak from within but not for the nation. Just as with earlier oral traditions of narration (which is a multi-layered and pluri-historical affair), this form of narrating demands a syncretic style - by which is meant a collection of art forms, a multi-layering of narratives, intertexts and artefacts/traditions. Djibril Diop Mambéty's film Hyenas (Senegal, 1992) is exemplary of this function. Through this allegorical tale about hope, greed and deception at a local (village) level where magic is an everyday reality and the exchange of oral narratives is central to the community's spiritual economy, Mambéty exposes the terrible poverty to which, first, colonialism and subsequently the World Bank have reduced the Senegalese people. But this film also shows how the indigenous people have not resisted and chosen to go down the false path of consumerism stretched out before them by the West. Denouncing colonization takes other forms, such as the denunciation of the effects of Christianity and Islam on African spirituality (see Sembene's Xala, 1974). The conflict between the old and new world orders is often at the heart of these films as well. The clash between Western political economies and the social economies of African society are highlighted in Mambéty's earlier film Touki-Bouki/The Hyena's Journey (1973), a wonderfully constructed satire on the conflict between tradition and modernity.

As for the aesthetics of decolonization, the film style of pan-African cinema is one that 'escapes' Eurocentric interpretation and resists readings that threaten to 'domesticate the subversive elements of [the films'] cultural traditions' (Ukadike, 1994, 2). The syncretism and intertextuality of the film narrative are matched by the synergistic use of time and space in these films (time moves at many speeds and the representations of time and space are incredibly dense). It is a style that mixes fiction with documentary, fantasy, allegory and myth. The style is also marked by a certain hybridity. Since so many film-makers trained outside of Africa, it is not unusual for them to play with tropes from Western cinema, or indeed other cinemas with which they are familiar (for example, Cuban, Indian and Egyptian). Films are structured around mythological patterns, not generic codes and conventions. The play, in this pan-African aesthetics, is with form not with genre (which has no function or meaning). An ethnographic approach to the memories of ancestors is also part of the experimental mode of representation and exploration of identity. Film language deliberately challenges its audiences with images that are innovative but also with images that repel (for example the end of Hyenas). As Ukadike, in his marvellously comprehensive book on African cinema, says, here is a cinema that cannot be reduced to simple economic determinism (1994, 12). (For further reading consult Appiah, 1992; Bakari and Cham, 1996; Diawara, 1986; Fanon, 1967, 1968; Martin, 1995; Shiri, 1993; Tomaselli, 1988, Ukadike, 1994, 1995, For journals consult Ecrans d'Afrique.)

North African cinemas North African cinemas consist of Egypt and two major groupings of nations, the Maghreb and the Eastern Arab states. Once again the ubiquitous presence of the Lumière brothers and their cinématographe can be traced to these countries. The year 1896 is again recorded as the date of its first screening exhibitions. Exhibition practices in these early days was fairly similar to those practised in India (see below). At first it was only elite audiences (mostly ex-patriot colonialists in the case of the Maghreb countries) who were privy to these screenings. A little later (1908) screenings were provided for a wider more popular indigenous audience. A tiny handful of indigenous films were made during the 1920s, by Egypt, the Lebanon and Syria. Egypt was the first, in the 1930s, to establish a film industry (the Misr studios were opened in 1935) which successfully produced a cinema with wide appeal, primarily in the form of the Egyptian musical. Other countries in Northern Africa were much later in coming to any such level of production. Thus, at this time, Egyptian cinema 'dominated' the Arab world. It was in fact the only cinema and exported its products to other Arab countries. It is unsurprising, therefore, that the impact of this early domination is still felt in other Arab nations and their cinemas in terms of production and consumption. Thus, when other Arab nations came to establish

their own cinemas their own film-making was very much influenced by the mechanisms, standards and practices introduced by Egyptian cinema. Furthermore, most other Arab countries have consistently experienced great difficulty in sustaining a viable indigenous cinema for a number of complex factors. First, due to the lack of a strong economic infrastructure, their film industry is unable to make enough films to meet national demand. Second, lack of movie theatres mean that not enough revenue can be generated to finance new products. Finally, imports (from Egypt, India and the USA) fill the gaps and are cheaper to hire.

Let us examine the case of Egypt's cinema first. Egypt made on average ten or so films a year in the 1930s, peaking at twentyfive films a year by the mid-1940s. Interestingly there were one or two women film-makers practising during the 1930s (e.g., Bahiga Hafiz, Leyla the Bedouin, 1937), setting a small tradition that has been perpetuated in one or two rare instances in other Arab countries. By the 1950s, film production in Egypt rose to fifty films per year, an average that was maintained until the late 1980s after which production rates declined by half due to poor investment in the industry and the concomitant rise in consumption of electronic entertainment (TV, videos, etc.). Egypt's increase in production during the 1940s and 1950s lead to a broader generic output. Beyond the earlier Egyptian musical, genres now included, social dramas, melodramas, farces, police films. epics (especially historical epics), and rural dramas. Although, predominantly, Egyptian narrative traditions and traditions of performance (song and dance) prevailed, by the 1950s and early 1960s, Egyptian cinema was happily pulling on elements of Hollywood cinema to enhance its own indigenous products. Three film-makers dominated the scene in the 1950s. Salah Abou Seif (known primarily for studio dramas), Youssef Chahine (whose name now is readily associated with the epic style, but whose work at that time covered all genres), and Toufik Saleh (whose socially committed work aligns him with the practitioners of Third Cinema).

In 1961, the Egyptian film industry came under the control of the state-sponsored Central Organisation of Egyptian Cinema. To all intents and purposes the industry was nationalized. This had a restricting effect on independent producers and the work of some of the established film-makers as a result of which some, like Youssef Chahine (who studied film-making in the USA), briefly left to work in the Lebanon (he returned shortly after

to make his homage to Nasser, Saladin, 1963). Other film-makers went to Syria. One lasting and positive effect of the nationalization, however, was the establishing of a film school to train indigenous film-makers (the Higher Film Institute in Cairo). Egypt is the only Arab country to boast a film school still in existence. This nationalization of the film industry lasted until 1971, when it was partially re-privatized by President Sadat. Since that date, film-makers have been able to return and/or continue to work with greater freedom once more even though financing projects has become increasingly difficult. As a result of the economic constraints, film-makers have established their own production companies (e.g., Chahine and his Misr International) and have turned to making co-productions, first, with other Arab states, and later with Western countries (such as France in the case of Chahine).

The Eastern Arab states (i.e., Syria, the Lebanon, Kuwait, the Sudan and Iraq) have yet to produce a national cinema that competes with Egypt or the Maghreb. Some countries (Syria, Lebanon and Iraq) established governing bodies called the General Organisation for Cinema whose purpose it is to implement policies for film-making (quotas and the fostering of new film-making talent). Thus, Syria and Lebanon have managed to produce a regular if small amount of films per year. The Lebanese film industry, until civil war (1975-91) broke out in Lebanon and suffered the Israeli raids and Syrian occupation, produced twenty to twenty-five films per year. Under strict censorship, production was resumed in the late 1980s with about ten films per year. But for the most part, Lebanese cinema is a diasporic one with film-makers in exile making documentary-fiction films that treat the war-torn Beirut they have left behind or to which they return to film at great personal risk. Maroun Baghdadi (killed in Beirut in 1993), made Hors la vie/Out of Life, 1990 (a French-Lebanese co-production). Shooting in extremely dangerous conditions, Heiny Srour took seven years to make her Layla and the Wolves (1984), a film about the participation of Palestinian women in the fight for independence. In the 1990s, a younger generation of Lebanese film-makers has emerged that is making films on the same nation-shattering topic (see for example, Samir Habshi, Vortex, 1992; Jean-Claude Codis, Histoire d'un retour/Story of a Return, 1994; Lavla Assaf, The Gang of Freedom, 1994).

Economic conditions, civil strife or political censorship make it difficult for any of the Eastern Arab states to boast of a national

cinema and it is much more the case of individual film-makers making a breakthrough or having to leave and work in other countries, migrating to other Arab or Middle Eastern countries or to the West. Where national film products are concerned, it is almost impossible to recover costs of a film from indigenous audiences, thus film-makers are obliged to turn to other solutions: either making shorts or documentaries or seeking out international co-productions. Only a few male film-makers have been able to opt for the latter solution, the handful of women directors that exist have traditionally opted for the first solution (Heiny Srour and Joceline Saab of the Lebanon, for example).

The 'birth' of cinema in the Maghreb countries is an effect of the 1950s and 1960s post-independence – although, the foundations of this new independent Maghrebine cinema were laid in the struggle for liberation from colonialist rule. This is particularly true for Algeria. During the war of liberation, Algeria had a resistant underground cinema which it established in 1957 (the Tebessan Film Unit, Groupe Farid, which was annexed to the provisional Algerian government based in Tunis, Tunisia). Tunisia and Morocco gained independence in 1956, Algeria in 1962.

Since the 1960s, if we take their cinema as a whole, these countries are, with Egypt, the other most 'prolific' film-producers of the North African countries. Although, unlike Egypt, their films do not enjoy the same popular acclaim within their own countries and are more readily seen outside of the Maghreb in film festivals. Thanks to the French colonial presence in the Maghreb, there is a stronger tradition for film-making than in most other Arab countries - although, after withdrawal, the French, for the most part, removed the studios they had established in the three countries (studios had been created for propaganda purposes to make Arab language films to counter the Egyptian products). The lack of infrastructure post-independence meant that the first films to be produced in the mid- to late 1960s were very much in the documentary-naturalist-realist tradition associated with Italian neo-realism. Equally, this lack of infrastructure, which still exists today, means that film-makers are either self-taught or tend to be trained abroad (mostly in France) - although Algeria briefly boasted a film school of its own (the Institut National du Cinéma d'Alger, 1964-7). In more recent years, film-makers have also come into film from television.

Of the three countries it is Algeria that is the most structured in terms of organizational bodies and their tutelage of the film

industry. But the industry's modest infrastructure means that it lacks technicians and production management still today. Its first central organization body, the Office National pour le Commerce et l'Industrie Cinématographique (ONCIC), was established in 1969, since when this body has known several different forms until its most recent one, established in 1987, when there was a major reorganization of the industry with the setting up of the Centre Algérien pour l'Art et l'Industrie Cinématographiques (CAAIC).

Algerian cinema was state-controlled until the mid-1980s. This meant that state policy tended to guide production. Thus the early years of liberation (mid-1960s to mid-1970s) saw a spate of anti-imperialist films, made by film-makers who had been involved in the struggle and had often been members of the FLN (Front de Libération Nationale). These films celebrated the revolutionary liberation struggle. Arguably, Gillo Pontecorvo's La Bataille d'Alger/Battle of Algiers (1965, an Algerian-Italian coproduction) was a reference film for this cinema. But more significant still was the crucial input, during the struggle years. of the French documentarist René Vautier, an FLN sympathizer who worked with the FLN freedom-fighters and (according to some accounts), led the Tebessan Film Unit. His two documentary films Afrique 50 (1955) and Algérie en flammes/Algeria in Flames (1958), which were banned in France, were the precursors to the documentary-realist tradition so much in evidence in the indigenous cinema of the first ten years of independence. Mohamed Lakhdar-Hamina's two films that span this period, Le Vent des Aurès/The Wind from the Aurès (1966) and Chronique des années de braise/Chronicle of the Years of Embers (1975), are exemplary of this tradition. By the 1970s, issues of rural reform were of primary concern, and feature films were produced to support the agrarian revolution introduced by President Boumedienne. These films exposed the poverty of rural life, and spoke out against traditional taboos and unjust property conditions that were based on native feudalism. As such, they were as much about the class and the rural struggle. They also touched upon female emancipation. Abdelaziz Tobi's Noua, 1972, is exemplary in addressing all three of these issues. The tradition of maraboutism (magic practised by holy men) and sexual segregation also came under attack in this cinema. These aspects of traditional culture and religion are represented as obstacles to progress (see, for example, Mohamed Slim Riad's Vent du sud/Wind from the South, 1975).

The first decade of Algerian cinema is marked, as Viola Shafik in her excellent study of Arab cinema makes clear (1998, 175-6). by a monumentalization first of the Algerian resistance hero and subsequently the peasant. Films at this stage were busily engaged in selling an Algerian national identity that was unified and not diverse. By the late 1970s, however, just prior to its dissolution as a state-controlled industry a more diversified cinema had emerged that talked about the poor social conditions experienced by most Algerians, and represented the contradictions inherent in Algerian society (as a hybrid culture) including the oppression of women. During this period, the only Algerian woman film-maker, Assia Djebar, made two films looking at the role of women during colonial occupation and the struggle for independence (La Nouba des femmes du mont Chenoua/The Nouba of the Women of Mount Chenoua, 1978, and La Zerda ou les chants de l'oubli/The Zerda and the Songs of Forgetfulness, 1980). The 1970s was also marked by a close collaboration with the state television service (Radio Télévision Arabe, RTA). Diebar's films were co-produced by RTA. And, by the 1980s, television-trained directors turned to film-making. From 1983 until the early 1990s, when the new military regime came into full force, Algerian cinema continued in this same vein but it also took a new, ironic look at its own history (Les Années folles du twist/Mad Years of the Twist, Mahmoud Zemmouri, 1983), and issues of multi-culturalism (Histoire d'une rencontre/Story of an Encounter. Ibrahim Tsaki, 1983). Despite fears that the political upheavals of the 1990s would affect production, the first half of the 1990s curiously has witnessed a slight increase in output over previous decades (averaging four films per year as opposed to three). Since 1995, however, conditions have deteriorated. Algerian film-makers who have been sentenced to death by the Islamist fundamentalists have gone into exile (e.g., Merzak Allouache), as a result indigenous production has come almost to a complete stop. (For further reading see Armes, 1996; Dines, 1994; Hadj-Moussa, 1994: Shafik. 1998.)

Moroccan and Tunisian cinemas do not enjoy the same industrial infrastructure that Algeria does. Although Morocco has almost as many cinema theatres as Algeria (around 250 to Algeria's 300 odd), the theatres are almost entirely dominated by foreign imports. Tunisia has only about 75 film theatres. So in the case of both countries (albeit for differing reasons) there is little resourcing for indigenous products. Film production is,

therefore, a far more individualistic affair. Film-makers are either self-taught or have trained outside the country. They do, however, have studios to work in in their native country. But financing remains the key issue. Although Morocco had established a state-sponsored Centre Cinématographique (CMM) as early as 1944, the CMM did not really take on an active role in funding until the late 1970s at which point production rose from a meagre average of one film every two years to an average three to four indigenous films per year. But this only helps finance projects to a degree, in much the same way as Tunisia's now defunct SATPEC (Société Anonyme Tunisienne de Production et d'Expansion Cinématographique, 1957-94) could only finance a small percentage of the cost of production. This lack of finance has three effects. First, Morocco and Tunisia have had to seek finance for their films through co-productions. Second, film-makers often only get to make one film per decade (in the case of Morocco, only Ben Barka, Nour Eddine Gounejjar, Hakim Noury and Mohamed Tazi have managed two). Finally, both countries have opened their studios to Western film-makers in an effort to boost their own industry. French film-makers in particular make avail of the cheaper labour costs offered by these countries. Tunisia for its part has also successfully pre-sold film rights to European television companies (French Arte and Channel Four in particular). In this way it has financed several international successes in particular the films of Ferid Boughedir (Halfaouine, 1990, and Un été à La Goulette, 1995). Tunisia also has a major standing as one of the most important festival venues for African and Arab cinema. The country hosts the bi-annual film festival (the Journées Cinématographiques de Carthage). Strict Islamic laws and severe censorship mean that women film-makers are extremely thin on the ground. Tunisia has the lead with four, two of whom have made a feature film (Moufida Tatli, Les Silences du palais/Silences of the Palace, 1994, and Selma Baccar, La Danse du feu/The Fire Dance, 1995). (For further reading see the excellent study by Viola Shafik on Arab cinemas (1998) and the very useful dictionary of North African cinemas by Roy Armes (1996.)

The cinemas of China Numerous cinemas make up China's cinema history. To give a sense of its history, it is perhaps helpful to first divide its history into two epochs. The first goes from the earliest presence of cinema in China, 1896, to the establishing of the People's Republic in 1949. The second stretches

from 1949 to the present day. These two epochs, however, subdivide into different periods producing different or assimilated or recuperated cinemas (as I will explain below).

1896-1949: The beginnings of cinema in China are not dissimilar from those of India. The first cinématographe screening took place on 11 August 1896 in Shanghai. Very quickly this was followed by itinerant showmen taking films out to other cities and provinces. By 1905, Chinese camera operators were filming local Chinese opera and by the 1920s China was producing melodrama and comedies. The first Chinese film was Dingiun Mountain (1905), a filming of Beijing opera performed by the renowned actor Tan Xinpei. Even at this time, though, this popular cinema displayed a resistance to Western imperialism. and for the following reasons. During this first period, Chinese cinema was not a thriving industry, companies quickly folded and in terms of cultural capital the dominant presence in Chinese cinema venues was Western cinema. Chris Berry (1996, 409) quotes the figures of dominance as 90 per cent foreign of which 90 per cent was American. This dominance lasted until 1949. In the period 1910-30, what little Chinese cinema there was found its sources in and drew its narratives primarily from the popular Mandarin Duck and Butterfly literary tradition. Although these were escapist films that narrated melodramatic and sentimental tales, they were films that warned against the effects of westernization which was already considerably in evidence in major Chinese cities, particularly Shanghai. Curiously therefore this populist cinema was both assimilated to its culture and resistant to it (it was escapist but challenging of Western ideology).

Shortly after this first period of populist film-making, during the 1930s, China witnessed the emergence of a second type of cinema, this time far more directly politicized, that of a nationalistic leftist cinema that would eventually become identified with the communist party in its fight to liberate China from Japanese imperialism (which lasted throughout the 1930s). The catalyst for this new cinema was the invasion of China by Japan in 1931. Intellectuals of the left infiltrated the film industry and some established communist cells. These leftist intellectuals were responsible for producing what are known as leftist films, a product which has come to exemplify the first golden age of Chinese cinema. However, the point needs to be made that these leftist films were directly inspired by the nationalistic May

Fourth Movement (1919) a crucial factor that would lead Chairman Mao to advocate their rejection in the new Revolutionary China (see below). The May Fourth Movement was a protest movement headed by intellectuals and students and led against the Chinese government for their pro-Western and pro-Japan policies. The movement also protested against the stifling nature of Chinese tradition and culture and advocated a new China that could be both patriotic and open to new and foreign ideas. The cinema produced by leftist intellectuals was based on the literary work to come out of that movement and while it was certainly politicized it none the less remained populist in its appeal as entertainment. During this entire fiftyyear span, Shanghai remained the film centre of China. Only after the revolution would more studios be established in Beijing (including a Film Academy) and Changchun. If, in 1949, this leftist cinema was rejected by Chairman Mao it was because of political self-interest. Accusing this cinema of being westernized (primarily because it was based in Shanghai, a melting-pot of many cultures, including those of the West), he sought to impose his own cultural apparatchiks who had been trained in Yen'an. By 1953, the Shanghai studios were nationalized, thereby effectively putting a stop to the production of films that were not considered consonant with the Maoist line. A form of total recuperation that would last on and off for thirty years.

Just before the People's Republic of China (PCR) came into being, China experienced what is referred to as its second golden age of production. During just three years, 1946–49 (after the war with Japan and the Second World War ended), leftist filmmakers re-established themselves in Shanghai and produced social realist films which 'documented' the civil war between the ruling bodies of that period and the communists as they fought to come to power.

1949–2000: There are five waves to this epoch of China's cinema. The first wave, 1949–66 was something of a paradox. It began with the Social Realist worker–peasant–soldier cinema which was heavily influenced by **Soviet cinema**. This cinema served to propagate the idea of a revolutionary nation and a classical revolutionary cinema. During this period, China set up an integrated national film industry, whereby the state controlled all aspects of production including, of course, censorship. By 1956, it was decided that cinema needed to change direction and should look to China's history rather than to its

present. The new directive was to produce a revolutionary realism and a revolutionary romanticism. To this effect, curiously, film-makers were able to return to the literary tradition of the May Fourth Movement as well as to the operatic tradition. In other words, cinema had reverted to a previously disavowed or at least denounced practice. This relaxation of the pressure to make politically motivated cinema stemmed from Chairman Mao's famous policy of a Hundred Flowers (Let a Hundred Flowers Bloom and a Hundred Schools of Thought Contend). Restrictions on the creative process of film-making were lifted. Film-makers were able to visit European Film Festival venues, and foreign (European and other Third World) films were allowed into China. Films that openly criticized the bureaucracy of government were allowed to pass uncensored. And it was at this time that studios were opened up in Beijing and Changchun, and Shanghai opened three more studios. This spirit of openness was an up and down affair. In 1957, 1958 and again in 1964, the Anti-Rightist movement accused certain films of bourgeois tendencies and effectively had them censored. This movement did not die away but was to re-emerge in 1966 as part of the Cultural Revolution. Indeed, its leader, Kang Shen became one of the Gang of Four who, along with Madame Mao, formed the uncompromising leaders of revolutionary taste during the terrible years of the Cultural Revolution. From 1966 to 1972 - the period of the Cultural Revolution - there was virtually no cinema at all. Only ten films were made. All of them had to adhere to the very strict rules and filmic guidelines imposed by Madame Mao. Strongly didactic and stylized, these films (which were revolutionary model-operas) propagated the myth of the perfect proletarian class hero and heroine. During this period, the Film Academy in Beijing was closed, many film-makers were sent to prison or to work-camps - many perished under those conditions.

From 1972–84 feature film slowly reprised and from 1977–84 a genre of films called 'scar' or 'wound' films emerged exposing the unjustified persecution that took place during the Cultural Revolution. A fourth wave occurred in the mid-1980s thanks to a new relationship between the state and the film industry which saw a relaxation of controls imposed upon film practice. First, the industry was no longer obliged to make films closely associated with Chinese operatic theatre. Second, film could now investigate the aesthetics of films and not be tied to the

revolutionary propaganda cause (the so-called revolutionary realism). Finally, the state agreed both to the principle and to the financing of a cinema that was audience-based which meant that entertainment films could now replace the earlier practice of didactic cinema. The effect, beyond entertainment films, was some ground-breaking experimental work produced by a 'movement' of young film-makers, graduates of the Beijing Film Academy (which had re-opened in 1978). They were known as the Fifth Generation. Their films were considered elliptical and were accused of elitism, and they were not successful with audiences. They remain, however, as a testimony to a moment of film language experimentation and modernization. A few Fifth Generation film-makers went on to produce more 'accessible' films, some of which were financed by foreign money (Taiwan, Hong Kong, UK/Germany). Of all the film-makers of that generation it is Zhang Yimou and Chen Kaige who have successfully managed to combine experimentation with popular narration. And, from that generation, it is their work that Western audiences get to see. Yimou's films have been highly acclaimed in the West. His Red Sorghum, 1987, won the Berlin Golden Bear in 1988. The Story of Qui Ju, 1992, won the Venice Golden Lion. And two other films Raise the Red Lantern, 1991 (banned in China), Shanghai Triad, 1995, have met with audience acclaim outside China. Chen Kaige's breakthrough film Yellow Earth, 1984, helped to put the Fifth Generation and China on the world film map and his Farewell My Concubine (1993) won the 1993 Cannes Palme d'Or. Incidentally, Yellow Earth was shot by Yimou and he is co-credited with the making of the film along with the designer He Qun.

The last phase of China's cinemas stretches from the late 1980s to the present, with films expressing different messages but in which it is not difficult to read a disenchantment with the government. The Tiananmen Square massacre of 1989 only brought further repression and censorship to film-makers (other than those attempting to produce commercial products such as action movies). Chen Kaige and Zhang Yimou now enjoy a sufficiently strong international reputation that they can obtain outside financing for their projects and post-produce outside China which effectively puts their films out of China's censorship net. Younger film-makers are not so lucky. They have essentially either had their projects censored and shelved or have had to go underground and attempt to get their films released

outside of China – in particular the black-listed film-makers Zhang Yuan and Ning Dai. This self-nominated Sixth Generation of film-makers has succeeded in obtaining international recognition with films such as Wang Xiaoshuai *The Days* (1993) and Zhang Yuan's *Mama* (1990, but only released in China two years later). His gay film – China's first (if we except *Farewell My Concubine* which is more **queer** than gay) – *East Palace, West Palace* completed in 1996 and screened in Western film festival venues has yet to be released in China. (For further reading see Berry, 1991; Browne, Pickowicz, Sobchack and Yau, 1994; Clark, 1987; Eder and Rossell, 1993; Rayns and Meek, 1980; Yau, 1996; Zhang, Y. and Xiao, Z., 1998; Zhang, X., 1998.)

Indian cinema Bearing in mind the distinctions drawn between Third and Fourth Worlds and cinemas, I need to make clear that this section is only going to deal with Indian cinema. Although there are other cinemas of the Indian continent which evolved either post-Partition (Pakistan, 1947) or post-independence (Bangladesh, 1971), I do not know if we can speak of them as cinemas of the Third World or Fourth and do not propose to enter into this debate here. Quantitatively, Pakistan ranks amongst the top ten film-producing countries, and for that reason there is a separate entry on Pakistan cinema (see below) but not on Bangladesh which only has a quite small output to date. However, to mention these cinemas is to raise again the difficulties of defining Third World Cinema and perhaps also the futility of attempting to do so. We deal with it because it is a term the West has invented and which Third World nations have been obliged to accept as a way of determining their identity, that is, through international economic status. But, as the entry on postcolonial theory makes clear, this term may not last forever.

It is something of a paradox to speak of Indian cinema as a Third World Cinema. Today it produces more films than any other nation, between 700 and 800 per year and in twenty-two languages (compared to USA's 400 to 600 films per year, usually in one language). Cinema is big business in India and as a cultural force it outstrips the USA (First World) cinema market in terms of consumption within its own cinema theatres and venues alone (i.e., more Indians watch their indigenous products than Americans do theirs). Indian cinema is big business also in relation to its **stars**. Stars have a major influence and standing and often play an active role in politics. Indian cinema is still a very popular form of entertainment since television is not yet

a household commodity for many. The dominant popular **genres** are mythologicals, melodramas, musicals, romance, adventure films – often these are all rolled into one and labelled as songdance-action films. Their popularity has to do with the tremendous legacy of India's theatre which has heavily influenced the generic tradition of mainstream Indian cinema. But beyond this extremely popular mainstream cinema there exists other cinemas – art cinema, which is often a state-subsidized cinema, and avant-garde cinema which is made by independents and is not necessarily state-subsidized.

Film began in India on July 7 1896. Maurice Sestier, an envoy of the Lumière brothers started cinématographe exhibitions in Bombay. By the 1900s, itinerant showmen took film beyond the cities of Bombay, Calcutta and Madras and set up tent shows which at times would house as many as 10,000 spectators. The making of the first Indian feature film is credited to Dhundiraj Govind Palke with his mythological Harishchandra (the date given varies as either 1913 or 1914). Palke is credited with introducing the mythologicals, which were extremely popular with 'ordinary' people (i.e., not the educated elite) - what postcolonial theory would term the subaltern classes. These mythologicals then developed in the mid-1920s into devotional or religious and allegorical films. However, if we are to be true to history, then Hiralal Sen is really India's first film-maker. He established the Royal Bioscope Company in Calcutta and filmed plays from the major theatres in that city. A first film of his (dating from 1903) Alibaba and the Forty Thieves not only marks Sen out as the first film-maker in India, but, interestingly, also pre-dates by four vears France's version of the same story (Pathé's Ali Baba, 1907).

The 1920s can be taken as the period when India truly established a film industry. At that time, Hollywood was a reference point for the structuring of the industry and remained as such until state intervention in the early 1960s changed the nature of industrial practice (see below). The mid-1920s saw the founding of the major studios first in Bombay and Calcutta then in Poona and later still in Madras (1930s). But the economic management and practice of these studios were a far cry from the seamless vertically integrated system of Hollywood. The financing for films was extremely difficult and dependent on the country's trader-industrialists (mostly mercantile traders) and if that failed, then, recourse had to be made to usurers. With the advent of sound, Indian cinema had to compete with foreign

products (particularly American films). It created its own indigenous sound film that included songs and dance. These routines were often extra-diegetic but they were a great success and so guaranteed the popularity of any particular film in which they featured. They also, of course, perpetuated and extended the star system to include not just theatre actors or dancers as stars but now singers too. If we could speak of an integrated cinema industry at that time, then it would be in terms of a cinema run by families and friends and financed by the lower rungs of capitalist entrepreneurialship and speculators. This made the industry a fairly precarious affair to say the least, so it is not surprising if, after the Second World War, the studio system collapsed.

The Bombay Talkies and musicals of the 1930s are considered the true precursor of today's mainstream Indian cinema. Bombay Talkies refers to a studio established in 1934 that made mostly rural melodramas. And Bombay musicals is a loose term used to refer to the song-dance-action movies. This heritage has won the Bombay studios the epithet of Bollywood. The three largest studios are the Kohinoor Film Company, The Ranjit Movietone studio and the Imperial Film Company (all established in the 1920s). Imperial produced India's first sound film Alam Ara, 1931. These studios produced Hindu mythologicals, melodramas, song-dance-action films. They also produced some realist films which transposed orientalist narratives into period movies so that they appeared to be allegories or mythologicals. In fact, they were thinly disguised criticism of the colonialnationalist conflict. Bombay, however, was not the only geographical site of the film industry and we need to be conscious of the important work being produced at that time by other studios dotted over the country: the Prabhat studios in Poona, the New Theatre studios in Calcutta and the United Artists Corporation in Madras. Nor should we forget the small Punjabibased studios in Lahore (which of course is now part of Pakistan) which, prior to the partition of 1947, produced fantasy films. After partition, many of these studios and film practitioners moved to India and their products became integrated into Indian cinema and are presently known as the Hindi 'masala' movies.

Someswar Bhowmik (1995) in his very useful overview of Indian cinema provides us with the following survey of pre-Independence cinema of the 1930s. Globally speaking it was made up of the following categories. Sixty per cent were

romance and love-affair films. This broad category includes many of the musicals, romance-melodramas, mythologicals and allegories associated with Indian cinema. Thirty per cent of film production was about problems facing Indian families (in-laws, marital maladjustments, and so on). This category includes films that are known as reform socials, films that reflected the state reform programme that called for widows to remarry and other programmes dealing with the condition of women. These films are the precursor to Indian melodramas of the post-independence cinema. The third category makes up 10 per cent of production and are films that reflect the growing awareness of a society in flux as it faces the almost insuperable conflicts of orthodoxy with modernity. Much of India's cinema, pre- and postindependence, makes allusions (however indirectly) to the struggle between traditional authenticity and capitalist modernity. And, in this context, it is worth citing one film-maker whose work straddles these two periods, Mehboob Khan and his fetish female star Nargis (who often embodied these tensions in her performances). Mehboob used the costume drama as his forum for his mise-en-scène of these conflicts (see Humayun, 1945, Romeo and Juliet, 1947, and Andaz, 1949).

Contrary to Eurocentric cinemas, India's boom in the industry occurred in 1979 and continues today. Pre-independence, India produced between 100 and 170 films per year. Post-independence. India made 200. This number subsequently grew to 400 films per year in the 1970s. By 1979 production soared to 700 up to 948 depending on the year. Lack of mass consumption of television sets is a part explanation of this extraordinary increase in film production, but so too is the shift in the conceptualization of the industry which only post-independence was properly geared to the reproduction of capital (Bhowmik, 1995, 38). Two other reasons are contributory causes. The first was the introduction of a series of state measures to aid the industry starting in 1960 with the Film Finance Corporation (FFC), an independent but stateestablished body. By the mid-1950s most of the studios were in a parlous state and had either closed down or attempted to break into the mainstream Bombay-Bollywood type of production. The FFC's objective was twofold: first, to promote and assist mainstream cinema and, second, to develop film as an instrument of national culture. In this latter respect the FFC made it possible for a whole new generation of film-makers to get into production. This in effect was the launching-pad of the New Indian Cinema

(see Third Cinema entry for more details of this cinema). In 1980, the FFC subsequently became the NFDC (the National Film Development Corporation) a quasi-(state) monopoly for financing, distributing and exhibiting films. The second reason for the extraordinary upswing in film production was the withdrawal in 1974 of the Motion Picture Export Association of America (MPEAA) from the Indian market which allowed India, in the form of the FFC, to import films for local distribution and make a tidy profit in the process and further finance its own production.

There are three major trends in Indian cinema dating from the 1960s: the Hindi movie (which embraces many different types but which refers in the first instance to the dance-songaction movie), the art cinema (best exemplified for Westerners, since he exported so well, by Satyajit Ray) and, finally, the avant-garde/formalist or counter-cinema more closely identified with Third Cinema practices (see entry on Third Cinema). The first trend follows much in the tradition of genres that were established pre-independence (for further detail see Chakravarti, 1993). There is considerable overlap between the other two cinemas (art and counter-cinema) although the latter cinema is closely identified with the earlier work of the Indian People's Theatre Association (ITPA), a communist-backed theatre and film movement. The art cinema, so associated with Ray's work, is one that looks to a way of representing history within the framework of post-independence discourses of the nationalist enterprise. Ray's cinema is a cinema of realism but whose content is often located in the past. It is also a regionalist cinema rather than a nationalist cinema – which in a sense reinforces the very point that Third Cinema makes that a national cinema is made up of many national cinemas. Ashish Rajadhyaksha, one of the leading experts on the history of Indian cinema, puts it well when he describes Ray's realism 'as a vantage point from where to restage "the past": to re-present memory in a land that could now, so to speak, celebrate the arrival of history' (1996, 682). This practice of returning to history to make history is a key to understanding Ray's films. In a different way, Ray's contemporary, Mrinal Sen also seeks to represent India and its history but does so through a realism grounded in the present.

In 'purely' political terms, India's post-1947 history falls into two phases: 1947–69, the period of secular nationalism advocated by Nehru and which was based on a politics of integration; and 1970 to the present day which has witnessed the increasing

importance of Hindu nationalism as exemplified by the rise in popularity of the BJP and its electoral success in 1998. What of the film industry? Partition divided the film industry and, in the early years of partition, India was the country to gain in terms of studios and personnel. A few years later, however, some film-makers returned to their now native Pakistan (see below). Indian films about the traumas of the partition were, however, very thin on the ground. Indeed, films that addressed the recent history of India tended to continue the earlier trend of preindependence films about the struggle for freedom and they were few in terms of numbers (twenty or so over a thirty-year period, 1925-57). Ritwik Ghatak's 1960s trilogy on refugee poverty and conditions in Calcutta was the first to show the effects of partition on ordinary people (Meghe Dhaka Tara/The Cloud-Capped Star, 1960, Komal Ghandar, 1961, Subarnareka, 1962). But the first film to impact hugely on audiences was Garam Hava (Hot Winds, M. S. Sathyu, 1973), a film which focused on the plight of a Muslim family in North India. Since then a handful of films have been made on this topic (the latest of which is Pamela Rooks Train to Pakistan, 1997). The 1990s has witnessed the emergence of films that address India's present political condition. Mani Rathnam's Roja (1992) and Bombay (1994) are extraordinary given the political upheavals of those times. Extraordinary, because Roja met with wide audience appeal, suggesting that Indians do want a political cinema. Extraordinary, because Bombay got through censorship. Roja is about the nationalist struggle between Kashmiri separatists and India. Bombay is a love story between a Muslim and a Hindu set against the backdrop of the Hindu-Muslim conflict (see Gokulsking, 1999). (For further reading on Indian cinema see first Ashish Rajadhyaksha and Paul Willemen (1994) Encyclopedia of Indian Cinema. This is the reference book on Indian cinema. For histories of Indian cinema see Bhowmik (1995), for representation in popular Indian cinema see Chakravarti (1993) and Gokulsking and Dissanavake (1998). And the journal Cinemaya: Asian Film Quarterly (which also includes articles on Arab diaspora cinemas).)

Pakistan cinema Although it mostly caters to the local market, Pakistan's film industry, with an average of eighty films per year, ranks amongst the top ten film production countries (Gazdar, 1997, 1). Little is known of this cinema outside of its own country with the exception of diasporas (for example, Birmingham and Bradford in the UK) where video club rentals

make these films available. Nor is there much written about this cinema in the West. However, readers seeking to find out more would find Mushtaq Gazdar's (1997) comprehensive study provides an informative picture of Pakistan's production.

United Players was the first studio to be established in Lahore in the 1920s (and one of its early film-makers was, in fact, the first Indian woman film-maker, Fatma Begum, who made Bulbule-Paristan, 1926). In terms of production it was not competitive enough to fight against the Bombay silent movies. Only the advent of sound brought about some success for films emanating from the Punjab. The 1947 partition had a considerable impact upon existing studios in the new Pakistan. Kamla Movietone (established 1924), later known as Shorey Studios, moved to Bombay after partition. The founder of Pancholi Art Pictures (established late 1930s), Dalsukh Pancholi, fled to Bombay. In 1948, these studios were taken over by Agha G. A. Gul who had already established his own Evernew Studios in 1937. Gul's dominant position meant that he became a major pioneer of Pakistan cinema after partition. During the early partition days there was some collaboration between India and Pakistan. And, two years after partition, there was some reverse in migration from Bombay to Lahore and some film-makers returned to their native city. One famous example is Nazir (born in Lahore) who returned in 1949 and became an actor, director and producer in Pakistan and worked in a successful partnership with his actress wife Swaranlata (see Pheray, 1949, Sachchai, 1949, Anokhi Dastan, 1950). The first Pakistan film was Teri Yaad (Daud Chand, 1948). but the first film made by an indigenous Pakistan film-maker was Do Ansoo (Anwar Kamal Pasha, 1949). At this stage, however, the Pakistan film industry was too small to meet audience demand. Consequently, cinema theatres relied mostly on Indian film imports.

Gul was the major producer of the 1950s. But quick to follow on his heels was J. C. Anand whose first big hit was *Sassi* (Chand, 1954). By the mid-1950s quota restrictions imposed on Indian imports greatly helped the Pakistan film industry to grow. And by the 1960s Lahore had become the Hollywood of Pakistan – Lollywood. While the state did little to help the industry, it did establish a very strict code of censorship. This meant that the cinema of the 1950s and 1960s was predominantly a-political (on both social and political issues). What dominates during this period are comedies, folk tales and musicals. Although films on

the history of Pakistan were deemed acceptable and represent a small exeption to dominant cinema of this time. Thus, Saifudin Saif made *Kartar Singh* (1959) about the effects of partition; Khahil Qaiser made a film on the anti-colonial struggle *Shaheed* (1962); and Raza Mir made a film based on the effects of partition on Hindu–Muslim relations *Lakhon Mein Eik* (1967).

In the late 1960s and early 1970s, the ascendancy of television began to take its toll on the film industry as indeed did the political upheavals that led to the secession of Bangladesh from Pakistan. In order to assist the ailing industry, the Bhutto government in 1973 established the National Film Development Corporation (NAFDEC, quite similar to India's NFDC) which was an autonomous body under the tutelage of the Ministry of Culture. Box office receipts on foreign imports went to NAFDEC (which was responsible for importing foreign films). These revenues went forward to finance indigenous products and the tendency was to finance big budget movies and stars. The net effect was a boom in film production during the 1970s

(averaging 100 films per year).

Then of course, in 1977, came the military coup of General Ziaul Haq who got rid of Bhutto (by execution in 1979), imposed martial law and established a dictatorship (the Zia junta) in the name of Islam. Zia's junta fought the Afghan war on behalf of its Western allies. It also governed on a policy of divide and rule by supporting sectarian and ethnic groups and leaving them to fight among each other. The effects on cinema (particularly that of the 1980s) was an increase in films glamorizing violence (e.g., Yunus Malik's Jeera Sain, 1977). Two social-realist films of the period stand out as exceptions to this trend. Muthi Bhar Chawal, made by the woman film-maker Sangeeta (1978), a film about village family life and the struggle of a family to survive once the mother becomes widowed. This social film on the condition and status of women in contemporary Pakistan pre-dates tougher censorship laws (introduced a year later) which might have got it banned. Even so, after the new laws, Sangeeta continued to be the prolific film-maker she had been throughout the 1970s making up to three films a year (as she did in 1979). The other film was Maula Jat, directed by Yunus Malik (1979), which deals with the indifference of officials to the plight of ordinary people. This film was banned in 1981 under the pretext that it was too violent, but clearly its reference was too close to the Bhutto story to be acceptable to the junta - or the new censorship laws (the

Motion Pictures Ordinance, 1979). These new laws represented a heavy clamp-down imposing moral and religious values (which was, in fact, a barely disguised form of political censorship). This led to a major decline in the film industry's output. It went from 100 films per year to 61 in 1980 and then balanced out at around 80 per year (a figure it maintains today).

The first half of the 1980s was a disastrous period for Pakistan cinema. Poor products (due to the all-pervasive censorship laws) met with declining audiences (especially among the elite classes). Cinema complexes were turned into shopping centres (especially in Karachi). The majority audience was now composed of rural and urban working-class male audiences and they were provided with a diet of comedies, musicals and above all violent films. By the late 1980s, rising costs and the decline in the film industry's fortunes had led to an increase in co-productions with South Asian and Far Eastern countries (not with India because of political tensions). This brought new talent into the industry, particularly in the form of stars (e.g., Sabita from Sri Lanka and Shiva from Nepal). In the 1990s, the effects of media globalization have led increasingly to commercially orientated films, imitating Hollywood and Bollywood, targeting youth audiences (e.g., Sangeeta's violent and sexually explosive film Khilona, 1996, which is based on contemporary Hollywood psychopath thrillers). (For further reading see Gazdar, 1997.)

Latin American cinemas Between 1896 when the Lumière brothers' cinématographe first penetrated Latin America and 1911, almost all the countries of this continent had established exhibition venues for the screening of short films either made by indigenous film-makers or imported from Europe. Audiences were mainly the elite classes who were privy to an exoticization of their country through the documentary images brought to them. We have seen how a similar exoticization occurred in countries of the African context, the major difference being that the images taken there were for the entertainment of the privileged colonizing classes and for export to the Motherland. In Latin America's case there was, however, a form of colonization which was effected by Hollywood's forceful distribution practices which soon penetrated the countries of central and southern America and by the 1920s had garnered 80 per cent of the indigenous markets (Mexico, in particular, has a very complex relationship with the USA that dates back, at least, to the Mexican Revolution, 1910-17).

Knowledge of the early years of Latin American cinema is presently very scant. Only now are film historians engaged in uncovering the hidden pre-1930s cinemas. What is known is that in the first decades, 1900–30, only Mexico, Argentina and Brazil had anything like an indigenous film production infrastructure. In Brazil, where films were made in regional centres, production by the 1910s had reached 100 films per year. These were mostly cowboy and rural dramas, a genre that was also extremely successful in Argentina. Mexican cinema, in these early years, focused on traditional narratives but also made controversial films (at least in the eyes of its northern neighbours in the USA) about the conditions of Mexican workers in Northern America.

The advent of sound in Latin American countries was a slow affair because of the enormous financial burden of equipping cinema theatres. However, it did have the advantage of promoting national cultures in a more specific way and it brought in its wake the musical genre. In Argentina it was the tanguera (tango melodramas based as the name suggests on Argentina's indigenous dance form, the tango). In Brazil it was the chanchada (a hybrid form of Hollywood musicals and the Brazilian samba dance, carnival and comic theatre traditions). In Mexico it was the ranchada (a cowboy musical) and the cabareteras (cabaret melodramas). The Mexican cowboy musical is a hybridization of the American genre with Mexican rural traditions, whereas the cabaret melodramas are more a hybrid of the Mexican street/ city genre and the Hollywood cabaret or backstage musical. Within this notion of hybridity, Brazilian and Mexican filmmaking has tended to merge the practices or genres of other cinemas with their own indigenous cultural traditions and film style. The overall effect of this hybridization is a deep textual and textural layering of meanings - what is known as syncretism (a syncretic style). Brazil mimicked the Hollywood action movies (especially Westerns) by transposing them into their own context and environment and Mexico's singing cowboy films came immediately upon the heels (spurs?) of the Hollywood prototype of the mid-1930s (first exemplified by John Wayne and shortly followed by Gene Autry and Roy Rogers).

The Mexican film industry was the first to be formed in Latin America in the mid-1930s and it enjoyed a golden age of cinema through until the 1950s (particularly the decade 1943–53). This period is marked primarily by the distinguished collaboration

between the film-maker Emilio Fernandez and the cinematographer Gabriel Figueroa. Figueroa trained in Hollywood under Gregg Toland (the cinematographic genius behind Welles' Citizen Kane, 1941). An early film Fernandez and Figueroa made together, María Candelaria (1943) won the Palme d'Or at Cannes in 1946. Figueroa also worked with Buñuel when he was in exile in Mexico and made Los Olvidados (1950) with him. Another, earlier formative influence on Mexican cinema was Eisenstein who visited Mexico in 1930–2 (where he shot ¡Qué viva Mexico!, 1931).

During Mexico's cinematic golden age, the Argentinian cinema went through a decline (partly due to its pro-fascist but supposedly neutral political stance during the Second World War which lead to the USA withholding vital film stock). In 1946, the ailing Argentinian film industry was given a boost by the newly established Peronist government. But the cinema produced, due to tremendous pressure and censorship, was mainly safe and uncritical bourgeois melodramas. Only one voice spoke out against the Peronist oligarchy, Leopoldo Torre Nilsson whose film *La Mano en la trampa* (*The Hand in the Trap*, 1961) won the International Press Prize at Cannes.

What all these cinemas had in common was a similarity of cultural references and an artisanal style that did in fact constitute a heritage for the later radical cinema of the 1960s and the still later cinema of the 1980s and 1990s. The Latin American cinemas drew on their landscapes, costumes, customs and traditions including their oral narrative traditions and their music. This local and culturally syncretic structure of their films was matched by an equally hybrid cinematic style that was both industrial and artisanal. What distinguishes the cinemas of that period from the later cinemas is the apparent lack of political motivation within the cinematic practice. What also marks this cinema of the 1940s and 1950s was the degree of cross-fertilization and the migration of talent. Europeans and Americans came to work in the Latin American continent; Latin American film-makers went to Europe: Cubans contributed to Mexican and Argentinian cinemas; Argentinians went to Brazil and Venezuela. This migrancy has also left an important heritage, one which is mirrored by the present trend of transnationalism (especially in the form of co-productions) in Latin American cinemas and one which, because of the dynamics of exchange, has come to be termed transculturation

The late 1950s saw a new cinema emerging, one which was to last through until the early 1970s across the Latin American continent. This cinema was a militant, revolutionary, countercinema. It was one which denounced poverty and celebrated protest. This new cinema was started by film-makers whose products often, ironically enough, were financed by the very state machineries they sought to criticize and militate against. A film made in Bolivia is an interesting example of these paradoxes and yet shows how militant and effective some of this cinema could be. The Blood of the Condor (1969), made by a Bolivian film collective (Ukamau), exposed the forced sterilization of Quechua Indian women by the American Peace Corps. The effect was the Peace Corps' expulsion by the Bolivian government. The year 1959 can count as the watershed year in which this radicalization of cinema came into practice, starting with the Documentary Film School of Santa Fe in Argentina, the cinema nôvo in Brazil and the Film Institute in Cuba (founded in that year after the Cuban Revolution). These groupings produced an ethnographic and social-realist cinema showing the poverty of their countries. They also made a cinema termed the Tropicalist style (see cinema nôvo entry for more detail). This was a syncretic and stylized cinema that fused Catholic religion with indigenous mysticism, allegory with legend and semi-pagan religion, cult with African-Latin American ritual, producing a more surreal cinema (see the works of Glauber Rocha, especially Antonio das Mortes, 1969). And the impact of these groupings was such that it grew into a movement that embraced all Latin American countries producing a resisting cinema. This movement became known as the New Latin American Cinema. At the same time, debates on representation and identity were taking place in film journals. The impact of this wave of change was enormous and had world-wide repercussions best exemplified by the huge influence of the Third Cinema Manifesto (written by the Argentinian film-makers Fernando Solanas and Octavio Getino in 1969) and the international impact of the Argentinian collective film La Hora de los hornos (The Hour of the Furnaces, Grupo Cine Liberación, 1968).

The Cuban Institute of Film Art controlled the film industry and between 1960 and the late 1980s (when the economy collapsed due to the demise of Soviet Russia) it was a model of socialist film-making. Production was small but consistent, and always experimental, with a yearly output of six to ten feature

films and forty or more documentaries. Santiago Alvarez was a leading light in the documentary tradition and Tomás Gutiérrez Alea was a major figure in the feature film domain. Both domains cultivated a deliberate counter-cinema, a cinema that is improvised, social-realist, allegorical — deeply experimental and deliberately rough-edged. An intentionally Imperfect Cinema as Julio García Espinosa puts it (see Chanan, 1996, 743–5).

The 1960s and early 1970s, therefore, produced an extremely vibrant cinema throughout Latin America even though (with the exception of Cuba which seemed to tolerate criticism) some films were banned and in certain countries, where military dictatorships had already taken hold, film-makers were persecuted. This revolutionary cinema worked outside of genre and more in the vein of syncretic cinema (see cinema nôvo entry). In Brazil, one form of this syncretic cinema that espoused the aesthetics of garbage (a cinema working with scavenged and scarce resources) was Tropicalism. This was a cinema based on Afro-Brazilian or Afro-Caribbean culture, allegory and mythology (see above and Shohat and Stam, 1994, 310 for more detail). By the mid-1970s everything worsened with military coups occurring over the entire Latin American continent forcing film-makers underground or into exile from where they made a cinema of exile. Persecution meant death not just the force of censorship. A diasporic film culture grew outside of the Latin American countries (in North America and France in particular). Militant film-makers like the Chilean Raúl Ruiz eventually ended up in France where he went on to make what we can certainly call radical and experimental films but films which would be considered more auteurbased than revolutionary (see La Ville des pirates/The City of Pirates, 1983, or his 1998 film adaptation of Proust's A la recherche du temps perdu).

In some regards, there has been a shift in cinematic practices since the 1980s towards an international art cinema. At least, that is one of the major trends. A primary reason for this shift has been the growing importance of television as a consumer commodity for the reasonably affluent middle classes (who make up most of the cinema-going audiences after all) as well as its presence as a shared commodity in shanty towns. In a sense, cinema has rebecome an elitist cultural artefact (as it was in its earliest days). Thus, it has had to pitch towards a more international audience if it is to remain viable. A film that well exemplifies this tendency is Brazil's recent Oscar contender

Central do Brazil/Central Station (Walter Salles, 1998), a multi-coproduction (Brazil/France/Spain/Japan) which has enjoyed enormous success outside of Brazil (winning the Berlin Golden Bear, 1998). A road movie, scored by indigenous (Brazilian) music, it focuses on two protagonists (young and old) whose individual quests for identity act as an allegory for contemporary Brazil. Past and present inflect this travel towards the unknown future. The protagonists' poverty is matched by the pain of deprivation and insecurity experienced by the great majority of rural and metropolitan Brazilians. Religion and myth intersect to countermand belief in rational chronology (a concept which the two protagonists profoundly mistrust any way).

But there has also been the emergence of another new type of cinema - or, rather, new movements in cinema. The 1980s and 1990s have seen the emergence of a woman's cinema, a gay cinema and the native residents' cinema (what Shohat and Stam, 1994, refer to as Fourth cinema, see above). Often, working in video and super-8, but not exclusively, this cinema continues the tradition of the resisting counter-cinema of the 1960s. But it has produced a new type of representation of national identity. a more complex and less homogeneous one than the one imaged in the 1960s by the militant New Latin American Cinema movement (see above) which pitted the true inheritors of the earth (i.e., the subalterns: the disenfranchised Indians, peasants, and workers) against the elites. This cinema breaks free from an evocation of the dependency culture to which the elites had subjugated the Latin American nations. Geographically and spiritually this cinema is a more fragmented one, very much a regional cinema that represents rural and metropolitan Latin America in its many manifestations. Indians film themselves (for example, the Kayapo Indians in Brazil, and the Nambiguara Indians of the Amazon Basin). Women relate their stories across generations of women (e.g., Suzana Amaral's A hora da estrela/The Hour of the Star, 1985). And gays get a very rare voice (e.g., Jaime Humberto Hermosillo's Dona Herlinda y su hijo/Dona Herlinda and Her Son, 1986). This fragmentation can be read (and probably should) as a positive sign and not as one of miserabilism. In other words, it can be read as if the national consciousness that was required of the earlier militant cinema of the 1960s is now surpassed and no longer a necessary driving force of contemporary Latin American cinemas. (For further reading see Barnard and Rist, 1996; Burton, 1986; Burton-Carjaval,

1996; Chanan, 1985, 1996; Johnson and Stam, 1982; King, 1990; Pick, 1993; Shohat and Stam, 1994. See also *Screen* special issue on Latin American cinema, 38: 4, 1997.)

Middle Eastern cinemas Iranian, Israeli, Palestinian, and Turkish cinemas come under this rather loose denomination. But there is considerable difficulty in talking about a Palestinian cinema - at least since 1948, when Palestine became an occupied territory. Palestine has in fact always been an occupied country. The Jews believe that it is their promised land and that they have the right to live there, but so too do the Palestinian Arabs. The present occupation of the territory came about in 1947 when the then Palestine was divided into a Jewish state (which officially became Israel in 1948) and an Arab state that was shared between Egypt (the Gaza strip) and Jordan (the West Bank). Both these Arab territories were reclaimed by Israel in the Seven-day War of 1967. And since then the territories have been continuously contested by Israelis and Arabs, including the Palestinian Arabs who quite clearly feel totally dispossessed. As things stand, the Palestinian Arabs remain without an official territory of their own, even though they possess a national identity. According to Shohat and Stam's categories (see above), film products made by Palestinian Arabs could arguably be considered as Fourth World cinema - they are certainly diasporic. Similarly, it is difficult to conceive of Israel as a Third World economy. Israel, in that it points its political and economic cap towards the USA, is in this respect a Euro-American nation, not a Third World one. Viewed in this context it is hard to see how we can speak of a Third World Cinema where Israel is concerned.

Having said that, I will briefly sketch out these two cinemas before discussing Turkey and Iran. The historic area of Palestine was a popular 'site' for early cinematographers. During the late 1890s early 1900s, the Lumière brothers and Edison made travelogue-documentary films of Jerusalem and the 'Holy Land'. However, *Palestinian cinema* itself emerged out of the resistance that was established after the defeat of the Seven-day War in 1967, when Egypt, Syria and Jordan were defeated by the Israelis. Most of its cinema is diasporic, created outside of 'Palestine' by Palestinian exiles (in Iraq, Jordan and Lebanon). A small group of film-makers founded a resistance film unit in Jordan that was directly annexed to the al-Fatah/PLO movement (led by Yasser Arafat). After the Black September Massacre of 1971 (the Jordanian massacre of Palestinian refugees and freedom-fighters)

the unit moved to Beirut (in Lebanon). Subsequent to Israel's invasion of Beirut in 1982 this unit as well as other Palestinian film-makers based in that city left and settled in Tunis (Tunisia). A major trend in Palestinian cinema is the documentary one (for obvious reasons of economy). But it is one which sits well with the Palestinian need to make a political cinema and with the Palestinian oral tradition. A major Palestinian film-maker is Michel Khleifi, an Israeli-Palestinian citizen who has lived in Belgium for the last twenty years (half his life). His feature films and documentaries are strongly politicized and address - among other issues - the lack of female emancipation within Palestinian political culture and Palestinian dispossession in the face of the Israelis (see his documentary Al Dhikrayat al Kasibah (al-Djakira al-khisba)/Fertile Memories, 1980). Similarly, he addresses the double occupation experienced by Palestinian women who suffer oppression both from their own patriarchal society and the Israeli occupation (Urs fil Jalil/Marriage in Galilee, 1987). His Tale of the Three Jewels (1995) mixes documentary style with fiction: against the backdrop of the Palestinian-Israeli conflict, a young man seeks the three missing jewels that will permit him to win the love of the young woman of his dreams. In a similar vein, Rachid Mashrawi mixes documentary and allegory in his film about Palestinian refugees packed into Gaza refugee camps (Curfew, 1993. Haifa, 1995). Elia Suleiman's two films of the 1990s (Homage by Assassination, 1990, and Chronicle of a Disappearance, 1996) are remarkable reflections on the psychological effects of dispossession and occupation. Finally, in this brief overview, mention must be made of May Masri, the first Palestinian woman to make films (documentaries) which she co-directs with the Lebanese film-maker Jean Chamoun.

Israeli cinema, since 1948, is, in many cases, nationalist and full of ethnic rhetoric vaunting its superiority over Arab nationalists (see Eli Cohen's Ricochets, 1986). Although, during the 1980s, Israeli cinema produced a different representation of the Israeli–Arab conflict, one which was sympathetic to and acknowledged a Palestinian entity. These films which gave 'progressive images of the conflict' (Shohat, 1989, 240) showed the Palestinians as victim. These films, made by Israeli filmmakers, were known as the Palestinian Wave films. They were not liked by the Israeli Right (who labelled them Leftist) nor were they appreciated by the Palestinians who viewed them with suspicion. For the most part, these Palestinian Wave films sought

to represent the conflict and the attempt to transcend it through a love affair between a mixed couple – mostly an Israeli woman and Palestinian man (e.g., *Hamsin*, Daniel Wachsman, 1982, although *A Very Narrow Bridge*, Nissim Dayan, 1985, controversially reverses the order).

Conversely, in the predominantly heroic-nationalist films, gender and sexuality are very differently represented. Often the female body is the site upon which much of the nationalist ideals get played out. Thus women are represented as persons who, unlike their Arab counterparts, have egalitarian status and wield weapons and work the land. The Israeli woman sacrifices herself for the nation, bears arms and suffers unconditionally for her supposed privilege of equality. The reality is of course more complex. Many different Jews make up the Israeli state, some of whom have greater equal status than others. There are European/Ashkenazi Jews and Oriental/Arab Jews. The Oriental Jews are either Palestinian Jews or Sephardi-Mizrahi Jews. These Jews are considered ethnically inferior to the European Jew. What is noteworthy (as Shohat and Stam point out, 1994, 315) is that Israel's 'conflictual syncretisms' have given birth to an indigenous genre, the Bourekas genre (which takes the form of either a comedy or melodrama), in which the tensions between the two ethnic lewish groupings are played out and in which the woman frequently figures as the Sephardi Jew. (For further reading see Shohat, 1989; Kronish, 1996.)

Turkey is the first country amongst these nations to produce an indigenous cinema, primarily in the form of documentaries (e.g., the 1914 documentary The Demolition of the Russian Monument at St Stephen). The early period of feature film production did not get under way until the 1920s. A small number of films were made and (like Indian and Chinese cinemas) the main source of reference was the Turkish theatre. During this first period of Turkish cinema, which lasted through until 1940, there was only one production company (Ipek) and one film-maker Mushin Ertugrul who worked in close association with the Municipal Theatre in Istanbul. This period was also one in which Turkey was very orientated towards the West, thus Western film styles strongly influenced what few products were made (particularly French and German vaudevilles and melodramas). The second period, that of the 1940s, saw the establishing of a second production company (Ha-Ka Film) which broke the previous monopoly and made it possible for

new talent to emerge and different types of films to be made that had more in common with Turkish national culture. The beginning of the boom years coincided with the coming of a multi-party system in 1950. By the late 1950s production had risen to a range of a 150 to 200 films per year (on a par therefore with, or even exceeding, France's output). Generic types were quite broad: melodramas, rural dramas and city-based dramas, action films and urban comedies. This decade also saw the birth of the star system. However, the military coup of 1960 changed the direction of Turkish cinema and it veered towards a more inward-looking (as opposed to Western-looking) cinema that would draw on Turkish visual culture and tradition in an effort to establish a national cinema. An indication of the difficulties involved in producing a national cinema is exemplified by the presence, during the 1960s, of two completely opposing national film movements. The first movement was based on the belief that Turkish national cinema had to address the fundamental conflict, embodied by the nation itself, between modern Western values and Islamic traditional values. The second was based on Islamic ideology only.

By the late 1960s early 1970s, repression under military rule and the effects of a sustained civil war led to a peculiar type of censorship whereby semi-pornographic films were not banned, but the social-realist films of committed nationalist film-makers were. A major victim of this repression was Yilmaz Güney, who after years in prison, spent the last few years of his short life in exile (in France). When in prison he wrote scripts that were produced. He scripted *Yol* (*The Way*), made in 1982 by Serif Gören, which won the Palme d'Or at Cannes in 1983.

During the 1970s which was a period of stiff competition on the exhibition front (against Hollywood majors primarily), production soared to an average of almost 300 films per year. This hugely inflated number is mostly due to the inclusion of uncensored soft-porn (and even hard-core porn) movies which made up half the total number of films, and the 'cheapie' karate films being made at the time. The more traditional arabesque (musical) genre also figures, but in a fairly minor way when compared to the porn movies. The effect, however, was a diminution of audience figures which led to a crisis in the 1980s. Production slumped to seventy films per year until 1986 when the Ministry of Culture intervened to protect Turkish cinema from competition (both from television and the American

majors). The result was a rise in production — not to former levels but to an average of 185 films per year. This is a remarkable achievement if one considers that the 1980s was a difficult period of censorship thanks to the new military regime which came in on the back of the 1980 military coup. But the post-coup Republic/military dictatorship endorsed a mixed culture of economic liberalism and apoliticization of its citizens (thus porn films continued to be made, but political cinema was censored).

The cinema of the late 1980s and the 1990s is one which draws once more on Turkish tradition and which has seen a resurgence of the type of national cinema first advocated in the 1960s (one that addresses the tensions inherent in Turkish society and which also reflects Turkish narrative traditions). And it is noteworthy, in this context, that the prime mover behind the nationalist cinema of the 1960s, Halit Refig, was back on the scene making films (The Lady, 1988, Two Strangers, 1990). Production of the more popular cinema (arabesques, comedies), has decreased greatly in the 1990s due to competition for financing and the effects of television. Ninety per cent of the cinema market is dominated by American products. And television's rapacious demand for film products means that channels will go for cheap imports rather than the more expensive indigenous product. On a more positive note, however, the state has put in place a system of aid and Turkey now accesses Euro-images which helps on the production and distribution side of the industry. Furthermore, the 1990s has witnessed the emergence of a new generation of film-makers which includes a very healthy proportion of women directors (Mahinur Ergun, Canan Gerede, Tomris Giritlioglu, Furuzan, Biket Ilhan, Hanan Ipekçi Isil Özgentürk, Yesim Ustaoglu, and Seckin Yasar). (For further reading see Basutcu, 1996: Ozguc, 1988; Woodhead, 1989.)

Iranian cinema (formerly Persian until the Revolution of 1978) began in the 1900s with documentary films commissioned by the Shah. These were, as one might expect given their source, spectacles of Royal ceremonies and attractions (weddings, births, the Royal zoo) and were made for an elite consumption, that is, the Shah and his Royal entourage. This state sponsorship of documentary still prevails today. Iran's first feature films appeared in the 1930s. First came a silent film, Abi and Rabi (Avanes Ohanian, 1930) then Iran's first sound film, The Lost Girl which was directed in India by Ardeshir Irani (1933). It took a long

time for Iran to set up its own film studios. Pars Film Studio, established in the late 1940s, was the first and was owned by Esma'il Kushan who directed the two first sound films produced in Iran (*The Tempest of Life*, 1948, and *Prisoner of the Emir*, 1949). Films of this era were based on the Iranian traditions of folklore and epics, a tradition that would return in a big way under the Revolutionary oligarchy.

In the 1960s the state took control over the film industry which until then had been a mixed economy of private sector film production and state-subsidized films. The move was political and motivated by the USA's concerns about the spread of communism into Islamic states. The Shah was perceived as a natural ally to (and controlled some might say by) the United States. Films of the late 1950s and early 1960s expressed concern over the increased erosion of traditional Iranian values in favour of Western ones. Thus the state take-over was intended to redress a perceived imbalance and to foster a more pro-Western cinema. Production for a while was quite mediocre which of course sent audiences off to other cinema venues to watch Western products. The indigenous types of films being produced were comedies, melodramas and action-hero movies (the latter did not attract as much as their 'superior' American prototype). However, in 1969, two films launched what became known as the Iranian New Wave. Oaisar by Mas'ud Kimai was an action-hero film with a difference, thus recasting the poorer Iranian prototype. The film shows the negative effects of American Westernization on the Iranian people (the action-hero rescues the Iranian damsel in Western distress). The other film, The Cow directed by Dariush Mehrju'i, was a rural film filmed in the social-realist vein. Although this was not the dominant cinema of the 1970s (indeed it had great trouble getting its products financed) this New Wave lasted and informed film practices through until the Revolution of 1978.

During the first years of the Revolution, cinema was proscribed. It was banished as corrupt and redolent with Western cultural imperialism. Cinema theatres were burnt down. Almost all indigenous products were banned and once production got underway again, only a quarter of new products were passed by censorship and, therefore, got made. Strict imposition of Islamic law meant that women virtually disappeared off the screen. Many film-makers sought exile from where they have continued to make a diasporic cinema of Iran. In 1983, the Ministry of Culture established the Farabi Cinema Foundation, a body whose

function was to overview film practice and to ensure high quality products. By 1987, women were allowed back on the screen, but were shot according to strict criteria for modesty. Women film-makers also began to appear (around six in all). Censorship remains unabated, however. Iranian film-makers have to negotiate not just delicate taboo issues (such as the proscription of sex and any physical contact between opposite sexes unless they are related in real life) but also the equally difficult issue of political taboos. There are five levels of censorship - all have to be passed before a film can be exhibited in the country. Thus, even films that have been made can subsequently be banned. The Islamist freedom-fighter and film-maker (who fought against the Shah) Mohsen Makhmalbaf has had his work banned by the censor board of Iran (Gabbeh, 1994, for being subversive, A Moment of Innocence, 1996, for being anti-revolutionary). However, he enjoys a popular reputation in Iran. Furthermore, Makhmalbaf has established his own production company and co-produces with France. In 1997 he co-produced his daughter's, Samirah Makhmalbaf, first feature film (La Pomme/The Apple) which passed through the levels of censorship. The strict laws in Iran can produce other anomalies such as, for example, the film-maker Abbas Kiarostami who has managed to escape censorship, but who is more widely applauded internationally than he is nationally. His films are not commercially successful in Iran but they are with Western audiences (see The White Balloon, 1995, Through the Olive Trees, 1996, A Taste of Cherry, 1997 which won the Cannes Palme d'Or).

Where Iranian cinema is presently concerned, therefore, it would be fair to say that, while the infrastructure for production has been put in place ensuring quality films, none the less, distribution and exhibition systems are in a parlous state (partly because of the burning down of so many theatres and partly due to lack of available funding to remedy the problems). Lack of products means that the television market (often 'illegally' accessed by satellite) and video black markets are taking care of audience needs. For further reading see Issa and Whitaker, 1999; Naficy 1979, 1992, 1993.

30-degree rule (see also **180-degree rule**) A rule applied in the name of continuity which stipulates that, when there is a cut to another camera position, the camera should be at least 30

degrees from the previous one. If this rule is not observed and two shots are cut together of the same person or object within the scene without the camera having moved more than thirty degrees, the effect on the spectator is of a jolt as if the camera has jumped a bit. Essentially in terms of spatial logic there is not enough difference between the two shots in terms of angle (and therefore a clearly understood renewed position on the object) for the transition between the two shots to remain unnoticed. The result is a noticeable jump, what is termed a **jump cut**. The 30-degree rule serves to create an undisturbed **seam-lessness** in the film because such a shift does not draw attention to itself and is logically motivated within the **narrative**.

thriller/psychological thriller – (see also fantasy, film noir, gangster movies, motivation, horror movies, science fiction, voyeurism/fetishism) A very difficult genre to pin down because it covers such a wide range of types of films. Thrillers are films of suspense, so clearly film noir, gangster, science fiction or horror films are in some respects thrillers, as are detective thrillers (see gangster films). Some purists will differentiate terror movies as being distinct from thrillers, since a thriller is supposed to instil terror into the audience. I shall ignore that sub-categorizing and focus primarily on the psychological thriller, bearing in mind the overlap with the aforementioned genres.

A thriller relies on intricacy of plot to create fear and apprehension in the audience. It plays on our own fears by drawing on our infantile and therefore mostly repressed fantasies that are voyeuristic and sexual in nature. The master of the thriller is Alfred Hitchock, the greatest creator of anticipation and builder of suspense. Almost unquestionably he is the film-maker who invented the modern thriller. His secret is of course in the construction of his films. Often at the centre of the narrative is a fairly basic theme, usually a struggle around love and/or money, so that is not what grabs and enthrals the spectator. Fundamentally Alfred Hitchcock works through delay. He delays the action which we know is going to occur. We know Marion Crane is going to be murdered (in Psycho, 1960), but we do not know when or how. We, like Norman Bates, have been watching her, unseen, as we peep through the holes alongside Norman. When will terror strike? When it finally does, we

almost feel relief, certainly a release from all the tension that has been building up through the set of **gazes** that have been conferred on Marion. In this respect, the attacks on women in Alfred Hitchcock's films are clearly sexually motivated. Even if in some films (such as *The Birds*, 1963) they do not die, Alfred Hitchcock's women are assailed by knives, birds or brutally strangled (*Frenzy*, 1972).

Thriller films are, then, sadomasochistic. Indeed, the psychological thriller bases its construction in sadomasochism, madness and voyeurism. The killer spies on and ensnares his victim in a series of intricate and sadistic moves, waiting to strike. The killer is most often psychotic and his madness is an explanation for what motivates his actions. He agences murderous power through his madness. Such is not usually the luck of the woman. Madness predominantly privileges women-as-victim far more than men. Their madness is a deep-rooted phobia that often has a sexual cause. Marnie's fear of men (in Marnie, Alfred Hitchcock, 1964) is due to her violent reaction to seeing her mother aggressed by a sailor - Marnie kills him, but is for ever stuck with the neurosis that men equal sexual aggression. She is stuck, that is, until her all-knowing husband cures her. In Repulsion (Roman Polanski, 1965), as the title already indicates, the heroine's revulsion at men's sexual advances is the result of the fear and repulsion she experiences when confronted by the primal scene (the parents copulating). Men who get too close to her get murdered.

Voyeurism operates within the film (is **diegetically** inscribed) but the film also operates to position us as voyeurs. One film that brilliantly exposes this process is Michael Powell's Peeping Tom (1960). The film itself foregrounds voyeurism, positions us as voyeur-director and as the victim, and in the closing shots makes us voyeur of our 'own' victimness (for a discussion of this point see foregrounding). In this way we too play out the sadistic scenario and derive pleasure from re-experiencing our primitive and infantile desires. It is noteworthy that many thrillers focus around bad parenting - or that bad parenting is the cause of psychotic behaviour. Norman Bates in Psycho and Mark Lewis in Peeping Tom both had bad parents: an overbearing mother in the first case, a disapproving father in the second. Sibling rivalry can also cause psychological disorders of a life-threatening kind (as in Whatever Happened to Baby Jane?, Robert Aldrich, 1962). But so too can sibling narcissism (as in Dead Ringers, David Cronenberg, 1988). The two identical twins, both brilliant gynaecologists (!), live in perfect harmony with one another until a woman enters their life with an amazing gynaecological problem (a triple cervix). She disrupts the twins' symbiosis and symbolically castrates them (well, she would with a triple cervix wouldn't she?). Incapable of coping with woman-as-difference and terrified of separation, one of the twins takes to drugs and becomes increasingly hysterical in relation to women. He eventually drags his brother down with him and the two finally succumb to a gruesome double-death.

One final point. Although thrillers are more about fantasy than reality, they do fulfil a very real need. Otherwise why would we go to the movies? We do have a psychological fascination with horror, we like being made afraid. For this reason many thrillers have an aura of 'the possible' about them. To achieve this, the settings are as ordinary as one's own familiar environment. Alfred Hitchcock's *Frenzy* is a good example of this everyday ordinariness in which ordinary women keep getting murdered (the setting is London, more specifically the former Covent Garden, the murderer an ordinary fellow, a fruiterer). Roman Polanski combines the fantastic with the ordinary in *Rosemary's Baby* (1966) where he juxtaposes demonic possession and witchcraft with contemporary New York.

time and space - see spatial/temporal contiguity

tracking shot/travelling shot/dollying shot Terms used for a shot when the camera is being moved by means of wheels: on a dolly (a low wheeled platform on which a film camera is moved) and on tracks (hence tracking shot), in a car or even a train. The movement is normally quite fluid (except perhaps in some of the wilder car chases) and the tracking can be either fast or slow. Depending on the speed this shot has different connotations (for example like a dream or trance if excessively slow, or bewildering and frightening if excessively frenetic). A tracking shot can go backwards, forwards, from left to right or right to left, and the way in which a person is framed in that shot has a specific meaning (for example, if the camera holds a person in the frame but that person is at one extreme or other of the frame, this could suggest a sense of imprisonment).

transitions - see cut, dissolves, fade, jump cut, unmatched shots, wipe

transparency/transparence (see also ideology) This concept takes both these spelling forms, and refers to the notion that cinema, does not provide a window on the world, any more than television does, that is, the idea that it offers a one-to-one relationship with reality is a myth. Both media can, however, offer a transparence on the world: they can give a reflection on the world that surrounds us. Thus a war film like All Quiet on the Western Front (Lewis Milestone, 1930) gives a reflection on the horrors of the First World War trench warfare — a reflection that is closer to the truth than the dominant tendency of war films which is to glorify victory and heroize the individual.

travelling shot - see tracking shot

underground cinema The underground cinema movement in the 1960s was very important to the growth of US cinema. It was bold, outrageous and scornful of dominant cinema practices. It was also known as the New American Cinema Group: this group, formed in 1960, signed a manifesto accusing mainstream or dominant cinema of being morally corrupt. Underground cinema was a name coined by Stan VanDerBeek to qualify this independent film-making movement based in New York and San Francisco. This movement grew out of the 1950s Beat Generation and its revolt against conventional artistic practices. VanDerBeek was one of the practitioners of this movement, as were, more famously, Andy Warhol, Stan Brakhage and Kenneth Anger. Censorship was still in practice in the US (it was abolished in the late 1960s), hence the term underground, because in subject matter the films produced by this movement were proscribable products. The movement was not a cohesive group but stood as one in its determination to defy the censorship laws, which it deemed unconstitutional. And in fact it was one of the movement's most notorious films, Jack Smith's Flaming Creatures (1963) - a fantasy film about a transvestite orgy - which was hounded by the New York police and the US Customs but which, in the end, was shown as evidence before the States Supreme Court hearing on the abolition of censorship.

The collective that made up underground cinema were not necessarily film-makers, but came from different artistic backgrounds and saw in film a new way of self-expression. The heritage of this movement is traced back to Maya Deren's influential experimental film work on the subconscious, most specifically her film *Meshes of the Afternoon* (1943). And indeed

she helped to finance projects by other independent film-makers, particularly Brakhage and Anger. The first so-called underground film, Pull My Daisy (1959), was a Beat Generation film made by Robert Frank and the painter Alfred Leslie starring Jack Kerouac as voice-over and Allen Ginsberg as the poet. Kenneth Anger's films explicitly explored homosexual fantasies, rituals and dilemmas (see Scorpio Rising, 1963). Andy Warhol filmed real time by placing his camera in front of a building for up to eight hours and just letting the film roll (see Empire, 1965 - in front of the Empire State Building). He also parodied Hollywood genres (for example Westerns in Lonesome Cowboys, 1968). Other film-makers were more closely associated in their work with the cinéma-vérité tradition. Lionel Rigosin's and Shirley Clarke's documentary approach produced such politicized films as Rigosin's film on a down and out alcoholic in New York, On the Bowery (1955), and the clandestinely shot film among Black South Africans, Come Back Africa (1959); Clarke's films focused on Black ghetto subculture in Harlem: drugs and jazz (The Connection, 1961); adolescent crime and survival (The Cool World, 1963); Black male prostitute fantasy (Portrait of Iason, 1967).

unmatched shots Cutting from one **shot** to another so that there is no apparent **continuity** in action. This type of **editing** is typically used in **avant-garde** and **surreal** films as a means of creating a sense of disorientation in time and space. A classic example is Luis Buñuel's *Un Chien andalou* (1929).

vampire movies - see horror movies

variation - see repetition

vertical integration A term used to refer to a film industry practice put in place by **Hollywood** (although there are precursors to Hollywood) whereby the entire system of production, distribution and exhibition is controlled by the studio making the film product. Thus the studio makes the film, distributes it and controls its exhibition (often in its own theatres).

violence - see censorship, voyeurism/fetishism

visual pleasure - see scopophilia

voyeurism/fetishism (for fuller discussion see gaze, psychoanalysis, scopophilia, spectator positioning, suture) Voyeurism is the act of viewing the activities of other people unbeknown to them. This often means that the act of looking is illicit or has illicit connotations. We pay to go to the movies, but once we are sat before the screen we are positioned as voyeurs, as spectating subject watching the goings-on of the people on-screen who are 'unaware' that we are watching them. It is from this positioning that we derive pleasure (known as scopophilia, pleasure in viewing). Voyeurism is not limited to the spectator, however. The camera that originally filmed the action is also a

'voyeur'. Often there is a voyeuristic positioning of a character within a film. Alfred Hitchcock is notorious for this (as in *Rear Window*, 1954, and *Psycho*, 1960). A film that admirably foregrounds the complexity of voyeurism and all the subject positionings possible is Michael Powell's *Peeping Tom*, 1960 (see **foregrounding** for a discussion of this film in this light).

Fetishism refers to the notion of over-investment in parts of the body, most commonly the female body. Thus, in films women's breasts or legs are often 'picked out' by the camera and are, thereby, over-invested with meaning. Similarly, dress-codes can be part of this fetishizing process. Thus, a woman might wear a slinky, tight-fitting dress and long black evening gloves. Alternatively, she might be wearing very high heels, stilettos perhaps, and have her fingernails thickly nail-polished (in deep red if it is a film in **colour**).

In psychoanalytic terms, voyeurism and fetishism are two strategies adopted by the male to counter his fear of sexual difference (between himself and the female, sexual other) and the fear of castration which he feels as a result of that difference (the woman lacks a penis, the male assumes 'she' has been castrated). Thus, adopting the first strategy he fixes the woman with his gaze, voyeuristically investigates her body, and therefore sexuality - she is the object of his investigation and in that way he safely contains her. As the object of his look and surveillance, meaning is ascribed to her by him. Voyeurism, at its most extreme, can lead to sadomasochistic behaviour. The man watches the woman, she may or may not know that he is looking at her, she cannot, however, return the gaze (because it is he who has agency over it and thus over her). Ostensibly, she is his victim and he the potential sadist who can violently attack or even kill her. Most thrillers and films noir depend on this sadomasochistic dynamic for their suspense. Psycho is an obvious example, but The Shining (Stanley Kubrick, 1980) is a more recent one. And by way of a rare reversal of power relations, at least until the bitter end, Kathy Bates in Misery (Carl Reiner, 1990) entraps her favourite popular fiction writer who has broken his leg and is therefore 'impotent'; she keeps him under constant surveillance and, when he 'dares' to 'look back' (by refusing to do her bidding and write the novel she wants written!), thinks nothing of brutally attacking him with axes and all sorts of penile or castrating instruments. But all ends well, he gets away - this after all is a comic thriller.

Fetishism is no more kind to the woman. Fetishism is a strategy to disayow difference. The male seeks to find the 'hidden' phallus in the woman. This fetishization takes place by a fragmentation of the body and an over-investment in the part of the body (or a piece of clothing) that has been fragmented off. The purpose of this over-investment is, ultimately, through perceiving them as perfection themselves, to make those parts figure as the missing phallus. The female form is contained this time by a denial of difference. She is phallic, therefore safe. Marlene Dietrich was a fetished form particularly in Von Sternberg's films - she takes on a masculinized female form (see Kaplan, 1983, 49ff.). Marilyn Monroe was kept sexually safe by over-investment in her breasts and legs. More recently, many of Kathleen Turner's and Theresa Russell's roles have them (phallically) dressed in tight black dresses, stiletto heels with highly varnished nails and long sweeping hair - the deep voice just adds the finishing touch.

war films (see also genre) Given the devastating effects of wars, especially world wars, on the populations of the nations involved, it comes as some surprise that war movies are very much a minority genre – both in the West and the East – and that, as far as colonized and formerly colonized countries and nations are concerned, there is even less transparence. What transparence there is tends to glorify or put forward the heroics of a particular triumphant nation. Only rarely do these films look at the horrors of war. Within Western cinema on the whole, the vanquishing nation or colonizer's rightness in its endeavours has hardly ever been questioned or indeed explained – that is until recently.

The West has known two world wars since the birth of cinema. It has also been involved in various combats with regard to decolonization (particularly France) and wars that have been partially the outcome of the Cold War waged between the two superpowers (the United States and the former Soviet Union). What follows is a synopsis, largely based upon these various periods, of the representations of war in Western movies.

The Great War 1914–18 and its representation in cinema 1914–39. The Great War had been the 'war to end all wars'. The loss of life had been colossal, almost beyond belief – at least 8.5 million servicemen died on the two sides of the combat (the Allies lost 5 million, the Central Powers 3.5) and a further 21 million combatants were wounded. The loss of life on the eastern front (Germany's eastern border) was as great as that on the western front, yet it is the latter front that is the more notorious in film and in history books – perhaps because of the devastating futility of the trench warfare fought out on both sides along the Franco-German border.

In Europe during this period, the propagandist nature of films only lasted for the early part of the hostilities. But the patriotic melodramas did their bit to help enlistment. England Expects (1914), The Fatherland Calls (Das Vaterland ruft, 1914) and French Mothers (Mères françaises, 1916) are just a sample of the titles that were intended to encourage men into battle and women to support their patriotic sons, lovers and husbands in the war effort. However, audience taste soon waned for these films that demonized the enemy or glorified the sacrificial spirit of the ordinary indigenous population. Preference was felt for the escapist nature of American comedies and series. Paradoxically, in terms of patriotic fervour it would be the United States that would pick up where Europe left off. Until 1917, when the Americans went to war, the United States had adopted an isolationist position in relation to the war, an isolationism that was reflected in the film output. And what few films were made about war were pacifist in nature (for example, War Bride, 1916, urges women to abstain from bearing children until fighting ceases). By 1917 all had changed and films became increasingly militantly pro-war (for example The Kaiser - The Beast of Berlin, 1918). The change of attitude came about largely as a result of Germany's offensive against the trade embargoes placed upon it and the two other countries of the Central Powers alliance (Austria-Hungary and Italy). To counter the Allies' attempts to deprive it of trading and receiving materials, Germany in 1915 launched a submarine (U-boat) campaign against the United Kingdom and the mercantile activities of the United States (one famous sinking was of the British liner Lusitania in 1915). Anti-German sentiment, not expressed until this period, at the loss of American lives during this campaign was partly responsible for the United States joining forces with the Allies (France, the Soviet Union and the United Kingdom). Now the German was exposed on film as a ruthless rapist intent on ravishing America's virgins (The Little United States, 1917, starring Mary Pickford as the almost hapless victim) or a terrorizing colonialist who would invade America's shores (for example The Sinking of the Lusitania, 1918). In terms of content, these films did little more than transpose into American culture the jingoistic tone and stereotyping of earlier British and French films (such as The Outrage, Cecil Hepworth, 1915; Herr Doktor, Louis Feuillade, 1917).

Only after the war could a more acerbic eye be turned upon the savagery of war. But even so the number of films produced was minimal. For example, in the immediate aftermath of the war, France produced only one, and it focused on the horrors of war: Abel Gance's J'accuse (1919). Not until the tenth anniversary of the Armistice would the French film industry produce another film on the atrocities of that war. If anything, the United States was the more prolific. Capitalizing on the success of Charlie Chaplin's Shoulder Arms (1918), Hollywood was quick to realize that there was a taste for war movies, and during the 1920s several grand-scale reconstruction films of the United States' fighting role in the war were made. The Four Horsemen of the Apocalypse (1921), The Grand Parade (1925) and What Price Glory (1926) are just three examples of films that reconstructed battle scenes (often using veterans as extras). William Wellman's Wings (1927) pays homage to the fighter pilots of the war (then in their infancy). His film won the first Oscar ever, for best film.

The film to describe most explicitly the merciless horror of trench warfare was one of the earliest **sound** films to be made, Lewis Milestone's All Quiet on the Western Front (1930). The effect of this film was all the stronger since it was the first to bring the sound of war to the **images**. A strongly pacifist film, it portrays both the Allies and the Germans as victims of war, a senseless war. Jean Renoir's La Grande illusion (1937) also picks up on this theme, but by the late 1930s, with war again imminent, the pacifism of his film was met with **censorship**. During the early 1930s, Germany also produced anti-war films, most famously Georg Pabst Westfront 1918 (1930). However, given that moment in history and the rise of Nazism, the tendency was for the Germans to pay tribute to their war heroes, particularly those working in the submarines (Morgenrot/Dawn, Gustav Uciciky, 1933).

With the advent of the Second World War, the First sunk into oblivion as a film theme until the late 1950s. Stanley Kubrick's Paths of Glory (1957) and Joseph Losey's King and Country (1964) were just two films among a handful that returned to that 1914–18 period and seriously questioned practices operated behind the war scene by officers in power over young conscripts. In both Kubrick's and Losey's film the issue is that of courtmartials: three Frenchmen in the former film, a British soldier in the latter. More historically accurate films like these appear periodically in attempts to put the record straight (showing for example the effects of blinding gas in Aces High, Jack Gold, 1976) or to put on record war efforts that had been

neglected (for example the contribution of Australian and New Zealand servicemen to the war in Gallipoli, Peter Weir, 1981).

The Second World War If ever proof were needed that wars do not end wars then perhaps the devastating mortality figures of the Second World War will stand as testimony. Over thirty million service people and civilians died in this six-year war that left the world divided into two ideological parts (at least): the capitalist West and the communist East (of course geography does not oblige with such a neat schism: Cuba is in the west and Japan in the east!). The boundaries of traditional warfare had been blown apart by the dropping of the atomic bomb first on Hiroshima and then on Nagasaki (two important Japanese seaports). The savagery of this war can be measured by the fact that almost as many civilians as service people perished (14.7 million civilians including the systematic annihilation of 5.7 million Jews and an unaccountable number of gypsies and homosexuals; 15.3 million service men and women).

In the United Kingdom, as elsewhere, the documentary was perceived as a vital instrument for both morale boosting and propaganda (see ideology). Already in the First World War the documentary had been used to chronicle some parts of the war, that is once the ban on cameramen (sic) was lifted in 1915, thus permitting them to go to the front. These documentaries included footage of the disastrous battle of the Somme. Documentary was already a strong tradition in the United Kingdom, harking back to work done for the GPO Film Unit by the Grierson Group - a group of documentarists headed up by John Grierson (see documentary). This film unit was renamed the Crown Film Unit in 1940. These documentaries focused both on the home front and on hostilities overseas. London Can Take It (Harry Watt and Humphrey Jennings, 1940) portrayed life going on as normal in London during the day despite the night raids by German fighter planes. This film was extremely influential in the United States in obtaining funds for Britain's war effort. In the same vein of Britons 'getting on with it' were Jennings's Heart of Britain (1941), showing ordinary people coping in the north of England, Listen to Britain (1942) about the British facing up to the hardships of wartime and Fires Were Started (1943) about the London fire service. Target for Tonight (Watt, 1941) portrayed the RAF bombing raids on Germany, showing what all the home-front hardship was for: victory. (The film was a studio reconstruction, although real RAF pilots were used.)

Nor was the focus uniquely on the confrontation with Germany on European soil. Films from the Service Film Units provided images of campaign victories in North Africa (*Desert Victory* and *Tunisian Victory*, both 1943) and the Far East (*Burma Victory*, 1945).

If the war can be said to have had any positive impact on the film-making industry, as far as the United Kingdom and France were concerned, it did free up slots for new talent to emerge. The American presence in Europe 'went home'. (The United States had not joined the war until 1941 after the Japanese had bombed its naval base at Pearl Harbor in the Pacific.) As for the French presence, certain of the established names, including immigré Germans and Austrians fleeing Nazi Germany, escaped to Hollywood. The new talent emerged from their lesser roles into that of film-maker: David Lean, Sidney Gilliat, Frank Launder and Charles Frend in the United Kingdom, Robert Bresson, Jacques Becker and Henri-Georges Clouzot in France. In the United Kingdom many of the films produced were about the RAF, the naval forces and the merchant navy. Exceptionally with the new generation of film-makers, the shift in emphasis was away from class, still very much in evidence in other established film-makers' work (see Anthony Asquith's The Way to the Stars, 1945). Their films exemplified group solidarity dissolving class lines, and they stressed the ordinariness of people fighting the war (see In Which We Serve, Lean, 1942; San Demetrio, London, Frend, 1943). The importance of women in the war was also signalled (see two 1943 films: The Gentle Sex, Leslie Howard, about the women in the Auxiliary Territorial Services, and Millions Like Us, Launder and Gilliat, about women working in a munitions factory).

For France the story was completely the reverse. As an occupied country (1940–44) France could not address the war either as resistant to the Germans or as collaborator. This is why the few films that did appear to have a 'message' commenting the time were read so conflictually as simultaneously resistant and collaborationist. A classic example is Clouzot's *Le Corbeau* (1943), a film about a small town riddled with fear as a result of a spate of poison-pen letters. Another example is Jean Grémillon's *Le Ciel est à vous* (1944), about a female aviator who, after successfully completing a transatlantic flight, returns to the bosom of her family and carries on as good mother and housewife. In post-war France very few films indeed reflected the immediate

past. Those that did eulogized the work of the French Resistance (eight films in all immediately after the liberation), most famously perhaps *La Bataille du rail* (René Clément, 1946).

In Germany propaganda had been underway throughout the Nazi régime since the early 1930s (with Goebbels as Hitler's propaganda minister). The work of Leni Riefenstahl is most often mentioned in this connection (see Triumph of the Will, 1934) although during the war she was virtually inactive. The primary message of Germany's propaganda was its Aryan superiority, its victorious war campaigns and its heroism. The most notorious 'documentary' film was Dr Franz Hippler's The Eternal Jew (Der Ewige Jude, 1940) which purported to document the evils that Jews had wreaked on Germany (including causing Germany the loss of the First World War) and showed them as degenerate, even barbaric, in their traditions and culture and as corrupters of German aesthetics. Apart from the documentary propaganda, the German film industry produced a fair number of historical films which, in particular, praised former great leaders of the nation (for example Bismarck, 1940). Historical films were also produced to target Germany's reviled enemy, Britain. These films attacked Britain as the evil oppressor in Ireland (The Fox of Glenarvon, 1940, and My Life for Ireland, 1941 - both made by Goebbels's brother-in-law, M. W. Kimmich). Alternatively, Britain was the imperialist creator of concentration camps run by Churchill during the Boer War (Uncle Kruger, 1941). This last piece of propaganda was in fact based in truth. During the Boer War the British did set up concentration camps in which some twenty thousand women and children perished.

Both Germany and Britain exploited the historical reconstruction to propagandistic ends: the Germans to show their courage, their genius and their sense of vision as a nation that was politically and culturally unified, the British to extol their indomitable spirit against all odds (what is now termed the Dunkirk spirit – oddly since Dunkirk refers to a 'valiant' retreat by the Allies in 1940 when France was occupied). Bismarck, Schiller, Bach and Diesel were just some of the geniuses Germany paraded before its cinemagoing **audiences** (in films of the same titles). Britain turned to Nelson, exhorting Britain to go to war against Napoleon (*That Hamilton Woman!*, Alexander Korda, 1941); to Disraeli and his defiance of Bismarck (*The Prime Minister*, 1941); and to Henry V and his rallying call to

the English for one more effort to overcome the enemy (*Henry V*, Lawrence Olivier, 1944).

The war established a documentary tradition for the Soviet Union, United States and Japan. The Soviets often compiled documentaries exemplifying the collective spirit of a united Soviet Republic (see A Day at War, 1942, with a hundred contributions from the front and Berlin, 1945, with forty contributions capturing the taking of Berlin). The documentary was exploited far less in Japan and on the whole extolled the duty to fight, but not without giving a realistic portrayal of the dangers of war (see Yamamoto's The War at Sea from Hawaii to Malaya, 1942, a reconstruction of the bombing of Pearl Harbor). In the United States documentaries were used to explain why the country had engaged in the war - a necessary procedure given its isolationism and fairly neutral pacifism during the first twoand-a-half years of hostilities. Most exemplary was Frank Capra's documentary series Why We Fight (1942-45). The seven documentaries that make up this series document the rise and spread of fascism, the aggression of those fascist nations on others and, finally, the threat of fascism to America. Questioning the merits of engagement does not arise. Indeed the series was commissioned by the United States War Department. The maverick style in which John Ford's equally propagandistic film The Battle of Midway (1942) was made and finally shown to President Roosevelt for approval also points to a committed unquestioning stance. Ford, a lieutenant-commander serving in the Pacific, brought back to the United States actual footage of the Battle of Midway, determined to make a film for the mothers of America so that they would be proud of their sons' bravery in war and be moved to support American engagement (and send more sons to fight). It was made in total secrecy, shown to the President and approved for general distribution. John Ford had become the John Wayne of war documentaries.

Before the United States joined the war it produced several films, made in Britain, in support of the British. For example, the British film *That Hamilton Woman!* was a United Artists London film. As already mentioned, this film was an historical reconstruction. Others showed British courage in the face of German bombing raids (William Wyler's *Mrs Miniver*, 1942). More usually, however, these films took the form of an American serviceman participating in a British campaign (as with *A Yank in the RAF*, Henry King, 1941). These types of film also had

the merit of not upsetting the isolationist camp in the United States which, despite Roosevelt's wish to assist Britain in the war effort, had a strong hold on how the nation conducted itself. Furthermore, these films were muted and were not allowed to be particularly anti-fascist for fear, according to the studios, of political and economic reprisals - although why this fear arose is questionable since by 1940 Hollywood could not export to most of mainland Europe because it was occupied by the Germans, who had imposed a complete ban on the import of American products, including films. This fear may point to the widely acknowledged belief at the beginning of the war that the Germans would win the war and that it would be foolish to lose future markets. A simple example will illustrate this fencesitting attitude. In 1939 (just prior to the war) Warners released Anatole Litvak's Confessions of a Nazi Spy, an explicitly anti-Nazi film. Germany, which still had a diplomatic presence in the United States, expressed its indignation and Warners were warned off making any such film in the future.

If until the United States' engagement in the war Hollywood played a rather minimal and unpartisan role in relation to the war effort, such was not the case once Pearl Harbor brought the United States into the war. Roosevelt put pressure on the studios to participate in the propaganda and morale-boosting necessary to get the United States behind the fight. Stars helped either by joining up (Clark Gable, James Stewart), by entertaining troops or getting ordinary Americans to buy war bonds (Bing Crosby, Bob Hope, Rita Hayworth, Bette Davis, Marlene Dietrich). The war film took off. Comedies, musicals, and combat films, films depicting the effects of the war on European citizens - all of these came pouring out of Hollywood, under the strictest of government guidelines. In the period 1942-45 Hollywood produced some five hundred war movies out of a total output of 1,700 films. The earliest films obeyed the governmental criteria of patriotism against fascism (see two 1942 films, Yankee Doodle Dandy, a musical, and Remember Pearl Harbor, a war film with a clear call to arms). A different form of patriotism is advocated in Jean Renoir's This Land is Mine (1943) and in some ways it is surprising it slipped through unnoticed when the war was at one of its most critical moments (the defeat of the Germans at Stalingrad and El Alamein). The central protagonist, played by Charles Laughton, declaims on two occasions in the film the right to freedom of speech, life, liberty, and democracy based on the founding principles of socialism: equal rights for all.

On the whole the stereotyping in the war films reveals a curious mixture of jingoism, ambivalence and naivety. The jingoistic attitude prevailed in the representation of the Japanese. They were the evil, sadistic torturers who would go to any lengths to win (as in Across the Pacific and Wake Island, both 1942, and the fiercely anti-Japanese Purple Heart, Lewis Milestone, 1943). As far as the representation of the Germans was concerned, they were either the evil Nazi (Hitler's Children, 1942) or the good German (The North Star, 1943). They could in fact be a blend of the two as in Conrad Veidt's Nazi in Casablanca (Michael Curtiz, 1942). Veidt, it will be recalled, was the fetish star of the German expressionist films (so not a little irony here since Hitler held the Jews responsible for the decadence of expressionism!). The ambivalence in these particular films can be understood in the light of the large numbers of German immigrants and second-generation Germans residing in the United States. The open hostility to the Japanese, however, resides in their otherness and purported inscrutability.

But, in terms of stereotypes, by far the oddest response was to the Soviets. In films such as Mission to Moscow, North Star and Song of Russia (all 1943), Soviets were cast as ordinary people just like the 'folks back home'. Ideologically there was little to separate the two 'great nations': the Soviet Union was a virtual reflection of the United States: singing, dancing and uncomplicated. Stalin was Uncle Jo, and his repression of dissidents a necessary step for national and international security in the time of war (let it not be forgotten that the United States had incarcerated thousands of Japanese-Americans in California, under the same pretext of national security). This whitewashing of a precarious ally - after all the Soviet Union had signed a nonaggression pact with Hitler which broke down only when the Germans decided to invade the Soviet Union in June 1941 is not astonishing in the light of war. Beyond the strategic need for fighting to take place on Germany's eastern front, thus dispersing German resources and weakening the enemy, there was doubtless a more hidden agenda that explains this naive representation of the Soviets. The Soviet armed forces were needed if public support for the war was to be maintained 'back home'. Presidential popularity, therefore security of office, is and always has been notoriously tied - in times of combat - to the

number of 'body bags' sent home. Eleven million Soviet combatants died in this war and seven million civilians (over half the total deaths in this war). American casualties were not light, but in relation to those figures they are certainly less awesome (292,131 combatants and 6,000 civilians).

The idea that the United States was fighting a just war and that sacrifices were necessary was not a mood that prevailed, however. By 1943, doubtless because returning servicemen were bringing the message home that the war was not being won, several films had begun to reflect a greater reality in sharp contrast to the heroization and fervent patriotism expressed in the general run of war movies. Several films reflected the setbacks and defeats suffered by American troops against the Japanese. Bataan (Tay Garnett, 1943) ends with the massacre of an American patrol. Air Force (Howard Hawks, 1943), Thirty Seconds over Tokyo (Mervyn Leroy, 1944) showed the gruesome reality of air combat. The Purple Heart depicted the torture of American prisoners of war at the hands of the Japanese.

Immediately after the war several American war movies began if not to question then certainly to expose the futility of war, its horrors and the atrocious conditions under which it is fought (as in The Story of GI Joe, William Wellman, and They Were Expendable, John Ford, both 1945). But by the late 1940s Hollywood was back to its more jingoistic practices, undoubtedly as a result of the Cold War and the activities of the House Un-American Activities Committee (HUAC). An exemplary film in this context is The Sands of Iwo Jima (1949), subtitled The Marines' Greatest Hour, and starring John Wayne. Warwearied Britain dropped the genre only to return to it with grand-scale heroization of the RAF in The Dam Busters (Michael Anderson, 1955). This jingoism and heroization was sharply contrasted by the sense of loss and defeat apparent in the few films made by the losing nations, Germany and Japan - it is revealing that they were not post-war films as such but products of reflection, coming some ten years after the end of hostilities. Kon Ichikawa's two films on the devastation and dehumanizing effects of war, The Burmese Harp (1956) and Fires of the Plain (1959), reveal the full horror to which Japanese troops were exposed. In the first film a former army scout becomes a Buddhist monk who roams across Japan burying the war dead; in the second, which is set towards the end of the war, starving troops are reduced to cannibalism. The desperate lengths to which Germany would go in the face of the inevitable loss of the war is virulently described in *The Bridge* (Bernhard Wicki, 1959). Short of manpower, young adolescents are conscripted to defend a bridge, futilely, since they get blown up.

As with the Western, the war movie, at least until this period, had a fairly unchanging iconography. Combat is either on a grand scale (military manoeuvres, tanks and so on) or on a small. even individual one (as with fighter pilots). Quite frequently there is a target to be obtained (a hill, a bridge). There is an ensemble within the corps of servicemen with whom we identify (see spectator identification) and who display different types of courage. Comradeship is paramount. The enemy is absent except as an impersonal other (and therefore bad). There were, of course some exceptions to this uncritical heroic representation of war. Class conflict destroying prisoner of war morale is central to David Lean's The Bridge over the River Kwai (1957), and the corruption of officers and their indifference to the fate of their men is exposed in Stanley Kubrick's film (based in the First World War) Paths of Glory. As with other genres in the 1950s, psychology was being introduced as a mainspring to character motivation. Thus, a certain number of films which attempted to go counter to the dominant trend tried to examine the psychological effects of warfare - as in Lewis Milestone's Halls of Montezuma (1950), about combat fatigue; and Robert Aldrich's Attack! (1956), which looks at officers' cowardice and the fear of fighting. More recently, in the 1990s, there have been films showing local heroism within the magnitude and horror of war. The gore of war is matched by the unheralded heroism of an individual who stands for humanity. For two contrasting versions of this representation of war see Steven Spielberg's Saving Private Ryan (1998) and Terrence Malick's The Thin Red Line (1998).

In general, vanquishing nations tend not to look too closely at the ambiguities of war. This is also true of film. Questions can be asked only if there is doubt, and victory is less conducive to doubt than defeat. And it is worth noting that, as far as the United States was concerned, only when the ignominy of defeat became undeniable and questions had to be asked – as they were over Vietnam – did an 'unglorious' look at war become more commonplace. But before that came the Cold War.

The Cold War and Vietnam The term Cold War refers to the hostilities between the two superpowers and their allies following

the Second World War. The fear of nuclear war (as exemplified by the effects of dropping atomic bombs on Hiroshima and Nagasaki) proscribed military confrontation (even though both powers reputedly stockpiled nuclear arms). So war was conducted on economic, political and ideological fronts. This was the epoch for the spy, counter-espionage, paranoia about the spread of communism or capitalism and, finally, the age of intervention into the political arena of countries too small to prevent the encroachment of the two superpowers who annexed them as satellites.

The Cold War produced anti-communist films from Hollywood (such as The Red Menace, The Red Danube, both 1949; I Was a Communist for the FBI, 1951; Big Jim McClain and My Son John, both 1952). These were virulent anti-communist melodramas where protagonists either wake up to the dangers of communism, and sniff it out or die for their mistake in believing that communism was a good thing. Alternatively the Red Menace could take an alien form, as in Red Planet Mars (1952) and Invasion of the Body Snatchers (1956). Paranoia was also felt at the risk of nuclear war. This mood generated a series of films either in the apocalyptic mode (The Beginning or the End?, 1947; White Heat, 1949) or in the post-holocaust one (Five, 1951; The World, the Flesh and the Devil, 1959). Unsurprisingly, the Soviets produced their own anti-American films. Mostly these focused on the imputed evildoings of the CIA (for example Secret Mission and Conspiracy of the Doomed, both 1950).

However, perhaps the film-maker most associated with Cold War movies is the American Sam Fuller. He made three films based on US intervention during the hostilities between North and South Korea: Steel Helmet, Fixed Bayonets (both 1951) and Hell and High Water (1954). They are all extremely violent films - since he mostly made **B-movies** he suffered less interference from the censors. But his representation of violence set a precedence for movies to come, particularly in the 1960s and 1970s films of Arthur Penn and Sam Peckinpah (for example Bonnie and Clyde, 1967 and The Wild Bunch, 1969, respectively). Fuller's influence extended beyond the depiction of violence, however. His editing style, which deconstructed the seamlessness of traditional Hollywood practices, considerably influenced Jean-Luc Godard and later certain film-makers of the New German Cinema (Rainer Werner Fassbinder and Wim Wenders), and later still Martin Scorsese. Fuller's modernity or prescience is

(arguably) evidenced by the fact that he was the first to portray the Vietnam War as an issue for the United States, long before it became officially engaged in the war. His 1958 film *China Gate* tells the story of an American legionnaire fighting for the French in Vietnam. As opposed to the traditional role of a legionnaire as detached from any patriotic or personal motivation, his fighting the communist enemy is personalized. He sees their defeat of the Vietcong as the imperative that will allow him to take his son (the progeny of his marriage to a Eurasian woman) back to the United States.

All wars remain remarkably difficult to 'talk' about in films - unless they are the jingoistic films we associate, say, with John Wayne (Green Berets, John Wayne/Ray Kellogg, 1968) and Sylvester Stallone (Rambo, George Pan Cosmatos, 1976). The 'truth' about the war - with one or two brave exceptions (usually censored) - rarely comes out until some decent amount of time has elapsed and the nation's psyche has had time to recover. Interestingly, this was not the case with Japan. After 1952, when the occupation of Japan by the American Allies was over, Japan made several post-Holocaust films about the atomic bombing of Hiroshima and Nagasaki that had brought the country to an abrupt cessation of hostilities with the Allies. Until that date. Japan was not permitted to broach the subject from a critical or realistic point of view. Once the ban was lifted, a variety of films on the subject of the effects of the atomic Holocaust were made. The horror of the holocaust was represented in Kaneto Shindo's Children of the Atom Bomb (1952), Heideo Sekigawa's Hiroshima, Hiroshima (1953) and Akira Kurosawa's Record of a Human Being (1955). The effects of the atomic fall-out, such as producing monsters and mutants, is the subject of Ishiro Honda's horror movie Godzilla (1955). Conversely and more typically, in the West, issues raised by the atomic bombing - such as the kind of reasoning that makes such attacks possible - did not get raised until the mid-1960s, some twenty years after the event. In 1964 Stanley Kubrick launched a virulent satire on those in charge and capable of unleashing atomic warfare (Dr Strangelove, 1964) and in 1965 Peter Watkins made a politically uncompromising film that examined the effects of a nuclear attack on Britain (The War Game).

With regard to Vietnam, the United States was, perhaps surprisingly, not so slow to produce films that attempted to view critically the impact of that war on the American mentality, particularly that of the American GI. The war was officially over by 1976. Martin Scorcese made Taxi Driver in the same year. Then in 1978 and 1979 came Michael Cimino's The Deer Hunter and Francis Ford Coppola's Apocalypse Now. These films focus on the effect of the war on the individual and in that light can be seen as progressive. They do not, however, question America's legitimacy in fighting that war. In Scorsese's film the neglected and despised Vietnam veteran becomes a self-appointed vigilante of urban New York and finally wins acclaim as a hero. In the other two films the real issue of why the war was being fought is again side-stepped and, although the protagonists are clearly severely disturbed by what has happened to them in Vietnam, there is no mistaking that the cause for the action in both films is the sadism of the enemy, the unknown other. The only film of the period that came close to a committed questioning of the United States' involvement in Vietnam was Hal Ashby's Coming Home (1978) starring Jon Voigt as the disabled veteran and Jane Fonda (who had been politically active against the war) as the woman who falls in love with him. Unfairly, perhaps, some critics slated the film as sentimental, worse still as letting America off the hook in terms of guilt about the war. Rather the film, while it does centre the Vietnam issue in one person, raises issues about why American troops were sent there and why they were so devalorized when they came home alive or half alive. It does, therefore, put America's warmongers on the stand. Ten years later, using a similar narrative, Oliver Stone's Born on the Fourth of July (1989) is in a position to take this questioning a whole lot further - condemning the war and exposing the lack of compassion and proper care made available to veteran victims of the war. In the late 1980s and early 1990s a smattering of films have attempted to address that war more realistically, with portrayals of American brutality, the horror of the actual fighting, the racism suffered by Black Americans from their own compatriots - and so on (for example Platoon, Oliver Stone, 1986 and Hamburger Hill, John Irvin, 1987, Full Metal Jacket, Stanley Kubrick, 1987).

Westerns (see also genre) Also known as the Horse Opera or Oater, the Western became a genre that was very early incorporated into the film industry's repertoire. The first, official, Western was by the American film-maker Edwin S. Porter, *The*

Great Train Robbery (1903). Although the Western is considered an exclusively American genre, this is not the case. The French, for example, were making Westerns and exporting them successfully to the United States at least until the First World War – most famously the *Arizona Bill* series, starring Joë Hammond (1912–14). And, of course, later on in the history of this genre the Italians turned to making the so-called spaghetti Westerns (1965–75).

In a sense, the silent Westerns (though of course they were accompanied by music) were simply carrying on where reality had left off. The 'civilizing' of the West was virtually completed when cinema was born, and the cowboy's life as a herder had more or less come to an end as a result of the landrush and subsequent homesteading. The effect of this great migration west was to close off the open range. The landrush to all intents and purposes made the cowboy defunct. Given the mythic value of the cowboy as far as Westerns are concerned, it comes as some surprise that as herders cowboys only existed fully for a brief period: 1865-80 - at which point the beef boom foundered. Homesteading was complete, the new towns and cities were established and there was no more need for driving the cattle west to feed the people. These factors - civilization and the open range or wilderness - are two first keys to the typology of this genre. The hero (sic) is constantly operating at the point of conjuncture of these two opposing values. He never really wants to accept civilization, as embodied by the woman (who brings with her from the east the notion of community, family and so on). Rather he is always desiring to be on the move in the Wild West. The cowboy, with his restless energy and rugged, dogged individualism, is in the Western the embodiment of American frontiersmanship, or at least the myth of that frontiersmanship. However, the fact that the cowboy or gunman is always represented as being caught between the two values points to the ideological contradictions inherent in the myth of that frontiersmanship. The hero's actual ambivalence reveals the nation's own ambiguous attitude towards the West. Civilizing the West meant giving up the freedom it represented, including of course freedom of the individual, a high price for Americans to pay for national unity. However, the duration of the genre - possibly the longest lasting one of all - points to America's fascination with the frontier as a site of hope for something new and better.

The tradition of the cowbov as mythic hero dates back to the Western dime novels published from the 1860s. These novels dramatized lives that were both real and fictional and elevated the cowboy to mythic status. In the early days of cinema, at least, these novels were the primary sources for the Western movie, which is a part explanation for the highly ritualized nature of this genre. These novels also heroized outlaws (Jesse James being a favourite) and indeed lawmen. And as we shall see, the heroization of the outlaw also became a typology of this genre. In fact, real-live outlaws and cowboys - especially cowboys who had been rodeo riders - came into the film industry up until as late as the 1930s and 1940s (Gene Autry and Roy Rogers are two well-known names). Buffalo Bill starred in his own film The Adventures of Buffalo Bill (1913). A reformed bank robber, Al Jennings, starred in several early Westerns. However his films did not glamorize the West, rather they told the truth about the sordid money-grabbing practices that were so prevalent (as in The Lady in the Dugout, 1918). These were not the images the public wanted to see, so his career soon ended.

Audience expectation, then, is a second factor explaining the ritualistic and formulaic nature of the Western. This ritualization needs to be discussed before continuing with the history of this genre. The dime novels tried to explain 'how the West was won', even though of course it was not won. It was taken away from the Indians by the 'few' property speculators, and what was left over from the good gold-mining terrain and profitable land, which they kept, was sold to the beleaguered pioneers who had come so far for so little. Dime novels could not tell this story any more than films. Audiences wanted to see the West as it should have been, that is as myth. The ritualistic narratives of the Western do, however, reveal the ideological contradictions of this myth. Rituals are about the fear of loss of control, of mastery (sic). Thus the eternal repetition, as represented by rituals and the formulaic construction of the genre as well as the audience's own ritual in going repeatedly to see these films, reflects the desire to reassert that control and mastery (we know this is not the truth, it is myth, but we keep going back to see it because we want it to be so). The narrative rituals of robbery, chase and retribution, of lawlessness and restoration of law, are iconographically inscribed in the Western, right down to the very last detail and gesture. Attacks are repeated in different ways. The stage-coach chase is replaced by the wagon-train attack, the train robbery, the cavalry charge or the Indians swooping down on 'innocent' homesteaders. Cattle drives, gold prospecting and railroad building are epic markers saluting the glory of going West. The ritual of the gunfight (in or out of the saloon), the pushing through the saloon swing-doors and swagger up to the bar – all are images that we immediately associate with the genre. All, of course, constitute a massive cover-up of how the West was colonized in the name of capitalism. That story would be told, but only rarely, and Al Jennings was one of the first to tell it so. However, back to history.

The first Western hero was one of his own making, Gilbert M. Anderson. He persuaded Thomas H. Ince to let him star in The Great Train Robbery. Just as importantly, it was he who took the Western out West in the name of authenticity. He formed his own production company, Essanay, and made a large number of films starring himself as Bronco Billy. The Bronco Billy series lasted from 1910-18 (for example Bronco Billy's Redemption, 1910; The Making of Bronco Billy, 1913). He was quickly followed by William S. Hart, who made his début in 1914. He too strove for authenticity and worked first for Ince, then for Paramount. Hart's films were quite pessimistic and bleak. He played the same role of the baddie who is really good deep down inside and who gets redeemed by the end of the film. His most accomplished film is Tumbleweeds (1925), which he produced and in which he starred. It contains extraordinarily realistic footage, including the settlers' landrush sequence composed of three hundred wagons and at least a thousand men, women and horses.

By the late 1910s the Western, by now a great favourite, spawned five big Western **stars**, whose careers went well into the 1920s – some lasting as long as into the 1930s (that is into **sound**). The five 'greats' were, first, Tom Mix, who wore highly stylized outfits, the first to do so, a tradition that carried on through into the fringed shirts, soft leather gloves and gaily painted leather boots worn by Roy Rogers. More macho in image and in action were Buck Jones and Tim McCoy, great stuntsmen who had, like Mix, started out their careers in rodeo and Wild West shows. The last two, Hoot Gibson and Ken Maynard, were often paired in films. Between them they significantly developed the iconography of this genre: Mix's costumes have already been mentioned; the horse became a focal point, almost a second hero; cowboys started to sing.

The first Western **epic** is James Cruze's *The Covered Wagon* (1923), closely followed by John Ford's *The Iron Horse* (1924). What is exceptional about Cruze's film, apart from the mammoth undertaking of attempting to put into film the enormity of the migration west, was that it was shot not in the studios but on location and was therefore a reconstruction of the migration as it had been experienced. Thus there were river crossings, Indian attacks and struggles through arduous weather conditions, all of which worked to give the film a **realism** that no other Western to that date had produced. Lasting two hours, the film convincingly evoked the two-thousand-mile trajectory undertaken by the pioneers.

The other contemporaneous epic, *The Iron Horse*, tells the end-part of the pioneering American spirit, the building of the railroads west. In this respect, this film and Cruze's are the bookends of the history of that epoch, at least the mythic version of it. Clearly, in this epic context, the mythical value of these films has nationalistic overtones. Indeed, Ford, the son of an immigrant family from Ireland, makes no attempt to disguise his commitment to the concept of America as the land of opportunity and to the Lincolnian belief in the America as one nation (he dedicated his film to Abraham Lincoln). The overriding message of this film is a belief in progress (the iron horse replaces the horse). However, not at any price: unity among men, not

individualism, is the only way of achieving it.

John Ford is arguably the greatest Western film-maker of all time, although Howard Hawks is a strong rival. Ford started his career making Westerns for Universal, the largest producers of the genre until the early 1920s (see studio system). In 1920, after three years with Universal, he went over to Fox. His film career spans over forty years (The Man Who Shot Liberty Valance, 1962, is a late example of his work in this genre alone). It is often said that, because of his own immigrant past and his desire to belong, he was obsessed with American history and with the notion of the family. Whatever the case, it is certain that the notion that unity creates stability and a sense of community is central to his films, including the Western. In this respect his vision seems to go counter to the ideology inherent in the Western of the wandering cowboy or gunhand who must restlessly move on. However, this first disposition of Ford's in fact enhances the tension in his film between the opposing values of wilderness and civilization precisely because, for the most part, his heroes do not settle down but live out and with this contradiction (as in *My Darling Clementine*, 1946; and, in a more complex way, *The Searchers*, 1956). His fetish star was John Wayne who, when he first worked with Ford, almost got himself thrown out of the studio for being insubordinate.

Back to the history of this genre. The advent of sound brought about a big drop in the production of the Western, at least as an A-movie. The drop occurred largely because there was so little dialogue. The audience was now used to 'talkies' and the Western did not adapt well at first. As an action-packed film, before sound, it had little need for much talk. Clint Eastwood's almost silent movies of the 1980s and 1990s merely carry on this tradition (although he is not that heavy on action either!). Interestingly however, during the 1930s, Westerns continued to be produced as **B-movies** and were very popular. As a B-movie, a Western was a low-budget product that could be quickly and cheaply produced to fill the double-bill requirement. The double bill was a practice introduced during the Depression years to attract audiences by giving two films for the price of one. The smaller studios, Monogram and Republic in particular, were largely responsible for this output although, among the majors, Warners was also a significant producer. It was the B-Westerns that launched the singing cowboy - starting with John Wayne in 1933 (Riders of Destiny) and closely followed by Gene Autry (Tumbling Tumbleweeds, 1935) and Roy Rogers. As a type the B-Western was iconographically simplistic and ideologically populist. The goodies and the baddies were easily identifiable. The former wore white, the latter black, and unquestionably the goodies would win. No room here for redemption - bad is bad. By the mid-1950s the B-Western (and the B-movie in general) had disappeared after the Supreme Court's decision in the Paramount case of 1948 finally took effect by breaking up the major studios' cartel (see studio system). But it did not go out with a whimper. In 1952 and 1954 Republic won best director Oscars for, respectively. Ford's The Quiet Man and Nicholas Ray's Johnny Guitar.

Briefly in the late 1930s there was a big surge once more in production of A-feature Westerns. A first cause was the United States' isolationism in the face of the war in Europe. The revival of the genre reflects an inward-looking nationalism that is simultaneously nostalgic, having regard for things American but things of the past, in this instance, the nation's heroic and civilizing

expansion into the west. By curious coincidence John Wayne, the true grit American as we now know him, finally attained star status in this brief period of production upswing when he starred in Ford's Stagecoach (1939). Pioneers were celebrated (as in The Westerner, 1940, with squeaky-clean Gary Cooper). Often the narrative depicted the individual fighting against giant corporations (railroad companies, banks, etc.). Certain outlaws were also celebrated. A particular favourite was Billy the Kid (see Billy the Kid, 1941 and Howard Hughes's The Outlaw, 1943 but not released until 1946 - see below). This heroization of outlaws, as already mentioned, was part of the mythologizing of the West started by the Western dime novels of the 1860s. Because the West was largely monopolized by land-grabbing companies, to take the law into one's own hands was perceived as a legitimate practice. An outlaw in these circumstances came to represent freedom in much the same way as the cowboy. The outlaw asserted individual 'rights' over the big bosses. Similarly the lonesome lawman was a hero in his standing up to the baddies who threaten to disrupt the community.

There was, however, the burgeoning of another type of Western: one that was more socially critical and which set a trend that would be more fully developed in the 1950s. William A. Wellman is credited with being the progenitor of this socalled 'modern Western' which, because it deals with social issues, is also described as the psychological Western. In the first of these films, The Ox-bow Incident (1943), Wellman polemicizes against the lynch law. The rough justice meted out in Western folklore is severely criticized but not through a goodies-versusbaddies confrontation. Collusion and passivity on the part of 'decent, ordinary folk' are as much responsible for the lynching of the innocent men as those baying for their blood. In this uncompromising film Wellman takes to task the ideological functioning of the traditional Western: nostalgic escapism at the service of corporate capitalism. He repeated this in his 1944 film criticizing the White colonization of the West, Buffalo Bill.

The introduction of **colour** on a bigger scale in the mid- to late 1940s meant that violence now appeared more real. This was greeted with considerable consternation by the censors. But far more to their consternation were the implications for sex on screen. Sex did not come on to the screen in the Western until the late 1940s and even so it came in with great difficulty. Howard Hughes's *The Outlaw* was made in 1943 and was a vehicle for his

new star, Jane Russell. However, the league of decency (see censorship) created a furore over its premiere, complaining that the over-exposure of Jane Russell's breasts was indecent. The film was withdrawn and rereleased with a few cuts in 1946. Jane Russell was the first of a number of actresses to play the role of a 'smouldering', sexy, décolletée Mexican woman. Sex was launched, but it had to be had with stereotypes. Plenty of hotblooded foreign womanhood but not 'nice, nice Ms American pie' - she had to be kept virginal at all costs. Until this eruption of sex the characterization of women was fairly peripheral. The Western is a man's movie. A man with a horse, a man in action, a loner who leaves the woman behind rather than staying. His lust for adventure far outweighs his lust for women. As a genre, the Western is the antithesis to the melodrama and domesticity. The Western stands out in its refusal to complete the Oedipal trajectory. It is very rare for the hero, having once rescued the abducted but pure woman, to go on to marry her. The hero's 'job' is to make the West safe for the virgins to come out and reproduce, but not with him, that is the job for the rest of the community. He has to 'move on out'.

In the Western very few exceptions exist to the misrepresentation of the frontierswomen. Women are either floozies in the saloon, who are to be driven out of town (not until after good use however) or shot, or pure as the driven snow and totally vulnerable to marauding men and, of course, abducting Indians. In truth, cowgirls did exist, gun-toting just like the men, and dressed in men's clothes. Indeed a recent film, The Ballad of Little Jo (Maggie Greenwald, 1993), is based on a real woman whose gender was discovered only after her death. During the 1930s only a handful of films paid homage to the role of women in the West. Annie Oakley (1935) was a first, starring Barbara Stanwyck, followed by Plainsman (1936) with Jean Arthur in the role of Calamity Jane. And two films starring Mae West, Klondike Annie (1936) and My Little Chickadee (1940) complete the list. The 1950s did not see any great improvement on this tally. Again, only a handful come to mind. Wellman's quite authentic film about frontierswomen and their dangerous and stressful drive out west to find husbands (Westward Women, 1951), is one. So too is Ray's Johnny Guitar, starring Joan Crawford as the gunslinging cross-dressed Vienna who, once she has cleared the town of the threat of a lynch mob and their leader (another woman, Emma, played by Mercedes McCambridge), is able to

don feminine clothes again (in fact, in the dramatic concluding sequences to the film, she switches back and forth with the greatest of ease between male and female attire). In all these films, cross-dressing occurs and represents diegetically an embodiment of power and independence. And, as far as the female spectator is concerned, despite the fact that in some of the films the woman gives up her clothes and gets her man, there is none the less a pleasurable identification with that empowerment. Not that those in feminine attire necessarily lack force. Barbara Stanwyck had several strong roles to play - most brilliantly in Forty Guns (Sam Fuller, 1957) where she is a ranch boss with forty hired guns. Finally, Marlene Dietrich (playing true to type) was the star in Rancho Notorious (Fritz Lang, 1952). Cross-dressed passing women in Westerns are extremely thin on the ground and seems doomed to remain a lesbian fantasy. Jo in The Ballad of Billie Jo is the one who comes closest - although as R. Ruby Rich argues there is no true 'play' with her sexuality, so her cross-dressing offers limited pleasures to a lesbian audience (see Rich's useful article in Sight and Sound, November 1993, vol. 3, issue 11, 18-22). Cowgirls, it would appear, never look like becoming a good idea in movies.

If you can count female Westerns on two fingers, you can count Black Westerns on just about one hand (if you include black presence in a major role). Unsurprisingly, the major 'spurt' of Black Westerns occurred in the early 1970s coming in the wake of or on the back of the successful blaxploitation movies. One such film that is guilty of exploiting the blaxploitation moment is Anthony Dawson's Take a Hard Ride (1975), with its crude 'rushing for the bounty' narrative that attempts to marry the Italian spaghetti Western with the Kung-Fu movie. El Condor (John Guillerman, 1970) just pre-dates the blaxploitation moment by one year and follows more in the trend of the newly violent Western à la Peckinpah. This flashily violent film features among its main protagonists a Black chain-gang fugitive and an Apache Indian hunting down buried treasure. Boss Nigger (aka The Black Bounty Killer, Jack Arnold, 1974) stands out among this generation of Black Westerns because of its intentional parody of the genre through its play with cliché and violence. In a different vein, Sidney Poitier's Buck and the Preacher (1971) examines the struggles of Black wagoners (freed slaves) trying to head out west. The Black cowboy reappears briefly in Silverado (Lawrence Kasdan, 1985). And that is about it until Mario Van Peebles' Posse

(1993) and the rather silly *Wild Wild West* (Barry Sonnenfeld, 1999). Apart from these few forays the Western remains an essentially all-White male affair. So let us return to its history.

By the 1950s the Western's hero had become more complex. more psychologically motivated (see motivation). He had a past. The introduction of psychoanalysis into this genre is credited to Wellman (as mentioned above), but it took off in a big way in the 1950s in part owing to the influence of the film noir. The broody, introspective, angst-ridden film noir protagonist reappears with spurs. Something in his past has deeply scarred his persona. He still rides in and out of the wilderness as before. but now that wilderness is also part of his temperament and embedded in his psyche. The other exemplary film-maker of this new type of Western was Anthony Mann, who worked with James Stewart as his fetish star. Before turning to the Western Mann had made several films noir (such as T-Men, 1947, and Raw Deal, 1948) so the cross-over of mood is quite visible in his films. He gave an uncompromising vision of the West. His heroes are often solitary, mentally and morally divided personae (as was their film noir prototype), bent on revenge and vet wanting to find peace of mind and thereby rest from their avenging souls (see Winchester '73, 1950; Bend of the River, 1952; The Naked Spur, 1953 - all Stewart vehicles). Mann's Westerns are intentionally violent - a tradition followed by Arthur Penn (as in The Left-Handed Gun, 1958) and Sam Peckinpah (The Wild Bunch, 1969).

The demise of the studios in the early 1950s led to location shooting, and this, coupled with the implementation of cinemascope and colour, gave the Western increased visual realism alongside this greater psychological realism. Although on the whole the Western, then as before, was seen as an escapist genre, none the less certain films, especially those made during the first half of the 1950s, can be read as commentaries on the contemporary political arena of McCarthyism as well as reflections of the political uncertainties of the Cold War. High Noon (Fred Zinnemann, 1952) and Johnny Guitar are the two that are most often cited as allegories of McCarthyism and the fear and mistrust brought about by the Cold War. The former film was scripted by Carl Foreman, a communist who was blacklisted (see Hollywood blacklist) and he clearly meant his loose adaptation of the novel The Tin Star (by John W. Cunningham) to act as an indictment of US justice and society. In the film the hero

(played by Gary Cooper) is the lone marshal who has to gun down an ex-convict and his gang bent on revenge. The marshal tries to drum up support but no one will come to his assistance. A similar instance of community cowardice and a refusal to get involved is present in *Johnny Guitar* (which was shot in Spain in 1954 while Ray was in self-imposed exile, and also free of the constraints of Hollywood). In this film the community hide behind the law to rid themselves of 'outsiders', 'aliens', people coming from outside and 'who don't belong' — even though, in the end, Vienna and Johnny put a stop to it.

High Noon certainly re-established the reputation of the Western, and the 1950s produced many great Westerns. Indeed the traditions of this epoch of films are at least partly a progenitor to Clint Eastwood's 1980s and 1990s Westerns. Alan Ladd's portrayal of nervous heroism in Shane (George Stevens, 1953), Gregory Peck's unsuccessful attempts to outrun his past as the fastest gun in the West in Gunfighter (George King, 1950) and the restless, drifting hero coming into town and then leaving having resolved a problem of a community in crisis – these are all hallmarks of Eastwood's performance as exemplified in two films also directed by him, Pale Rider (1985) and Unforgiven (1992).

Until the 1950s Indians on the whole were represented as killers, abductors and pyromaniacs - hardly ever as individuals. certainly not with any attempt to understand or reflect their side of history. John Ford's Searchers is a perplexing and difficult film in this context. In one respect it appears to advocate (by the end of the film) greater tolerance of difference. However, it is not difficult to read the entire narrative - with its expressed anxiety about rape, miscegenation and the genetic determination of race (an anxiety embodied incidentally by the ruthless Ethan Edwards, played by John Wayne) - as a metaphor for concern about the growth in the 1950s of the Civil Rights movement. Furthermore, no attempt is made to 'explain' the Indian side of the story. There were, however, one or two exceptions to this ahistorical approach to Indian Western history. In these rare films there is a new respect for the Indian (Broken Arrow, Delmer Daves, 1950) and a bitter condemnation of the exploitation of the Indian by the White man (Devil's Doorway, Mann, 1950). Kevin Costner's Dances with Wolves (1990) is but one of the last in a short line of this attempt to redress the history of the West.

By the 1960s, in an attempt to attract audiences back into the cinemas, the Western went super-epic. The psychological realism

was dropped in favour of bulk value for money: wide-screen productions filled with as many stars as possible (like John Sturges's The Magnificent Seven, 1960, with seven stars and reworked three times). The community had gone, and with it the notion of service. Group solidarity was in but only among the gang. Alternatively the protagonist was motivated by revenge, but, contrary to the complex Western of the 1950s, there was no visible reason or moral point of view that explained this motivation (see Henry Hathaway's Nevada Smith, 1966). What also prevailed was an aesthetics of violence not seen heretofore, primarily in Penn and Peckinpah's films (for example, Peckinpah's Straw Dogs, 1971). One explanation for this violence could be the abolition of film censorship in the United States, since this new, even excessive. violence characterizes many films of that decade and the next (notably Arthur Penn's Bonnie and Clyde, 1967). Another could be that the old-established generation of film-makers (particularly Ford and Hawks) were coming to the end of their careers and a new way had to be found of telling what is intrinsically the same story. The Western had become as action-packed as in its early silent days, but on the whole it lacked inventiveness, bar a few smash hits (like Butch Cassidy and the Sundance Kid, George Roy Hill, 1969). A third reason might be that it was a genre out of touch with the climate of the times. The United States had proved to itself that it was still a violent and corrupt country (the Watergate scandal, the assassinations of President Kennedy, his brother Robert Kennedy and Martin Luther King), so the myth of pioneering spirits, frontiersmanship and a united nation - with all that it denotes of optimism, wholesomeness and integrity - did not sit easily with reality.

The Western, perhaps the longest-lasting genre, looked set to die out, even though Peckinpah was still making them. See for example his Pat Garrett and Billy the Kid (1973), an answer perhaps to the revisionist Chisum made in 1970 by Andrew McLaglen and starring the ubiquitous Western iconic star John Wayne. But its fortunes were revived, largely thanks to its moving eastward to Europe and its shift in emphasis from reality to parody. The success of the so-called spaghetti Westerns (so called in the belief that they were shot in Italy; in fact they were, for the most part, shot in Spain) came about as a result of a fortunate meeting in 1964 between the Italian film-maker Sergio Leone and a fairly unknown actor Clint Eastwood. The quiet, almost static aloofness of the 'man with no name', as Eastwood

was known in his first film, A Fistful of Dollars (1964), in combination with Leone's ironic treatment of the Western proved to be unbeatable. And if the genre has been revitalized on the American front, then its regeneration is in large part due to the parodying it underwent under Leone's direction. The genre itself was called into question – a criticism of the ideological operations at work in Hollywood's mythic construction of the West. The footage was not all action-packed, the pace was slowed down. Eastwood hardly spoke and barely moved. Eastwood claims that he deliberately cut out most of the dialogue to facilitate direction since he and Leone had no common language. This first film was such a success that Eastwood went on to make three more. Other American actors went to Europe to work with Leone (Henry Fonda, Charles Bronson and Rod Steiger). And the whole series of spaghetti Westerns lasted a decade. But the Western was changed for ever, away from the prevailing optimism, puritanism and nationalism it had displayed before. The genre had been deconstructed, it could now go back West. (For further reading on spaghetti Westerns see also Staig and Williams, 1975: Frayling, 1998.)

The success of the spaghetti Westerns is their difference. Their caricatural nature pokes fun at the iconography of the Western. The baddies are not only bad, they are ugly and dirty. The films themselves are cynical in tone. Sleaziness and dishonesty are the order of the day. Only one man, Eastwood, can clean it all up and even then not for long if the first sequel to A Fistful of Dollars is anything to go by – For a Few Dollars More (1966). Following the success of these films, Eastwood returned to the United States, since when he has been directing and producing and starring in his films (e.g. The Outlaw Josey Wales, 1976). He has become the icon of the contemporary Western to the point that he is almost solely identified with it.

For further reading see Bold, 1987; Buscombe, 1988; Tompkin, 1992; Tuska, 1976; Wright, 1975.

wipe A transition between two shots whereby the earlier one appears to be pushed aside by the latter, creating the effect of wiping off a scene and replacing it with another.

women's films - see melodrama and women's films

Z

zoom The zoom lens was developed in the 1950s, constituting another technological attraction for audiences, as did the introduction of colour and cinemascope in the same decade. A zoom shot is one that is taken with the use of a variable focal length lens (known as a zoom lens). A zoom-forward normally ends in a close-up, a zoom-back in a general shot. Both types of shot imply a rapid movement in time and space and as such create the illusion of displacement in time and space. A zoom-in picks out and isolates a person or object, a zoom-out places that person or object in a wider context. A zoom shot can be seen, therefore, as voyeurism at its most desirably perfect.

BIBLIOGRAPHY

- Abel, R. (1984) French Cinema: The First Wave, 1915-1929, Princeton, NJ, Princeton University Press
- Abel, R. (1994) The Ciné Goes to Town: French Cinema 1896–1914, Berkeley, New York and London, University of California Press
- Ahmad, A. (1996) The Politics of Literary Postcoloniality, in: Mongia, P. (ed.) Contemporary Postcolonial Theory: A Reader, London, New York, Sydney and Auckland, Arnold
- Akomfrah, J. (1989) Introduction to the Morning Session, Birmingham Third Space Section of the 1988 Birmingham Film and Television Film Festival, *Framework*, Vol. 36
- Alexander, K. (1988) Ethnic Notions: Towards a Cinema of Cultural Diversity, London, British Film Institute Publishing
- Althusser, L. (1984) Essays in Ideology, London, Verso
- Altman, R. (1989) The American Film Musical, Bloomington, Indiana, Indiana University Press
- Altman, R. (ed.) (1992) Sound Theory and Sound Practice, New York and London, Routledge and American Film Institute
- Altman, R. (1999) Film/Genre, London, British Film Institute Publishing Anderson, L. (1954) Only Connect!, Sight and Sound, Vol. 23, No. 4, April/June
- Andrew, D. (1984) Concepts in Film Theory, New York and Oxford, Oxford University Press
- Andrew, D. (1995) Mists of Regret: French Poetic Realism, Princeton, NJ, Princeton University Press
- Appiah, K. A. (1992) In My Father's House: Africa in the Philosophy of Culture, Oxford, Oxford University Press
- Armes, R. (1974) Film and Reality: An Historical Survey, Harmondsworth, Pelican
- Armes, R. (1996) Dictionnaire des cinéastes du Maghreb/Dictionary of North African Filmmakers, Paris, Editions des Trois Mondes
- Ashcroft, B., Griffiths, G. and Tiffin, H. (1995) The Post-Colonial Studies Reader, London and New York, Routledge

- Ashcroft, B., Griffiths, G. and Tiffin, H. (1998) Key Concepts in Post-Colonial Studies, London and New York, Routledge
- Astruc, A. (1948) Naissance d'une nouvelle avant-garde, Le Film, No. 144
 Attille, M. and Blackwood, M. (1986) Black Women and Representation,
 in: Brunsdon, C. (ed.) Films For Women, London, British Film Institute
 Publishing
- Bad Object-Choices (1991) How Do I Look?: Queer Film and Video, Seattle, Bay Press
- Baird, R. and Rosenbaum, S. (eds) (1991) *Pornography*, Buffalo, Prometheus Books
- Bakari, I. (1993) Le Facteur X du nouveau cinéma afro-américain, *Ecrans d'Afrique*, No. 4
- Bakari, I. and Cham, M. (eds) (1996) African Experiences of Cinema, London, British Film Institute Publishing
- Barnard, T. and Rist, P. (eds) (1996) South American Cinema: A Critical Filmography 1915–1994, New York, Garland
- Barsam, R. M. (1992) Non-Fiction Film: A Critical History, Bloomington and Indianapolis, Indiana University Press, revised edition
- Barthes, R. (1957) Mythologies, Paris, Editions du Seuil (also available in English translation: A. Lavers (trans.) London, Paladin, 1989)
- Barthes, R. (1973) Le Plaisir du texte, Paris, Editions du Seuil
- Basutçu, M. (ed.) (1996) Le Cinéma Turc, Paris, Editions Centre Georges Pompidou
- Baudry, J.-L. (1970) Cinéma: effets idéologiques produits par l'appareil de base, *Cinéthique*, Nos 7–8, translated as Ideological Effects of the Basic Cinematic Apparatus, in: Rosen P. (ed.) (1986) *Narrative*, *Apparatus*, *Ideology*, New York, Columbia University Press
- Baudry, J.-L. (1975) Le Dispositif, *Communications*, No. 23, translated as The Apparatus: Metaphysical Approaches to Ideology, in: Rosen, P. (ed.) (1986), *Narrative, Apparatus, Ideology*, New York, Columbia University Press
- Bazin, A. (1967) What is Cinema? Vol. I (essays selected and translated by H. Gray), Berkeley, University of California Press
- Bellour, R. (1975) Le blocage symbolique, Communications, No. 23
- Bendazzi, G. (1994) Cartoons: One Hundred Years of Cinema Animation, transl. Anna Taraboletti, London, Paris and Rome, John Libbey
- Benveniste, E. (1971) Problems in General Linguistics, Miami, University of Miami Press
- Benvenuto, B. and Kennedy, R. (1986) The Works of Jacques Lacan: An Introduction, New York, St Martin's Press
- Bergstrom, J. (1985) Sexuality at a Loss: The Films of F. W. Murnau, *Poetics Today*, Vol. 6, Nos 1–2
- Bernardi, D. (ed.) (1996) The Birth of Whiteness: Race and the Emergence of US Cinema, New Jersey, Rutgers University Press
- Bernstein, M. and Studlar, G. (eds) (1997) Visions of the East: Orientalism in Film, London and New York, I. B. Tauris Publishers

Berry, C. (ed.) (1991) Perspectives on Chinese Cinema, London, British Film Institute Publishing

Berry, C. (1996) China before 1949, in: Nowell-Smith, G. (ed.) *The Oxford History of World Cinema*, Oxford and New York, Oxford University Press

Bhabha, H. (1989) The commitment to theory, in: Pines, J. and Willemen, P. (eds) Questions of Third Cinema, London, British Film Institute

Bhabha, H. (1994) The Location of Culture, London, Routledge

Bhowmik, S. (1995) Indian Cinema: Colonial Contours, Calcutta, Papyrus Black, G. D. (1994) Hollywood Censored: Morality Codes, Catholics, and the Movies, Cambridge, Cambridge University Press

Bluestone, G. (1971) Novels into Film, Los Angeles, University of California

Press

Bobo, J. (ed.) (1998) Black Women Film and Video Artists, London and New York, Routledge

Bogle, D. (1988) Blacks in American Film and Television: An Encyclopedia, New York and London, Garland Publishing Company

Bogle, D. (1994) Coons, Mulattoes, Mamies and Bucks: An Interpretative History of Blacks in American Films (third edition), Oxford, Roundhouse Publishing Company

Bold, C. (1987) Selling the Wild West: Popular Western Fiction 1860–1960, Bloomington and Indianapolis, Indiana University Press

Bordwell, D. (1986) Narration in the Fictional Film, New York and London, Routledge

Bordwell, D., Staiger, J. and Thompson, K. (1985) The Classical Hollywood Cinema: Film Style and Production to 1960, London, Routledge & Kegan Paul

Bordwell, D. and Thompson, K. (1980) Film Art: An Introduction, Reading, MA, Addison-Wesley Publishing Company (fourth edition (1993), New York, McGraw-Hill)

Bordwell, D. and Thompson, K. (1994) Film History: An Introduction, New York, McGraw Hill

Bottomore, T. (1984) The Frankfurt School, London and New York, Tavistock Publications

Bowser, P. and Spence, L. (1996) Identity and Betrayal: *The Symbol of the Unconquered* and Oscar Micheaux's 'Biographical Legend', in: Bernardi, D. (ed.) *The Birth of Whiteness: Race and Emergence of US Cinema*, New Jersey, Rutgers University Press

Branigan, E. (1992) Narrative and the Comprehension of Film, London and New York, Routledge

Bratton, J., Cook, J. and Gledhill C. (eds) (1994) Stage, Picture, Screen, London, British Film Institute Publishing

Braudy, L. (1992) From the World in a Frame, in: Mast, G., Cohen, M., Braudy, L. (eds) *Film Theory and Criticism*, New York and Oxford, Oxford University Press

Bristow, J. (1997) Sexuality, London and New York, Routledge

- Brooks, P. (1976) The Melodramatic Imagination: Balzac, Henry James, Melodrama and the Mode of Excess, New Haven, Yale University Press
- Brosnan, J. (1991) The Primal Screen: A History of Science Fiction Film, London and Sydney, Orbit Books
- Browne, N., Pickowicz, P. G., Sobchack, V. and Yau, E. (1994) New Chinese Cinemas: Forms, Identities, Politics, Cambridge, Cambridge University Press
- Bruno, G. (1987) Ramble City: Postmodernism and Blade Runner, October, No. 41
- Brunovska Karnick, K. and Jenkins, H. (eds) (1995) Classical Hollywood Comedy, New York and London, Routledge
- Brunsdon, C. (ed.) (1986) Films for Women, London, British Film Institute Publishing
- Burch, N. (1973) Theory of Film Practice, New York, Praeger
- Burch, N. (1990) *Life to Those Shadows* (transl. and edited by B. Brewster), London, British Film Institute Publishing
- Burns, E. (1983) Introduction to Marxism (ninth reprint), London, Lawrence & Wishart
- Burston, P. and Richardson, C. (eds) (1995) A Queer Romance: Lesbians, Gay Men and Popular Culture, London and New York, Routledge
- Burton, J. (ed.) (1986) Cinema and Social Change in Latin America: Conversations with Filmmakers, Austin, Texas, The University of Texas Press
- Burton, J. (1990) The Social Documentary in Latin America, Pittsburgh, The University of Pittsburgh
- Burton-Carjaval, J. (1996) South American Cinema, in: Hill, J. and Church Gibson, P. (eds) *The Oxford Guide to Film Studies*, Oxford, Oxford University Press
- Buscombe, E. (ed.) (1988) The BFI Companion to the Western, London, André Deutsch/British Film Institute Publishing
- Butler, J. (1990) Gender Trouble, New York and London, Routledge
- Butler, J. (1993) Bodies that Matter, London and New York, Routledge
- Cameron, I. (ed.) (1992) The Movie Book of Film Noir, London, Studio Vista
- Cartmell, D. and Whelehan, I. (1999) Adaptations: From Text to Screen, London and New York, Routledge
- Caughie, J. (ed.) (1981) Theories of Authorship, London, Routledge & Kegan Paul
- Cawelti, J. G. (1992) *Chinatown* and Generic Transformation in Recent American Films, in: Mast, G., Cohen, M. and Baudry, L. (eds) *Film Theory and Criticism* (fourth edition), Oxford, Oxford University Press
- Chakravarti, S. S. (1993) National Identity in Indian Popular Cinema 1947–1987, Austin, University of Texas Press
- Chambers, I. and Curti, L. (1996) The Post-Colonial Question, London and New York, Routledge
- Chanan, M. (ed.) (1983) Twenty-Five Years of the New Latin American Cinema, London, British Film Institute Publishing

- Chanan, M. (1985) The Cuban Experience, London, British Film Institute Publishing
- Chanan, M. (1996) Cinema in Latin America, in: Nowell-Smith, G. (ed.) The Oxford History of World Cinema, Oxford, Oxford University Press
- Childs, P. and Williams, P. (1997) An Introduction to Post-Colonial Theory, London and New York, Prentice Hall/Harvest Wheatsheaf
- Chion, M. (1982) La Voix au cinéma, Paris, Cahiers du Cinéma, Editions de L'Etoile
- Chion, M. (1985) Le Son au cinéma, Paris, Cahiers du Cinéma, Editions de L'Etoile
- Chow, R. (1995) Primitive Passions: Visibility, Ethnography, and Contemporary Chinese Style, New York, Columbia University Press
- Christie, I. and Taylor, R. (eds) (1993) Eisenstein Rediscovered, London and New York, Routledge
- Clark, P. (1987) Chinese Cinema: Culture and Politics since 1949, Cambridge, Cambridge University Press
- Coates, P. (1991) The Gorgon's Gaze: German Cinema, Expressionism and the Image of Horror, Cambridge, Cambridge University Press
- Comolli, J.-L. and Narboni, J. (1969/1977) Cinéma/Idéologie/Critique, Cahiers du cinéma (Oct-Nov 1969); English translation in: Screen Reader: Cinema/Ideology/Politics, London, Society for Education in Film and Television, 1977
- Cook, P. (1980) Duplicity in *Mildred Pierce*, in: Kaplan, E. A. (ed.) Women in Film Noir, London, British Film Institute Publishing (revised edition)
- Cook, P. (ed.) (1985) The Cinema Book, London, British Film Institute Publishing
- Cook, P. (1996) Fashioning the Nation: Costume and Identity in British Cinema, London, British Film Institute Publishing
- Cook, P. and Dodd, P. (eds) (1993) Women and Film: A Sight and Sound Reader, London, British Film Institute Publishing
- Copjec, J. (ed.) (1993) Shades of Film Noir, London and New York, Verso Corrigan, T. (1983) New German Film: The Displaced Image, Austin, Texas University Press
- Courthion, P. (1968) Introduction, in: Ragon, M. (ed.) Expressionism, London, Heron Books
- Cowie, E. (1984) Fantasia, m/f, No. 9
- Creed, B. (1993) The Monstrous Feminine: Film, Feminism and Psychoanalysis, New York and London, Routledge
- Creekmur, C. K. and Doty, A. (1995) Out in Culture: Gay, Lesbian and Queer Essays on Popular Culture, London, Cassell
- Cripps, T. (1977) Slow Fade to Black: The Negro in American Film 1900–1942, Oxford and New York, Oxford University Press
- Cripps, T. (1978) Black Film as Genre, Bloomington and London, Indiana University Press
- Cripps, T. (1982) New Black Cinema and Uses of the Past, in: Yearwood, G. (ed.) Black Cinema Aesthetics: Issues in Black Filmmaking, Ohio, Ohio

- University Papers on Afro-American, African and Caribbean Studies
- Cripps, T. (1993) Making Movies Black: The Hollywood Message Movies from World War Two to the Civil Rights Era, Oxford and New York, Oxford University Press
- Culham, S. (1988) Animation From the Script to the Screen, London, Columbus Books
 - Davies, K., Dickey, J. and Stratford, T. (eds) (1987) Out of Focus: Writings on Women and the Media, London, The Women's Press
 - Davis, A. (1981) Women, Race and Class, New York, Random House
 - Dayan, D. (1974) The Tudor Code of Classical Cinema, Film Quarterly, Vol. 28, No. 1
 - De Lauretis, T. (1984) Alice Doesn't: Feminism, Semiotics, Cinema, Bloomington, Indiana University Press
 - De Lauretis, T. (1985) Oedipus Interruptus, Wide-Angle, Vol. 7, Nos 1-2
 - De Lauretis, T. (1989) Technologies of Gender: Essays on Theory, Film and Fiction, London, Macmillan
 - De Lauretis, T. and Heath, S. (eds) (1980) The Cinematic Apparatus, New York, St Martin's Press
 - Diawara, M. (1986) Sub-Saharan African Film Production: Technological Paternalism, *Jump Cut*, Vol. 32
 - Diawara, M. (ed.) (1993) Black American Cinema: Aesthetics and Spectatorship, New York and London, Routledge
 - Dines, G. and Humez, J. (eds) (1995) Gender, Race and Class in the Media, London, Sage
 - Dines, G., Jensen, R. and Russo, A. (1998) Pornography: The Production and Consumption of Inequality, London and New York, Routledge
 - Dines, P. (1994) Images of the Algerian War: French Fiction and Film 1954–1992, Oxford, Clarendon Press
 - Doane, M. A. (1982) Film and the Masquerade: Theorising the Female Spectator, *Screen*, No. 23, Vol. 3–4
 - Doane, M. A. (1984) The Woman's Film: Possession and Address, in: Doane, M. A., Mellencamp, P. and Williams, L. (eds) *Re-vision: Essays in Feminist Film Criticism*, Frederick, Maryland, The American Film Institute/University Publications of America
 - Doane, M. A. (1987) The Desire to Desire: The Woman's Film of the 1940s, Bloomington, Indiana University Press
 - Doane, M. A. (1992) Femmes Fatales: Feminism, Film Studies and Psychoanalysis, New York and London, Routledge
 - Doane, M. A., Mellencamp, P. and Williams, L. (eds) (1984) Re-vision: Essays in Feminist Film Criticism, Frederick, Maryland, The American Film Institute/University Publications of America
 - Donald, J. (1989) Fantasy and the Cinema, London, British Film Institute Publishing
 - Dorenkamp, M. and Henke, R. (1995) Negotiating Lesbian and Gay Subjects, New York and London, Routledge

Dworkin, A. (1991) Pornography: Men Possessing Women, London, Women's Press

Dyer, R. (1977a) Entertainment and Utopia, Movie 24

Dyer, R. (1977b) Gays and Film, London, British Institute Publishing

Dyer, R. (1980) Stars, London, British Film Institute Publishing

Dyer, R. (1986) Heavenly Bodies: Film Stars and Society, London, Cinema British Film Institute Series, Macmillan

Dyer, R. (1990) Now You See It: Studies in Lesbian and Gay Film, London and New York, Routledge

Dyer, R. (1993) The Matter of Images: Essays on Representation, London and New York, Routledge

Dyer, R. (1997) White, London and New York, Routledge

Dyssanayake, W. (ed.) (1994) Colonialism and Nationalism in Asian Cinema, Bloomington, Indiana University Press

Easton, S. (1994) The Problem of Pornography, London and New York, Routledge

Eder, K. and Rossell, D. (eds) (1993) New Chinese Cinema, London, National Film Theatre, British Film Institute Publishing

Eisner, L. (1969) The Haunted Screen: Expressionism and the German Cinema, London, Thames and Hudson

Ellis, J. (1982) Visible Fictions, London and New York, Routledge & Kegan Paul

Elsaesser, T. (1987) Tales of Sound and Fury: Observations on the Family Melodrama, in: Gledhill, C. (ed.) Home Is Where the Heart Is: Studies in Melodrama and the Woman's Film, London, British Film Institute Publishing

Elsaesser, T. (1989) New German Cinema: A History, London, British Film Institute Publishing

Elsaesser, T. (1996) Germany: The Weimar Years, in: Nowell-Smith, G. The Oxford History of World Cinema, Oxford and New York, Oxford University Press

Fanon, F. (1967) Black Skin, White Masks (first published in 1952), New York, Grove Press

Fanon, F. (1968) The Wretched of the Earth (first published in 1961), New York, Grove Press

Ferncase, R. (1995) Film and Video Lighting: Terms and Concepts, Newton, MA, Focal Books, Butterworth-Heinemann

Feuer, J. (1982) The Hollywood Musical, London, Macmillan

Fischer, L. (1989) Shot/Countershot: Film Tradition and Woman's Cinema, Princeton, NJ, Princeton University Press and London, British Film Institute/Macmillan Education Ltd

Fiske, J. and Hartley, J. (1978) Reading Television, London and New York, Methuen

Flitterman-Lewis, S. (1990) To Desire Differently: Feminism and the French Cinema, Urbana and Chicago, University of Illinois Press

Foucault, M. (1977) Discipline and Punish: The Birth of the Prison, trans. A. Sheridan, New York, Pantheon

- Foucault, M. (1978) The History of Sexuality, Vol. 1, trans. R. Hurley, New York, Pantheon
- Frayling, C. (1998) Spaghetti Westerns: Cowboys and Europeans from Karl May to Sergio Leone, London, IB Taurus
- Freud, S. (1931) Female Sexuality, reprinted in *The Standard Edition of the Complete Works of Sigmund Freud*, trans. J. Strachey, London, Hogarth Press, 1953–74, Vol. 21, pp. 64–145
- Frieden, S., McCormick, R. W., Petersen, V. R. and Vogelsang, L. M. (eds) (1993) *Gender and German Cinema: Feminist Interventions*, Vols I and II, Providence, Rhode Island and Oxford, Berg Publishers Inc.
- Friedman, L. (ed.) (1993) British Cinema and Thatcherism, London, University College London Press
- Furniss, M. (1998) Art in Motion: Animation Aesthetics, London, Paris and Rome, John Libbey
- Fusco, C. (1989) About Locating Ourselves and Our Representations, Birmingham Third Space Section of the 1988 Birmingham Film and Television Film Festival, *Framework*, Vol. 36
- Fuss, D. (ed.) (1992) Inside/Out: Lesbian Theories, Gay Theories, New York and London, Routledge
- Gabriel, T. (1989) Third Cinema as Guardian of Popular Memory: Towards a Third Aesthetics, in: Pines, J. and Willemen, P. (eds) *Questions of Third Cinema*, London, British Film Institute Publishing
- Gabriel, T. H. (1982) Third Cinema in the Third World: The Aesthetics of Liberation, Ann Arbor, Michigan University Press
- Gaines, J. (1988) White Privilege and Looking Relations: Race and Gender in Feminist Film Theory, *Screen*, Vol. 29, No. 4
- Gazdar, M. (1997) Pakistan Cinema: 1947–1997, Karachi, New York, Oxford, Delhi, Oxford University Press
- Genette, G. (1980) Narrative Discourse, trans. J. E. Lewin, Oxford, Blackwell Gever, M., Parmar, P. and Greyson, J. (eds) (1993) Queer Looks, New York and London, Routledge
- Gidal, P. (1989) Materialist Film, London and New York, Routledge
- Gill, J. (1995) Queer Noises, London, Cassell
- Gilroy, P. (1993) The Black Atlantic: Modernity and National Consciousness (reprinted 1995), London and New York, Verso
- Givanni, J. (1992) Black Film and Video List, London, British Film Institute Publishing
- Givanni, J. and Reynaud, B. (1993) Images de femmes noires, CinémAction, No. 67
- Gledhill, C. (1980) *Klute* 1: A Contemporary Film Noir and Feminist Criticism, in: Kaplan, E. A. (ed.) *Women in Film Noir*, London, British Film Institute Publishing (revised edition)
- Gledhill, C. (ed.) (1987) Home is Where the Heart Is: Studies in Melodrama and the Woman's Film, London, British Film Institute Publishing
- Gledhill, C. (ed.) (1991) Stardom: The Industry of Desire, London and New York, Routledge

- Godard, J.-L. (1980) Introduction à une véritable histoire du cinéma, Paris, Albatros
- Gokulsking, K. M. (1999) Fatal Attraction? Nationalist and Patriotic Themes in Indian Films, unpublished paper
- Gokulsking, K. M. and Dissanayake, W. (1998) Indian Popular Cinema: A Narrative of Cultural Change, Staffordshire, Trentham Books
- Grant, B. K. (ed.) (1986) Film Genre Reader, Austin, Texas, University of Texas Press
- Grant, B. K. (ed.) (1995) Film Genre Reader II, second edition, Austin, Texas, University of Texas Press
- Grant, J. (1987) Encyclopedia of Walt Disney's Animated Characters, New York, Harper & Row
- Griffin, S. (1988) Pornography and Silence, London, The Women's Press
- Griffith, J. (1997) Adaptations as Limitations, Cranbury, University of Delaware Press
- Grodal, T. (1997) Moving Pictures: A New Theory of Genres, Feelings, and Cognition, Oxford, Clarendon Press
- Grosz, E. (1990) Jacques Lacan: A Feminist Introduction, London and New York, Routledge
- Grosz, E. and Probyn, E. (eds) (1995) Sexy Bodies: The Strange Carnalities of Feminism, London and New York, Routledge
- Guerrero, E. (1993) Framing Blackness: The African American Image in Film, Philadelphia, Temple University Press
- Guerrero, E. (1994) Framing Blackness: the African-American Image in the Cinema of the Nineties, *Cineaste*, Vol. XX, No. 2
- Guha, R. (ed.) (1982) Subaltern Studies 1: Writings on South Asian History and Society, 7 vols, Delhi, Oxford University Press
- Hadj-Moussa, R. (1994) Le Corps, L'Histoire, Le Territoire: Les Rapports de genre dans le cinéma d'Algérie, Montreal and Paris, Les Editions de Balzac
- Hardy, P., Milne, T. and Willemen, P. (eds) (1986) The Aurum Encyclopedia of Horror, New York, Harper & Row
- Harper, S. (1987) Historical Pleasures: Gainsborough Costume Melodrama, in: Gledhill, C. (ed.) Home is Where the Heart Is: Studies in Melodrama and Women's Film, London, British Film Institute Publishing
- Harper, S. (1994) Picturing the Past: The Rise and Fall of the Costume Drama, London, British Film Institute Publishing
- Hart, J. (1999) The Art of the Storyboard: Storyboarding for Film, TV and Animation, Woburn, MA, Butterworth-Heinemann
- Hartley, J. (1982) Understanding News, London, Edward Arnold
- Haskell, M. (1974) From Reverence to Rape: The Treatment of Women in the Movies, Harmondsworth, Penguin Books
- Hawthorn, J. (1992) A Concise Glossary of Contemporary Literary Theory, London, Edward Arnold
- Hayward, S. (1992) Ahistory of French Cinema: 1895–1991 Pioneering Filmmakers (Guy, Dulac, Varda) and Their Heritage, *Paragraph*, Vol. 15, No. 1

- Hayward, S. (1993) French National Cinema, London and New York, Routledge
- Heath, S. (1978) Difference, Screen, Vol. 19, No. 3
- Heath, S. (1981) Questions of Cinema, London, Macmillan
- Higson, A. (1993) Re-presenting the National Past: Nostalgia and Pastiche in the Heritage Film, in: Friedman, L. (ed.) *British Cinema and Thatcherism*, London, University College London Press
- Higson, A. and Maltby, R. (1999) Film Europe and Film America: Cinema, Commerce and Cultural Exchange 1920–1939, Exeter, Exeter University Press
- Hill, J. (1986) Sex, Class and Realism: British Cinema 1956–63, London, British Film Institute Publishing
- Hoffer, T. J. (1981) Animation Reference Guide, Westport, CN, Greenwood Press
- hooks, b. (1981) Ain't I a Woman: Black Women and Feminism, Boston, Long Haul Press
- hooks, b. (1989) Choosing the Margin as a Space of Radical Openness, Birmingham Third Space Section of the 1988 Birmingham Film and Television Film Festival, *Framework*, Vol. 36
- hooks, b. (1992) Black Looks: Race and Representation, Boston, South End Press
- Horne, P. and Lewis, R. (eds) (1996) Outlooks: Lesbian and Gay Sexualities and Visual Cultures, London and New York, Routledge
- Horton, A. and Magretta, J. (1981) Modern European Filmmakers and the Art of Adaptation, New York, Frederick Ungar Publishing Co., Inc
- Hull, G., Scott, P. B. and Smith, B. (eds) (1982) All the Women Are White, All the Blacks Are Men, But Some of Us Are Brave, New York, The Feminist Press
- Huyssen, A. (1986) After the Great Divide: Modernism, Mass Culture and Postmodernism, London, Macmillan Press
- Huyssen, A. (1990) Mapping the Postmodern, in: Nicholson, L. (ed.) Feminism/Postmodernism, New York and London, Routledge
- Issa, R. and Whitaker, S. (eds) (1999) Life and Art: The New Iranian Cinema, London, British Film Institute, National Film Theatre Publishing
- Itzin, C. (1992) Pornography: Women, Violence and Civil Liberties, Oxford, Oxford University Press
- Jackson, C. And Tapp, P. (1997) The Bent Lens: A World Guide to Gay and Lesbian Film, St Kilda, Victoria, Australian Catalogue Company
- Jakobson, R. (1960) Concluding Statement: Linguistics and Poetics, in: Sebeok, T. (ed.) Style in Language, Cambridge, MA, MIT Press
- Jameson, F. (1983) Postmodernism and Consumer Society, in: Foster, H. (ed.), *Postmodern Culture*, London, Pluto Press
- Jancovich, M. (1992) Horror, London, B. T. Batsford
- Jancovich, M. (1996) Rational Fears: American Horror in the 1950s, Manchester and New York, Manchester University Press

- Johnson, R. and Stam, R. (eds) (1982/1995) Brazilian Cinema, Toronto, Associated University Presses
- Johnston, C. (1973) Notes on Women's Cinema, Screen Pamphlet, London, Society for Education in Film and Television
- Johnston, C. (1976) Women's Cinema as Countercinema, in: Nicholls, B. (ed.) *Movies and Methods*, Berkeley, University of California Press
- Jones, J. (1991) The New Ghetto Aesthetic, Wide Angle, Vol. 13, No. 3 and 4
- Kaes, A. (1996) The New German Cinema, in: Nowell-Smith, G. The Oxford History of World Cinema, Oxford and New York, Oxford University Press
- Kaplan, E. A. (ed.) (1980) Women in Film Noir, London, British Film Institute, revised edition
- Kaplan, E. A. (1983) Women and Film: Both Sides of the Camera, New York and London, Methuen
- Kaplan, E. A. (ed.) (1990) Psychoanalysis and Cinema, New York and London, Routledge
- Kaplan, E. A. (1992) Motherhood and Representation: The Mother in Popular Culture and Melodrama, London and New York, Routledge
- Kaplan, E. A. (1997) Looking for the Other: Feminism, Film, and the Imperial Gaze, London and New York, Routledge
- Kennedy, L. (1993) Is Malcolm X the Right Thing?, Sight & Sound, Vol. 3, 2
- King, B. (1985) Articulating Stardom, Screen, Vol. 26, No. 5
- King, J. (1990) Magical Reels: A History of Cinema in Latin America, London, Verso
- King, J., Lopez, A. and Alvarado, M. (eds) (1993) *Mediating Two Worlds:* Cinematic Encounters in the Americas, London, British Film Institute Publishing
- Kirkham, P. and Thumin, J. (eds) (1995) Me Jane: Masculinity, Movies and Women, London, Lawrence and Wishart
- Knight, J. (1992) Women and the New German Cinema, London and New York, Verso
- Konigsberg, I. (1993) *The Complete Film Dictionary*, London, Bloomsbury Kracauer, S. (1992) From Caligari to Hitler, in: Mast, G., Cohen, M. and Braudy, L. (eds) *Film Theory and Criticism: Introductory Readings*, fourth edition, New York and Oxford, Oxford University Press
- Kronish, A. (1996) World Cinema: Israel, Flicker Books, Madison, Farleigh Dickinson University Press
- Krutnik, F. (1991) In a Lonely Street: Film Noir, Genre, Masculinity, London and New York, Routledge
- Kuhn, A. (1982) Women's Pictures: Feminism and Cinema, London and Boston, Routledge and Kegan Paul
- Kuhn, A. (1985) The Power of the Image: Essays on Representation and Sexuality, London and New York, Routledge and Kegan Paul

- Kuhn, A. (1988) Cinema, Censorship and Sexuality 1909–1925, London and New York, Routledge
- Kuhn, A. (1990) Alien Zone, London and New York, Verso
- Kuhn, A. (ed.) with Radstone, S. (1990) The Women's Companion to International Film, London, Virago
- Lacan, J. (1977) Ecrits: A Selection, trans. A. Sheridan, London, Tavistock Publications
- Lapsley, R. and Westlake, M. (1988, reprinted in 1992) Film Theory: An Introduction, Manchester, Manchester University Press
- Lassiter, J. and Davy, S. (1995) Toy Story: The Art and Making of the Animated Film, New York, Hyperion
- Lebeau, V. (1994) Lost Angels: Psychoanalysis and the Cinema, London and New York, Routledge
- Lesage, J. (1974) Feminist Film Criticism: Theory and Practice, Women and Film, Vol. 1, Nos 5-6
- Lord, P. and Sibley, B. (1998) Creating 3-D Animation: The Aardman Book of Filmmaking, New York, Harry N. Abrams Inc.
- Lovell, A. and Hillier, J. (1972) Studies in Documentary, London, Secker & Warburg
- Low, G. C.-L. (1996) White Skins, Black Masks: Representation and Colonialism, London and New York, Routledge
- Lurie, S. (1980) Pornography and the Dread of Women, in: Lederer, L. (ed.) *Take Back the Night*, New York, William Morrow
- McClintock, A. (1995) Imperial Leather: Race, Gender and Sexuality in the Colonial Context, London and New York, Routledge
- Macdonell, D. (1986) Theories of Discourse: An Introduction, Oxford, Blackwell
- McFarlane, B. (1996) Novel to Film: An Introduction to the Theory of Adaptation, New York and Oxford, Clarendon Press
- McMahon, B. and Quin, R. (1986) Reel Images: Film and Television, South Melbourne, Australia, Macmillan
- McNair, B. (1996) Mediated Sex, London, Arnold
- Maingard, J. (1998) Strategies of Representation in South African Anti-Apartheid Documentary Film and Video from 1976–1995, unpublished PhD thesis, University of the Witwatersrand
- Malik, K. (1996) The Meaning of Race: Race, History and Culture in Western Society, New York, New York University Press
- Malkiewicz, K. (1986) Film Lighting, New York, Prentice Hall
- Manvell, R. and Fraenkel, H. (1971) The German Cinema, London, J. M. Dent & Sons Ltd.
- Marcus, F. (ed.) (1971) Film and Literature: Contrasts in the Media, New York, Chandler Publishing
- Marcus, M. (1993) Filmmaking by the Book: Italian Cinema and Literary Adaptation, Baltimore, Johns Hopkins University Press
- Martin, M. T. (ed.) (1995) Cinemas in the Black Diaspora: Diversity, Dependence and Oppositionality, Detroit, Wayne State University Press

Mast, G., Cohen, M. and Baudry, L. (eds) (1992) Film Theory and Criticism (fourth edition), Oxford, Oxford University Press

Matthews, T. D. (1994) Censored, London, Chatto & Windus

Mayne, J. (1984) Women at the Keyhole: Women's Cinema and Feminist Criticism, in: Doane, M. A., Mellencamp, P. and Williams, L. (eds) *Re-vision: Essays in Feminist Film Criticism*, Frederick, Maryland, The American Film Institute/University Publications of America

Mayne, J. (1993) Cinema and Spectatorship, London and New York, Routledge Medovoi, L. (1998) Theorizing Historicity, or the Many Meanings of Blacula, Screen, Vol. 39, No. 1

Mellen, J. (1974) Women and Their Sexuality in the New Film, New York, Dell

Mellencamp, P. (1995) A Fine Romance: Five Ages of Film Feminism, Philadelphia, Temple University Press

Mell-Metereau, R. (1993) Hollywood Androgyny, New York, Columbia University Press

Mercer, K. (ed.) (1988) Black Film: British Cinema, ICA document No. 7, London, British Film Institute/ICA Publishing

Mercer, K. (1990) Diaspora Culture and the Dialogic Imagination: the Aesthetics of Black Independent Film in Britain, in: Alvarado, M. and Thompson, J. O. (eds) *The Media Reader*, London, British Film Institute Publishing

Merquior, J. G. (1985) Foucault, London, Collins

Metz, C. (1971) Essais sur la signification au cinéma, Tome I, Paris, Editions Klincksieck.

Metz, C. (1972) Essais sur la signification au cinéma, Tome II, Paris, Editions Klincksieck. Both volumes translated by M. Taylor (1974) as Film Language: A Semiotics of the Cinema, New York, Oxford University Press Metz, C. (1975) The Imaginary Signifier, Screen, Vol. 16, No. 3

Modleski, T. (1982) Never To Be Thirty-Six Years Old: Rebecca as Female

Oedipal Drama, Wide Angle, Vol. 5, No. 1

Modleski, T. (1988) The Women Who Knew Too Much: Hitchcock and Feminist Theory, New York and London, Methuen

Modleski, T. (1992) Time and Desire in the Woman's Film, in: Mast, G., Cohen, M. and Baudry, L. (eds) Film Theory and Criticism, fourth edition, Oxford, Oxford University Press,

Moi, T. (1985) Sexual/Textual Politics: Feminist Literary Theory, London and New York, Routledge

Mongia, P. (ed.) (1996) Contemporary Postcolonial Theory: A Reader, London, New York, Sidney and Auckland, Arnold

Monk, C. (1996) Review of Sense and Sensibility, Slight and Sound, Vol. 6, Issue 3

Moraga, C. and Anzaldúa, G. (eds) (1981) This Bridge Called My Back, New York, Persephone Press

Morrissette, B. (1985) Novel and Film: Essays in Two Genres, Chicago, Chicago University Press

Mudimbe, Y. V. (1988) The Invention of Africa: Gnosis, Philosophy and the Order of Knowledge, London, James Currey

Mudimbe, Y. V. (1992) The Surreptitious Speech: Présence Africaine and the Politics of Otherness, 1947–1987, Chicago, University of Chicago Press Mudimbe, Y. V. (1994) The Idea of Africa, Bloomington, Indiana University Press

Mulvey, L. (1975) Visual Pleasure and Narrative Cinema, Screen, Vol. 16, No. 3,

Mulvey, L. (1977) Notes on Sirk and Melodrama, Movie, No. 25

Mulvey, L. (1987) Notes on Sirk and Melodrama (updated), in Gledhill, C. (ed.) *Home is Where the Heart Is: Studies in Melodrama and Woman's Film*, London, British Film Institute Publishing

Mulvey, L. (1989) Visual and Other Pleasures, London, Macmillan

Murray, B. (1990) Film and the German Left in the Weimar Republic: From Caligari to Kuhle Wampe, Austin, University of Texas Press

Naficy, H. (1979) Iranian Feature Films: A Brief Critical History, Quarterly Review of Film Studies, Vol. 4

Naficy, H. (1992) Islamizing Cinema in Iran, in: Farsoun, S. K. and Mehrdad Mashayeki (eds) *Iran: Political Culture in the Islamic Republic*, London and New York, Routledge

Naficy, H. (1993) The Making of Exile Cultures: Iranian Television in Los Angeles, Minneapolis, University of Minnesota

Naficy, H. and Gabriel, T. (eds) (1993) Otherness and the Media: The Ethnography of the Imagined and the Imaged, Switzerland, Chur, Harwood Academic Publishers

Neale, S. (1980) Genre, London, British Film Institute Publishing

Neale, S. (1985) Cinema and Technology: Image, Sound and Colour, London Macmillan/British Film Institute Publishing

Neale, S. (1990) Questions of Genre, Screen, Vol. 31, No. 1

Neale, S. and Smith, M. (1998) Contemporary Hollywood Cinema, London and New York, Routledge

Neupert, R. (1995) The End: Narration and Closure in the Cinema, Detroit, Wayne State University Press

Nichols, B. (1991) Representing Reality: Issues and Concepts in Documentary, Bloomington, Indiana University Press

Nicholson, L. (ed.) (1990) Feminism/Postmodernism, New York and London, Routledge

Nowell-Smith, A. (1987) Minnelli and Melodrama, in Gledhill, C. (ed.) Home is Where the Heart Is: Studies in Melodrama and Woman's Film, London, British Film Institute

Ohanian, T. A. and Phillips, M. E. (1996) Digital Filmmaking: The Changing Art and Craft of Making Motion Pictures, Washington, Focal Press, Butterworth-Heinemann

Orr, J. (1993) Cinema and Modernity, Cambridge, Polity Press

Oshana, M. (1985) Women of Colour: A Filmography of Minority and Third World Women, New York and London, Garland Publishing Inc.

O'Sullivan, T., Hartley, J., Saunders, D. and Fiske, J. (1992) Key Concepts in Communication, London and New York, Routledge (sixth reprint)

Oudart, J.-P. (1977) Cinema and Suture, Screen, Vol. 18, No. 1

Ozguc, A. (1988) A Chronological History of the Turkish Cinema: 1914–1988, Istanbul, Ministry of Tourism

Paul, W. (1994) Laughing Screaming: Modern Hollywood Horror and Comedy, New York, Columbia University Press

Penley, C. (1985) Feminism, Film Theory and the Bachelor Machines, m/f, No. 10

Penley, C. (1988) Feminism and Film Theory, New York, Routledge, and London, British Film Institute Publishing

Penley, C. (1989) The Future of an Illusion: Film, Feminism and Psychoanalysis, New York and London, Routledge

Pick, S. (1993) The New Latin American Cinema: A Continental Project, Austin, University of Texas Press

Pillig, J. (ed.) (1992) Women and Animation: A Compendium, London, British Film Institute Publishing

Pillig, J. (ed.) (1997) A Reader in Animation Studies, London, Paris and Rome, John Libbey

Place, J. (1980) Women in Film Noir, in: Kaplan, E. A. (ed.) Women in Film Noir, London, British Film Institute (revised edition)

Pribham, D. (ed.) (1988) Female Spectators, London and New York, Verso Rajadhyaksha, A. (1996) India: Filming the Nation, in: Nowell-Smith, G. (ed.) The Oxford History of World Cinema, Oxford, Oxford University Press

Rajadhyaksha, A. and Willemen, P. (1994) Encyclopedia of Indian Film, New Delhi and London, British Film Institute Publishing and Oxford University Press

Rayns, T. and Meek, S. (eds) (1980) Electric Shadows: Forty-five Years of Chinese Cinema, London, British Film Institute Publishing

Reid, M. A. (1993) Redefining Black Film, Berkeley, Los Angeles and Oxford, University of California Press

Renov, M. (ed.) (1993) Theorizing Documentary, New York and London, Routledge

Rentschler, E. (1988) West German Filmmakers on Film: Visions and Voices, New York and London, Holmes & Meier

Rheudan, J. (1993) The Marriage of Maria Braun: History, Melodrama, Ideology, in: Friedan, S., McCormick, R. W., Petersen, V. R. and Vogelsang, L. M. (eds) *Gender and German Cinema, Feminist Interventions*, Oxford, Berg Publishers

Rodgerson, G. and Wilson, E. (eds) (1991) Pornography and Feminism: The Case Against Censorship, London, Lawrence and Wishart

Rose, J. (1986) Sexuality in the Field of Vision, London, Verso

Rosen, M. (1973) Popcorn Venus: Women, Movies and the American Dream, New York, Coward McCann & Geoghegan

Ross, K. (1996) Black and White Media: Black Images in Popular Film and Television, Cambridge, Polity Press

- Rothman, G. (1976) Against 'The system of the suture', in: Nicholls, B. (ed.) *Movies and Methods: An Anthology*, Berkeley, University of California Press
- Russo, V. (1981) The Celluloid Closet: Homosexuality in the Movies, second edition, 1987, New York, Harper and Row
- Saïd, E. (1978) Orientalism, New York, Pantheon
- Salt, B. (1977) Film Style and Technology in the 1940s, Film Quarterly, Fall Salt, B. (1983) Film Style and Technology: History and Analysis, London, Starword
- Schatz, T. (1981) Hollywood Genres, New York, Random House
- Screen (1984) Special issue on the soundtrack, Vol. 25, No. 3
- Screen (1988) Special issue on race, Vol. 29, No. 4
- Screen (1992) Sexing the Subject: A Screen Reader in Sexuality, London and New York, Routledge
- Segal, L. and McIntosh, M. (eds) (1992) Sex Exposed: Sexuality and the Pornography Debate, London, Virago
- Shafik, V. (1998) Arab Cinema: History and Cultural Identity, Cairo, The American University in Cairo Press
- Shiri, K. (ed.) (1993) Africa at the Pictures, BFI Dossier No. 10, London, National Film Theatre Publication
- Shohat, E. (1989) Israeli Cinema: East/West and the Politics of Representation, Austin, University of Texas Press
- Shohat, E. and Stam, R. (1994) Unthinking Eurocentrism: Multiculturalism and the Media, London and New York, Routledge
- Showalter, E. (ed.) (1989) Speaking of Gender, New York and London, Routledge
- Silberman, M. (1996) What is German in the German Cinema?, Film History, Vol. 8
- Silverman, K. (1981) Masochism and Subjectivity, Framework, No. 12
- Silverman, K. (1983) The Subject of Semiotics, Oxford, Oxford University Press
- Slaig, L. and Williams, T. (1975) Italian Western: The Opera of Violence, London. Lorrimer
- Snead, J., MacCabe, C. and West, C. (eds) (1994) White Screen, Black Images: Hollywood from the Dark Side, New York and London, Routledge
- Solanas, F. and Getino, O. (1983) Towards a Third Cinema, in: Chanan, M. (ed.) *Twenty-Five Years of the New Latin American Cinema*, London, British Film Institute Publishing
- Solomon, C. (ed.) (1987) The Art of the Animated Image, Los Angeles, American Film Institute
- Solomon, C. (1994) History of Animation, New York, Wings Books, Random House
- Sorlin, P. (1991) European Cinemas, European Societies 1939–1990, New York and London, Routledge
- Spivak, G. C. (1985) Can the Subaltern Speak? Speculations on widow sacrifice, *Wedge*, Vol. 7, No. 8

- Spivak, G. C. (1987) In Other Worlds: Essays on Cultural Politics, New York, Methuen
- Stacey, J. (1993) Star Gazing: Hollywood Cinema and Female Spectatorship, London and New York, Routledge
- Staig, L. and Williams, T. (1975) The Italian Western: The Opera of Violence, London, Lorrimer
- Stam, R. (2000) Film Theory: An Introduction, London and New York, Blackwells
- Stam, R., Burgoyne, R. and Flitterman-Lewis, S. (1992) New Vocabularies in Film Semiotics: Structuralism, Post-Structuralism and Beyond, New York and London, Routledge
- Stam, R. and Shoat, E. (1994) Unthinking Eurocentrism: Multiculturalism and the Media, New York and London, Routledge
- Stead, P. (1989) Film and the Working Class, London and New York, Routledge
- Stephens, M. L. (1995) Film Noir: A Comprehensive Illustrated Reference to Movies, Terms and Persons, North Carolina and London, McFarland & Co. Inc. Publishers
- Strong, J. (1999) Six Novels Adapted for Cinema, unpublished PhD thesis, Stirling University
- Studlar, G. (1985) Masochism and the Perverse Pleasures of the Cinema, in: Nicholls, B. (ed.) *Movies and Methods*, Vol. 2, Berkeley, University of California Press
- Suleri, S. (1992) Woman Skin Deep: Feminism and the Postcolonial Condition, *Critical Inquiry*, No. 18, Vol. 4
- Tasker, Y. (1993) Spectacular Bodies: Gender, Genre and the Action Cinema, Comedia Series, New York and London, Routledge
- Taylor, C. (1986) The L.A. Rebellion: New Spirit in American Film, Black Film Review, Vol. 2, No. 2
- Taylor, C. (1996) The Re-birth of the Aesthetic in Cinema, in: Bernardi, D. (ed.) *The Birth of Whiteness: Race and the Emergence of US Cinema*, New Jersey, Rutgers University Press
- Taylor, R. (1996) The Encyclopedia of Animation Techniques, Oxford, Boston, Johannesburg, Melbourne, New Delhi and Singapore, Focal Press
- Taylor, R. and Christie, I. (eds) (1994a) The Film Factory: Russian and Soviet Cinema in Documents 1896–1939, London and New York, Routledge
- Taylor, R. and Christie, I. (eds) (1994b) Inside the Film Factory: New Approaches to Russian and Soviet Cinema, London and New York, Routledge
- Taylor, R. and Spring, D. (eds) (1993) Stalinism and Soviet Cinema, London and New York, Routledge
- Tomaselli, K. (1988) The Cinema of Apartheid, New York, Smyrna Press Tompkin, J. (1992) West of Everything: The Inner Life of Westerns, New York, Oxford University Press
- Tudor, A. (1989) Monsters and Mad Scientists: A Cultural History of the Horror Movie, Oxford, Basil Blackwell

- Turim, M. (1989) Flashbacks in Film: Memory and History, New York and London, Routledge
- Turner, G. (1988) Film as Social Practice, London and New York, Routledge Tuska, J. (1976) The Films of the West, New York, Doubleday & Co. Inc.
- Ukadike, N. F. (1994) Black African Cinema, Berkeley, Los Angeles and London, University of California
- Ukadike, N. F. (ed.) (1995) New Discourses of African Cinema, Special Issue of Iris, No. 18
- Vasey, R. (1997) The World According to Hollywood: 1918–1939, Exeter, Exeter University Press
- Verhoeven, D. (1997) The Sexual Terrain of the Australian Feature Film: Putting the Out:back into the Ocker, in: Jackson, C. and Tapp, P. *The Bent Lens: A World Guide to Gay and Lesbian Film*, St Kilda, Victoria, Australian Catalogue Company
- Vieler-Portet, C. (1991) Black and Third World Cinema: Film and Television Bibliography, London, British Film Institute Publishing
- Vieyra, P. S. (1975) Le Cinéma Africain des origines à 1973, Paris, Présence Africaine
- Vieyra, P. S. (1983) Le Cinéma au Sénégal, Brussel and Paris, OCIC/L Harmattan
- Wagner, G. (1975) The Novel and the Cinema, New York, Associated University Presses Inc
- Weiss, A. (1990) Vampires and Violets: Lesbian Representation in the Cinema, London, Pandora Press
- Whisman, V. (1995) Queer by Choice: Lesbians and Gayness and the Politics of Identity, New York, Routledge
- Wilkins, M. (1989) I'm Gonna Git You Sucka: A Glance at the Blaxploitation Era, Black Face, No. 1
- Willemen, P. (1989) The Third Cinema Question: Notes and Reflections, in: Pines, J. and Willemen, P. (eds) *Questions of Third Cinema*, London, British Film Institute Publishing
- Willemen, P. (1994) Looks and Frictions: Essays in Cultural Studies and Film Theory, London, British Film Institute Publishing
- Williams, C. (ed.) (1980) Realism in the Cinema, London and Henley, Routledge & Kegan Paul
- Williams, L. (1984) When the Woman Looks, in: Doane, M. A., Mellencamp, P. and Williams, L. (eds) *Re-vision: Essays in Feminist Film Criticism*, Frederick, Marylands, The American Film Institute/University Publications of America
- Winston, B. (1995) Claiming the Real: The Documentary Film Revisited, London, British Film Institute Publishing
- Wollen, P. (1972) Signs and Meaning in the Cinema, London, Secker & Warburg Wollen, P. (1982) Semiotic Counter-Strategies: Readings and Writings, London, Verso
- Wood, R. (1992) Ideology, Genre, Auteur, in: Mast, G., Cohen, M. and Baudry, L. (eds) Film Theory and Criticism, Oxford, Oxford University Press

- Woodhead, C. (ed.) (1989) Turkish Cinema: An Introduction, London, Centre for Near and Middle-Eastern Studies, Occasional Paper 5
- Wright, W. (1975) Six Guns and Society: A Structural Study of the Western, Berkeley, Los Angeles and London, University of California Press
- Xavier, I. (1997) The Humiliation of the Father: Melodrama and Cinema Nôvo's Critique of Conservative Modernization, *Screen*, 38: 4
- Yau, E. (1996) China after the Revolution, in: Nowell-Smith, G. (ed.), The Oxford History of World Cinema, Oxford and New York, Oxford University Press
- Young, L. (1996) Fear of the Dark: 'Race', Gender and Sexuality in the Cinema, London and New York, Routledge
- Zhang, X. (1998) Chinese Modernism in the Era of Reform, North Carolina, Duke University Press
- Zhang, Y. and Xiao, Z. (eds) (1998) Encyclopedia of Chinese Film, London and New York, Routledge
- Zizek, S. (1999) The Fright of Real Tears: The Uses and Misuses of Lacan in Film Theory, London, British Film Institute Publishing

INDEX OF FILMS

A bout de souffle 77, 146, 206 A hora da estrela (The Hour of the Star) 432 A nous la liberté 19 Aafrique 50 412 Abi and Rabi 437 Accused, The 355 Aces High 451 Across the Pacific 457 Adventures of Buffalo Bill, The 464 Adventures of Priscilla, Queen of the Desert 49, 53, 310, 313 African Queen, The 73 Afrique sur Seine 403 Age of Innocence, The 5, 75 Aguirre, Wrath of God 181 Air Force 458 Airport 359 Ajantrik (The Unmechanical) 393 Al Dhikrayat al Kasibah (al-Djakira alkhisba) (Fertile Memories) 434 Alexander Nevsky 342 Algérie en flammes (Algeria in Flames) 412 Ali Baba 420 Alibaba and the Forty Thieves 420 Alien trilogy 109, 188, 305, 317 All Quiet on the Western Front 371, All that Heaven Allows 217, 220 Amadi 401 American in Paris, An 247, 251

Andaz 422

Annie Hall 373

Annie Oakley 469

Anokhi Dastan 425 Antonio das Mortes 56, 430 Apocalypse Now 462 Arroseur arrosé 73 Attack! 459 Babes in Arms 246 Babes on Broadway 246 Baldwin's Nigger 32 Ballad of Little Jo, The 469, Bande à part 279

Baldwin's Nigger 32
Ballad of Little Jo, The 469, 470
Bande à part 279
Barkleys of Broadway, The 251
Bat, The 81
Bataan 458
Battle of the Midway, The 455
Battleship Potemkin 96, 340, 342
Beginning or the End?, The 460
Beloved 5
Ben Hur 103
Bend of the River 471
Berlin 455
Bezhin Meadow 342
Bhaji on the Beach 34

Big Jim McClain 460 Big Timers 37 Bigger than Life 219

Billy the Kid 468 Birds, The 441

Birth of a Nation, The 36, 37, 103, 327

Birth of a Race 38 Bismarck 454 Black Joy 252 Blackmail 265 Blacula 42

Index of Films

Blade Runner 317 Blazing Saddles 168

Blood of the Condor, The 430

Body Beautiful, The 34

Bombay 424

Bonnie and Clyde 369, 460, 473

Born in Flames 308

Born on the Fourth of July 462

Borome Sarret 403

Boss Nigger (The Black Bounty Killer)

42, 470

Boyz'n the Hood 48, 192

Bride of Frankenstein, The 371

Bridge over the River Kwai, The 459

Bridge, The 459

Bringing up Baby 333, 370

Broadway Melody, The 243

Broken Arrow 472

Bronco Billy's Redemption 465

Brood, The 188

Brute, The 38

Buck and the Preacher 470

Buffalo Bill 468

Bulbule-Paristan 425

Burma Victory 453

Burmese Harp, The 458

Burning an Illusion 32-3

Butch Cassidy and the Sundance Kid

52, 169, 473

Butterfly Kiss 310

Cabaret 254

Cabin in the Sky 247, 252

Cabinet of Dr Caligari, The 80, 175,

176, 177-8, 187

Carefree 245

Casablanca 135, 368, 457

Cat People 50

Central do Brazil (Central Station) 432

Charlie Chan 374

Children of the Atom Bomb 461

China Gate 461

Chisum 473

Christopher Strong 220

Chronicle of a Disappearance 434

Chronique d'un été 92

Chroniques des années de braise

(Chronicle of the Years of Embers)

412

Citizen Kane 81, 82, 135-6, 228,

370, 429

Clean Pastures 13

Cleopatra 104

Cleopatra Jones 43

Close Encounters of the Third Kind 317

Coal Black and De Sebben Dwarves 13

Coalface 90

Cobweb, The 219

Coffy 43

Color Purple, The 5, 327

Color of Money, The 53

Coma 305

Come Back Africa 445

Coming Home 462

Compulsion 307

Confessions of a Nazi Spy 456

Congorilla 403

Connection, The 445

Conspiracy of the Doomed 460

Cool World, The 40, 445

Covered Wagon, The 466

Cow, The 438

Created Surface of the Earth, The 338

Cry Freedom 406

Crying Game, The 163

Curfew 434

Cyrano de Bergerac 105

Dam Busters, The 143, 458

Dances with Wolves 472

Dancing Darkies 36

Dancing Nig, The 36

Daughters of the Dust 44

Day at War, A 455

Day for Night 210

Days, The 419

Dead End 81

Dead Ringers 109, 170, 442

Deer Hunter, The 462

Demolition of the Russian Monument at

St Stephen, The 435

Desert Hearts 308

Desert Victory 453

Desperately Seeking Susan 74

Destiny 178

Deuses e os Mortos (The Gods and the Dead) 57

Deux ou trois choses que je sais d'elle 148

Devil's Doorway 472

Dhaka Tara (The Cloud-Capped Star)

Dharti Ke Lal (Children of the Earth)

393 Dingjuin 415

Dirty Gertie from Harlem 37

Do Ansoo 425

Do the Right Thing 45

Dolly Sisters, The 246

Dom 14

Dona Herlinda y su hijo (Dona Herlinda and Her Son) 432

ana Hei 30n) 432

Double Indemnity 130, 138-40

Dr Jekyll and Mr Hyde 188

Dr Mabuse, the Gambler 174, 178

Dr Strangelove 461

Dracula (1931) 187, 371

Dracula (1992) 188, 189

Dragnet 373

Dreaming Rivers 33

Earth, The 340

East Palace, West Palace 310, 419

Easy Rider 68, 253, 313

Edward II 307

El Condor 470

Empire 239

En résidence surveillée (Under House

Arrest) 403

England Expects 450

Entr'acte 28, 78

Equal Wages for Men and Women 182

E.T. 317, 372

Et Dieu créa la femme 145

Eternal Jew, The (Der Ewige Jude) 454

Even Cowgirls Get the Blues 308

Every Day Except Christmas 144

Expresso Bongo 248

Extraordinary Adventures of Mr West in the Land of the Bolsheviks, The 340

Fall Guy, The 37

Fame 49

Fantasmagorie 12

Fantômas 153

Farewell My Concubine 310, 418, 419

Fatal Attraction 109, 348, 355

Father Son and Holy War 393

Fatherland Calls, The (Das Vaterland ruft) 450

Fear Eats the Soul 181

Felix the Cat 12

Fifth Element, The 317

Fires of the Plain 458

Fistful of Dollars, A 474

Flaming Creatures 444

Fly, The 109, 305

Flying Down to Rio 244

Follow the Fleet 245

For a Few Dollars More 474

For Massa's Sake 36

Forrest Gump 280

Forty Guns 470

Four Horsemen of the Apocalypse, The

451

Fox of Glenarvon, The 454

Foxy Brown 43

Frankenstein 187, 371

Frantz Fanon: Black Skin White Mask

33

French Lieutenant's Woman, The 231

French Mothers (Mères françaises) 450

Frenzy 441, 442

Fresh Kill 308

Friendly Persuasion 374

From Here to Eternity 228

Full Metal Jacket 462

Full Monty, The 4

Funny Girl 248

Funny Lady 248

Gabbeh 439

Gang of Freedom, The 410

Garam Hava (Hot Winds) 424

Index of Films

Gaslight 223 Genesis 14 Gentle Sex, The 453

Gentlemen Prefer Blondes 73 Germany in Autumn 181

Gertie the Dinosaur 12

Gigi 250

Gilda 131, 305, 373 Girl Crazy 246

Glenn Miller Story 247

Go Fish! 308, 310 Godfather, The 278

Godspell 248 Godzilla 188, 461

Gold Diggers of 1933 245

Gold Rush, The 372

Gone With the Wind 65, 70, 75, 369

Grand Parade, The 451

Grease 248

Great Gatsby, The 5

Great Train Robbery, The 98, 462-3,

465

Green Berets 461 Green Pastures, The 37 Gueule d'amour 151 Gunfighter 472

Haifa 434 Hair 248

Halfaouine 414 Hallelujah 252

Halls of Montezuma 459 Hamburger Hill 462

Hamsin 435

Hand, The (Ruka) 14 Handsworth Songs 33

Happy Birthday Tüke! 183

Hard Day's Night

Hard Day's Night, A 248 Harder They Come, The 248

Harishchandra 420 Harlan County 92 Heart of Britain 452

Heimat 179

Hell and High Water 460

Hello Dolly! 248

Help! 248

Henry V 454-5

Heritage... Africa 393

Herr Doktor 450

High Noon 85, 372, 471, 472

Hiroshima, Hiroshima 461

Hiroshima mon amour 95, 146, 206

His Girl Friday 333 Histoire d'A 92

Histoire d'un crime 133

Histoire d'un retour (Story of a Return)

410

Histoire d'une rencontre (Story of an

Encounter) 413 Hitler's Children 457

Homage by Assassination 434

Home Away from Home 33

Home from the Hill 219 Homesteader, The 38

Hors la vie (Out of Life) 410

House Behind the Cedars, The 38 Howard's End 105

Humayun 422 Hunger, The 188 Hyenas 407, 408

I Am a Fugitive from a Chain Gang

I Was a Communist for the FBI

460

Il tetto (The Roof) 203 I'll Cry Tomorrow 246

I'm Gonna Git You Sucka 44

Imitation of Life 218, 220 In the Heat of the Night 40

In the Heat of the Night 40 In the Line of Fire 227, 357

In Which We Serve 453 Incendiary Blonde 246

Industrial Britain 91

Interview with the Vampire 188

Invaders from Mars 316

Invasion of the Body Snatchers 460

Invisible Man, The 371 Iron Horse, The 466

It Came from Outer Space 316
It Conquered the World 316

It Happened One Night 333, 373 I've Heard the Mermaids Singing 308

J'accuse 451 Jackie Brown 43 Jail House Rock 248

Jaws 96, 372

Jazz Singer, The 153, 243, 332, 368 Jeanne Dielman, 23 Quai du Commerce, 1080 Bruxelles 29

Jeera Sain 426

Jemima and Johnny 31 Jesus Christ Superstar 248

Johnny Guitar 1, 309, 374, 467, 469–70, 471–2

Jollies 308 Juju 393 Junior 305

Jurassic Park 15, 111-12, 166, 372

Just Another Girl on the IRT 48

Kaddu Beykatt (Letter from My village) 403

Kaiser – The Beast of Berlin, The 450 Kameradschaft 178

Kanta of Kebbi 401 Kartar Singh 426

Keep Punching 37

Keystone Kops 73

Khilona 427 Khush 308

Killer of Sheep 44

Kind of Loving, A 51 King and Country 451

King and I 248

King Kong 12, 370

King Solomon's Mines (1937) 252

King Solomon's Mines (1973) 403

Kings of the Cannibal Islands 402 Kiss Me Deadly 131, 279, 305

Kiss of the Spiderwoman, The 165

Kitchen 239

Klondike Annie 1, 469 Komal Gandhar 393, 424

Kukurantumi 393

La Bataille d'Alger (Battle of Algiers) 394, 412

La Bataille du rail 454

La Bell équipe 150

La Belle et la bête 95, 190

La Chinoise 29, 148

La Coquille et le clergyman 20, 28, 238

La Danse du feu (The Fire Dance) 414

La Grande illusion 142, 451

La Hora de los hornos (The Hour of the Furnaces) 394, 430

La Mano en la trampa (The Hand in the Trap) 429

La Nouba des femmes du mont Chenoua (The Nouba of the Women of Mount Chenoua) 413

La Nuit américaine 231

La Pointe courte 146

La Pomme (The Apple) 439

La Règle du jeu 150

La Souriante Mme Beudet 28

La terra trema (The Earth Trembles) 202, 203

La Vie de Christ 3

La Vie est à nous 150

La Vie et passion de Jésus Christ 3

La Ville des pirates (The City of Pirates) 431

La Zerda ou les chants de l'oubli (The Zenda and the Songs of Forgetfulness) 413

Ladri di bicicletti (Bicycle Thieves) 203

Lady in the Dugout, The 464 Lady Sings the Blues 246

Lady, The 437

Ladybird, Ladybird! 258

Lakhon Mein 426

L'Année dernière à Marienbad 97, 206

L'Arlésienne 259

L'Assassinat du duc de Guise 386

Last Laugh, The 177

Last Temptation of Christ, The 54

Laura 305

Lawrence of Arabia 103, 374

Layla and the Wolves 410

Le Beau Serge 146

Index of Films

Le Chagrin et la pitié 92 Le Chant d'amour 307 Le Ciel est à vous 453 Le Corbeau 453 Le Crime de M. Lange 150 Le Jour se lève 86, 129, 150, 228, 230 Le Mépris 17, 58, 335 Le Rouge aux lèvres 188 Le Sang d'un poète 307 Le Vent des Aurès (The Wind from the Aurès) 412 Left-Handed Gun, The 471 Legend of Nigger Charlie, The 42 Les Années folles du twist (Mad Years of the Tivist) 413 Les 400 Coups 146 Les Demoiselles de Rochefort 49 Les Panapluies de Cherbourg 49 Les Silences du palais (Silences of the Palace) 414 Les Vampires 187 Letter from an Unknown Woman 222 Leyla the Bedouin 409 Lillian Russell 246 Listen to Britain 452 Little Caesar 130, 153, 154, 368 Little United States, The 450 Locket, The 137 London Can Take It 452 Loneliness of the Long Distance Runner, The 51 Longtime Companion 53 Look at Britain 144 Look Back in Anger 51, 144 Looking for Langston 33, 310 Los Olvidados 429 Losing Ground 49 Lost Girl, The 437

M 178
Machorka-Muff 181
Magnificent Seven, The 473
Making of Bronco Billy, The 465
Malcolm X 48
Maltese Falcon 129

Love Brewed in an African Pot 393

Maly Western 14 Mama 419 Man with a Movie Camera 337, 339 Man Who Fell to Earth, The 317 Man Who Shot Liberty Valance, The 466 Man Who Would be King, The 374 Manon des sources 105 María Candelaria 429 Marnie 122, 134, 220, 224, 441 Marriage in Galilee 273 Marty 372 Maula Jat 426 Meet Me in St Louis 247, 252 Meghe Dhaka Tara (The Cloud-Capped Star) 393 Memorias del subdesarrollo (Memories of Underdevelopment) 394 Menace II Society 47 Meshes of the Afternoon 29, 238, 444 Metropolis 174, 177, 178, 316, 317 Mildred Pierce 85, 132, 134, 135, 137, 218, 224, 305 Millions Like Us 453 Mirror Image of Dorian Gray in the Yellow Press, The 182 Misery 447 Miss Oueencake 34 Mission to Moscow 457 Mississippi Marsala 35, 49 Moana 90 Modern Times 372 Mol 403 Moment of Innocence, A 439 Momma Don't Allow 143, 144 Mommie Dearest 304 Morgenrot (Dawn) 451 Mother 340, 342 Mr Magoo 13 Mrs Miniver 455 Murder My Sweet 130, 305 Muthi Bhar Chawal 426 My Darling Clementine 467 My Fair Lady 248, 369 My Life for Ireland 454

My Little Chickadee 469

My Own Private Idaho 308, 356 My Son John 460

Nagarik (The Citizen) 393 Naked Spur, The 471 Nanook of the North 91 Napoléon vu par Abel Gance 135

Napoléon vu par Abel Gance 135 Nashville 254 Naughty Marietta 244 Negro Dancers 36 Nevada Smith 473 New Jack City 45–6, 192 New Moon 244 Night and Day 246 Night of the Living Dead, The 188

Night Mail 90 Nightfall 279 Ninotchka 251 North Star, The 457

Nosferatu: A Symphony of Terror 178, 187

Notorious 370 Now Voyager 122, 220, 224

October 96 Oklahoma 248, 251

Old and the New, The/The General Line 342

On the Bowery 445

On a Clear Day You Can See Forever 248

On the Town 247 On the Waterfront 228, 259, 374 One Flew over the Cuckoo's Nest 373

One Hundred Men and a Girl 246 One Night Stand 212 One Potato, Two Potato 40 Ossessione (Obsession) 201, 202 Out of Africa 278 Out of the Inkwell 12

Outlaw, The 468, 468–9 Outrage, The 450

Ox-bow Incident, The 468

Pale Rider 10, 191, 472 Panagraph 218 182 Paris is Burning 308 Paris Texas 68, 313

Passion of Remembrance, The 33 Pat Garrett and Billy the Kid 473

Paths of Glory 451, 459

Peeping Tom 140-1, 188, 231, 441, 447

Pépé le Moko 150 Perfect Image? 33 Pheray 425 Philadelphia 308 Philadelphia Story 73

Pickanninies 36

Piel de verano (Summer Skin) 394 Pierrot le fou 58, 239–42, 335

Pirate, The 247 Plainsman 469 Planet of the Apes 108 Platoon 462

Player, The 278, 343 Porgy and Bess 252 Portrait of Jason 445 Portrait of a Lady 5

Possessed 137, 224
Postman always Rings Twice, The 202
Power of Men is the Patience of Women,

The 182
Pressure 32
Pretty woman

Pretty woman 278
Pride and Prejudice 4
Prime Minister, The 454
Prisoner of the Emir 438
Private Life of Henry VIII 372
Pricks 65, 66, 100, 110, 188

Psycho 65, 66, 109, 119, 188, 200, 290, 295–6, 440, 447

Public Enemy, The 153, 154, 368 Pull My Daisy 445 Pulp Fiction 279

Purple Heart, The 457, 458

Quai des brumes 150 Qué viva Mexico! 341, 429 Quiet Man, The 374, 467

Rabid 188 Railroad Porter, The 37

Index of Films

Raise the Red Lantern 418

Rambo 461

Rancho Notorious 470

Rear Window 446-7

Rebecca 86, 121-2, 223

Rebel Without a Cause 109, 219, 354,

369

Record of a Human Being 461

Red Danube, The 460

Red Menace, The 460

Red Planet Mars 460

Red Sorghum 418

Reggae 32

Remember Pearl Harbour 456

Reservoir Dogs 155, 278

Rhapsody in Blue 246

Ricochet 434

Roaring Twenties, The 368

Robe, The 11, 103, 367

Rocky 373

Roja 424

Roma città aperta (Rome Open City)

201, 203

Roman Scandals 245

Romeo and Juliet (1947) 422

Romeo and Juliet (1996) 4

Room at the Top 51

Room with a View, A 8, 105

Rope 307 Rose, The 246

Rosemary's Baby 442

Sachchai 425

Saint Valentine's Day Massacre, The

278

Saladin 410

San Demetrio, London 453

Sanders of the River 252

Sands of Iwo Jima, The 458

Sans toit ni loi 29

Sassi 425

Saturday Night Fever 248

Saturday Night and Sunday Morning

51, 144-5

Saving Private Ryan 459

Scarface 153

Scorpio Rising 445

Searchers, The 36, 467, 472

Sense and Sensibility 7

Sergeant York 368, 369

Seven Brides for Seven Brothers 251

Seven Songs for Malcolm X 33

Seven Year Itch, The 73

Shaft 41, 42, 254

Shane 472

Shanghai Triad 418

Shape of Things to Come, The 316

She's Gotta Have It 45

Shining, The 447

Shivers 188

Shoulder Arms 451

Silence of the Lambs, The 190

Silences of the Palaces 273

Silk Stockings 251

Singin' in the Rain 243, 278, 334

Sinking of the Lusitania, The 450

Snow White and the Seven Dwarfs 12,

13

Soldier's Story, A 327

Some Like it Hot 73, 164

Song of Russia 457

Sophie's Choice 359

Soul of Nigger Charlie, The 42

Sound of Music, The 249

South Pacific 248

Spare Time 91

Speak Like a Child 33

Stagecoach 468

Star is Born, A 70, 246, 354, 369

Stars Look Down, The 332

Staying Alive 49

Steamboat Willie 12

Steel Helmet, Fixed Bayonets 460

Stella Dallas 218, 305

Still a Brother: Inside the Negro Middle

Class 40

Sting, The 52

Story of GI Joe, The 458

Story of Qui Ju, The 418

Straight Out of Brooklyn 48

Strangers on a Train 230

Straw Dogs 473

Streetcar Named Desire, A 228

Strictly Ballroom 49

Strike 96, 341

Strike up the Band 246

Strongman Ferdinand 181

Subarnareka 393, 424

Summer Holiday 248

Sunset Boulevard 135, 278

Superfly 41, 42, 254

Sweet Charity 254

Sweet Sweetback's Baadasssss Song 41-2

Swoon 307

Symbol of the Unconquered, The 38, 39

Take a Hard Ride 470

Tale of the Three Jewels 434

Target for Tonight 452

Taste of Cherry, A 439

Taste of Honey, A 51

Taxi Driver 462

Tempest of Life, The 438

Ten Bob in Winter 31

Ten Commandments, The 103, 367

Ten Minutes to Live 39

Teri Yaad 425

Terra em Transe (Land in Anguish) 56,

394

Tess of the D'Urbevilles 75

Texas Chainsaw Massacre 188

Thank God it's Friday 252

That Hamilton Woman! 454, 455

Thelma and Louise 53, 258, 313

They Drive by Night 368

They Were Expendable 458

Thin Red Line, The 459

Thing, The 188

Thirty Seconds over Tokyo 458

This Land is Mine 456

This Sporting Life 51, 145

Thriller 76

Through the Olive Trees 439

Till the Clouds Roll By 246, 247

To Have and Have Not 369

Tom Jones 52

Toni 311, 332

Tootsie 164, 165

Top Hat 245, 370

Touki-Bouki (The Hyena's Journey) 407

Towering Inferno 359

Toy Story 15

Train to Pakistan 424

Trainspotting 4

Tramp, The 374

Triumph of the Will 454

Trouble I've Seen 49

Trouble with Love, The 182

Tumbleweeds 465

Tumbling Tumbleweeds 467

Tunisian Victory 453

2001: A Space Odyssey 170, 316-17,

318

Two Strangers 437

Un chien andalou 28, 97

Un été à La Goulette 414

Uncle Kruger 454

Unforgiven 10, 191, 357, 472

Urs fil Jalil (Marriage in Galilee) 434

Usi Roti (Our Daily Bread) 393

Vampire in Brooklyn 44

Vampire Lovers 188

Vampyres 188

Vent du sud (Wind from the South) 412

Vertigo 229

Very Narrow Bridge, A 435

Vidas Secas (Barren Lives) 56

Visage de femmes (Faces of Women) 405

Voodoo Vengeance 402

Voyage à la lune 11-12

Wake Island 457

War at Sea from Hawaii to Malaya, The

455

War Bride 450

War Game, The 461

War of the Worlds 316

Way to the Stars, The 453

Way We Were, The 248

Wayne's World 74

We are the Lambeth Boys 144

We Make History 393

Index of Films

Weekend 29, 148 West Side Story 248 Westerner, The 468 Westfront 1918 451 Westward Women 469 What Price Glory 451 What We Have Against It 182 Whatever Happened to Baby Jane? 441 When Night is Falling 308 White Balloon, The 439 White Heat 460 Why We Fight 455 Wild Bunch, The 460, 471 Wild Wild West 471 Wings 451 Wizard of Oz, The 245, 369 Woman in the Window 131, 305 Woodstock 248

Wooing and Wedding of a Coon, The 402 World, the Flesh and the Devil, The 460 Worlds and Music 246 Written on the Wind 220

Xala 407

Yank in the RAF, A 455 Yankee Doodle Dandy 246, 456 Years of Hunger 182 Yellow Earth 418 Yesterday Girl 181 Yol (The Way) 436 Young Mr Lincoln 25, 194 Young Soul Rebels 33 Young Törless 181

NAME INDEX

Abbas, K.A. 393 Abbott, 278, 371 Abel, Richard 12 Akerman, Chantal 16, 29, 89, 307 Akomfrah, John 33, 34, 396 Aldrich, Robert 131, 279, 441, 459 Alea, Tomás Guttiérez 394 Allégret, Yves 150 Allen, Woody 359, 373 Allouache, Merzak 413 Althusser, Louis 23–4, 25, 59, 60–1, 115, 193, 323, 326, 360 Altman, Robert 249-50, 252, 254, 278, 343, 350 Alvidson, John 373 Amaral, Suzana 432 Ampaw, King 392, 393 Anand, J.C. 425 Anderson, Gilbert M. 465 Anderson, Lindsay 50, 51, 90, 142, 143, 144, 145 Anderson, Michael 143, 458 Andreotti, Giulio 203 Andrew, Dudley 28 Anger, Kenneth 307, 444, 445 Ansah, Kwaw Painstil 392, 405 Antonioni, Michelangelo 204 Appiah, Kwame 268, 399 Araki, Gregg 308 Arbuckle, Fatty 55, 73, 367 Armstrong, Louis 13 Arnold, Jack 42, 470 Artaud, Antonin 20 Arthur, Jean 469

Arzner, Dorothy 220, 221, 225, 367
Ashby, Hal 462
Ashcroft, B. 267
Assaf, Layla 410
Astaire, Fred 243, 245, 247, 250, 253, 350, 370
Astruc, Alexandre 20, 387
Attenborough, Richard 51
Attile, Martine 33
Austen, Jane 7, 234
Autant-Lara, Claude 11
Autry, Gene 374, 428, 464, 467
Avery, Tex 13

Babenco, Hector 165 Bacall, Lauren 220, 350, 369 Baccar, Selma 414 Baghdadi, Maroun 410 Baker, Roy Ward 188 Balogun, 404 Bardot, Brigitte 17, 145, 350, 352 Barka, Ben 414 Barthes, Roland 23, 83, 254, 255, 303, 320, 360 Bates, Alan 51 Bates, Kathy 447 Baudrillard, Jean 271 Baudry, Jean-Louis 2, 15, 300, 343, 344 Baudry, Leo 168 Bazin, André 4, 10, 20, 57, 82, 95, 312, 328 Beatles, The 248 Beaumont, Harry 243

Becker, Jacques 453 Brooks, Peter 214 Beckett, Samuel 232 Brown, Jim 42 Begum, Fatma 425 Browning, Tod 187 Bruckner, Jutta 182 Belafonte, Harry 42 Bellour, Raymond 2, 157, 158, 300, Bunuel, Luis 28, 97 Burch, Noël 80, 98 343, 344-5 Burnett, Charles 44, 48 Belmondo, Jean-Paul 206 Burton, Richard 51, 104, 350, 352 Belmont, Charles 92 Bendazi, G. 14 Benning, Sadie 308 Cagney, James 369 Cain, James M. 202 Bentham, Jeremy 232 Caine, Michael 51 Benveniste, Emile 99, 100 Bergman, Ingmar 18 Calloway, Cab 13 Bergman, Ingrid 369 Campion, Jane 5 Canudo, Ricciotto 386 Bergstrom, J. 319 Capra, Frank 333, 373, 455 Berkeley, Busby 245, 253 Carlyle, Robert 4 Berlin, Irving 244, 245 Carné, Marcel 86, 128, 129, 144, Berlin, King 252 150, 151, 228 Bernardi, Daniel 35-6 Carpenter, John 188 Bernhardt, Curtis 137 Carvani, Liliani 16 Berri, Claude 105 Besson, Jean-Luc 87, 317 Castro, Fidel 391 Césaire, Aimé 270 Bhabha, Homi 268, 396, 398 Bhowmik, Someswar 421 Chabrol, Claude 145, 146, 148 Blackwood, Maureen 33 Chada, Gurinder 34 Blair, Les 401 Chahine, Youssef 409, 410 Bogart, Humphrey 350, 369 Chamoun, Jean 434 Chand, Daud 425 Bonham-Carter, Helena 4 Chaney, Lon 371 Borden, Lizzie 308 Bordwell, David 64, 65, 66, 81, 210, Chaplin, Charlie 73, 333, 340, 349, 367, 372, 374, 451 242 Borowczyk, Walerian 14 Charisse, Cyd 247, 251 Boughedir, Ferid 414 Cheang, Shu Lea 308 Boyle, Danny 8 Chen Kaige 310, 418 Brahms, John 137 Chrétien, Henri 10 Churchill, Winston 454 Brakhage, Stan 444, 445 Cimino, Michael 462 Branagh, Kenneth 282 Branch, William 40 Cissé, Souleymane 392, 404 Brando, Marlon 1, 228, 259, 354, Cixous, Hélène 378 367 Clair, René 19, 28, 78, 238 Brandt, Joseph 373 Clampett, Bob 13 Clarke, Shirley 40, 445 Braque, Georges 234 Brecht, Bertolt 29, 89, 254, 339 Clayton, Jack 5, 51 Bresson, Robert 90, 453 Clein, John 37 Bronson, Charles 474 Clément, René 454

Clift, Montgomery 228, 353

Brooks, Mel 168

Close, Glenn 348, 355 Clouzot, Henri-Georges 453 Cocteau, Jean 95, 144, 190, 307 Codis, Jean-Claude 410 Cohl, émile 12 Cohn, Harry 373 Cohn, Jack 373 Colbert, Claudette 333, 354 Collins, Kathleen 49 Comolli, J.-L. 195 Connelly, Marc 252 Connery, Sean 224 Cook, Pam 114, 189 Cooper, Gary 85, 468 Cooper-Hewitt, Peter 207 Coppola, Francis Ford 63, 188, 189, 278, 462 Cosmatos, George Pan 461 Costa-Gavras, Constantin 149 Costello, 278, 371 Costner, Kevin 472 Cowie, E. 348 Crain, William 42 Craven, Wes 44 Crawford, Broderick 373 Crawford, Joan 1, 224, 304, 309, 352, 369, 374, 469 Crichton, Michael 305 Cripps, Thomas 36 Cronenberg, David 109, 170, 188, 305, 442 Crosby, Bing 247, 367, 456 Crosland, Alan 154, 243, 332, 368 Cruise, Tom 53, 357 Cruze, James 466 Cukor, George 70, 73, 219, 354 Cunningham, John W. 472 Curtis, Bernhardt 224 Curtis, Tony 164 Curtiz, Michael 85, 102, 132, 134, 135, 218, 305, 457 Cushing, Peter 187

Das Gupta, Chidananda 400 Dash, Julie 44, 48 Daves, Delmer 472

Davis, Bette 106, 183, 352, 353, 354, 357, 369, 456 Dawson, Anthony 470 Day, Doris 62, 71, 351, 355 Dayan, Daniel 383 Dayan, Nissim 435 De Gaulle, Charles 24, 360 De Lauretis, Teresa 120-1, 122, 124, 125-7 . De Mille, Cecil B. 367 De Niro, Robert 106, 171, 353 Dean, James 1, 55, 110, 218, 228, 352, 353, 354, 369 Deitch, Donna 308 Delaney, Shelagh 51 Delluc, Louis 27, 238 Demme, Jonathan 5, 190, 308 Demy, Jacques 249 Deren, Maya 29, 80, 238, 444 Derrida, Jacques 80, 376, 388 Dietrich, Marlene 352, 367, 372, 448, 456, 470 Disney, Walt 12, 13, 70 Djebar, Assia 413 Dmytryk, Edward 130, 305 Doane, Mary Ann 124, 215, 221, 222, 223, 224 Dobson, Tamara 42, 43 Donen, Stanley 243, 334 Dörrie, Doris 182, 183 Dors, Diana 350 dos Santos, Nelson Pereira 56 Douglas, Gordon 188 Dovzhenko, Alexander 339, 340 Duke, 252 Dulac, Germaine 20, 27, 28, 80, 238 Duras, Marguerite 29, 280 Durbin, Deanna 246, 371 Duvivier, Julien 129, 150 Dyer, Richard 189, 211-12, 244, 249, 253, 351, 352

Eastwood, Clint 10, 68, 95, 183, 191, 227, 351, 357, 467, 472, 474 Ecaré, 405 Eckhard, Sabine 182

Eddy, Nelson 244, 245 Edeson, Arthur 81 Edison, Thomas Alva 18, 36, 332, Eisenstein, Sergei 28, 83, 94, 96, 238, 337, 338, 339, 341, 341-2 Eliott, Stephen 310, 313-14 Ellington, Duke 247 Elliott, Priscilla 53 Ellis, J. 355 Elsaesser, Thomas 104, 107, 174, 181, 220 Epstein, Jean 27, 238 Ergun, Mahinur 437 Ertugrul, Mushin 435 Espinosa, Julio García 431 Eustache, Jean 59 Everett, Francine 37

Fairbanks, Douglas Snr 340, 367, 372 Fanon, Frantz 268, 406-7 Fassbinder, Rainer Werner 21, 179, 180, 181, 460 Fay, Alice 367 Faye, Safi 403, 404 Fellini, Federico 204, 254 Fernandez, Emilio 429 Fetchitt, Stepin 13 Feuillade, Louis 153, 187, 386, 450 Field, Shirley Ann 350 Fields, W.C. 73, 333, 371 Figgis, Mike 212 Figueroa, Gabriel 429 Fincher, David 109, 305 Finney, Albert 51 Firth, Colin 4 Fischer, Lucy 222 Fiske, J. 322 Fitzgerald, Scott 5 Flaherty, Robert 90, 91, 144 Fleischer, Dave and Max 12-13 Fleischer, Richard 307 Fleming, Victor 70, 75, 245, 369 Flitterman-Lewis, Sandy 122 Flynn, Errol 369

Fonda, Jane 462 Forbes, Bryan 51 Ford of Dagenham 143-4 Ford, John 21, 36, 144, 194, 367, 374, 455, 458, 466-7, 468, 472, 473 Foreman, Carl 471 Forman, Milos 373 Forster, E.M. 7, 8, 75 Fosse, Bob 254 Foster, Bill 36, 37 Foster, Jodie 355 Foucault, Michel 122-5, 310, 376 Foxworth, Heather 49 Fraenkel 175 Franju, Georges 91 Frank, Robert 445 Frears, Stephen 280 Freed, 245, 247 Freleng, Fritz 13 Frend, Charles 453 Freud, Sigmund 2, 110-11, 118, 121,

136, 157, 196–8, 218, 221, 261, 288–9, 290–2, 294, 298–300, 303, 344

Fuller, Samuel 21, 460, 470

Fuller, Samuel 21, 460, 470 Furuzan, Tomris Giritlioglu 437 Fusco, Coco 396

Gabin, Jean 150, 218 Gable, Clark 333, 456 Gabriel, Teshome 391, 394, 395 Gance, Abel 135, 451 Garbo, Greta 183, 349, 352, 369 Gardin, Vladimir 338 Gardner, Ava 350 Garland, Judy 55, 246, 247, 354, 369 Garnett, Tay 458 Garson, Greer 369 Gazdar, Mushtaq 425 Genet, Jean 307 Genette, Gérard 257 Gerede, Canan 437 Gershwin, George 244, 247, 252 Gershwin, Ira 244

Fonda, Henry 367, 474

Getino, Octavio 57, 389, 394, 395, 430 Ghatak, Ritwik 393, 400, 424 Gibson, Hoot 465 Gidal, Peter 59 Giersz, Witold 14 Gilliat, Sidney 453 Ginsberg, Allen 445 Giroud, Françoise 145 Gledhill, Ruth 131, 168, 216, 221, 351, 354 Godard, Jean-Luc 17, 21, 22, 29, 59, 76, 77, 85, 89, 145, 146, 148, 205, 206, 239-42, 279, 335, 460 Goddard, Paulette 367 Goebbels, Josef 454 Gold, Jack 451 Gören, Serif 436 Gounejjar, Nour Eddine 414 Grable, Betty 367 Gramsci, Antonio 59, 60, 184, 270, 273, 323 Grant, Cary 2, 246, 333 Greaves, William 40 Greenwald, Maggie 469 Grémillon, Jean 144, 150, 151, 453 Grier, Pam 43 Grierson, John 90, 91, 143, 331, 341, 452 Griffiths, D.W. 36, 37, 103, 327, 367, 372 Grosz, E. 289 Guérin, François 59 Guerra, Rui 56, 57 Guerrero, Ed 36, 46 Guillerman, John 470 Guillotine, Dr 233 Gul, Agha G.A. 425 Güney, Yilmaz 436 Gutiérrez, Tomás 431

Habshi, Samir 410 Hafiz, Bhagia 409 Hall, Stuart 268 Hammerstein, Oscar 244 Hammond, Joë 463

Haq, Ziaul 426 Harlow, Jean 369 Harper, S. 225 Harris, Julie 228 Harris, Leslie 48 Hart, John 11 Hart, Lorenz 244 Hart, William S. 367, 465 Hartley, J. 322 Haskell, Molly 113-14, 115, 118 Hathaway, Henry 473 Hawks, Howard 21, 73, 153, 333, 369, 370, 458, 466, 473 Haynes, Todd 308 Hays, William H. 55, 184 Hayworth, Rita 71, 352, 373, 456 Heath, Stephen 121, 383, 384 Henie, Sonja 367 Hepburn, Katherine 73, 225, 333, 354 Hepworth, Cecil 450 Hermosillo, Jaime Humberto 432 Herzog, Werner 180, 181 Heston, Charlton 372 Higson, A. 6 Hill, George Roy 52, 169, 473 Hill, Jack 43 Hippler, Franz 454 Hitchcock, Alfred 21, 65, 86, 109, 119, 122, 134, 140, 188, 200, 220, 223, 229, 230, 265, 290, 307, 350, 370, 440, 442, 446 Hitler, Adolf 454 Hodkinson, W.W. 367 Holden, William 373 Holiday, Amanda 34 Holliday, Judy 373 Honda, Inoshiro 188 Honda, Ishiro 461 Hondo, Med 392, 404, 405 hooks, bell 39, 396 Hooper, Tobe 188 Hope, Bob 367, 456 Hopper, Dennis 68, 253, 313

Hopper, Edward 279

Howard, Leslie 453

Hudlin, Reginald 48 Hudlin, Warrington 48 Hudson, Rock 220, 351 Hughes, Albert 47 Hughes, Allen 47 Hughes, Howard 371, 468 Hughes, Langston 33 Huillet, 181 Hunter, Holly 4 Huston, John 129, 374

Ichikawa, Kon 458 Ilhan, Biket 437 Ince, Thomas H. 465 Ipekçi, Hanan 437 Irani, Ardeshir 437 Irigaray, Luce 378 Irons, Jeremy 106 Irvin, John 462 Issartel, Marielle 92 Ivens, Joris 59 Ivory, James 75, 105

Jackson, Michael 353 Jakobson, Roman 228 James, Henry 5 Jameson, Fredric 275 Janni, Joseph 51 Jannings, Emil 173, 176 Janowitz, Hans 178 Jarman, Derek 307, 308 Jennings, Al 464, 465 Jennings, Humphrey 91, 143, 144, 452 Jewison, Norman 40, 327 Iimbo, Matsue 14 Johnson, Al 332 Johnson, George 36 Johnson, Noble 36 Johnston, Claire 114-15, 125, 157, 325, 349 Jones, Buck 465 Jones, Chuck 13 Jones, Jacqui 45 Jordan, Neil 162, 188, 280, 282 Julien, Isaac 33, 308, 310

Kalin, Tom 307, 308 Kalmus, Natalie 69, 70 Kan Shen 417 Kandinsky, Wassily 172 Kaplan, E. Ann 109, 158, 159, 221, 225, 383 Kaplan, Jonathan 355 Kaplan, Nelly 16 Kasdan, Lawrence 471 Kasper, Barbara 182 Kaul, Mani 393 Kazan, Elia 228, 259, 367, 374 Keaton, Buster 73, 333 Keighley, William 252 Kellogg, Ray 461 Kelly, Gene 246-7, 250-1, 278, 350 Kennedy, John F. 104 Kerensky 342 Kerkorian, Kirk 370 Kern, Jerome 244, 245 Kerouac, Jack 445 Kerr, Deborah 2, 71 Khan, Mehboob 422 Khleifi, Michel 434 Kiarostami, Abbas 439 Kidman, Nicole 4 Kimai, Mas'ud 438 Kimmich, M.W. 454 King, George 472 King, Henry 455 King, Martin Luther 40-1 Kinski, Klaus 180 Kleifi, Michel 273 Klein, Melanie 111 Kliegl brothers 208 Klimt, Gustav 172 Kluge, Alexander 180, 181 Knight, Julia 182 Kooning, Willem de 283 Kopple, Barbara 92 Korda, Alexander 252, 372, 454 Kosma, Joseph 151 Koster, Henry 11, 103 Kracauer, S. 178 Krauss, Werner 173

Kaes A. 180, 181

Kristeva, Julia 72, 378 Kubrick, Stanley 170, 316, 318, 447, 451, 459, 461, 462 Kuhn, Annette 93, 112, 113, 114, 160, 164, 194, 326 Kuhn, T. 100, 101, 107 Kuleshov, Lev 96, 336, 337, 338-40, 341 Kurosaa, Akira 461 Kushan, Esma'il 438 Lacan, Jacques 2, 99, 109, 117, 122, 157, 161, 196–8, 199, 261, 271, 287, 290-300, 302, 360, 378-81 Laemmle, Carl 371 Lakhdar-Hamina, Mohammed 412 Lamar, Hedy 367 Lamour, Dorothy 367 Lane, Charles 48 Lang, Fritz 129, 131, 174, 177, 178, 316, 317, 470 Lapsley, R. 2, 101 Lassally, Walter 144 Lasseter, John 14-15 Laughton, Charles 456 Launder, Frank 453 Lauria, Vincent 53 Lauste, Eugène 332 Lawrence, Florence 349 Le Corbusier 235 Le Fanu, Sheridan 187 Lean, David 103, 374, 453, 459 Lee, Ang 7 Lee, Christopher 187 Lee, Spike 44, 45, 48, 49 Leigh, Janet 372 Leigh, Mike 258

Leigh, Vivien 350, 354 Lemmon, Jack 164 Lenica, Jan 14 Lenin, V.I. 336, 337 LeRoy, Mervyn 130, 153, 458 Lévi-Strauss, Claude 23, 255, 257, 360 Lewton, Val 50 Litvak, Anatole 456

Livingstone, Jennie 308 Lollobrigida, Gina 350 Loren, Sophia 350 Losey, Joseph 451 Lubitsch, Ernst 178 Lucas, George 15 Lumière brothers 420, 427, 433 Lurhmann, Baz 4 Lurie, Susan 121 Lynch, David 21 Lynd, Laurie 308 Lyne, Adrian 109, 348, 355

Lyotard, Jean-François 376

Mabéty, Djibril Diop 392, 393 McCambridge, Mercedes 470 McCarthy, Joseph R. 186 McCay, Winsor 12 McCoy, Tim 465 MacDonald, Jeannette 244, 245 McGregor, Ewan 4 McLagen, Andrew 473 McNair, Brian 266 Madame Mao 417 Magnani, Anna 203 Maingard, Jacqueline 394 Makhmalbaf, Mohsen 439 Makhmalbaf, Samirah 439 Malick, Terence 459 Malik, Yunus 426 Malkovich, John 227 Malle, Louis 149 Malloy, Terry 259 Malone, Dorothy 220 Mambéty, Djibril Diop 404, 405, 406, 407 Mamoulian, Rouben 251 Mankiewicz, Joseph 367 Mann, Anthony 471, 472 Mann, Delbert 372 Mansfield, Jayne 350 Manvell, 175, 178 Marcus, M. 5, 6 Marcuse, Herbert 59, 60-1 Marglova, Jan 14 Marinetti, Filippo Tommasso 151–2

Marker, Chris 59 Marx brothers 73, 333, 367 Marx, Karl 59, 60, 61, 192-3, 339, 340 Mason, James 246 Masri, May 434 Mayer, Carl 178 Mayer, Louis B. 243 Maynard, Ken 465 Medovoi, Leerom 43, 47 Medvedkin, Alexander 91 Mehrju'i, Dariush 438 Méliès, Georges 11, 69, 315-16 Mellen, Joan 114, 115 Menzies, William 316 Merchant, Ismail 75, 105 Messmer, Otto 12 Metz, Christian 2, 24-5, 157, 168, 300, 301, 318, 343, 344, 345, 360, 361, 388 Micheaux, Oscar 36, 37, 38-40, 47 Milestone, Lewis 371, 443, 451, 457, 459 Miller, Glenn 247 Mineo, Sal 110 Minnelli, Vincente 219, 247, 250, 252 Mir. Raza 426 Miranda, Carmen 367 Mix, Tom 465 Modleski, T. 120, 221, 265, 319, 347 Moi, Toril 292 Mongia, Padmini 267, 269 Monk, 6 Monroe, Marilyn 1, 55, 73, 322, 323, 350, 358, 367, 448 Morin, Edgar 92 Morrison, Toni 5 Mozzhukhin, Ivan (Mosjoukine) 338 Mudimbe, V.Y. 268 Mulvey, Laura 2, 114, 115, 117, 119-20, 157, 158, 215, 216-17, 302, 318–19, 344, 345–7 Munch, Edvard 172 Muni, Paul 369

Murdoch, Rupert 367 Murnau, Friedrich 176, 177, 178, 187 Murphy, Eddie 44, 45, 327 Musidora 187 Mussolini, Benito 201 Myles, Linda 115

Nair, Mira 35, 49 Narboni, I. 195 Nargis 422 Nasser, Gamal Abdel 410 Neale, Steve 70-2, 164, 166-7, 169-70 Nehru, 423 Newman, Paul 52, 351 Ngakane, Lionel 31 Nicholson, Jack 106, 357 Nilsson, Leopoldo Torre 394, 429 Ning Dai 419 Noiret, Philippe 146 Notcutt, L.A. 404 Noury, Hakim 414 Nowell-Smith, A. 221

Oberon, Merle 209 Ogundipe, 405 Oirter, Edwin S. 462 Olivier, Lawrence 455 Olmi, Emmanuel 204 O'Neal, Ron 42 Onwurah, Ngozi 34 Ophuls, Marcel 92 Ophuls, Max 129, 219, 222 Orr, John 237, 280 Osborne, John 50, 51, 142, 144 Ostaoglu, Yesim 437 Ottinger, Ulrike 182, 307 Oudart, Jean-Pierre 378, 382, 383 Ouedraogo, Idrissa 392 Ové, Horace 31-2 Özgentürk, Isil 437

Pabst, Georg 178, 451 Pagnol, Marcel 7 Pakula, Alan 359

Münsterberg, Hugo 387

Palke, Dhundiraj Govind 420 Pancholi, Dalsukh 425 Panijel, Jacques 59 Paretsky, Sara 156

Paretsky, Sara 156 Paretti, Giancarlo 370 Parks, Gordon Jnr 41

Parks, Gordon Snr 41 Parman, Pratibha 307

Pasha, Anwar Kamal 425

Patwardham, 393

Peck, Gregory 367, 472

Peckinpah, Sam 460, 471, 473

Peirce, C.S. 320

Penn, Arthur 369, 460, 471, 473

Perincioli, Cristina 182 Perkins, Anthony 350

Perry, Frank 304 Petersen, Wolfgang 357

Philipe, Gérard 145 Phoenix, River 55, 356

Picasso, Pablo 234

Pickford, Mary 340, 349, 353, 367, 372, 450

Pietrangeli, Antonio 201

Pines, J. 395

Place, Janey 131, 132

Poitier, Sidney 40, 42, 327, 470

Polanski, Roman 75, 442

Polidori, Dr 187 Pollack, Sydney 164 Pollard, Bud 37 Pollock, Jackson 234

Pommer, Erich 175, 178

Pontecorvo, Gillo 394, 412

Porter, Cole 244, 246 Porter, Edwin S. 98 Potter, Dennis 280

Potter, Sally 76

Powell, Michael 140, 188, 231, 346, 441, 447

Power, Tyrone 367 Preece, Larry 40

Preminger, Otto 129, 252, 256, 305

Presley, Elvis 248 Prévert, Jacques 151 Propp, Vladimir 169, 257 Pudovkin, Vsevolod 339, 340, 342

Qaiser, Khahil 426

Rajadhyaksha, Ashish 423

Rappeneau, Jean-Paul 105 Rapper, Irving 122, 220

Rathnam, Mani 424

Ray, Aldo 279

Ray, Nicholas 1, 109-10, 219, 354,

374, 467, 469, 472

Ray, Satyajit 204, 393, 400, 423

Reckord, Lloyd 31 Redford, Robert 52

Reed, Carol 332

Refig, Halit 437

Reichenbach, François 59

Reiman, Walter 177 Reinhardt, Max 173

Reisz, Karel 50, 51, 142, 143, 144-5, 231

Reitman, Ivan 305 Reitz, Edgar 179

René, Norman 53

Renoir, Jean 21, 81, 129, 142, 144, 150, 202, 332, 451, 456

Resnais, Alain 18, 90, 91, 95, 97, 146, 205, 227, 280

Riad, Mohamed Slim 412

Rich, B. Ruby 308, 470

Rich, Matty 48 Richard, Cliff 248

Richardson, Tony 50, 51, 52, 142,

143, 144

Riefenstahl, Leni 178, 454

Rigosin, Lionel 445 Rivette, Jacques 145

Robbe-Grillet, Alain 280

Roberts, Rachel 51

Robertson, John 188 Robeson, Paul 252

Robinson, Bill 'Bojangles' 13

Robinson, Edward G. 130, 350, 369

Rocha, Glauber 56, 430 Rodgers, Richard 244 Rodgers, Will 367

Roeg, Nicholas 317 Rogers, Ginger 243, 245, 350, 370 Rogers, Roy 374, 428, 464, 465, Rohmer, Eric 145-6 Röhrig, Walter 177 Romero, George 188 Rooks, Pamela 424 Rooney, Mickey 245, 370 Roosevelt, Franklin D. 25, 155, 195, 456 Rosen, Marjorie 114, 115 Ross, Karen 30 Rossellini, Roberto 201 Rothman, G. 383, 384 Rouch, Jean 58-9, 92, 312 Rowntree, Richard 42 Rozema, Patricia 308 Ruiz, Raúl 431 Ruspoli, Mario 59 Russell, Jane 355, 367, 469 Russell, Ken 91 Russell, Rosalind 333, 354 Russell, Theresa 448

Sabita 427 Sadat, Anwar 410 Sade, Marquis de 233 Saïd, Edward 267-8, 269 Saif, Saifudin 426 Saint-Saens 386 Saleh, Toufik 409 Salt, B. 383 Sander, Helke 182 Sanders-Brahms, Helma 182 Sangeeta 426, 427 Sarkar, Kobita 400 Sarris, Andrew 22, 113 Sathyu, M.S. 424 Saussure, Ferdinand De 23, 24, 320-2, 360, 361 Schaffner, Franklin 108 Schenk, Joseph M. 366 Schiele, Egon 172 Schlesinger, John 51 Schlöndorff, Volker 180, 181

Schneeman, Carolee 239 Schoedask, Ernest B. 12, 370 Schygulla, Hanna 180 Scorsese, Martin 5, 54, 63, 75, 87, 460, 462 Scott, Emmett J. 36, 38 Scott, Ridley 53, 188, 258, 313, 317 Scott, Tony 188 Seberg, Jean 206 Seidleman, Susan 74 Seif, Salah Abou 409 Sekigawa, Heideo 461 Selznick, David O. 370 Sembene, Ousmane 392, 403, 404, 407 Sen, Mrinal 393, 420, 423 Senghor, Léopold Sédar 270 Sennett, Mack 73, 367 Sestier, Maurice 420 Shabazz, Menelik 31 Shah of Iran 437-8 Shakespeare, William 4 Shearer, Norma 369 Shelley, Mary 187 Shelley, Mary Wollstonecraft 109 Shindo, Kaneto 461 Shiva 427 Shohat, Ella 399, 400, 433 Shub, Esfir 337, 341 Sica, Vittorio de 144, 201, 203 Signoret, Simone 352 Silberman, Marc 175, 176 Sillitoe, Alan 51 Silverman, K. 383, 384 Sinatra, Frank 247 Singleton, John 48, 49, 192 Siodmark, Richard 129 Sirk, Douglas 129, 217, 219, 220 Smith, Jack 444 Solanas, Fernando 57, 389, 394, 395, Solás, Humberto 394 Soutine, Chaim 172 Spielberg, Steven 5, 15, 87, 96, 111, 166, 282, 317, 327, 372

Spivak, Gayatri 268

Srour, Heiny 410 Stack, Robert 220 Stahl, John 218, 220 Stalin, Josef 336, 337, 340, 342, 457 Stallone, Sylvester 358, 461 Stam, Robert 56-7, 399, 400, 433 Stanislavsky, Konstantin 227 Stanwyck, Barbara 367, 369, 469, 470 Starrett, Jack 43 Steiger, Rod 228, 474 Sternberg, Josef von 129 Stevens, George 472 Stevenson 252 Stewart, James 358, 372, 456, 471 Stoker, Bram 187, 188 Stokowski, Leopold 246 Stone, Oliver 462 Storey, David 51 Straub, Jean-Marie 180, 181 Streep, Meryl 106, 353, 358 Streisand, Barbra 248, 353, 357 Stroheim, Erich von 367 Strong, J. 6, 8-9 Studlar, G. 319 Sturges, John 473 Sucksdorff, Arne 144 Suleiman, Elia 434 Swanson, Gloria 367 Swaranlata 425

Tan Xinepei 415
Tarantino, Quentin 43, 155, 278–9
Tatli, Moufida 414
Taylor, Clyde 35, 36
Taylor, Elizabeth 104, 353
Tazi, Mohamed 414
Thalberg, Irving 369, 371
Thompson 210
Thompson, Emma 4, 7
Tlatli, Moufida 273
Tobi, Abdelaziz 412
Toland, Gregg 81, 429
Touraine, Alain 61
Tourneur, Jacques 279

Syberg, Hans Jürgen 180

Tracey, Spencer 73, 370
Trauner, Alexander 151
Travolta, John 248, 249, 250
Trnka, Jiri 14
Troche, Rose 308
Trotsky 342
Trotta, Margarethe von 21, 182, 239
Truffaut, François 20, 21, 22, 146, 210, 231, 295
Tsaki, Ibrahim 413
Turim, Maureen 101, 133, 138
Turner, Kathleen 448
Tushingham, Rita 51

Ukadike 408

Vadim, Roger 145 Valentino, Rudolph 371 Van Dyke, Woody 244, 369 Van Gogh, Vincent 172 Van Peebles, Mario 41-2, 45, 49, 192, 471 Van Sant, Gus 308, 356 VanDerBeek, Stan 444 Varda, Agnès 16, 21, 29, 76, 91, 146, Vautier, René 412 Veidt, Conrad 173, 177, 457 Verhoeven 309 Verne, Jules 315 Vertov, Dziga 58, 91, 336, 337, 339, Vidor, Charles 131, 373 Vidor, King 218, 252, 305 Vieyra, Paulin Soumano 403 Vigo, Jean 21, 144 Visconti, Luchino 201, 202 Voigt, Jon 462

Wachsman, Daniel 435
Walker, Alice 5
Waller, Fats 13
Walsh, Raoul 1, 369
Wang, Wayne 35
Wang Xiaoshuai 419
Warhol, Andy 94, 239, 307, 444, 445

Warm, Hermann 177 Watkins, Peter 461 Watt, Harry 452 Wayne, John 1, 68, 95, 213, 357, 374, 428, 458, 461, 467, 468, 472, 473 Wayne, Keenan Ivory 44 Wegener, Paul 174, 177 Weir, Peter 452 Welles, Orson 21, 63, 81, 135, 228, 370, 372, 429 Wellman, William A. 153, 451, 458, 468, 469, 471 Wells, H.G. 315 Welsh, Irvine 8 Wenders, Wim 21, 68, 180 West, Mae 1, 367, 469 Westlake, M. 2, 101 Whale, James 187, 371 Wharton, Edith 5, 75 Wiene, Robert 80, 177, 187 Wilder, Billy 73, 129, 130, 135, 138, 164, 278, 305 Willemen, P. 395 Williams, Linda 121, 159 Williams, Robbie 309

Williams, Spencer D. 37

Williamson, Fred 42
Winterbottom 310
Wise, Robert 248–9
Wollen, Peter 28
Wong Kar-Wai 310
Wood, Natalie 110
Wood, Robin 167
Woolf, Virginia 234
Wright, W. 169
Wyler, William 374, 455
Xavier, Ismail 57

Yamamoto 455 Yasar, Seçkin 437 Young, Lola 31

Zecca, Ferdinand 133
Zemmouri, Mahmoud 413
Zhang yimou 418
Zhang Yuan 310, 419
Zia 426
Zinneman, Fred 85, 228, 372, 471
Zola, Emile 331
Zukor, Adolph 363–4, 367

Zanuck, Darryl F. 366, 368

SUBJECT INDEX

ABC 143 absence/presence 1-3, 345; and realism 311; and stars 351, 355 Actors Studio 227 adaptation: classic 4-8; defined 3-4; female fiction 221-2; fidelity criticism 5-6; melodrama 221-2; modern 8-9; types 4 Africa, film industry 390, 392-3; North African 408-14; Sub-Saharan 401-8 Afrocult Foundation Limited 405 agency 9, 447; and melodrama 223; and scopophilia 318-19; and thrillers 441 Algeria, film industry in 392, 411-13 alienation 293-4 ambiguity 9-10; in classic Hollywood cinema 65, 66; in colour 71; in film noir 130; in gangster movies 156 anamorphic lens 10-11 angry young men films 51 animation 11-15; Eastern European Schools 13-14; Japanese 14 apparatus 15-16, 110-11, 343 Arab States, Eastern, film industry in 410-11 Argentina, film industry in 428 art cinema 10, 16-18, 66, 75, 78, 104-5, 149 Asia, film industry in 390 aspect ratio 11, 18

A-movies 49, 467

Association of Revolutionary Cinematography (ARC) 337 asynchronization/asynchronous sound 10, 18-19 audience 19, 25, 87, 107, 348; for adaptations 6-7; and cinemascope 58; diagetic 85; expectation 192; and feminist theory 124; and modernism 237; and science fiction 316; and stars 349; threats to 18; and thrillers 440; and Westerns 464 auteur/auteur theory 17, 19-27, 321, 387; and genre 24, 166, 168; and mise-en-scène 21; and structuralism 22-5, 362 Autorenfilm 20 avant-garde 17, 27-9, 66, 75, 234, 237, 307; American 238-9; and Black African-American cinema 49; distanciation in 89; montage cuts in 78; and psychoanalysis 287

B-movies 8, 49–50, 128, 278, 365, 467
Beaver Films 51
Bioskop 175
Black African-American cinema 34–49, 395; Blaxploitation 40–4; early days 36–40; ghettocentric 46–7; musicals 252, 254; new aesthetic/post-Blaxploitation 44–8; race/racism in 35–6; women in 38, 47–8

Black Audio Film Collective 31 Black British cinema 30-4; documentary 30, 33; feature films 32; feminist 33-4; representation in 32 - 3Black cinema: in Africa 405-6; African-American 34-49, 252, 254, 395; in Britain 30-4; and sexuality 327 Blau Reiter 172 Blaxploitation 40-4; post- 44-8 Bollywood 390, 422 Bombay Talkies 421 Brazil: cinema nôvo 55-7; film industry in 390, 428 Britain: auteurism in 23, 24, 25; Black cinema in 30-4; censorship in 54; colour movies in 69; comedy in 73-4; documentaries in 50, 90-1, 142-4, 432-3; film industry in 105, 142-4; musicals in 248; and Second World War 452 - 3British Black cinema 395, 396 British Film Insititute (BFI) 143 British Lion 51 British New Wave 8-9, 50-2, 144, 204, 332

Brücke group 172
Bryanston Films 51
buddy films 52–3, 309
Burkino Faso 392, 403

Cahiers du cinéma; on auteurism 20–1,

24–5; and cinemascope 57–8; Young Mr Lincoln debate 25, 194–5 Camera Obscura 118 cameraman 87 Carry-On movies 74 censorship 54–5, 107, 366, 444; German 181; and melodrama 219–21; USA 184; and Westerns 469, 473; see also Hays code Central Organisation of Egyptian Cinema 409 Centre Algérien pour l'Art et l'Industrie Cinématographiques (CAAIC) 412 Centre Cinématographique (CMM) 414 chiaroscuro 129 China 390; film industry in 394, chronological editing 94-5 ciné-train 91 Cinecittà studios 201 cinema nôvo 55-7, 308 cinéma-vérité 31-2, 58-9, 92, 148, 312, 332, 341 cinemascope 11, 18, 57-8, 471; colour in 70; epic 103 cinematographer 87 class 59-64; and feminism 113; and gangster movies 154; Italian 202; Marxian definition 59-62; and melodrama 214; and modernism 236; naturalizing 258; and psychoanalysis 302; relevance to film studies/film theory 61-4; and stars 354; and war films 453 classic Hollywood (narrative) cinema 9, 63, 64-8, 83; closure in 65; editing in 66-7, 94-5; excess in 106-7; and film noir 130-1; and lighting 210; and motivation 64-5; and Oedipal trajectory 290-1; and sexuality 326; and spectator 346; and suture 382; see also Hollywood; narrative close-up shots 328 codes and conventions 68; ambiguity in 9; and art cinema 17; and avant-garde 29; in counter-cinema 75; in film noir 128-9; and flashbacks 133; and musicals 253; in road movies 313; and scopophilia 318-19; and sexuality 325; of shots 330; and spectator 346; and stereotypes 359; and Third Cinema 391

Cold War 242, 449, 460-1, 471

Colonial Film Unit (CFU) 404 colour 68-72, 103; in animation 12; in British cinema 52; and gender 164; history 68-70; in musicals 247; as subversive 71-2; theory 70 - 2colour in movies 447; and lighting 208-9; in Westerns 468 Columbia 364, 365, 373-4 comedies, cross-dressing in 165 comedy 72-4; and class 61; and Oedipal trajectory 291; and sound compilation shots 78 connotation 83-4, 322 content 141 continuity cuts 77 continuity editing 74, 94, 101, 106 costume dramas 75, 226; colour in 70 counter-cinema 75-6, 80, 237, 239, 308, 389; and avant-garde 27; distanciation in 89; and feminism 115-16; foregrounding in 140 cross cuts 78 cross-cutting 67, 76-7, 95, 97; and structuralism 361 cross-dressing 164-5, 470 Crown Film Unit 452 Cuba, film industry in 391-2, 430-1 Cuban Institute of Cinematographic Art and Industry 391-2, 430 cut 77-9, 324; compilation shots 78; continuity 77; cross 78; cutaways 78; eyeline matching 106; jump 77; match 78; montage 78 cutaways 78

Decla-Bioskop 175, 178 deconstruction 80–1, 97, 388; and flashback 135; of gender 162; and psychoanalysis 302 deep focus/depth of field 10, 58, 81–3, 95–6; and realism 312

Czech School 14

denotation 83-4, 322

desire 116, 109 diachronic 84 diegesis 84-6, 257; and sound 333; and stars 356-7 director 86-7 director of photography 87 discourse 87-8, 131, 322; absence/presence 1; and colour 71; and poststructuralism 362; and psychoanalysis 298; and realism 312; Revolutionary 342 Disney Productions 12, 13, 15 disruption 88-9 dissolve 89, 97, 133 distanciation 89-90; and avant-garde documentary 90-2; Black 92; British 90-1; cinema nôvo 56; cinémavérité 58-9; colour in 69; European 91-2; feminist 92; Free British Cinema 50, 142-5; German 181; Italian neo-realist 202; and social realism 331; Soviet 336, 455; and war films 452-3 dollying shot 442 dominant/mainstream cinema 64, 87, 93, 100, 185; and feminism 113; and ideology 194; and myth 255 double meaning see ambiguity

Ealing Comedies 74
Eastern Trust 185
Eastman-Kodak 69, 70
editing 78, 94–7; in avant-garde 27;
chronological 94–5; in classic
Hollywood 66–7; continuity 67;
cross-cutting 95; deep focus 95–6;
in French New Wave 146; parallel
95; Soviet montage 96–7; and
suture 383–4
Egypt, film industry in 390, 408–10
ellipsis 97
emblematic shot 98
Empire Marketing Board 90
Enlightenment 232–3, 235, 270

Dziga-Vertov group 59

enunciation 27, 98–103, 389; and genre 170; and narrative 257; and poststructuralism 363; relevance to film theory/cinematic address 100–3

epics 103–4; and cinemascope 58; Westerns 466, 473

Essanay studios 374

European cinema 17, 104–5; avant-garde in 29; war films 450

excess 106–7; in melodrama 216; and postmodernism 278–9; and stars 351

extreme close-up shots 328 extreme long shots 329 eyeline matching 67, 78, 106, 382

fade 97, 108, 133, 324 Famous Players-Lasky Corporation 364

fantasy 108–11, 348, 444; female 116; and melodrama 217; and psychoanalysis 287

Fédération Panafricaine des Cinéstes (FEPAC) 392, 406

FEK (Factory of the Eccentric Actor) group 339

feminism 389; and avant-garde 29; Black 45; colour movies 71–2; and counter-cinema 76; and deconstruction 81; and epics 104; Foucauldian 123–6; history and development 112–27; and melodrama 114, 119–20; and poststructuralism 363; and psychoanalysis 115–19; and queer cinema 309; and sexuality 119, 325; and spectator 115, 117; and suture 378

Festival Panafricaine du cinéma de Ouagadougou (FESPACO) 392, 406

fetishism 180, 446–8; and Imaginary/Symbolic 200; and Oedipal trajectory 262; and scopophilia 318; and sexuality 327; and stars 354-6, 457

Film d'Art 20

Film Finance Corporation (FCC) 422–3

film noir 128–32, 171, 447; ambiguity in 9; excess in 106–7; and feminism 118–19; flashbacks in 136; and German expressionism 129, 178; iconography in 192; and lighting 210; lighting in 129–30; and melodrama 218; and narrative 256; and psychoanalysis 295, 303; and realism 312; stars in 350

First National 364

First World War see Great War flashbacks 74, 89, 95, 230;

biographical 135–6; confessional 139–40; diagetic 85–6; enunciation 101–2; in film noir 131–2; and history 134–5; and melodrama 136, 219; and postmodernism 278; and psychoanalysis 133, 136–40; and subjectivity 134

foregrounding 140-1, 156, 164, 187, 237, 391, 441

form 141

fort da game 291, 293, 294

Fox Film Corporation (20th Century Fox) 364, 366–7

Fox Studios 11

framing 141-2

France: art cinema in 16, 17; auteurism in 20–2, 25; avant-garde in 27; censorship in 54; cinéma vérité in 58–9; colour movies in 69; comedy in 73–4; countercinema in 76; film industry in 11, 105, 145, 148, 149; film noir in 128; and the Great War 450, 451; and modernism 239–42; poetic realism in 129, 149–51, 202; protectionism in 104–5; and Second World War 453–4; and stars 349; Westerns in 463

Frauen und Film (journal) 182

Free British Cinema 50, 90, 142–5, 332
French New Wave 16, 20, 58, 144–9, 204
futurism 27, 151–2, 335

Gainsborough Studios 226
gangster movies 128, 153–6, 171;
Black (African-American) 46; cross
cuts in 78; editing in 95;
iconography in 191–2; stars in 350;
stereotypes in 358; see also thrillers
garbage cinema 308
Gaumont 149, 332, 363
gaze/look 28, 76, 118, 156–9; and
gender 164; and melodrama 223;
in musicals 245; naturalizing 258;
and Oedipal trajectory 262; and
postmodernism 285; and queer
cinema 310; and stars 355–7; and

suture 384; and thrillers 441

gender 103, 159-65, 389; absence/presence 1; in Black (African-American) cinema 47-8, 49; in buddy films 53; and class 59, 62; in classic Hollywood cinema 67-8; in colour movies 71-2; and comedy 73; and deconstruction 80-1; in documentary 92; enunciation 102-3; and epics 104; and feminism 112, 125-7; and film noir 130-1; and flashbacks 137-8; and ideology 194; Imaginary/Symbolic 161, 197-9; and melodrama 221; and modernism 240; and musicals 249; naturalizing 258; post-colonial 270; and postmodernism 275, 284; and psychoanalysis 302; and scopophilia 318-19; and sexuality 325, 326; and spectator 120

genre 165–6, 389; and auteurism 25, 166, 168; and class 61; and feminism 113; general principles 166–8; and ideology 167–8; mixed

28; and motivation 242; and postmodernism 277; and stereotypes 358–9; structuralist 168–9

German expressionism 17, 80, 171–8; and avant-garde 28; and film noir 129, 178; and horror movies 187; and lighting 129–30, 209; and montage 82; and setting 325

Germany: art cinema in 16; auteurism in 19–20, 180; censorship in 54, 55, 181; and the Great War 449–51; and Second World War 454

gesturality 183 Ghana, film industry in 392, 403, 404–5 Ghanaian Film School 403 ghettocentric cinema 45–7 GPO 90

Great War 449-52

Hammer Productions 187
Hays Code 16–17, 55, 105, 156, 184; see also censorship
hegemony 76, 184–5; and Black
(African-American) cinema 49; and censorship 54–5; and feminism 125; and sexuality 326; and suture 383

history: African 406–7; in classic Hollywood 65; epics 103–4; and flashbacks 134–5; and genre 171; historical films 185; and ideology 194–5; and stereotypes 358–9; and war films 454

Hollywood 150, 185–6; and art cinema 17; B-movies 50; and Black cinema 45–6; blacklist 186; and British cinema 51, 52; and censorship 55; dominance of 349–50; editing in 95; film industry 286; and gaze/look 158; match cuts in 78; and melodrama 218; and narrative 257; and stars 349; and war films 451; see also

classic Hollywood (narrative) cinema hood movies 46-7 horror movies 187-90; and feminism 118-19; foregrounding in 141; and German expressionism 187; and lighting 210; massacre 188, 189; psychological 189; unnatural

188-9; vampire 187-8 House of Un-American Activities Committee (HUAC) 186, 366

iconography 191-2; in gangster movies 155; and genre 171; in musicals 252; in road movies 313; and sexuality 325; of stars 349; in Westerns 464-5; of women 192 ideology 192-5; and apparatus 15; and auteurism 22, 25-6; and avant-garde 29; in cinéma-vérité 59; and class 60; in classic Hollywood cinema 64, 65-6; and colour 69; in dominant cinema 93;

in gangster movies 155; and genre 167-8; of lighting 211-12; Marxian 192-3; in melodrama 216; and modernism 236; in musicals 244; naturalizing 258; and postmodernism 275; and realism 311; and semiotics 320; and sexuality 325; and sound 335; Soviet 336; and structuralism 360;

image 196, 230; fade 108; and feminism 116; and flashbacks 133; and melodrama 223; and modernism 237; postmodern 276-7; and psychoanalysis 301; and sexuality 326; and sound 332; and spectator 345; and suture 382-3; and war films 451; in Westerns 464

and suture 383; and Westerns 463

Imaginary/Symbolic 196-200; absence/presence 2-3; and fantasy 109; in film noir 131; and gaze/look 157-8; and gender 161, 197-9; and melodrama 224; and

postmodernism 282; relevance to film theory 199-200; and subjectivity 376; and suture

independent cinema 200-1 India, film industry in 390, 392, 419-24

Indian People's Theatre Association (ITPA) 423

Industrial Light and Magic 15 intertextuality 26, 201, 388; Black 44-5; motivation 242-3; and postmodernism 277, 279; and poststructuralism 362; and spectator 348; and stars 352 Iran, film industry in 437-9 Israel, film industry in 434-5 Italian Film School 202 Italy: film industry in 201-2; neorealism in 56, 201-4, 312, 325, 332

jouissance 293, 297, 379, 382 Journées cinématographiques de Carthage (JCC) 406 jump cuts 10, 77, 97, 147, 205-6, 324

lap-dissolve 89 Latin America, film industry in 390, 392, 393-4, 427-33 Law of the Father 292-5, 297, 379,

Lebanon, film industry in 410 lesbians 92, 187

lighting 83, 116; ambiguity in 9; and black actors 211; in classic Hollywood cinema 67; day-for night/night-for-night 210; in film noir 129, 129-30; and gender 163-4; in German expressionism 173; high-key/low-key 210; and horror movies 187; ideology 211-12; Klieg 211; practice 209-11; technology 207-9 Listener, The 142

London Women's Film Group 115 long shots 329 look see gaze/look

Maghreb countries, film industry in

411 - 14mainstream see dominant/mainstream Marxism: definition of class 59-62; and ideology 192-3 masala movies 421 Mass Observation Unit 91 match cuts 67, 78, 213 mediation 213; and psychoanalysis 296; and realism 312 medium close-up shots 328 medium long shots 329 medium shots 328-9 melodrama 64; as adaptations of female fiction 221-2; and class 60, 61-2, 214; codes, conventions, structures 217-21; costume 226; excess in 107; female 221-6; and feminism 115, 119-20; flashbacks in 136; and ideology 195; Italian neo-realist 201; and mise-en-scène 215; and modernism 214, 221; and Oedipal trajectory 263; and psychoanalysis 218-19, 222, 224-5,

women's films 213–26
metalanguage 227
metaphor 229–30
method acting 227–8, 259
metonymy 228–30
Metro-Goldwyn-Mayer (MGM) 13, 243, 244, 247, 364, 369–70
Mexico, film industry in 427–9
Middle East, film industry in 390, 433–7

303; stereotypes in 358; and

mise-en-abîme 141, 230–1, 278 mise-en-scène 81, 102, 140, 231; in adaptation 6; ambiguity in 9; and auteurism 21; in melodrama 215; and psychoanalysis 305; and sexuality 327; and spectator 348; and suture 385 modernism 151–2, 214, 232–42, 335; French 239–42; and melodrama 214, 221; and psychoanalysis 236; and science fiction 317; and structuralism 236

Monogram Picture Corporation 49, 374, 467

montage: and cinemascope 57; cuts 78; deep focus in 82, 96; editing 94–7; and German expressionism 176–7; and modernism 238; and postmodernism 280; Soviet 27, 82, 96–7

Morocco, film industry in 392, 413–14

Motion Picture Export Association of America (MPEAA) 423

Motion Picture Producers and Distributors of America (MPPDA) 184

motivation 242–3; in adaptation 6; artistic 243; generic 242; intertextual 242–3; Italian neorealist 203; and melodrama 222; and musicals 250

Movie (journal) 23, 24

musicals 85; back-stage story 243; biographical 246; Black 252; boymeets-girl 244; Broadway hits 247–8; colour in 70; cross-dressing in 165; folk 251–2; hip sixties 248; history of 243–9; kids putting on a show 245–6; melodrama in 218; and motivation 242; naturalism in 246–7; pairings 250–1; and postmodernism 279; road movie 249; rock 248; and sexuality 325; song-and-dance 244–5; and sound 333; stars in 350; structures and strategies 249–54; teenage 248; utopian 249–50

myth 83, 254–5, 321, 443; in Black African-American cinema 46; and cinema nôvo 56; in classic Hollywood cinema 66; and denotation/connotation 83–4; and fantasy 108; and film noir 132; in French New Wave 145; Freudian 197; in Westerns 262, 463

narrative 84, 256-8; in adaptation 6; ambiguity in 10; in art cinema 17; and censorship 55; and cinemascope 58; and class 62; and feminism 113, 116; in film noir 131; in French New Wave 147; in French poetic realism 151; in gangster movies 155; and gaze/look 158-9; Italian neo-realist 203; and metalanguage 227; in musicals 244; and Oedipal trajectory 262; and postmodernism 279; and queer cinema 310; and realism 311; in road movies 313; and social realism 331; and sound 19, 333; and spectator 344; and structuralism 23, 360; and suture 383; and thrillers 440; see also classic Hollywood (narrative) cinema naturalism 247, 259

naturalizing ideology 258, 323; and

class 62; and flashbacks 134; and gender 160; and narrative 256–7

neo-realism, Italian 56, 201-4, 325, 332, 411

New American Cinema Group 444 New German cinema 179–83 New Scottish cinema 8, 9

New Wave: British 50–2, 144, 204; French 16, 58, 144–9, 204

North Africa, film industry in 408–14

Oedipal trajectory 93, 231, 261–3, 290; absence/presence 2–3; in classic Hollywood cinema 65; and fantasy 111–12; female 116, 118, 121–2; and flashbacks 138; and gaze/look 158; and melodrama 218; and narrative 257–8; and spectator 344; in Westerns 469

Office National pour le Commerce et l'Industrie Cinématographique (ONCIC) 412 180-degree rule 11, 74, 263-4 oppositional cinema see countercinema

Pakistan, film industry in 390, 424-7 Palestine, film industry in 433-4 parallel reversal 265 Paramount Pictures Corporation 12, 363, 364, 365, 367-8, 467 Pathé Frères 69, 149, 363 Phonofilm 332 Pixar studio (California) 14-15 poetic realism, French 129, 149-51, 202 political cinema 239 politique des auteurs 21-2 pornography 266-7, 310 post-structuralism 80, 272, 361, 362-3, 388-9; and auteurism 25-6; and class 61; literary adaptations 5 postcolonial theory 267-74; application of 273-4; and hybridity 272-3; and subaltern 273 postmodernism 274-5; mainstream/oppositional 275-80; negative vs positive 280-5; and queer cinema 309 preferred reading 10, 130, 170, 213, 285-6, 302, 312, 345 presence see absence/presence producer 286 psychoanalysis 24, 26-7, 286-305, 318; and avant-garde 28; and female subject 297-300; and feminism 114-19; and film theory 300-5; and flashbacks 133, 135-40; Freudian 288-91; and gender 160-3; and horror movies 189-90; Lacanian 291-7; major concepts 287; and melodrama 218-19, 222, 224-5; and modernism 236; and poststructuralism 363; and sexuality 326; and stars 353; and structuralism 360; and subjectivity 376–7

queer cinema 307-10

Rank Organisation 143
realism 17, 311–13; in animation 12;
and art cinema 17–18; in British
New Wave 50; and cinemascope
57–8; in classic Hollywood cinema
66; and colour 71; and deep focus
82; French poetic 129, 149–51;
German 181; Italian 203; and
lighting 208; and melodrama 221;
and modernism 233–4, 239;
motivated 311, 312; in musicals
248; and seamlessness 67, 311–12;
and sound 334; in Westerns 466

Red Seal studio 12 Republic Pictures 49, 374, 467 resolution 88–9

reverse-angle shots 106, 141, 205, 330-1

RKO (Radio Pictures Incorporated) 50, 243–4, 364, 370–1

road movies 68, 248, 253, 313–14, 432

RTA (Radio Télévision Arabe) 413

Sankofa 31

SATPEC (Société Anonyme Tunisienne de Production et d'Expansion Cinématographique) 414

science fiction 170, 315–18; animated 14; codes and conventions in 68; and narrative 256

scopophilia 117, 318–19; and colour 70–1; and suture 385

Screen (journal) 25

seamlessness 75, 147, 319; in art cinema 17; and flashbacks 134; and ideology 194; and lighting 211; and modernism 234, 236–7; and spectator 344

Second World War 452–9 semiotics (semiology) 26, 83, 319–23; and feminism 114; and stars

Senegal, film industry in 392, 402 Sequence (film review) 143 sequencing 324

setting 325; in adaptation 7–8; in costume dramas 75; feminist 119–20; in film noir 129; in German expressionism 176; and musicals 252–3

sexuality 101, 325–7; in art cinema 16–17; and Black cinema 40; in buddy films 52–3; feminine 118; in film noir 130; and modernism 237; and narrative 257; naturalizing 258; post-colonial 270; and psychoanalysis 298; and queer cinema 308; and science fiction 317; and stars 351, 354; and suture 385

shots 106, 201, 328–31, 338; 30–degree rule 205; 180–degree rule 11, 74, 264; angle of 330; closeups 328; establishing 324; extreme long 329; long 329; low-angle 142; master 67; medium 328–9; medium close-up 328; medium long 329; in musicals 245; and realism 312; reverse-angle 67, 106, 141, 205, 330–1; tracking 442; unmatched 28, 445; whole scene 66–7

signs (semiology) 26, 83, 319–23, 338, 354–6

social realism 331–2; in art cinema 18; and class 61; in gangster movies 155; Italian 204

sound 79, 332–5, 364; ambiguity in 10; in animation 12; asynchronous 18–19; and comedy 73; diagetic 85; digital 334, 335; Dolby 334, 335; and horror movies 187; and melodrama 218, 225; memorable music 45; optical 334; and

spectator 333, 347; in war films 451

South Africa, film industry in 403 Soviet Union 416; and avant-garde 28; and documentaries 336, 455; film industry in 89, 336–42; futurist 151–2; and modernism 237–8; and montage 78, 82; State Film School 336

Sovkino 337 space and time 6

space and time 66, 343 spaghetti Westerns 463

spectator 25, 318; absence/presence 2-3, 345; and agency 9; and ambiguity 10; and apparatus 15-16; and cinemascope 58; and class 63; in counter-cinema 76; and enunciation 100-1; and fantasy 109; feminist 114, 116-17; and flashbacks 134; in gangster movies 154; and gender 120; and genre 169-70; and horror films 190; and ideology 193; and melodrama 217; and metalanguage 227; and modernism 237; and musicals 249; and postmodernism 278-9; and poststructuralism 363; and psychoanalysis 287; and queer cinema 309; and semiotics 323; and sexuality 326; and sound 333; as subject-effect 25; theory of 343-8; and Westerns 470

stars 25, 147, 340, 349–58, 388; absence/presence 1–2, 355; in British cinema 50–1; as capital (exchange) value 63, 349–50; and censorship 55; and colour 71; as construct 350–2; as cultural value 354–6; as deviant 353–4; fetishist 180, 457; and genre 170; and musicals 243; and postmodernism 284; and stereotypes 358; strategies of performance 356–8; and structuralism 361; and Westerns 465, 468

stereotypes 358–9; Black 44; in comedy 73; in film noir 129; and stars 349; in war films 457; in Westerns 469

structuralism 359–62, 387–8; and class 61; and gender 112; and genre 168–9; impact on auteurism 22–5; literary adaptations 5; and modernism 236; and semiotics 320; and subjectivity 375–6

studio system 25, 50, 52, 148, 149–50, 185–6, 363–75; and genre 170; major studios 366–71; minor studios 371–4; smaller studios 374

sub-genre see genre

Sub-Saharan film industry; Anglophone 404–5; Black 405; colonial 401–3; Francophone 404; infrastructure 403; Lusophone 401,

infrastructure 403; Lusophone 401, 404; post-colonial 406–8; shorts 403 subject 98–9, 318, 344, 375; in Black

African-American cinema 48–9; and ideology 25, 193; and melodrama 215, 223; and narrative 256; and postmodernism 281; and psychoanalysis 297–300; spectator as 15–16

subjective camera 377–8 subjectivity 81, 98–9, 116–17, 344, 375; in art cinema 18; and flashbacks 133, 134; and gaze/look 157–8; and horror films 189; and melodrama 224; and modernism 238; and postmodernism 282; and psychoanalysis 376–7; and sexuality 326; and structuralism 375–6

surrealism 27, 237, 378 suture 98; Imaginary/Symbolic 378–82; theory of 378, 382–5 Symbolic *see* Imaginary/Symbolic synchronic 84

Tebessan Film Unit 412 Technicolor Motion Pictures Corporation 69 television 18, 103, 147, 437 theory: and class 59, 61–4; development of 386–9; and psychoanalysis 300–5; suture 378, 382–5

Third Cinema 34, 35, 57, 389–96 Third World Cinemas 397–400; African continent 400–1; China 414–19; and cinema nôvo 57; Indian 419–24; Iranian 437–9; Latin America 427–33; Middle Eastern 433–7; North African 408–14; Pakistan 424–7; Sub-Saharan 401–8

30-degree rule 205 thrillers 50, 128, 440–2, 447; cross cuts in 78; editing in 95; foregrounding in 141; and lighting 210; and melodrama 218; and queer cinema 307; see also gangster movies

Tobis-Klangfilm 332, 334 tracking shot 442 transparency/transparence 321, 443 travelling shot 442 Tunisia, film industry in 392, 413–14 Turkey, film industry in 435–7

UFA (Universum-Film Aktiengesellschaft) 175 underground cinema 16, 76, 237, 307, 444–5 United Artists Corporation 364, 365, 372–3

United Players 425 United Productions of America (UPA) 13

United States: art cinema in 16–17; auteurism in 22; avant-garde in 28, 238–9; Black cinema in 34–49; buddy films in 52–3; censorship in 16, 54, 55; and Cold War 242, 449, 460–1; colour movies in 68, 69–70; documentaries in 92; film industry in 105; and film noir genre in 128–9, 171; film trade

agreements 104–5; and Great War 450; and Second World War 451, 455–7, 458; underground cinema in 444–5; and Vietnam 52, 241, 461–2

Universal Pictures 364, 371-2 unmatched shots 28, 147, 445

vampire movies 187–8
vertical integration 446
Vic Films 51
video 92
Vietnam War 241, 461–2
Vitaphone 332
voyeurism 28, 231, 446–8; and gaze/look 159; and
Imaginary/Symbolic 200; and
Oedipal trajectory 262; and
scopophilia 318; and stars 355; and
thrillers 441

war films 65, 443, 449–62; Cold War 449, 459–62; Great War 449–52; Second World War 452–9; Vietnam 461–2

Warner Brothers 13, 143, 154, 333, 364, 365, 368–9 weepies: female 222; male 219

Western Electric 332, 334
Westerns 50, 85, 187; ambiguity in 10; Blacks in 470–1; and cinemascope 58; codes and conventions in 68; cross cuts in 78; editing in 95; epic 466, 473; and feminism 118; gender in 1; history of 462–74; iconography in 191–2, 464–5; Indians in 472–3; modern

468; and Oedipal trajectory 262; and sexuality 325; stereotypes in 358, 469

wipe 324, 474 women: as ageing stars 351–2; in Black African-American cinema 38, 47–8; and colour film 71–2; Doris Day factor 62; feminist theory 112–27; as femme fatale

Subject Index

130–1, 199; iconography of 192; and melodrama 218; as modern/liberated 225–6; myth of 167; and sexuality 326–7; as victim 141, 199–200; and Westerns 470 Women and Film collective 118 women's films: and counter-cinema 76; documentary 92; female

masochism 222–3; German 181–2, 181–3; and ideology 195; Latin American 432; Lebanese 434; and melodrama 213–26; paranoid 223 Woodfall Films 51–2, 144

Zagreb School 14 zoom 475